Carra Ferguson O'Meara

MONARCHY AND CONSENT

The Coronation Book of Charles V of France

British Library MS
Cotton Tiberius B. VIII

HARVEY MILLER PUBLISHERS

Contents

Preface

THIS STUDY began as an enquiry into the realism of the Parement Master. I was
particularly interested in the coincidence that the artist's earliest known work, the
Parement de Narbonne for which he is named, was executed at approximately the same time
(*c.* 1378) that its patron, Charles V of France, commissioned Nicole Oresme's *Livre du Ciel et
du Monde*, a translation and commentary of Aristotle's *De Caelo*. Because much in these
works pertains to the visual analysis of physical phenomena that are of direct concern to
the artist — e.g. perception of form in space and of various optical phenomena such as
perspective, angles of the radiation of light, refraction, reflection, cast shadows, the effects
of light on colour — I wondered whether the accessibility of these theories to the
francophone audience of Charles's court had any bearing on the art of the Parement
Master, whose works display a precocious understanding of these same physical
phenomena.

A research grant from the National Endowment for the Humanities gave me the oppor-
tunity to study most of the extant illustrated manuscripts from the library of Charles V that
are now scattered among libraries in numerous countries. While in Paris I benefited from
the generous assistance and advice of François Avril to whom I am greatly indebted. This
same grant also enabled me to examine relevant manuscripts in libraries in Belgium, Hol-
land, Germany, Switzerland, Italy and the Vatican. Having seen the most important sur-
viving manuscripts from Charles's library, I was unprepared for the revelation that
awaited me at the British Library where, for the first time, I saw the *Coronation Book*. Be-
cause the Master of the Coronation Book had been ignored or even disdained by critics, I
had not expected to find anything that would be of consequence for my investigation. But
as I studied the miniatures, I began to notice that, although somewhat awkward, these
paintings presented many of the stylistic and technical elements usually associated with
the Parement Master, despite being executed thirteen years before the latter's earliest
known work. Certainly the Master of the Coronation Book was not the Parement Master at
an early stage in his career, but it was obvious that the empirical realism associated with
the Parement Master neither originated with him nor with the relevant theoretical corpus
that had been made accessible by Nicole Oresme's translation. The question of the emer-
gence of an empirical approach to painting was far more complex than I had imagined and
it was especially perplexing to find these nascent efforts, not in a work that could be re-
lated in a direct way to the revival of Aristotelian physical science, but in what was consid-
ered to be a formulaic liturgical text.

It appeared to me that the Coronation Book was a key monument for Charles V, not
simply for his art patronage, but for his reign as a whole. As I probed more deeply into the
manuscript it became increasingly evident that the images and text were so interwoven as
to constitute the warp and woof of the same fabric. I found it impossible to limit my study
to the images alone, or even to a group of images, for it was plain that text and images were
developed together as part and parcel of the same programme. If the images and their real-

ism were to be understood, I had to learn as much as I could from the manuscript as a whole, for the text, the images and the structural support all presented an exceptional abundance of factual detail. The more closely I looked, the more I discovered, and even after so many years of studying this manuscript, I know that there remain many further avenues to explore.

As the Coronation Book identifies its patron, date, and a host of individual historical personages, my first task was to understand the precise historical context of the coronation of Charles V, to identify the individuals portrayed and to learn as much as possible about their role in that context. In the first chapter I set out to tell the story of the accession of Charles V and to expose the issues that I found to have a direct bearing on the text and the images. As I investigated the text and images I discovered that much of what they contained had not been explained by the secondary literature, and although reluctant, I felt that I could only arrive at a better understanding by identifying the sources and the meaning of the various textual and pictorial components. This obliged me to study the sacring ritual as it developed, not only in France, but also in England and Germany. In Chapter Two I present an overview of the development of the sacring rite as it contributed to the sources and ancestry of the rituals and images of the Coronation Book. In Chapters Three and Four the text and images of the Coronation Book are analysed in order to identify traditional elements and innovations. In Chapter Five findings are presented concerning the physical organization of images and text and the evidence contained in miniatures and script for the processes by which the illustrations were created. This analysis reveals the extent of the programmatic interrelationship of the images both to the text and to each other, and although it is in this chapter that the *modus operandi* of the Coronation Book Master emerges, a fuller consideration of his *oeuvre* is reserved for Chapter Six. This discussion provides many indications of the milieu to which the Master belonged and an in-depth investigation of this evidence is set forth in Chapter Seven. There, visual and documentary evidence is considered which, I hope, sheds new light on painters and painting at the court of Charles V and the relationship between artists, intellectual advisors and the king. In the course of this chapter evidence for the identity of the Parement Master is reviewed that supports the identification of this artist with Jean d'Orléans, *pictor regis* of Charles V, and the origins of his nascent empirical realism are elucidated.

At an early stage of this investigation I discussed my findings with Carl Nordenfalk who admonished me to 'stick with the Parement Master as publishers like beautiful works and you will never find a publisher for a study of a manuscript with all of those peculiar little people!'. Fortunately, I found in Elly Miller a publisher who saw the importance of the Coronation Book and its artist. Equally perceptively, she encouraged me to include the English and German background, rather than insisting that I narrow my scope. This allowed me to consider the interrelated histories of the French, English and German sacring rituals and, in so doing, to arrive at a more thorough grasp of the sources and meaning of the assembled rituals of the Coronation Book.

There are so many people who have been helpful. Anyone who embarks upon a study related to Charles V has a wealth of excellent scholarship with which to begin. Besides the still valuable founding work of Delachenal there are the numerous publications of

François Avril, Millard Meiss, Richard A. Jackson, Raymond Cazelles and Clare R. Sherman, the latter deserving special mention for her pioneering research into the interrelationship between images and texts. I am most indebted to the staff of the British Library for having graciously and generously facilitated my research over the years. I am particularly grateful to Janet Backhouse who went beyond the call of duty on many occasions and who carefully read an earlier version of my study and made many valuable suggestions. Michelle Brown desrves special mention for her generous assistance, in particular with some palaeographic problems. I also wish to thank Professor Gabrielle Spiegel of the Department of History of the Johns Hopkins University for her criticism and advice with the historical sections of my study. Throughout the years Dr Irene Vaslef, director of the Byzantine Library of Dumbarton Oaks, has facilitated my research by allowing me access to that excellent research library. Sarah Kane courageously took on the daunting task of editing my manuscript.

Georgetown University encouraged my research by awarding me two sabbatical leaves from my teaching responsibilities and a year's appointment as Distinguished Research Professor in Art History that enabled me to prepare my study for publication. Finally, I wish to express my love and gratitude to my daughter Alix, who has grown to adulthood with Charles V as a sibling, and above all to my husband Dominic who has been my faithful support throughout. I dedicate this book to the memory of my parents, Raymond and Margaret Ferguson.

The Author and Publishers wish to thank all Institutions, Museums and Libraries
who have made photographs available for reproduction in this volume.
Where captions to illustrations cite folio numbers only,
these always refer to the Coronation Book of Charles V, BL MS Cotton Tiberius B VIII.
Plate references throughout the text refer to the sequence of colour plates placed in Chapter 3
between pages 112 and 113. A full list of illustrations can be found on p. 357.

1. Colophon of Charles V, fol. 74v [pl. 39]

Introduction

*'Ce livre du sacre des Rois de france
est a nous Charles le Ve de notre nom
Roy de france et le fimes coriger
ordener escrire et istorier lan mccclxv
Charles'*

(British Library, MS Cotton Tiberius B. VIII, fol. 74v)

IN THE CATHEDRAL OF REIMS on Trinity Sunday, 19 May 1364, Charles V was consecrated and crowned king of France. He was the third king of the Valois line, a dynasty whose claims to the throne, contested by the kings of England and Navarre, were contributing causes of the Hundred Years War.[1] This war was a series of conflicts between France and England from 1337 to 1453 over issues of territorial jurisdiction and dynastic succession with repercussions involving the papacy, Flanders, Italy, Ireland, Scotland and the Holy Roman Empire.[2] Ruling France from 1364 until 1380, and as a close blood relative of many of the leading figures, Charles's reign is chronologically, politically and geographically central to the conflict.

The fragmentary documentary references to the sacre of Charles V and his queen, Jeanne de Bourbon, provide sketchy and occasionally conflicting testimony.[3] But the British Library possesses a witness of singular importance for this event, the Coronation Book of Charles V (Cotton Tiberius B. VIII), or as it is called in the above colophon written in the manuscript by Charles himself, the *livre du sacre des Rois de france*.[4] Although not specifically named in the body of the text, Charles is identified with the ceremony described in the manuscript by this colophon, which states that he ordered the manuscript 'to be compiled, corrected, transcribed and illustrated in 1365' (ill. 1).

Rarely is a work of medieval art anchored in its historic setting with this precision; the colophon places it in a specific moment in time while identifying the patron and testifying to the unprecedented personal involvement of a monarch with the compilation, presentation and illustration of a coronation ordo.[5] There can thus be little doubt of the deliberate intention to identify the ritual described in the manuscript with the coronation of Charles V and Jeanne de Bourbon.

The king's involvement in editing the manuscript and his authorship of its colophon, along with the precise dating to the year after his coronation, might not in themselves offer sufficient proof to identify the coronation ritual in the manuscript with his consecration. The most solid evidence for such an identification is provided by the cycle of thirty-eight miniatures (Colour plates 1–38) that depict the successive acts of the ceremony with precise historical detail and identify the principal participants through lifelike portraiture.[6] This deliberate historicity is reinforced by exacting attention to the physical description of other features such as costume, insignia, and armorials, that endow the illustrations with a degree of representational realism that is unprecedented in manuscript illumination and unsurpassed by any written source on the coronation of Charles V. Moreover the insistent

11

individuation injects another level of intention into the image, for not only do the miniatures serve to identify a particular historical event: they also provide an official account of the sacre of Charles V and Jeanne de Bourbon, how it was performed and who participated in it.

The first text in the Coronation Book (fol. 35–41)is an approximate and abbreviated French translation of a 'directory' or 'protocol' (a normative description of what is to be done) for the sacre of a king and queen, that was compiled for, and probably at, Reims *c.* 1230, around the beginning of the reign of St Louis.[7] This is followed by the Latin text of the coronation oath and a list of the ancient and the new peers of France (fols. 41v–42),[8] continuing with the major component of the manuscript, the complete Latin text of an '*ordo*' (plural '*ordines*', a collection of prayers, formularies, hymns and rubrics of a liturgical ritual) for the sacre of a king and a queen (fols. 43–71v) which has special importance in the history of royal liturgy.[9] For, although composed mostly of elements derived from a range of sources from different periods and regions — Carolingian, Spanish, English, Roman, German Imperial, and a compilation known as the Last Capetian Ordo — the unprecedented selection, arrangement, and comprehensiveness of its components distinguish it as a new ordo that has been called the 'Ordo of Charles V'.[10] Not only is this ordo richer and more comprehensive than any previous ordo in that it includes elements drawn from major royal ordines of the European past, but it is also a monument to tradition and a *summa* of ruler-making ritual characterized by its deliberate internationalism and historicity. As we will see, these references to the past were enhanced by significant innovations that redefined the meaning of kingship and paved the way for early modern monarchy.

Monarchy was the system by which power was embodied in the Middle Ages and the *sacre* was the quintessential medieval ceremony through which this power was conferred. Although often conjoined, 'sacre' and 'coronation' are two distinct ritual acts. The latter is the placement of an insignium of authority, the crown, on the head of the ruler to symbolize recognition of election to office. In itself the act of coronation is not constitutive, that is, it does not invest the ruler with the power or authority to rule, but merely recognizes the ruler's election. The sacre, however, is the constitutive and status-changing sacramental rite in which the ruler is anointed by a high prelate of the Church with sacred oils believed to be capable of transmitting the divine power, charisma, authority, and wisdom that are essential to rule.

Perhaps no ritual has been invested with greater importance for defining the political aspirations of a society than that for the inauguration of a ruler or head of state. An analysis of the images and ritual of the Coronation Book will reveal that this illustrated manuscript, the first to be commissioned by Charles V after his sacre, was not made to be a simple souvenir of the event. Rather, it delineated the premises of the monarchy that this ritual created, a kingship conceived as a ministerial office of secular and religious character that is shared with other members of society including the queen, the nobility, and the ecclesiastical hierarchy. The present study shows that the Coronation Book was commissioned to be a veritable blueprint for Charles's strategy to establish the sovereignty of the king of France in his kingdom and in relation to other spiritual and temporal rulers of Christendom.

This manuscript takes its readers to the frontier where the spiritual and temporal domains converge and interact. It is a multidiscipinary production of artists, scribes, litur-

gists, legists, and theologians, collaborating under the direction of the king himself, to formulate powerful political, theological and juridical notions and to give them visual expression in text, image and ritual. The Coronation Book opens a window onto the role of art and ritual for constructing political order, shaping consensus and resolving conflict in a period of political and economic upheaval. Despite its size and the fact that it is an illustrated manuscript, it is a work of monumental importance. More than a work of liturgy, art, and historiography, the Coronation Book was made to be an effective instrument of Charles's political programme, intended to chart the course of his reign by articulating an ordered vision of government to an elite ruling-class audience.

The ritual of the Coronation Book was designed to respond to the changing circumstances of the fourteenth century with consequential innovations in the procedure of ruler-making, as well as in the methods of manuscript illustration. The most original contribution, as it turns out, is the cycle of realistic miniatures.[11] In the exceptional instances when earlier ordines were illustrated, these were limited to decorative initials for particular prayers, scenes of biblical antetypes or selected acts of the ritual. Never had so many ritual acts been illustrated in a royal ordo. The miniatures of the Coronation Book appear to be, individually and as a cycle, visual counterparts of the text, but the relationship of images and text is very complex.[12] Most of the detail that appears in the miniatures is inspired by the text, yet portions of the text have not been illustrated. A considerable amount of detail in the images is not in the text at all: factual details about objects, setting and staging of the ceremony; numerous personages; and some entire miniatures have no textual counterpart whatsoever. This investigation will show that the miniatures constitute what is virtually a visual text that runs parallel to the written text, interacting with it somewhat like a gloss and commentary to constitute an intertextual, visual-verbal discourse that generates levels of meaning which transcend the purely textual content. As this is the original manuscript of the ordo, the present study will disclose that the text cannot be fully understood without the miniatures because those images are so integrally related to and actively involved with the text.

The intention to identify the ritual with a particular historical sacre called for a naturalistic and factual style of painting. The artist eschewed established models of manuscript illumination and developed new ruler-making imagery incorporating observed features of the participants, setting, and objects of a specific historical sacre. The lifelike portraits, which include profile, frontal and three-quarter views of individuals and groups, are forerunners of Northern Renaissance portraiture and key monuments in the development of the modern portrait.[13] Consistently directed at describing the physical objects and the setting of a contemporary event and the likenesses of the participants, the insistent actuality of this style could be described as historical realism, for indeed the historicity would have been impossible without this new approach to representation. We will see that the artist of the manuscript, known as the Master of the Coronation Book,[14] belongs to progressive currents of book illumination and official panel painting in the vanguard of an artistic and cultural renascence fostered by Charles throughout his reign. Although at first glance the Master's assiduously descriptive style may seem awkward and somewhat primitive when compared with later painting commissioned by the king's younger brothers John, duke of

Berry and Philip, duke of Burgundy, the empirical descripton of the objects of the physical world in the images of the Coronation Book broke ground for these later achievements.

As the manuscript was made in the year after Charles' and Jeanne de Bourbon's sacre, it must be emphasized that it is not the actual manuscript used on that occasion, a fact that complicates the question of the manuscript's intended function. It has been proposed that it was made to be used at the sacre of Charles's son and heir, Charles VI, but this must be ruled out for several reasons (see Epilogue), not least because the royal couple did not have a male heir until 1368. It has also been supposed that it was commissioned to be a souvenir of Charles's accession.[15] But one can reasonably say, even at the outset, that it was unlikely to have been a personal pictorial memoir, like a family album recording special moments in the lives of ordinary folk. For the family in question was the ruling dynasty of France, related, furthermore, to the ruling houses of England, Germany, Flanders, Milan, Castille and Navarre (see Genealogical Chart, pp. 20-21), and the special family event was the coming together of the magnates of this dynasty to participate in and witness the making of one of their own into a monarch. Such an event was inevitably fraught with political implications, and a book that meticulously records this event was not a personal matter if only because of the power of all of the individuals involved.

Readers are led through the itinerary of the sacre of Charles V and Jeanne de Bourbon by means of the illustrations which, in their episodic reconstruction of the successive acts of that rite, transport one through time and space to that event. The miniatures perpetually re-enact that ceremony, constantly renewing and reaffirming it. More important still, with their unmistakeable testimony of who did what on the occasion, the illustrations provide authoritative witness of the ceremony, and as such, are in a very practical way a record with legal implications, a point that will be considered later in this study.

The monarchy that is presented in the ritual and images of the Coronation Book departs in important ways from early medieval kingship. Not the least of these departures is that kingship is here shown to be the result of the consensual enactment of ritual process. The cycle of illustrations insists upon describing the terrestrial, material reality of that process as carried out by identified individuals at a specific moment in the setting of the cathedral of Reims. The personages who appear in the miniatures as participants in this ritual were living contemporaries. Although the enactment of a sacre inevitably makes history, because its ritual is composed of timeless symbolic formulations, it is essentially antithetical to the writing of history that recounts particular and accidental happenings in a specific time and place.[16] This intrinsic conflict between the universal and the particular was reconciled ingeniously by the artist through a skilful intermeshing of symbolic imagery and observed contemporary facts. The king and queen are not crowned by the hand of God, nor by Christ or a saint, as in most earlier depictions of ruler-making. No divine figures or saints participate, and integrity of historical time and place have been rigorously respected.

This is not to say that the divine has been excluded, for its presence is invoked by the detailed altarpieces and statuary that are depicted in the miniatures. And it is mystically present in the Eucharist, the relics which are specified by the text or depicted in the miniatures, and, most especially, by the Celestial Balm that is contained in a vial known as the *Sainte Ampoule* or Holy Ampulla. The workings of the supernatural are present in the transmis-

sion of real political power through the agency of this mysterious and miraculous substance, the heavenly unguent that, according to legend, was contained in the Sainte Ampoule sent by God to St Remi for the baptismal anointing of Clovis, who thus became the first Christian king of the Franks. The present analysis reveals that the Coronation Book was a kind of reliquary for the ritual of the Celestial Balm in its most authoritative form, as enacted at the sacre of Charles V and Jeanne de Bourbon.

It is noteworthy that the miniatures do not recount the legend of the Celestial Balm. References to the legendary account and the heavenly personages involved in it were unnecessary because the society that gathered at Reims accepted the heavenly origins of the balm and reaffirmed their belief in it by participating in this ritual. What is at issue is the precise relationship of the individuals assembled at Reims to this balm, and the miniatures spell out that relationship. The text and the illustrations affirm that the abbot and monks of the abbey of Saint-Remi are the recognized guardians of the balm who transport it from the abbey to the cathedral. The abbot of Saint-Remi transmits it to the archbishop of Reims who anoints the king with it. The miniatures demonstrate that the king is the only individual who is anointed with the Celestial Balm, and they show precisely how he is anointed.

It is generally assumed that the sacre centres on the figure of the king, but the text and illustrations of this manuscript delineate the construction of a corporate body politic in which the king is joined by other individuals whose presence defines and qualifies his position. Especially important are the queen, the archbishop of Reims, and certain nobles and representatives of the laity, all invested with unprecedented importance in an incorporated structure of power. The king created by the ritual of the Coronation Book is the central figure in a collegial monarchical body.

More than a quarter of the text and miniatures are devoted to the consecration and investiture of the queen who is involved in nearly twice the number of ritual acts than any previous queen.[17] This ordo goes further than any prior ordo to elevate the queen with respect to the king. The meaning of the king's ceremony is conditioned by the rituals and attributes that it shares, and differences that it presents, with the queen's. No previous king's rite was so qualified and conditioned by an accompanying queen's ceremony.

The miniatures also assign unprecedented prominence to the peers, the princes of the blood, and members of the secular nobility. The duke of Anjou appears in twenty-five of the illustrations in the role of seneschal bearing the king's sword, a prominence which is not justified by a text that merely mentions the optional nature of the seneschal and does not mention Anjou at all. The king's youngest brother Philip the Bold, duke of Burgundy, appears along with many other members of the secular nobility who have been identified by portraiture and heraldry.

By far the most important figure is Jean de Craon, archbishop of Reims, exalted throughout the text and images. Not only does he occupy the centre field in the majority of the scenes; he is usually the only member of the clergy singled out for identification through portrait likeness and armorials. Moreover, the episcopal see of Reims is further honoured because many of the ritual acts in the ceremony were derived from earlier compilations of the Pontifical of Reims; because the Coronation Book exalts the special powers of the Celestial Balm preserved at Reims; and because it gives the archbishop unpreceden-

15

ted importance where, for example, it calls for him alone to perform many of the rituals.

Together the ritual and images of this manuscript delineate the abstract political structure of the Crown of France. The ritual created this structure and the illustrations manifest it in clear and comprehensible visual terms. As a political ritual regarded by many as a sacrament of the Church, it is not enough that the sacre transforms the character of the individual spiritually: the spiritual changes that transform the individual into the ruler must be felt throughout the entire body politic. This is accomplished as much by the images as it is by the actual ritual, so that, as always, images are essential for the making of a monarch.

Through their historical realism and factuality, the thirty-eight miniatures of this manuscript provide an official account of the sacre of Charles V and Jeanne de Bourbon, of the ritual acts performed, and of the key actions of identified participants. By emphasizing particular king-making rituals borrowed from past royal consecrations, and by supplying information about how the ceremony was conducted, the illustrations present a carefully constructed argument for the efficacy and indelibility of the particular coronation rite performed at Reims on 19 May 1364, testifying to the thoroughness and the correctness with which the rite was carried out. They define in explicit visual terms the special sacerdotal and episcopal character of the French king who is transformed by the anointing with the Celestial Balm and the power of the Holy Spirit that it was believed to contain. Through this rite he becomes *rex* and *sacerdos*, and the text and images disclose the implications of the king's temporal and sacerdotal character. The ritual of the Coronation Book is the process that makes the *rex christianissimus*, successor to the sainted kings of his ancestral heritage, Clovis, Charlemagne, St Louis and others.

The manuscript presents one of the most comprehensive arguments in favour of the hereditary succession of the eldest son of the king of France, a concept that had been displaced at the time of the 'election' of the first Valois ruler, Charles's grandfather King Philip VI. Before the Carolingian period, Frankish kings had been elected by the secular magnates of the kingdom. When the last Merovingian king was deposed, the first Carolingian, Pippin, was anointed king of the Franks by Boniface on behalf of the Frankish episcopate, and election by the secular magnates was from that point gradually displaced by priestly anointing as the constitutive act in ruler-making.[18] From thence, in theory, the king was still elected, but the ecclesiastical hierarchy had imposed themselves as the principal electors. Moreover, the candidate for this 'election' was chosen according to an unwritten principle, a system of hereditary succession in which the oldest male offspring of the reigning king was the elect heir to the throne.[19]

The secular magnates did not again have an active and integral part in the elevation of a monarch until the thirteenth century with the very ceremony that is translated into French at the beginning of the Coronation Book, compiled at a time when the concept of elected monarchy had become the subject of renewed interest, mainly amongst some groups of intellectuals. At this time a serious challenge to the entire system of monarchy, whether hereditary or elective, was posed by newly-enfranchised elective assemblies and by some who advocated the radical notion of a democratic representative government elected, not by the peers, but by a citizenry, a Greco-Roman concept that had all but disappeared during the early Middle Ages.

The Ordo of Charles V contains a host of responses to these developments. Most importantly, it introduced segments that affirmed the principle of hereditary succession of the eldest son of the king and subtly reinterpreted traditional passages of the ritual which allude to election of the monarch. The text and images of the Coronation Book argue for the validity and indelibility of the consecration to kingship in the recitation of a particular version of the prayer *Sta et retine* explicitly affirming hereditary succession, recited after the imposition of the crown and before the enthronement while the peers surround the king and sustain the crown.[20] This act simultaneously affirms the principle of the succession of the king's eldest son and involves the peers of the realm in this affirmation.

The unprecedented importance given here to the queen strengthens the traditional role of a queen in a system of hereditary succession as the genetrix of the heir. But it also goes beyond the queen's traditional duty to produce an heir to invest her with vital responsibilities in the administration of the realm. Because the couple was childless at the time of their sacre, the miniatures give emphasis to the king's brothers, especially Louis duke of Anjou, who, until the birth of the future Charles VI, was the male heir apparent. Significantly, at the sacre of John the Good, Charles, as John's heir, had performed Anjou's role.[21] The present analysis suggests that the ritual of the Coronation Book was designed to assure the orderly transmission of power and its distribution to recognized representatives of segments of society, particularly by involving magnates of the great provincial apanages in the process of constituting the Crown.

A consequential innovation of the ritual of the Coronation Book is the insertion of a clause into the oath sworn by the king at the start of the ceremony in which he promises to defend the unity and inalienability of the 'Crown'. The implications of this clause as developed through the interaction of texts and images are considered, and it will be seen that the individual(s) who compiled the text sought to define an abstract and transcendent notion of a sovereign monarchy, distinct and separate from the person upon whose head the material crown was placed.

As the most comprehensive and authoritative of royal installation rituals, the manuscript is also a document for the history of medieval ruler-making, commissioned to be, as Charles V indicated in his colophon, 'the book of the consecration of the Kings of France', a model for future coronations founded on the precedents of history. The miniatures were designed to demonstrate that Charles was the rightful king of France who, consecrated according to the sacred, indelible ritual contained in this manuscript, had no superior on earth. In demonstrating, and indeed establishing, these propositions, the Coronation Book was nothing less than a charter for sovereignty. Comparable to a consecrated member of the clergy, it was anathema to assassinate him or to depose him from his divinely ordained office or *ministerium*. Only God was his sovereign. The political implications of the ritual of the Coronation Book went beyond sovereignty to lay the foundation for the construction of the divine right of kings. Painting, script, liturgy, law and history — all integral to the cultural and political programmes of Charles V — intersect in the first work that he commissioned as king. The manuscript thus provides a foundation stone for the cultural and political history of the reign of this king, as well as being an innovative creation in the history of art at the end of the Middle Ages and the beginning of the Renaissance.

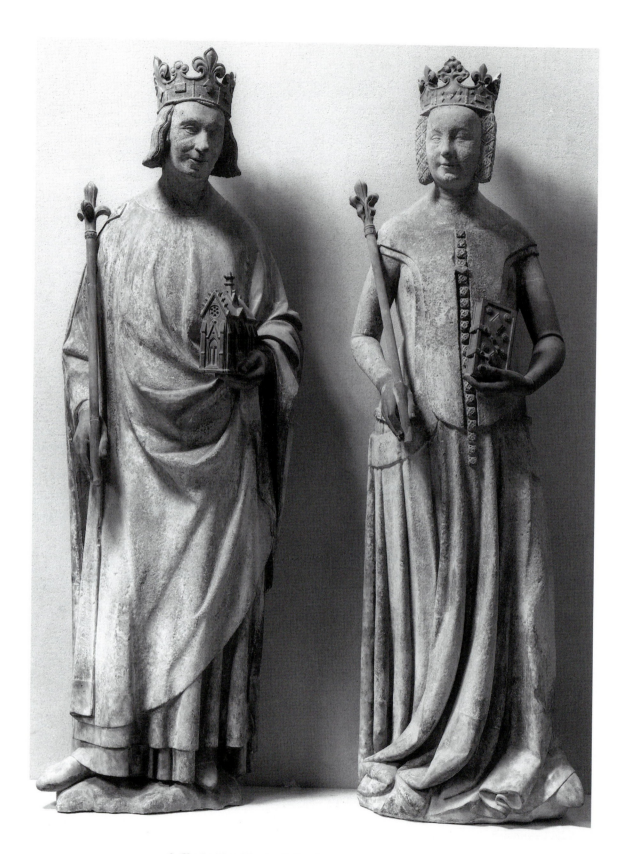

2. Charles V and Jeanne de Bourbon. Paris, Musée du Louvre

Chapter 1. The Historical Context
of the Coronation Book

T HE FOURTEENTH CENTURY was a period of transition between the Middle Ages and
the Renaissance, and the life of Charles V spans the middle of that century. He was a
ruler who was aware of his place in history and he was equally aware of his own capacity
to shape the course of history, not only through his deeds, but also through the patronage
of works of art and architecture which he used to guide the perceptions and aspirations of
his contemporaries. The present analysis of text and miniatures of the Coronation Book
reveals that the manuscript responds in precise ways to the changing circumstances that
challenged the French monarchy in the second half of the fourteenth century. In order to
understand how Charles sought to use the art and ritual of a single illustrated manuscript
as instruments for the construction of social and political order, it is essential to indicate at
the outset the historical circumstances to which the Coronation Book responds.

I. The Accession of Charles V

1. Charles V, Jeanne de Bourbon and the Dauphiné

Charles was born at the royal château of Vincennes on the feast of St Agnes, 21 January
1338, during the reign of his grandfather Philip VI, the first king of the Valois line. His
father was John II 'the good', who was duke of Normandy at the time of Charles's birth.
His mother was John's first wife, Bonne of Luxembourg, the daughter of King John 'the
Blind' of Bohemia and the sister of the Holy Roman Emperor Charles IV.[1]

When he was twelve years old Charles married Jeanne de Bourbon, the daughter of
Pierre I, duke of Bourbon and Isabeau of Valois, the half-sister of King Philip VI (ill. 2).
Jeanne was born at the château of Vincennes on 3 February 1338, a few days after Charles.
The couple were cousins (see Genealogical Chart), and their parents were related not only
by blood, but also by friendship and political alliance. Charles's parents were Jeanne's
godparents. Because of the couple's consanguinity and youth their union required a papal
dispensation. This was granted by Pope Clement VI in August 1349, and the marriage took
place on 8 April 1350 after the payment of Jeanne's dowry.[2] Because the text and images of
the Coronation Book give Jeanne de Bourbon greater importance than had ever been ac-
corded any previous queen in a royal accession rite, she is central to the present discussion.

Jeanne and Charles were not destined from the beginning for marriage, for in 1340
Philip VI had arranged for Jeanne to marry the count of Savoie, and in 1348 her father
promised her to the dauphin Humbert.[3] Between 1340 and 1349 the Valois sought to unite
the Dauphiné with the kingdom of France, and Clement VI was instrumental in realizing
this Valois objective.[4] At his urging, the dauphin Humbert, deeply indebted to the Holy
See, agreed to abdicate and convey the Dauphiné to the eldest son of the king of France on

GENEALOGICAL CHART

Philip II Augustus (1165-1223)
m. Isabelle of Hainaut

Louis VIII (1223-26)
m. Blanche of Castille

Louis IX (Saint Louis) 1226-70
m. Margaret of Provence

Philippe III (1270-85)
m. *1* - Isabelle of Aragon
m. *2* - Marie of Brabant

Margaret
m. John
Duke of Brabant

Pierre
Count of Alençon

Philip IV 'The Fair' (1286-1314)
m. Jeanne of Navarre

Charles of Valois
m. *1* - Margaret of Anjou-Sicily
m. *2* - Catherine of Courtenay
m. *3* - Mahaut of Châtillon St. Pol

Margaret of France
m. Edward I
King of England
(1239-1307)

Edward II
m. Isabelle of France

Jeanne d'Ev
m. Charles

Blanche of F
m. Philip
Duke of Or

Louis X
(1315-16)
m. Margaret
of Burgundy
(repudiated)
m. Clemence
of Hungary

Philip V
1316-22
m. Jeanne of
Burgundy
|
4 daughters

Charles IV
1322-28
m. *3* - Jeanne
d'Evreux
|
Blanche of
France
m. Philip
Duke of Orléans
(brother of
John 'The Good')

Isabelle
m. Edward II
King of
England
|
Edward III
King of
England

Blanche
m. Charles IV
of Luxembourg

Isabelle
m. Pierre I
of Bourbon

John I
'The Posthumous'
Nov. 15-19, 1316

Philip VI
(1328-50)
m. *1* - Jeanne of Burgundy
m. *2* - Blanche of Navarre

Charles of
Alençon

Jeanne of Navarre
m. Philip of Evreux

Charles 'The Bad'
King of Navarre
m. Jeanne of France

Blanche of Navarre
m. Philip VI
of Valois

John II 'The Good'
(1350-64)
m. *1* - Bonne of Luxembourg
m. *2* - Jeanne of Boulogne

Philip Duke of Orléans
m. Blanche of France
(daughter of Jeanne d'Evreux)

Jeanne of France

Charles V
(1364-80)
m. Jeanne of Bourbon

Louis
Duke of Anjou
m. Marie of Blois
hairess of Charles
of Blois,
Duke of Brittany

Jean
Duke of Berry

Philip 'The Bold
Duke of Burgund
m. Margaret of Flan

John the Fearles

Philip 'The Good

Charles 'The Bold

Mary of Burgund

Charles VI
(1380-1422)
m. Isabeau of Bavaria

Louis
Duke of Orléans
m. Valentina Visconti

Charles VII
m. Marie d'Anjou
|
Louis XI
m. *1* - Margaret of Scotland
m. *2* - Charlotte of Savoie

Charles,
Duke of Orléans

Robert I
unt of Artois
ne of Artois)

Alphonse of Poitiers
m. Jeanne
Countess of Toulouse

Charles of Anjou
m. Beatrice of Provence

Angevin
Kings of Naples and Sicily

Blanche of France
m. Ferdinand of la Cerda
infant of Castille

Jean Tristan
(heir of Valois)
m. Yolande of Nevers

Agnes of France
m. Robert
Duke of Burgundy

Robert of Clermont
m. Beatrix of Bourbon

uis of Evreux
Margaret Artois

Alphonse
of Lunel

Ferdinand
of la Cerda

Last Capetain
Dukes of
Burgundy

Margaret of
Burgundy
m. Louis X

Jeanne of Burgundy
m. Philip VI
of Valois

Louis I of Bourbon
m. Marie of Hainaut

arles of Evreux
Marie of Spain

Marie of
Spain

Louis II
unt of Evreux

Philip of Evreux
m. Jeanne of Navarre

Pierre I
Duke of Bourbon
m. Isabelle of Valois
(half sister of Philip VI)

Jacques of Bourbon
m. Jeanne of
Châtillon St. Pol

Beatrix of Bourbon
m. John of Luxembourg
King of Bohemia

Charles
'The Bad'
King of Navarre

Blanche

Jeanne of Bourbon
m. Charles V

Louis II
Duke of Bourbon

Bonne of Luxembourg
m. John II 'The Good'
King of France

Charles IV
of Luxembourg
Emperor of
the Romans
m. Blanche
of Valois

Charles V of France

Jeanne
n. Guillaume
of Hainaut

Margaret
m. Guy de Châtillon
Count of Blois

Philippa
n. Edward III
ng of England

Charles of Blois,
Duke of Brittany

Marie of Blois
m. Louis of Anjou

Jeanne
of France
m. Charles of
Navarre

Marie of France
m. Robert
Duke of Bar

Isabelle of France
m. Giangaleazzo
Visconti
Duke of Milan

Valentina Visconti
m. Louis Duke of
Orleans
(son of Charles V)

the payment of a sum of money.[5] In 1349, when the Dauphiné was in the process of being transferred to the Valois, Jeanne was betrothed to Charles and Pierre de Bourbon promised a dowry of 100,000 florins, conveyed to Humbert as compensation for the Dauphiné.[6] Humbert relinquished his lands and title upon receipt of this payment and he entered the Dominican order. The Dauphiné was transmitted to the eldest son of the king of France, and two months before his marriage Charles became the first dauphin of France.[7]

In this union, Jeanne's heritage was at least as important as her dowry (see Genealogical Chart). She was a direct descendant of St Louis on both maternal and paternal sides: her father was the grandson of Robert of Clermont, a son of Louis IX, and her maternal grandfather was another grandson of Louis IX, Charles count of Valois. Charles's descent from St Louis was more remote, deriving only from his paternal great-grandfather Charles of Valois.[8] Jeanne's direct descent from the Capetian royal saint was a valuable asset that united the blood of the Valois with that of this sainted royal progenitor.[9] Marriage was a practical means of constructing alliances between families and territories alike, and that of Charles and Jeanne solidified the bonds between the Valois rulers and the Bourbon dukes who controlled the territories along the southwestern frontier with the English-held feudal domains of Guyenne and Gascony. Equally important, Jeanne was the niece of Beatrix de Bourbon, the wife of King John of Bohemia and the mother of Bonne of Luxembourg and the Emperor Charles IV. In one stroke this marriage wove a web of alliances unifying the Bourbonais, the Auvergne, and the Dauphiné to France and strengthening the bonds of family and friendship between the Valois and the Holy Roman Empire. Marriage to Jeanne brought financial resources, created political alliances necessary for annexing the Dauphiné to the kingdom, and reinforced the ties of the Valois to the sainted blood of St Louis.

2. The Crisis of Valois Succession

At the time of his marriage, it was far from certain that Charles would succeed to the throne. Since the accession of Philip VI Valois, the principle of hereditary succession of a king's eldest male heir was no longer universally accepted (for reasons to be discussed presently), and there were other contenders to the throne, notably the kings of England and Navarre. Any consideration of Charles V and fourteenth-century France involves the question of succession which was one of the most significant determinants for French history during the last three quarters of the fourteenth century.[10] It is a central issue for the Coronation Book.

For several centuries the Capetians had consistently produced a male heir, allowing them to advance the notion that God himself willed the kingship of the Capetian dynasty by regularly assuring the birth of a male successor. Indeed, Philip Augustus and Philip IV the Fair used this theme in a programmatic effort to sacralize the Capetian dynasty as a *christianissimum genus*, a sacred blood line.[11]

Beginning in 1316 succession became a recurrent problem for the Capetians: the death of Louis X, the eldest son and heir of Philip IV, meant that for the first time in centuries a reigning French monarch had died without a male heir. An exceptional set of circumstances attended the succession of Louis X who, at the time of his death, had a young

daughter from his first wife, and his second wife, Clemence of Hungary, was awaiting the birth of a child. An assembly of barons met and decided that if Clemence gave birth to a boy, Louis's brother Philip V would be regent until the age of majority of the child. The baby was a boy, John I, who lived only five days, a contingency unforseen by the assembly.[12] Early in 1317, before the guardians of Louis X's young daughter by his first wife could advance her claims, Louis's brother Philip V had himself and his wife, Jeanne de Bourgogne, consecrated and crowned. By any measure Philip V's accession was in a juridical grey area: in passing over the daughter of Louis X, the accession represented a break with feudal law which recognized the rights of women to inherit; and, for obvious reasons, it could not conform with established Capetian precedents of royal succession by the eldest male offspring of the king. To forestall potential objections to the problematic legality of his action, Philip convened an assembly of princes, barons, and prelates, and to broaden support and reinforce the authority of the decision of the assembly, he included representatives of the bourgeoisie and a panel of doctors of the University of Paris. This assembly decided in favour of Philip's kingship.[13] At this point female heirs had not been officially excluded from succession to the throne of France on the basis of any recognized legal precedent.[14]

In 1322 Philip V died without a male heir, and, following the precedent established in 1316, the third and last son of Philip the Fair, Charles IV, became king. But in 1328 he died without a male heir, leaving his third wife, Jeanne d'Evreux, in her seventh month of pregnancy. Before his death Charles IV had designated his first cousin, Philip, count of Valois to be regent if the infant was male, but if female, he instructed the peers and barons to meet and award the crown to 'the candidate who had the right to it'.[15] Following the precedent of 1316–17, an assembly decided that if the queen gave birth to a boy, Philip of Valois would remain regent until the child reached majority, but in the event that she gave birth to a girl, he would ascend to the throne. Philip of Valois assumed the regency to await the delivery of the queen, and when she gave birth to a daughter, Philip of Valois became the first king of the Valois line.[16] Technically, Philip ascended the throne through an elective decision of an assembly, but his candidature was founded on the fact that, as the son of Charles of Valois who was the brother of Philip the Fair, he was the closest living male relative of Charles IV (see Genealogical Chart).

The assembly that met to settle the succession of Charles IV passed over the fourth child of Philip the Fair, a daughter, Isabel, married to King Edward II of England and mother of another king of England, Edward III.[17] They also passed over Jeanne, the daughter of Louis X and his first wife, and Blanche, the newborn daughter of Charles IV and Jeanne d'Evreux.[18] The assembly did not explicitly reject the right of women under feudal law to inherit a domain, and the exclusion of these princesses thus posed a serious legal dilemma. Although women had the right under feudal law to inherit a domain, was a kingdom a feudal territory that could be inherited? At a time when the kingdom was evolving from a relatively small realm consisting largely of Capetian-held fiefs to a sovereign nation composed of a multiplicity of annexed territories, royal rules of succession had not been established to allow for a clear and unambiguous ruling.

Although Philip had been duly elected by an assembly of peers and representatives of the French nobility who were counselled by university doctors, his authority rested upon

the continued authority of that election as much as it did upon the acceptance of the notion that the anointing of the king was an irrevocable and indelible sacrament of the Church. Despite the legitimacy of Philip's election to the throne, inherent in this election was the potential for his authority to be challenged, and it was only a matter of time before these challenges arose, the most serious of them presented by the kings of England and Navarre and their partisans in France.

Edward III had a special status in this context, for, according to the provisions of the Treaty of Paris of 1259 between Henry III and Louis IX, the king of England was a vassal of the king of France for Gascony and much of Guyenne, domains inherited by the Plantagenets ultimately from Eleanor of Aquitaine.[19] The terms of the treaty obliged him to swear liege homage to the king of France for these domains, just as his ancestors had done. In the feudal alliance a vassal was subordinate to his lord and was bound by solemn oath not to take up arms against him. The issue of liege homage was always a bone of contention between the successors of Louis IX and Henry III, particularly because it presented the problematic subordination of one sovereign monarch to another, a situation contested at every opportunity by Edward who stubbornly held back from making full liege homage to the king of France.[20] When Philip VI (ill. 3) asserted his feudal sovereignty by confiscating English-held possessions in Guyenne, Edward III responded by declaring that he, and not Philip VI, was the rightful king of France. The ensuing war which lasted thirteen years, until the accession of Philip's son John II, was the first phase of the Hundred Years War.[21]

An unsettled issue was whether a woman could transmit rights of inheritance to her son, even though most, if not all authorities, agreed that she herself had no right to succeed to the throne of France. Edward III rejected the legal grounds for the rulings that a woman neither inherits nor transmits the right to inherit the throne of France. After all, if the king of France was enforcing his feudal rights in Guyenne, why should he not turn the tables on Philip and assert his feudal claims to inherit in France (as the eldest son of Isabel, the only living heir of Philip IV)? The ability of a woman to succeed and to transmit the right to succeed remained at the centre of the conflict between France and England for the rest of the century.

The assembly that elected Philip VI of Valois had settled only the question of the succession of Charles IV, the last Capetian of direct male descent, and had not ruled on the succession of Philip VI, leaving an opening for other contenders to assert their claims. There is every indication that the succession of Philip VI's son, John the Good, was not regarded by contemporaries as inevitable, that the election of Philip of Valois was not universally accepted as the permanent substitution of the Valois line for the Capetian, and that many contemporaries no longer viewed the principle of succession by primogeniture as the rule of the realm. One of the most eloquent testimonies is given by St Brigitte of Sweden in her *Revelations*, where she wrote that the Virgin Mary appeared to her and declared that

> although Edward III is the closest to the throne, it is nevertheless true that Philip of Valois was *loyally chosen by his electors*, incited to this choice, some by fear of England, others by their ignorance of the rights of Edward III, others finally by the promise of favours, and that the *regularity of this election* gives to the Valois the right of remaining on the throne *during his lifetime* (emphasis is mine).[22]

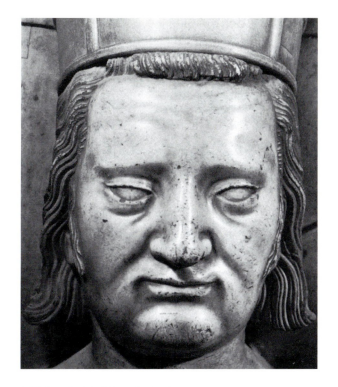

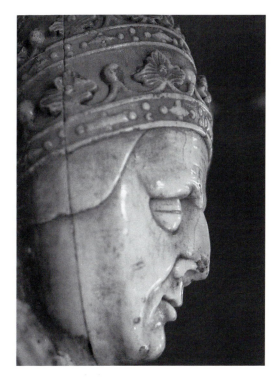

3. Philip VI. Detail from the tomb
in the Cathedral of Saint-Denis

4. Clement VI. Detail from the tomb
in the Abbey of La Chaise-Dieu

This statement testifies to the acceptance on the part of some, in this case one of the most influential individuals of the time, of the notion that election carries greater authority than hereditary succession. Furthermore, it indirectly recognizes the sanctity and indelibility of royal anointing and the power of the clergy to consecrate, for St Brigitte does not admit of any possibility of challenging or deposing a duly elected and consecrated king during his lifetime.[23]

Philip VI made several gestures in the direction of reinstating hereditary succession: in 1333, when he had his barons swear to recognize his son John as king in the event of his death, and when he wrote in an act that 'our very dear son John of France, who, after our decease, when God so pleases, *must* be king of France'.[24] But in 1344 he softened his stance in an act in which he referred to his elder son as the 'nearest to the succession of the kingdom', merely indicating his elder son's primary position in succession.[25] More importantly, there is evidence of active resistance, not the least being the armed attempt to prevent the coronation of John the Good made upon the death of Philip VI on 22 August 1350. At that time, Edward III and his army sought to join partisans waiting in France to assist him to be crowned at Reims, but he was stopped on 29 August by a Castilian fleet supporting John the Good, who went on to Reims to be crowned.[26]

We have already noted the instrumental part played by Clement VI in the annexation of the Dauphiné to the kingdom of France. The former Pierre Roger made his career in the service of the Valois (ill. 4). At the behest of Pope John XXII, the chancellor of the University of Paris conferred a doctorate in theology on Pierre as well as a chair and licence to

teach theology. As a member of the theology faculty of the University of Paris, it is probable that he participated in the assembly that elected Philip VI, whom he served in various
capacities, as counsellor, as ambassador to the papal see in Avignon and to the court in
England, and perhaps also as chancellor. Pierre was consecrated archbishop of Sens in
1329, and in the following year he was made archbishop of Rouen. He was instrumental in
bringing about the homage of Edward III to Philip VI for Gascony. His loyalty to the
French cause was expressed without equivocation in 1338, the year of Charles's birth,
when he delivered a sermon on behalf of the king of France to 'encourage men of arms
against the English'. Although his theological works have received little scholarly attention, his writings include a treatise on the rights and liberties of the French Church and another defending the terrestrial authority of kings. In 1338 he became a cardinal and in 1342
he was elected to the papal see. As pope he was the first to write to John II to recognize his
accession, and he simultaneously wrote to the king of England to exhort him likewise to
recognize John's kingship.[27]

Throughout the reign of John the Good (ill. 5), Edward III continued to press his claims
to the throne of France.[28] The situation became even more dangerous when the son of the
disinherited Jeanne of Navarre, Charles, King of Navarre, reached majority and asserted
his claims to the French throne. In the absence of universally accepted laws of succession,
if the dauphin was going to succeed to the throne he needed partisans to support him.[29]
This created a dangerous potential for factions to use opposing claimants to further their
own interests. The bourgeoisie and the artisans of various cities, minor nobility, and entrenched classes of royal administrators supported one claimant or another. The result
was that disorder reigned and the door to anarchy was opened.

The dispute over the exclusion of three female heiresses at the accession of Philip of
Valois needed a valid legal basis in order to be resolved. Arguments founded on biblical
precedents were presented as were newly defined arguments that asserted that the sacred
kingdom of France with its sacerdotal kingship was too great a dignity for a woman to inherit.[30] Eventually the Valois rediscovered a redaction of the Salic Law of the Franks that
had been revised at the court of Charlemagne containing an article that excluded women
from inheriting Salic land [*De terra salica, nulla portio hereditatis mulieri veniat, sed ad virilem
sexum tota terrae hereditatis perveniat*].[31] Although this law was not expressly cited at the accession of Philip VI of Valois, during the reigns of the first three Valois kings the exclusion
of women from the throne of France was progressively developed into a doctrine.[32] One of
the earliest citations is a copy of a translation of the *Echecs moralisés* of Jacques de Cessoles
made between 1337 and 1350 by Jean de Vignay for John the Good, then duke of Normandy.[33] According to Colette Beaune, the Salic Law was not elevated into a rule of succession until the reign of Charles V for whom numerous works were commissioned that
specifically cite it to defend the exclusion of women from the throne of France.[34]

A recurrent theme in French politics since the reform ordinances of Charlemagne had
been the ideal of the reform of the kingdom,[35] and some of the most influential contemporary partisans of reform are portrayed in the miniatures of the Coronation Book. Among
the most important of these is Jean de Craon, archbishop of Reims,[36] although others who
were not especially known for their support of reform are also present, such as Geoffroy

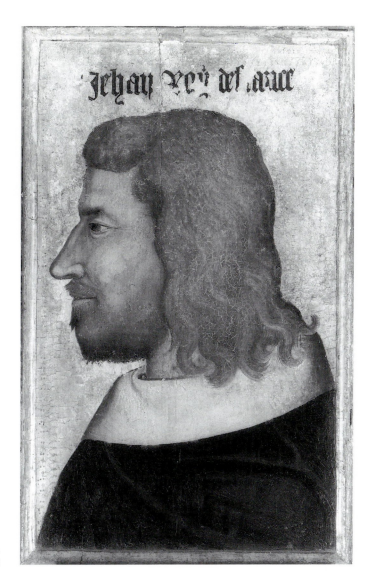

5. Portrait of John the Good.
Paris, Musée du Louvre

Le Meingre, bishop of Laon and brother of the maréchal de Boucicaut Jean Le Meingre, and Jean de Dormans, archbishop of Beauvais. The goal of the reformers was to establish peace and prosperity which necessitated a stable currency, a means to prevent the monarch from alienating domains of the kingdom, and a resolution of the problem of succession.[37] Some of the reformers defended the principle of election of the king and others supported the principle of hereditary succession. The debate took various forms. Because of the complexity of the legal issues involved and because the legal positions were often written in Latin, they were inaccessible to entire classes of potential partisans, especially non-clerical peers, the aristocracy and the bourgeoisie. To reach a wider audience, the arguments were translated into the vernacular, advanced in the form of poetry or song, and they were presented in visual form in illustrated manuscripts, paintings and sculpture. We will see that through the particular combination of French and Latin texts, images and ritual, the Coronation Book develops a network of arguments that defend the principle that the only eligible candidate for anointing with the Celestial Balm is the eldest son of the king of France.

27

3. From Poitiers to Reims: the Struggle for the Crown of France

Philip VI and John the Good had taken measures to strengthen Charles's prospects of succeeding to the throne. These included obtaining the Dauphiné for the young prince, arranging his marriage to Jeanne de Bourbon,[38] and investing him with the duchy of Normandy in 1356.[39] But everything was thrown into doubt after the battle of Poitiers on 19 September 1356, when the English army led by the Black Prince defeated the French army led by John the Good. Many of the most prominent nobles of France were killed or, like John the Good, captured and held for what was literally a king's ransom. The ensuing disorder is one of the most desperate chapters in French history, and when one surveys the aftermath of the battle of Poitiers it seems almost miraculous that Charles managed to chart a course through the perils to reach his coronation at Reims in 1364.

The defeat at Poitiers of the French king and nobility left the kingdom of France in a shambles politically, economically, materially, and morally. The most immediate and dangerous result of the débâcle was that it unleashed a vicious internal conflict involving assassinations, mass murder, pillage, private wars, banditry, treason, peasant and popular uprisings, reprisals, famine, and plague. The eight year period between the battle of Poitiers and the accession of Charles V is a case study in mayhem. Although Charles eventually succeeded to the throne according to the principle of hereditary succession of the first son of the king, he earned that right by demonstrating exceptional ability and moral stature through consistent adherence to the principles of law and by rising above the narrow pursuit of personal interests of inheritance. Charles's coronation at Reims is a testimony to the pragmatic value of endurance, judicious action, restraint, and unwavering loyalty to ideals and partisans. Through this troubled period Charles was the only contender to the throne whose actions appear to have been guided by a constructive vision. In the long run even his enemies knew that he was the only candidate whom they could trust.

If the eighteen-year-old dauphin managed to avoid death and capture by fleeing the battlefield at Poitiers, it was not out of cowardice but the ability to evaluate a set of circumstances and to identify the best course of action. A few days after the battle the prince entered Paris and took the title 'lieutenant of the king' in a first step to substitute himself for his captured father. John the Good had failed to designate a lieutenant so that, in the absence of the king and his counsel, there was no legally invested head of government.[40] In October a general assembly of the Estates was called at which Jean de Craon spoke for the clergy, Philip, duke of Orléans, the brother of John II, spoke for the nobility, and Etienne Marcel, provost of the merchants of Paris, spoke for the cities.[41] With the support of the Estates, Charles assumed the official titles 'first born son of the king of France' and 'heir', implicitly declaring his right to succeed through primogeniture.[42] And although that may have been his ultimate objective, at this desperate moment it is probable that the Estates were less concerned with assuring the dauphin's eventual succession than with investing an individual with the authority to govern, and in the circumstances these titles could achieve just that. The first official reference to Charles as *'ainsné fils du Roy de France ...'* occurs in the Journal of the meeting of the Estates General in Paris in October 1356, and by thus referring to the dauphin, the Estates were the first to recognize the prince's position as

the eldest son of the king as a justification for vesting him with the government of the kingdom of France in the absence of the king.[43]

Although this meeting of the Estates gives the appearance of cooperation and solidarity, there was a treacherous struggle between the provincial nobility and the urban bourgeoisie led by Paris, both factions seeking to control the dauphin, and through him, the kingdom. On 3 March 1357 the Estates passed an ordinance which, amongst its many articles, imposed taxes on the revenues of the nobility and the clergy, raised an army from the inhabitants of the cities, established a stable gold and silver coinage, and ordered the suspension of the royal officers who had been collecting taxes on behalf of the king. If this was not, as some have claimed, the replacement of a monarchy by a republic, it did represent a move in the direction of a monarchy limited by an elected assembly.[44]

Late in 1357 the bourgeoisie of Paris and some northern cities such as Amiens and Laon aligned themselves with the dauphin's rival for succession, Charles of Navarre. The latter, imprisoned for the brutal murder of the *connétable* of France, Charles of Spain, was liberated.[45] By early January 1358, with the duke of Orléans at his side, and advised by his chancellor Jean de Dormans, the dauphin announced his intention to govern and to assume responsibility for taxation. This was in open defiance of Marcel and his bourgeois partisans.[46]

The dauphin's declaration unleashed a contest the viciousness of which is revealed by the author of the *Grandes Chroniques* who recounts the incident during which Marcel and a group of his partisans broke into the dauphin's chambers in the Palais de la Cité, and, with the terrorized prince looking on, brutally slaughtered Jean de Conflans, maréchal of Champagne, and Robert of Clermont, maréchal of Normandy. For a brief period the dauphin fell into the hands of Marcel and his party, but this incident was a rallying point for the nobility, particularly that of Champagne, Normandy and the Dauphiné.[47]

By 14 March 1358, after the deliberation of the Grand Conseil with the prelates, barons and the bourgeoisie of the cities, Charles announced his decision to use the title of *régent du royaume* and to exercise 'royal authority' and the 'government of the kingdom'.[48] He met the Estates of Champagne who promised him money, material, and men of arms. In a movement of solidarity their aim was to avenge the murder of their maréchal, Jean de Conflans. From then on the Champenois remained the core of Charles's support.[49] This was a turning point for the prince, and now the provincial nobility increasingly moved into his camp to support him with financial and legal assistance. Finding the means to impose order and authority, rather than pursuing his personal rights of inheritance, continued to be Charles's foremost concern.

Sporadic waves of violence disrupted the river and land routes of the kingdom, bringing commerce and agriculture to a halt. There were numerous private wars in the provinces and an outbreak of peasant violence, the so-called Jacquerie, probably fomented by Marcel, spread terror amongst the minor nobility around Paris.[50] During this period Marcel convinced Parisians to extend and reinforce the walls of Paris to defend the city. The Parisians made the fatal mistake of electing Charles of Navarre to be 'captain of the kingdom',[51] and some proposed electing him king of France.[52] The Parisians had hoped that he would defend them, but Navarre, usually his own worst enemy, gathered companies of English mercenaries (many recruited from the same bands against whom the Parisians

had rebuilt their walls) and installed them inside the walls of Paris, ostensibly for the defence of the city.[53] Thirty-four of these mercenaries were massacred by the Parisians during a tavern brawl, and the comrades of the murdered mercenaries avenged these deaths by slaughtering an army of Parisian artisans. Now in total disarray, the Parisians vented their anger by murdering Marcel and executing the *echevin* of merchants, Charles Toussac, and another leader of the commune, the goldsmith Josseran de Macon. Learning of this turn of events, Charles of Navarre fled Paris and sought refuge at Saint-Denis as the Parisians went on bended knees to the dauphin promising him their support.[54]

In the meantime John the Good negotiated a treaty with Edward III in which he agreed to cede to the English king nothing less than full sovereignty over the western half of the kingdom of France from Normandy to Guyenne, including the Limousin, Saintonge, Angoumois, Poitou, Perigord, Agenais, Quercy, Touraine, Anjou, Ponthieu, Maine, the vicounty of Montreuil, and Calais, as well as an exorbitant ransom in gold. This Treaty of London was unanimously rejected by the Estates, so at the very least it unified the various factions, if only temporarily.[55] However, this rejection was a declaration of war, and in order to prepare for it, Charles made peace with the king of Navarre and the provincial Estates voted financial support.[56]

For the remainder of John's captivity, Charles continued to demonstrate his capacity to govern while building support for his succession, especially amongst the nobility and the provincial clergy.[57] The dauphin's actions must be understood in the context of his circle of counsellors, who included Jean de Dormans, bishop of Beauvais, Jean de Craon, archbishop of Reims, his uncle Philip, duke of Orléans, and Charles of Blois, duke of Brittany. Late in 1359 and early in 1360 Edward III led his army in a charge from Calais to Reims. As regent, Charles had written to the city the preceding year warning them to prepare for such an event. Jean de Craon led the city in fortifying the walls, laying in provisions and even destroying anything in the countryside that might be of use to an enemy army. Edward's siege was unsuccessful. Did Edward choose Reims because he intended to have himself crowned?[58] The archbishop was his cousin, and Edward may have been counting on him to open the city to him and perhaps even consecrate him as king of France. In retrospect it may seem far-fetched, but Edward was ambitious, and it is symptomatic that during this period the Black Prince referred to himself as 'son of the noble king of France and England'.[59] If Edward had believed that Reims would receive him as king, he was mistaken, because the city and the archbishop refused to open the gates of Reims and Edward was obliged to move on to less-prepared Burgundy before unsuccessfully laying siege to Paris.[60]

Had he planned to become king, his destructive campaign through France eroded any support he may have had amongst his potential subjects. His campaign of siege and plunder was a military and moral failure, and now Edward was prepared to negotiate. The outcome was the Treaty of Bretigny, signed in May 1360, which was almost as humiliating for the French as the Treaty of London, although a slightly reduced ransom was agreed upon and the territories to be ceded were somewhat less extensive. The king of France renounced sovereignty over the duchy of Aquitaine including Poitou, the Limousin, Perigord, Quercy, Saintonge, Angoumois, Rouergue, Agenais, the Marche, the Counties of Ponthieu, Guines, and the city of Calais. The troublesome question of homage for

Guyenne was couched in ambiguous terms that left Edward with the opportunity to reinterpret his status as vassal of the king of France.[61] For all of this Edward III vowed to rid Normandy of the companies of English mercenaries who had been disrupting the countryside. And he promised to release John the Good in exchange for a host of John's close relatives as hostages, including two of his sons, Louis, then count of Anjou, John, who lost his title to the county of Poitou (and was later compensated with the Berry), his brother Philip, duke of Orléans, and his cousins Louis, duke of Bourbon, Pierre d'Alençon, Jean d'Evreux, and others. In a few strokes of the pen John the Good signed away a considerable portion of the kingdom and agreed to send into captivity the cream of French nobility. Moreover, the people of France were indentured to pay an enormous sum in gold without having been consulted. For nearly a century French jurists had been advancing the principle of *quod omnes tangit*, according to which those who are affected by a decision must be consulted and give their consent.[62] The advances of a century in the direction of representation and sovereignty were set aside by the terms of the Treaty of Bretigny.

Upon the return of John to France, the Treaty of Bretigny was announced. John's government was dominated by the archbishop of Sens and others who had been with John throughout his captivity, Charles and his counsellors being excluded from the royal government.[63] Edward did not fulfil his promise to evacuate the companies of mercenaries and troubles continued in Normandy. Plague recurred during this period and a succession of very cold winters resulted in crop failures. The North was depleted and the companies of mercenaries expanded their activity of pillaging to the wealthier South in Languedoc and the region of Avignon. Amidst all of these problems the pope convinced John to go on a crusade, which had the immediate benefit of allowing the king to levy an important tax on the clergy.[64] John was becoming less popular with his subjects than either Edward III or the king of Navarre.

Although excluded from his father's government, Charles persisted in his efforts to gather support. Throughout this period he used the title *Karolus primogenitus regis Francorum*.[65] Petrarch referred to him as *regem christianissimum primogenitumque ejus illustrem Normanorum ducem ardentissimi spiritus adolescentem*.[66] A dramatic turning point occurred in December 1361 in the house of Guillaume de Machaut at Reims, when Charles made one of the strongest assertions of his right to succeed on the principle of primogeniture. The bourgeoisie of Reims had been engaged in a conflict with the archbishop Jean de Craon over a range of issues, including a dispute over payments that they had refused to make to the archbishop for the defence of the city (for the walls that had proven so effective against Edward). Charles attempted to convince the inhabitants to give in to their archbishop's requests. Upon hearing of their refusal '... the duke [of Normandy] responded ... to the *echevins* that they had little understanding of his person ... who is the first born son of the king and heir'. On the following day the bourgeoisie of Reims apologized to the prince and accepted his position, recognizing that 'the discord touches the right and heritage of the king ... as his right and his heritage are yours as his eldest son to succeed to the Crown of France'.[67] This was the first official recognition of Charles's right to succeed, and it was the beginning of a long alliance between the people of Reims and the prince which would culminate three years later in his sacre at Reims.

6. Bertrand du Guesclin. Detail from the tomb in the Cathedral of Saint-Denis

From 1362 Charles had the benefit of the brilliant military strategy of Bertrand du Guesclin (ill. 6) who remained with him until the end of his reign.[68] That same year he concluded a treaty with Edward III for the release of some of the hostages exchanged for his father and a reduced ransom was agreed upon.[69] Still estranged from John's government, Charles journeyed in January 1363 to meet his uncle Emperor Charles IV at the castle of the archbishop of Reims at Mouzon in imperial territory. He was accompanied by the archbishop Jean de Craon (ill. 9) and by Louis d'Evreux, count of Etampes, and a group of nobles from the Dauphiné. Although the purpose of the meeting is not known, shortly thereafter there was an open reconciliation between Charles and his father who conferred on him the title 'lieutenant of the Langue d'oïl'.[70]

Charles's illustrated manuscripts from this period belong to a concerted campaign to proclaim his rights of primogeniture. The French translation of Ptolemy's *Quadripartite* probably translated by one of the intellectual leaders of the reform movement, Nicole Oresme, is dedicated to Charles as the 'heir and governor of the kingdom', a phrase that suggests an early date of 1357–8, making it the earliest known manuscript dedicated to the prince as well as the first indication that the university intelligentsia (Oresme was a philosopher from the College of Navarre) were demonstrating interest in his future prospects (ill. 8).[71] And the *Petite Bible Historiale* of 1362–63 has a portrait of the dauphin (ill. 7) accom-

32

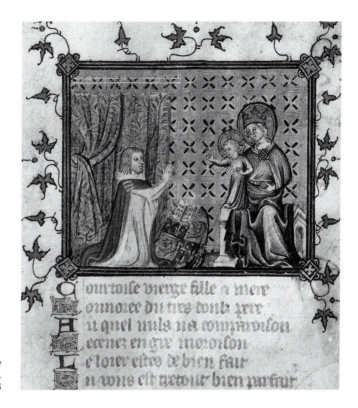

7. Charles, as Dauphin, kneeling to the Virgin and Child. *Petite Bible Historiale,* Paris, BN, MS lat. 5707, fol. 368

panied by a poem, the first lines of which form an acrostic dedication to *Charles, aisné filz du Roy de France, Duc de Normandie, et Dauphin de Viennois.*[72] This tribute to the dauphin comes a year after John the Good issued a charter re-uniting Normandy to the Crown.[73] These manuscripts are considered below in the chapter on the Master of the Coronation Book.

It is unclear why John the Good returned to London on 3 January 1364.[74] On his departure, he referred to his son as *regni regimi Karolo, duci Normaniae, filio suo primogenito,*[75] language that appears to be a designation of Charles as his successor. John died in England a few months later during the night of 8–9 April 1364. Even at this point there was absolutely no certainty that Charles would succeed.

4. The Coronation of Charles V

At John's death many signs pointed to the uncertainty of Charles's succession, even at that late moment.[76] Several critics have stressed that, contrary to the practice of the period, Charles was not called king immediately upon the death of his father, and ten days passed before he was informed of his father's death, a meaningful delay that has been interpreted as a sign of resistance to his succession. In marked contrast with Capetian practice, the great seal of the king of France was not used from the death of John the Good until after the

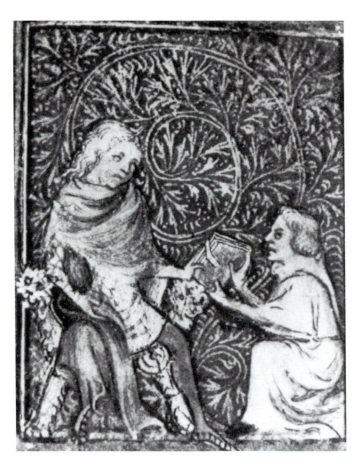

8. Nicole Oresme presents his translation of Ptolemy's *Quadripartite* to Charles. Paris, BN, MS fr. 1348. fol. 1

sacre of Charles V.[77] During this time the *Grandes Chroniques* referred to Charles as duke of Normandy, and it is only a month later on 7 May, after his father's burial at Saint-Denis, that Charles is referred to in the *Grandes Chroniques* as 'King of France'.[78]

All of this is symbolic, and there are other possible interpretations for this reticence.[79] More concrete and factual evidence of the opposition to Charles is presented by the armed attempt of partisans of the king of Navarre to prevent Charles from being crowned. The king of Navarre led an army to intercept the dauphin on his journey to Reims, and the *Chronicle of the First Four Valois* reports the opposition of his sister Blanche, the widowed second wife of Philip VI, whose army held her castle at Vernon against the dauphin when he and his army arrived to take this strategic stronghold.[80] Simultaneously an army of English, Navarrese, and Gascons tried to prevent the coronation from taking place,[81] but they were defeated by Bertrand du Guesclin and his army in a battle at Cocherel on Thursday, 16 May 1364, three days before the coronation.[82] Among contemporaries who regarded this battle as an attempt to prevent Charles from being crowned were Christine de Pizan[83] and Froissart.[84] In the *Traité du Sacre* Jean Golein specifically stated that the battle of Cocherel was an effort 'to prevent the coronation of Charles V'.[85] This source gives an especially intimate perspective on the sacre of Charles V because Golein was a member of the immediate entourage of Charles V who commissioned him to write the treatise on the sacre to explain its political and theoretical meaning. The principal copy of this treatise was kept in the royal library built by Charles in the Louvre along with other works pre-

9. The Archbishop of Reims, Jean de Craon,
with Charles. Detail of fol. 46v [pl. 5]

pared by Golein at Charles's request.[86] The *Chronicle of the First Four Valois* also indicates
that the objective of the battle had been to prevent Charles from being consecrated king. It
cites the letter of Bertrand du Guesclin, written on the vigil of the Trinity, that is, the day
before the sacre, to announce the victory in which he addressed Charles as 'king'. The
chronicle adds that on receiving this news the 'king raised his hands towards heaven and
rendered thanks to God for this victory which God had given him'. Clearly, Charles V's
succession as the first born son and heir of the king of France not only met serious resis-
tance, it met armed opposition. Charles and his partisans interpreted this victory as a sign
that he had been elected by God.[87]

II. The Wider Struggle

1. A Question of Church and State

The most embattled boundary of the Middle Ages was that dividing the spiritual and
temporal realms, the Church and State, the clergy and laity, the soul and the body.
Although immaterial and symbolic, this divide had far-reaching political, economic,
cultural and social ramifications. Where was this boundary situated? Where did the
authority of one estate end and the other begin? Was the State within the Church and
subject to it, or was the Church within and subordinate to the State? Or were they each

35

separate and sovereign entities? Who governed and who chose the ruler? To whom did the ruler answer? To God? To the Church? To the people? Once the text and images of the Coronation Book have been analysed, it will become apparent that the rituals contained in it articulate the position of the king in a monarchical constitution and define the boundaries between the ecclesiastical and secular authorities within that institution.

The reforms begun by Pope Gregory VII at the end of the eleventh century articulated the division between the spiritual and temporal domains and the priority of the former over the latter, an order that was given legal expression in the twelfth century by the following passage of the Decretals of Gratian (Causa XIII, q. 1, c.7):

> There are two classes of Christians. The first are devoted to divine office and consecrate themselves to contemplation and prayer; it is fitting [for them] to live apart from the noise of the world. These are the clergy, who are dedicated to God … [whom] God has chosen … .They are kings because they dominate and reign over others by virtue; their reign is in God. They are signified by the tonsure [which is] the crown on their head given them by the Roman Church as a sign of their kingship … .There is another class of Christian, the laity. 'Laos' in effect means 'people'. They are permitted to possess temporal goods, but only for their needs … they are allowed to marry, to cultivate land, to settle quarrels through judgments and … appeal, to place offerings on the altar, and to pay taxes.[88]

This twofold division was expressed visually by the architecture of the church and the liturgy celebrated within it: 'Within the walls of a basilica the clergy have their own proper place and function and laymen theirs, so outside the church ought they to be known and kept separate by their duties … as light differs from darkness, no less does the priestly order differ from the laity'.[89]

The clergy administered the liturgy and the sacraments that give admission to the Church and status within it. The laity received Baptism, Penance and the Eucharist from the priest who celebrated the Mass and consecrated the Eucharist. Daily reception of the Eucharist in the form of bread and wine was the privilege of the clergy, while the laity received only the form of bread on special feast days. The remainder of the sacraments were the jurisdiction of the ecclesiastical hierarchy: bishops ordained priests and administered the sacrament of Confirmation, archbishops, assisted by suffragan bishops, consecrated bishops. As already noted, Germanic kings had been elected by the nobility, but by the eighth century bishops assumed the prerogative of anointing rulers into their office. Thus, through the sacramental rites, the ecclesiastical hierarchy determined admission to, and status within, Christian society and imposed order on it as a whole.

The divide between the clergy and the laity also operated in the intellectual realm. Except for the fields of medicine and civil law, higher learning had been the monopoly of the Church since the Early Christian period. The *sapientia* of the spiritual orders justified a claim of authority over the laity, even in secular matters. The clergy exploited their intellectual superiority over the laity: 'Among Christians there are two classes of men: the clergy who are superior in dignity and more intelligent in learning (science) … and the laity'.[90] A layperson was defined as one 'without Holy Orders and without instruction in the

36

liberal arts … [an] idiot'.[91] The possession of intellectual superiority was a prerequisite for political power and authority: because the laity 'are ignorant, [they] … must be instructed rather than instruct, be guided rather than guide … must not direct the cleric but be directed by him'.[92]

Indeed, Pope Gregory VII asserted the primacy of the Church over secular authority when he told the ecclesiastical hierarchy: '… if you can bind and loose in heaven, here on earth you can remove anyone and grant to anyone on their merits empires, kingdoms, principates, duchies, marquisates, counties, and indeed the possessions of all men'.[93]

Writing to the archbishop of Ravenna in 1198 Innocent III said that 'Ecclesiastical liberty is never better preserved than when the Roman Church obtains full power both in temporal and spiritual matters'.[94] After King John Lackland acknowledged that he held England as a papal fief, Innocent III affirmed the superiority of the priesthood over rulers:

> The king of kings and lord of lords Christ Jesus, 'priest forever according to the order of Melchizedek', has so established the kingdom and the priesthood in the Church that the kingdom is priestly and the priesthood royal … so that, as body and soul, both the kingdom and priesthood should be unified in the single person of the vicar of Christ to the great advantage and augmentation of both.[95]

In 1234 the Decretals of Gregory IX reinforced the position of the pope at the head of the Church hierarchy, in particular by granting judicial supremacy in appeals for cases that until then had been heard by courts at the diocesan level.[96] This had the effect of diminishing the judicial authority of bishops in their episcopal sees and simultaneously contributing to the growth of a centralized papal administration. By the end of the thirteenth century the papal government had attained unprecedented temporal authority aided by theoreticians like Giles of Rome who argued in his *De Ecclesiastica Potestate* that 'all dominion on earth belongs to the clergy while the laity are serfs (*servi*) of the Church'.[97]

During the twelfth and thirteenth centuries the laity became increasingly interested in ecclesiastical reform. Movements of lay spirituality appeared in the Rhône valley, Languedoc, Flanders, the Rhineland, southern Germany, and northern Italy. Some of these groups such as the Humiliati were tolerated because of their evident piety and charitable activity and because they did not challenge canonical doctrine, even if their renunciation of property was looked upon with suspicion. One preoccupation of these groups was the denial to the laity of the Eucharist in two species, for communion in the form of both bread and wine was reserved for the clergy.[98] Others, like the Cathars and their exponents in the southwest of France known as the Albigensians, were regarded as highly dangerous because they preached heterodox positions such as the rejection of all priestly authority and sacerdotal ministry. In particular, they denied the power of the priest in the ministry of the sacraments, and they expressly denied the validity of the sacrament of Baptism and the status of marriage as a sacrament. Most importantly they denied the doctrine of transubstantiation, that is the change of bread and wine into the body and blood of Christ through the consecration by the priest in the sacrament of the Eucharist.[99] The Cathars developed their own liturgy and doctrine that was written and preached, not in Latin, but in the vernacular language of their following, who were largely recruited from the urban

populations of textile workers, dyers, weavers, smiths and grave-diggers, in addition to members drawn from the merchant classes and the newly affluent urban patriciate as well as the provincial aristocracy. The Cathar movement appears to have had a considerable organization because it became so widespread that it has been described as a rival church.[100] One aspect of the Cathar movement was that, unlike Catholicism, women were not forbidden to preach and there are instances, albeit rare, of women who preached, who operated schools to instruct in Cathar doctrine, and even who occupied positions of authority in the cult.[101]

The position of the Church with regard to the laity, as discussed above, must be understood against this background of challenge to its authority and doctrine posed by these lay spiritual movements. In 1207 Innocent III requested Philip Augustus to intervene in Languedoc against the heretics, and in the following year Raymond VI, the count of Toulouse, was excommunicated for his failure to suppress the heretics in his territories. This was followed by a military campaign led by Simon de Montfort, whose armies were enticed by the promise of receiving the properties of ousted heretics.[102] In 1215 the Fourth Lateran Council met to address the situation. This was the first general Church council to convoke members of the two estates, clergy and laity. Among the representatives of the Christian states were Frederick II, the kings of France, Hungary, Jerusalem, and Aragon, representatives for the king of England and representatives of the great nobles.[103] The latter, however, were not given an active part in the proceedings.[104] The Lateran Council imposed a profession of faith on heretics, aimed at Cathars and Albigensians, requiring them to affirm their belief that 'the bread is transubstantiated into the body, the wine into the blood, by divine power'.[105] The Council required that a lord expel heretics from his territory and sanctioned his dispossession if he failed to suppress heretical movements. As a result of these deliberations, Raymond VI of Toulouse lost portions of his domains that had been confiscated and occupied in the crusade led by Simon de Montfort before the Council.[106] This is a telling example of how a Church council could have an impact upon secular dominion. We will see that these issues have a direct bearing on the evolution of the French royal ordines as they appear in the Coronation Book, notably in the inclusion of a specific reference in the king's oath to expel heretics from his kingdom in accordance with the constitution of the Fourth Lateran Council.

Faced with the menace of widespread heresy, Innocent III granted to the king of France a concession that would later become a double-edged sword for the papacy. Wishing to use Philip II Augustus in his struggles against heretics and at the same time respond to the German emperor's claim of universal dominion, Innocent issued the bull known as *Per Venerabilem* formulated by canonists who had expected to use it to establish a Christendom of multiple but juridically equal powers. The operative phrase was that 'the king has no superior in the temporal realm'. This permitted Philip Augustus and his successors to articulate the doctrine that the king of France had been chosen by God as the *rex christianissimus*, the defender of orthodoxy.[107]

A king occupied a special position between clergy and laity. According to the interpretation of some, he was at once *rex* and *sacerdos*, king and priest. This priestly character derived from the sacre which involved not only the acts of coronation and enthronement, but

also an anointing with holy oil similar to that administered to priests at their ordinations. The sacerdotal character of kingship was formulated during the Carolingian and Ottonian periods, but it was contested after the reforms of Gregory VII. Honorius of Autun protested against those 'inflated with pride, [who] pretend that kings, because they are anointed with the oil of priests, do not count with those who number amongst the laity'.[108]

At the end of the thirteenth century Pope Boniface VIII took the papal claim of sovereignty over secular rulers to its most extreme temporal expression in a series of bulls especially directed at the taxation of ecclesiastical property and the clergy by King Philip IV the Fair, who had asserted that he had sovereign authority to impose taxes within his kingdom because 'in temporalities we are subject to no one'.[109] Boniface responded that he had the authority to depose Philip, and in 1302 he issued the strongest statement ever of the plenitude of papal power, the bull known as *Unam Sanctam* in which he stated:

> There is one holy Catholic and apostolic Church ... outside of this Church there is no salvation or remission of sins ... we therefore declare, state, define and pronounce that it is altogether necessary for salvation for every human creature to be subject to the Roman pontiff.[110]

In response Philip sent an army to Italy to pressure Boniface into retreating from this position. He also called an assembly of Church prelates, nobles and representatives of the cities of the kingdom, and in order to persuade them of the justice of his case against Boniface, he commissioned scholars to investigate the question of the relationship of the secular and ecclesiastical authorities. The result was four treatises that provided a legally founded arsenal of arguments defending the principle of the sovereignty of the monarch in the kingdom of France.[111] These works cited a range of authorities including the Bible, Roman law, canon law, natural law and the newly re-discovered works of Aristotle that had been translated into Latin and incorporated into the curriculum of the University of Paris in the second half of the thirteenth century.[112] Charles considered these treatises of Philip the Fair to be sufficiently important to commission Raoul de Presles to translate them into French, and he kept multiple copies of them in his library.[113]

2. The Revival of Aristotle

The natural and political philosophy of Aristotle provided a theoretical apparatus for shaping a response to the pervasive social and economic changes of the thirteenth and fourteenth centuries brought about ultimately by the transformation from a feudal to a commercial society.[114] Tensions and strife accompanied the emergence of new and dynamic segments of a rapidly growing urban society that now included the crafts, merchants, industrialists, and labourers.[115] These new populations generated unprecedented material wealth, and the absence of legal, fiscal, and political structures to organize them and to integrate them into society presented serious potential for civil and economic disorder.

One cannot overstate the importance of the Aristotelian translations for changing the intellectual climate of Europe.[116] These works challenged established theological teaching and made possible the articulation of new theories about the order of the physical world

and the relationship of this world to the spiritual, or, in more Aristotelian terms, the 'metaphysical'.[117]

In the early medieval Augustinian system of cognition, truth was attained through the study of revelation as contained in authoritative editions of Holy Scripture, the ultimate source of truth. In the Aristotelian system, however, sense perception in its proper sphere is absolutely true and the source of all knowledge.[118] The rediscovery and translation of Aristotle's physical corpus generated a vivid scholastic debate on the question of the essence of reality. The University of Paris became the centre for the study of Aristotle's physical science, and among the scholastics who reiterated Aristotle's position was Albertus Magnus in his interpretation of Aristotle's *De Anima* where he explicitly stated that 'sense experience is the origin of all universal knowledge'.[119] This position was to have far-reaching consequences in every aspect of intellectual endeavour, for it rehabilitated the physical world as an object of study and natural phenomena thenceforth became objects of demonstrative science. Knowledge could be attained through the empirical analysis of phenomena of the natural world. The human eye was now more than the instrument for reading authoritative scriptural texts and commentaries — it was the organ *par excellence* for studying the created revelation of the physical world. This scholastic discourse on the essence of knowledge also redefined the task of the artist, for the sense of sight became the privileged vehicle for apprehending truth, and the physical world itself became the primary object of study, description and representation. Because of the importance of vision in this system, the artist inevitably assumed a new status due to his (and sometimes her) ability, not only to see the physical world, but also to represent what was seen.

Aristotle's natural philosophy also made possible the formulation of a conception of a natural social order and a natural state in which the material and spiritual were clearly separated, in opposition to the established Augustinian conception of two cities in one, a superior, heavenly 'City of God' and an inferior city of sinners. The Aristotelian argument that the social nature of mankind requires an organization to assure the necessities for its material existence provided the theoretical foundation for defining the principle of the natural sovereignty of the State.[120] The political and moral philosophy of Aristotle inspired new thinking about political organization and especially about the necessity for the consent of the citizens and their participation in government.[121] Indeed, the critical importance of consent in Aristotle also impinged upon the doctrine of the sacraments, raising questions about the validity of infant baptism and the need for proof of consent of both parties for a valid marriage. On the practical plane of action, this philosophy contributed to the formulation of a theoretical framework for the emergence of representative assemblies during the last decades of the thirteenth century and the beginning of the fourteenth.

For Aristotle, kingship was the best form of constitution, so it was inevitable that the reception of his philosophy would generate a reconsideration of the question of monarchy. The oldest form of government, existing from prehistory to the present day, monarchy was *the* system by which society was organized and power embodied throughout the Middle Ages. The translation of Aristotle's political philosophy in the thirteenth century was followed by an efflorescence of treatises re-evaluating the institution of monarchy, including those by Dante, Aquinas, Giles of Rome and Marsilius of Padua, to cite just a few.[122]

Each presented a different interpretation of the nature, authority, and organization of the institution of monarchy.[123] One of the questions often posed was whether monarchy was the best form of government. Following the model of Hebrew kingship, Christians had long regarded the ruler as the chosen of God who revealed his will through his intermediary the high priest. From the time of Charlemagne up to the fourteenth century, the ecclesiastical hierarchy had been the interpreters of God's will in the recognition of a Christian ruler. The translation of the Aristotelian corpus raised the question of how the ruler was to be chosen, initiating a reappraisal of the nature of the authority with which the ruler was endowed. What are the qualifications of a monarch? Should the monarch be chosen by a principle of hereditary succession alone? Should the monarch be elected, and if so, who can be a candidate for election and who elects?

Theorists also referred increasingly to Roman law and to the writings of Cicero in order to formulate a theory of the State.[124] In considering the question of property and property rights — an issue with direct implications for inheritance and succession — they distinguished between public and private so as to articulate a theory of goods that were not rightfully owned by an individual, even if that individual was a king, but belonged, by nature, to the community as pertaining to the Common Good, the *Bien Commun*. The State is a *Res Publica*, even if it is a kingdom. Because it is a collectivity, that which pertains to the collectivity cannot belong to any individual as personal property, nor can it be inherited or given away by any individual. This included the material property of the State such as land and currency, but also cultural and spiritual goods, in the abstract and ideal sense, such as justice and freedom. But how was this new thinking to be reconciled with the system of monarchy? This theoretical questioning produced the framework for the reinterpretation of the feudal system of property and inheritance. But it also allowed the question to be posed as to whether the Head of State could rightfully inherit the State if that State was a *Res Publica*, and whether it was the ruler's to give away or alienate.

The papacy and the German empire were elective monarchies. Some theoreticians began to envision a compromise between hereditary and elective monarchies, and they began to broaden the notion of the electorate to include electors who had never before had a voice in the choice of their ruler. Among the most influential of these was Thomas Aquinas, whose *Summa Theologiae* held up the biblical model of the constitution of the Jews who chose to be governed by a king counselled by a body of elders elected by the people:

> For this is the best of all polities, being a mixture of monarchy, in so far as one leads, of aristocracy, in so far as many rule according to virtue, and of democracy, that is, of the power of the people, in so far as the rulers are to be chosen from the popular elements and the election of these rulers pertains to the people.[125]

In his continuation of Aquinas's *On the Rule of Princes*, Ptolemy of Lucca cited Aristotle to advance a theory of elected monarchy in which the king

> was elected by the wise, chosen from all the grades of the citizenry; and this appears consonant with reason, that a king should be raised up to rule the people by the consent of the whole council, as the cities of Italy commonly do

41

today. For this is what the word city means, being, according to Augustine's *City of God*, 'a multitude of men bound together by a certain bond of society'. Whence a city is the unity of the citizens.[126]

Giles of Rome was among the theorists who used the same Aristotelian works to reconcile hereditary monarchy with elective government. But for him election and the participation of the many courted the danger of sedition. Dynastic succession from father to son is natural, but he also admitted that a monarchy is not only the ruler but the whole system which is bound together into a body politic:

> We may therefore say that it is useful for a realm for a son to succeed in the government of his father, and, if there is any defect in the royal child to whom the royal cares should come, it can be supplied by wise and good men whom the king should join to himself in a kind of society as his hands and eyes.[127]

The translation of Aristotle's philosophy gave impetus to the recognition of a citizenry endowed with a natural right to participate in the political life of the state.[128] Indeed Clare Sherman has observed that when Nicole Oresme translated Aristotle's *Politics* for Charles V, he was obliged to include in his glossary a definition of the word citizen and to define it for his francophone readers.[129] For Aristotle, consent of the citizens was the source of the power and authority of the State, but who were the citizens? And what constituted consent? We should not imagine a modern democracy, for Aristotle did not include the entire populace (*hoi poloi*) in the citizenry. He excluded from participation the 'bestial' who are incapable of reason, and he excluded all women and foreigners. For Aristotle, only males endowed with reason and free will were eligible to participate in the political life of the city-state.[130] Although by modern democratic standards a far too narrow definition, in the late thirteenth and early fourteenth century it presented the possibility for a controlled broadening of the base of power by extending participation to two vital segments of society. The first included university intelligentsia and jurists who were increasingly present as orators in assemblies where they were needed to interpret the law in all of its branches, civil, canon, scriptural, and natural.[131] The second group corresponded to the segment of the population which Aristotle described as the *persuadibiles*, those of the populace who though not amongst the intellectual elite were, unlike the bestial, capable of being persuaded by reason.[132] Thus, Aristotelian political science supplied a rationale which justified the participation in assemblies of a broad representation of the secular nobility and bourgeoisie. These same Aristotelian arguments provided a theoretical foundation for the exclusion of women that was given legal expression during the reign of Charles V.

Indeed, the introduction of the Aristotelian notion of the *persuadibiles* gave new impetus to the art of persuasion in its various manifestations:rhetoric, music, poetry, the visual arts, and ceremony, all directed at this newly empowered secular audience. The emergence of secular artistic expression is situated in this context. The present analysis of the Coronation Book reveals that its ritual and imagery respond in a host of ways to the changing cultural environment of the fourteenth century. Notably, a particular definition of election is articulated that seeks to reconcile divine election with the consent of an enlarged constituency composed not only of the national episcopate, but also a broad representation of secular magnates of the realm along with lesser nobles, including, even, a few

women. The images and text delineate a means by which a monarchical constitution is constructed through the consensual participation of a constituency in a sacred and binding ritual process.

The articulation of a theory of the sovereign state derived from the model of nature also contributed to the validation of vernacular languages. Because the natural order is expressed in the diversity of forms, peoples, cultures and languages, the natural goodness of a plurality of states as opposed to a single universal domination of the many by one is thereby demonstrated. It is according to the natural order that people within a state must be governed by those who speak the language of that land as their mother tongue. Consensual participation depends upon persuasion, which in turn requires a means of communication that is comprehensible to the constituency. Latin had been the language of the Church, an international language of an educated élite class of clerics. Although it transcended political frontiers, Latin was judged inadequate because it was not capable of reaching all the citizens of a state. The Aristotelian corpus was thus a catalyst for the legitimation of vernacular language as an authoritative means of political communication, a move as crucial for the empowerment of the laity as it was for the definition of the boundaries of sovereignty.[133] In this connection the Coronation Book is prefaced with the earliest French translation of a royal ordo, that from the time of the accession of St Louis.

Important as this intellectual movement was for formulating the theory of a sovereign state founded upon consent of the citizens, it must not be forgotten that this theory was developed in a setting of social conflict. Assertions of papal supremacy or royal sovereignty were made within a political and economic landscape shaken by popular movements that challenged royal and ecclesiastical authority. The conflicts of the later Middle Ages re-defined the jurisdiction of the spiritual and temporal realms, of pope, emperor, kings, bishops, nobility, and the people of the urban centres. Who would have the right to legislate, to judge, to tax, to receive and transmit property? Who would have access to higher learning, to science? Where did the authority of one end and the other begin? The images and texts of the Coronation Book delineate a systematic and reasoned response to these questions.

III. Charles the Fifth of Our Name, the Sage

If Philip the Fair broke new ground for the sovereign secular state in his conflict with Boniface VIII, the reign of Charles V of France (1364–80) was a decisive episode in the construction of its ideological and theoretical foundations. A key figure in this transitional period between the Middle Ages and the Renaissance, Charles was in many ways the prototype for modern kingship.

1. The Imitation of Charlemagne

In the colophon of the Coronation Book (ill. 1), as in many of the subsequent works that he commissioned, the king referred to himself as 'Charles the fifth of our name', thereby placing himself in a line of kings of that name beginning with Charles I, the Great. As his mother, Bonne of Luxembourg, was a descendant of Charlemagne, it is not surprising that he emphasized his Carolingian heritage, using the historic and symbolic associations of his name as an emblem of his political strategy.[134] Indeed, his Carolingian heritage could suffice to explain the importance of the figure of Charlemagne for Charles's sacre, for which he commissioned a gold sceptre surmounted by an image of Charlemagne enthroned (ill. 10). But there is evidence that the meaning of the figure of Charlemagne went beyond that of a dynastic allusion.

An inscription accompanying the portrait of Charlemagne's grandson Charles II the Bald in the *Codex Aureus* of St Emmeram declares: 'He has received this name which was that of Charles the Great, and that name presaged that one day he would carry his sceptre'.[135] Thus, already in the Carolingian period, the name Charles was regarded by Charlemagne's descendants as a designation of a prince's predestination to rule. So baptized by his parents, both of whom were conscious of the political significance of the union of the Valois and Carolingian houses, it was clear that they regarded Charles as destined to be king. Perhaps even more than a designation for rulership, it was also an implicit declaration of his right to succeed to the throne in a period when hereditary succession was challenged by a movement towards the acceptance of the notion of the natural right of citizens to elect their ruler.

In Germany and France Charlemagne was invoked to symbolize the source of law and the legislative powers of rulers. The imperial office of Aix-la-Chapelle celebrated Charlemagne as *Fons Juris*, and in the *Kaiserchronik* he was shown legislating on a number of issues and as the author of a collection of imperial law.[136] We have already noted that Charles V revived the version of the Salic Law which had been redacted in the court of Charlemagne, elevating it to the status of a sacrosanct doctrine. In 1165 Frederick Barbarossa led a movement to have Charlemagne canonized, and indeed the cult of Charlemagne was celebrated in the court of Charles V.[137] Charlemagne was Charles's patron saint.

Much of this was anticipated by the Capetians, who, as Gabrielle Spiegel has shown, sought to consolidate their connection with the Carolingian line through intermarriage with princesses of Carolingian descent and by embracing the figure of Charlemagne as the

10. Coronation Sceptre of Charles V.
Paris, Musée du Louvre

special patron of France.[138] She points out that, during the twelfth century, not only was Charlemagne associated with the kingdom of France in eschatological literature and in the songs of minstrels, but that a false charter forged at the monastery of Saint-Denis declared that Charlemagne had donated the realm of France to Saint-Denis and that thenceforth the successors of Charles the Great held the kingdom from God and the monastery. The monks of Saint-Denis furthered this association with the legend of the 'Journey of Charlemagne to Jerusalem' and the *Chanson de Roland* identified the oriflamme — the banner of the kingdom of France given by the monastery of Saint-Denis to the king as its vassal for the Vexin — with the banner given by Charlemagne to the monastery of Saint-Denis.[139]

Philip II Augustus, the son of Louis VII and the Carolingian princess Adele of Champagne, married another Carolingian princess, Elizabeth of Hainaut, and Charlemagne became the focus of a virtual cult at Philip's court. Among those who celebrated Philip's Carolingian ancestry was William le Breton in his *Philippide*, and Gilles de Paris held up Charlemagne as a model for Philip's son Louis VIII.[140] Spiegel convincingly argues that Philip's purpose in celebrating the Carolingian legacy was legitimation of his programme of territorial acquisition rather than legitimation of the Capetian dynasty. She observes that his conquest of Plantagenet continental holdings might simply be explained as a penalty for John Lackland's insubordination as vassal of the king of France for the duchy of Normandy, were it not for the fact that at Bouvines Philip also defeated a German emperor. This elevates Philip's victory from a feudal matter to one with international and imperial consequences. She cites the conclusion of the *Philippide* where Louis VIII is exhorted to continue his father's work by 'extending the kingdom to the Pyrenees where Charlemagne had set up his tent', a phrase that presages a record of territorial expansion pursued

45

by Louis VIII, Louis IX and Philip the Fair. According to Spiegel the Capetians sought to justify this expansion by identifying themselves with Charlemagne. By systematically developing this association, they erected it into a claim to empire, in particular through the *Reditus Regni ad Stirpem Karoli Magni*, a text that prophesied the restoration of the realm of Charlemagne that was given prominence in the *Grandes Chroniques*.[141] One should not imagine that Philip Augustus and his heirs meant to revive the former Carolingian empire but rather to establish the sovereignty of the king of France amongst the rulers of Latin Christendom. This is the intention that is expressed by the dictum of St Louis that *le roi ne tient de nului fors de Dieu et de lui*, a stance that prepared the ground for Philip the Fair's quest for sovereignty.[142]

From the time of the conflict between Boniface VIII and Philip the Fair, Charlemagne had been invoked as the historic precedent for the political claim that the king of France was emperor in his kingdom. Philip IV the Fair was the son of Philip III whose second wife Mary of Brabant was a descendant of the Carolingian house.[143] As with Philip Augustus, the emphasis placed upon Charlemagne conveys more than a dynastic allusion. Jacques Krynen has shown that beginning with Philip the Fair, the *imitatio Karoli* conveyed a juridical claim of the sovereignty of the king of France in his kingdom. This argument was advanced in the aforementioned four treatises commissioned by Philip the Fair in his contest with Boniface VIII that were later translated for Charles V by Raoul de Presles, himself the son of a jurist in the service of Philip the Fair. The *Quaestio in utramque partem* explicitly affirmed that 'because all these conditions which pertain to the emperor also pertain to the king of France *who is emperor in his kingdom*'. This same position was reiterated in the *Disputatio inter clericum et militem*, which asserted that the imperial power of the king of France was founded on the *divisio imperii*, that is the division of the empire between the grandsons of Charlemagne which awarded the Western Empire to Charles the Bald. This treatise, translated into French for Charles V, was the direct inspiration for the most forceful statement of this position, which was presented in the *Songe du Vergier* (ill. 11), an anonymous treatise commissioned by Charles V (1378) that has been characterized by Jeannine Quillet as a 'charter of royal sovereignty'.[144] The *Songe du Vergier* affirmed that the kingdom of France issued from the division of the empire at the death of Charlemagne; that, as king of France, Charlemagne never made homage to the pope, but rather, in his capacity of emperor of the Germans; and in the 'land of France … sovereignty … originated from God through the bishop of Reims to whom the Holy Spirit carried the Holy Balm for the anointing of the kings of France without any form of papal mediation'.[145]

Already in the twelfth century Louis VI and Suger, abbot of Saint-Denis, had qualified the king of France as *Imperator Franciae*.[146] Philip Augustus based his claims of sovereignty on the bull of Pope Innocent III known as *Per Venerabilem*, issued in 1202 to recognize the independence of kings from any claims of sovereignty over them made by the German emperor.[147] This decree permitted St Louis to affirm that the king of France held his realm from God and no other. At the end of the reign of St Louis the theologian Guillaume Durand (Lat. Durandus), an opponent of papal claims to plenitude of power, argued in his *Speculum juris* (1270–1) that the king of France has *imperium* over everyone in his kingdom.[148] Finally, in her biography of Charles V, Christine de Pizan cited the papal decree *Per*

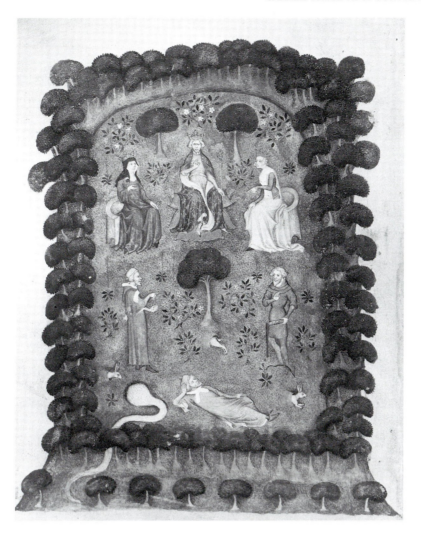

11. Debate between Cleric and Knight. Frontispiece of *Songe de Vergier*,
London, BL, MS Royal 19 C IV, fol. 1v

Venerabilem as proclaiming that 'more than any other prince of the earth you (Charles) do not recognize any sovereign but God'.[149] In citing the historical precedent of the division of Charlemagne's empire, both Philip the Fair and Charles V sought to tie claims of sovereignty to a Carolingian foundation.

The figure of Charlemagne symbolized more than the sovereignty of the king of France in his kingdom. Both the legend of the Celestial Balm carried from heaven to St Remi, bishop of Reims, for the baptism of Clovis and the legend of the origin of the oriflamme are associated with Charlemagne in the Coronation Book and in the *Songe du Vergier*. Charles commissioned Jean Golein, a student of Raoul de Presles, to prepare the *Traité du Sacre*, a treatise on the symbolic and political significance of his sacre that was inserted into Golein's French translation of Durand's *Rational of Divine Offices* (ills. 12, 50, 51), a liturgical and theological treatise on the episcopal office. There Golein emphasizes that Charlemagne is the patron

47

saint of the kings of France. He then cites the two legends of the origins of the Celestial Balm and the oriflamme which he uses to develop three arguments: the king of France is emperor in his kingdom; he has no superior on earth in temporal matters; and he is chosen by the principle of male succession.[150] Later in the present analysis we will see that the rituals contained in the Coronation Book build upon the anti-Boniface treatises of Philip the Fair to provide a legal foundation for the doctrines that are asserted by Golein.

2. *The Philosopher King and the Politics of Wisdom*

Not since Charlemagne and Charles the Bald had a French monarch been such an avid and knowledgeable patron of learning. Like his Carolingian namesakes, Charles V's patronage of learning was bound up with his patronage of art and architecture.[151] This devotion was fostered by his parents, John the Good and Bonne of Luxembourg, both distinguished patrons of illustrated manuscripts. Pierre Roger, later Pope Clement VI, was an important figure in shaping the intellectual and political climate of the French court during the reign of Charles's grandfather Philip VI. This scholar and bibliophile was a personal acquaintance of Petrarch whom he urged to search for manuscripts of Cicero. There is evidence that he was involved in the education of John the Good and probably also of Bonne of Luxembourg, since an entry in the diary of her brother, the emperor Charles IV, states that Pierre Roger was his tutor during his youth spent at the French court.[152] As archbishop of Rouen, he was instrumental in the installation of Charles's parents as duke and duchess of Normandy. Their court in Normandy and John's court in Paris were frequented by scholars, poets and musicians, including the Italian humanist Petrarch and the greatest French poet and musician of the age, Guillaume de Machaut, formerly librarian to Bonne's father before he accompanied the princess to France at the time of her marriage.[153] Charles had close contact with all of these learned individuals during his youth.

During his lifetime Charles V was called *le Sage*, a title that, far from being empty flattery, conveyed specific moral and legal claims and, like the emphasis upon the symbolism of his name, belonged to a deliberate cultural and political strategy. Although usually translated into English as 'wise', the meaning of the word to fourteenth-century contemporaries was closer to the English word 'sage'. It connoted one who loves wisdom, a philosopher endowed with superior knowledge, intellectual and moral authority, combined with the generosity of spirit to transmit this wisdom and learning to the community and to posterity.[154] The fourteenth-century usage is illustrated by the following passage from the prologue of William Ockham's commentary on Aristotle's *Eight Books of Physics*, a work undoubtedly known at Charles's court since it appears in the inventories of the king's library:

> Past ages have begotten and reared many philosophers distinguished by the title 'sage'. Like shining lights they have illumined with the splendour of their knowledge those who were plunged in the dark night of ignorance. The most accomplished man to have appeared among them is Aristotle ... with the eyes of a lynx as it were, he explored the deep secrets of nature and revealed to posterity the hidden truths of natural philosophy.[155]

Wisdom was a central theme of Charles's cultural programme: authors praised him as a wise king in the prologues of books and translations that he commissioned.[156] These included Raoul de Presles, in the prologue to the translation of Augustine's *City of God*; Golein, in his translation of Durand's *Rational of Divine Offices* (ill. 12); and Denis de Foulechat, in his translation of John of Salisbury's *Policraticon* (ill. 13). Christine de Pizan dedicated Part III of her biography of Charles to his wisdom and patronage of learning and the arts. For Christine Charles 'the Sage' was a 'true philosopher'.[157] The historical value of Christine's work has often been underestimated because of its panegyric character and because it was written two decades after the death of its subject. However, raised at court, the daughter of Charles's personal physician and astrologer Thomas of Bologna (also called Pizano), Christine's remarkable erudition in some of the most difficult philosophical issues of the time is an eloquent witness to the level of learning and education that was imparted at what might fairly be described as the 'court school of Charles V'. Christine deployed Aristotelian arguments on the sovereignty of wisdom to advance the cause of the sovereignty of the king of France:

> The gift of the intellect is the sovereign good as all the other faculties are subordinate to it; it is natural that sages govern others; inversely those who are feeble of spirit are naturally serfs, exactly as in nature we see that the body obeys and the soul commands … .The arts and the sciences are all ruled by a sovereign science that one calls wisdom: thus it is with mankind because it is fitting that one of them would be king whose role is to reign on others. It is therefore just, as Giles of Rome recalls in his book on the *Government of Princes*, that the king be wiser and more competent than any of his subjects.[158]

Here we witness the appropriation on behalf of the monarchy of the same arguments put forth by the Church to advance its claims of sovereignty. Charles's wisdom placed him above other rulers and revealed him to be a vassal only to God. His wisdom is the demonstration and justification of his sovereignty:

> Because the brilliance of your crown surpasses that of all other kingdoms, all the lands are lit by that light and it is for that reason that you are called 'vassal of God' and 'first of kings' surrounded not only by material ornaments but also by the aura of interior richness. Probity regulates your life. You cultivate virtue. You are the sustenance and benefactor of the people; you love the just and the wise. That is why you merit to be called the fifth to carry the name Charles, to receive because of this virtue the surname 'the Sage' — you who know that the gifts of the Spirit are the Sovereign Good, you have learned the profane *scientia*, you are a savant among philosophers, a great astrologer (astronomer); you know that in the hierarchy of sciences the highest is wisdom.[159]

Christine's praise for Charles's wisdom is laced with phrases which were invested with precise legal meaning in the fourteenth century. Of course the traditional Christian ideal of the wise king is rooted in the Bible, where Solomon's wisdom was rewarded by peace and prosperity for God's people. The reception of Aristotle's philosophy was accompanied by an expanded definition of the ideal of wisdom, and the possession of wisdom and *scientia* became necessary qualifications for participation in political activity and government. In

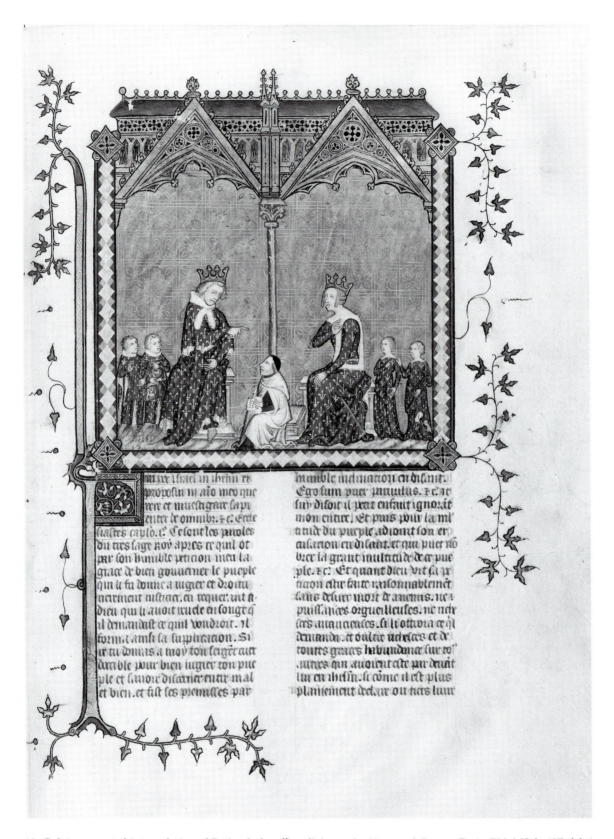

mair iliacl in iehrin ct hirmble inclinacion en difant
propofin in aio meo que Ego fum puer partulus. z c
rere et inucligrair fapi fuy difoit il peat enfant ignorat
enter de omnib: z c. Eccle mon cintice. Et puis pour la mi
liaftes capto. c. Celont les puoles ti tud du puerle adioint fon er
du tres fage roy apres ce quil ot culacion en difadt. et qui puer no
par fon humble peticion meu la bier la grant multitud de ce puc
grace de bien gouuerner le puerle ple. z c. Et quant dieu vit fa pri
qui li fu donne a iugier et droiti naon eftir fante raifonnablemet
ncirment nifliaer. en requer int a fans defirer mort d ancmis. ne z
dieu qui li auoit inucle en fonge ç puiffances orgueilleuses. ne nchi
al demandaft ce quil uondroit. il ces auaricences. fi li ottroia ce qil
forma ainfi fa fupliicacion. Si demanda. et baileir richeces et d
ur tu donnis a moy ton feruer aut toutes graces habundanar fur to
aerible pour bien iugier ton pue autres qui auoient efte par deuat
ple et fauoir difcarier entre mal lur en ihefin. fi come il eft plus
et bien. et fift fes premiffes par plaineiment declar ou tiers luir

12. Golein presents his translation of *Rationale des offices divins* to the King and Queen. Paris, BN, MS fr. 437, fol. 1

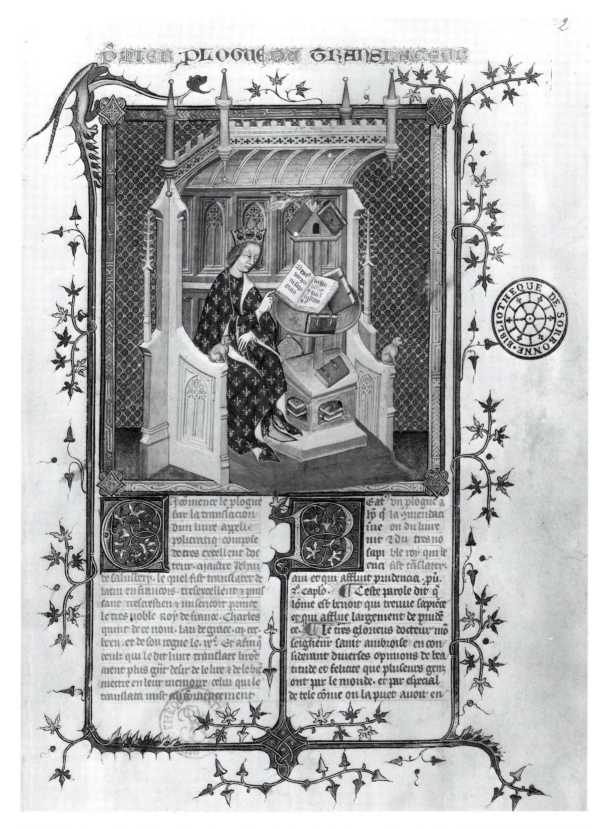

13. Frontispiece of Denis Foulechat's translation of John of Salisbury's *Policraticon*. Paris, BN, MS fr. 24287, fol. 2

order to legislate a ruler had to possess *scientia*. Already in the Carolingian period *imbecilitas* was a condition for deposing a monarch from office, the reason that the last Merovingian was replaced by a Carolingian. John of Salisbury had reiterated an earlier medieval popular saying that 'an unlettered king is almost a crowned ass'. In the four-teenth century ignorance of letters and absence of wisdom were advanced as criteria for denying access to royal office. John Buridan, a philosopher who was doubly distinguished as chancellor of the University of Paris and the master of Nicole Oresme, further insisted that a good prince must be capable of interpreting the law, which in his time included the divine law of scripture, natural law, canon law, civil law and common law.[160] In other words, in order to be capable of ruling, the king had to be a scholar who was lettered in all of these areas. Charles's patronage of learning was a cornerstone of his political strategy.

There are further connotations to the title 'Sage'. *Sagesse* subsumed in its meaning knowledge, reason, prudence and *scientia*. In his *Traité* Jean Golein praised Charles for

> the great prudence of the sovereign lord who had me translate this consecration (the text of the sacre), that is to say the wise, pious king Charles the fifth … .God has given grace to my aforesaid lord who has applied his subtle genius to studies so that he can understand the terms of theology for his salvation and the honour of God, and the other sciences that pertain to the government of the kingdom.[161]

In a similar vein Christine de Pizan emphasized Charles's *science* and asserted that it 'is natural for wise men to be lords over others'.[162] Both Golein and Christine were asserting a specific legal claim to sovereign power, for the clause *ex certa scientia* was a juristic term, used as a synonym for the fullness of power (*plenitudo potestatis*). First appearing in docu-ments issued by the papal chancery, the term was taken over by Philip the Fair and his ju-rists to advance claims of monarchic sovereignty.[163] The assertion that Charles was in possession of *sagesse* and *scientia* was not merely to project an image of wisdom; it was es-sential for endowing him with the authority to interpret and enforce the law as well as with the plenitude of power to legislate. Charles had to become the living embodiment of the Aristotelian wise king, not merely to demonstrate his worthiness to rule, but to vali-date his sovereign authority.

Since the Early Christian period bishops had been the repositories of *sapientia*.[164] In this capacity, they assumed responsibility not only for overseeing the instruction of the faithful in the fundamentals of Christian doctrine but also for the education of the clergy. Indeed, at the beginning of the bishop's consecration the candidate is interrogated on whether he will 'teach the people for whom you are ordained, both by words and by example, the things you understand from the divine Scriptures'. This is the bishop's first responsibility to his people. Bishops were also the source of the priesthood, and as part of this responsibility they oper-ated episcopal schools to educate priests, they decided who was admitted, they determined the curriculum, provided the books, and assembled a library that was organized by a librar-ian. Their educational responsibilities included decoration and embellishment of the church. The Registers of Pope Gregory VII gave official recognition of the combined respon-sibilities of bishops for the literary arts and the adornment of the church.[165]

14. *Bible Historiale* of Jean de Vaudetar,
Jean de Vaudetar presents his Bible to Charles V.
The Hague, Museum Meermano-Westreenianum,
MS 10 B 23, fol. 2

It is of the utmost significance that Charles V asserted his prerogative to exercise these ca-
nonical episcopal functions.[166] Analysis of the text and illustrations of the Coronation Book
reveals that his actions were legitimized by the ritual of this manuscript which goes further
than any previous king-making rite to endow the king of France not only with priestly quali-
ties but also with an episcopal character, to ordain him into the 'royal religion'.[167]

Portraits of Charles receiving copies of the Bible and theological works such as St Au-
gustine's *City of God* or Durand's *Rational of Divine Offices* are not simply images which
present Charles as a wise ruler. These images include details pertaining to his intervention
in the domain that had been the exclusive preserve of the ecclesiastical hierarchy: he is of-
ten shown seated on a seat comparable to the *cathedra* of a bishop and wearing gloves simi-
lar to those worn by bishops (ill. 14). We shall see that both the cathedra and the gloves
were among the innovations of the royal rite contained in the Coronation Book that en-
hanced the traditional episcopal attributes given to kings since Carolingian times. In the
Traité Golein explains the sacerdotal and prelatial symbolism of the royal garb. When not

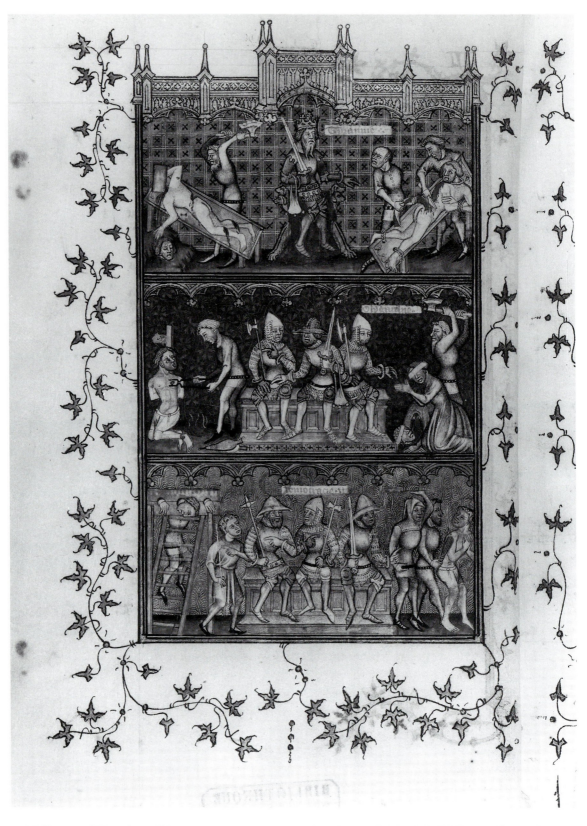

15. Tyranny, Oligarchy and Democracy. Nicole Oresme's translation of Aristotle's *Politiques et Economiques.*
Brussels, Bibl. Roy., MS 11201-2, fol. 1v

shown in this coronation garb, Charles is portrayed wearing, not the costume of the secular estate, but the long robes worn by theologians and philosophers of the University of Paris, who were almost without exception clergymen in that period.[168]

The colophon that Charles personally inscribed in the Coronation Book is particularly meaningful in the context of his priestly and episcopal qualities, because he explicitly states that the book is his and that he had it 'corrected, ordered (i.e. arranged), written and illustrated'. As the ritual of the consecration of a king was part of the episcopal liturgy normally contained in the pontifical, a bishop's liturgical book, Charles was inserting himself into the traditional domain of the bishop in a bold and unprecedented way, not only by ordering the book, but also by intervening in the compilation, correction, copying and illustration of the liturgical texts, all of which had been until then episcopal prerogatives and responsibilities. Charles's beautiful script (pl. 39; ill. 1), resembling that of a chancery notary, is testimony to his expertise in scribal art. And the frequency of the corrections that he entered into manuscripts that he commissioned is proof of his literacy and learning in areas that had been the domain of theologians and the clergy. In this connection, Charles commissioned Golein's *Traité du sacre* as part of a comprehensive translation and commentary of Durand's *Rational of Divine Offices*, a manuscript to which he added his personal comments and corrections on numerous folios.

In the *Traité* Golein develops a specific political platform on this very claim of the prelatial status of the king of France. In the table of contents he states that 'according to the new constitution of the Lateran Council, the king takes an oath to put heretics out of his kingdom'. Golein continues that the three oaths the king takes at his sacre signify the faith of the Trinity whereby the king must extirpate all evil, falsehood and especially heresy, adding 'that it is for this reason that Masters of Theology alone in France are held in such great reverence because they are judges to determine what is, and what is not, heresy; and on account of this Christians are … subjected to holy theology as those who have the key to the Catholic knowledge'. According to Golein 'this is why the king of France is not subject to any other', for only a Doctor in Theology from the University of Paris can present himself before him (the king), and it is because Charles is subject only to these divine laws 'that he holds his kingdom from God and no other'.[169]

Charles's personal involvement throughout his reign with the content of his books is evidenced by the presence in many of them of his autograph and by textual corrections in his own hand.[170] Charles employed the most renowned scholars, almost all clergy, to write new treatises or to translate from Latin into vernacular French works of ancient and medieval literature and philosophy. Among these scholars was Raoul de Presles who, besides translating for Charles the treatises commissioned by Philip the Fair for his contest with Boniface VIII, made a French translation of the Bible and the first French translation of Augustine's *City of God*. Charles commissioned Nicole Oresme to make the first complete translation into French of Aristotle's *Politics*, *Economics* (ill. 15) and *On the Heavens*.[171] This activity of commissioning theological, liturgical and philosophical manuscripts, commenting upon them and correcting them, and ordering their decoration, constitutes an appropriation of clerical authority, an action justified, as we shall see, by the ritual of the Coronation Book.

Counselled by the foremost intellectuals of the University of Paris, Charles envisioned kingship as a collegial architectonic process, one of designing an ideal political structure and of giving it physical expression in the State.[172] The foundation for this structure was not in the form of stones and mortar, but in the corpus of thought that he assembled in his library, an ambitious collection of texts of ancient, medieval and contemporary writings, many translated into French and illustrated with original cycles of paintings in an experimental realistic style. Most of the works commissioned by Charles V were destined for the royal library that he established in a specially refurbished tower of the Louvre.[173] By the time of the king's death in 1380 this library contained more than a thousand volumes including works of history, science, philosophy, theology, canon and civil law, medicine, liturgy, political science and literature, all intended to serve the *Bien Commun* of the Crown of France. The library was the most extensive royal library of the time and the rival of any ecclesiastical library of the medieval period. The preparation of a series of library catalogues during his reign demonstrates, through the systematic classification of the books according to a hierarchy of subjects, that this library was intended to be a centre of higher studies.

A ruler of vision, Charles's reign was marked by creativity in all areas of human activity as he confronted the challenges to his kingdom not only with improved military organization and strategy but also with diplomacy and a vigorous programme of persuasion involving a wide range of artistic expression which advanced new ideas about organizing society within a monarchy. This bibliophile king used art, literature, and ritual as efficient implements for restoring order, establishing peace and reforming the social and political order. Although the aesthetic dimension was important, the works were not primarily intended as aesthetic objects for the effete pleasure of idle courtiers and princes, but as a means of making the monarch's message more attractive and persuasive to its intended audience.[174] These works were designed to educate and persuade an élite audience of powerful individuals of the justice of his political vision for the Crown of France. In a modern democracy, mass media are essential for persuading a large voting population, but in an age when power was still held in the hands of a few, a single illustrated manuscript could have political consequences by shaping the point of view of a small group or even that of one single powerful individual. For Charles these books were not idle amusement, but, as often proclaimed in the introductions, they contained knowledge for the 'public utility' and the 'common good'.[175] The interaction of the verbal and visual languages of these manuscripts, and indeed the interaction between the manuscripts, was nothing less than the working basis of a dialectic of social and political reform.

Charles invited to his court the greatest names of French and Flemish art of his age, the sculptors Jean de Liège and André Beauneveu, the painters Girard and Jean d'Orléans and Jean Bondol, the goldsmiths Guillaume and Jean de Vaudetar and Hennequin de Bruges, and the architect Raymond du Temple. The works commissioned by Charles V display a preoccupation with precision and exactitude in the description of physical objects and a manifest concern for identification and documentation, the latter contributing to the revival of the lifelike portrait. Within months of his accession he commissioned a number of dynastic monuments with overt political implications. His first commission was a series of

tombs with funerary effigies for his Valois predecessors, himself and his queen Jeanne de Bourbon for the abbey of Saint-Denis (ill. 107), the cathedral of Rouen and the monastery of Maubuisson. Charles's portrait on his tomb at Saint-Denis (ill. 16) is the first royal effigy sculpted *ad vivam* and the uncompromising realism which its sculptor André Beauneveu achieved had not been attained in portrait sculpture since antiquity. [176] Beauneveu imbued this funerary effigy with vitality, truthfully rendering the homely details of the king's face, suppressing neither the lines of the face nor the ungainly proportions of the long nose. The result is a tomb portrait that paradoxically pulses with life down to the veins on the hands. Other monumental works were commissioned at the same time, including the standing portraits of Charles V and Jeanne de Bourbon that once flanked a portal of a royal edifice (ill. 2). Many of the monumental dynastic commissions have been destroyed, but those that survive witness the artistic renascence which occurred at the accession of Charles V.

Contemporary with these dynastic sculptures, the Coronation Book is a cornerstone for the art patronage of Charles V because it is the first work of painting, book illumination and literature commissioned during the reign of this ruler. Like the tomb sculptures, it is concerned with capturing the physical appearance of contemporary persons; but it accomplishes something more than the sculpture, for the portraits appear in the context of a text and a series of scenes that narrate an actual contemporary event. Thus, besides its importance in the history of coronation ritual, as a legal and historical document for the coronation of Charles V and Jeanne de Bourbon and because of the king's personal involvement, the Coronation Book is as important for Charles's kingship as it is for his patronage of illustrated manuscripts, art and learning.

16. André Beauneveu: Charles V.
Detail from the tomb in the Cathedral of Saint-Denis

17. Charles the Bald between two Bishops. Metz Sacramentary. Paris, BN, MS lat. 1141, fol. 2v

Chapter 2. The Art and Ritual of Ruler-making: The Ancestry of the Coronation Book

IN ORDER TO UNDERSTAND the institution of monarchy and the premises on which it was founded, how monarchy operated as a system for organizing society, creating and sustaining a ruler, and generating real political power, one must look at a range of sources: myths, hagiographic texts, sermons, chronicles, charters, legal and political treatises. But texts alone do not suffice. Fundamental for understanding the institution of monarchy are the liturgical rituals of ruler-making, as indeed the images of rulers and of ruler-making ritual. These were instrumental in creating and sustaining rulers and endowing them with political power. It is in the consideration of the development of the royal consecration ceremony, as it contributed to the ancestry of the Ordo of Charles V that one gains a better understanding, not only of the tradition out of which the Coronation Book emerged, but also the meaning of the monarchy that it was designed to create.

I. The Ritual of Royal Consecration

1. Monarchy and Myth

What may well be the earliest description of a medieval king-making ritual is not in a liturgical text but in the hagiographic account of the *Life of Columba*, written between 688 and 704 by Adomnan, abbot of the monastery of Iona, off the west coast of Scotland. According to Adomnan, his ancestral predecessor Columba had a vision in which an angel of the Lord brought him 'a book made of glass for the ordination of kings'. Columba read the book at the angel's command, but he refused to follow the orders that were given him in the book and ordain Aidan as king because he preferred Aidan's brother. The angel scourged him, leaving a scar that Columba bore for the rest of his life, and addressed the saint thus: 'Know with certainty that I am sent to you by God with the book of glass, in order that, according to what you have read in it, you will ordain Aidan to the kingship. If you refuse I will strike you again'. On the two following nights, after Columba twice more refused and twice more was scourged by the angel, he at last agreed to do as commanded, and, 'laying his hand upon Aidan's head, he ordained and blessed him'.[1]

What is to be made of this late seventh-century hagiographic account of a sixth-century royal accession? Is it history or myth, reality or fantasy? This account contains some core elements of medieval king-making ritual: God chooses a ruler for his people by revealing his choice to a member of the Church hierarchy to whom he sends a celestial gift to be used to 'ordain' the ruler to kingship. Adomnan did not mention a crowning, but three times referred to the 'ordination' of Aidan, a word usually applied to the consecration of priests

and bishops. Does the use of this word indicate that Aidan was consecrated to the kingship in an anointing ritual? The answer to this question is problematic. Certainly, the angel and the book of glass undermine the historical value of the account, at least in the eyes of a positivistic critic, casting doubt on the account as evidence of royal anointing for this early date. Yet, if the book of glass and Columba's scars do not satisfy our notion of evidence, there are nevertheless elements of historical fact: St Columba founded the monastery of Iona *c.* 565; Aidan reigned over the northern kingdom of the Irish (*Scoti*) from 574; and Adomnan was abbot of Iona from 679 to 704. Although there are no references in the *Annals of Ulster* to a royal anointing until 794, the *Collectio Canonum Hibernensis*, compiled during the lifetime of Adomnan, described the biblical anointing of Saul by Samuel under the heading *De ordinatione regis*.[2] Thus, by Adomnan's time, if not in Columba's day, royal anointing in insular society was regarded as an ordination and was associated with the biblical model in the First Book of Samuel.

Another early account of a royal anointing is that given by Julian of Toledo in his *Historia Wambae regis* where he describes the anointing of the Visigothic ruler Wamba at his accession in 672. The existence of the practice of royal anointing in Spain is further supported by references in other Visigothic sources dating from the 630s to 701.[3]

By far the most consequential medieval account about the origins of Christian king-making is that of the miraculous Celestial Balm carried from heaven in a Holy Ampulla, according to some accounts by a dove, and later accounts by an angel, to St Remi, the first bishop of Reims, for the baptism of Clovis, the first Christian king of the Franks. Although Clovis became king in 481, he was probably baptized on 25 December 498.[4] The earliest account of the Celestial Balm is not from the time of Clovis, but occurs nearly four centuries later in the *Life of St Remi*, written between 877–81 by Hincmar, archbishop of Reims (845–82). Hincmar affirmed that Clovis was baptized by St Remi in the cathedral of Reims and 'anointed and consecrated as king with a chrism sent from heaven that we still have'. He repeated this affirmation in a letter addressed to Adventius of Metz concerning the anointing of Charles the Bald at Metz in 869 at which Adventius and Hincmar officiated.[5] However fantastic the story may seem, Hincmar had something more tangible even than St Columba's scars to testify to the veracity of his account. He had the very container sent from heaven to his predecessor St Remi, the Holy Ampulla, and its heavenly contents, the Celestial Balm.

Angelic messengers bringing books of glass and Celestial Balm to saintly abbots and bishops of the distant past may be dismissed as products of the medieval imagination, but they are the stuff out of which the very palpable reality of medieval rulership was created. Five centuries later the Celestial Balm and its ritual were celebrated, not in a book of glass brought to earth by an angel, but in a quite tangible book for the consecration of the king and queen of France, the Coronation Book of Charles V.

2. Sacre and Sacrament

Along with language and myth, art and ritual are cognitive and mnemonic systems with which society confronts the unknown, imposes meaning and structure on reality, and

preserves and transmits what it knows and holds to be true to its membership. Far more effective than weapons and force, these are the means of persuasion with which society constructs consensus and political order.[6] The Coronation Book offers a visible demonstration of the role played by these systems, and most especially by ritual and images, in the making of rulers and political power. Vital for the comprehension of the text and ritual, the images of the Coronation Book provide a concrete exposition of the process that transforms an individual into a king, whose authority and power they also serve to define. In so doing they visualize the nature of the State and give a pragmatic visual demonstration of how power is transformed from the symbolic and conceptual dimension to the real and effective. If political power must be perceived to exist, these illustrations, meant to shape that perception, were crucial for making the abstract and symbolic perceptible and real. Art and ritual are interrelated on a very basic level, since ritual is a dynamic process of image-making involving verbal, auditory, and visual imagery. In order for its political potential to be realized, the sacre must be imprinted on the eyes and minds of the body politic. Images are thus vital for this dimension of the sacre because they shape the perceptions of the participants while extending the audience of the ritual across time and distance, even to those who were not present.

In ritual, society strives to interact with the supernatural, to call forth its power, and to effect a transformation, whether spiritual or material. Because it binds the members of society together around its collectively held convictions, ritual plays a primary role in the construction and preservation of social order.[7] It is thus a structuring social system that imposes a hierarchy of class order; membership of a society is determined through initiation rituals, and the status of individuals within society through coming-of-age rites, marriage rites, ordination rites, and inauguration rites. Healing and purification rites effect an individual's re-entry into society, and funeral rites lead the individual from the society of the living to that of the dead. In a recent analysis, Catherine Bell shows how ritual works as a practical instrument for negotiating power by building consensus and resolving conflict. She undertakes to reconsider how ritual operates to construct authority and to stabilize power by shaping a social order based upon office and status and by organizing a unified corporate body in which the members consent to their place by virtue of their participation in the ritual itself.[8] For ritual to be an effective instrument for preserving and transmitting the ordering principles of society, it must be performed, and through the regular performance of the symbolic mimetic acts of ritual, society transmits through time its collective ideas and beliefs and reaffirms its commitment to them. The annual cycle of civic and religious rituals mark off time into measured segments, while the greater rituals, the rituals of ruler-making, mark historical periods.

More than a means of installing a ruler into a position of authority, or a rite of passage that transforms an individual into a king, the sacre is a dynamic symbolic system by which a society orders and structures itself.[9] Though consisting of symbolic actions, the sacre should not be dismissed as having merely symbolic value. Amongst religious rituals it has the greatest political potential. Much of political action consists, not of concrete facts, but of the manipulation of symbols which, though largely fictitious, are the fictions which organize reality.[10] Political power is not a material substance but an abstract and symbolic

61

social construction.[11] It is subjective, a matter of the convictions and perceptions which a society collectively holds and is thus ephemeral and as open to change as the human mind.[12] As Clifford Geertz so aptly put it, concerning politics 'the real is as imagined as the imaginary'.[13]

The sacre is a mnemonic ritual edifice, the successive courses of which, through the passing of time, were built upon the preceding layers, not unlike a venerable archaeological site (Saint-Denis or Saint-Remi, for example). The distinct layers of successive centuries are there to be uncovered and identified, and the operating processes are similar: an ancient shrine becomes the *locus* where spiritual charisma continues to be manifested and thus cannot be abandoned because of its accumulated sanctity.[14] Through the passage of time, having become inadequate and worn by use, it undergoes repairs, modifications, and successive reconstructions, each shaped by the previous structures. Even if they become unwieldy and cumbersome, whether they fall or are demolished, the stones of earlier structures, material or symbolic, are inevitably present under anything built in its place. In this way the past is ever present, incorporated in and by these monuments of memory. In enacting the sacre, society not only remembers the past, it embodies it.

The sacre operates simultaneously on two levels which it endeavours to reconcile: it is a historic event with secular consequences in which a specific ruler is officially invested with office, and it is a sacred religious rite consisting of prescribed prayers and actions which, in order to be efficacious, must be performed according to canonical formulae. Neither a purely secular inauguration by which a people designate and recognize a ruler, nor a merely symbolic ceremony, the sacre had constitutive and legal force because of the solemnly sworn oaths which it incorporated and because it was a sacramental consecration recognized by society to effect a permanent transformation of the individual's character and status through anointing.[15]

This anointing, administered by a designated member of the priestly hierarchy, the pope, or an archbishop in France, England and Germany, endowed the ruler with the grace of the Holy Spirit transmitting the wisdom and power to rule over God's people and transforming the ruler physically and spiritually into a *Christus domini*. Anointed, the ruler became a *christos*, an *imago Christi*, and his rule, an *imitatio Christi*. In theory this transmission of power was not from ruler to ruler, nor from consecrator to ruler, but from God to ruler, who consequently became a *rex Dei gratia* and *vicarius Dei* whose power originated with God. This anointing through the agency of a minister of the ecclesiastical hierarchy altered the ruler's relationship to God and to his subjects, and he became, like a priest, a mediator between God and his people.[16]

The French royal consecration owed its special charisma to the unique character of the holy oil employed for the anointing of the king, distinguished above all other oils, even the sacramental oils of the Church, by its legendary heavenly origin. Besides the anointing of Clovis, who was already king when he was anointed at his baptism, there is no concrete evidence that Frankish kings of the Merovingian line were anointed at their accession. When the last Merovingian king was deposed, the first of the Carolingian rulers, Pippin, was elected king in 751 by the Frankish magnates, and he was anointed with chrism in a

rite that was concelebrated by the West Saxon missionary to the Franks, the papal legate Boniface and the Frankish episcopate.[17] The sources do not allude to a coronation. This anointing, inspired by the biblical model of Samuel anointing Saul the first king of Israel, was no doubt introduced as a means of placing Pippin's kingship on a legitimate footing and to afford him ecclesiastical protection.[18] Some critics argue that Boniface was inspired by the anointing of Wamba; but others find that Boniface was drawing upon his own West Saxon heritage and they attribute his inspiration to the insular practice of anointing Celtic and Anglo-Saxon kings, also modelled on biblical anointings such as those of Saul and David by Samuel or Solomon by Nathan and Zadok.[19]

Carolingian kings were anointed with blessed oil or the oil of catechumens. It is not until Charles the Bald's anointing at Metz that a contemporary document, a letter of Hincmar, mentions that the heavenly balm was used for the anointing.[20] At first, ecclesiastical anointing of the ruler took place separately from secular crowning.[21] Hincmar of Reims linked these two rituals when he anointed and crowned Charles the Bald as king of Lotharingia, referring to the legend of the Celestial Balm in order to distinguish the anointing received by Charles the Bald from other royal and ecclesiastical anointings, as well as to advance the position of the archbishop of Reims who, as St Remi's successor, could claim a custodial relation to the balm and its special prerogatives. Although the fully developed ritual of the Celestial Balm is not known to have been incorporated into a coronation ordo until the first ordo compiled during the reign of Louis IX in the thirteenth century (the ceremony at the beginning of the Coronation Book), Hincmar's innovations provided the basis for the French king's claim to the privilege of being anointed with a mixture of the Celestial Balm and chrism. Accordingly, the king of France was distinguished from bishops, priests, and other kings, all of whom were simply anointed with chrism, a mixture of olive oil and balsam consecrated by a bishop or archbishop.

The introduction of anointing likened the king to a priest, and one of the most important traditions of king-making that is celebrated by the Ordo of Charles V is the quasi-sacerdotal and episcopal character bestowed upon the king at his sacre. Like earlier ordines, the Ordo of Charles V contains a prayer recited by the archbishop of Reims stating that the king participates in the *ministerium* (ministry) of bishops, introduced in the Carolingian period when the consecration of a Frankish king was first likened to the consecration of bishops.[22] Anointed as a priest in the sacrament of Holy Orders, and vested with sacerdotal robes, the king was consecrated like a bishop. The regalia and vestments with which Charles V was invested have their counterparts in episcopal vestments and insignia, a tradition initiated in the ninth century when Ebbo, archbishop of Reims, added the staff to the bishop's insignia to balance the king's sword. Both bishop and king received a ring, and Ebbo's successor Hincmar instituted consequential modifications in the liturgies for the consecration of kings and bishops, establishing between them emphatically stated parallels, including an oath comparable to that administered to a bishop at his consecration.[23] Thereafter, the royal-episcopal parallelism was progressively strengthened. The king was vested with garments modelled on and named for episcopal garb: his tunic, the *camisia*, was like that of a priest or bishop, his mantle, the *cappa*, was

modelled on the bishop's cope, and the royal shoes were inspired by the episcopal and papal *caligi*. The prayer recited for the imposition of the king's crown was the same as that recited for the imposition of the mitre in the episcopal consecration. We shall see that several new features enlarging upon this parallelism have been introduced into the Ordo of Charles V.[24]

What is perhaps the most remarkable development of the ritual in the Coronation Book is that many of the sacerdotal and episcopal elements have been extended to the queen in her *sacre*, where they are comparable to the consecration of abbesses who, before the Council of Trent (1545–63), held some episcopal authority and attributes. Significantly, the miniatures illustrate most of the traditional elements and all of the innovations which liken the consecration of king and queen to an episcopal consecration.

Because it is a consecration with holy oil, the *sacre* was sometimes referred to as the eighth sacrament, even after the twelfth century when it was excluded from the official seven sacraments.[25] The sacraments are the seven gifts of the Holy Spirit whose grace animates and empowers them specifically through the vehicles of sanctified sacramental elements, combined with the priestly recitation of the word of God excerpted from authoritative Holy Scripture, and the execution of prescribed ritual gestures performed by the priest. All sacraments are a covenant and alliance between God and the participants. The *sacre* incorporates aspects of all seven sacraments, drawing features from the four anointing sacraments of Baptism, Confirmation, Holy Orders and Extreme Unction. It includes matrimonial and penitential implications, as the king's sins are all forgiven at his *sacre*, and Eucharistic dimensions. It is the most political of sacraments because it is a corporate sacrament, in which an entire community defines its membership and organization before God. Participation in the *sacre* is a corporate negotiation of consent of the participants to the entire configuration of premises of the rite, mutually and solemnly affirmed before God and the assembled community. It must be stressed that in the *sacre*, as in all sacraments, an accord is made between the participants and God. A sacrament is, therefore, a form of binding contract in which the parties undertake specific obligations to each other and to God.[26]

With the *sacre*, society objectifies power, makes concrete that which is abstract, detaching it from a single individual and situating it in an autonomous institution. Perhaps more important than the ruler that it creates, it places access to power in the hands of those who perform the ritual and assigns a share of power to those who participate in it. The *sacre* is a ritual for and of the political class who are thereby bound together into a consensus around the figure of the ruler. The text and images of the Coronation Book expose the nature of this institution and the importance it bestows, not only on its recipient, but also on those who administer it and participate in it.

As with the other sacraments, the sacring ritual is conserved in liturgical books.[27] The earliest sacring texts are usually in sacramentaries or benedictionals, and although the Ordo of Charles V has been treated as an autonomous entity in the Coronation Book, it is actually an excerpt from the *Liber episcopalis*, more commonly known as the pontifical, a collection of rituals performed by a bishop or archbishop. Placing the ritual of ruler-making amongst the sacraments performed by a bishop, and preserving the ritual in

the episcopal books, were decisive political acts removing access to rulership from the secular segment of society and placing it into the hands of the ecclesiastical hierarchy. It is significant that the monumental images of Roman imperial ritual, so vital for defining the emperor to the Roman public, were relatively rare in the Middle Ages, and that the images of rulers and ruler-making from the Carolingian period on, with very few exceptions, are on the folios of ecclesiastical service books. This suggests that the audience of these medieval works was not the public, but rather the élite who had access to these books.

An integral part of the Catholic faith, the sacraments are the ritual representation of the sacred mystery and historic acts of the life of Christ that are regarded as the fulfilment of Old Testament prophecy.[28] Baptism, for example, re-enacts the death, entombment and resurrection of Christ, as well as the water miracles of the Old Testament such as the salvation of Noah from the waters of the flood and the Israelites crossing the Red Sea. Thus, the sacraments telescopically unite the Old and New Testaments, calling them forth into the contemporary moment when the sacrament is enacted. In this way the sacrament simultaneously exists in a moment in historic time and in a dimension which transcends history.

Symbolism is fundamental to the sacramental doctrine of the Church. It is essential to take into account the integral importance of images and symbols in early Christian and medieval theology that synthesized Platonic and Neo-Platonic notions of images and divine models with aniconic Jewish teaching. The sacre was capable of generating and transmitting real political power, not only by virtue of the pragmatic capacity of symbols to organize reality, but also because of their special place in medieval Christian belief, according to which all creation is a revelation of the Creator, and the physical world is constituted of symbols which participate in that creation.[29] The efficacy of the sacraments derives from the very process of signifying through mimetic acts of symbolizing. For the Pseudo-Dionysius, the void between physical and spiritual reality is traversed through the mediating agency of symbols that participate in the higher reality through mimesis of that reality.[30] Hugh of Saint Victor in his treatise on the sacraments explains that even the most stereotypical formulae of sacramental action express the higher meaning inscribed in created things. That higher reality remains concretely present and visible because every symbol contains the reality it symbolizes in a manner that directs the *translatio* of the believer's mind from the material to the spiritual mystery. It is this mystical realism that endows the symbols of the sacraments and all cultic acts with their power.[31]

Fundamental to the power of the sacre is the belief in the intrinsic dynamism of the sacraments, their power to elicit the outpouring of grace of the Holy Spirit necessary to effect a transformation of spirit and matter. In the liturgy of the sacraments dogma is acted out through the synchronized performance of symbolic gestures, the application of symbolic natural elements of oil, water, bread, wine, fire, ashes, etc., and the recitation of prescribed prayers composed of words of God drawn from Holy Scripture. On another level, the efficacy of the sacraments also derives from the psychological realism generated by the liturgy itself. This comes about through the juxtaposition of symbolic images that act simultaneously upon the five senses of the participants in order to heighten the sensation of their psychological experience. Besides the verbal imagery of prayers and the acoustic and numerical imagery of music, there are the natural symbols of the sacramental

65

elements that engage the senses of sight, touch, smell, and taste. The symbols of colour and number play an important role in sacramental liturgy, as do the vestments and the sacred ritual vessels, which are often works of art in themselves. In the liturgy, there are no frontiers between art and ritual. The liturgy unfolds in a building designed to be the physical setting for it and filled with the imagery of paintings, stained glass and sculptures, all made to interact with the ritual which is played out there. The illustrations of the Coronation Book confirm this point by describing in such detail all of these features and their function in the liturgy.

This belief in the dynamic power of the sacraments to transform matter is best illustrated by the doctrine of transubstantiation, when the priest performs specific ritual gestures while reciting the words of Christ spoken at the Last Supper: 'Do this in memory of me ... This is my body ... this is my blood ... '. According to the doctrine officially proclaimed at the Fourth Lateran Council in 1215, this sacramental action calls forth the real presence of Christ's body and blood in the Eucharist. The grace of the Holy Spirit is similarly present in the blessed oil of Baptism, Confirmation, Holy Orders, Extreme Unction, and the sacre.[32] The power of the oil used in the anointing of kings derives from the grace of the Holy Spirit it is believed to contain, founded on I Samuel 16:1, which reads: 'Then Samuel took the horn of oil and anointed him in the midst of his brethren, and the Spirit of the Lord came upon David from that day forward'. The anointing prayer *Spiritus Sancti gratia...* calls for the grace of the Holy Spirit to descend upon, and to penetrate into the king. This prayer is followed by another, *Deus Dei filius, Iesus Christus...*, invoking Jesus, who was anointed by the Father through the infusion of the grace of the Holy Spirit when the Paraclete descended above his head at his baptism.

The doctrine of the real presence of divine power in the sacraments, and especially the Eucharist, became the focus of controversy from the beginning of the twelfth century. The Cathars, the Albigensians, and other heterodox groups rejected the doctrine that spiritual power is transmitted through material means. In particular, they denied the doctrine of transubstantiation. For the Albigensians the people are the church in which the initiated celebrate communion without benefit of ordained ministers. The Fourth Lateran Council was convened to address these challenges to priestly authority and sacramental teaching. The Albigensians were judged as heretics, and were obliged to recant and to profess their belief that the priest alone, as an ordained minister of God, had the power to consecrate.[33] Despite such efforts, these heretical movements continued to divide Christendom throughout the thirteenth and fourteenth centuries.[34] We will see below that these issues have direct implications for the rituals in the Coronation Book.

II. The Early Medieval Development of the Sacre and the Ancestry of the Ordo of Charles V

For the purposes of the present study it is neither practical nor necessary to attempt a comprehensive history of the development of the texts and images of the sacring ritual. The following overview is limited to the most important ruler-making texts and, where

applicable, to their images, that were central for the development of the western royal consecration as it contributed to the ancestry of the Ordo of Charles V and the Coronation Book.[35]

When Eusebius laid the foundations for Christian ruler-making ritual with the accessions of Constantine and his sons, he was the first to impose the episcopal presence. Another bishop, Ambrose, reaffirmed and strengthened these foundations during the reign of Theodosius.[36] Besides Adomnan's references to the ordination of Aidan by Columba, Julian of Toledo's to the anointing of Wamba, and Hincmar's to the anointing of Clovis with the Celestial Balm, the evidence for royal accession ritual between the fifth and the ninth century is sparse.[37] There is a hiatus in the evidence for the development of the accession ritual between the Theodosian period and the ninth century, when the ritual appears in a developed sacramental form and is recorded in the liturgical books of the ecclesiastical hierarchy as part of their ritual responsibility.

Royal anointing rituals in missals, benedictionals or sacramentaries were not as a rule illustrated with historiated scenes of the ritual acts, perhaps because these ruler-making texts in ecclesiastical liturgical books were not made to be historic accounts of a particular accession, but rather to be exemplars of the liturgy of a particular bishopric to be used if the occasion presented itself. Few ordines are known to have been compiled for a specific historical accession. Thus it would appear that their actual use in a particular ritual was secondary and that the primary consideration was their inscription into the liturgical books as an effort by the Church hierarchy to impose their authority in the making of rulers. It was less important to document an actual historic enactment of a royal ritual than it was to defend the very principle of ecclesiastical anointing of the ruler. This would explain why, when illustrations of royal anointings begin to appear in ecclesiastical ritual texts, they are not historic scenes, but lavish decorated initials that treat the words of the rite like the powerful and sacred relics that they were indeed considered to be. In other cases, illustrations are not of contemporary ceremonies, but rather of the Old Testament paradigms of priestly anointing, Samuel anointing Saul or David, or the anointing of Solomon by Zadok and Nathan, or illustrations of New Testament manifestations of the power of the Holy Spirit. This would seem to be because what was really important was the scriptural foundation of episcopal authority in the anointing of rulers.

1. The First English Ordo and the Judith Ordo

Janet Nelson has argued that the oldest surviving ordo for the consecration of a king is a copy of the First Recension of the English royal ordo, preserved in the so-called Leofric Missal (Oxford, Bodleian Library, MS Bodley 579). The manuscript is a composite of three sections, two later sections ('B', an Anglo-Saxon Paschal calendar, and 'C', assorted masses, historical data and manumissions) dated to the 970s, and, bound between these two sections, an older section (Leofric 'A') which is a Gregorian Sacramentary recently shown on palaeographical grounds to have been copied at Saint-Vaast, Arras, in the 880s.[38] The royal ordo appears in this section, that is the largest component of the manuscript, written in a pure Caroline minuscule with several full pages of decorated initials in the

so-called Franco-Saxon style of illumination for the *Vere dignum* (fol. 60v), the Preface (fol. 61r), and the *Te Igitur* (fols. 61v–62). Although of considerable historical importance, the text of the royal ordo has not been singled out in any way for special emphasis through the decoration.

This is not the place to consider all of the problems pertaining to the Leofric Missal. However, the ordo in Leofric A is relevant to the present consideration, not only because it may well be the earliest surviving royal ordo, but also because it was significant for the subsequent development of English and French royal ordines including the Ordo of Charles V. Although it appears in a Carolingian manuscript, Nelson, building on the arguments of earlier critics, has presented a subtle and convincing argument that the royal ordo is not Frankish, but English, and that it derives from earlier sources. The presence of several archaic features points to Insular liturgical sources perhaps dating back as early as the beginning of the eighth century and that, furthermore, may even reach back to early Celtic usages.[39] These archaic features include the explicit Old Testament symbolism in the anointing segment that follows a literal application of the Old Testament model, as the oil is to be poured onto the king's head from a horn while the consecrator recites the antiphon referring specifically to the anointing of Solomon (*Uncserunt Salomonem*). While this differs from later Continental royal ordines, it is consistent with the judaicizing tendencies of Insular liturgy, law, and historical and hagiographical writings of the sixth and seventh centuries. One of the most significant judaicizing aspects is that it calls for the active participation of the secular princes in the anointing of the king, in his enthronement, and in his recognition. The king, described as 'newly ordained', is enthroned on an elevated tribune or *solium* with the active participation of the *principes* who are instructed to kiss the king in a ritual of recognition, before he is acclaimed by the people with the *Vivat rex*. These features recall the biblical models of David's anointing 'in the midst of his brethren (I Samuel 16:13), Solomon's anointing in the presence of all the princes of Israel (I Paralipomenon 23:2–29, 22), and Solomon's first anointing (III Kings 1:37–9) when his throne was 'higher than the throne of my lord king David' and 'the people said "God save king Solomon"'. In these aspects, as Nelson observed, the ritual explicitly draws upon the biblical models of I Kings, 39 and Daniel 2, 4, and the enthronement on the solium in the company of the princes is a specific reference to I Paralipomonon 29, 22–4, *Seditque Salomon super solium Domine in regem pro David* Other archaic features in this ordo include the use of the word *pontifex* instead of bishop, a usage common in late Roman contexts as in the Visigothic *Liber Ordinum*, and instead of coronation with a crown, a helmet, the principal *Herrschaftszeichen* of the Anglo-Saxon kings, along with a sceptre, another Anglo-Saxon royal insignium.[40]

The Leofric Ordo had an important influence on the subsequent development of Continental and Insular royal ordines. It appears in two later manuscripts, the Egbert and the Lanalet Pontificals, and it was the basis of a major revision in the sacring ritual represented by the Second English Ordo and its Continental variants (see below).[41] In the major sacring ordines after this recension, all of the roles that had been filled by the secular ranks were taken over by the clergy, but, as we will see, the active participation of the princes in the transmission of the insignia and in the enthronement on the solium would

be restored in the Ordo of Charles V and its antecedents from Reims, and this presents the possibility that the recension of the Leofric Ordo was a source for that important change.

Although it is unlikely that the editor of the Ordo of Charles V had seen the Leofric Missal, it is entirely possible that he had access to the Lanalet Pontifical (Rouen, Bibl. Mun., MS A. 27), an important illustrated Anglo-Saxon manuscript that was in Normandy from the eleventh century. As the first two Valois dukes of Normandy, as protégés of successive archbishops of Rouen, and as patrons of painting and illustrated manuscripts, Charles and his father John the Good would undoubtedly have taken an interest in great illustrated manuscripts to which they had access, and the Lanalet Pontifical is such a manuscript.[42]

Although the Leofric Ordo does not have a queen's ordo, it is closely related to the Judith Ordo, composed by Hincmar of Reims for Judith, the thirteen-year-old daughter of Charles the Bald, for her marriage to the Anglo-Saxon king Aethelwolf in 853. This ceremony includes an anointing for the queen along with prayers closely corresponding to those in the Leofric Ordo. Although scholars disagree over the relationship of the Judith Ordo to that in Leofric A, Janet Nelson convincingly argues for the priority of the Leofric Ordo over the Judith Ordo. She makes the observation that Judith would not have been consecrated in this manner had Aethelwolf not already been consecrated at the time of her marriage to him. This suggests that Hincmar, in composing the Judith Ordo, sought to reconcile Judith's consecration with an extant Anglo-Saxon practice, and that he consulted existing Anglo-Saxon ritual sources. Indeed, the evidence from the *Life of Columba* indicates that royal anointing was practised in Insular society by 700, and perhaps a century before that. There are other indications that Ecfrith, the son of King Offa of Mercia, was anointed in 787.[43] The so-called Franco-Saxon style of the decoration in the Leofric manuscript is consistent with these conclusions, as this style is characterised by its insistent use of an Insular aesthetic — specifically, a rejection of figural imagery and a preference for initials composed of a decorative vocabulary of hybrid animal interlace.

2. The Protocols of Hincmar

During the reign of Charles the Bald important changes were made in the process of ruler-making.[44] The earliest surviving Frankish accession formularies are the 'protocols' written by archbishop Hincmar of Reims for the sacre of Charles the Bald as king of Lotharingia at Metz in 869 and for the sacre of his son Louis the Stammerer as king of the West Franks in 877.[45] These are not complete ritual texts in liturgical books but, rather, descriptions of what was done at these specific historical sacres. Both protocols were transmitted in the same lost manuscript, formerly in Saint-Laurence in Liège, that also contained Hincmar's protocols for the sacring of Judith and of Ermintrude, the second wife of Charles the Bald, in 866.[46]

Prior to the consecration of Charles the Bald as King of Aquitaine at Orléans in 848, when the Frankish bishops began to assert their prerogative in anointing the Frankish king, royal anointing had been dominated by the papacy.[47] When Charles the Bald was subsequently consecrated and crowned king of Lotharingia at Metz, two prelates officiated: Adventius, bishop of Metz, and Hincmar, archbishop of Reims, the first time that an

archbishop of Reims had been directly involved with a sacre.[48] Hincmar introduced several important innovations into the royal consecration that were to have far-reaching consequences for the history of ruler-making, for the theory of rulership, and for defining the place of the ruler in relation to Church and State. With these innovations, Hincmar simultaneously effected liturgical and political change. The first innovation was the introduction of a sequence of preliminary acts that preceded and remained outside of the status-changing rites proper. Nelson has shown that these preliminaries, which altered the premises of the royal consecration and the entire notion of kingship, consisted of an *adnuntiatio* in which the bishop-consecrator directed questions to the prince who was now merely a candidate for kingship, and not even a king-elect. These questions concerned the candidate's orthodoxy and especially his intention to protect and respect ecclesiastical property. The prince responded with sworn promises to the consecrator, after which the metropolitan archbishop, Hincmar of Reims, satisfied with the prince's *responsio* and acting as the divinely appointed interpreter of God's will, presented the king-elect to the people for their acclamation.[49]

In the Leofric Ordo the secular ranks actively participated in the elevation of the king on the throne, but in Hincmar's ritual the laity have been excluded from the status-changing acts of the sacre and divested of their role as the electors of the king. No longer does the candidate arrive at the rite as the elect of the people. Rather, he is admitted to the consecration as the elect of God, and divine action is identified here with episcopal action.[50] The people accept God's will. In the Protocol of 869 all of the status-changing acts are performed by members of the ecclesiastical hierarchy, a fact which is emphasized by the verbal process of the *adnuntiatio* which states that Charles the Bald 'is crowned and consecrated to the Lord in possession of the kingdom by the agency of the bishops'.[51]

Nelson has demonstrated the important consequences of this preliminary section for the legal and constitutional re-definition of kingship in the Frankish state. Through these promises sworn to the consecrator, the king submits to the authority of the consecrator, who thus has the authority to judge whether the king upholds his promises and to depose him if he fails to do so. Not only does the consecrator become the agent in electing and elevating the king, he becomes the sole agent to remove him from office. Hincmar modelled his preliminaries after those in the consecration of a Frankish bishop, in which the consecrating bishops addressed a *petitio* to the candidate who responded with a sworn statement of his orthodoxy, and the consecrator, satisfied with the *responsio*, admitted the bishop-elect to the consecration rite. Thus the bishop was subject to the authority of his consecrator who could judge him and depose him if he failed to live up to his vows.[52]

With these changes Hincmar re-defined kingship as an office within the ranks of the ecclesiastical hierarchy, submitting it to their authority. Juristic theory, expressed in this rite in the king's promises as solemnly made vows, had the force of law. As the Frankish bishops backed up their professions with written statements, so the Frankish king followed up with written statements kept in the cathedral archives along with other legal documents, a practice that strengthened the bishop's role as custodian of the law.[53]

While the Leofric Ordo compared the consecrator to the high priest who anointed the king of the Israelites, the consecration prayer and the coronation prayer in Hincmar's rite

state that the king is consecrated and crowned by God, emphasizing the notion that the bishop-consecrator is the mediator between God and his people. From the anointing of Pippin until the sacre of Charles the Bald at Metz, crowning and anointing remained two distinct actions, usually taking place on separate occasions.[54] The two actions are joined together by Hincmar. The conception of kingship that is reflected in the insignium of a crown differs from that in the Leofric Ordo, where the helmet signified the kingly virtue of fortitude as stated in its coronation prayer. In the rites of Hincmar, the king is crowned by God with the crown of glory, associated with the illumination of the Holy Spirit as explicitly stated in the anointing prayer (*Coronet te Dominus corona gloriae … et ungat te in regni regimine oleo gratiae Spiritus Sancti sui, unde unxit sacerdotes, reges, prophetas et martyres …*). This represents a significant change in the meaning of the crown. Until then crowns had been the outward symbol worn by the king to signify his election to kingship by the magnates. It thus carried associations of the consent of the people to the king's secular authority.[55]

Although a queen's ordo is not attached to this rite, Hincmar's Protocol for the sacring of Ermintrude at her marriage to Charles the Bald presents a parallel with the rite of 869. The event occurred in the context of an episcopal synod at Soissons in 866. Hincmar's Protocol indicates that the queen submitted to an *adnuntiatio* of two bishops before she was consecrated, and, as in the rite of 869, there was no ring, something rather exceptional for a marriage ceremony.[56] After this sacre the officiating bishops delivered a sermon emphasizing that the queen's consecration was essential for the defence of the kingdom as God would give posterity to the king, ostensibly to assure an uncontested succession. This sermon also alluded to the sacre of Ermengarde, the consort of Louis the Pious, by Pope Stephen IV, thereby linking it to an earlier precedent.[57]

The Sacramentary of Metz (Paris, Bibliothèque Nationale, MS lat. 1141, fol. 2v), one of the finest products of the so-called Court School of Charles the Bald, has been associated with Charles's sacre in Metz.[58] The painting in this manuscript is related to a number of important illuminated manuscripts connected with this ruler and bearing his portrait, including the First Bible of Charles the Bald (Paris, BN, MS lat. 1), the Bible of San Paolo fuori le mura, given by Charles the Bald to the pope (Rome, Abbey of San Paolo f.l.m.), the *Codex Aureus* of St Emmeram (Munich, Bayerische Staatsbibliothek, Clm. 14000), and others.[59] The Sacramentary's association with Charles the Bald, his court, and his sacre at Metz is supported by its presence in Metz during the Middle Ages and by the fact that the artist is identified with other illustrated manuscripts made for this ruler. It has been observed that the manuscript is less a sacramentary and more a commemorative coronation book, as only the canon tables are completed, and its unfinished state has prompted speculation that this is due to the deposition of Charles the Bald on 8 August of the year after his sacre in Metz.

The full-page illustration (ills. 17, 18 [detail]) shows the hand of God descending from clouds to hold a golden crown over the head of a youthful king who stands between two bishops. The scene seems to make a direct appeal to Constantinian models because it corresponds closely to the gold medallion of Constantine crowned by the hand of God in Vienna (ill. 19), although in the medallion Constantine is flanked by two of his sons instead of two bishops.[60] The portrait of the king in the Metz Sacramentary is not sufficiently

71

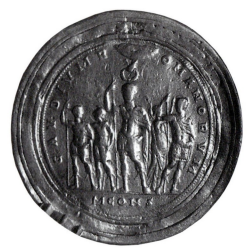

18 *(left)*. The Hand of God through the Clouds. Detail of ill. 17
19 *(right)*. Constantine crowned by the Hand of God. Gold medallion. Vienna, Kunsthistorisches Museum

individualized to be identified with absolute certainty, complicating the identification of the subject and whether indeed it does represent Charles's coronation at Metz. Because all three figures are nimbate, it has been proposed that they do not represent contemporary historical figures, but three saints such as Clovis, St Remi and another episcopal saint (Arnulf of Metz?). They may even be biblical figures such as Solomon who was anointed by Zadok and Nathan, the image being similar to the representation of that subject in the Bible of San Paolo. Another hypothesis is that the illustration is allegorical or typological, representing the relationship of the secular and ecclesiastical powers, or that it is an idealized allegorical image about the nature of medieval kingship. Given the polyvalent character of sacring symbolism and its tendency to call forth the sainted ancestry of kings and priests, it is plausible that all of these meanings were intended.

It is worth noting that Hincmar wrote that Charles the Bald issued from the race of Clovis and Arnulf of Metz, and he explicitly compared Charles's sacre to the anointing of Clovis by St Remi at Reims.[61] This evidence suggests that the image was intended to present Charles the Bald as the embodiment of Clovis and Hincmar, of St Remi. In explicit ways this image is a visual expression of Hincmar's ideology of kingship as expressed in his Protocol of 869. The hand of God descending from a cloud to hold a jewelled golden crown over the head of the king is a direct visual expression of the prayers recited in this rite for the consecration and crowning which state that 'The Lord crowns you with the crown of glory (*Coronet te Dominus corona gloriae*)'. Similar to Hincmar's Protocol in which two bishops officiated, the king is flanked on each side by a bishop wearing the *pallium* and bearing a book, attributes emphasizing their episcopal authority and their liturgical responsibilities.

The fact that all three figures are nimbate also refers to the imagery and ideology of this protocol. It has been noted that two references are made in the protocol to the crown of glory, the first in the prayer recited by the consecrator when he anoints the king's head and the second when he places the crown on the king's head. While a literal crown is placed on

the king's head for the latter, the reference to the crown of glory made when the king's head is anointed corresponds to anointing. The anointing prayer states 'God crowns you with the crown of glory ... and anoints you into the governing of the kingdom with the oil of the grace of the Holy Spirit, with which were anointed priests, kings, prophets and martyrs ... '. Here, the crown is unmistakeably identified as the grace or illumination of the Holy Spirit conveyed by the anointing of the head of the king, the same consecration received by priests and bishops. The king and bishops in this image correspond to two of these categories, kings and priests, and perhaps three if one considers Hincmar's activities as a biblical scholar who interprets the word of God as a continuation of the work of prophets. The aureoles around the heads of the king and bishops are an apt expression of the anointed, charismatic character of which kings and bishops partake.

The king stands between the bishops as he is crowned, yet another resemblance to the Protocol of Hincmar in which the king is not enthroned on the solium as in the Leofric Ordo, but stands to be crowned. He stands between the bishops with comparable dignity, conferred by his aureole and commensurate stature, apt expressions of his sharing in the ministry of the ecclesiastical hierarchy after his consecration according to Hincmar's Protocol of 869, which states that the king participates in the ministry of bishops. Yet, his distinctly secular attire also indicates his status amongst the secular ranks, and the image expresses the dual character of the ruler.

Another correspondence between the image and the Protocols is the manner in which both bishops turn towards the king, raising their right hands to administer the oath and instruct the king. These details convey the notion that the king is submitted to the authority of his consecrator who speaks in the place of God. The king's sworn obligation to listen to his consecrator was perhaps the reason why Hincmar anointed Charles on his ears as well as on the forehead and the crown of the head as specified in the protocol. In this image the king's ears are given unusual prominence and a peculiar ring-like form evoking the actual wording of the anointing rubric in which the word for ear *auriculum* literally means 'little ring'. The bishop on the right turns his head so that his ear is visible, recalling the image on a subsequent folio of the same manuscript depicting St Gregory inspired by the Holy Ghost in the form of a dove speaking into his ear as if to show him to be a successor of this biblical scholar who inspired by the Holy Ghost.

There are further indications that this image refers to Charles the Bald and his two consecrators. The artist took pains to distinguish the heavenly and earthly spheres in this painting by including the cloud from which the hand of God emerges, a detail that makes it clear that the three figures stand below the heavens on a terrestrial plane. Furthermore, the king wears a diadem in addition to the crown which God is placing over his head, consistent with the historical situation as Charles wore the crown of Aquitaine at the time of his sacre at Metz.

After the sacre of Charles the Bald, the Sacramentary remained at Metz, where it would have served as a continuous reminder of the new order established by Hincmar in which the king joined the ranks of the Church hierarchy and was subjected to the authority and judgment of his consecrators. The image so closely reflects Hincmar's thinking that it must

have been conceived by him and executed by an artist working under his direction, a conclusion consistent with the artist's connections with Reims and Metz.[62] We might conclude our consideration of this image with Hincmar's own words to Charles: 'After this anointing which you have merited, that of which the apostle Peter said "you, chosen race, royal priesthood", it is by this anointing episcopal and spiritual, rather than by a worldly authority, that you carry the royal dignity. God commits to you the ministerium of the kingdom'.[63]

3. The West Frankish Ordo of c. 900 (the Erdmann Ordo)

Although they represented significant changes in the procedures of ruler-making, the Protocols of Hincmar did not receive universal acceptance, and by the end of the ninth century there was no single canonical procedure for the sacre of the Frankish king.[64] After the Protocols of Hincmar, the next major development of the royal consecration ritual appears c.900, or possibly even earlier in the 880s or 890s, in an ordo which has been identified in a pontifical from the diocese of Sens (St. Petersburg, Public Library, MS Q.v.I 35, fols. 85v–90) where it was taken during the French Revolution.[65] This ordo has been described as the 'first modern formulary of accession liturgy' as it includes short titles and rubrics which clearly set out the procedures to be followed in the ritual, and its structure is that of all later ordines.[66] Recently Richard Jackson identified several other copies of this ordo which was so influential for the subsequent development of the sacre.[67]

The West Frankish ordo was composed from elements derived, for the most part, from Hincmar's Protocols of 869 and 877. The role of the bishops is the same and the preliminary sequence of the Protocol of 869 is maintained. Besides the crown and the sceptre which the king received in Hincmar's rites, he is now also given a sword, ring, and *baculum* (or staff). The bishop received a ring and baculum at his consecration, and their addition to this rite reinforced the parallelism with the episcopal consecration. This parallelism was given further emphasis by the additional prayers recited at the transmission of the ring and baculum in both the royal and episcopal consecrations. Thus the king's ministerial status and his episcopal character underwent further elaboration.

The most important new aspect of this ordo is the ceremony for the consecration of the queen, for the first time joined to the king's consecration rite. The queen's ordo in this version became the basic model for all subsequent queens' ordines in France and in England. It is the core of the Ordo of Jeanne de Bourbon in the Coronation Book. The ordo for the consecration of the queen is more complex than either of the two earlier queen-making rites of Judith and Ermintrude. It introduces a special ceremony for the queen's entry into the cathedral. She prostrates herself before the altar in a fashion similar to the prostration of candidates for ecclesiastical ordination, and she is then led to the altar by one, and possibly two, bishops. She inclines her head as the archbishop recites blessings over her. She is anointed on the head, and, in a manner reminiscent of the Early Christian episcopal consecration, the bishop imposes his hands on her head in 'instituting' her queen. She then receives a ring and is crowned. In other words, this ordo goes very far to establish parallels with the consecrations of kings and bishops. The comparison with

ecclesiastical consecrations is furthered by the consecration prayer derived from prayers for the consecration of an abbess in the Frankish Gelasien sacramentaries.[68]

This ordo contains no reference to the Celestial Balm used for the anointing of Clovis, and because it is in a manuscript identified with the archdiocese of Sens, one might perceive in this omission a rejection of Hincmar's pretensions for the see of Reims as well as an effort on the part of an archbishop of Sens to reassert the historical priority of Sens as the primatial see of Gaul.

Bautier made the tantalizing proposal that this ordo was compiled for the sacre of Raoul (Ralph, Lat. Rodulfus) of Burgundy at Soissons on 13 July 923.[69]

4. The Seven Forms Ordo (or Ordo of Stavelot)

The Seven Forms Ordo is another witness for the development of the West Frankish, English and German sacring traditions. The principal copy of this ordo is in a thirteenth-century manuscript from Stavelot (Brussels, Bibl. Roy., MS 2067–73), but it represents an earlier stage in the development between the West Frankish Ordo of *c.* 900 and the Second Recension of the English Ordo and the Ordo of Mainz. Once considered a defective copy of the German Ordo, it was later identified as an independent ordo in its own right, of West Frankish origin, later to become the main component of the German Ordo. It also influenced the Ordo of Burgundy and was later incorporated into an eleventh-century pontifical from Milan. Janet Nelson has proposed that this ordo could have been compiled in the 880s or 890s.[70]

Its most important contribution to the development of the sacre is the presence of the *Sta et retine*, a formula recited at the enthronement that affirms the ruler's right to the throne on the basis of paternal inheritance. This formula became thereafter a key element in most sacring ordines.[71]

5. The Second English Ordo

Version A: The Ratold Ordo (or Fulrad) and the 'SMN' Ordo

The Second English Ordo was called the Edgar Ordo because it was once thought to have been compiled for the accession of Edgar at Bath in 973. However, only the latest revision of this ordo can be associated with that event.[72] The story of this compilation is a very complicated matter illustrating the interdependent, even interlocking, developments of the English and Continental royal ordines.

There are two distinct versions, an earlier one known also as the Ratold Ordo because the best copy of this recension appears in the Ratold Sacramentary (Paris, BN, MS lat. 12052) written for Ratold, abbot of Corbie (d. 986), and a slightly later revision which has two different sub-groups.[73] Although the Ratold version exists only in Continental manuscripts in a form adapted for a French situation, it closely reflects the original state of the Second English Ordo which has not survived in any manuscript in its original form.[74] The

Ratold Ordo included one of the earliest expressions of the hereditary principle: *Sta et retine a modo locum (var. statum) quem hucusque paterna suggestione tenuisti haereditario jure* ..

The Ratold Ordo had enormous influence on the development of the French *sacre* and survives in at least seventeen French pontificals dating from the eleventh to the fourteenth centuries.[75] How and when this version of the Second English Ordo crossed the Channel remain uncertain, but already the Ratold Ordo had been adapted for a French situation, leaving in place passages that only make sense in an English context. For example, the consecration prayer mentions 'the sceptres of the Saxons, Mercians and Northumbrians' (hence the abbreviation 'SMN'). This passage remarkably continued to be repeated in French pontificals deriving from the Ratold Ordo, including the later French ordines, the Ordo of 1250, the Last Capetian Ordo and the Ordo of Charles V.[76] The continued presence of this phrase is a striking testimony to the intermingled histories of the English and French royal ordines.

The Second English Ordo was composed of elements drawn from the First English Ordo, from Hincmar's Protocol of 869, the West Frankish Ordo of *c.* 900 and the Seven Forms Ordo. The most important change in the Second English Ordo is the introduction of the preliminaries of Hincmar's Protocol of 869 that defined the king's office as a 'ministerium' and placed it under the authority of the episcopal consecrator.[77]

Unlike the First English Ordo, the Second English Ordo includes a queen's ordo derived directly from the West Frankish Ordo of *c.* 900 with some slight changes. Nelson has argued that these modifications must have been produced, not as a liturgical model, but for a specific queen because it refers to a political union made by the father of the king for whom the new consecration was compiled. She proposes Alfred, whose sons inherited a kingdom unified from separate kingdoms, and suggests that the original version of the Second English Ordo was compiled soon after Alfred's death, perhaps before the consecration of his son Edward in 900.[78] Because the queen's ordo includes prayers based on the benediction of abbesses, Nelson thinks it appropriate for Edward's second wife Aelffled who was a patroness of the arts and of monasteries, which she sought to reform and to which she made significant donations. Because collateral succession was a common practice in England at the time, and in 900 Edward had uncles and brothers who could claim to succeed him, sanctifying the queen would have been a means for justifying paternal succession from father to son rather than from king to brothers. Aelffled's daughter Edith (Eadgytha) was consecrated when she married Otto I, suggesting that Edith may have been following an English precedent.[79]

Derek Turner showed that the Second English Ordo underlies French usage, and suggested that it was imported to France for practical (rather than literary) purposes. He identified this with the return of Louis IV d'Outremer to France in 936, after years of exile in Wessex, to be consecrated king at Laon by the archbishop of Reims. Louis IV was the son of Charles the Simple, king of West Francia from 893–922 and Eadgifu, another daughter of King Edward of England.[80] The dynastic connections are sufficiently close between the Frankish and Anglo-Saxon royal houses during this period to support the hypotheses of Turner and Nelson.[81]

The English tradition behind the Ratold Ordo is reflected by the decoration of the Ratold Sacramentary, a late variant of what is generally known as the Franco-Saxon style, characterized by full-page initials composed of interlace in gold and silver. They recall the vocabulary of decoration of the seventh-century Canterbury school of illumination that introduced gold and silver to the Anglo-Saxon decorative repertoire. In this tradition the initials concentrate on the word and the letter that are treated like sacred relics, to focus the reader's attention upon the text itself.[82]

Version B: The Benedictional of Archbishop Robert

There are two distinct sub-groups of this revision of the Second English Ordo.[83] The earliest copy of the first sub-group is an illustrated manuscript of the Winchester School of illumination, the Benedictional of Archbishop Robert (Rouen, Bibl. Mun., MS Y7). The manuscript (ill. 20) contains benedictions pointing to New Minster, Winchester as the original destination. It is clearly related to the greatest masterpiece of Anglo-Saxon illumination, the Benedictional of St Aethelwold, since several paintings in the Benedictional of Archbishop Robert were painted by the artist of the Benedictional of St Aethelwold.[84] On iconographic and stylistic grounds the manuscript has been dated to c. 975, during the period when Aethelwold (963–84) was abbot of New Minster.[85]

This version introduced a modification of the coronation oath modelled after the *tria precepta* of the First English Ordo and the earlier version of the Second English Ordo. Following the preliminaries of Hincmar's Protocol of 869 and the West Frankish Ordo of c. 900, what had originally been a statement of intention made by the newly-consecrated king after his enthronement (in the First English Ordo), was now placed at the beginning of the rite where it became a promise sworn to the officiating clerical hierarchy and a pre-condition for admission to the consecration. The ordo also includes the new antiphon *Vivat rex*.[86] The queen's ordo was copied without change from version A.

Nelson has proposed that this revision was carried out by Aethelwold, who was closely associated with Edgar from the 950s while he was abbot at Abingdon and the atheling was his protégé. Aethelwold sent to Fleury and Corbie for liturgical exemplars to reform the English monastic liturgy. The consecration of an abbot in this recension has been derived from the royal blessing of the First and Second English ordines, reinforcing parallels between the abbatial and royal office. Nelson suggested that such a significant revision was likely to have been made for a specific sacre. Ruling out Edgar's sacre at Bath in 973, she proposes Edgar's accession at the beginning of his reign in Wessex c. 960, given Edgar's active support of monastic reform and his close association with Aethelwold.[87]

In this sacre a recurring theme is the power of the Holy Spirit that is transmitted by the anointing. Although there are no illustrations for the royal ordo, the three sumptuous illustrations in this manuscript celebrate the Holy Spirit as the divine source of royal and priestly power. The scene of Pentecost, a splendid expression of the Winchester style, represents a stream of orange fire descending from the Holy Spirit into the mouths of the twelve apostles (ill. 20).

From the eleventh century the Benedictional of Archbishop Robert was in Normandy in the library of the chapter of the cathedral of Rouen.[88] The manuscript had special importance

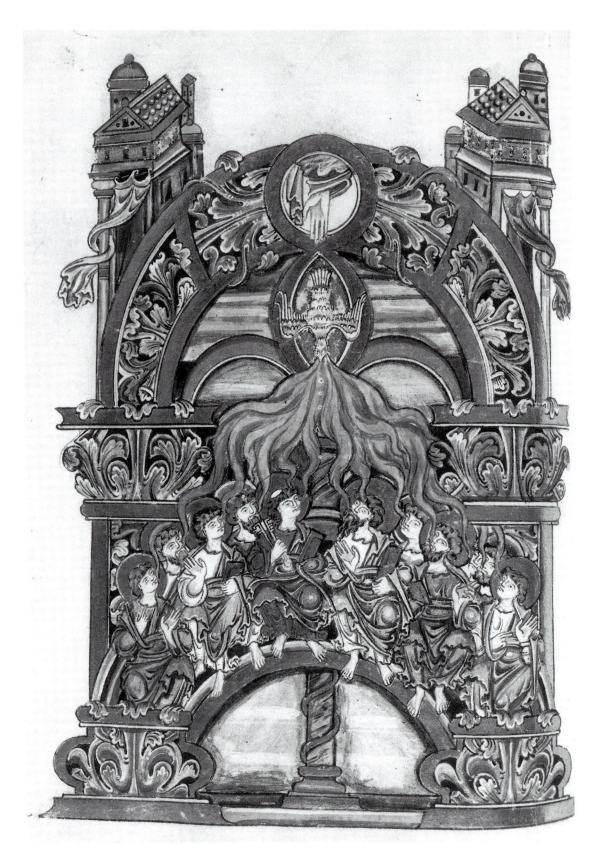

20. Pentecost. Benedictional of Archbishop Robert. Rouen, Bibl. Mun., MS Y. 7, fol. 29v

in Normandy because the rite for the investiture of the duke of Normandy was added in a thirteenth-century hand.[89] When John and Charles were installed respectively as the first and second Valois dukes of Normandy, this manuscript may well have been used for the ceremony. Certainly, the royal ordo in this recension was an important source for the Ordo of Charles V, but it is even possible that this specific manuscript was consulted.

6. The Romano-Germanic Ordo

One of the most important sources for the Ordo of Charles V is the Romano-Germanic Ordo. Widikund of Corvey provided a detailed description of the consecration and crowning at Aachen in 936 of Otto I and his queen, the Anglo-Saxon princess Eadgytha (Edith), daughter of Edward the Elder of England. The present ordo resembles the rite described by Widikund, but the earliest manuscripts of the German Ordo are all later than 936. The royal rite of the Romano-Germanic Pontifical corresponds closely enough to the rite described by Widikund to indicate that this rite had largely taken its developed form by the 930s.[90]

It was once thought that two different stages of the German rite existed, an early stage and a developed stage. Erdmann identified six recensions of this rite, but Andrieu demonstrated that the considerable variation occurs primarily in secondary details and in wording, and that they all pertain to a family of pontificals that he called the *Pontificale Romano-Germanicum* to reflect the mixed German-Roman character and sphere of geographical influence. This compilation is also known as the Pontifical of Mainz because many medieval liturgical manuscripts with this rite are associated with the pontifical compiled at the abbey of St Alban at Mainz in the tenth century. It is also sometimes called the Ottonian Pontifical because Otto I brought it to Italy where it was influential in the reform of the Roman liturgy.[91]

This ordo is more complex and fuller than the previous ordines. It has an elaborate series of preliminary rubrics that call for a group of bishops and clergy to fetch the king from a *thalamus*, a word that denotes a bed chamber or a bridal chamber, explicitly associating the royal consecration with the marriage ceremony which in the Middle Ages included the blessing of the nuptial chamber (*Benedictio thalami*).[92] Two bishops lift up and support the king, one on his right and the other on his left.[93] The rubrics call for the bishops to be 'vested honorifically' with 'relics hanging from their necks' and for the remaining clergy to wear chasubles. Together the king, bishops and clergy go in procession to the cathedral while chanting the antiphon *Ecce mitto angelorum* as the people follow them. All of these features reappear in the Ordo of Charles V.

When the procession arrives at the entrance of the cathedral, prayers are recited by the archbishop of Mainz. The 'king designate', as he is called in the ordo, is led into the cathedral and up to the choir. Here he deposits his arms and prostrates himself on the ground while a litany is chanted, recalling the ordination of priests and the consecration of bishops. The archbishop interrogates the prince on his orthodoxy and whether he promises to uphold the rights of the Church. After receiving the promise from the king, he

calls out to the assembly to ask if they accept to be subject to the king, and they acclaim their consent.

The anointing section is considerably expanded beyond previous ordines. In addition to the head, anointing is administered to the hands, breast, shoulders, and joints of the arms, each action accompanied by a blessing formula. This is followed by an expanded transmission sequence for the sword, the *armillae* (protective bracelets), *pallium* (mantle) and ring, sceptre, baculum and crown. The traditional parallelism between the consecration of the ecclesiastical hierarchy and the royal consecration is heightened by the presence of the anointing of the hands, transmission of the ring, baculum, and pallium, all direct parallels with the episcopal sacre. The prayer for the imposition of the crown in this ordo includes a passage explicitly stating that the king participates in 'our ministerium', 'our' referring to the metropolitan archbishop and his assisting suffragans. Indeed, the entire ordo heightens the king's episcopal and prelatial character, beginning with the newly introduced section of the fetching of the 'prince designate' by the bishops, ecclesiastical hierarchy and clergy, to the exclusion of the secular orders, making it clear that a parallelism is intended with the sacerdotal rite of the ecclesiastical hierarchy.

The culmination is the *Sta et retine*, given special prominence with detailed rubrics. This formula first appeared earlier in the Seven Forms Ordo and in the Ratold Ordo. Whereas Ratold (and its later recension) has *suggestione*, in the Romano-Germanic Ordo (and its recension) the phrasing becomes *Sta et retine a modo locum quem hucusque paterna successione …* . This change of a few letters would not seem to be a scribal error since the word *suggestione* occurs consistently in the later recensions of the Ratold Ordo while *successione* appears in the recensions that follow the Romano-Germanic Ordo. Rather it seems to have been a deliberate choice of a different Latin word, one that weakens the elective principle and strengthens the hereditary principle i.e. substitution of the word *suggestione* ('to suggest, to indicate as possible, to put forward for consideration') by the word *successione* (i.e. succession to a position of authority). The archbishop and bishops proclaim the king's hereditary right in the recitation of this version of the *Sta et retine*. After this the archbishop places the king on the throne, here called a *solium*, a word that recalls the enthronement in the First English Ordo. The archbishop bestows the kiss of peace on the king who is then acclaimed by the clergy who sing the *Te Deum*.

The queen's ordo that follows is simpler than either the queen's ordo in the West Frankish Ordo of *c.* 900 or in the Ratold Ordo. She is led into the cathedral, blessed before the altar, anointed with holy oil and crowned. As in the Frankish queen's ritual, she does not here receive a ring.

In the Ottonian period, according to Henry Mayr-Harting, Christ-centred kingship was emphasized at the expense of Old-Testament kingship. As Ottonian art brought the imperial image and the divine nature closer than ever before in the West, so the Christ-centred image of the emperor associated Ottonian kingship with divine rule. For the Ottonians ritual and liturgy were substitutes for an administrative and bureaucratic structure lacking in Ottonian society. Not only was liturgy a substitute for bureaucracy that 'daily reaffirmed and displayed the structure of the Christian kingdom, it was the

collective memory that preserved and transmitted these structures from generation to generation and across the far-flung distances of the empire'.[94]

One might add that the sacre was central to this ritualization of Ottonian society for it identified the king with Christ, in particular through the ritual anointing. The Romano-Germanic Ordo institutionalized these changes through changes in the ritual itself. For although the ritual retained the traditional references to the Old Testament *exempla* of kingship, priesthood and anointing, there is a new emphasis on Christ, his kingship, and his pre-anointing by God the Father and the Holy Spirit.[95] In Ottonian liturgy the emperor was more than an *imago Christi*, he was identified with Christ.[96] One might add that it was this royal consecration rite that made him so.

Mayr-Harting observed that there was no single ruler-making manuscript, but a great many ruler-making manuscripts. However, one Ottonian liturgical manuscript seems to express in very precise ways Ottonian notions of Christocentric kingship as created by the Romano-Germanic Ordo. It is the Sacramentary of Henry II (Munich, Bayerische Staatsbibl., Clm. 4456).[97]

This manuscript is dated after 1002 when, on 6 June, Henry II was consecrated and crowned in Mainz by Willigis, archbishop of Mainz. The role of Willigis in Henry's consecration is stressed by Henry's biographer in the *Vita Henrici II*, where the 'ritualist aspects' of Henry's campaign to succeed to the throne are emphasized. Mayr-Harting associates the heightening of the ideology of divine kingship, along with the increased emphasis upon ritual and the production of liturgical manuscripts during Henry's reign, with his struggle to obtain the German succession at the death of the childless Otto III. He observes that 'Henry's primary method of prosecuting his claim to the throne was through ritual'.[98] The German royal ordo would have been a cornerstone of Henry's ritualist campaign, particularly because it culminates in the *Sta et retine,* the ritual affirmation of the hereditary right of the ruler to occupy the throne.

At Mainz, Henry would have been consecrated and crowned by the archbishop of Mainz according to the rite of the Pontifical of Mainz. The image of Henry II crowned by Christ (ill. 21) on fol. 11 presents several features that respond in direct ways to passages of the German royal rite in the *Pontificale Romano-Germanicum*. Indeed, it represents a visual expression of the host of innovations in that ordo, compressed into a single powerful image. We have already noted that the rite introduced a new sequence of preliminaries to the *petitio* of the bishops and the *responsio* of the 'prince designate' in which the consecrating bishops and members of the clergy fetch the prince from a thalamus. It also introduced an expanded series of anointings and transmissions of insignia, and an elaborate *sublimatio* and enthronement sequence accompanied by the *Sta et retine* formula affirming the right of hereditary succession. All of these segments of the ritual are expressed in this image.

Henry II appears supported on each side by a bishop, the one on his right identified as St Udalric and the one on his left as St Emmeram, a direct response to the rubrics of the introductory sequence that call for two bishops to raise the prince, one on his right and one on his left. The bishops are to be honorifically vested and wearing relics hanging from their necks. Here, instead of bishops wearing relics, we have bishop saints. After the

bishops raise the prince they lead him to the cathedral chanting the hymn *Ecce mitto angelum meum*, reflected in the painting by the presence of angels who descend from above to assist in the transmission of the Holy Lance and the sword. The bishops raise the king up by his elbows, a detail giving special emphasis to the introduction in this ordo of the anointing of the king's elbows, while the mandorla surrounding Christ and enclosing the king's head to rest on his shoulders, emphasizes two parts of the king's body which are anointed in this ritual.

Vital for understanding this image is the *Sta et retine*, recited by the metropolitan archbishop after the transmission of the insignia, when the king is led to the altar and stands before the throne as the metropolitan recites on behalf of the episcopate the affirmation of the principle of hereditary succession. The image so closely corresponds to the wording of this formula that it merits translation in full:

> Stand and hold the place that you hold by paternal succession, and delegated to you by hereditary right through the authority of the omnipotent God and our present tradition, that is, that of all the bishops and other servants of God. And as much as you see the clergy closer to the sacred altars, so much more you will remember how much greater the impending honour is in suitable places to the extent that, as a mediator of God and men, you are a mediator of the clergy and the people …
>
> Let Jesus Christ our Lord, king of kings, lord of lords, confirm him in the seat (solium) of the kingdom and make him reign with him in the eternal kingdom, who with God the Father and the Holy Spirit lives and reigns in the centuries of centuries, Amen.

In this image Henry is literally lifted up into the spiritual realm, so that the temporal and the spiritual converge. He is between Christ and the bishops, on the one hand, and the earth on the other, a position expressive of the spiritual position to which he ascends, according to these passages of the consecration rite. The consecrating bishops are replaced by their saintly predecessors, and Henry occupies the place of his paternal ancestors. This is probably a likeness of Henry, who appears with blond hair and a beard. He is compared to Christ who has been made to resemble Henry in this image. Henry is the only member of the contemporary terrestrial domain who has been elevated to the spiritual realm occupied by Christ, angels, and the patron saints of the consecrating bishops.

Henry II was the grandson of the founder of the Ottonian dynasty, Henry I, the duke of Saxony, who, elected to the German kingship, refused to be consecrated by the archbishop of Mainz. Otto I is believed to have been the first Ottonian ruler to have been consecrated according to this rite that was later recorded in the Pontifical of Mainz. The *Vita Henrici II* emphasizes Henry's blood relationship both to Otto I and to Charlemagne. Otto I had been aided in his lifetime by St Udalric, the episcopal saint who supports the right arm of Henry II in this painting. Clearly, in being consecrated according to this rite, Henry II was, as stated in that ordo, standing in his hereditary paternal succession.

The Holy Lance that Henry holds in his right hand instead of the royal baculum or verge of the text is a specific reference to Henry's ancestor, Henry I. In this image the Lance joins the celestial and the temporal realms, since this sacred and miracle-working relic

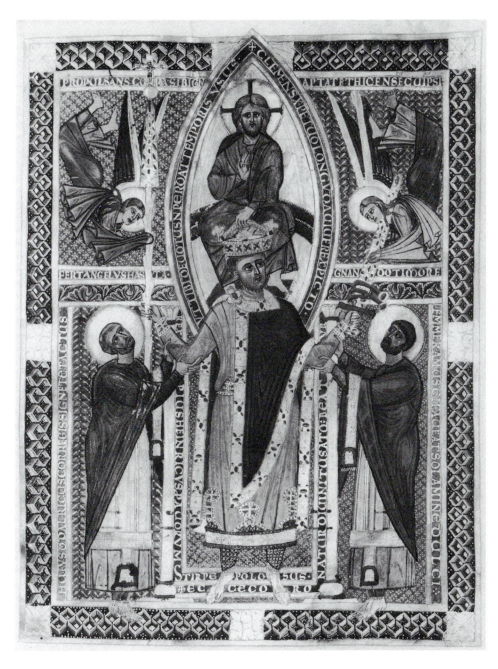

21. Emperor Henry II crowned by Christ. Sacramentary of Henry II.
Munich, Bayerische Staatsbibl., Clm. 4456, fol.11

came into the possession of the Ottonians as a gift to Henry I from king Rudolph II of Burgundy. Although Widikund does not mention the Lance in his account of the consecration of Otto I, Otto nevertheless exploited the political potential of this relic, attributing to it his victories over the Magyars. It was thus identified with imperial victory over the enemies of Christ. Reputed to be the lance of Constantine, the 'Labarum' that he carried into battle against Maxentius at the Milvian Bridge, the point of this lance was identified with the lance of Longinus that pierced the side of Christ at the Crucifixion.

According to legend it was given to Constantine by Saint Helena, and the point of the lance encloses a nail said to have been used for the Crucifixion. Possession of this relic was regarded as proof of God's election of the Ottonian rulers, associating their rule with Christ and his triumph over sin at the Crucifixion. It is thus meaningful that Henry stands in a position that mirrors that of Christ on the Cross. Liutprand of Cremona wrote *c.* 960 that 'the Lance was a gift from heaven through which God bound together the earthly and the heavenly, as the cornerstone of the powers of both'.[99] The image reflects this ideology of God's election of the Ottonian rulers by his gift of the Lance, for the angel above to the right of Christ holds the Lance and transmits it to Henry.

The Holy Lance remained the most sacred insignium of German kingship for the Ottonians. On the death of Otto III in January 1002, Henry gained possession of the royal insignia, with the exception of the Lance, which he was obliged to wrest from archbishop Heribert of Cologne who had possession of it.[100] The image celebrates Henry's hereditary succession as well as his divine election by virtue of his possession of this relic. Henry and his queen, Kunigunde, were venerated as saints in the twelfth century.

As Mayr-Harting so aptly characterized art's utility in defending a contested rule: 'Ideological presentation of hieratic rule in art may often be regarded as a response to pressure on the ruler and conflict within the ruling élite rather than a sober expression of political reality'.[101]

7. The Third English Ordo

The Third English Ordo is relevant to the present investigation if only because a pontifical from the province of Canterbury of the late twelfth century containing the revised version of the Third Recension of the English Ordo was once bound with the Coronation Book.[102] Numerous critics have argued that the Third Recension is a compilation of texts drawn from the Second Recension combined with texts taken from the royal rite in the *Pontificale Romano-Germanicum*.[103] As Ward observed, only the most important Anglo-Saxon forms have been retained in a rite in which 'the German ceremony here seems to have triumphed'.[104] From the Second English Ordo only directions for the procession and the coronation oath remain, along with the forms for the crown, sceptre and rod. But eleven prayers from the German Ordo were added, including the forms for the *armillae* and the pallium, the anointing of the hands, chest, shoulders, and elbows. It does not include the fetching of the 'prince designate' at the beginning of the German Ordo, although it introduces the *Sta et retine* according to the German Ordo. For the queen's rite German forms were combined with existing Anglo-Saxon forms.[105]

The recension survives in seven manuscripts that are classified into two sub-groups. The first group consists of manuscripts that are dated around the middle of the twelfth century and the second group, to which the pontifical bound with the Coronation Book belongs, includes usages from Rouen from *c.* 1200 and a fuller ordo for the queen than the earlier group.[106] The liturgy of the consecration of the bishop in this recension points to the province of Canterbury.[107] Illustrations do not play a prominent role in this recension.

III. The Immediate Ancestry of the Ordo of Charles V

1. The Liber ad honorem Augusti of Petrus de Ebulo

In the present consideration of the sources of the *Coronation Book*, one manuscript stands alone because it contains an extended cycle of narrative scenes depicting the successive actions of the anointing and investiture of the German emperor Henry VI by Pope Celestine III on Easter Monday, 15 April 1191. The *Liber ad honorem Augusti* of Petrus de Ebulo (Berne, Burgerbibliothek, Cod. 120 II), was in France, probably from the time of Philip Augustus, and certainly during the reign of Charles V when it was given to the Celestines of Sens, a house founded by Charles in 1366.[108] The manuscript, also known as the Chronicle of Pietro of Ebulo, is unique for the extensive historical and liturgical detail that it provides concerning the anointing and crowning of Henry VI.[109]

For the purposes of the present investigation, of interest is fol. 105 (ill. 22) which presents a sequence of scenes beginning with Henry's journey to Rome for his imperial coronation. On the top register, Rome (identified by inscription) is emblematically depicted as a city of multiple towers. In the second register, Henry rides on horseback into Rome. Wearing a green *chlamys*, he is already crowned and bearing the imperial orb. Several knights follow on horseback, and the entire group is led by a mounted standard-bearer who holds a red-orange banner with a golden cross (resembling the oriflamme). In the second register the actions are enclosed within an arcade identified as the 'church of Saint Peter' (*ecclesia beati Petri*). Henry is now bare-headed and he carries a sceptre. In the next scene Henry makes a gesture of homage by placing his right hand in the right hand of Pope Celestine (*papa Celestinus*), wearing full pontifical attire. Behind the pope, a chalice stands on an altar covered with a green brocade cloth and flanked by four burning candles, over which hangs a thurible. In the next register the king stands and bows his head as he extends his hands over a golden vessel for the pope to pour chrism over them (*primo manus unguntur crisma*). In the next scene the pope anoints the king's arms (*secundo brachia*) using an object resembling a long thin vial. In the third scene on this register the pope gives Henry the sword (*tercio hensem papa [tradit]*). On the bottom register, Henry again wears the green imperial *chlamys* as he receives the sceptre from the pope (*quarto virgam*). In the next scene the pope places the ring on his finger (*quinto anulum*). And in the last scene the pope crowns him with a 'mitre' (*ultimo mitram*), the term for an episcopal crown.

This pictorial cycle emphasizes the priestly character received by the German emperor through anointing, not by a German archbishop as in the Pontifical of Mainz, but by Pope Celestine. The anointing of the hands with chrism is given special emphasis, and following the gesture of homage in which Henry placed his right hand in the right hand of the pope, it signifies that he was a vassal of the pope. The chronicle emphasizes the papal actions of anointing and placing what the text specifies as a 'mitre' on Henry's head. This is, therefore, not the usual imperial coronation in which the German emperor was simply crowned by the pope. Nor does it represent the Ottonian royal consecration by the bishops, for this imagery asserts a papal role in ritual actions performed by the German

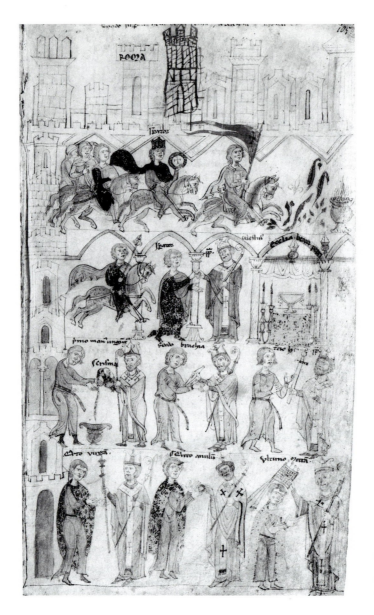

22. Emperor Henry VI crowned.
Petrus of Eboli,
Liber ad Honorem Augusti. Berne,
Burgerbibliothek, Codex 120 II,
fol. 105

bishops in the Pontifical of Mainz. This cycle delineates an anointing sequence comparable to that of the German rite, but it places the pope in the role of the archbishop for the acts of anointing and crowning with an episcopal mitre rather than a crown. By implication it appears that this cycle of scenes is asserting papal authority in the royal consecration.

2. The Ordo of Reims and the Directory of c. 1230: The Celestial Balm of Reims

One of the most important traditions that is celebrated in the Ordo of Charles V is that of the Celestial Balm, first mentioned in the writings of Hincmar of Reims in connection with the sacre of Charles the Bald in 869.[110] The ritual of the Celestial Balm was not actually incorporated into a royal ordo until the reign of St Louis, after which it was an abiding element of the French royal consecration in the Ordo of *c.* 1250, the Last Capetian Ordo,

and the Ordo of Charles V.[111] The first ritual known to have included a sequence dedicated to the Celestial Balm and the Holy Ampulla is that compiled *c.* 1230, either late in the reign of Louis VIII or during the early years of the reign of Louis IX, which survives, not as an ordo, but as a directory describing the principal acts and indicating the prayers. The presence of the sequence of the transmission of the spurs and sword has been interpreted by some as an indication that the ritual was compiled in the milieu of the French court. Jackson is surely right that the emphasis placed on the Celestial Balm, the procession of the monks and abbot of Saint-Remi with the Holy Ampulla, and the archiepiscopal see of Reims and its archbishop, are evidence that this ritual was compiled at Reims, and he makes the important point that the earliest of the three manuscript copies of this directory is still in Reims.[112] The French translation of this directory appears at the beginning of the Coronation Book where it has been used like a *prooemium* for the Ordo of Charles V (fols. 35–42v).

One detail of this directory points to a member of the chapter of the cathedral of Reims for the compilation. It includes preliminary preparations to be carried out the day before the sacre. These give unusual importance to the archbishop and clergy of Reims. The first paragraph concerning the preparations for the ceremony describes the construction of a tribune or solium before the choir of the cathedral upon which the throne is placed.[113] The directory specifies: 'On the day that the king comes to be crowned he must be received by a procession of the canons of the mother church and the persons of the other conventual churches'.[114] These additions give unprecedented importance to the clergy of Reims.

This directory introduces many other acts that are also included in the three subsequent French ordines. These include an expanded series of anointings and insignia, along with numerous parallels strengthening the traditional Carolingian and Ottonian analogies with the episcopal consecration. The role of the archbishop of Reims is given singular and unprecedented importance because it calls for the archbishop of Reims alone to transmit the sword, administer the oath, and anoint and crown both the king and the queen. It also calls for him alone to kiss the king at his enthronement on the solium.

A noteworthy detail of this directory is that it mentions a *palais* (fol. 41), and although not specifically named, the context indicates that it is the palace of the archbishop of Reims, to which the king and queen go in procession after the ceremony. Because this palace is given such prominence in the Coronation Book, the introduction of this motif in the Directory of *c.* 1230 is a precedent and a catalyst for the rituals that occur in the palace of the archbishop of Reims in the Ordo of Charles V.

The introduction of a sequence dedicated to the Celestial Balm in this ceremony is explained by a passage in the directory calling for the archbishop to use a 'golden needle' to extract the 'oil sent from heaven, and mix it with great diligence with the chrism ... to anoint the king *who alone of kings is resplendent before all the other kings of the earth because of the glorious privilege that only he is anointed with oil sent from heaven*' [emphasis is mine].[115] This ritual, therefore, complies with a strategy of defining the king of France according to the doctrine expressed by Innocent III in *Per venerabilem* (1202) 'that the king of France knows no terrestrial superior'. This transformation in the sacre was a fundamental step for the development of the claim of the king of France to the exclusive title of *rex*

christianissimus and thus for establishing the sovereignty of the king of France within the kingdom and amongst the rulers of Christendom. With this passage we see that the Celestial Balm was the effective instrument for justifying this claim. The introduction of this passage is of the utmost importance, and it remained in all of the succeding ordines including the Ordo of 1250, the Last Capetian Ordo and the Ordo of Charles V.[116]

With the possible exception of the communion in both species that is introduced in this rite, all of the elements emphasizing the sacerdotal character of the king are already present in the German Ordo. It therefore emerges that the *Pontificale Romano-Germanicum* was consulted in the compilation of this ritual. The comparisons are so numerous that it suggests that one motivation underlying its creation was to endow the king of France with a sanctity surpassing that of the German ruler, since it goes beyond all of the episcopal parallels in the German Ordo. It was thus intended to establish the king's sovereignty with respect to the emperor.

The German Ordo also inspired the ritual of the transmission of the sword by the archbishop, but with modifications: the French ritual calls for the king to hand over his sword to a seneschal, a refinement that introduces a member of the laity into the royal rite in an important position, as a secular officer of the king. In past rites the king held his sword to signify his role as defender of the Church. That this function is here turned over to a member of the laity is an affirmation of the special sacerdotal character of the king of France because, although it was the duty of a Christian king to defend the faith, a strict interpretation of scripture and canon law forbade an anointed minister to bear arms, an injunction not always respected. The introduction of the seneschal to bear the king's sword resolves this conflict between the king's military duties and his sacerdotal character: as defender of the Church the king receives the sword from the archbishop, but in transmitting it to a seneschal, he delegates this responsibility to a secular officer.

The Directory of *c.* 1230 echoes the German rite in the pre-eminence that it gives the national episcopate in the anointing of the king, and this is surely one of the reasons that the German Ordo was consulted. The directory opens with a procession of 'the canons of the mother church', that is to say the cathedral of Reims; it mentions other clergy of the church of Reims; and it gives prominence to the archbishop of Reims and his suffragans. It introduces the abbot and the monks of Saint-Remi who transport the Holy Ampulla from the abbey to the cathedral where the abbot transmits it to the archbishop. The bishop-peers clearly play a supporting role as do the lay peers, and it is of the utmost significance that both are specified. The oath sworn by the king reiterates the traditional Carolingian oath in which the king promises 'to respect and make others respect the right of bishops and the Church'.[117] In other words, the promise restores the privileged position of the bishops in relation to the king and to the Church within the kingdom. This has special relevance in a period when the papacy was striving to consolidate its authority at the expense of the national episcopates.

A significant modification appears in the oath that is administered to the king where he swears 'to put heretics out of his kingdom according to the constitution of the Fourth Lateran Council'.[118] This added reference is especially meaningful with respect to the changes in this rite emphasizing the unique authority of the archbishop to consecrate the

king and the queen, in which the king's sacerdotal qualities are not only emphasized, but enhanced; and in which the king and the queen 'take from the hand of the archbishop the body and the blood of our Lord'. In other words, the rite affirms the very doctrines that were the subject of the Fourth Lateran Council of 1215: the doctrine of the real presence of the body and blood of Christ in the Eucharist, and the necessity for an ordained minister to consecrate the sacrament and indeed to administer all sacraments. Moreover, the introduction of the phrase in which the king swears to put heretics out of the kingdom invests the king with both the legal authority and sworn duty to enforce Church doctrine within his kingdom, ultimately allowing him to lead a crusade against his own Christian subjects and even to dispossess heretics or those who harbour heretics in their territories.

Finally, this directory reintroduces the participation of members of the laity where it charges the chamberlain with the investiture of the royal shoes and the duke of Burgundy with the investiture of the spurs. It is the first ordo to call for the 'peers', clerical and lay, to sustain the crown, to lead the king to the throne while sustaining the crown, and to sustain it as he is enthroned. The copy of this directory in the Coronation Book includes a list of the six clerical peers and the six lay peers. The reintroduction of secular peers within the ceremony is a major development, for, as we have seen, secular magnates had not participated in the internal parts of a sacre since the First English Ordo.

The enhanced importance of the secular peers is particularly meaningful in the context of events before and after the Fourth Lateran Council. The count of Toulouse is listed as a peer, putting the compilation of the new ordo into a more focussed setting. Because of his tolerance of the Cathars, the count of Toulouse, Raymond VI, had been excommunicated and a crusade, led by Simon de Montfort, was launched against the heretics in the territories of the count of Toulouse. Raymond VI was dispossessed of many of his fiefs which were given to the crusaders in Simon's service. At the Fourth Lateran Council a decision was reached in which most, if not all of these territories would remain in the hands of the crusaders and Simon de Montfort was recognized as Count of Toulouse.[119] Simon was killed in 1218 in a battle against Raymond's son, Raymond VII, who was attempting to reclaim his heritage. Simon's son Amaury de Montfort ceded all of his father's rights to Louis VIII.[120] In 1226 Louis VIII began an assault against heretical enclaves in Languedoc and an assembly held at Pamiers in that year declared that all fiefs confiscated from heretics belonged to the king of France.[121] This sequence of events allows us to see that the oath that was added to the sacre at this moment, specifically citing the constitution of the Fourth Lateran Council, provided the king of France with a divine mandate to expel heretics and even to dispossess them and take over their domains. The coronation oath gave him a legal prerogative to appropriate territories and thus extend his dominion and his authority, and was therefore an instrument for the subsequent expansion of the kingdom of France. These events also suggest that the Directory of c. 1230 reflects the political situation after the assembly of Pamiers in 1226, and that it belongs to the period immediately before the death of Louis VIII and the accession of Louis IX. These observations lend substance to the tradition in the earliest published versions of this directory that it was compiled under Louis VIII and was used for the sacre of Louis IX. It clearly belongs to the period of the accession of Louis IX.

The incorporation of the secular magnates into the sacre would also be consistent with a strategy of bringing under the control of the king insubordinate nobility, many of whom had been engaged in rebellion against the king of France over juridical rights in their domains.[122] The Albigensian movement, and its rejection of sacerdotal ministry and the doctrine of transubstantiation, was but one manifestation of the larger struggle of the laity to win a degree of authority and autonomy.[123] (One might note, for example, that the Magna Carta dates to precisely the same period in England.) Indeed, the very fact that this rite of *c.* 1230 was promulgated in a vernacular translation is symptomatic of this specific context: the vernacular movement began in Aquitaine, the county of Toulouse, and Languedoc, where Cathar or Albigensian texts and preaching were in the language of the people rather than the language of the clergy. Given that this directory is perhaps the earliest liturgical text to be translated into French, it is an important landmark in the development of vernacular culture, and at the same time it represents a response on the part of the ecclesiastical and secular authorities to this nascent movement. We witness in this directory an attempt to resolve conflict through the apparatus of ritual.

3. The Ordo of Reims of c. 1250 and its Illustrations (Paris, BN, MS lat. 1246)

Besides a pontifical of the Use of Paris (Metz, Bibl. Mun., MS 1169) with one illustration for the king's ordo (fol. 122) and another for the queen's (fol. 131v),[124] there are two extant copies of French coronation rituals that are accompanied by a cycle of illustrations pre-dating the Coronation Book: the first, a copy of the Ordo of *c.* 1250, and the other a copy of the Last Capetian Ordo. Prior to the Coronation Book, the most extensively illustrated coronation ordo is in an excerpt of a pontifical now in Paris with the only surviving copy of the Ordo of *c.* 1250 (BN, MS lat.1246; ills. 23–26).[125]

The date and provenance of this manuscript and its ordo have been the subject of debate. Schramm dated the ordo to around 1300. The manuscript contains litanies of Châlons-sur-Marne (the city has recently changed its name to Châlons-en-Champagne) suggesting that it was either compiled or commissioned for a bishop of Châlons-sur-Marne, a suffragan of the archbishop of Reims, an ecclesiastical peer, and an officiant of the sacre. Leroquais thought that the manuscript was made in the second half of the thirteenth century and that it was once part of a pontifical from Châlons, but these conclusions have been challenged because the presence of litanies for Châlons-sur-Marne prove merely that it was intended for someone associated with that see. In either case, it belongs to the archdiocese of Reims. The autonomy and small format of the manuscript suggest that it was probably never part of a fuller manuscript of a pontifical.[126] Robert Branner identified the artist of these illustrations with an illuminator active in Paris in the 1240s, and he concluded that the manuscript was made in Paris *c.* 1250.[127] Thus the dating of the manuscript and its royal ordo depends upon the miniatures. On the basis of this stylistic evidence, Jackson rejected Schramm's title and dating, 'Compilation of 1300', and the Godefroys' title 'Ordo of Louis VIII', and he adopted instead the 'Ordo of 1250', a title that

has taken hold in recent scholarship.[128] Jackson believes that the manuscript was made in Reims and not Paris, and he is followed by Le Goff who thinks that although the style of the miniatures is Parisian, the manuscript's presence for centuries in Reims argues for that provenance.[129] The ties between the French court and Reims were so strong during the period after 1230, when the ritual sequence of the Celestial Balm was first introduced into the sacre, that the argument would seem to be purely academic were it not that this ordo incorporates modifications of the slightly earlier directory that reinforce the importance of the archbishop of Reims and heighten the sacerdotal and episcopal character of the king. These modifications are therefore a further step in elevating the authority of the archbishop of Reims in the making of the king. There can be little question that it was compiled under the eye of the archbishop of Reims.

Instead of the procession of the canons of the cathedral of Reims as in the Romano-Germanic Ordo, the king exits from the thalamus, after which the group of bishops lead him in a procession to the cathedral while chanting the *Ecce mitto angelum meum*. At the portal of the cathedral the archbishop, accompanied by bishops, recites a blessing over the king. The canons have been omitted and replaced by the archbishop and bishops. The archbishop recites a prayer over the king that states that he is the preferred of God's people (*ut famulus tuus N(omen) quem populo tuo voluisti praeferri ...*). The entire assembly of bishops, archbishop and king enter the cathedral. Nobles do not appear prominently at this point. Once inside the cathedral the procession of the monks and abbot of Saint-Remi arrives with the Holy Ampulla borne by the abbot who walks under a canopy (*corona serica*) suspended on poles held by four monks. They procede to the altar where they are met by the archbishop who then administers the oath to the king. The passage concerning the Lateran Council is not included in this ordo. After the oath is administered two bishops call out in a loud voice to ask for the assent of the people. When that has been given, the *Te Deum* is sung. Then an additional sequence of oaths is administered. The king prostrates himself before the altar, his body stretched out in the form of the Cross.

The illustrations show the arrival of the Holy Ampulla carried by the abbot and monks of the abbey of Saint-Remi, who present it to the archbishop, thereby giving exceptional emphasis to the Celestial Balm and thus to the uniqueness of the king's anointing with this heavenly unguent. In including this scene the editor followed the previous ordo in placing the church of Reims and its bishop, the monastery of Saint-Remi and the clergy of the cathedral of Notre Dame de Reims, in a privileged position in the elevation and consecration of the French king. The archbishop of Reims was not always the favoured consecrator, nor Reims the exclusive site for the sacre of the French monarch. Some of the Carolingians were crowned at Soissons and, undoubtedly because of their Burgundian connections, some of the later Carolingians were crowned by the archbishop of Sens who was regarded as the primate of Gaul.[130] The ritual of the Celestial Balm not only elevated the king of France above the anointed kings and prelates of Christendom, it also favoured the episcopate of Reims.

Several elements in the Ordo of Charles V have been identified as new because they are neither in its immediate antecedent, the Last Capetian Ordo, nor in the Directory of

Tertio inter scapulas. Quarto in
scapulis. Quinto in compagib;
brachiorum. Dicens.

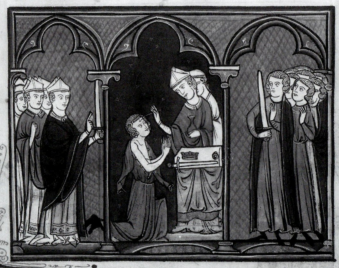

Ungo te in regem de oleo sct̄ō
ificato. in nomine patris
et filii et spc̄ sanct̄i. Dicant om̄s.
Amen. J. et cantetur hec antiph.

23. Anointing the King's Head. Pontifical of Châlons-sur-Marne.
Paris, BN, MS lat. 1246, fol. 17

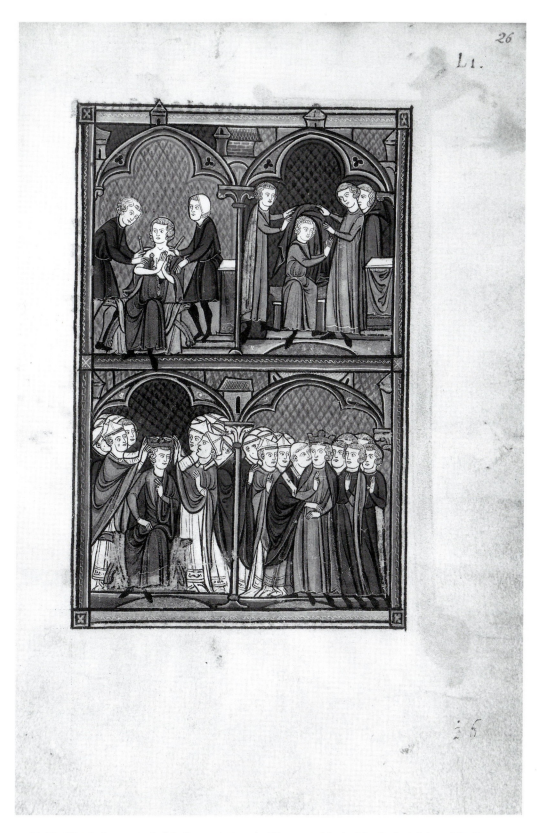

24. The King's Garments closed after anointing; the King vested in the Mantle; Sustaining of the Crown; Kiss of the Archbishop. Pontifical of Châlons-sur-Marne. Paris, BN, MS lat. 1246, fol. 26

c. 1230.[131] These include the anointing of the king's hands, a ritual emphasizing the sacerdotal character of kingship. These elements, however, are not new in royal consecration ordines for they were derived from the Ordo of 1250. Although not in the Directory of *c.* 1230, the anointing of the hands, which had been introduced to the king-making rite in the Carolingian period and then rejected, was reintroduced in the Ordo of 1250. It was then eliminated from the Last Capetian Ordo.[132] The above preliminary sequence in this rite was incorporated into the Ordo of Charles V which elaborated further upon it.

In the Ordo of 1250 the traditional parallelism between royal and episcopal consecrations was strengthened by the introduction of several features not in earlier French ordines, including the special prayers recited over the king by the consecrator who sits on his episcopal throne. The text and miniatures emphasize several rituals that are derived from sacerdotal consecrations, most notably the anointing of the hands, the presentation of consecrand to consecrator by two officiating bishops, and the kiss of the consecrand by the officiating archbishop. The archbishop transmits the ring, crown and sceptre, all of which have analogies to the consecration of a bishop. The Ordo of 1250 was a precedent for the two auxiliary bishops and the ritual prostration in the Ordo of Charles V. The text specifies that the king and queen receive the 'body and the blood of the Lord from the hand of the archbishop'. The miniatures include a scene of the king taking communion in the form of bread and wine, a privilege then reserved for the clergy. All of these features reinforcing the royal-episcopal parallelism were later taken up in the Ordo of Charles V.

This manuscript thus demonstrates in text and images the special character of kingship conferred by anointing with the Celestial Balm and the priority of the see of Reims in the making of that kingship. However, all of the elements that express the sacerdotal character of the king were already present in the *Pontificale Romano-Germanicum* that emerges as an important source for the Ordo of 1250. Another detail of the Ordo of 1250 that was derived from the German Ordo is the fetching, or raising, of the king in the thalamus.[133] The Ordo of 1250 also calls for the king and the queen to deposit their crowns after the mass before they return to the *palatium*, and although the palace is not identified by the text, the return of the king and queen to the palace is illustrated in the miniatures of the Ordo of 1250.

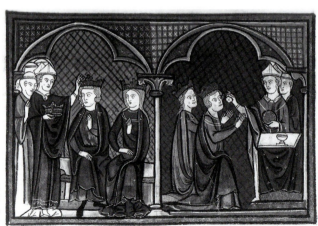

25. King's Crown exchanged before receiving Communion; King received Communion; Pontifical of Châlons-sur-Marne. Paris, BN, MS lat. 1264, fol. 37v

THE IMMEDIATE ANCESTRY OF THE ORDO OF CHARLES V

The Ordo of 1250 follows the Directory of *c.* 1230 by including the participation of the secular nobility for the investiture of the royal shoes by the chamberlain, the spurs by the duke of Burgundy, and the bearing of the king's sword by the seneschal. The role of the lay peers is expanded in the Ordo of Charles V.

One of the most significant details of the Ordo of 1250 is the *Sta et retine* that follows the ritual affirmation of hereditary succession from father to son according to the German Ordo as cited above.[134] This version was subsequently rejected in the Last Capetian Ordo that followed the wording of the Seven Forms Ordo and the Ratold Ordo where the principle of hereditary succession is expressed as suggestion.[135] The Ordo of Charles V reinstated the wording of the *Sta et retine* according to the formula of the Ordo of 1250.

The Ordo of 1250 also enhanced the queen's consecration with many elements derived from the king's consecration. This compilation contributes to the cumulative process of the development of royal consecrations by building upon the West Frankish Ordo of Sens of *c.* 900, the first to join the queen's ceremony to the king's and to extend to the queen the anointing of the head, a ritual until then reserved for priests, bishops, and kings, as well as the sacerdotal privilege of reception of the Eucharist in two species.[136] This exclusive privilege of the clergy in the Middle Ages had been extended to the king in the Ratold Ordo and was reintroduced for the king (and perhaps the queen) in the Directory of *c.* 1230 and its French translation.[137] The queen's ordo in the Coronation Book therefore takes its most significant features from the compilations of 1250, from the Directory of *c.* 1230, from the Ratold Ordo and ultimately from the late Carolingian West Frankish Ordo of *c.* 900.

The text of the Ordo of 1250 in the Pontifical of Châlons is accompanied by a cycle of fifteen miniatures, many compartmentalized to allow for double, triple or quadruple scenes, so that at least 24 ritual acts are illustrated. It is the most extensively illustrated royal ordo until the Coronation Book.

The following are the rituals that are illustrated in the Ordo of 1250:

(i). Procession of the king to the cathedral and his reception by the clergy before the cathedral; the king is placed on a seat as the clergy pray before the altar, fol. 1.

(ii). Procession of the monks and abbot of Saint-Remi with the Holy Ampulla carried under a silk canopy by the abbot of Saint-Remi; arrival of the Holy Ampulla at the altar, fol. 4.

(iii). Two bishops present the king and accompany him to the altar for the chanting of the *Te Deum* as the bishops pray at the altar, fol. 4v.

(iv). Chanting of litanies; the king prostrates himself before the altar, fol. 5v.

(v). The Grand Chamberlain of France puts the royal shoes on the king; the duke of Burgundy applies the golden spurs, fol. 15v.

(vi). The arrival and blessing of the sword; the sword presented on the altar with the crown and ring as the king is anointed on the forehead by the archbishop who applies the oil with a golden needle rather than his thumb; and the transmission of the sword to the seneschal, fol. 17 (ill. 23).

(vii). Initial U [*Unguantur...*] beginning the anointing prayer with illustration of the anointing of the king's hands, fol. 19.

95

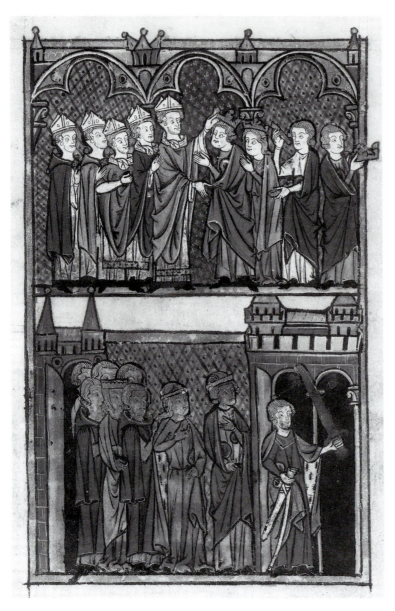

26. Removal of Crowns; Procession
to the Palace.
Pontifical of Châlons-sur-Marne.
Paris, BN, MS lat. 1246, fol.42

(viii). Initial V beginning the word *Vere...* showing the priest saying mass,
fol. 22v.

(ix). Full-page illustration divided into four compartments with the closing of
the king's garment after the anointing; vesting of the king in the mantle
(*soccus*); the peers sustain the crown and king's enthronement; archbishop of
Reims, mitre removed, kisses the king, fol. 26 (ill. 24).

(x). Initial A [*Accipe...*] illustrating archbishop transmitting the sword to the
king, fol. 26v.

(xi). Initial A [*Accipe...*] illustrating archbishop placing the ring on the king's
finger, fol. 27v.

(xii). Initial A [*Accipe...*] illustrating archbishop presenting the sceptre to the
king, fol. 28.

(xiii). The king stands as the archbishop places the crown on his head, fol. 29.

(xiv). The coronation crowns of the king and queen, both seated, are removed and replaced with smaller diadems; the king and queen take communion and both the bread and the chalice are evident, fol. 37v (ill. 25).

(xv). The king and queen stand as their crowns are removed to be carried away; the king and the queen, wearing small diadems and accompanied by an entourage of laity and clergy, leave the cathedral and proceed to a palace facing the cathedral, fol. 42 (ill. 26).

The miniature cycle accompanying the Ordo of 1250 anticipates that of the Coronation Book, if not in the interpretation of the individual rituals, at least in its major themes. Both cycles present the unfolding of a rationalized ritual process, and both emphasize the ritual innovations of their respective ordines. Just as those in the Coronation Book, these illustrations depict the event with a temporal coherence by showing only personages who participated in the ritual and by excluding divine, saintly, biblical or allegorical figures, thus endowing the miniatures with chronological integrity. Unlike earlier images of ruler-making, the king is not crowned by a divinity, the hand of God, Christ, or the Virgin. But the miniatures do not go so far as to depict a specific historic enactment of the ritual as in the Ordo of Charles V, for details that might situate it in a specific historic setting are absent. The miniatures of the Ordo of 1250 stress the role of the archbishop of Reims in the crowning and in the investiture of the sword and they accord a role to the nobility in the transmission of the royal vestments and insignia. Furthermore, the text and illustrations give great importance to the queen, who is the beneficiary of an extensive consecration ritual consisting of numerous actions parallel to those in the king's consecration.

Most importantly, the Ordo of 1250 anticipates the Coronation Book by celebrating in text and images the power of the Celestial Balm, affirming its necessity for French kingship and its unrivalled superiority over other oils in king-making. It asserts the pre-eminence of the archbishop and the metropolitan see of Reims in the anointing of the French king, a role that had been claimed by other prelates, in particular the archbishop of Sens. Anticipating the treatment of this subject in the Coronation Book, the mythical account and the heavenly personages are entirely omitted from the text and the miniatures of this manuscript. Both cycles define the precise relationship of the participants in the ritual to this balm: the text and miniatures affirm that the abbot and monks of Saint-Remi are the recognized guardians of the balm, who transport it to the cathedral from the abbey where it is safeguarded (ill. 24); and it is the abbot of Saint-Remi who transmits it to the archbishop of Reims, identified as the individual designated to mix it and to anoint the king. The miniatures also affirm that the king is the recipient of the anointing, and they demonstrate precisely how and where he is to be anointed (e.g. ills. 23, 25). The workings of the supernatural are thus present, but through the agency of the Celestial Balm, the substance which effects this union between Christ and those gathered at Reims.

The miniatures of the Ordo of 1250 show that the balm is associated with Christ in a very clearly defined way, because, when it is applied to the king's forehead, it leaves a brilliant red cruciform mark. This is perhaps an echo of the Franciscan cult of the stigmata,

given the importance of the Franciscans for St Louis. But of greater relevance is the association that it makes between the king of France and the Passion of Christ, an association which St Louis had been encouraging by collecting the relics of the Passion and later building the Sainte-Chapelle to house these relics. The king's transformation through the anointing at the sacre is likened through this detail to Christ's immolation on the Cross. The dating suggested by Branner and Avril on stylistic grounds situates the manuscript in the 1240s, precisely when St Louis vowed to embark on a Crusade.[138] The emphasis on the red cross with which the king is marked by the Celestial Balm could be read as an echo of this historical context, as could the importance given to the sword and to the spurs. Yet this ritual, although compiled during the reign of St Louis, is not the record of an historic sacre. Not only is there an absence of any precise historic indicators, but no French king was actually sacred during the period when this manuscript was made, and had not been since 1223. However, it may have been compiled with the intention of being used for a son of Louis, especially as it places such emphasis upon hereditary succession. As it happened, Louis died while on Crusade and it was in fact the arguments based upon the hereditary rights of succession that were asserted to ensure that the kingship passed to Louis's son rather than to his brother. The presence of the *Sta et retine* according to the formula asserting the principle of paternal succession would have been crucial for assuring the succession of Louis's eldest surviving son.

Although these rituals anticipate those of the Coronation Book, a comparison of the two cycles shows that many of the same ritual acts were interpreted in fundamentally different ways, and it is clear that the later cycle was not copied from the earlier. For example in the Ordo of 1250, as in the German rite, the king stands in order to be crowned, whereas in the Coronation Book he kneels to receive the crown. The rituals also occur in different sequential orders: the close association between the transmission of the sword and the anointing sequence in the Ordo of 1250 contrasts with the Coronation Book, where these two rituals have been emphatically separated from each other. The archbishop of Reims was emphasized in the earlier ordo, but is given considerably greater emphasis in the Coronation Book. Nevertheless, the seeds of the innovations of the Coronation Book are already present in the Ordo of 1250.

There are indications that the manuscript was made for very different ends from those of documenting a specific historic sacre. The miniatures show the ritual innovations of this ordo in such a way that they indicate the purpose of the compilation and its illustrations. First, the Ordo of 1250 throws the investiture of the traditional regalia into a special light. The crown, sword, ring, sceptre, main-de-justice and the folding throne resembling the so-called Throne of Dagobert appear in the illustrations. All of these were safeguarded at the abbey of Saint-Denis, and the text makes it clear that they were to be transported to Reims by the abbot of Saint-Denis for the sacre. But the text and the miniatures specify that the archbishop of Reims invests the king with these regalia. This would explain the importance of the last scene showing the removal of the coronation crowns and an individual carrying them away, for the text stipulates that they were to be returned to Saint-Denis. The following scene shows the king and queen wearing other crowns as they enter the palace across from the cathedral, a scene that indicates that they are entering the

palace of the archbishop of Reims, adjacent to the cathedral, as the miniature shows (ill. 26). Indeed, it seems to effect a compromise between the two rival churches, or at least to make a concession to the traditional role of Saint-Denis.

Other innovations of the Ordo of 1250 give prominence to the archbishop of Reims. The text and miniatures emphasize several rituals which are derived from clerical consecrations, most notably the anointing of the hands, communion of the 'body and blood', ritual prostration before the altar, presentation of the consecrand to the consecrator by two of the officiating bishops, and the ritual kiss of the consecrand by the officiating archbishop. This manuscript thus not only makes a ritual defence of the kingship of the Celestial Balm but also presents an argument in ritual and images for the priority of the archiepiscopal see of Reims and its archbishop in the making of that kingship.

Schramm identified this manuscript with an item in the inventory of the library of Charles V, placing it in Paris at the time of the production of the Coronation Book. Thus the Ordo of 1250, which today exists only in Paris (BN, MS lat. 1246), a manuscript that was probably in the library of Charles V, emerges as one of the most important sources for the Ordo of Charles V and its cycle of illustrations.

4.The Last Capetian Ordo

Before the Ordo of Charles V, the Last Capetian Ordo was unsurpassed for the comprehensiveness of its formularies for the consecration of a French king and queen. It was compiled largely from the two earlier French rituals, the Ordo of 1250 and the Directory of *c.* 1230.[139] Schramm had dated this ordo to *c.* 1300 or a little later. Recently Jackson, who has identified this ordo in at least fourteen manuscripts, has shown that its presence in a manuscript dated to *c.* 1270 situates it in the context of the late years of the reign of St Louis.[140] Several elements of the Last Capetian Ordo were derived from the Directory of *c.* 1230, which introduced the elevated tribune for the enthronement of the king and queen and the rituals for the investiture of the spurs and the sword. The editor of the Last Capetian Ordo supplemented these features with additions from the German royal ordo,[141] and from the Ratold Ordo.[142]

Prior to the Ordo of Charles V, the Ordo of 1250 was unrivalled for the clarity and comprehensiveness with which the royal-episcopal parallelism was expressed. Between these two ordines stands the Last Capetian Ordo, which built upon the foundation of the Ordo of 1250, maintaining most of its parallels between the royal and episcopal consecrations except for the anointing of the king's hands. By eliminating hand anointing the royal consecration was deprived of its most important sacerdotal element.

While the Last Capetian Ordo emphasizes the Celestial Balm, it plays down in subtle ways the singularity of the role of the archbishop of Reims that had been accentuated in the Ordo of 1250, and in so doing allows the abbey of Saint-Remi to assert its presence. The thalamus is eliminated from the preliminaries, and the opening procession includes the archbishop, bishops and barons. The episcopal peers are seated in honorific seats arranged around the altar, and they are named according to the following order: Laon, Beauvais,

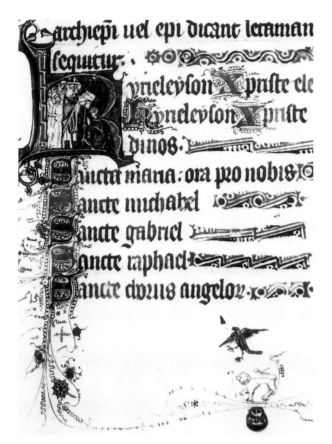

27-28. Initials from a Coronation Book. Urbana-Champaign, Library, University of Illinois

Langres, Châlons, Noyon. This is followed by the procession of the abbot and monks of Saint-Remi with the Holy Ampulla according to the previous ordines. The *Sta et retine* does not follow the wording of the Ordo of 1250 that affirms succession, but rather the version with suggestion. [143] Finally, the Last Capetian Ordo adds the blessing of the oriflamme, an act that had always been the prerogative of the abbot of Saint-Denis.

In concluding this overview of the three French antecedents of the Ordo of Charles V, we can see that all three give equal emphasis to the uniqueness of anointing with the Celestial Balm and to the episcopal character accorded the king. But they present subtle differences which suggest nuances of interpretation. Most notably, the archbishop of Reims has greater importance in the Ordo of 1250 than in the Directory of *c.* 1230 or in the Last Capetian Ordo, both of which give slightly greater emphasis to the participation of a *collegium* of episcopal and noble peers. The differences between the three ordines from the reign of St Louis constitute a sort of intertextual discourse on the structure of the body politic.

We might at this point add some observations on the illustrated manuscript in the library of the University of Illinois at Urbana-Champaign, which is the most fully illustrated text of the recension known as the Last Capetian Ordo.[144] This manuscript has forty-eight initials, filigree scrolls, rinceaux, and decorated line endings in abstract and geometric patterns (ills. 27, 28). Twenty-two of the initials are figural or historiated, nine are heraldic, and the remainder are decorative.[145] The presence in the manuscript of coats

100

of arms affords a possibility for identifying the patrons, although the portraits cannot be described as likenesses and the figures in the historiated scenes are generalized, verging on schematic. The miniatures do not therefore furnish indications which might allow one to identify specific patrons with any precision, and it is far from certain that the manuscript was meant to be an historic document of a specific sacre.

The manuscript escaped the notice of scholars of pontificals and coronation ordines until Harry Bober studied it before it was presented for sale. Citing the correspondence of Sir Sydney Cockerell who identified the armorials as those of France, Evreux and Montmorency, Bober concluded that the manuscript was the 'Coronation Book of Charles IV and Jeanne d'Evreux' made for their coronation on 11 May 1326. Puzzled by the prominence of the arms of Montmorency and by internal evidence linking the manuscript to Reims, given that the royal couple were crowned in Paris, he also noted that the style of the painting, while sharing certain general features with the art of Pucelle, differed from the work of this artist whom Charles IV commissioned to make the famous Book of Hours of Jeanne d'Evreux.[146]

All of this gives reason to question the identification of this manuscript with that king and queen.[147] I would propose as a more likely identification Philip VI of Valois and his second wife Blanche of Navarre, the daughter of Jeanne of Navarre and Philippe d'Evreux and a niece of Jeanne d'Evreux. The couple were married on 19 January 1350 after the death of Philip's first wife Jeanne de Bourgogne, marking a reconciliation of the feuding houses of Valois and Navarre. The Last Capetian Ordo, with the most extensive queen's ritual prior to the Ordo of Charles V, would have had special meaning to Blanche as a direct descendant of one of the last Capetian kings.

The arms of Montmorency are especially relevant to this couple, for from the 1350s they were among the firmest of the Valois supporters, and the Montmorency Matthieu de Trie was maréchal of France under Philip VI.[148] A note on fol. 8 names Matthieu's brother Guillaume de Trie, who was the archbishop of Reims who crowned Philip VI on Trinity Sunday, 29 May 1328. As a clerical peer he played a central role in the election of Philip VI. The text of the Last Capetian Ordo would have been especially appropriate for an elected monarch like Philip VI as it contains the formula for the *Sta et retine* which rejects paternal 'succession' and substitutes the version affirming 'suggestion'.

Another indication that the manuscript dates to *c.* 1350 is the close stylistic resemblance of its miniatures to the work of an artist active in Parisian manuscript painting at the end of the reign of Philip VI and the beginning of the reign of John the Good. The historiated initials and other decorative elements of the Illinois manuscript present many affinities with the illustrations of a Latin Bible in Montpellier (Bibl. Ecole de Médecine, MS 195) which was made in Paris *c.* 1345–50,[149] and with a group of service books related to that Bible which were made for royal chapels *c.* 1345–50.[150]

A comparison of these miniatures with those of the Ordo of *c.* 1250 reveals differences and similarities. In several respects the Illinois manuscript responds to the earlier compilation. The two manuscripts include illustrations for several of the same rituals and these illustrations correspond in numerous iconographic details. The Illinois miniatures are by no means copies of the earlier cycle, for comparable rituals have been interpreted

quite differently in each manuscript. Nevertheless, both cycles present a very similar message emphasizing the singular importance of the Celestial Balm for the anointing of the king of France and the pre-eminence of the archbishop and the metropolitan see of Reims.

In contrast to the illustrations in the Ordo of 1250, the Illinois illustrations are small initials rather than framed panels. Consequently, the illustrations of the former are more independent of the accompanying text than are the historiated initials of the Illinois manuscript that are integrated into the text, establishing a close visual liaison between the imagery of the initials and the text. In the illustrations of the Ordo of 1250 greater attention is given to describing details of each ritual action and figures are more clearly articulated and proportions more natural than in the Illinois manuscript.

There are some subtle but significant changes. Although the text of the Last Capetian Ordo slightly diminishes his importance, the emphasis accorded the archbishop of Reims in the miniatures has been somewhat strengthened as compared to the illustrated Ordo of c. 1250, and the queen has been emphasized more than in any previous ordo. Although her role was magnified in the Ordo of 1250, the illustrations did not really include any explicit demonstration of the queen's newly important role in that ritual. The queen was introduced in the illustrations of that ordo as the consort of the king, although that ordo introduced important innovations for her anointing and investiture. Not only do the illustrations of the Illinois manuscript include several scenes of the queen's ritual, but they also emphasize the parallelism between the anointing and investiture of the king and queen, including images of the queen's investiture with the regalia.

According to Bober, a note in the manuscript indicates that it was 'taken from Reims'. It is fairly likely that this manuscript would have been known to important members of the circle of Charles V, many of whom had close ties to Reims, its clergy and its archbishop, especially given its connection with Guillaume de Trie. All of these observations suggest that this illustrated coronation ritual occupied a special place in relation to the first Valois rulers.

5. The Fourth Recension of the English Ordo, Anglo-Norman Translation

One further ordo should be considered in the present survey of the ancestry of the Ordo of Charles V. This is the Fourth English Ordo, but in the Anglo-Norman translation.[151] In the fourteenth century there were two major revisions of the English royal ordines. The first is the Fourth English Ordo, made for the sacre of Edward II in 1308.[152] The text used for the consecration of Edward III in 1327 is believed to be reflected in the Anglo-Norman translation of the rite of 1308 (ill. 29).[153] The Fourth Recension of the English Ordo revived the tradition of the Second English Ordo, the latter having been displaced by the Third Recension which largely embraced the Romano-Germanic rite.[154] The Fourth Recension includes a hymn borrowed from the *Magnificat* antiphon for St Edmund, king and martyr, which would seem to accentuate the English royal saint as a predecessor to the king who is consecrated by this rite, seemingly a response to the recent canonization of St Louis. The king's hieratic stature is emphasized by other additions in this rite, belonging to a programme of strengthening the prestige of the English monarchy with respect to the

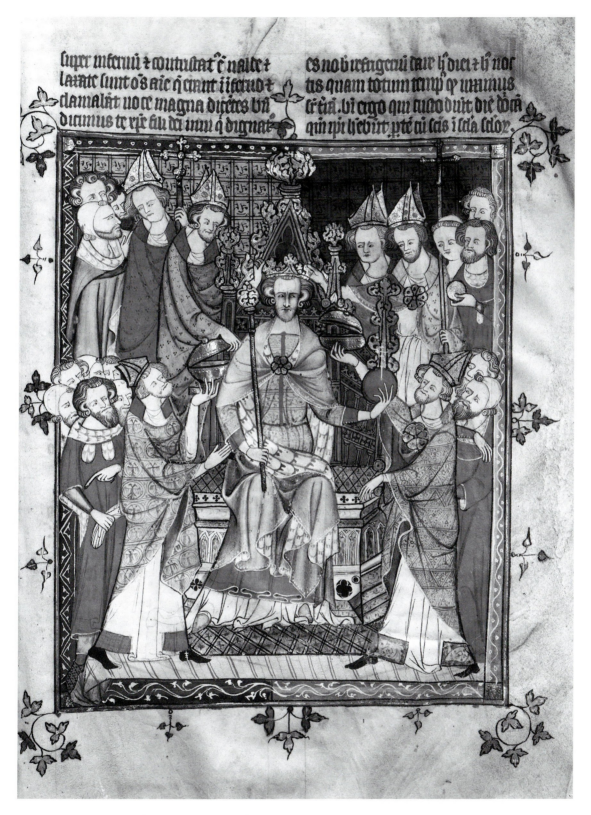

29. Coronation of Edward III(?). Apocalypse and Coronation Ordo. Cambridge, Corpus Christi College, MS 20, fol. 68

French as well as responding to the pretensions of Boniface VIII asserted in recent bulls such as *Unam Sanctam*.[155] The second revision of the Fourth Recension was made in 1377 for the sacre of Richard II. In this version the English royal rite was given its final form.[156]

Several features of the Fourth Recension have parallels with developments in the French sacre; at the same time there are features anticipating the Ordo of Charles V. The Fourth Recension gives exceptional prominence to the secular magnates of the kingdom who are included in the elaborate fetching ceremony at the start of the rite. The Anglo-Norman version, for example, calls for the participation of the counts of Chester, Huntingdon, Warwick, and the barons of the five ports. The barons of the five ports are also assigned active roles in the queen's rite. In this recension there is an elaborate scene of the fetching of the king (derived directly from the Third English Ordo, and indirectly from the Pontifical of Mainz) set in the Palace of Westminster instead of the thalamus of its two sources. This precise location thus anticipates this detail in the Ordo of Charles V in which the comparable action is set in the palace of the archbishop of Reims (see following chapter).

The ordo also emphasizes English tradition in reviving features of the Second English Ordo, associated with Edgar, and in specifying that St Edward's chalice is to be carried and used in the rite. It thereby gives special importance to two relics of this patron saint of the English royal house. It also specifies the enthronement on the 'see' at Westminster, identified by this text as St Edward's Chair. English royal sainthood is therefore emphasized in a way that appears to respond to the Capetian policy, beginning with Philip the Fair, of celebrating the sainthood of St Louis, canonized at Philip's insistence by Boniface VIII. Although the English monarchy had a host of royal saints in their ancestry, these references to the sainthood of Edward are first cited with the coronation of Edward II in 1308, so that their introduction comes in the wake of the canonization of Louis IX.

It has recently been shown that the oath taken by Edward II included a fourth clause, the authoritative version of which was 'administered and responded to in French, not in Latin'. The wording of this clause has been variously interpreted. According to one interpretation the king accepted a circumscription of his power as well as a revised definition of his position in the 'community of the realm', representing an effort to restore cooperation between king and magnates that had deteriorated under Edward I.[157] In any event, we have seen that the increased importance of the magnates had already been introduced into the French Directory of *c.* 1230, well before 1308.

A copy of the Anglo-Norman version is prefaced by a large illustration in Cambridge, Corpus Christi College, MS 20 (ill. 29), a manuscript that contains a richly illustrated copy of the Apocalypse and an apocryphal letter of St Paul. This painting is the work of a French artist close to the Master of the Missal of Robert de Coucy (Cambrai, Bibl. Mun., MS 157), canon of the cathedral of Cambrai. This artist, who was active in the early 1330s, also painted illustrations in two manuscripts made for John the Good when he was duke of Normandy, his *Grandes Chroniques* (London, BL, MS Royal 16 G. VI), and his copy of the *Miroir historial* of Vincent of Beauvais, now divided between Paris (Bibl. de l'Arsenal, MS 5080) and Leyden (Bibl. Univ., MS Voss. Gall.).[158] On the basis of the dating of these manuscripts, the illustration in the Cambridge manuscript was probably not made much before 1330, and the script has been dated to *c.* 1325. Throughout the text, the king is

named Edward, but as Legg remarked, kings named Edward sat on the throne of England from 1272–1377.[159] Nevertheless, the dating of the script and the stylistic dating of the illustration suggest that the painting was not executed before the sacre of Edward III.

This is an exceptionally large illustration (189 x 230 mm) that has the character of a panel painting with its rectangular frame. The king, whose individualized countenance poses the possibility that it is a likeness, is seated on a high-backed seat with architectural features such as gables surmounted by golden foliate crockets and pinnacles. Legg noted that the seat resembles the Chair of St Edward in Westminster Abbey.

In the scene, the king is vested in the royal robes and he carries the royal insignia. He wears a *pallium quadrum* in a gold and peach-coloured brocade, fastened with a brooch identical to the morse with six lobes and red jewels worn by two of the bishops on the king's left. The episcopal and sacerdotal character of the king is thus expressed by his vestments which also include a dalmatic with broad yellow and golden horizontal bands, and a cope like those of the bishops in the foreground. The red vertical band running from the neck to the waist probably indicates the opening of the garment for anointing the king's chest, shoulders and arms. Beneath this the king wears a bright red tunic over a white garment. In his right hand he holds a sceptre surmounted by a golden foliate finial and, in his left, a red orb surmounted by a small white cross. His crown is a golden circlet supporting three gables with golden fleurons resembling fleurs-de-lis, an explicit reference to Edward's maternal ancestry. He is surrounded by six bishops. Legg has identified four of these as the archbishop of Canterbury, the abbot of Westminster (who had episcopal status), the bishops of York and Rochester, none sufficiently identified by attributes or gestures to indicate which is which.[160] The two bishops in the foreground are the most prominent, suggesting perhaps that they are the archbishop of Canterbury on the king's left, who wears an episcopal morse like the king's, and the abbot of Westminster on the king's right. The laity are notably absent from this image, although they have been given increased prominence in the text.

The moment that is depicted is that immediately after the king has been placed on the throne by the archbishop of Canterbury, when the members of the clergy chant the *Te Deum* and the archbishop recites the *Sta et retine*, which in this version is translated into Anglo-Norman. As noted above, this formula is an affirmation that the officiants accept the king's rights to the throne according to paternal hereditary succession. A small but highly meaningful adjustment appears in the translation, a poignant response to the political situation. The reference to 'paternal' has been eliminated, and instead we read the following: *Esteed & recevez … le lui que vous tenetz par succession de la heritage & par lautorite de dieu & nostre baill …* ; the translation thereafter continues unchanged from the earlier versions.[161] The elimination of the word 'paternal' in the context of the conflicts of the 1330s enlarges the scope of hereditary succession from the restrictive sense of paternal descent and heritage, allowing the potential for his heritage to encompass his maternal heritage. This illustration provides a witness to the recitation of this crucial passage by the archbishop and the participation of the clergy in the revised version of the *Sta et retine*, and the illustration shows him seated in St Edward's Chair, according to his heritage.

105

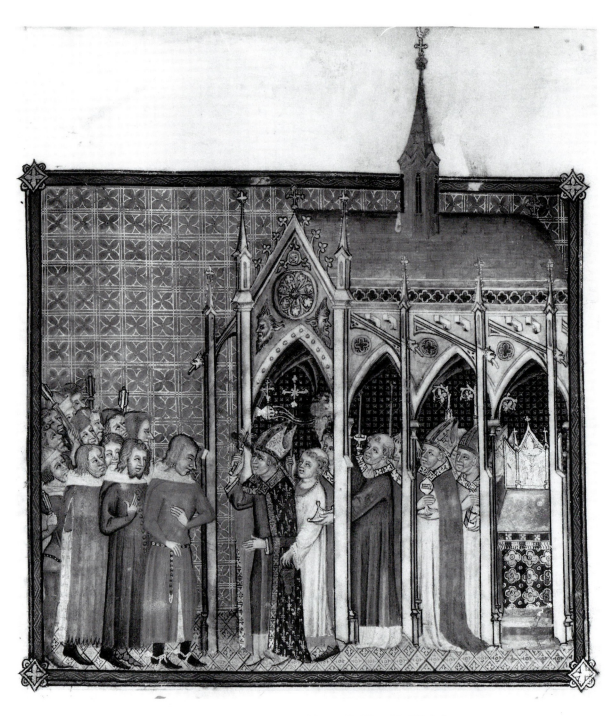

30. The Archbishop of Reims blesses the King, fol. 35 [pl. 1]

Chapter 3. The Coronation Ordo of Charles V: Tradition, Innovation and Author

I. Tradition affirmed in the Ordo of Charles V

THE ORDO OF CHARLES V encapsulates elements from each of the royal consecration ordines considered in the preceding chapter. It is virtually an amalgam of the Last Capetian Ordo and the Ordo of 1250, along with the Directory of c. 1230.[1] The editor (or redactor) of the Ordo of Charles V supplemented these with elements derived from the *Pontificale Romano-Germanicum*, the Ratold Ordo and the West Frankish Ordo of c. 900. Besides these it includes elements from the Pontifical of Milan and the Pontifical of Guillaume Durand.[2] Although compiled mostly from elements taken from this wide range of sources spanning different periods and regions, the unprecedented comprehensiveness, selection, and arrangement of its components set it apart as a new ordo.[3] The Coronation Book is not a pastiche or montage of textual excerpts and quotations, nor is it a mere support for an ensemble of texts and images. The whole is much more than the sum of its parts. It is a symphonic composition of ritual texts of iconic value enshrined in the Coronation Book like relics in a reliquary. Assembled from rites associated with the royal and episcopal saints of the dynastic ancestry of Charles V, this synthetic compendium constituted the summa of ruler-making. It was compiled to be nothing less than the ordination rite for the *rex christianissimus*.

The composition unites in a single rite discrete segments drawn from texts concerning the priestly anointing of kings from the Bible, French legend, and European history: David by Samuel, Solomon by Nathan and Zadok, Clovis by St Remi, Charles the Bald by Hincmar, Henry II (St Henry) by bishops representing the German episcopal saints Udalric and Emmeram. Its most important antecedent, the Directory of *c.* 1230, which is placed intact at the beginning of the manuscript, was compiled late in the reign of Louis VIII and coincides with the historical circumstances of the beginning of the reign of St Louis. It is quite possibly the rite used for his sacre.[4] The recipient of the Ordo of Charles V is more than *rex et sacerdos*, for the combined effect is an unprecedented calling forth of royal and priestly sainthood to preside over what amounts to a mnemonic assembly for the conferral of divine grace on an individual who is a living embodiment of this royal ancestry. For as the direct descendant of the lines of Charlemagne (celebrated as a saint in the Holy Roman Empire and in Charles's chapels) and St Louis, Charles was uniquely qualified to receive this rite.[5] Raoul de Presles made this very point in the prologue to his translation of Augustine's *City of God*, where he emphasized the uniqueness of Charles's descent from both the kings of France and the emperors.[6] Moreover, none of the individuals of the past who are recalled through the rites that elevated them to kingship (and ultimately sainthood) had received all of the individual blessings of the ritual of the Coronation Book. Nor for that matter did any other living ruler or ecclesiastical prelate.

The uniqueness of this anointing received by the king of France is the principal theme of the Coronation Book. Together, the assembled rituals of the Ordo of Charles V make the king of France the most nobly consecrated individual in Christendom. The rite is the very foundation for the claim of the French king to have no terrestrial superior. It is the ritual construction of the sovereignty of the king and kingdom of France.

Because it includes elements from the most hallowed royal rituals of the European past, it is also a memorial to tradition characterized by its internationalism and its deliberate reference to history. The editor reinforced these references with important innovations which have gone unnoticed. All of these innovations were expressed in the cycle of miniatures of the Coronation Book, the principal copy of the Ordo of Charles V. This chapter considers these innovations as they build upon and strengthen earlier traditions of the French and European sacring ritual and reveal the political strategies which underlay the creation of the manuscript. The new textual changes and innovative imagery also show some of the traits of the personality of the redactor(s) who compiled this new ordo.

1. Tradition and the Sources of the Ordo of Charles V

The position of the French translation of the Directory of c. 1230 at the beginning of the manuscript is programmatic. One could conclude that its presence here was merely intended to serve as a French translation of the Latin ordo that follows and, perhaps, also as an introductory synopsis of it. Although it does indeed fulfil these functions to an extent, it is neither a translation nor a synopsis of the Ordo of Charles V. For, although the Ordo of Charles V does incorporate all the rites of the French directory, they have been arranged differently: some have been reinterpreted, and numerous new elements have been added. Because the directory has been presented as a textual entity, intact at the beginning of the Coronation Book, it has been given special emphasis that treats it like a textual relic inserted intact before a later composition, as a venerable icon or sacred relic might be enclosed within a later setting. One is reminded of the way that the thorn from the Crown of Thorns was inserted into the crown of St Louis or into the golden crown that Charles commissioned.[7]

The placement of the French directory from the time of the accession of St Louis at the beginning of the Coronation Book was undoubtedly intended to invoke the memory of the sainted ancestor of Charles V and Jeanne de Bourbon. It is thus a visible reminder that the couple descend from this sainted progenitor from whom issues the superior Christianity of the French royal line, a *genus* that has demonstrably produced sainted kings.[8] By commemorating this rite, the sainthood of Louis and its charisma are brought to bear on the ordo that follows it in the manuscript and which also incorporates it.

It is also meaningful that the text is the French translation and not the Latin version of the directory because, as we have seen, the Directory of *c.* 1230 was probably the first translation of a king-making text into vernacular French, addressed to an audience of the secular magnates who, at the time of St Louis and his immediate predecessors, were being incorporated into a confederation of apanages subordinated to the king of France. Subordination of the magnates centralized authority around the monarch and eroded the re-

gional autonomy of the nobility and the episcopate. The involvement in the sacre of the lay and ecclesiastical peers was a means of implicating them in the collective acceptance of the premises affirmed in that rite: that they were subordinate to the central authority of the king and that they promised him their support and loyalty. Indeed, subordination of the magnates continued to be a central concern during the reigns of the successive Capetian and Valois rulers, and the subordination of magnates like the duke of Guyenne, who happened to be the king of England, was one of the most troublesome problems for the Valois. This Directory was the first royal rite since the First English Ordo to reintroduce secular magnates into the status-changing segments of the ruler-making rite. The redactor of the Coronation Book thus chose to highlight a venerable historical precedent, both for including the lay magnates and for presenting the content of the necessarily Latin liturgy in a language comprehensible to this important contingent of lay participants and witnesses of the sacre. This tells us that the audience of the Coronation Book was not only the clergy — the usual audience of a liturgical manuscript — but also this crucial secular audience.

In keeping with the reintroduction of lay participation in the Directory of c. 1230 and the emphasis upon making it comprehensible to a lay audience, the miniatures of the entire cycle of the Coronation Book, beginning with the frontispiece for the French translation, insist upon the expanded presence of the laity, both as peers and as witnesses, for almost all of the actions of the sacre. The miniatures are composed according to a tripartite compositional scheme with the secular orders on the left (from the reader's viewpoint) and the ecclesiastical orders on the right, with the king and the archbishop of Reims joining the two groups in the centre. Throughout, they illustrate the participation of specified lay peers for the investiture of the spurs and for the sustaining of the crowns of both the king and the queen. The miniatures show members of the laity who perform actions specified by the text: the seneschal, the chamberlain, the port-oriflamme, and specific secular peers such as the duke of Burgundy, the counts of Toulouse and Flanders, for example. But they go beyond the text to include ranks of laity who are not mentioned in the text, members of the nobility, the legal profession, representatives of the university, all of whom wear the costume of their station. Also included are members of the knightly classes dressed in elegant short costume, some carrying golden batons, insignia of their office as maréchaux of the grand apanages.

Notably absent from the ranks of the laity in both the text and the images are peasants, artisans and the working classes, who customarily wore plain short tunics in natural, undyed colours, and usually aprons or other attire of their profession, and one notes the omission of individuals who might be identified as merchants. Some of the highest ranking artists had been ennobled, and would have been clad accordingly, and indeed prosperous merchants would also have been elegantly attired. If they *are* portrayed in these miniatures they have not been identified by professional attributes. The laity who appear are identified as princes, scholars, lawyers, or knights with military attributes.

Nevertheless, although not identified as participants of the sacre, the classes of artisans and merchants are represented, if not in person, at least by the emphasis given in the miniatures to their products, through the detailed 'portraiture' of the splendid objects of gold-

smiths, jewellers, painters, architects, sculptors, weavers, drapers, furriers, couturiers, cabinetmakers, etc., that have their equivalents in contemporary inventories. Might we not suspect that contemporary readers would have recognized the artistry of Charles's goldsmith and *varlet* Guillaume de Vaudetar in some of the precious objects of gold-work such as the crown he made for Charles that enclosed thorns from the Crown of Thorns.[9] Might they not have recognized the artistry of the goldsmith Hennequin du Vivier who was paid in December 1364 for work 'in his métier' executed for Charles?[10] Might they not have identified the paintings of Jean d'Orléans *nostre aimé paintre et varlet de chambre* who was paid for work that he did for the sacre?[11] Are the luxurious textiles appearing throughout the miniatures those recorded in a payment made in December 1364 to Barthelemi Spiffami for 'fabrics for the sacre'? Perhaps these textiles also correspond to the sumptuous brocades of Lucca imported by the prosperous family of Lucchese merchants headed by Bernard Belon (Belloni or Belnati), bourgeois of Paris, who received a payment in September 1364. They certainly resemble the brocade textiles of Lucca.[12] The society assembled at Reims would no doubt have identified the sheer white linens of the ecclesiastical garments as the products for which Reims and Laon were famous.[13] Two important Parisian textile magnates are also represented indirectly in the figure of the bishop of Beauvais, Jean de Dormans, who received an income from the confiscated properties of Etienne Marcel, the provost of Paris and prosperous textile merchant and draper who was murdered by the Parisians after he opened the city to English mercenaries; and Charles Toussac, decapitated for his part in the same uprising and whose widow was given in marriage to Dormans' brother Pierre.[14] Because of these redistributions of the confiscated wealth of condemned opponents, individuals like Jean de Dormans, who appears so prominently in the illustrations, gained a substantial portion of their income from the textile trade of Paris, textiles which would not have been unlike those which are displayed in the Coronation Book.[15] The absence of figures representing these segments of society from the ranks of the participants portrayed throughout the cycle would seem to be a response of the editor of the Coronation Book directed at the previous eight years leading up to the accession of Charles V in which the urban and bourgeois alliance, led by Marcel and aided by the king of Navarre, was defeated by the dauphin allied with the nobility. The population that appears in the Coronation Book is an alliance between royalty and the secular and ecclesiastical nobility.

After the Directory of *c.* 1230, very little was added to the role of the laity in the texts of the successive French ordines. The Ordo of *c.* 1250 even slightly downplays the lay participation (e.g. the entry does not call for the presence of the lay barons), but at the same time it does introduce the fiction of election with the two bishops who call out to inquire of the assembly 'of people and clergy' if they consent to the candidate for the consecration.

The miniature at the beginning of the French directory also announces the consistent effort throughout the entire cycle to paint a picture of social and political harmony, in which clergy and laity join together to sustain the king and queen and form a united body politic around them. Although this is carried out through a constellation of historically precise details, it is nevertheless an ideal picture, for, as we have seen in the introduction, these very ranks of society were engaged in a social conflict which involved vying for position

and contesting rights to land and profit. Canons often opposed bishops and archbishops; episcopal churches vied with monasteries and with the papacy for revenues and privileges; nobility contested the rights of the Church and the king; the new urban classes of merchants, artisans and bankers sought to insert themselves into a system designed for a feudal agrarian society and escape the tax burdens that were being imposed upon them; the peasants and urban proletariat engaged in frequent uprisings against the feudal lords or the bourgeois patriciate.[16] The archives of Reims and Paris reveal a picture of upheaval and conflict similar to that in so many other cathedral cities of the period. But in the miniatures of the Coronation Book conflicting factions appear joined in harmony. In the middle of the fourteenth century, when this crisis was reaching the point of anarchy, the age of St Louis had come to symbolize a golden age of peace and promise. Reform of the kingdom meant a revival of the age of St Louis.[17]

We have also seen that the Directory of *c.* 1230 introduced into the traditional oath a clause that referred to the profession of faith imposed upon heretics after the Fourth Lateran Council, and it introduced the reception of the Eucharist in two species by the king and queen, explicitly affirming the doctrine of transubstantiation and the necessity of priestly consecration of the sacrament which was promulgated at that council.[18] The vow to uphold the constitution of the Fourth Lateran Council and put heretics out of his kingdom charged the French king with a special mission to defend the Catholic faith, further sanctified by special blessings of the sword and the spurs. But the weaponry of this rite was not only material and spiritual, it was also legal and political, for this oath empowered the monarch with a duty and a legal mandate to rid his kingdom of heretics. As an instrument for territorial appropriation as much as a weapon against heresy, it provided the king with the authority to judge cases that came within the definition of heresy in the provinces and also the pretext for the confiscation of the domains of heretics, permitting the extension of the domain of the kingdom of France throughout the thirteenth century.

The Directory went further than any previous rite to enhance the sacerdotal and ministerial character of its recipient. The king of France became the most extensively anointed and consecrated individual in Christendom. But he was also the most nobly anointed, because all others were anointed with mere chrism created through episcopal blessing, while the king of France, alone of the kings of the world, was anointed with the Celestial Balm carried from heaven. Because the text of the Directory has been included in its entirety at the beginning of the Coronation Book, its premises are reiterated and reaffirmed.

The immediate source for much of the Ordo of Charles V is the Last Capetian Ordo, compiled, as we have seen, as an amalgam of the two earlier French sacring rituals from the reign of St Louis, the Ordo of 1250 and the Directory of *c.* 1230.[19] The incorporation of the Last Capetian Ordo almost in its entirety establishes a continuity between the last Capetians and the Valois. The Last Capetian Ordo also celebrates St Louis by incorporating much of the two earlier ordines from his reign. Indeed it contains almost the entire Ordo of 1250 and the Directory of *c.* 1230 including the procession of the Holy Ampulla, the anointing with the Celestial Balm, the enthronement of the king and queen on an elevated tribune or solium, and the rituals for the investiture of the spurs and the sword which emphasized the king's role as the *defensor Christi*. These rituals are given promi-

nence in the miniatures of the *Coronation Book*, the solium appearing in the illustrations of the peers leading the king to the throne (pl. 25) and in the illustration of the enthronement in which the king receives the kiss from the archbishop (pl. 26). In its original state the Coronation Book included five illustrations of the transmission of the sword. The editor of the Last Capetian Ordo supplemented the rituals pertaining to the Holy Ampulla and the Celestial Balm, introduced in the Directory of *c.* 1230, with further elements appropriated from the royal ordo in the *Pontificale Romano-Germanicum* and the Ratold Ordo.[20]

The Ordo of Charles V takes directly from the Last Capetian Ordo the instructions for the preparation of the elevated tribunes for the thrones of the king and queen, the procession of the monks of the abbey of Saint-Remi bringing the Holy Ampulla to the cathedral of Reims, the investiture of the king with his sword, crown, ring, spurs, sceptre, baculum or main-de-justice, shoes, tunic and mantle. The ceremony for the mixing of the Celestial Balm with the chrism is similar, as are the rituals for anointing the king's head and breast, the enthronement of king and queen, the sustaining of their crowns, and their reception of the Eucharist in two species. Although neither the king nor queen receives a ring in the French translation of the Directory of *c.* 1230, both receive rings in the Last Capetian Ordo. The matrimonial alliance is an important component of this ordo. All of these scenes are illustrated in the Coronation Book.

The queen's ordo in the Coronation Book is composed of the entire queen-making ritual of the Last Capetian Ordo that was derived from the queen's consecration ceremony in the Ordo of 1250. The latter, in turn, was an amplification of the Ratold Ordo and ultimately the West Frankish Ordo of *c.* 900. Among the features of the queen's ceremony in the Ordo of Charles V that were taken over from the Last Capetian Ordo are the anointing of the queen on the head and breast and her investiture with the regalia (see following chapter).

There are several rituals in the Ordo of Charles V that are neither in the Last Capetian Ordo nor in the Directory of *c.* 1230, and because of this they have been considered to be new elements in the Ordo of Charles V.[21] They are not innovations, however, for they were taken directly from the Ordo of 1250. Among these is the anointing of the king's hands.[22] Although basing himself largely on the Ordo of 1250, the redactor of the Last Capetian Ordo left out the hand anointing. In reviving hand anointing, the redactor of the Ordo of Charles V strengthened the analogy between the royal and the episcopal consecrations. In the Ordo of Charles V the *Sta et retine* does not follow the wording of the Last Capetian Ordo but rather it revives the wording of this formulary according to the Ordo of 1250 and its source the German Ordo, the ritual affirmation of hereditary succession from father to son.[23] The Ordo of 1250 provided at least a partial precedent for the two auxiliary bishops, the ritual prostration at the beginning of the ceremony, and the communion in two species in the Ordo of Charles V. Thus, this compilation, which today exists only in a manuscript now in Paris (BN, MS lat. 1246) which was probably in the library of Charles V, emerges as a source for the Ordo of Charles V.[24]

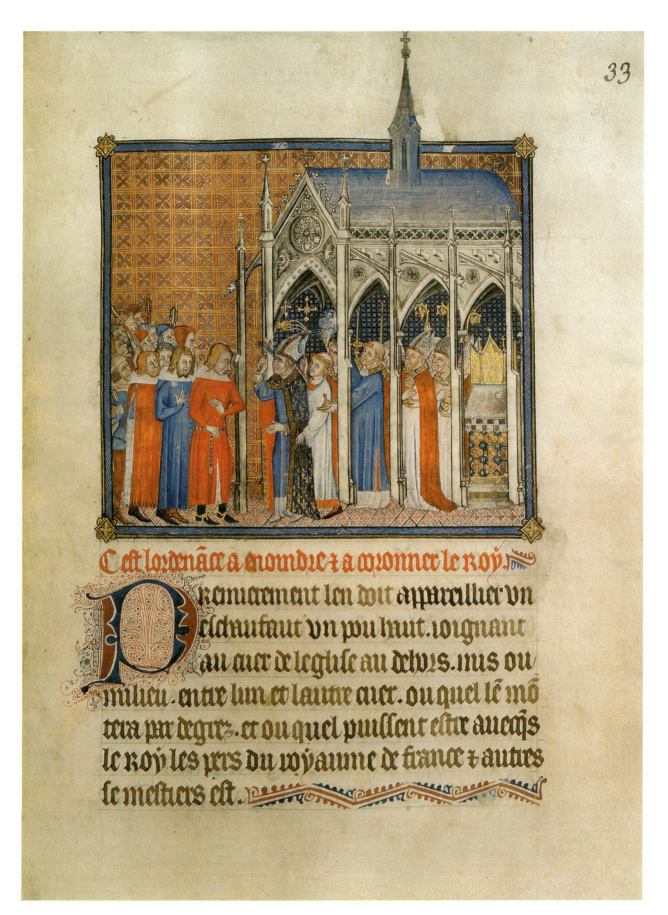

Cest lordenãce a enoindie z a coronner le roy.

Premierement len doit appareillier vn
eschaufaut vn pou haut. ioignant
au cuer de leglise au dehors. mis ou
milieu. entre lun et lautre cuer. ou quel lẽ mõ
tera par degrez. et ou quel puissent estre auecqs
le roy les pers du royaume de france z autres
se mestiers est.

Pl. 1. The Archbishop of Reims blesses the King (fol. 35)

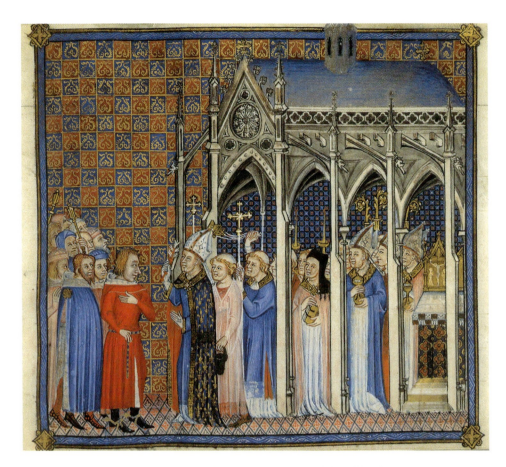

Pl. 2 The Archbishop of Reims blesses the King (fol. 43)

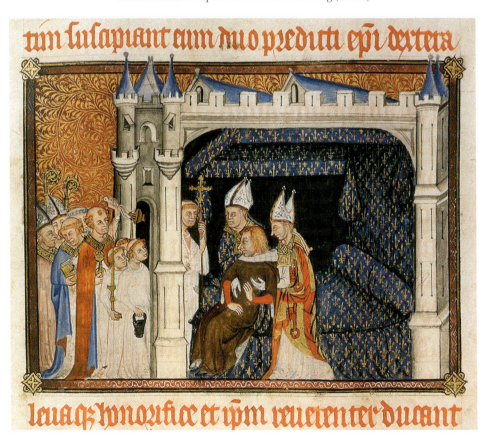

Pl. 3. The Procession of Canons and the Raising of the King in the Palace of the Archbishop of Reims (fol. 44v)

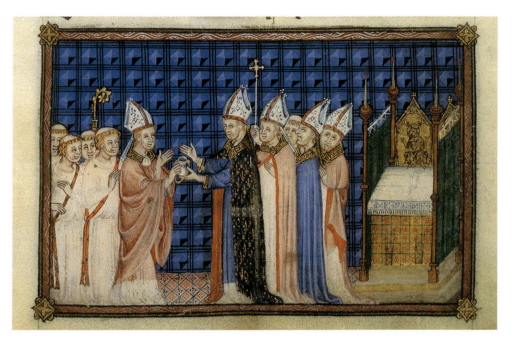

Pl. 4. The Abbot of Saint-Remi conveys the Ampulla to the Archbishop of Reims (fol. 46)

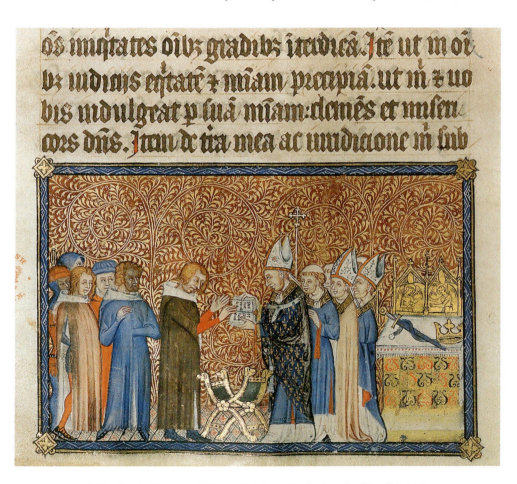

Pl. 5. The Archbishop of Reims administers the Oath to the King (fol. 46v)

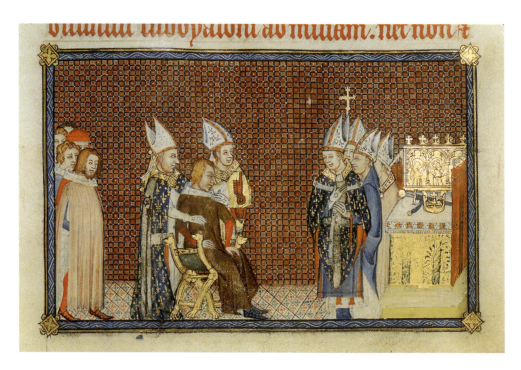

Pl. 6. The Bishops of Laon and Beauvais place the King on the *Cathedra* (fol. 47)

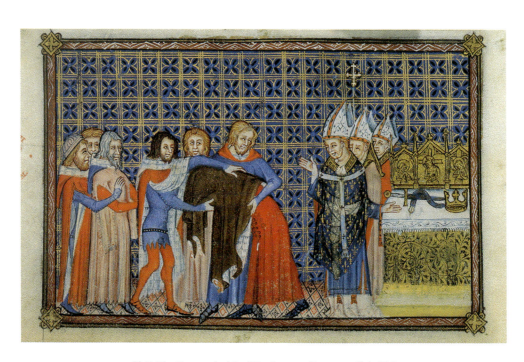

Pl. 7. The Removal of the King's outer Garments (fol. 47v)

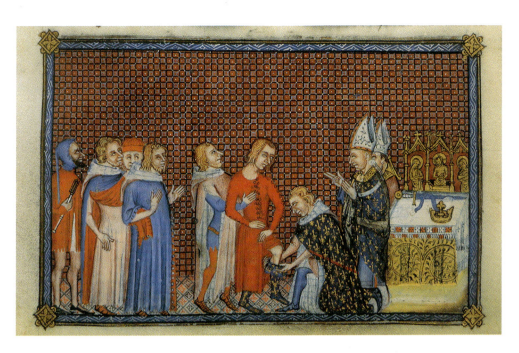

Pl. 8. The Duke of Bourbon vests the King with the Royal Shoes (fol. 48)

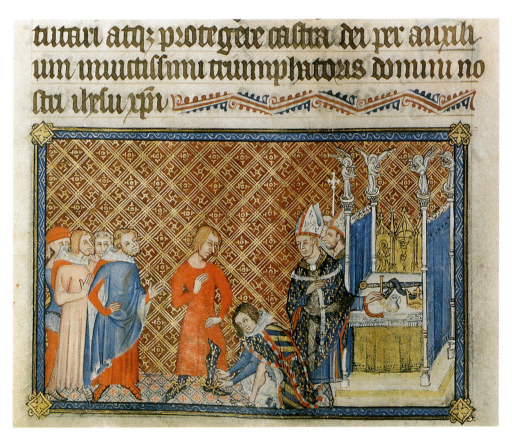

Pl. 9. The Duke of Burgundy vests the King with the Spurs (fol. 48v)

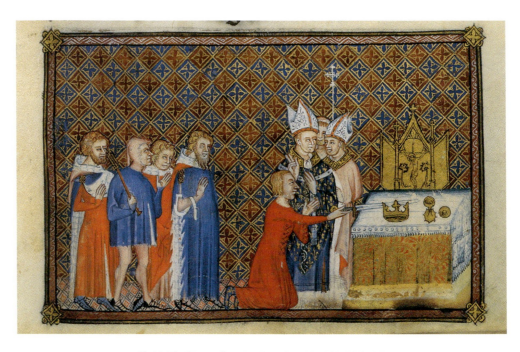

Pl. 10. The King offers the Sword on the Altar (fol. 49)

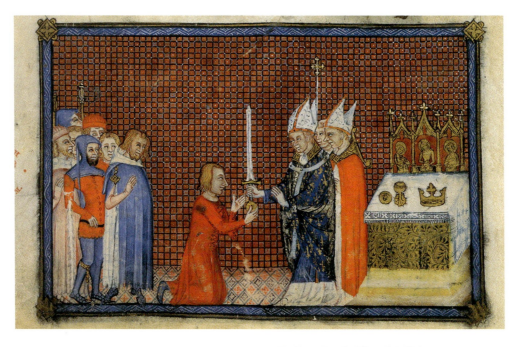

Pl. 11. The Archbishop of Reims returns the Sword to the King (fol. 49v)

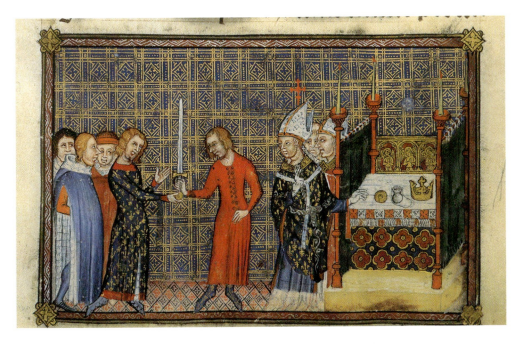

Pl. 12. The King transmits the Sword to the Seneschal
and the Archbishop of Reims prepares to bless the Holy Ampulla (fol. 50)

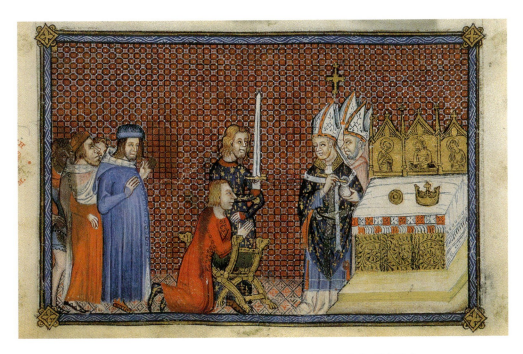

Pl. 13. The Archbishop of Reims prepares the Holy Balm (fol. 50v)

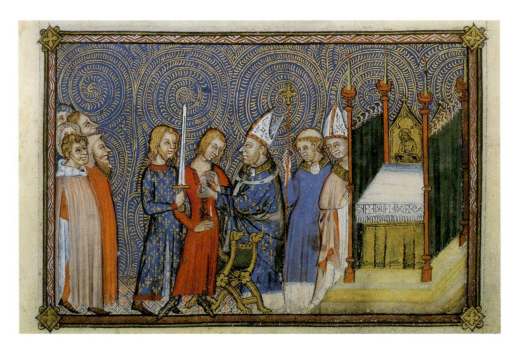

Pl. 14. The Archbishop of Reims unfastens the King's Tunic (fol. 51)

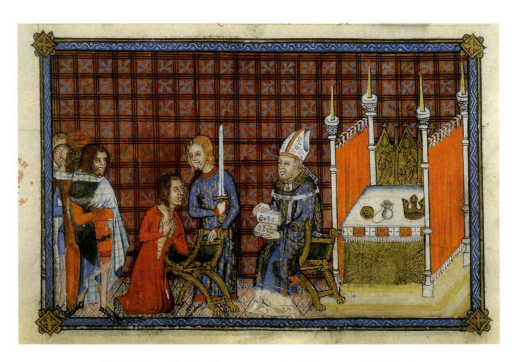

Pl. 15. The Archbishop of Reims recites the 'Te Invocamus' (fol. 51v)

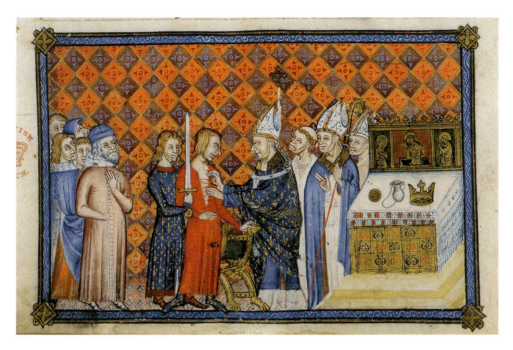

Pl. 16. The Archbishop of Reims closes the King's Tunic after anointing the King's Breast (fol. 54v)

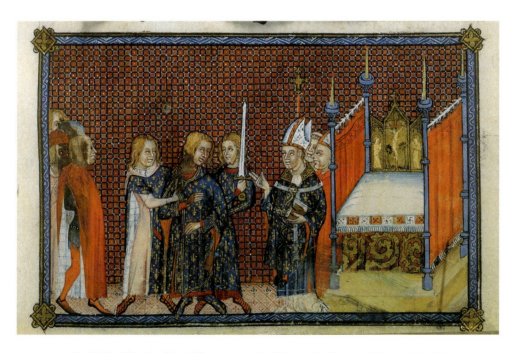

Pl. 17. The Chamberlain of France vests the King in the Tunic and Mantle (fol. 55)

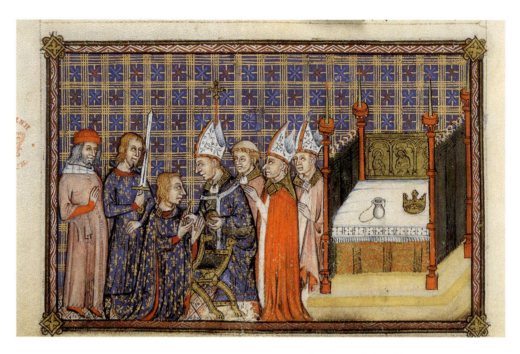

Pl. 18. The Archbishop of Reims anoints the King's Hands (fol. 55v)

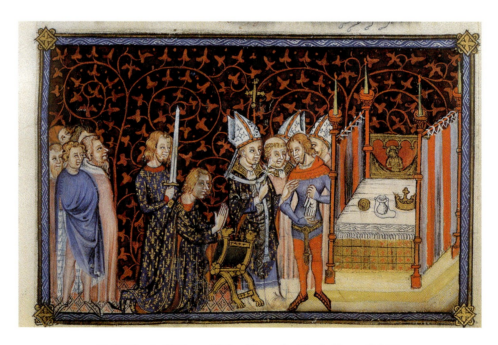

Pl. 19. The Archbishop of Reims blesses the King's Gloves (fol. 56)

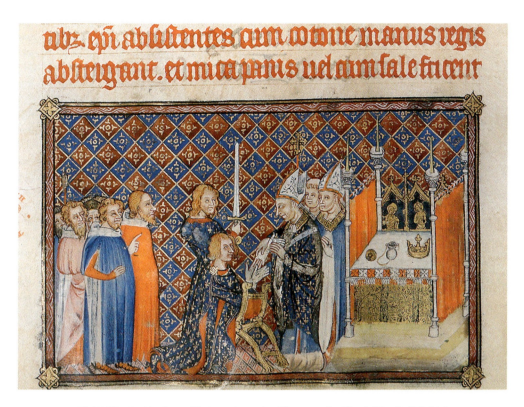

Pl. 20. The Archbishop of Reims places the Gloves on the King's Hands (fol. 56v)

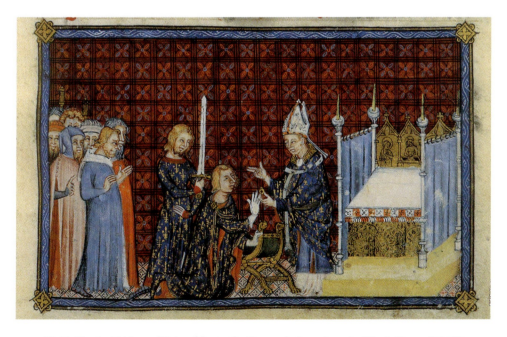

Pl. 21. The Archbishop of Reims blesses the Ring and places it on the King's Finger (fol. 57)

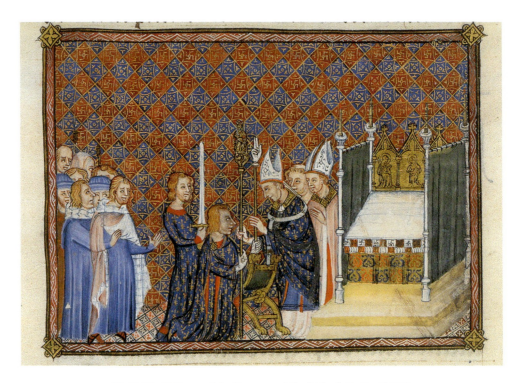

Pl. 22. The Delivery of the Sceptre and the *Main-de-Justice* (fol.58)

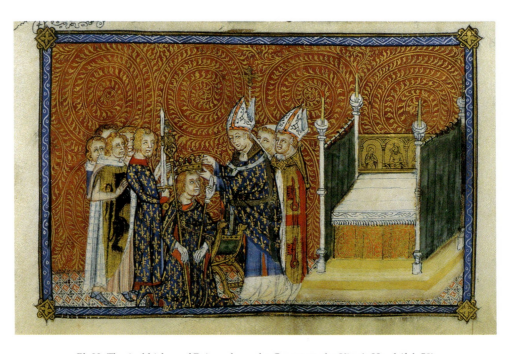

Pl. 23. The Archbishop of Reims places the Crown on the King's Head (fol. 59)

pr officium sue bndictionis. Et cum fide ir
ta et multiplia bonox oprum fructu ad co
ronam peruenias regni perpetui ipo largien
te cuius regnum et imperium permanet in
secula seculorum. Qua oratione dicta pone
do coronam in capite dicat archiepiscopus.

Accipe coronam regni. in nomine pa
tris et filiy et spiu[us] sancti
ut spreto antiquo hoste. spretisq; contagiys
uitiox omnium sic iusticiam. misericordiam

Pl. 24. The Peers sustain the Crown and the Enthronement of the King on the *Cathedra* (fol. 59v)

cornua unicornutis cornua illius i ipis
uentilabit gentes ulq; ad terminos terre.
quia ascensor celi auxiliator suus i sem
piternu fiat. per d. Deinde coronatus rex z
ducatur per manu ab archiep concomitan
tibz paribz tam prelatis q laicis de altari p
chor ulq; ad solium iam antea preparatum.
Et dum rex ad solium uenit. archiep ipm collo
cet in sede. Et hic regis status designatur z
dicat archiepiscopus

Sta et retine a modo statum que huc
usq; paterna successione tenuisti heredi
tario iure tibi delegatum per auctoritate
dei omnipotentis et per presentem tradici
onem nram: omniu salicet epor ceterorq;
seruor dei. Et quanto clerum propinquio
rem sacris altaribz prospicis: tanto ei poti
orem in locis congruentibz honorem impe

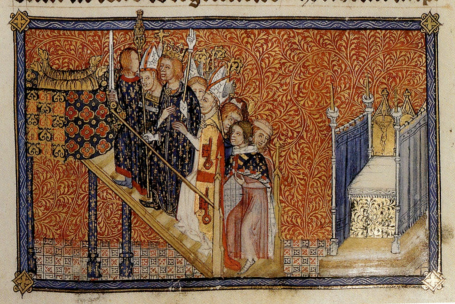

Pl. 25. The Peers lead the King to the Throne (fol. 63)

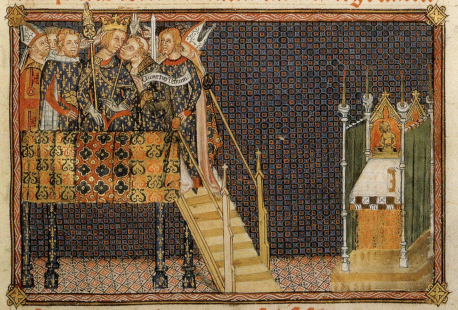

pia mater oracionis exauditione confirma. Habemus et nos apud te sancte pater dominum saluatorem. qui pro nobis manus suas tetedit in cruce per quem eciam precamur altissime. ut eius potencia suffragante. inuasor hostium frangatur impietas. populusque tuus cessante formidine te solum timere consistat. per eundem ꝛc. His expletis archiepiscopus cum paribus coronam sustentantibus regem taliter

insignitum et deductum in solium sibi preparatum sericis stratum et ornatum ubi collocauit eu i sede

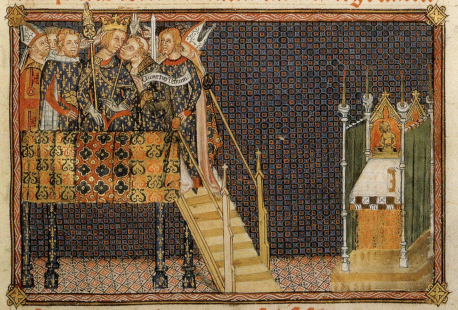

Pl. 26. The Enthronement and the Kiss of the Archbishop, the Acclamation `Vivat Rex Aeternum',
the Second Sustaining of the King's Crown (fol. 64)

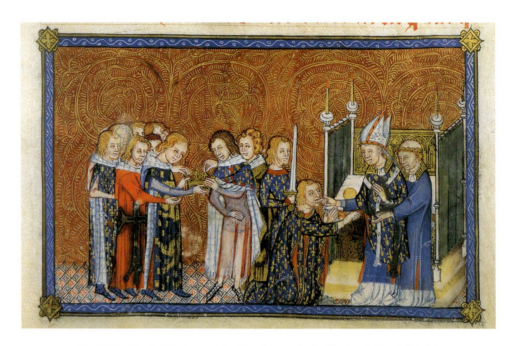

Pl. 27. The King's Offering and the King kisses the Archbishop's Hand (fol. 65)

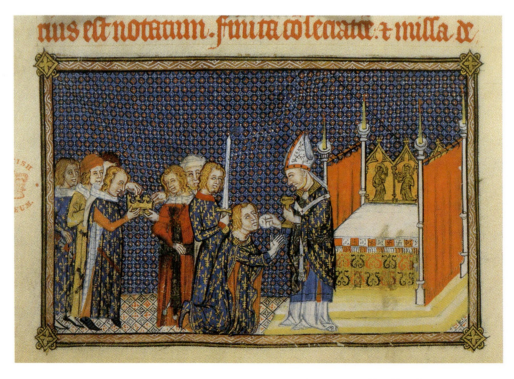

Pl. 28. The King receives the Eucharist in Form of Bread and Wine (fol. 65v)

bent iterum huidem barones reducere scam
ampullam ulqz ad scm renignu honorifice
et secure. et eam restituere loco suo.

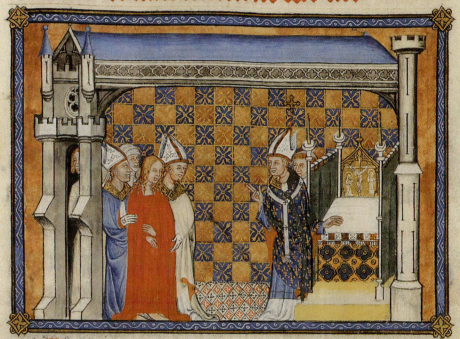

Ordo ad regniam benedicendam que
debet consecrari statim post factam
consecrationem regis. debet ei para
ri solium i modum soly regis. debet tamen a
liquantulum minus ee. debet aute regina ad
duci a dnobz epis in ecclam. et rex in suo so
lio sedere. in omnibz ornamentis suis regis

Pl. 29. The Queen's Entry into the Cathedral (fol. 66)

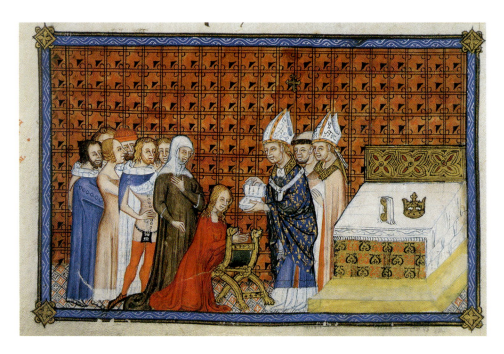

Pl. 30. The Queen kneels at the *Cathedra* as the Archbishop of Reims reads the Prayer over her (fol.66v)

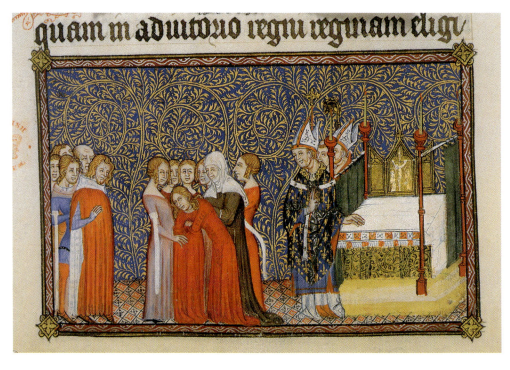

Pl. 31. The Opening of the Queen's Tunic in Preparation for Anointing (fol. 67v)

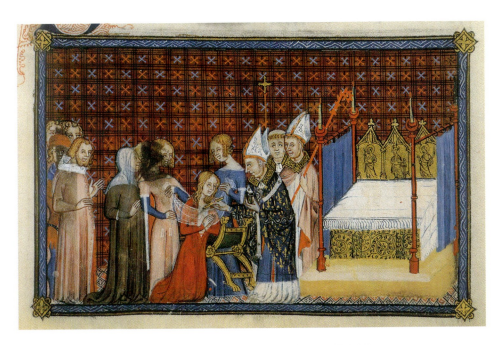

Pl. 32. The Anointing of the Queen's Breast (fol. 68)

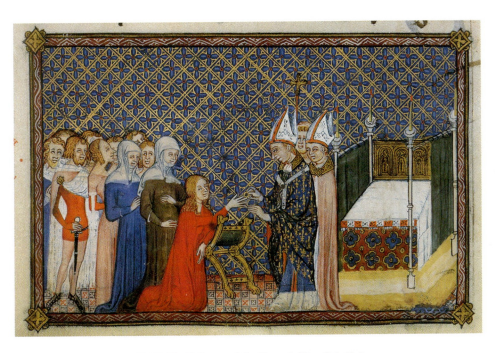

Pl. 33. The Delivery of the Queen's Ring (fol. 68v)

di ꝙ ſceptꝛū regium ⁊ uirga conſimilis ūgꝛ
regie. Et ſi tradendo dicat archiepſ

Accipe uirgam uirtutis et equitatis. ⁊
Eſto pauꝑibꝫ miſericoꝛs ⁊ affabilis.
uiduis pupillis. ⁊ oꝛphanis diligētiſſimā
curam exhibeas. ut omnipotens deus auge
at tibi gͤram ſuam. Qui uiuit et regnat

Sequitur poſt datoiné ſceptꝛi ⁊ uirge lᵉc oꝛatᵒ

Omips ſēpiterne deus affluenté ſpin
tue bñdictionis ſuper famulā tuā
nobis oꝛantibꝫ propiciatus infunde. ut
que per manus ñre impoſitionem hodie ꝛe
gina inſtituitur. ſāficatione tua digna et
electa permaneat. ut nunꝗ poſt modum de
tua gracia ſepaꝛetur indigna. per d̄ Tunc
debet ei ipſi a ſolo archiepſ coꝛona i capite ip
ſius ꝗn impoſita ſuſtentare debent undiꝗ ba
rones. archiepſ autē debet dicͤe i impoſicoͤe oꝛdem

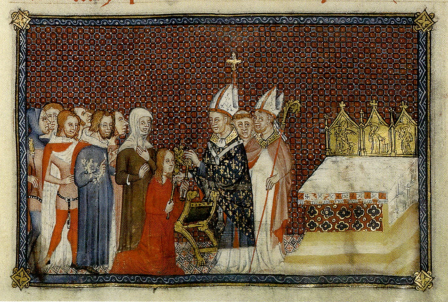

Pl. 34. The Delivery of the Queen's Sceptre and Verge (fol. 69)

splendida fulgeas. et eterna exultatione
coroneris. Ut scias te esse consortem reg
ni. populoq; dei semper prospere consulas.
et quanto plus exaltaris. tanto amplius
humilitatem diligas atq; custodias. Vn
de sicut exterius auro et gemmis redimita
enites. ita et interius auro sapientie uir
tutumq; gemmis decorari contendas. qua
tenus post occasum huius seculi cū prude
tibz uirginibz sponso perhenni dīo nīo ihe
su xpō digne et laudabiliter occurrens regi
am celestis aule merearis ingredi ianuā.
Auxiliante dīo nīo ☩ **post impositā coronam**
Omniū dīe fons **dicat archiepiscopꝰ**
onor et auctor dator pronectui
tribue famule tue. Ʒ. a deptam bene rege
dignitatem. et a te sibi prestitam in ea
bonis operibz corrobora gliam. per d̄.

ihesu xpō. Qui cum
pre et spiritu sco ui
uit et regnat. per ī
finita secula sclōz.
Amen.

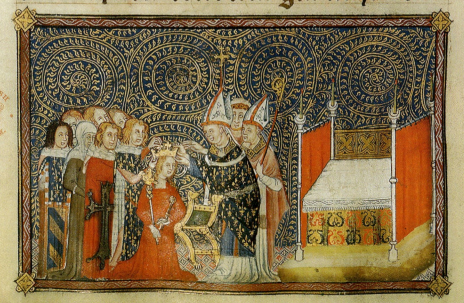

Pl. 35. The Imposition and Sustaining of the Queen's Crown (fol. 69v)

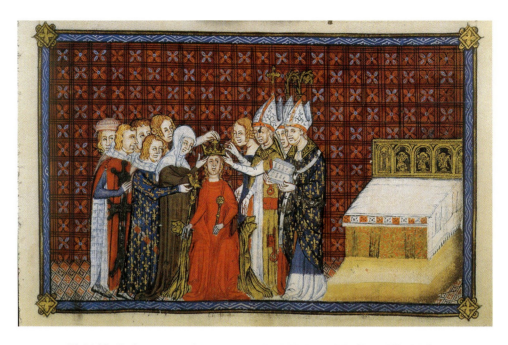

Pl. 36. The Enthronement of the Queen on the *Cathedra* and the Second Sustaining
of the Queen's Crown (fol. 70)

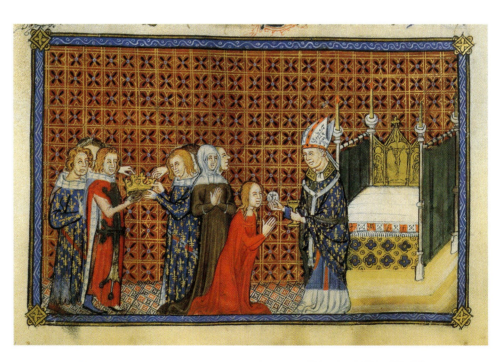

Pl. 37. The Queen receives the Eucharist in Form of Bread and Wine (fol. 72)

Sca katerina · oz | Ut pacem nobis do

Sce chorus uirginu | nes tx

ora pro nobis | Ut mia et pietas tua

Omnes sci orate pro | nos custodiat tx

Propicius esto par | Ut gram sci spiritus

nobis domine · | cordibz nris clementer

Propicius esto liba | infundere dignis tx

nos domine · | Ut ecclam tuã regere

Ab insidiis dyabli l̃ | et deffendere dignis tx

A dampnatione per | Ut dompnum apostolu

petua l̃ | cum et oms gradus

Per misterium sce i | ecclesie i sca religione

carnationis tue l̃ | conseruare dignis tx

Per passionem et cru | Ut archiepiscopũ no

cem tuam l̃ | strum · N · cum omni

Per graciam sci spũs | grege sibi cõmisso in

paracliti l̃ | tuo sco seruicio confor

In die iudicii l̃ | tare et conseruare di

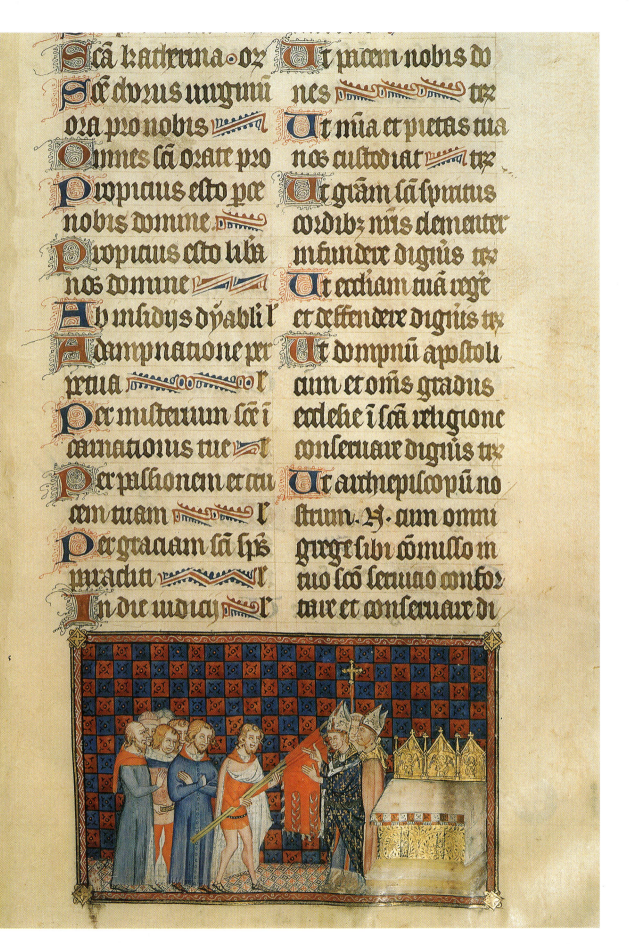

Pl. 38. The Blessing of the Oriflamme (fol. 73)

Ce livre du sacre des rois de France, est a nous
Charles le Ve de notre nom, roy de France, et
le fimes coriger, ordener, escrire et istorier
l'an mil cccc. lxv.

· J · Charles ✕

C'est le serment que fait le chevalier a qui le roy baille a porter l'oriflambe

Vous jurez et promettez sur le precieux corps Jhucrist sacre et pris
et sur le corps de monsst et denys et ses compaignons qui cy sont que vous
loyaulmt en vre personne tendrez et conserverez l'oriflambe du roy monsst
qui cy est atone et qy fit de lui et de son royaume, et po doubte de mort ne
dautre aventure qui puisse avenir ne la delairez, et ferez par tout bie
devoir come bon et loyal chlr doit fe envers son souverain et droit urier seign.

Pl. 39. Colophon of Charles V (fol. 74v)

2. Anointing and the Celestial Balm

Among the traditions reaffirmed in the Ordo of Charles V and the Coronation Book is the anointing with the Celestial Balm.[25] All three of the French ordines which predate the Ordo of Charles V celebrate the unique powers received by the king of France through his anointing with the balm sent from heaven to St Remi for the baptismal anointing of Clovis.[26] Indeed the Ordo of Charles V adheres scrupulously to the preceding tradition, and thus reaffirms it.

From the time of Philip II Augustus, the kings of France began to claim special prerogatives founded on the Holy Ampulla and the Celestial Balm. In the *Philippide*, an epic poem in praise of Philip Augustus written during the reign of Louis VIII, Guillaume le Breton evoked the miracle of the balm with which

> the king of heaven … exalts above all of the kings of the earth him who alone
> is consecrated with the holy unction from heaven, whereas the others are con-
> secrated only with an entirely material essence.[27]

According to this poem, his anointing with the Celestial Balm gave Philip victory at Bouvines over Otto of Brunswick and John Lackland, regarded as heretics for their alliance against the papacy.[28] The balm therefore elevates the king of France above all other terrestrial rulers and bestows on him the grace that brings victory over his enemies who are the enemies of God.

Not surprisingly, Philip IV seized upon this theme. To cite only one of many examples, in the *Quaestio in utramque partem* (1302) the author evoked the Holy Ampulla and the curing of scrofula as irrefutable evidence of a 'kingdom held in possession from God and without other means'.[29] Raoul de Presles translated this and other anti-Bonifacian works into French for Charles V.[30] Indeed, Raoul de Presles, Jean Golein, and the author of the *Songe du Vergier* all used the treatises written for Philip IV as the foundation of their programme of constructing the sovereignty of the king of France. They systematically exalted the gifts from God — anointing with the balm in the Holy Ampulla, the curing of scrofula, the oriflamme and the fleurs-de-lis — as celestial signs of the superiority of France and its position at the head of Christendom.[31] But the cornerstone of the strategy was anointing with the Celestial Balm.

In the prologue for his translation of Augustine's *City of God*, Raoul de Presles delineated his thesis that Charles is the most Christian king because of the uniqueness of his descent from both the kings of France and the emperors and his anointing with the Celestial Balm:

> … first, concerning your birth, it is certain that you are the son of the king of
> France, who, as king of France, is the greatest, highest, most catholic and most
> powerful Christian king. Along with this, you are also issued from the line of
> Roman emperors who carry the eagle for their first insignium. [Anointed]
> with this condiment (ie. the oil), you are the most worthy Christian king
> because, along with that holy chrism with which you are anointed in your
> baptism as any ordinary good Christian, you are the consecrated king *par
> excellence*, as worthily anointed as the Holy Lord, who by a dove — whom we

113

> hold firmly was the Holy Spirit in this form — carried from heaven in his beak in a little ampulla or vial, came amongst the people and [put it] in the hand of my lord St Remi[gius], then archbishop of Reims, for him to use to consecrate and anoint in the font (ie. the baptismal font) king Clovis, the first Christian king. And in this reverence and power, this very great and noble mystery, all of the kings of France, since this first creation, have been consecrated at Reims with the liquor of that holy ampulla. And no one can maintain that this consecration is without very great dignity and noble mystery because by it you … have such virtue and power that it is given and attributed to you by God to make miracles in your life … that you cure the very horrible malady called scrofula that no other earthly prince can cure except you … .[32]

The same ideological programme is set forth by Raoul de Presles's student, the Carmelite Jean Golein, in his *Traité du Sacre* which he inserted into his French translation of Guillaume Durand's *Rational of Divine Offices*.[33] Golein begins his treatise by explaining how

> in the manner of his predecessors Charles was crowned and consecrated at Reims, not with the oil or balm that was confected by a bishop or an apothecary, but the holy celestial liquor in the holy ampulla which is conserved and guarded at Saint-Remi at Reims as that carried from heaven by the hand of angels to anoint the noble and worthy kings of France more nobly and with greater sanctity than any king of the old law or of the new, and for this he is called the most noble and most Christian defender of the faith and the Church which recognizes no temporal sovereign over him.[34]

Other sources that exalt the special sacramental status of the anointing of the French king at Reims with the Celestial Balm are the *Chanson de Geste de Charles le Chauve* and the *Songe du Vergier* (ill. 11).[35] The latter, written for Charles V by an anonymous author whom some identify with the legist Evrart de Trémaugon, presents the most extreme formulation of the thesis:

> And who, also, would call into doubt that the most powerful king of France was not ordained and established by God? Because, if we consider, firstly, how God, by very marvellous manner sent to the king of France his arms (the shield with the fleurs-de-lis in sign of the Trinity); secondly how the angel carried from heaven the holy ampulla with which today all of the kings of France are consecrated; thirdly, the glorious saints who issue from the house of France; fourthly how the kings of France cure a malady only by touch, the malady called scrofula; fifthly how in this century God made the king his special treasurer of such a noble treasure which is that which he guards in his Sainte-Chapelle. If we consider all of these things and many other graces and miracles that God has made singularly for the kings of France over all other kings, we can say without doubt that God has made and ordained him his vicar in temporality of the very noble and very powerful kingdom of France.[36]

Following Colette Beaune, Jacques Krynen has shown that, beginning with Charles V, the Celestial Balm was used to justify the transformation of the appellation *rex*

christianissimus into the exclusive title of the king of France, a title which conferred on the king an array of legal prerogatives. It permitted him to assert that he did not receive his kingship either from the emperor or the pope and that he had no superior but God. It therefore justified the claim of the sovereignty of the king of France in his kingdom, and became a central doctrine of the French monarchy, ultimately erected by them into the theory of the divine right of kings.[37] I would assert that it was the ritual of the Coronation Book that provided a legal foundation for this programme.

In the Coronation Book the ritual of the Celestial Balm corresponds with that in the three earlier French ordines, but is given new importance by the miniatures. Indeed in the manuscript's original state at least ten illustrations, a quarter of the cycle, pertained to the Celestial Balm, either by including the Holy Ampulla in the scene or by depicting a specific ritual act involving the balm. The miniatures, along with the Latin and the French texts, give an account of the arrival of the balm at the cathedral and the transmission of the balm to the archbishop of Reims (pl. 4; ill. 31), the mixing of the balm with chrism (pls. 12, 13), secondary acts before or after the anointing (pls. 14, 16, 19, 20), and the series of anointings administered to the king (pls. 18 and two lost scenes as shown in the codicological analysis in chapter 5).

Unlike the illustrations of the Ordo of 1250 in the Pontifical of Châlons-sur-Marne, where the marks of the anointing appear as red crosses on the body of the king, the anointing in the illustrations of the Coronation Book leave no visible, miraculous marks. Only the physical aspects of the balm and the ritual procedure are shown: the specific individu-

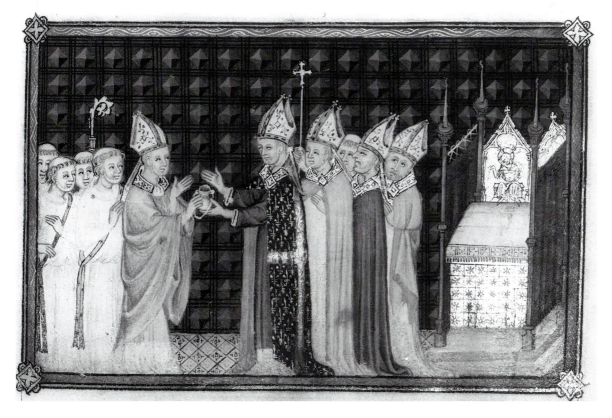

31. The Abbot of Saint-Remi conveys the Holy Ampulla to the Archbishop of Reims, fol. 46 [pl. 4]

als who handle the balm, the precise ritual actions involved with it, and the objects that come into contact with it. The material form of the ritual objects is clearly illustrated, such as the shape and size of the Holy Ampulla and the detail that it had a longish golden chain attached to the rim of the vessel. The other ritual objects used in conjunction with the Celestial Balm have also been depicted, including the paten for mixing it with the chrism, and the golden stylus or needle used by the archbishop for the anointing.

3. Royal-Episcopal Parallelism and the 'Royal Religion'

Reaffirming the traditional parallels between the royal and episcopal consecration rites was one of the major themes of the ordo and its illustrations in the Coronation Book.[38] Beginning in the Carolingian period, the consecration rituals for kings and bishops underwent a symbiotic development in which the two ceremonies were increasingly likened to each other.[39] The ritual and theoretical foundations of the royal ministerium were introduced to the king-making rite with the addition of features taken from the rites for the ordination of priests and the consecration of bishops, while simultaneously, features of the royal rite were transposed to the episcopal consecration.[40] The Ordo of Charles V, like earlier ordines, contains a prayer recited by the archbishop of Reims at the imposition of the crown stating that the king participates in the ministry of bishops.[41] This prayer was derived directly from the *Pontificale Romano-Germanicum*.[42]

The fetching of the king in the palace of the archbishop of Reims by two bishops and a group of clergy (pl. 3) announces at the outset the analogy with the consecration of bishops. The king's oath is that introduced by Hincmar of Reims in his Protocol of 869, taken from the oath administered to the bishop. In a key scene Charles is shown swearing on an open book held by the archbishop of Reims, on the pages of which we can read the opening words of the oath (*Te promitto*) (pl. 5). The divestiture of the garments before the consecration (pl. 7; ill. 32) is another analogy with the sacerdotal consecration, as are the various anointing procedures, especially the anointing of the head (lost in the Coronation Book) and the anointing of the hands (pl. 18). As in the episcopal consecration, where the new bishop kneels at a faldstool for the archbishop to recite over him the episcopal benediction before the anointing, Charles kneels at a faldstool as the archbishop of Reims recites the words of the benediction, derived from the episcopal rite (pl. 15). Similarly, like a newly-consecrated bishop in the episcopal consecration, Charles kneels at a faldstool to receive from the archbishop the ring (pl. 21), sceptre, verge (pl. 22), and crown (pl. 23). Two further traditional parallels with the episcopal consecration are the kiss given by the metropolitan to the newly consecrated king (pl. 26) and the reception of the Eucharist in two species (pl. 28).

The sacramental and sacerdotal dimensions of the sacre were especially important to Charles V and his political programme. In his *Traité du Sacre*, Golein emphasized the sacramental status of the sacre. He stated that the king deposited his vestments in order to take on those of the 'royal religion', which he compared with the entry into 'religion' through the sacrament of Holy Orders.[43] For Golein, therefore, the 'royal religion' refers to the consecrated and sacerdotal character of the king. This treatise on the sacre of Charles V was in-

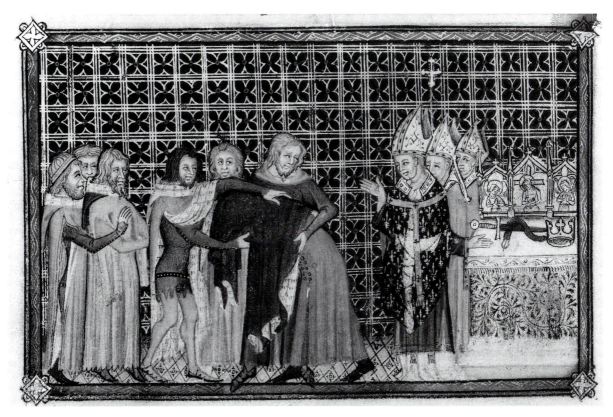

32. The Removal of the King's outer Garments, fol. 47v [pl. 7]

serted into Golein's translation of the *Rational of Divine Offices* immediately after the section on the consecration of bishops, a significant placement because, central to Golein's treatise is the notion that, through his consecration, the king of France enters into a religious ministry similar to one who has received the sacrament of Holy Orders. After exposing the sacerdotal significance of the royal garments and insignia, Golein explains that

> when the king disrobes it signifies that he relinquishes the worldly state to which he belonged before in order to take that of the Royal Religion, and if he takes it in such devotion, as he must, I hold that he is cleansed of his sins as is he who enters into religion … of which Saint Bernard speaks at the end of the book of precepts and dispensations, that, as at baptism, sins are pardoned also at the entrance into religion.[44]

Golein asserts that because of the sacerdotal nature of the king's anointing in the sacre, he must, like a priest, 'wear the coif all of his life' out of reverence for that anointing which was administered on his head but also as an outward sign of this 'anointing with the most worthy holiness'.[45] He adds that the mixing of the balm of the ampulla with chrism

> signifies the mixing of the royal and the priestly of which it is written *Vos estis genus electum regale sacerdocium* (I Peter 2:9) [You are a chosen generation, a kingly priesthood]. Because of that, he is the most worthy king and the most gloriously anointed, who alone and above all others is privileged of divine unction sent from heaven.[46]

117

The scriptural passage that Golein cites (I Peter 2:9) is particularly meaningful because it is a paraphrase of Exodus 19:6: 'And you shall be to me a priestly kingdom, and a holy nation. These are the words thou shalt speak to the children of Israel ... '. This is the biblical passage designating the chosen people of God, a priestly kingdom and a holy nation. For Golein that priestly kingdom and holy nation are to be identified with France. In citing this scriptural passage on the nation of Israel, Golein takes a first step towards defining the nationhood of France.

The strengthening of the sacerdotal and episcopal character of the king of France was the keystone of the strategy to establish the 'royal religion'. This ideology situated the king in a unique position within the hierarchy of both Church and State. The royal religion girded the king with an aura of sanctity which elevated him above any other consecrated of the Lord. This developed ultimately into the claim that the king of France was the *rex christianissimus,* unrivalled by any other anointed minister. By increasing his mystique and sacral aura the king of France was set above and apart from any other anointed of the Lord.

On a practical plane it also enabled the king to pretend to authority both in secular and ecclesiastical matters, for as the highest member of the laity he was now invested with the qualities of a prelate of episcopal rank. Why was this aspect of the king's ministry strengthened? On an immediate pragmatic level, his sacerdotal character extended to him an increased level of protection that is afforded the consecrated of the Lord. David's refusal to kill Saul in the wilderness of Ziph was the biblical model for the anathema against rendering any harm to the anointed of the Lord: 'Thy blood be upon thy own head: for thy own mouth hath spoken against thee, saying "I have slain the Lord's anointed"' (I Samuel 26:9–11 and II 1:16). Any violence done to the Lord's anointed, whether kings or priests, was a cause for excommunication. The king's royal and episcopal anointing had the practical advantage of shielding him from the menace of assassination or execution.[47] There were schemes to assassinate John the Good, and Charles was also the target of assassination attempts. So it seems that the reinforcement of the sacerdotal and episcopal character of the king was motivated, at least in part, by a desire to afford him a greater degree of physical protection in times which were extraordinarily violent.

Anointing also afforded the king greater independence from challenges that might be brought by any secular agency including, for example, the newly enfranchised popular assemblies. He was not a mere secular leader, for he had been anointed like a bishop. He could thus neither be judged, condemned, nor deposed by a secular tribunal. This in itself gave the king an important degree of sovereignty over the secular estate within his kingdom. It would certainly have strengthened his authority over the secular peers and would have put him on a comparable footing, at the very least, with the ecclesiastical peers. Furthermore, reinforcing his episcopal character would have endowed him with considerable authority in ecclesiastical matters, at least within his kingdom. This had the double advantage of inscribing him in the prelatial ranks of the ecclesiastical ministry while at the same time avoiding the pitfalls of the potentially heretical intrusion into the domain of the ordinary priest, whose unique power to consecrate the Eucharist and effect the transubstantiation of bread and wine had become such an important and controversial issue after the Fourth Lateran Council. The Ordo of Charles V avoided asserting any such claims while at

the same time insisting upon the miraculous powers that the king received through the anointing with Celestial Balm.

There is one remaining aspect of sacerdotal kingship that might be mentioned. We have noted that in 1317, when Philip V died without a male successor, no clear law excluded women from succeeding to the throne; yet he was succeeded by two of his brothers rather than a daughter. According to Krynen the first explicit statement of the exclusion of women appeared during the reign of Charles IV (1322–8) in a glossed commentary of St Augustine's *City of God*, Book III, chapter 21, written by the Franciscan Francis de Meyronnes. Francis objected to the injustice of the *lex Voconia* forbidding women from inheriting property, but he also sought to accommodate his position with Augustine's acceptance of this law by distinguishing between a woman's right to inherit private property and her inability to inherit 'dignities'. For this he cited the Jewish priesthood transmitted to males in the lineage of Aaron.[48] In 1371 when Raoul de Presles prepared his translation and commentary of the *City of God* for Charles V he developed this same argument, using a commentary prepared for Philip VI by the English Dominican Thomas Waleys and invoking arguments made earlier by Meyronnes. According to Raoul de Presles the kingdom is not an inheritance, but a dignity regarding the administration of all public things; women are not equal in dignity according to the law and thus must not succeed to the kingdom; and lastly, the proof is that the dignity of the Aaronic priesthood descended by succession, but never to women.[49] Raoul gives numerous scriptural examples to defend his point. Similar positions are expressed by Nicole Oresme in his translation and commentary on Aristotle's *Politics*; here he states that women must not succeed to the kingdom because it is not a private inheritance but a dignity that he, like Meyronnes, compares to the Aaronic priesthood. Accordingly, no one can succeed to the kingdom if a woman, or through a woman.[50] The exclusion of women from the priesthood provided a scriptural law for the exclusion of women from the priestly dignity of the royal religion. The innovations of the Ordo of Charles V reinforce the king's sacerdotal and prelatial character and in so doing validate the doctrines of the 'royal religion' and of male succession and the exclusion of women.

II. Innovations of the Ordo of Charles V

The review of the tradition and sources for the assembled textual segments of the Ordo of Charles V reveals that most of its rituals and prayers reaffirm past tradition. However, some features are without precedent in earlier royal ordines and represent innovations in the sacring rite itself that were introduced in the Ordo of Charles V and given special emphasis here through its illustrations. Among the original features of the Ordo of Charles V is the fact that the queen's ordo has been integrated more fully with the king's than in any previous ordo. This integration is so clearly and consistently established that the ordo might appropriately be called the Ordo of Charles V and Jeanne de Bourbon.[51] Percy Ernst Schramm observed that, along with its comprehensiveness, the most original feature of the Ordo of Charles V is the miniature cycle of the Coronation Book.[52] Not

119

having studied these illustrations in depth, however, he and others have overlooked the remarkable innovations that they bring to the royal consecration liturgy.[53] Some of the most important innovations occur, not in the text, but in the illustrations.

1. Inalienability of the Crown

In a valuable study of the history of the coronation oath Marcel David recognized that the king's oath in the Ordo of Charles V contains a clause that had never appeared in any previous coronation ordo.[54] This passage is as follows:

> … et superioritatem iura et nobilitates corone francie inviolabiliter custodiam
> et illa nec transportabo nec alienabo. (fol. 46v).
> [I will guard inviolate the superiority, laws and dignities (nobilities) of the
> crown of France and that I will neither transfer (transport) nor alienate these].

It is beyond the scope of the present investigation to resolve the numerous problems that are posed by this controversial passage. David overlooked Dewick's observation concerning the folio on which the oath was written, namely that immediately after the words *nostro arbitrio in omni* the remainder of the oath, including the above passage, was written 'by a coarser hand' over an erasure.[55] Jackson concluded from this that the crucial clause on the inalienability of the Crown was not present in the original version of the oath in the Ordo of Charles V and that it is a later interpolation.[56] I was inclined to follow Jackson and exclude the oath from the present consideration of innovations of the Ordo of Charles V. However, after examining this passage and its relationship to the folio and to the miniature below, I observed a configuration of details that indicate that the passage is not a later interpolation and that the erasure and recopying of the oath were carried out, not in order to incorporate a later development in the oath, but rather to arrive at a more satisfactory placement of key passages of the oath in relation to the miniature below depicting Charles taking the oath (pl. 5).

The most important evidence that the clause does not postdate the Coronation Book is that a version of the coronation oath with the entire clause on the inalienability of the Crown appears earlier in the manuscript on fols. 41v–42. There it is part of the original transcription of the text as it has not been written over erasures: it has been copied within the margins on the pre-ruled lines by the scribe who copied the rest of the manuscript. The presence of this clause demonstrates both that it was known to Charles and the redactors of the Ordo of Charles V and that it had been formulated prior to the execution of the Coronation Book.

It is instructive at this point to recall that, in the colophon, Charles affirmed that he ordered the manuscript to be 'corrected'. Might not the erasure and re-copying of the oath on fol. 46v be such a correction? In favour of this conjecture, as Michelle Brown pointed out to me, the script is by a hand that is so close to the main hand that is gives every appearance of being by a contemporary, if slightly less accomplished hand. Indeed both the erasure and the coarser script resemble corrections made by Charles himself in several manuscripts which he commissioned.[57] But why was the correction made if it was not to insert the clause on inalienability? The relationship of text and image on the folio may provide

some clues. For immediately above the miniature on fol. 46v is the momentous clause introduced into the coronation oath after the Fourth Lateran Council which invests the king with the duty and the authority to expel heretics: *Item de terra mea ac iuridicione mihi subdita universos hereticos ab ecclesia*. It is noteworthy that this passage is absent from the version of the oath on fols. 41v–42. Had the scribe referred to that version when copying the oath in the Ordo of Charles V, it is entirely conceivable that he would have omitted this crucial clause on expelling heretics that had proven so useful to St Louis and his successors. It is not impossible that the individual who was responsible for making the correction sought, not only to reintroduce this clause, but to place it directly above the image of Charles taking the oath. There it would also be on the same folio with the new clause on the inalienability of the Crown, and, in placing the two clauses above the miniature, a strident visual discourse was engaged that insisted that the oath taken on 19 May 1364 did indeed include these two passages. The relationship between text and image is underscored by means of the image in which the folios of the open book upon which Charles is shown taking his oath are inscribed with the opening words of the oath (including decorated initial) that appear on the page of the actual book. Whether Charles did or did not take the oath as written here matters very little, for not only do the image and text argue that he did, but the presence of both clauses elsewhere in the manuscript prove that both clauses were known by 1365. It can be stated unequivocally that the clause on the inalienability of the Crown is among the innovations of the Ordo of Charles V.

It should be emphasized that the notion of the crown as an abstract symbol — indeed, as stated by the clause, as a dignity — was not an invention of the theoreticians of either John the Good or Charles V, for, already during the reigns of Louis VI and Louis VII, Suger had spoken of the *corona regni* as a symbol of the authority of the king.[58] The principle of the inalienability of the Crown appears in an act of John the Good of November 1361 in which he ordered the 'reunion to the Crown' of the duchies of Normandy and Burgundy and the counties of Champagne and Toulouse. In this act John also proclaimed that 'his eldest son must succeed him to the kingdom' and stated that when he (Charles) is crowned he must take an oath never to divide or separate the provinces thus unified.[59] The elevation to a political doctrine of the notion of inalienability has been regarded as a response to the Treaty of Bretigny. From early in his reign the doctrine of inalienability was used by Charles to retract alienations made in that treaty.[60]

Despite its concision, this clause had far-reaching implications which went beyond the narrow objective of undoing the damage of Bretigny and attempted to redefine monarchy and to herald a fundamental reinterpretation of the theory of a sovereign government. Throughout the reign of Charles V the doctrine of the inalienability of the Crown was refined and defined by his theoreticians including Jean Golein, Nicole Oresme and Raoul de Presles. But the explanation given by Evrart de Trémaugon in the *Songe du Vergier* is the most clear and forceful:

> ... to the king pertains sovereignty and supreme jurisdiction in all the
> kingdom, but in such a way that he cannot give this sovereignty away,
> transport or otherwise alienate it, nor can he renounce it because this
> sovereignty and final jurisdiction are by such manner conjoined and annexed
> to the Crown that they cannot be separated from it because they are the
> principal nobilities (dignities) of the Crown.[61]

Thus we see that the king retains sovereignty but that the Crown is an entity separate from and superior to both the king and kingdom. The kingdom is a physical, geographic and territorial reality, whereas the Crown is a transcendent, metaphysical reality.[62] The Crown is thus defined as a perpetual and divine institution that cannot be the material property of any individual.

Prior to Hincmar's Protocols the coronation crown had been the symbol of the election of the king by the magnates, while the act of coronation signified recognition of this election. We have seen that Hincmar linked the crown with the 'crown of glory' of priestly anointing, thereby sacralizing what had been a secular insignium. The crown from thence became an insignium of the king's anointed, sacral character and his divinely ordained authority. The introduction of the clause on the inalienability of the Crown in the Ordo of Charles V has implications for the image of the crown as it appears in the Coronation Book and for the meaning of the rituals in which it appears.

The traditional prayer that is recited by the archbishop for the imposition of the crown begins: 'Accept the crown of the kingdom ... '. The prayer goes on to state that the king 'participates in our ministry', comparing his reign to the eternal reign of the Lord Jesus Christ 'in consortium with the saints' (fol. 59; ill. 33). The presence of the clause on the inalienability of the Crown redefines these traditional prayers within the ordo so that its transcendent, metaphysical significance is brought to the fore in otherwise traditional elements of ritual pertaining to the Crown.

The *Traité* of Jean Golein gives some clues concerning the significance that the crown took on in the Ordo of Charles V. According to Golein, the royal jewels are put on the altar

> to demonstrate that all royal and noble insignia come from God. The crown
> signifies true loyalty in royal majesty because it is round in shape without end
> or beginning ... noble and royal without rupture and interruption ... , carried
> on the head to signify that it is in true domination and surrounded by justice
> without bending more to one part than to another.[63]

In all of the rituals pertaining to the crown in the Coronation Book the peers are given a prominent and active role, and the ritual and imagery make it clear that the peers are linked with the crown. For the entrance into the cathedral the king must be 'accompanied by the archbishops, bishops, dukes, princes, counts, and he must be especially surrounded by the twelve peers like the twelve apostles around Jesus Christ'.[64] The peers surround the archbishop of Reims as he takes the crown off the altar and places it on the king's head. They sustain the crown for the king's enthronement on the cathedra, his journey to the solium, his enthronement on the solium, and for the recitation of the *Sta et retine*. According to Golein, the *Sta et retine* is recited when the king is placed in his throne at the

per officium nre benedictionis. Item fide recta et multiplici bonorum operum fructu ad coronam pervenias regni perpetui ipso largiente cuius regnum et imperium permanet in secula seculorum. Qua oratione dicta ponendo coronam in capite dicat archiepiscopus.

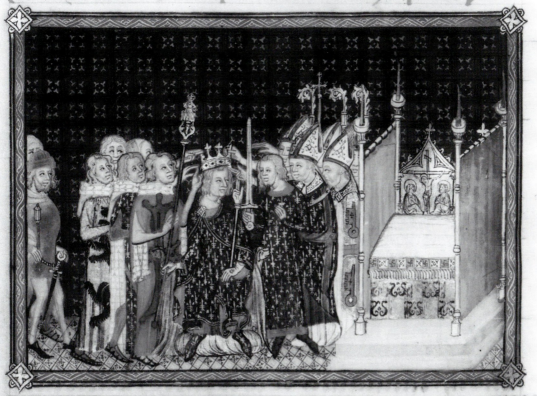

Accipe coronam regni. in nomine patris et filii et spiritus sancti. ut spreto antiquo hoste. spretisque contagiis vitiorum omnium. sic iusticiam. misericordiam

33. The Peers sustain the Crown, and the Enthronement of the King on the *Cathedra*, fol. 59v [pl. 24]

exact moment when the archbishop recites the words *[huc]usque paterna successione tenuisti hereditario jure* while the secular and ecclesiastical peers sustain the crown.[65] The 'peers surround the king as the apostles surrounded Jesus, according to John 15:15: "I will not now call you servants, for the servant knoweth not what his lord doth. But I have called you friends, because all things whatsoever I have heard of my Father, I have made known to you"'.[66]

According to Golein the peers signify

> the force surrounding Solomon 'holding swords and most expert in war ... ' [Canticles 3:8], because swords are kept near so that they can be taken when needed to defend king and kingdom. And for the imposition of the crown the archbishop, peers, prelates, and knights must put their hands on the crown to sustain it all around without breach or failure as it is said in the Scriptures: ' ... and round about and within they are full of eyes' [Revelations 4:8].

That is to say that the royal house and all around are all of the offices full of eyes to attend to Good Government of the Kingdom. In this manner these noble lords sit on a high seat well prepared in an obvious place where they can be seen by all parties.[67]

The peers sustain the crown as the king is enthroned on the high seat which is placed on the solium or *eschaufaut*. According to Golein, this solium

> must be large enough to hold the twelve peers ... for indeed that judgment and all royal acts must have many assistants. In this guise God ordered his sovereign court when he put twenty-four elders sitting in judgment in white vestments and especially when he put twelve seats to judge the twelve tribes of Israel; in this it appears that great judgments in France are regulated by the divine law of God ordered by the twelve peer assistants.[68]

Here Golein includes the crucial reference to the responsibility of judgment that the king shares with the peers, both secular and ecclesiastical. Thus the peers assist the king by supporting or sustaining the weight of the crown and in so doing they participate in the offices that oversee the administration of 'Good Government of the Kingdom'. The peers are defined as 'assistants' and are not given independent authority to judge in their regional jurisdictions. Indeed, the configuration that is manifested in the scene of the peers sustaining the crown on the solium would seem to demonstrate the position that judgment is invested in the Crown, and although the king is in the place of the judge, he is assisted by the twelve peers. By standing on the solium at this point and participating in this aspect of the ritual, the peers affirm their consent to the premises that are implicitly stated. The authority to judge had been one of the most contested of the regalian rights since the time of St Louis; it was then that the movement towards centralization displaced the jurisdiction of the seigneurial and episcopal courts with royal authority as represented by the king's bailiffs. This aspect of the ritual appears to be an effort to resolve this conflict by bringing about the union of the peers to the Crown and obtaining their consent for their subordination to it.

For Golein the tribune signifies 'how it is that the king of France recognizes no temporal lord'.[69] For it is there that the archbishop kisses the king, followed by the secular and eccle-

siastical peers, 'to demonstrate that they pay homage to him and offer him amiable and peaceful union'.[70] Thus, the enthronement on the elevated solium was a visible expression of the superior sovereignty of the Crown of France, an amiable union of secular and ecclesiastical peers and king for the administration of good government and justice, in emulation of the 'perpetual reign of Jesus Christ in communion with the saints' as stated in one of the accompanying prayers.

The above passages from Golein's *Traité*, considered in conjunction with the images and text of the *Coronation Book*, allow us to see that with the introduction of the clause on the inalienability of the Crown the redactors of the Ordo of Charles V and the Coronation Book were constructing the framework of a corporate government that joined clergy and laity around the monarch under the symbol of the crown. Together all participated in a consortium for the administration of the realm. The miniatures demonstrate this ideology by showing the crown as the bond that ties together the king and the peers into a union or a corporate body, and the images award considerable importance to the equally shared participation of the lay and ecclesiastical peers in sustaining the crown. However, one should note here that, with the exception of the clause on inalienability, the text does not add anything that is not already in the Directory of *c.* 1230. There the peers sustained the crown after the archbishop placed it on the king's head, during the journey to the solium, and while the king was enthroned on the solium and during the recital of the *Sta et retine*. Indeed, the introduction of these actions into that earlier rite suggests that the origins of the notion of the crown as an expression of a corporate bond between the king and the great apanages is already inherent in that rite of the early 1230s.[71] But with the introduction to the Ordo of the phrase on the inalienability of the Crown, the sustaining of the crown by the peers becomes not only an expression of the union of the apanages to the kingdom, but also of the subordination of the peers to the Crown. For in consummating these acts of the ritual they confirm that their domains are unequivocally and permanently united to the Crown, and by thus sustaining the crown, they consent to this newly articulated constitution.

In keeping with this, the reign of Charles V was decisive for the translation of a theory of the Crown into a corporate system of government administration consisting of offices discharged by officers, some of whom were elected, exercising their functions in the name of the Crown. Currency was minted and taxes were levied in the name of the Crown. And, perhaps most significant of all, the kingdom was conceived as the domain of the Crown.[72] The Crown thus became the symbol for a sovereign state. With the addition of a few words to an oath, affirmed solemnly through ritual, a revolution in government had been instituted. The insertion of the clause on the inalienability of the Crown into the king's oath eliminates, in theory at least, the possibility for any individual ever again to treat the Crown as his personal property and to sign it away or alienate it. We will see later in this study that this clause will be instrumental to empower the king with the authority to re-appropriate property of the Crown that had been alienated.[73] This is probably why the individual who corrected the transcription of this oath in the Coronation Book also sought to include on the same folio the passage concerning the expulsion of heretics from the kingdom.

125

2. The Blessing of the Oriflamme

Among the celestial signs that Charles used as demonstration of the superior Christianity of the kingdom of France and its monarch, their special tie to God, and their place at the head of God's people was the oriflamme.[74] The oriflamme had been celebrated as a special insignium of the monastery of Saint-Denis; only gradually did it take on a larger role as an emblem of the divine election of France at the head of Christendom. It was especially during the reign of Charles V that it came to be used in a systematic way to signify that the kingdom of France was not held from anyone but from God.[75]

Among the efforts to celebrate the celestial gifts to the kingdom of France and to define its superior Christianity, as well as to expand the participation of the laity in the proceedings of the royal rite of the Coronation Book, is the inclusion of the brief rite for the blessing and transmission of the oriflamme (fols. 71v–72). It appears after the queen's rite following the conclusion of the Mass of the sacre, so strictly speaking it is outside of the actual sacre, although it is placed before the litany and the king's colophon. No rubrics explain how the transmission is carried out.[76] However, the prayer is accompanied by an illustration in the lower margin of fol. 73 (ill. 34) that gives some indication about the performance of the rite. As the blessing of the oriflamme had been joined to the Last Capetian Ordo, its presence in the Ordo of Charles V is not an innovation, but the rite has been illustrated for the first time in the Ordo of Charles V, and this illustration presents several significant new developments.

Instead of the traditional form of the oriflamme with flame-like tails, the miniature shows not one, but three identical rectangular banners, each in brilliant red-orange with golden fringe, colours corresponding to the legendary flaming gold of the banner (hence *auriflamme* or *oriflamme*).[77] Philippe Contamine has noted that this is the only image depicting the blessing of multiple oriflammes, although multiple oriflammes and different forms of oriflammes are documented in numerous sources.[78] The oriflamme that was given to the king to carry into battle against infidels, heretics and schismatics, or foreign invaders, was a counterfeit of the original kept on the altar of the abbey of Saint-Denis.[79] Jean Golein wrote that 'when the kings of France went into battle they beheld that which Charlemagne brought back from Constantinople and had the new one blessed, and they left that of Charlemagne and took away the new one and after the victory they brought that one back to Saint-Denis'.[80] The three banners in the image in the Coronation Book are undoubtedly such counterfeits.

The oriflamme was distinguished by the red colour of the banner and by the lance to which the banner was attached.[81] A rich mythology associated the origins of the lance with the Labarum that brought victory to Constantine and his army of Christians at the battle of the Milvian bridge — a lance reputed to incorporate nails that had fastened Christ's feet to the Cross which was identified with the lance of Longinus that pierced Christ's side at the Crucifixion. It was also identified with the lance of Charlemagne.[82]

The image on fol. 38 is not only exceptional for the three oriflammes, but also because the blessing is performed by the archbishop of Reims and not by the abbot of Saint-Denis, the individual who had traditionally blessed the banner that was guarded in his monas-

tery along with the crowns, sceptre, main-de-justice, and other regalia.[83] It is above all due to the illustration that there can be no doubt that the blessing in the Coronation Book is for the oriflamme, because the colours of the banners corresponds with that of the oriflamme, and the prayer is that recited by the abbot of Saint-Denis over the oriflamme. This illustration clearly depicts Jean de Craon in the vestments and armorials of the archbishop of Reims blessing the oriflamme. Despite the fact that the blessing of the oriflamme was already joined to the sacre in the Last Capetian Ordo, one scholar incorrectly concluded that the scene in the Coronation Book represents the blessing of the oriflamme by the abbot of Saint-Denis because the 'oriflamme never served at the sacre of Capetian or Valois kings'.[84] That may be so, but the miniature in the Coronation Book asserts otherwise, for it clearly shows that the archbishop of Reims, Jean de Craon, is blessing the oriflammes. Furthermore, the images on the altar in the miniature are not the three reliquaries of St Denis and his companions at the abbey of Saint-Denis, as has been asserted, but rather icons of three angels which appear in several miniatures of the Coronation Book, surely to allude to the celestial origins of the oriflamme.[85]

In contrast to the reticence of the text of the Coronation Book concerning the significance of this addition to the sacring rite, Golein presented a lengthy and animated diatribe on the legend of the oriflamme and its significance that consumes four folios recto and verso in his *Traité* (fols. 51 to 54v). Indeed Golein's text makes an important contribution to the mythology of the oriflamme.[86] He recounts the legend of the dream of the Byzantine emperor Manuel who, besieged by Saracens, prayed for aid. In his sleep he had a vision of

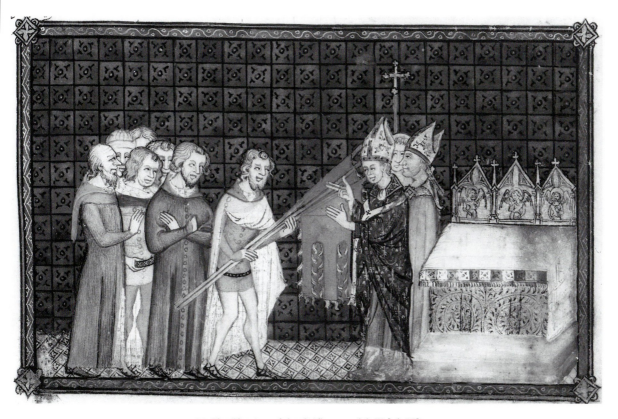

34. The Blessing of the Oriflamme, fol. 73 [pl. 38]

an armed knight mounted on a great horse and carrying a lance from which golden flames emanated like a flaming banner. The emperor recognized the knight as Charlemagne, king of 'France'. He wrote to the pope who enlisted Charlemagne to take his men of arms to the abbey of Saint-Denis where they received this banner from the hand of the abbot in the presence of the twelve peers (who strictly speaking did not exist at that time). Charlemagne vowed to guard and carry this banner and to deliver the Holy Land and Constantinople from the Saracens.

After recounting the legend of the origin of the oriflamme Golein explained its significance, particularly that its red colour signified the blood of Jesus Christ. But Golein supplied a very specific interpretation for the banner that attacks English and German imperial pretensions on the sovereignty of the kingdom of France and presents an argument defending the principle of male succession:

It (ie. the oriflamme) foretold that Charlemagne would be emperor of the Roman people ... and that the imperial insignium would be left in France *in sign of the perpetual empire by succession of male heirs* and not by election as the empire of the Romans of Germany. Also it is better that the emperor of France (who is) anointed with the precious ointment carried from heaven would be more worthy to engender children *having succession as their paternal and God-ordained heritage* [emphasis is mine]:

> The vermeil oriflamme signifies the Son in humanity raised on the Cross
> reddened with his bloodTherefore ... this dignity pertains better to man
> than to woman and ... the king of England, Edward ... is in error for a long
> time, saying that because of his mother he has a right to the kingdom of
> France. He is not well informed on this matter ... [87]

The presence of the blessing of the oriflamme and its illustration thus reinforces themes running through the Coronation Book, the implicit arguments concerning the divinely ordained superiority of the king of France over other rulers as defender of the faith and *rex christianissimus*. At the same time it defends the principle of male succession of the candidate for anointing with the Celestial Balm.

It is also noteworthy that, although the legend of the oriflamme links the banner with the abbey of Saint-Denis, the miniature shows the archbishop of Reims and not the abbot of Saint-Denis, who may perhaps be the prelate of episcopal stature behind the archbishop although the absence of indications in the miniature or text hamper identification. This substitution of the archbishop of Reims in the place of the abbot of Saint-Denis is consistent with other scenes in the miniature cycle in which the presence or participation of the abbot of Saint-Denis is consistently effaced and the archbishop of Reims appears in his stead.[88] As in so many other scenes in the manuscript the archbishop of Reims is given exceptional, and in this case unprecedented, preeminence.

3. The Cathedra Regis and Royal-Episcopal Parallelism.

Several new features in the Ordo of Charles V enlarged upon the traditional episcopal-royal parallelism of the sacre. We have seen that the miniatures illustrate most of the traditional comparisons with the episcopal consecration, but they also illustrate the

innovations in this ordo which strengthen that traditional theme. The result is that in the Coronation Book the episcopal character of the king is developed further and is expressed more comprehensively and with greater clarity than ever before. The liturgical innovations of the Ordo of Charles V exalt the position of the archbishop of Reims in the consecration of the king and queen of France. Even the earlier ordines from the diocese of Reims did not give this degree of prominence to the archbishop of Reims.

A golden seat in the form of a faldstool occupies a central position throughout the cycle of miniatures, appearing in thirteen of the twenty-eight scenes of the king's cycle and six of the eight scenes of the queen's cycle. Central for articulating the episcopal-royal theme, this seat and the ceremony pertaining to it were appropriated directly from the episcopal consecration ceremony, and their introduction into the Ordo of Charles V, as well as into the Ordo of Jeanne de Bourbon, was a decisive elaboration of the traditional royal-episcopal parallelism of the sacre, meant to express the notion that through the sacre king and queen enter into the royal religion.[89]

For the first time in any king-making ritual the Ordo of Charles V introduces two textual references to this seat, both with indications for its significance. The first reference occurs in the rubrics at the beginning of the ordo (fol. 45v) where the seat upon which the king is placed by the two bishops at the beginning of the ceremony is identified as a *cathedra*, the name for the seat of a bishop or archbishop:

> … the aforesaid bishops lead the king who is to be consecrated to be seated in the *cathedra* prepared for him in view of the *cathedra* of the archbishop [*in conspectu cathedrae archiepiscopi*].[90]

The text, therefore, not only introduces an episcopal seat for the king, but also indicates that it is to be placed 'in the view of the cathedra of the archbishop', stressing the resemblance of these chairs through nomenclature and placement, and delineating their physical and spiritual relationship. The miniature illustrating this text shows the bishops of Laon and Beauvais presenting the king to the archbishop of Reims by placing him in this seat (ill. 36). The second textual reference to the seat occurs in the rubrics giving directions for the archbishop to recite the *Te invocamus* which unequivocally declare the episcopal character of the sacre when they instruct the archbishop that he 'must sit as if he is going to consecrate a bishop'.[91]

The miniature illustrating the above passage (pl. 15) underscores the episcopal connotations of the king's cathedra and the ceremony pertaining to it. It depicts the archbishop seated on his cathedra and facing the king who kneels against his cathedra, shown in the illustration to be identical to the archbishop's. These rubrics appear for the first time in a royal consecration ordo. This seat, against which the king kneels throughout the consecration and investiture, is thus identified as a cathedra. Although not specified by the text for the other scenes in which it appears, its presence in those scenes is dictated by these two citations. The text and miniatures of the Ordo of Charles V show that Charles was enthroned twice, first on the cathedra, and then (as was traditional) on the seat on the solium. Furthermore, the text and miniatures disclose the significance of this dual enthronement. The cathedra is the seat of episcopal authority from which a bishop governs, teaches and dis-

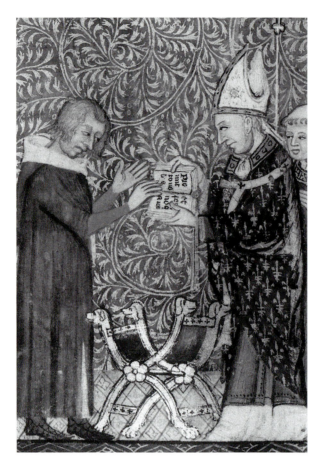

penses justice. With the introduction of the *cathedra regis*, the redactor of the Ordo of Charles V constructs a platform of authority on which the king will operate in the capacity of a teacher and judge who holds episcopal authority.

The introduction of a cathedra for the king (and for the queen, as we will see in the following chapter) is an especially meaningful innovation of the Ordo of Charles V, particularly because this seat plays such a prominent role in the scenes of anointing and investiture. In all of the scenes in which it appears, it is the focal point, a leitmotif that signals the implicit significance of the scene.

At the same time that the text and the miniatures compare the royal cathedra with the archiepiscopal seat, they clearly distinguish it from the king's throne, described in considerable detail in the rubrics at the beginning of the ordo. There, the throne is called a *sedes* 'prepared for the king before the ceremony and placed on the solium', which the miniatures illustrate as an elevated tribune 'erected like a scaffold contiguous to the choir on the right side of the church'. The rubrics further explain that the solium is reached by stairs.[92] Both rubrics and miniatures clearly differentiate between the throne placed on the elevated tribune before the opening of the ceremony (pl. 25, 26), and the king's cathedra (e.g. pl. 15) placed on the floor of the church in front of the altar in view of the archiepiscopal seat. For the first time in king-making liturgy, the king has two ceremonial seats, and the introduction of the *cathedra regis* represents a liturgical, iconographic, and political muta-

130

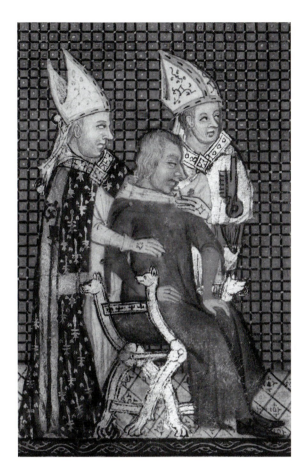

36. The King placed on the *Cathedra*, fol. 47
[detail of pl. 6]

tion which asserts that the seat of episcopal authority has been extended to the king. This seat occupies a central place in the miniature cycle accompanying the successive acts of consecration and investiture in the king's ordo.

In the first illustration in which the cathedra appears, the king is shown taking an oath on a book held over it (ill. 35). The oath sworn by Charles V is essentially that sworn by Charles the Bald and authored by Hincmar of Reims on the model of the oaths sworn by his suffragan bishops before their consecration, with the addition of the phrase on the inalienability of the Crown of France [fol. 46v]. The king's sworn duty to defend the unity and integrity of the domain of the Crown is now combined with the other traditional items of the oath: to defend the privileges of the Church, to protect it from rapacity, to guard the peace of the Christian people, to judge with equity and mercy, to expel heretics. In this scene, Hincmar's successor holds the book over the cathedra, a juxtaposition that highlights the sanctity and the ministerial character of the oath, linking it with his duty to defend the faith.

The illustration in which the king is placed on the cathedra by two bishops (ill. 36) parallels the entry of the bishop-elect who, in the episcopal consecration, is led into the church by two bishops and placed in a cathedra prepared before the ceremony and placed in view of the cathedra of the consecrating archbishop.[93] Following the model of the episcopal ceremony, the Last Capetian Ordo strengthened the episcopal parallelism by having two

131

bishops lead the king into the church and present him to the consecrating archbishop, and the Ordo of Charles V enlarged upon this by having the two bishops place the king in the cathedra at this point.[94]

In the illustration in which the archbishop of Reims prepares the balm for the anointing, the king kneels against the cathedra (ill. 37). This action is not mentioned by the text, but it is comparable to the episcopal consecration in which the bishop-elect kneels against the cathedra as the archbishop-consecrator prepares the unction.[95]

The redactor of the Ordo of Charles V took a bold step to strengthen the royal-episcopal parallelism by introducing into the king-making ritual for the first time the blessing and bestowal of the gloves, a ritual action directly inspired by the recent addition of these rituals in the episcopal consecration in the Pontifical of Durandus.[96] The appropriation of the gloves and the related ritual from the episcopal consecration further reinforced the episcopal character of the king, visually comparing his consecrated hands with those of a bishop. In the miniatures the gloves of king and archbishop are juxtaposed so as to stress their similarity (pls. 19, 20). In the Coronation Book the king's episcopal seat dominates the scenes of the anointing of the hands (pl. 18) and the blessing and delivery of the gloves, acts that parallel the anointing of a bishop's hands and his investiture with blessed gloves.[97]

The presence of the cathedra also expresses the royal-episcopal parallelism in the scenes of the transmission of sceptre and verge (pl. 22), ring (ill. 38) and crown (pl. 23), analogous respectively to the bishop's investiture with baculum and ring, and his crowning with the mitre.[98] At the culmination of the episcopal consecration, the newly-consecrated bishop is enthroned in his cathedra after which the consecrating

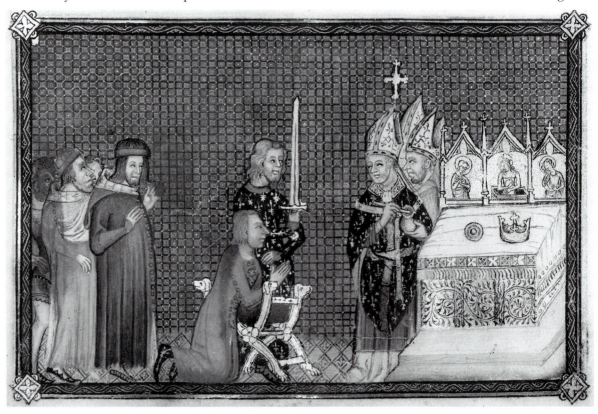

37. The King kneels against the *Cathedra*, fol. 50v [pl. 13]

archbishop bestows on him the kiss of peace and the latter in turn kisses the hand of his consecrator (pl. 27). All of these rituals are in the Ordo of Charles V where they are emphasized by illustrations. Furthermore, like a newly consecrated bishop, the king receives communion in two species during the mass which follows (pl. 28).[99]

Roland Delachenal observed that the ritual of the sword had been separated from the transmission of the other insignia and placed ahead of the anointing (the first instance of such a separation in royal ordines).[100] I would suggest that this was prompted by a desire to separate the king's military and priestly offices, the entire ceremony of the investiture of the sword having been removed from the actions that have sacerdotal significance. The desire to distinguish between the king's priestly and military roles is suggested by the absence of the cathedra from scenes pertaining to the king's military responsibilities. It is absent from the miniature in which the king is shown holding the sword, whereas in the following scene, after the king has passed on the sword to the seneschal, who will bear it for the duration of the ceremony, the king again kneels at his cathedra. The two motifs, cathedra and sword, refer to the king's two roles, his traditional military responsibility to defend the kingdom and the Church, and his ministerial status. We have already noted that the military role of a king would conflict with his sacerdotal and quasi-episcopal character because, strictly speaking, priests have always been forbidden to bear arms. According to Giles of Rome, the sword must be subordinate to the Church as its servant.[101] Indeed, the sword in the feudal system is a sign of subordination to the service of a lord. It is noteworthy that once he was consecrated, Charles V systematically avoided the bearing of arms, something for which he was criticized in some sources. Christine de Pizan praised

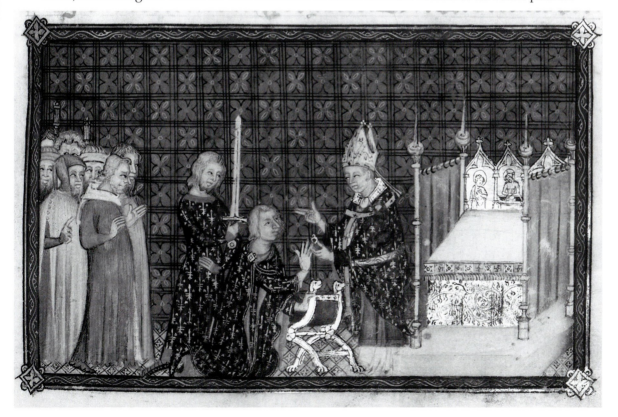

38. The Archbishop of Reims blesses the Ring and places it on the King's Finger, fol. 57 [pl. 21]

Charles's ability as a military strategist, but his military responsibilities were always dele-
gated to an able lieutenant such as Bertrand du Guesclin. This is a plausible explanation
for the relocation of the investiture of the sword to the segment prior to the anointing, thus
separating it from the transmission of insignia pertaining to the king's sacerdotal and min-
isterial status which are bestowed with anointing. It also sheds light on the prominence
given the seneschal throughout the miniatures, for he is mentioned only rarely in the text,
where, furthermore, his role is indicated to be optional (' ... the king gives over his sword
to be borne by the seneschal *if there is one*').[102] The presence of the seneschal who bears the
king's sword for him is a constant reminder throughout the cycle of miniatures of the
king's priestly character and its separation from the military role of a ruler, that responsi-
bility being delegated to a lieutenant.

4. The King's Enthronement on the Cathedra

One miniature merits special attention because it was not inspired by the text. The
miniature following the scene of the imposition of the crown shows the peers sustaining
the crown as the king is seated on the cathedra (ill. 39). This enthronement must not be
confused with the traditional enthronement of the king on the elevated throne on the
solium.[103] After the king is crowned he is enthroned on the cathedra and his crown is
sustained by the peers. This seat is on the ground of the church in front of the altar and is
unmistakably the cathedra against which he knelt for his consecration and investiture.
Consequently the scene represents the king's enthronement on the cathedra and not the
traditional enthronement on the royal throne.

This enthronement is not mentioned in the text of the Ordo of Charles V, nor does it ap-
pear in any previous royal ordo. Instead, the rubrics pertaining to this action in the Ordo of
Charles V call for the king to remain in a kneeling position for the imposition of the crown.
They give no instructions for the king to rise or to be enthroned on the cathedra while the
peers sustain the crown.[104] The introduction of this enthronement for the king owes its in-
spiration to the consecration of a bishop who is enthroned *in cathedra* by the consecrating
archbishop at the completion of the consecration and investiture rituals.[105]

The textual references to the cathedra that were inserted into the beginning of the Ordo
of Charles V set the stage for the appropriation of an episcopal enthronement for the sacre
of Charles V, and according to the pictorial account, if not the text, Charles V was twice en-
throned. His enthronement on the cathedra was the climactic point in the cycle of scenes
that enunciate the episcopal character of the king's anointing. After this enthronement he
journeys to his royal *sedes* (pls. 25, 26; ill. 40) in a ritual called the *sublimatio* in which, as
Golein explained, the king takes leave of the earth and is lifted to a point between heaven
and earth, a position expressive of the spiritual place of the king as intercessor between
God and the people.[106]

Because the cathedra signifies the spiritual and temporal authority of the bishop to rule,
to teach and to judge, the extension of this seat to the king implies that these aspects of
episcopal authority have been extended to Charles V. This would suggest that it gives the
king the authority to speak, to instruct and to judge, particularly in instances concerning

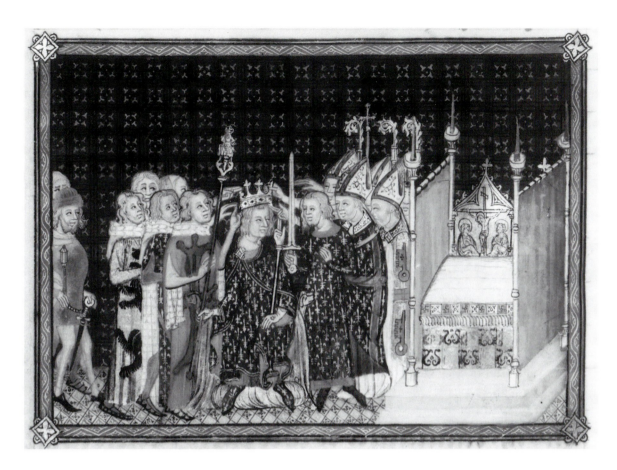

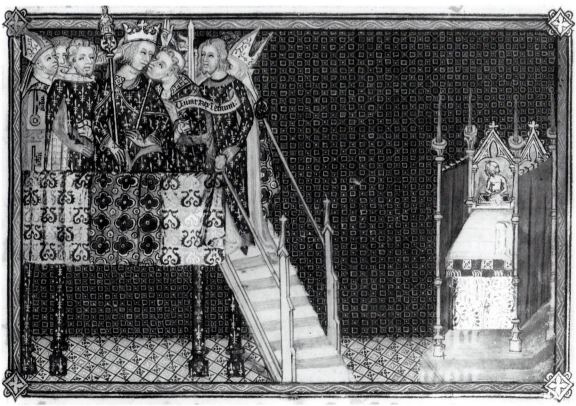

39 *(above)*. The Enthronement of the King on the Cathedra, fol. 59v [pl. 24]
40 *(below)*. The Enthronement on the *Solium* and the Kiss of the Archbishop, fol. 64 [pl. 26]

doctrinal heterodoxy and the king's sworn duty to expel heretics from the kingdom. There are further ramifications, for the king's cathedra is described by text and miniatures as having been placed 'in view of the cathedra of the archbishop', words implying that the archbishop of Reims sits in a position to oversee the king as he does his suffragan bishops. This recalls Hincmar's elaboration of the royal and episcopal consecrations, and especially his introduction of the oath, or *promissio*, into the royal consecration ritual by which he laid the foundation for the authority of the archbishop of Reims to oversee and to judge the Frankish king. The introduction of the *cathedra regis* into the Ordo of Charles V elaborates upon Hincmar's invention.[107]

The formulary for the imposition of the crown (*coronet te Deus corona gloriae*) was first inserted into the royal consecration liturgy by Hincmar for the coronation of Charles the Bald at Metz in 896, and it unequivocally declares that the king of France is crowned by God.[108] Golein confirmed in the *Traité du Sacre* that the archbishop of Reims is a *vicarius Dei* 'when the archbishop comes to the altar the king must rise in respect because he (the archbishop) represents the person of God'.[109] Not only is he *vicarius Dei* in administering the king's oath and the Celestial Balm, but also in his surveillance over the king.

The introduction of the *cathedra regis* seems to address a structural contradiction in the sacre: that the king, anointed by God with the balm sent from heaven, has no superior on earth, yet he must be anointed by the archbishop of Reims who has been chosen by God to mediate in the transmission of the anointing. These conflicting claims make the king at once above his consecrator and also subject to him. Enthroned on a cathedra the king partakes of episcopal authority under the surveillance of the archbishop of Reims. Yet, when the king climbs the solium he rises above the cathedra placed on the ground of the cathedral. On the solium the archbishop places the king on the *sedes*, proclaims the *Vivat rex* and kisses the king while the peers sustain the crown a second time. In these actions the archbishop is one of the peers. The miniature of the enthronement on the solium includes a remarkable detail that is not in the text: the archbishop has removed his mitre and is bare-headed. In medieval vestimentary language an uncovered head signifies homage and submission to a lord. In the rite of homage the candidate comes before his lord with bare head in order to swear his fealty. The same idea also underlies the removal of the king's crown before he kneels to receive the Eucharist. This signifies his homage and submission to Christ as his lord and is the only time that the king appears without head-covering after his consecration. When the king is enthroned on the solium, even the archbishop is subject to the king. The king's two thrones would seem to express a mutuality of submission: although the king has authority in the domain signified by the *cathedra*, he is subject to the archbishop, but the archbishop is subject to the king in the domain signified by the throne on the elevated solium.[110]

5. The Golden Needle

Because the Ordo of Charles V goes beyond any earlier ordo in establishing a comparison between the consecrations of king and bishop, departures from this parallelism, particularly when they occur in the crucial anointing sequence, take on special significance. The most important departure occurs in the central ritual act, the anointing: whereas in the episcopal consecration, the archbishop uses his thumb to anoint a bishop with chrism, the miniatures show the archbishop of Reims using a golden needle or stylus to anoint Charles.

This golden needle is mentioned in the French directory at the beginning of the Coronation Book, so it is not an innovation of the Ordo of Charles V.[111] Although the French translation of the Directory of *c.* 1230 and the text of the Ordo of Charles V call for the archbishop to use the golden needle to extract the Celestial Balm from the Holy Ampulla and to use it to mix the balm with chrism, neither calls for the archbishop to use it to anoint the king as the miniature shows (ill. 41). The French directory is not explicit about how the ointment is to be applied, but the Ordo of Charles V calls for the archbishop to use his finger to mix the balm and to anoint the king, corresponding to the manner that a bishop is anointed.[112] Because the miniature in the Coronation Book departs from the text of the ordo that emphatically expresses parallelism with the episcopal consecration, an explanation is called for.

The use of the golden needle for anointing and mixing the Celestial Balm with chrism eliminates the potential for the archbishop to touch the balm, for had he used his thumb as

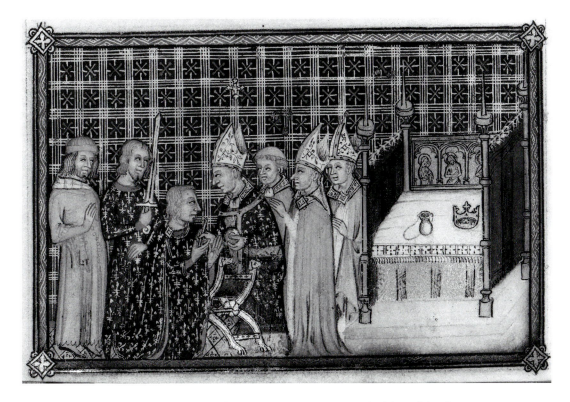

41. The Archbishop of Reims anoints the King's Hands, fol. 55v [pl. 18]

the text indicates, he would inevitably have touched it and the king would not have been the single human to have come into physical contact with this celestial unguent. The use of the golden needle, therefore, both preserves and visibly demonstrates the exclusivity of the king's anointing with this substance. The rubrics suggest this as the reason for the use of the golden needle and emphasize that the king of France is singled out from all the kings of the earth to be anointed with the oil sent from heaven.[113] Golein emphasizes this very notion as the foundation of the title of the king of France as *rex christianissimus* in his treatise. Here he states that the king of France ' … is the most worthy king and most gloriously anointed that no other, and above all others is privileged by divine unction sent from heaven'.[114]

This avoidance of the archbishop's contact with the balm might seem on the face of it to diminish the status of the archbishop of Reims and to contradict the conclusions about his importance in supervising the king. However, the archbishop of Reims is implicitly exalted by the use of the golden needle. For by using it to extract the Celestial Balm from the ampulla sent by God, for mixing the balm with chrism and for anointing, the archbishop of Reims does not intercept or interfere with the transmission of the balm from its celestial source to its royal recipient, and thereby expedites for God this direct anointing. In this way the use of the golden needle throughout the entire anointing procedure underscores the divine origin of the balm and implicitly expresses the unique position of the archbishop of Reims as the divinely designated agent of its transmission. It thus signals his role as *vicarius Dei* in the anointing, and in so doing serves to declare that God is the ultimate consecrator. The role of the archbishop of Reims as *vicarius Dei* is confirmed by Golein's statement that 'when the archbishop comes to the altar the king must rise in respect because he (the archbishop) represents the person of God'.[115]

6. The Miniatures within the Text: A Cycle for the Archbishop of Reims

The location of the miniatures in relation to the text plays an important part in singling out the archbishop of Reims and identifying him as the divinely ordained minister of the Celestial Balm. Indeed the cycle of miniatures in the Coronation Book consists of two orders of illuminations, those located within the rulings for the text and those located in the ample lower margins (see Chapter 5 below).

The majority of the miniatures are located in the lower margins. But a number of illustrations are within the rulings for the body of the text and are thus set apart from the miniatures in the margins. These miniatures assume a priority in relation to the text, not only because of their position within the text, but also because they are bound to it in other ways. Many are preceded and/or followed by rubrics that refer directly to the illustrations; several have objects within the picture that penetrate the frame as if to point to the surrounding text, reinforcing the visual liaison between text and miniature; and several textual miniatures have objects that have been drawn on the horizontal rulings for the lines of text. Because of this concerted effort to anchor these miniatures to the text, they partake of a more integral relationship to the text than do the marginal miniatures. Set

138

apart from the marginal miniatures, they are drawn together as a group and thus assert themselves as a distinct sub-cycle.

The following miniatures, including those which are presumed to have been on the lost folios (see also chapter 5, p. 184), belong to this sub-cycle:

fol. 35 [pl. 1].　The archbishop of Reims blesses the king at the portal of the cathedral of Reims. Frontispiece for the French translation of the Directory of *c.* 1230.

fol. 43 [pl. 2].　The archbishop of Reims blesses the king at the portal of the cathedral of Reims. Frontispiece for the Ordo of Charles V.

fol. 44v [pl. 3].　The bishops of Laon and Beauvais fetch the king at the palace of the archbishop of Reims

missing folio between 48v and 49.

　　　　　　[The blessing of the sword by the archbishop of Reims]

missing folio between 48v and 49

　　　　　　[The archbishop of Reims gives the sword to the king]

missing folio between 53v and 54

　　　　　　[The anointing of the king's head]

missing folio between 53v and 54

　　　　　　[The anointing of the king's breast]

fol. 58 [pl. 22].　The archbishop of Reims invests the king with the sceptre and *main-de-justice*

fol. 59v [pl. 24]. The enthronement of king *in cathedra*

fol.64 [pl. 26].　The enthronement of the king on the solium

fol. 66 [pl. 29].　The entry of the queen into the cathedral and the blessing of the queen by the archbishop of Reims

The coexistence of two orders of miniatures poses the question as to why some miniatures were singled out for special emphasis by their inclusion in this sub-cycle. Some of them could conceivably be a sort of de luxe punctuation, to structure the text by marking the beginning of separate ordines.[116] For example, the first two textual miniatures are frontispieces for the French and the Latin texts respectively, and another marks the beginning of the queen's ordo. But the remainder of textual miniatures appear neither at the beginning of a text, nor at the beginning of a discrete ritual sequence, nor at the beginning of a signature. They form a cluster within signature IV, and the cut-out folios that once had textual illustrations are located in the centre of signatures II and III where they do not mark the beginning of a ritual sequence.

Nor does this sub-cycle of textual illustrations represent a core of traditional coronation illustrations. Like earlier cycles such as that of the Ordo of 1250 (ills. 23–26) and the University of Illinois coronation book (ills. 27, 28), it includes illustrations of the rituals of the delivery of the sword, sceptre, *main-de-justice*, crown, enthronement, and a scene for the queen's ceremony. But this sub-cycle in the Coronation Book differs in significant ways from those earlier cycles. It does not include scenes of such important acts as the anointing of the hands or the arrival of the monks and abbot of Saint-Remi with the Holy Ampulla.

More significantly, the cycle of textual miniatures includes scenes that are unprecedented in king-making rituals such as the fetching of the king in the palace of the archbishop of Reims, the enthronement of the king on the *cathedra*, and the enthronement on the solium.

One of the illustrations within the rulings for the text merits special consideration, not only because it is unprecedented in French royal ordines and their illustrations, but also because it makes an historically specific statement about the role of the archbishop and see of Reims in assuring the succession of Charles V. This is the double scene of the procession of the canons of the cathedral of Reims to the palace of the archbishop of Reims and of the moment when the bishops of Beauvais and Laon lift the king-elect in the grand chamber of the archbishop's palace (ill. 42). As this is one of the illustrations within the body of the text, it has been placed in an especially close relationship with this new text as well as in a place of priority in the pictorial cycle. It illustrates in a literal way the rubric at the beginning of the Ordo of Charles V. Although this rubric reproduces the entire text of the opening rubrics of the Last Capetian Ordo, five sentences have been introduced in the Ordo of Charles V (the first time such wording appears in French royal ordines, including those associated with Reims). The miniature illustrates these last sentences, which are as follows:

> And the canons of the church of Reims must go in procession to the palace of the archbishop with two crucifixes, candles, thurible with incense. And the bishops of Laon and Beauvais, who are the first of the episcopal peers, must be in the said procession having the relics of saints hanging from their necks. And in the *thalamus* they should find the prince who is to be consecrated in the kingship sitting, as if on a thalamus befittingly ordered [*ordinatum*] … [117]

The text then calls for the bishop of Laon to say over the prince the prayer *Omnipotens sempiterne deus: qui famulum tuum* … for which the rubric continues thus:

> The two aforesaid bishops take him up on the left and the right and lead him honorifically into the church singing the prescribed prayer [*Ecce mitto angelum meum qui precedat te*] along with the aforesaid canons. [118]

This elaborate ceremony for the fetching of the king in a thalamus in the palace of the archbishop of Reims is an innovation of the Ordo of Charles V. There is, however, a partial precedent for it in the Ordo of Mainz, which introduced a comparable ritual at the beginning of the ceremony. These elements refer back to the Pontifical of Mainz which similarly used the term 'thalamus' for the chamber where the bishops took up the king-elect.[119] As in the German ceremony the word makes a direct reference to the medieval marriage ceremony which included the blessing of the nuptial thalamus (*Benedictio thalami*).[120] In using this term the sacre is presented as a nuptial alliance between the king and the Church. The Ordo of Mainz is analogous with the Ordo of Charles V in the following details: the king is taken up in a thalamus by two bishops with relics hanging around their necks, who accompany him honorifically from there and lead him to the church while they recite the prayers *Omnipotens sempiterne deus, qui famulum tuum, Ecce mitto angelum meum* … and *Israel, si me audieris* … [121]

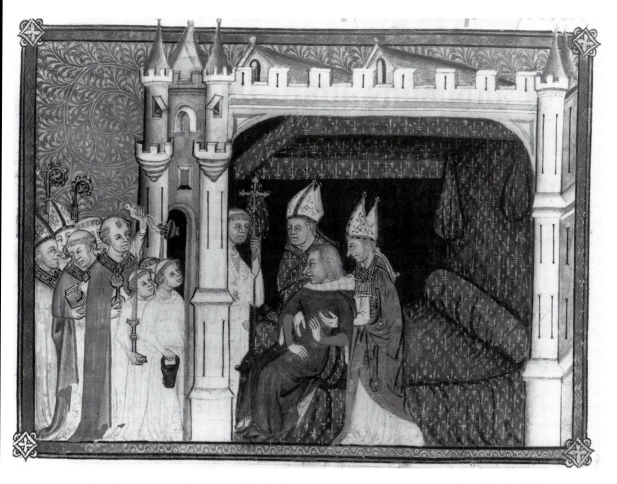

42. The Procession of the Canons and the Raising of the King in the Archbishop's Palace, fol. 44v [pl.3]

But the Pontifical of Mainz did not specify a palace, and for obvious reasons did not mention that of the archbishop of Reims, nor did it mention the bishops of Laon and Beauvais, nor a procession of the canons of the church of Reims. These elements were added by the redactor of the Ordo of Charles V, and their introduction into the text and miniatures places extraordinary emphasis upon the metropolitan church of Reims and its prelate. The earlier French ordines specified 'a procession of canons of the mother church',[122] but they did not call for the procession to go to the palace of the archbishop of Reims, nor did they have the king taken up in the thalamus in that palace. The miniatures of the Ordo of 1250 include a scene of the king and queen in procession after their sacre from the portal of the cathedral to a *'palais'*, and it is reasonable to conclude that this palace was meant to represent the archiepiscopal palace at Reims and not a palace in Paris or else-where, because it appears immediately after the sacre and its placement in the miniature suggests a close physical proximity between the cathedral and the palace. Instead, the Last Capetian Ordo and the French directory at the beginning of the Coronation Book call for the king to make a night vigil in the church. Following the Last Capetian Ordo, the open-ing rubrics of the Ordo of Charles V specify a night vigil before the ritual fetching of the king at the archiepiscopal palace, although this night vigil is not illustrated.

141

The Ordo of Charles V, text and miniatures alike, also gives unprecedented importance to the canons of the cathedral of Reims. The Directory of *c.* 1230 had introduced the canons where it specified that 'the day that the king is to be crowned he must be received by a procession of the canons of the mother church and the other conventual churches'. It also called for the presence of the 'canons and the clergy of the church' at the beginning of the ceremony, before the arrival of the procession from the abbey of Saint-Remi. The Ordo of Charles V is more precise in calling for the canons of the 'see of Reims to go in procession … to the *archiepiscopal palace* along with the bishops of Laon and Beauvais who are the first peers'. The first three textual illustrations include figures of the clergy of the cathedral of Reims. The Ordo of Charles V and the Coronation Book thus give increased emphasis to the church of Reims by recognizing the separate clerical groups belonging to that church, with the cathedral clergy given priority over the monastic clergy of Saint-Remi.

Also new is the passage of the text calling for the bishops of Laon and Beauvais to lift the king from the thalamus. Laon and Beauvais were suffragans of the metropolitan see of Reims. The scene gives exceptional prominence to the bishop of Beauvais who is identified by a detailed facial likeness and the armorials of his see on his cope (or, a cross between four keys paleways, wards in chief, gules). Beauvais is placed in front of the bed and it is he who is actually lifting Charles out of the bed. This is clearly a special tribute to the bishop of Beauvais, Jean de Dormans, who had served Charles since 1357 as his chancellor for Normandy and the Dauphiné and while Charles was regent.[123] Dormans was Charles's most trusted counsellor and political strategist. Named chancellor to the dauphin in 1355 he served Charles until his death in 1373. Originating from the village of Dormans in Champagne, the family had been in royal service since the reign of Philip the Fair whose queen was countess of Champagne. Dormans' father was a Procurer of Parliament and a chamberlain of Philip VI who endowed a chapel dedicated to St Louis in the parish church of Dormans. Both Jean and his brother Guillaume had received law degrees from the University of Orléans, as had members of their family for more than a century. The brothers were lawyers in the Parliament in Paris and they were legal advisors to Louis, duke of Orléans, the city of Reims, the counts of Clermont and cardinal Gui de Boulogne, the powerful member of the papal curia at Avignon.[124] It was probably through the latter that Jean de Dormans became the legal advisor of John the Good, whose second wife, Jeanne de Boulogne, was the cardinal's niece. John the Good ennobled Guillaume in 1351. It was due to these Avignon connections that Dormans received the bishopric of Beauvais and was later named cardinal. Many papal letters addressed to him witness his central position in the counsel of Charles V. His continued association with Jean de Craon is witnessed not only by their frequent collaboration in the royal council and in the Estates, but also by the personal detail in the last will and testament of Craon where he left his 'beautiful mitre' to Jean de Dormans.[125] Certainly his personal guidance of the prince's public career is honoured in this miniature that presents him as an intermediary between the house of the archbishop of Reims and Charles. It was probably through Dormans that the archbishop of Reims had the king '*in conspectu cathedrae archiepiscopi'*.

The bishop of Laon was Geoffroy Le Meingre, who, along with Dormans and Jean de Craon served as a counsellor of the Dauphin shortly before and after his accession. He was

the brother of Jean Le Meingre, better known as the maréchal de Boucicaut. The brothers originated from the Touraine, and Boucicaut had served John II in the south west of France, and later negotiated with the English on several occasions. Geoffroy replaced the previous bishop of Laon, Robert Le Coq, who had been exiled to the Spanish territories of the king of Navarre for his part in the uprising of Etienne Marcel.[126]

Placing the king in the palace of the archbishop, on the eve of the sacre, stages the beginning of the consecration ritual in the household of the archbishop of Reims, giving him greater prominence than in any earlier ordo, and signalling at the very start the central role of the archbishop of Reims in this ceremony. The text uses the word thalamus that compares the king to a bridegroom. Because this is the house of the consecrating archbishop, the king is also shown to be a bridegroom in the manner of an episcopal ordinand who is the bridegroom of the Church at his episcopal consecration.[127] At the same time, introducing the canons of Reims into this procession gives increased recognition to the clergy of the cathedral of Notre Dame of Reims.

All of the illustrations in this sub-cycle enunciate specific prerogatives of the archbishop of Reims in the making of the king and queen of France. Each scene of the cycle within the rulings of the margins centres upon a special claim of the archbishop. For example, the scene of the new ritual of the enthronement of the king *in cathedra* is amongst the textual miniatures. Both the French and the Latin texts begin with a separate illustration of the blessing of the king by the archbishop at the portal of the cathedral of Reims (pls. 1, 2). These two scenes simultaneously emphasize the importance of the archbishop, the cathedral, and the chapter of Reims, as well as the monks and abbot of Saint-Remi, for the blessing of the candidate for consecration. The scene of the blessing of the king by the archbishop of Reims at the portal of the cathedral of Reims has been given double emphasis by its repetition in the cycle and by the large size of these miniatures. These two scenes show the archbishop of Reims blessing the king, underlining the importance of the archbishop for the ceremony and asserting that he has a special authority to sanction the candidate for anointing by his blessing.

In one respect this sub-cycle affirms the pretensions of the archbishop of Reims against those of the archbishop of Sens and the abbots of Saint-Denis and Saint-Remi. Prior to the Directory of *c.* 1230, Reims did not have a monopoly on the sacre. Michel Bur has shown that from 1223 until 1825 twenty-five out of twenty-seven sacres took place in the cathedral of Reims, celebrated by the archbishop of Reims. Before that period, from 848 until 1017, the archbishop of Reims presided over only eight of thirteen sacres while the archbishop of Sens presided over the remaining five. Three sacres were performed in the province of the archbishop of Sens and ten in the province of Reims, but none took place in the cathedral of Reims. Those that took place in Reims were performed at the abbey of Saint-Remi. The palatine chapel in Compiègne, built by Charles the Bald, was the site of four sacres. The cathedral of Orléans was twice the site of a sacre. And the cathedrals of Saint-Médard at Soissons, Laon, and Noyon each hosted a sacre.[128] Some of the early Capetians were crowned by the archbishop of Sens who was the primate of France.[129]

Throughout the eleventh century the archbishops of Sens and Reims were in competi-

tion to consecrate the king of France.[130] Between 1027 and 1179 the Capetians were anointed five times at Reims and once at Orléans.[131]

While the miniature cycle as a whole emphasizes the Celestial Balm, it also obscures the importance of some of the other bishops and archbishops of France as well as the abbot and monks of Saint-Remi, who are not given an entire scene as they had been in the Pontifical of Châlons-sur-Marne (ill. 24). Instead, in the marginal miniature of the arrival of the Celestial Balm (pl. 4), the abbot and monks of Saint-Remi have been pushed to the left side, while the centre of the miniature is dominated by the archbishop of Reims, his suffragans and the clergy of the cathedral. The effort made in the sub-cycle of miniatures within the text to associate the archbishop of Reims with the investiture of the regalia seems especially directed at the claims of the abbey of Saint-Denis to special rights to the safekeeping and investiture of the regalia, including the sword, sceptre, main-de-justice, and throne, all included in this sub-cycle. A forged charter purporting to have been authored by Charlemagne was submitted by the abbey of Saint-Denis to affirm that the successors of the kings of France could not be crowned elsewhere but at the abbey of Saint-Denis by the abbot of Saint-Denis.[132] This forgery guaranteed the abbey the right to guard the regalia. Jackson has shown that the three French ordines, all dating from the reign of St Louis, respond to these pretensions by emphasizing the unique powers of the Celestial Balm in the Holy Ampulla, thereby strengthening the claims of Reims. It is interesting that in this sub-cycle all of the scenes of the transmission of the Holy Ampulla are marginal miniatures. This recognizes the unique king-making powers of the Celestial Balm, but gives priority to the actions of the archbishop of Reims, while putting the abbot and monks of Saint-Remi in a secondary position. In addition, the abbey of Saint-Denis had been a traditional site for the sacring of the queen by the archbishop of Sens.[133] Jeanne de Bourbon was a notable exception, the last queen to be consecrated at Reims. The first miniature of the queen's ceremony (pl. 29) has been singled out for inclusion in this sub-cycle, and in the context of the other scenes of this cycle, the queen's entry into the cathedral of Reims and her presentation to the archbishop should be understood as an assertion of the prerogative of the archbishop of Reims to consecrate the queen of France.

The manner in which the miniatures of this sub-cycle have been integrated into the text connects them not only to each other, but also to the archbishop of Reims. The existence of such a sub-cycle thus plays a key role in affirming the relationship of the archbishop of Reims to the Ordo of Charles V; it asserts the pre-eminence of the archbishop of Reims over the other prelates, including the archbishop of Sens and the abbot of Saint-Denis who claimed special jurisdiction over the investiture of the regalia and the anointing of the queen; and it makes an important contribution to the comprehensive iconographic programme of the Coronation Book as a whole, which exalts the priority of the archbishop of Reims in the making of the king and queen of France.

7. The Archbishop of Reims, Jean de Craon and the Coronation of Charles V

The pre-eminence of the archbishop and the episcopal see of Reims is the centre-piece of the innovations of the Ordo of Charles V and its miniature cycle. The archives of the city of

Reims show that the archbishop of Reims was held responsible for the expenses of the sacre, a concrete fact that demonstrates the archbishop's economic importance for the ritual.[134] Although the three previous French sacring rituals emphasize the Celestial Balm and the abbot and monks of Saint-Remi, it is the Ordo of Charles V, especially through its pictorial cycle in the Coronation Book, that goes beyond all previous ordines to celebrate the unique and extensive king-making powers of the archbishop of Reims. The Coronation Book is in many respects the book of the archbishop of Reims: it derives from several earlier compilations of the Pontifical of Reims; it glorifies the special powers of the Celestial Balm preserved at Reims; it includes the liturgical reforms of Hincmar of Reims; its text assigns a central role to the archbishop by placing the king's cathedra in his view; and it calls for the archbishop of Reims, alone, to anoint the king, to place the crown on his head, and to pronounce the *Vivat rex.*

The miniatures, as we have seen, award particular emphasis to the archbishop of Reims. Indeed he appears in thirty-seven of them, whereas the king appears in twenty-seven, and the queen merely in nine. He even appears in scenes which do not require his presence: the removal of the king's cloak (pl. 7), the great chamberlain of France putting on the king's shoes (pl. 8), the duke of Burgundy putting on the king's golden spurs (ill. 43), the king vested in the royal tunic and mantle by the chamberlain of France (pl. 17), and the opening of the queen's robe for the anointing (pl. 31). Identified by portraiture and armorials, he usually occupies the centre field of the miniature, and with the exception of the scene in which he bestows the kiss on the king, he is the tallest figure in the compositions. In the majority of the scenes he is the only member of the clergy who has

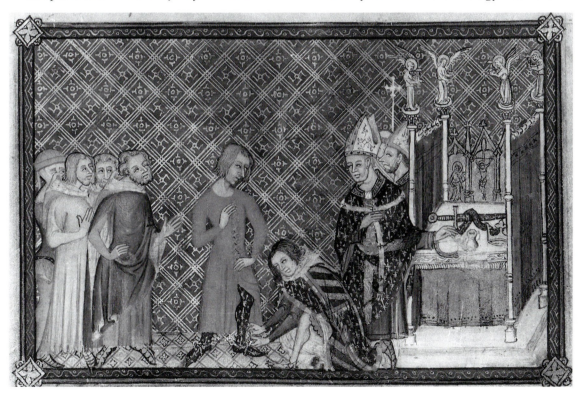

43. The Duke of Burgundy vests the King with the Spurs, fol. 48v [pl. 9]

been identified. This prominence is not entirely justified by the text that follows earlier French ordines, also associated with Reims, in which the bishops of Laon and Beauvais are identified as the 'first of the clerical peers', followed by the bishops of Langres and Châlons whose roles in this manuscript have been entirely suppressed in the miniatures although mentioned by the text.[135]

The fact that the archbishop of Reims is accorded such importance in the sacre of Charles V, and that he has been identified personally in the miniatures, indicates that both the individual and the office are of significance. Placing Charles V in the chamber at the palace of the archbishop of Reims thus refers to the strategic role played by Jean de Craon in bringing about the succession of Charles V. Jean Golein singled out Jean de Craon by name in the opening paragraph of the *Traité du Sacre*, emphasizing that it was he who consecrated the king of France on the feast of the Holy Trinity, and that the sacre was carried out according to the ordinance in the Pontifical of Reims, a point which he reiterates throughout.[136]

Jean de Craon was a member of a great aristocratic family of Anjou.[137] Not only was he related to the counts of Flanders, but he was also a cousin of the Valois kings of France and of the king of England for whom his father, Amaury III de Craon, had served as seneschal of Aquitaine before he turned to support the Valois. In letters that survive, Charles referred to the archbishop of Reims as his beloved cousin.[138] The archbishop's brother Guillaume de Craon was lieutenant of John the Good in Normandy, Anjou, and Maine. He fought at John's side at Poitiers, where he was captured and held hostage in England.[139] Jean de Craon was also a cousin of Jeanne de Bourbon and of Charles IV of Luxembourg, the Emperor of the Romans.[140] He had family ties to the house of Châtillon and was, therefore, a relative of Charles of Blois, the duke of Brittany whose daughter, Marie de Blois, was the wife of Louis duke of Anjou, who appears so prominently throughout the miniatures bearing the king's sword in the role of seneschal.[141] As Charles did not have an heir at this time, Anjou was the heir apparent at the sacre.

Jean de Craon was connected with Pope Clement VI, whose support was as important for his rise in the ecclesiastical hierarchy as it was for the marriage of Charles V and Jeanne de Bourbon, since Clement VI named Jean de Craon bishop of le Mans in 1348. Both Jean de Craon and Clement VI were counsellors of successive Valois kings from Philip VI on, and both were ardent supporters of the Valois cause.[142] At the time of the war with England in 1355, when his cousin Edward III was besieging France, Jean de Craon was chosen as the orator for the clergy at the Estates, and he was a member of the counsel of John the Good[143]; and after John was imprisoned in England, he was a counsellor of the dauphin,[144] supporting the prince in a time of great personal difficulty.[145] The dauphin was at Jean de Craon's side when the archbishop needed his support in his contest with the bourgeoisie of Reims and in the wake of the siege of Reims by Edward III. Indeed Jean de Craon was an outsider who had been given the episcopal see of Reims by the papacy, and the aid of the Valois and the papacy were vital for his continued survival against the often vehement opposition which he met from the regional aristocracy and the bourgeoisie, many of whom had sons who were amongst the clergy of the cathedral. A letter from the dauphin dated 12 January 1361 in the archives of the city of Reims documents a visit of the dauphin to Reims

in an effort to persuade the inhabitants of the city to concede to the demands of 'our very dear and beloved cousin, the archbishop of Reims'.[146] Upon learning of their refusal, the prince is recorded as having protested on the grounds that they 'had little knowledge of his person … who was the first born son of the king and (his) heir'.[147] On the following day the bourgeoisie of Reims submitted to the prince on the grounds 'that the descent touches the right of the heritage of the king … as his right and heritage are yours (the dauphin's) as his first born son to succeed to the Crown of France'.[148] Both Delachenal and Cazelles cite this event as the earliest recorded public declaration made by the prince of his right to inherit the throne on the principle of succession through primogeniture; and it is the earliest public recognition given by any political body of the prince's right to succeed as the first born son of the king of France. Surely the miniature of the king in the archbishop's palace and the prominence of the archbishop of Reims throughout the cycle are a tribute to the archbishop of Reims's support for the dauphin in the years prior to his sacre, when he was engaged in the struggle to assert his rights to succeed to the throne of France against the claims of the kings of England and Navarre and their factions in France.[149] This emphasis upon the see of Reims also acknowledges the loyal role which was played by the secular and clerical segments of the city in supporting Charles to chart the troubled waters which he had to navigate from Poitiers to his sacre in Reims. It is fair to say that without Reims, its archbishop, clergy and bourgeoisie, things would have turned out very differently.

8. The Redactors of the Ordo of Charles V

Who compiled the Ordo of Charles V? In view of his authorship of the *Traité du Sacre* and his commentary on the Pontifical of Durandus, Jean Golein would seem to be a plausible candidate. For this Traité shows its author to be profoundly informed sbout the symbolism and ideology of the sacre, an expert on all the issues connected with it. Yet there are a few curious discrepancies between the *Traité* and the ordo that are perplexing. For example, in the *Traité* Golein stated that the Te Deum was sung at the beginning of the ceremony, whereas in the ordo it is sung not there, but at the end of the ceremony, after the enthronement on the solium and the recitation of the *Sta et retine*. This is an important detail and it is troubling that this might have been forgotten by the redactor of this ordo. Furthermore, Golein's list of peers differs slightly from that in the Ordo of Charles V.

Although the identity of the redactor is not known, there are numerous clues in the ordo itself. Clearly, the author was an expert in liturgy who was versed in the consecration liturgy, not only of priests and bishops, but also of nuns and abbesses, as we will see in the following chapter on the queen's ordo. Golein was the recognized specialist in liturgy and theology at the court of France, as evidenced by his translation and commentary for Charles V of the Pontifical of Durandus. But at the same time the redactor was conversant with the royal consecration liturgies of France, imperial Germany, Rome, and England. In the selection and arrangement of the components, the redactor demonstrated extensive knowledge of history, including liturgical history. This knowledge presupposes that the editor had access to collections of royal and ecclesiastical manuscripts, but also, more specifically, that he had access to the books of the royal library of the kings of France, as sug-

gested by his consultation of the illustrated copy of the Ordo of 1250 that was in the library of Charles V. The redactor was clearly a partisan of the cathedral, canons and archbishop of Reims who was well-versed in the intricacies of the pontifical of the archbishop of Reims. This makes Golein a somewhat less likely candidate, although he does emphasize the importance of the Pontifical of Reims in his *Traité* despite his lack of connection with that episcopal see. It also appears that the redactor knew the royal liturgy of England, most probably through the collection of the chapter of the cathedral of Rouen. Golein was born near Rouen where he entered the Carmelite order before going to the University of Paris where he received a degree in theology in 1361 or 1362.[150] His first translation for Charles V was that which he made in 1369 of a collection of the works of the inquisitor of the Albigensians, Bernard Gui, the original copy of which is illustrated by the Master of the Coronation Book (ill. 73).

The importance of Reims is overriding and compelling, and there is yet a further way in which the see of Reims is honoured: the canons of Reims are given unprecedented prominence in the miniatures, which may have been intended to do more than merely emphasize the metropolitan see of Reims and its archbishop. Among the canons of Reims at the time was Guillaume de Machaut, who was directly involved with the events surrounding the dauphin's first public declaration of his rights to succeed. The profile of the redactor that is revealed by the assembled rituals and formularies of the Ordo of Charles V bears some remarkable coincidences with the *curriculum vitae* of Guillaume de Machaut, who had close ties with the family of the king and queen: he had been the secretary of Charles's maternal grandfather, John the Blind of Bohemia, who was married to Beatrix de Bourbon, the aunt of Jeanne de Bourbon; and he became the librarian to their daughter, Bonne of Luxembourg, whom he followed to the court of France upon her marriage to John the Good.[151] As librarian to John of Bohemia he is likely to have had first-hand knowledge of German imperial ritual and of manuscripts in the collection of the Luxembourg descendants of the Carolingian kings. During his service to this imperial family it is fair to suppose that he would have become acquainted with Carolingian history and also, no doubt, German imperial coronation liturgy. It can be assumed that Machaut would have been familiar with French court ceremony because John the Blind was often at the court in Paris. Bibliophile and librarian by profession, he would have had access to the royal library, an assumption that also applies for the library of the cathedral of Reims where he was a canon in the years before the sacre of Charles V. He is likely also to have had access to the library of the cathedral of Rouen where he served Bonne of Luxembourg as her librarian.

After Bonne's death, Machaut joined the faction opposing the Valois to support Charles of Navarre, whom he praised in verse and song. However, following Navarre's part in the brutal murder of Charles d'Espagne, he abandoned the cause of Navarre to become one of the first to support the dauphin in his struggle to succeed. The aforementioned document from the archives of Reims mentions that the prince stayed in the house of Guillaume de Machaut in Reims in 1361 on the very occasion that Charles made the first public assertion of his right to succeed as the eldest son of the king of France.[152] Machaut was instrumental as an intermediary in reconciling the opposing factions in this incident. As a member of an aristocratic family of Champagne that rose to prominence in the service of St Louis, his

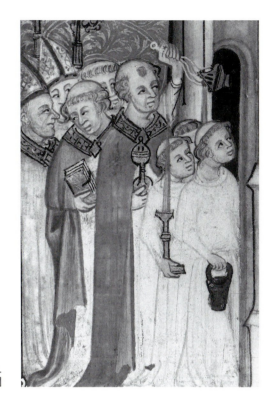

44. Guillaume de Machaut (?).
Detail of fol. 44v [pl. 3]

profile is characteristic of aristocratic sons who received cathedral prebends. The documents cited above reveal Machaut interceding with the bourgeoisie of Reims on behalf of the archbishop. It is tempting to ask whether the canon of Reims who appears prominently in the first miniatures carrying a book (ill. 44) might not represent Guillaume de Machaut, the canon who supported the dauphin in his campaign to succeed.

Besides poetry and secular music, Machaut wrote a beautiful polyphonic Mass that still survives, considered by some experts to be a mass for a coronation. Because he was a cleric, he would have known the liturgy of ecclesiastical consecrations, and the existence of this polyphonic Mass testifies to his expertise and creative involvement in ceremonial liturgy of a grand scale, even if it cannot be proven that it was written for a sacre. Machaut mentioned the coronation of Charles V in his poem *Prise d'Alexandrie* suggesting that he was present at that event.[153] His writings testify to his knowledge of history. He was involved with illustrated manuscripts and has been shown to have directed artists in the illustrations of his own works. If these observations are insufficient to prove that Guillaume de Machaut compiled the Ordo of Charles V, there is another point that ties Machaut to the Coronation Book, for the Master of the Coronation Book worked in the early stages of his career illustrating the de luxe edition of the works of Guillaume de Machaut, a volume made during the life of the poet and almost certainly under his direction (ill. 72).[154] If the figure carrying the book in the procession of the canons of Reims (ill. 44) is indeed Machaut, then the scene may have been intended as a signature, affirming Machaut's association with the kingship of Charles V, and possibly also with the compilation of the text and the formulation of the pictorial cycle.

149

Certain aspects nevertheless remain outside the expertise of Machaut, raising the question of whether the ordo might not have been a collaborative effort. For the Ordo of Charles V includes several subtleties that strengthen its legal implications, particularly with the introduction into the oath of the clause concerning the inalienability of the Crown. This clause was the master-stroke of a legal strategist. The career of Jean de Dormans presents a configuration of activity that coincides with the political ideology that is advanced in the Coronation Book, so that he may well have been involved with its compilation, particularly in introducing a few turns of phrase that were later used by Dormans and Charles as legal traps to ensnare their opponents. These insertions were introduced by a legal strategist who understood the implications they would have in the future.[155]

As a native of Champagne and protégé of Jean de Craon, as a bishop, as lawyer to John the Good, and as chancellor of the duke of Normandy, Dormans would have had access to most of the manuscript sources cited for Machaut (with the exception of the German imperial sources). Above all, he was the architect of Charles's strategy to define the sovereignty of the Crown of France.[156] He is identified specifically in six scenes, and it seems significant that, besides the scene of the raising of Charles in the palace of the archbishop, Dormans is identified in most of the scenes concerning the ritual of the crown: the coronation of Charles, the enthronement *in cathedra* with the sustaining of the crown by the peers, the climbing of the solium where the king is enthroned and the crown sustained by the peers, and the sustaining of the queen's crown. Below we will consider the connection between Dormans and Charles's first charter issued after his sacre, namely that by declaring the inalienability of the Hôtel St-Pol as a possession of the Crown, illustrated by the Master of the Coronation Book (see ill. 82).[157] Evidence to be considered in the epilogue will reveal a meaningful convergence between Jean de Dormans and the formulation of the sovereignty of the Crown. All things considered, I would suggest that the Ordo of Charles V was a collaborative effort between a theologian (Golein), a liturgist (Machaut), a legist (Dormans), and an artist (Master of the Coronation Book.)

In summary, the redactors of the Ordo of Charles V constructed the core of this compilation by combining the principal elements of the three French ordines from the reign of St Louis: the Directory made at Reims *c.* 1230, the Ordo of 1250, and the Last Capetian Ordo, dated by Jackson to *c.* 1270. It emphasized the lineage of Charles and Jeanne de Bourbon with the sainted *genus* of St Louis and the continuity between the last Capetian successors of St Louis and the Valois. This French foundation was supplemented with elements chosen from an array of sources including the Pontifical of Durandus, the Pontifical of Mainz, the Ratold Ordo, and the Protocols of Hincmar, so that the result was an ordo unprecedented and unsurpassed for its comprehensiveness, internationalism and historical specificity.

In his *Traité du Sacre* Golein affirmed that the right to the throne of France belonged to the male heir who was nearest in direct descent from the king. He reminded his readers that the prayer *Sta et retine* was recited at the sacre of Charles V, and he repeated the essential lines of that prayer which acclaim the hereditary succession from father to the eldest son.[158] Golein developed this theme by recalling a general Church council that took place after Charlemagne's victory over the Saracens which

instituted that election of the pope pertained to cardinals, election of the emperor to the nobles of Germany, and the kingdom of France remained to the kings of France descending in the holy and sacred line by male heir, so that this blessing remained in transfusion from one to the other.[159]

The editor of the ordo was governed in his choice of formulae and rituals by a desire to affirm the principle of the hereditary succession of the throne of France, to reinforce the episcopal character of the king of France, and to assert the priority of the archbishop of Reims in the making of the king of France (see ill. 45). No previous king of France was as comprehensively anointed and invested as Charles V. By reinforcing the sacerdotal and episcopal character of this anointing, the redactors strengthened the authority of this king's consecration and at the same time defended its claim to indelibility as a sacerdotal and episcopal consecration. By placing the king *in cathedra* the editor of the ordo laid the groundwork for placing the king above the challenge of any secular power. The powers of the archbishop of Reims had reached their summit with the Coronation Book.

However, the full import of the Ordo of Charles V cannot be fully understood without a consideration of the ordo for the consecration of the queen that follows it. In the next chapter we will see that the Ordo of Jeanne de Bourbon was vital for developing the major themes of the Ordo of Charles V. No king's ordo had ever been so conditioned and qualified by an accompanying queen's ordo.

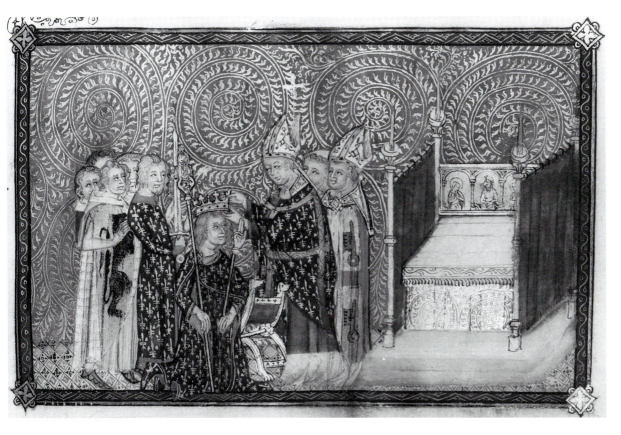

45. The Crown placed on the King's head, fol. 59 [pl. 23]

bent iterum hndem barones reducere sciam
ampullam usqz ad sciam temigum honorifice
et secure. et eam restituere loco suo.

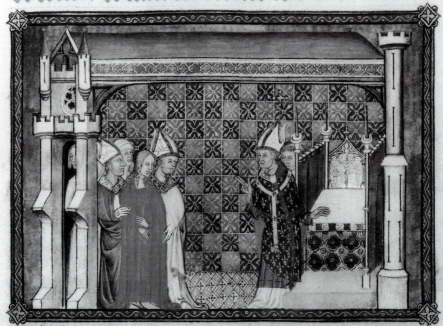

Ordo ad reginam benedicendam que
debet consecrari statim post factam
consecrationem regis. debet ei para
ri solium i modium soly regis. debet tamen a
liquantulum minus ee. debet aute regina ad
duci a dnobz epis in ecciam. et rex in suo so
lio sedere. in omnibz ornamentis suis regys

46. The Queen's Entry into the Cathedral, fol. 66 [pl. 29]

Chapter 4. The Ordo of Jeanne de Bourbon and the Ministerium of the Queen of France

MEDIEVAL QUEENS have fuelled the popular imagination and excited the interest of scholars. Some are remembered as saints and some as Jezebels, but beyond the biases of convention and stereotypes lies a long roster of royal women who distinguished themselves by their political achievements and their capacity to wield power in spite of the considerable restraints that were imposed upon them by virtue of their gender. Among the most memorable one might mention queens such as Balthild,[1] Judith,[2] Melisende of Jerusalem,[3] Matilda 'the Empress',[4] Eleanor of Aquitaine,[5] Eleanor of Castille,[6] or Blanche of Castille.[7]

Recent scholarship has advanced our understanding of queenship within the system of medieval monarchy.[8] The road to queenship was different from that which brought a king to the throne, for only in a few exceptional cases did a queen inherit her position.[9] A daughter of a ruling monarch was not designated from birth for queenship. In a certain sense a queen was elected, though not by the people or the magnates and peers, but by the king or the king's family, usually in consultation with royal counsellors.[10] Nevertheless, the queen's heredity was not entirely irrelevant, for although not required to be of direct royal descent, she had to be of noble and distinguished lineage, worthy of the dignity and responsibility, most particularly, to bear an heir.[11] Almost without exception a woman was chosen, not for beauty or love, but rather for the advantages that she would bring to the king and kingdom.[12] These might be land, monetary wealth, favourable political alliances, or symbolic prestige, as, for example, descent from an especially noble or sainted progenitor such as Charlemagne or St Louis. Jeanne de Bourbon brought all of these — lineage, wealth, political alliances, and sainted blood — to her marriage to Charles V (see Genealogical Chart, pp. 20–21, and chapter 1).

A medieval queen was much more than the 'king's wife'.[12] Never merely a private affair between a man and a woman, a royal marriage was a matter of state which, as a rule, produced an alliance with another kingdom or an apanage. If a royal marriage could construct peace and social order, it could also sow the seeds of catastrophe.[13] In attempting to seal a peace with England, Philip the Fair could not have anticipated the eventual outcome of the marriage of his daughter Isabel to Edward II.[14]

The responsibilities of a queen were often ponderous. It was in her interest to ensure diplomatic relationships between her own family and that of her spouse, and because of the political importance of the respective families this duty was almost always a matter of state. Queens were instrumental in arranging royal marriages that would be advantageous for the family and the kingdom. They conducted diplomacy with prelates of the Church (who were often close relatives) and many queens made substantial donations to ecclesiastical foundations. They administered the finances and affairs, not only of the royal household, but also of their often extensive personal territorial holdings. Capetian queens of the twelfth century assumed official functions, sitting as members of the *curia*

regis and sharing in the decision-making of government. One queen in particular, Blanche of Castille, exercised considerable political and judicial authority as regent.[15]

Some queens were called upon to govern the realm in the event of the king's absence or early death. Shortly before his death, Louis VIII designated Blanche of Castille to administer the realm as regent until their son Louis IX was capable of taking the reins of government himself. She was not only the guardian of the royal children, responsible for their welfare and education, but was invested with full judicial authority. After he reached maturity Louis IX transferred full authority to Blanche who was to govern in his stead when he departed on crusade.[16] It might also be said that Blanche charted her son's course to sainthood.

Jeanne de Bourgogne, the first wife of Philip VI Valois, was especially active and visible in governing the realm.[17] Jeanne was her husband's most trusted confidant and advisor whom he designated to govern the realm while he conducted his wars. Jeanne was invested with judicial authority, and she had full responsibility for raising the finances to support Philip's military campaigns. According to André Poulet no king had ever before put so much authority into the hands of a queen.[18] The grandmother of Charles V, Jeanne was an educated woman who took an active interest in sponsoring translations of the Bible and historical compendia. Jean de Vignay, who was in her service as a translator, dedicated his translation of Vincent of Beauvais' *Miroir Historial* to her, and among the numerous translations that she commissioned was a French translation of the *Bible Historiale*.[19] Jeanne's correspondence with popes John XXII, Benedict XII and Clement VI reveals the workings of a skilled diplomat with an astute political mind.[20] On numerous occasions John XXII and Clement VI asked her to intercede on their behalf with Philip VI.[21] As a descendant of the house of Burgundy, we might recall the Burgundian precedent of Queen Emma who had been assigned important responsibilities in the government of the kingdom, and, given her interest in history, it is not inconceivable that Jeanne de Bourgogne knew this historical precedent.[22] It is also possible that Jeanne's correspondent Clement VI, a former archbishop of Sens, would have known the West Frankish Ordo with its extensive queen's rite that would have endowed Emma with so much authority.[23]

In marked contrast to his father, John the Good did not designate either of his wives as regent. However, one cannot draw any conclusions about the development of the regency of queens during his reign because Bonne of Luxembourg died before his accession, and he did not have that essential requirement for a regent, a relationship of complete trust, with Jeanne de Boulogne, his second wife.

Charles V never departed on crusade nor did he participate personally in any of his war campaigns, so the situation never arose in which he was required to name a regent to govern the kingdom in his absence. Nevertheless, his reign was consequential for the offices of queen and regent. The exclusion of women from the succession to the throne was advanced during the reign of Charles through the promotion of the Salic Law as the law of the succession of the kingdom.[24] Charles provided for the eventuality of an early death with a series of ordinances promulgated in 1374 that legislated on succession, the regency and the majority and education of the royal children.[25] Invoking terms such as 'edict', 'law and constitution' these ordinances are regarded by modern critics as the 'first constitu-

tional law of the French monarchy'.[26] The first of these fixed the majority of French kings at the first day of their fourteenth year. The ordinance officially declared that the eldest son of the deceased king succeeds to the throne, and in the absence of a son the nearest male heir succeeds, favouring direct descent from the eldest male line. Should the eldest son of the king die before his father, and should that son himself have a son, then the latter would succeed to the throne. The right of the nearest male heir to the sacre at Reims cannot be contested. Election to the throne is definitively excluded in this ordinance. Women were categorically excluded from succeeding to the throne and from transmitting to their sons the right to succeed to the throne.

A second ordinance designated the queen as the guardian, tutor and governor of the royal children. This ordinance is specifically concerned with the education and protection of the royal children as well as with the designation of the sources of their revenues. It also stipulated that the queen would be assisted by the dukes of Burgundy and Bourbon, that is to say, a brother of the king and of the queen. The queen and dukes would be advised by a counsel of tutelage composed of twelve members drawn from the ranks of prelates of the Church, officers of the Crown, representatives of the king's hotel, Parliament, Chambre des Comptes, and bourgeoisie of Paris. Among the individuals named to this council were Bertrand du Guesclin and Evrart de Trémaugon, the legist who is the presumed author of the *Songe du Vergier*. All of these individuals would be obliged to take an oath to carry out their duties faithfully.[27]

In the ordinances of 1374 Charles did not name Jeanne de Bourbon as regent. Rather, he entrusted to his brother Louis the duke of Anjou 'the authority and full power to govern, guard and defend the kingdom', giving him instructions that distinguished between public goods of the Crown that could not be alienated and the private property of the king.[28] While some queens of the past had governed and raised the royal children, these measures distinguish sharply between the role of a governing regent and that of a royal mother.

What is the meaning of the clear-cut separation between the duties given to Anjou and to Jeanne de Bourbon? In keeping with the definitive exclusion of women from succession with the promotion of the Salic Law during Charles's reign, it could be concluded that the intention was to preclude the queen from acting as regent and to restrict her to managing the royal children and household.[29] This separation could be interpreted as an effort to detach the public domain of royal responsibility from the private domestic sphere of the king.[30]

However, in this ordinance royal motherhood is not a mere private matter of the king's household. It is a mistake to regard the royal family that is delineated in these ordinances as belonging to a private domain. Rather, as Autrand makes clear, these ordinances elevate the protection, education, and nurturing of the royal children to the status of a public duty of state invested, not only in the queen, but also in other members of the body politic including representatives of most sectors of French society, from grand nobles to the bourgeoisie.[31] Just as the Ordo of Charles V redefined kingship as an office within the Crown, so these ordinances redefine the office of queenship in the new system. I would suggest that the official state responsibilities of the queen as mother, protector and educator of the heir to the throne that are legally defined by this remarkable document are presupposed by the

structure of government that is set out in the ritual and images of the Coronation Book. As the position of the king is redefined in the Ordo of Charles V, so is the queen's in her ordo. The queen is the centre-piece of this institution. Not only does she participate in the ministry of the king along with the peers and magnates, but the most important duty of her ministerium, that of protecting and nurturing the royal children, is also shared with others who constitute with her a corporate body of tutelage. It seems significant that Charles did not refer to Anjou as 'regent' in delegating to him specific powers to govern the realm.[32] If Charles avoided using the terms *régent* and *régence*, it was perhaps to circumvent the individualism implicit in these terms. All of the duties that these ordinances distribute to various individuals were at times in the past held by a single regent, Blanche of Castille, or Charles himself, for example. The ordinances do not name an individual as regent. Rather they define a collegial body politic that constitutes a corporate regency, a condominium similar to the structure created by the ritual of the Coronation Book.

If these ordinances delineate a constitution of government, their primary purpose is to assure the hereditary succession of the direct male line. It may not be a mere coincidence that the ordinances were published ten years after the sacre: their publication may have been intended to mark the first ten years of Charles's reign. In this respect it seems to mark a decennial. Charles and Jeanne had been childless at the time of their sacre, and Louis, duke of Anjou was at the time Charles's closest male heir. The birth of two male children to Charles and Jeanne altered the position of Anjou, and it is significant that these ordinances give considerable attention to circumscribing Anjou's position. For Charles and his contemporaries no doubt remembered that two male regents had displaced the deceased king's infant heirs (see chapter 1). Throughout the history of monarchies, the most serious threat to a deceased king's heir has often come from the king's surviving brothers. In this light, Charles judiciously removed Anjou from the royal household and precluded him from any direct contact with his wife and heirs whom he placed under the protection of the dukes of Burgundy and Bourbon. There is an obvious geographical symmetry in the choice of a royal guardian drawn from the great apanage of Burgundy on the eastern side of the realm and Bourbon on the west. But there may also have been a more pragmatic rationale: as Charles's youngest brother, Philip of Burgundy was the furthest removed from the line of succession with two older brothers, and as the queen's brother, the duke of Bourbon had a serious vested interest in assuring her survival. As we turn now to consider the Ordo of Jeanne de Bourbon, we will see that the re-formulation of the office of the queen that is advanced in the ordinances of 1374 is already delineated in the images and text of the Coronation Book.

The Ordo of Jeanne de Bourbon is especially important in the history of queen-making rituals. It is the first queen's ordo to be accompanied by a cycle of historically detailed illustrations of the most important ritual acts with lifelike portraits that identify the principal participants.[33] Unlike the symbolic and decorative character of illustrations in earlier queens' ordines (considered above in chapter 2), all of which lacked details enabling one to identify them confidently with a particular coronation, the Ordo of Jeanne de Bourbon is the first historically documented and illustrated ordo for the coronation of a

French queen. It is unsurpassed for the comprehensiveness of its rituals, with nearly twice the formularies and ritual acts than are found in any earlier queen's ordo.[34] As Clare Sherman has observed, although the Ordo of Jeanne de Bourbon is shorter and has fewer illustrations than the Ordo of Charles V, the ratio of illustrations to the text in the queen's cycle is approximately the same as that of the king's.[35] Far from demonstrating the queen's inferiority to the king, it goes further than any previous ordo to establish a symmetrical relationship between the king and queen. The effort to compare the queen with the king, given emphasis by the miniatures, is among the unique features of the ceremony in the Coronation Book.

The historical realism of the illustrations plays other roles beyond identifying the ordo with a specific historic event. Through the same attention to historical details of portrait likeness, armorials, realistic description of actions, gestures, costumes, and objects which runs throughout the king's cycle, the queen's cycle continues and complements the historicity of the illustrations of the Ordo of Charles V, and establishes between them an emphatic parity and continuity, reinforcing the concerted editorial effort to link and unify the two ceremonies.[36] This integration of the queen's ceremony with the king's is accomplished by formal, iconographic, and liturgical parallelisms between the two cycles of miniatures. Comparison with the king's cycle is invited by the similar format, compositions, background patterns, frames and colour schemes.[37] The miniatures were painted by the artist of the king's cycle and were executed in the same style. The figure of the queen in the miniatures echoes and reiterates the figure of the king. The establishment of similarities between the queen's and the king's cycles was clearly a primary concern; indeed it is key to understanding the meaning and purpose, not only of the queen's cycle and its prominence in the manuscript as a whole, but also of the *Coronation Book*. This integration establishes an interdependence between the ordines of king and queen which had until now been relatively separate, if sequential, existences. Here, the queen's ordo achieves an unprecedented symmetrical balance with the king's, relating to it more as a complementary component than as an appendage. The resulting parity between queen and king qualifies the meaning of the king's ritual, even rendering it dependent upon the queen's. No prior king's ritual is so conditioned by an accompanying queen's ceremony.

Several departures from the symmetry with the king's cycle are significant because they express consequential differences between the king and queen. These differences, as well as the innovations of the Ordo of Jeanne de Bourbon, cannot be appreciated unless the traditional features of that ordo, and the similarities that it shares with the king's ordo, have been identified. The traditional elements are the foundation of the Ordo of Jeanne de Bourbon, preserved intact by the redactor and enhanced with the addition of several innovations; and it is the preservation of the tradition that reaffirms the continuity of the queenship of Jeanne de Bourbon with the queens of the past.

I. Tradition in the Ordo of Jeanne de Bourbon

Composed of elements borrowed from earlier ordines, the Ordo of Jeanne de Bourbon, like the Ordo of Charles V, is indeed a monument to tradition. It is imperative to underscore the fact that the increased length and comprehensiveness of the Ordo of Jeanne de Bourbon are not due to textual innovation since there is virtually nothing in the text that did not appear in earlier queens' ordines.[38] It is an amalgam of the queen's rituals in the Directory of c. 1230, the Ordo of 1250 and the Last Capetian Ordo.[39] As a compilation made from earlier ordines it not only affirms the traditions of the past, but also adheres to its sources more closely even than does the Ordo of Charles V.

1. The Tradition of Marriage and Anointing in the Making of Queens

Because queenship depended upon marriage, the earliest queens' rituals emphasized the matrimonial aspects of queenship.[40] When a woman married a reigning king, she was usually installed in her public role at the time of her marriage and her consecration would take place in the context of the nuptial ceremony.[41] The earliest surviving formularies for the consecration of a queen are derived from the marriage ritual and they emphasize the queen's role as spouse and bride. These coronations took place during a nuptial mass and the insignia bestowed on the queen were those received by a bride: a ring and a crown inspired by the Early Christian wedding crown. The earliest is that for the marriage in 856 of Judith, daughter of Charles the Bald, to Aethelwolf king of the Anglo-Saxons. It was compiled by Hincmar, the archbishop of Reims who also compiled the Carolingian ordines for the consecrations of the king and bishop, ordines which established the comparison between the consecration of king's and bishops.[42] Although anointing with oil is not explicitly stated, the fact that the Judith Ordo contains a prayer derived indirectly from the *missa chrismatis* poses the possibility of a ritual anointing in this earliest surviving queen's ritual. The direct source for this phrase in the Judith Ordo, rather than being the chrism mass, was the liturgy for the consecration of nuns or abbesses that also mentions the chrism but does not specify physical anointing.[43]

In instances when the king acceded to the throne after his marriage, the coronation of king and queen could not take place in the context of their wedding. Moreover, many queens assumed official public and state duties. In these instances the marriage theme was not sufficient to endow the queen with authority extending beyond that of a king's wife.[44] The earliest ordo intended for such an occasion is probably the West Frankish Ordo of c. 900, generally regarded as the first in which a queen's ordo was joined to a king's. It is also thought to be the first explicitly to specify the anointing of the queen, indicating that she is to be anointed on the head in precisely the same manner as the king in that compilation.[45] We have seen above in chapter 2 that this ordo elevated the queen to a more symmetrical position with respect to the king by extending to the queen's rite many of the rituals and attributes of the king's. The queen is the king's consort who shares with him the insignia of ring and crown, but also an authority of rulership that transcends her status as

his bride and wife.[46] Like the king she prostrates herself before the altar as do candidates for entry into the religious orders, and like them she is anointed on the head. Like prelates of the Church, king and queen receive the ring as the 'sign of the Holy Trinity against all heretics and barbarians' and the 'crown of glory'. In the manner of Early Christian prelates, the queen is 'instituted' by the imposition of the consecrator's hand on her head. In this ordo the queen is God's servant who receives a sacred ministerium shared with the king.[47] In this ordo and its successors the queen receives special blessings so that she will be the helpmate of the king and share in his ministry. The ordo makes no reference to biblical matriarchs, and thus it is silent concerning what is usually regarded as the queen's responsibility for continuing the dynasty,[48] although scholars have suggested that the anointing was introduced for the queen primarily to sanctify her mission to produce a successor.[49] The anointing of the queen in the West Frankish Ordo of *c.* 900 is the ultimate ancestor of the Ordo of Charles V and Jeanne de Bourbon. The redactor of the Ordo of Jeanne de Bourbon drew upon a continuous tradition which was already present in the later Carolingian period in this ordo.

The introduction of anointing was the most consequential step in elevating the position of the queen. She was the only woman in Christendom to be anointed physically in a manner similar, not only to kings, but also to priests and bishops. For, although the liturgy for the benediction and consecration of females — nuns or abbesses — alludes to anointing, this is probably a figurative spiritual anointing since a physical anointing is not specified.[50] Thus, her anointing set the queen apart from other members of her gender, as well as from male laity. The introduction of anointing was a decisive step in the evolution of the queen's sacre that elevated the queen's importance and reinforced the symmetry of her position with the king's. Bouman thought that the West Frankish Ordo was not compiled for a specific historic ceremony but was developed as part of a collection of liturgical models, probably in the context of a liturgical reform.[51] However, as suggested above in chapter 2, this ordo may well have been compiled for the accession of King Raoul and Queen Emma. Indeed, the consecration of the queen was instrumental for investing her with genuine authority to govern, if not in her own name, then in that of her absent husband or, in the event that the king died before the heir had reached majority, their eldest son. The queen's consecration in the West Frankish Ordo had a considerable impact upon all future queen-making rites. It has been regarded as the model for the Anglo-Saxon Edgar Ordo and the Ratold Ordo in which the queen was anointed on the head and the breast and received a ring and crown, the same insignia given to the king with the exception of the sword.[52] By the twelfth century the Continuator of Suger testifies to the anointing and crowning of Louis VII's second wife Constance of Castille and of his third wife Adele of Champagne.[53]

Each of the ordines of Reims added new formularies and ritual actions to the queen's consecration that elevated the queen *vis-à-vis* the king and strengthened the parallelism with his consecration. They considerably amplified the queen's ceremony in the West Frankish Ordo of *c.* 900 and the Ratold Ordo. In those the queen prostrates herself before the altar, in emulation of the consecration of kings and bishops, and like them she is anointed on the head, she receives a ring as the 'sign of the Holy Trinity', and she is

crowned with 'the crown of glory'. But she is neither enthroned nor anointed on the breast.[54] The Directory of *c.* 1230 calls for the queen to be anointed on the head and breast, to receive a rod, sceptre and crown that is sustained by barons who then lead her to the solium prepared for her enthronement.[55] In the Ordo of 1250 the queen's ceremony is considerably lengthened by the addition of prayers invoking biblical queens, matriarchs and prophetesses, including Judith, Esther, Rebecca, Lea and Rachel, and the Virgin Mary.[56] As in the sacre of the king, a solium is prepared for the queen before the ceremony. This solium is similar to the king's but on the left side of the choir. She is blessed before the altar and anointed on the head and breast 'not with the oil sent from heaven, but with simple blessed oil'. She does not receive a ring. The archbishop gives her a sceptre 'of a different form from that of the king' and a rod 'similar to the king's'; then the archbishop alone places the crown on her head, and it is sustained by the barons. She is led to the solium and enthroned on the seat prepared for her there where she is surrounded by the barons and noble matrons. The king and the queen descend from their respective platforms to receive the Eucharist in two species from the hand of the archbishop. The Last Capetian Ordo closely follows the Ordo of 1250 with slight changes: the queen's solium is 'smaller than the king's'; she is anointed on the head; and this ordo specifies that her tunic and *camisia* must be opened to the waist so that she can be anointed on the breast with holy oil (*oleo sancto*). The archbishop gives her a sceptre, rod, and a ring, which the queen did not receive in the Ordo of 1250, and he alone places the crown on her head. The crown is sustained by barons who continue to sustain it as they lead her to the solium, and she is enthroned on the solium surrounded by the barons and noble matrons. While the Last Capetian Ordo gives special directions for the king to receive the Eucharist in two species, it does not contain the explicit instructions of the Ordo of 1250 that state that the queen partakes of this same privilege.

By referring to biblical mothers and the Virgin Mary, the French ordines of Reims, the immediate antecedents of the Ordo of Jeanne de Bourbon, express the idea that the queen receives this special blessing so that she will be endowed with the grace to be the mother of the hoped-for successor to the throne. The union of the king and the queen is thus given special sanctification and grace.[57] Together they will share responsibilities for governing the kingdom, one of the most important being to assure the peaceful transition of the government of the realm from one generation to the next by producing an heir to the throne. The special blessing of the queen is vital for a system that relies upon hereditary succession for the orderly transfer of the reins of government, a point that is central to the meaning of the Coronation Book.

There is some evidence for a popular belief among the early Franks that the oil of unction, made from olive oil, a Mediterranean product rare in the north, was considered to bring fertility, and the Franks may have viewed the introduction of ritual anointing in the early Carolingian coronation ceremony as conveying the life-giving power of the oil itself.[58] However, this particular belief remained on a purely popular level in Frankish Christianity; for the culture of the Early Christian and medieval Mediterranean, sacramental unction was (and still is) believed to transmit something more transcendent than physical fecundity, namely the mystical power and grace of the Holy Spirit. The references to

biblical queens and matriarchs that are made in one of the typological prayers of the Ordo of Jeanne de Bourbon are not original to her ordo, but belong to a tradition reaching back at least to the Capetian era as these prayers are found in both the Ordo of 1250 and the Last Capetian Ordo.[59] Thus fortified with the special blessing of anointing, the queen was considered, at least on a popular level, to have been blessed with a substance capable of endowing her with fertility. But more relevant to Christian beliefs about anointing, the queen was blessed with the grace of the Holy Spirit, that which had descended upon the Virgin at the moment of her conception of Christ.[60]

No single queen's ordo before that of Jeanne de Bourbon included all the insignia, anointings and innovations introduced in the miniature which compare the queen to the king.

2. The Queen's Ministerium and the 'Royal Religion'

One important aspect of queens' rituals has been overlooked: that the queen at her sacre enters into a ministry comparable to the entry into the religious state. The ministerial character of the queen's office was affirmed more forcefully than ever before in the Ordo of Jeanne de Bourbon and its illustrations. In his *Traité du Sacre* Jean Golein emphasized that at her sacre the queen, like the king, entered into the 'royal religion' which invested her role with the character of a sacred ministerium similar to that assumed by one who consecrates his or her life to the service of God and the Church. Through her anointing, no other woman, according to Golein, comes so close to priestly dignity.[61] He emphasized that at their consecration both the king and queen enter into the 'royal religion' mixing the royal with the sacerdotal,[62] and that their priestly dignity is demonstrated by their reception of the Eucharist in two forms, a privilege from which those who are not priests are excluded.[63] As the queen's confessor and a member of the immediate entourage of Charles and Jeanne, Golein provides us with an intimate contemporary perspective.[64]

The theme of Jeanne de Bourbon's entry into the religious state belongs to a tradition already present in the earliest queen-making rituals. Although primarily a nuptial for the marriage of Judith, the daughter of Charles the Bald, to Aethelwolf, king of the Anglo-Saxons, the Judith Ordo included passages derived from the liturgy for the consecration of a nun, a ceremony with its own special nuptial connotations since the maiden who enters into the religious state is the bride of Christ.[65] The Ordo of Jeanne de Bourbon includes the phrase *ut qui per nostre manus hodie impositionem regina instituitur*, a paraphrase of the prayer recited for the laying-on of hands in the benediction of an abbot or abbess, introduced into the queen's ceremony in the Carolingian period.[66] It is in the West Frankish Ordo of *c.* 900, and also in the Ratold Ordo.[67] Before Hincmar, bishops had been consecrated with a ritual laying-on of hands rather than the anointing ritual that appeared in the Carolingian period. Dewick noted that although this phrase is not in a king's consecration ceremony, it must have been in an earlier king's ceremony where its presence was motivated by a desire to consecrate the king in a manner similar to the consecration of a bishop, as the same phrase appears in the story of Columba's ordination of king Aidan.[68]

In the earliest texts the anointing of the queen does not differ substantially from that of

the king. Both are anointed on the head with blessed oil. But in the thirteenth century the French queen's anointing was differentiated from the king's by negation, as she was no longer anointed with the same oil as the king. By that time the formularies specifically call for the king to be anointed with the Celestial Balm, mixed with chrism, the consecrated oil of Holy Orders and episcopal consecrations, while the formularies call for the queen to be anointed merely with the sacramental oil that is used for baptism, the oil of catechumens.[69] This difference is emphasized by Golein and it is also present in the French ordines compiled during the reign of St Louis and in the Ordo of Charles V and Jeanne de Bourbon.[70] Thus, while the anointing elevated the queen's status with respect to all women and compared her to the king, it came to be the means of distinguishing the degree and quality of her anointing from that of the king. The queen's anointing with simple oil blessed by a bishop heightened the charismatic mystique and sanctity of the king's anointing, for she did not receive the divine mandate bestowed on the king of France through his anointment with the Celestial Balm. Nevertheless, it was significant that the queen was anointed, even if only on the head and breast with the simple oil of catechumens.

Golein explained the mimetic character of the sacre as similar to a mystery play in which the king represents Christ, the archbishop represents God the Father, the queen symbolises the Virgin Mary, and the peers stand for the Apostles. The meaning of the three principal characters of the drama derives from the sacred figure whom they impersonate. The unction signifies the action of the Holy Spirit.[71] Because the archbishop 'represents the person of God'[72], Jeanne de Bourbon, like Charles V, is anointed by God with the unction of the Holy Spirit. The queen represents the Virgin Mary, the Queen of Christians, the Bride of Christ, who because of the '… love of the sovereign king, He made you the mother and daughter of his son and anointed you sovereign queen by the mystery of the Holy Spirit'.[73]

In his explanation of the queen's consecration Golein added that her anointing pertains to the ministerium that she shares with the king in governing the kingdom, the central duty being that together they engender and nurture a royal heir to assure the continuity of the sainted royal line.[74] In the text of the queen's prayer to the Virgin, which Golein translates in full, the queen's anointing is compared with that of the Virgin Mary who was 'anointed sovereign queen by the mystery of the Holy Spirit'.[75] In this prayer the queen asks the Virgin for assistance 'so that also with my lord we can govern the kingdom and together engender, nurture, and raise such children that his name will be honoured and thy people kept in peace.'[76]

Golein's main point concerning the consecration of the queen is that engendering and raising an heir is central to the establishment of peace, and as the *genetrix* of this heir, the queen is of utmost importance for governing the realm. He also makes it clear that the queen is essential for a system of hereditary succession.

Elected by the king through marriage, the queen was eligible to receive this special blessing of the Holy Spirit to endow her with the grace to fulfil the duties of her elevated office. She would receive the wisdom to assist the king in governing and continuing that government's peaceful transition to the next generation. Where transmission of authority proceeds by the rules of hereditary succession, the queen's blessing by the Holy Spirit is expected to endow her with grace to conceive an heir and with the wisdom essential for

educating him.[77] That successor must be of proper paternal and maternal lineage, and he must be nurtured and educated to assume his responsibilities when the time arrives.[78] On one level the consecration of the queen was a means of ensuring that no claims of unsuitability to rule might be brought against the successor which she produced. But on a higher plane it was a means of assuring that the next generation would descend from the sacred and sainted *christianissimum genus* of kings who produced saints and whose descendants were worthy to succeed and to receive the anointing of the Holy Ampulla.

In the system of hereditary succession that he defends in his treatise, Golein viewed the queen's consanguinity with the king, not as a liability, but a vital asset. For her descent from the same holy and sacred line as the king — the line of St Louis — strengthens her suitability as a *genetrix* for a male heir who has as his hereditary right succession to the throne of France, descended as he is from that sacred and sainted line of kings.[79]

This review of the traditional elements of the Ordo of Jeanne de Bourbon reveals that many of the themes stressed by Golein, particularly the anointing of the queen, express the queen's role in establishing and sustaining a system of succession from the direct male line as the divinely ordained law of succession of the kingdom of France. The editor of the Ordo of Jeanne de Bourbon used the Last Capetian Ordo, but supplemented it with elements from earlier ordines that emphasized the ministerium of the queen or which referred to the procreation of a successor to the throne. By combining these traditional elements, the editor of the Ordo of Jeanne de Bourbon invoked tradition to defend the cause of Valois succession.

II. Innovation in the Ordo of Jeanne de Bourbon

The miniatures of the Ordo of Jeanne de Bourbon introduce several new ritual acts, some inspired by innovations in the Ordo of Charles V which amplified the sacerdotal and episcopal character of the king, and others inspired by the rituals for the consecration of nuns or abbesses. All of the innovations in the Ordo of Jeanne de Bourbon parallel the king's cycle by exploiting the principal theme of the Coronation Book: that the sacre is a consecration in which the queen, like the king, takes leave of the secular state to enter into the ministerium of the 'royal religion'. In particular, they expose the central role of the queen in a system of succession through primogeniture, in which her role is to engender, nurture and educate a male heir.[80] After he succeeded in having Boniface VIII canonize Louis IX, Philip the Fair and his successors began systematically to evoke their descent from the *sancti et christianissimi Francorum reges* and to advance the notion that they were issued from the *christianissimum genus* of royal saints who are divinely ordained to wear the crown of France.[81] Reinforcing the anointed stature of the queen gave further expression to the queen's divinely ordained mission to assure the continuation of this sacred line. Finally, these innovations, in addition to establishing an unprecedented symmetry between the king and the queen, exalt the role of the archbishop of Reims as the divinely chosen vicarius Dei in the transmission of the Celestial Balm.

After the Carolingian queen-making rites that introduced the ring, the crown and the anointing of the queen's head, the sceptre and verge were added, first to the king's ceremony and then to the queen's. These attributes are not innovations of the Ordo of Jeanne de Bourbon, because for centuries they had already been included amongst the queen's regalia and belonged to the programme of likening the consecration of the queen to that of the king. What is new, however, is that *all* of these traditional similarities with the king's consecration have been combined into a single ordo and, furthermore, have been illustrated. Also new is the emphasis given in the illustrations to the parity of the queen's ordo with the king's.[82]

The cycle of illustrations of the Ordo of Jeanne de Bourbon presents some significant modifications in the ritual of queen-making that make the queen instrumental for demonstrating the uniqueness of the anointing administered to the king of France. Two of these modifications are inspired by innovations of the Ordo of Charles V: the use of a golden needle for the anointing of the queen's breast (ill. 49) and the introduction of a second seat for the queen, distinct from her throne and comparable to the king's cathedra, against which the queen kneels for her anointing, investiture, communion (pls. 30–5, 37; ill. 47), and upon which she is enthroned (ill. 53). Neither this cathedra nor the golden needle is mentioned in the text of the Ordo of Jeanne de Bourbon nor in any previous queen's ordo. The source is the miniatures of the Ordo of Charles V, and their introduction into the queen's ceremony strengthens the comparison of her consecration to the king's. Through the introduction of the queen's cathedra, the episcopal theme that is so important in the king's ceremony is extended to the queen, along with the concomitant emphasis that it

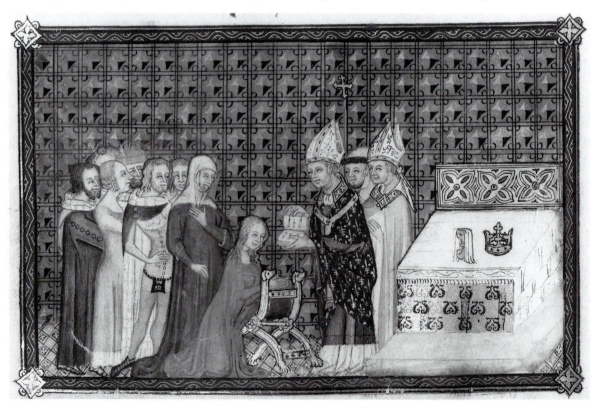

47. The Queen kneels at the *Cathedra*, fol. 66v [pl. 30]

places upon the archbishop of Reims, who is also the beneficiary of the use of the golden needle for the queen's anointing.

Another new feature introduced by the miniatures of the Ordo of Jeanne de Bourbon is the veil (pls. 31, 32; ills. 48, 49) that is mentioned neither in the text of this ordo nor in any previous queen's ordo. The source of this motif is not the king's ordo, but is, I would argue, the liturgy for the consecration of a nun as the bride of Christ; its introduction, along with the introduction of the cathedra and other motifs, belongs to the comprehensive programme elaborated in the Coronation Book of expressing the notion that through their consecrations the king and queen enter into the ministerium of the 'royal religion'.

1. The Golden Needle

Among the new features of the Ordo of Jeanne de Bourbon is the use of a golden needle or stylus by the archbishop of Reims to anoint the queen's breast (ill. 49). It was noted above in the discussion of this motif in the king's ordo that the golden needle first appeared in thirteenth-century kings' ordines associated with Reims that call for it to be used only for extracting the Celestial Balm from the ampulla but not for anointing. The needle used by the archbishop for anointing Jeanne de Bourbon is shown to be identical to that in the king's cycle where it is used to extract the Celestial Balm from the ampulla, to mix the balm with chrism, to anoint the king's hands, and presumably also to anoint his breast, although that scene has been lost from the manuscript (pls. 13, 18). The consideration of this motif in

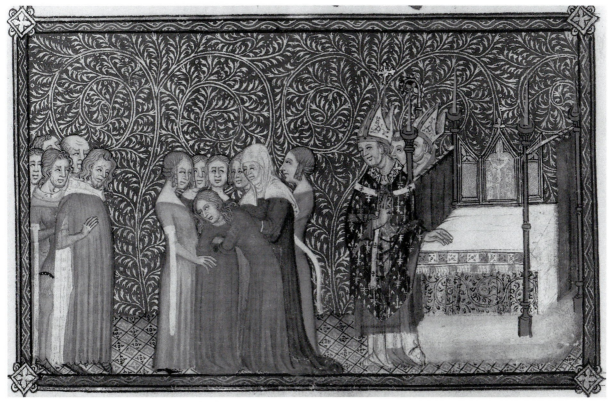

48. The Queen prepares for the Anointing, fol. 67v [pl. 31]

the Ordo of Charles V revealed that its use for anointing the king was introduced, not by the text of the king's ordo, which called for the archbishop to use his thumb to anoint the king, but by the miniatures of the king's ordo.[83]

The text of the Ordo of Jeanne de Bourbon does not mention the golden needle at all, and suggests, rather, that the archbishop anointed the queen in the normal manner with his thumb.[84] This departure of the miniature from the text of the queen's ordo was no doubt inspired by the lost miniature of the anointing of the king's breast.[85] This is supported by the paired scenes of the anointing of the breast of king and queen in Charles V's copy of Golein's translation of the *Rational of Divine Offices* (ills. 50, 51), a juxtaposition that confirms the intention to draw a comparison between the two anointings. The extension to the queen of anointing with the golden needle underscores the parallelism between the anointing of the king and queen. Administered in the same manner, her anointing is compared in form with the king's and is thereby accorded greater sanctity.

We have seen that the use of the golden needle for the anointing of the king eliminated the touch of the archbishop, the single human intermediary between the divine source of the Celestial Balm and the king, conveying the notion that the king was anointed by God. The elimination of the human touch of the archbishop thereby implies, as Golein witnesses in his treatise, that the consecration of the queen is '… from God without other means …'.[86] Surely the reason for the use of the golden needle for the queen's anointing is to express the notion that in her sacre the queen represented the Virgin Mary, anointed by God with the unction of the Holy Spirit[87]: it declares that she is anointed by God through his *vicarius* the archbishop of Reims.

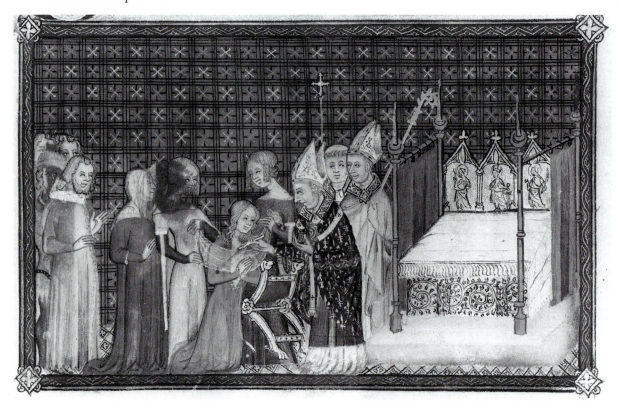

49. The Anointing of the Queen's Breast, fol. 68 [pl. 32]

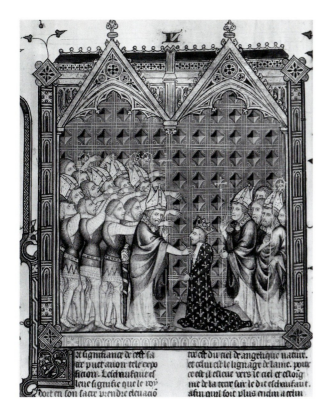
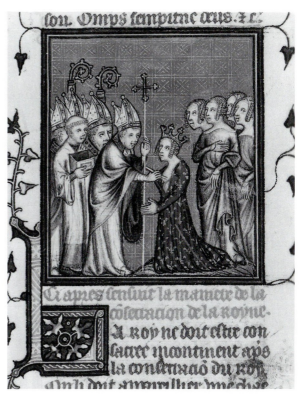

50-51. The Anointing of the King's Breast; the Anointing of the Queen's Breast. Golein's translation of *Rationale des offices divins.* Paris, BN, MS fr. 437, fols. 44v and 50

The anointing of the queen's breast in this manner has further implications. The king wore special sacerdotal garments to cover the parts of his body which were anointed so that nothing unconsecrated would come into contact with the Celestial Balm: gloves that had been given a special blessing covered his hands, a cap and a crown covered his head, and he wore priestly garments over his anointed shoulders and breast.[88] This implies that the queen's breast was sanctified for the necessary contact with the king's anointed body, enabling her to fulfil the sacred duty to engender and nurture an heir. As the couple did not have an heir at the moment of the sacre, the anointing of the queen, like the anointing of the Virgin with the grace of the Holy Spirit at the moment that she conceives, could be expected to bring a similar blessing upon the queen. The queen's procreative responsibilities are thus consecrated as a ministerium and her union with the king elevated to a sacred duty of Church and State.

Despite the use of the golden needle in the queen's anointing, the queen was not anointed with the Celestial Balm. In his *Traité* Golein emphasized that she was anointed with the oil sanctified by the archbishop and explained the significance of her anointing with this oil, invoking his version of the Salic Law:

… woman cannot and must not inherit in France … nor does the anointing of the Holy Ampulla pertain to a woman; therefore, neither royal succession nor election pertain to a woman … the kingdom of France must be held by succession of the closest male heir in the (direct) line, because every

167

> reasonable man can sufficiently conclude that the dignity of such an anointing does not pertain to a woman, nor … (the right) to govern because that seems more (according to) a divine than a human ordinance … .[89]

While likening the queen's anointing to the king's in form, the use of the golden needle contrasts her anointing to the king's in substance. In this way the uniqueness of the king's anointing is expressed in visual terms. The use of the golden needle exalts the queen's anointing, giving her greater importance, while simultaneously differentiating her anointing from that of the king.

2. The Queen's Cathedra

The second innovation presented by the miniatures of the queen's cycle is the cathedra against which she kneels for her anointing and investiture and upon which she is enthroned (ills. 47, 53). As mentioned above, neither the text of the Ordo of Jeanne de Bourbon nor any previous queen's ordo mention this seat that appears so prominently in the queen's cycle. She is shown kneeling against it for her anointing, for the transmission of ring, verge and sceptre, and for the imposition of the crown, after which she is enthroned on it. The similarity of the queen's pose to the king's in the respective scenes of his anointing, investiture, crowning and enthronement, suggests not only that these scenes of the queen's cycle were modelled upon the king's cycle,[90] but also that this formal similarity was intended to express a similitude of ritual and meaning. Thus, not only does this motif of the queen's cycle depend upon the king's, but it also defines another level of parallelism between the queen's consecration and the king's. Further indication of the dependence of the queen's ordo upon the king's is that most of the innovations in the queen's cycle which are not in the text of her ordo, are important elements either in the text or the miniatures of the king's ordo.

Among the comparisons between the two cycles is the introduction of the two bishops, who play a prominent role in the queen's sacre. The Ordo of Jeanne de Bourbon is the first in which the queen is given an elaborate entry, being led into the cathedral by two bishops who present her to the consecrating archbishop (ill. 46).[91] We have seen in the preceding chapter that the Ordo of Charles V assigns a prominent role to two bishops who fetch the king at the palace of the archbishop of Reims, lead him to the altar and present him to the archbishop, and place him on the cathedra in a manner comparable to the actions of the two auxiliary bishops in the episcopal consecration.

The king's ordo is the source for what is perhaps the most significant innovation in the queen's cycle, namely her enthronement on the cathedra, against which she knelt for her consecration and investiture (ill. 53). This scene has been mistaken for a traditional placement of the queen on her throne or the crowning of the queen,[92] but there is good evidence that two scenes have been lost, the queen's *sublimatio* and her enthronement on the solium, both rituals specified in the text. The rubrics at the beginning of the Ordo of Charles V state that before the king's ceremony the queen's throne is prepared and placed on the queen's elevated solium. The queen's ordo describes the ritual *sublimatio* in which the queen leaves the ground level of the church and climbs to the solium where she is enthroned in the com-

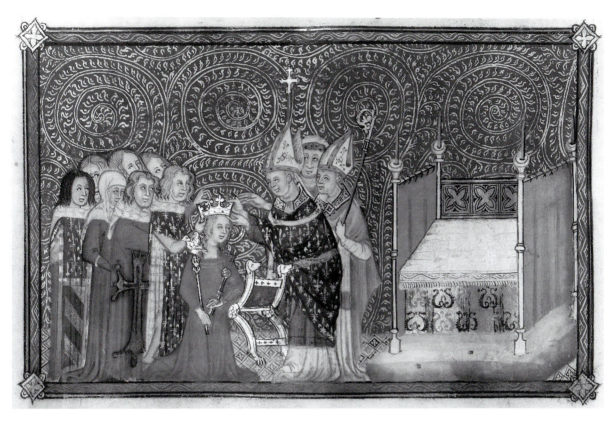

52. The Imposition of the Queen's Crown, fol. 69v [pl. 35]

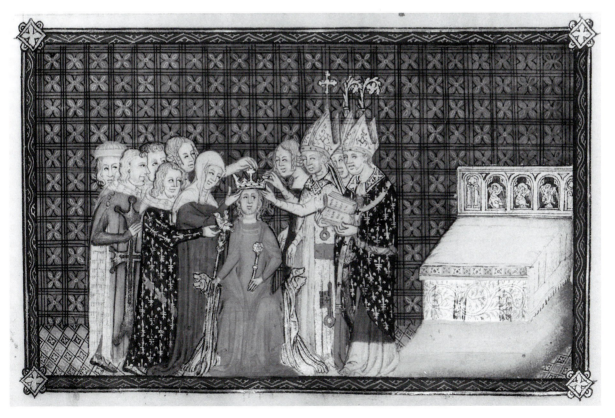

53. The Enthronement of the Queen on the *Cathedra*, and the Sustaining of her Crown, fol. 70 [pl. 36]

pany of the barons who sustain her crown. As with the king's ordo, the text of the queen's ordo does not mention her enthronement at the ground level of the church before the altar, yet, the cathedra in this scene is unmistakeably placed on the floor of the church before the altar. It cannot, therefore, be the throne which, as the rubrics state, was placed before the ceremony on the queen's solium where it remained throughout the entire ceremony.[93] It is the cathedra against which the queen knelt for her consecration and for the transmission of the ring, sceptre, verge and crown (pls. 30–5). Both miniatures and text confirm that the enthronement of the queen on fol. 70 is not the enthronement on the queen's solium but a second enthronement on the cathedra against which the queen knelt throughout the ceremony. As the cycle of Charles V introduced the ritual enthronement of the king on a cathedra, the cycle of Jeanne de Bourbon introduced a similar scene to pair with the king's.

Confirmation that the queen's enthronement on the cathedra was derived from that of the king is offered by the formal resonances between the two scenes (pls. 24, 36): the seats are the same, they occupy the same position in the miniatures, and they are similarly draped; like the king, the queen is seated in a frontal position holding her sceptre and verge as he does, and her crown is sustained in the same manner as the king's with the attendants standing in similar poses.[94] The absence of a textual source in the queen's ordo, combined with this formal similarity with the illustration of the king's enthronement on the cathedra, points to the latter as the model for this innovation in the queen's cycle. It is worth noting that these rituals have been placed side-by-side at the beginning of the history of Charles V in his illustrated copy of the *Grandes Chroniques* (ill. 54).

Since the source of this innovation in the king's cycle the liturgy for the consecration of a bishop, and because the prominence of the cathedra in the king's cycle belonged to a programme of borrowing from the episcopal consecration ceremony, it must be asked whether an episcopal seat, literally a cathedra, could have been extended to a woman, and indeed whether many of the motifs in the king's cycle that were derived from the episcopal consecration could have been extended to the queen. It might at first seem implausible that sacerdotal and episcopal powers should have been extended to a woman until it is recalled that, before the Council of Trent, the abbess of a monastery was invested, like an abbot, with episcopal authority and powers at her consecration ritual, a ritual which was modelled on the episcopal consecration. Like a bishop, an abbess administered territory, raised taxes, and, like the queen, sat in governmental councils. She was the only woman in Christendom with the authority to sit in judgment, direct education, commission scholarly and religious books, establish libraries and schools. Furthermore, comparable to that of a queen, the abbess had a maternal role, for the primary religious responsibility of her ministerium was to be the mother of the nuns in her community and the spiritual mother of the people in the territories administered by her. She represented at once the Mother Church and the Virgin Mary.[95]

The liturgy for the ordination of an abbess presents many similarities with sacerdotal ordinations and episcopal consecrations: her installation ceremony, like that of a king or a queen, was contained in an ordo in the pontifical; she was consecrated by a bishop; to signify her authority she was invested with a baculum, and she was enthroned in a cathedra by the consecrating bishop.[96] While the ceremony for the abbess parallels in many respects

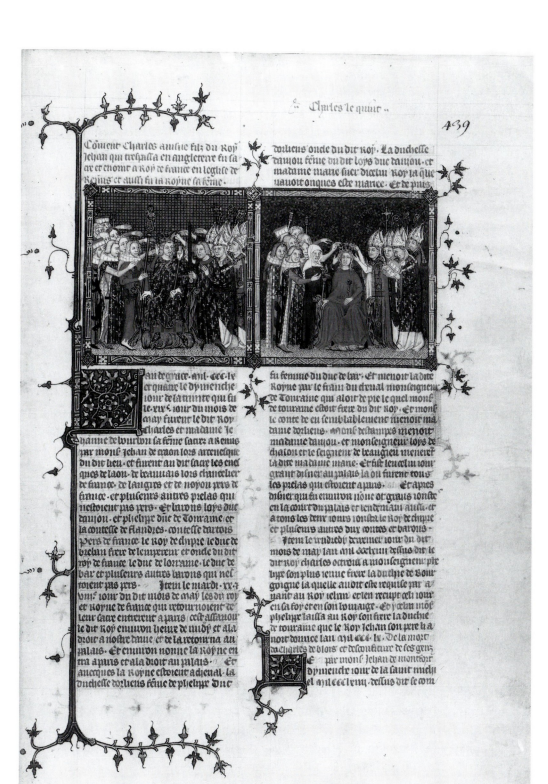

54. The Coronation of Charles V and Jeanne de Bourbon. *Grandes Chroniques of Charles V.*
Paris, BN. MS fr. 2813, fol. 439

the consecration of a bishop, it also presents features that are comparable to the Ordo of Jeanne de Bourbon.

Dewick observed that although many prayers and rituals in the queen's ordo have parallels in the king's ceremony, one prayer in the Ordo of Jeanne de Bourbon, recited after the tradition of sceptre and verge, contains no parallel in the king's ceremony. This prayer includes a remarkable phrase that corresponds to a prayer recited in the '*De benedictione abbatisse*: *ut que per manus nostre impositionem hodie regina instituitur ...*'.[97] Although this prayer occurs in earlier queens' ordines, including the West Frankish Ordo of *c*. 900, there is one element of the Ordo of Jeanne de Bourbon that is without precedent in queens' ordines but is a prominent element in the ritual for the consecration of an abbess: the enthronement on the cathedra before the altar by the consecrator.

The consecration of an abbess is also comparable to the Ordo of Jeanne de Bourbon in other respects. Throughout the illustrations Jeanne de Bourbon is surrounded by an entourage of women, even though, as in the Ordo of 1250 and the Last Capetian Ordo, the text calls for 'noble matrons' to be present only for the anointing and for the sustaining of the crown. Indeed three women play a prominent role from the beginning, and since the liturgy for the consecration of an abbess calls for the elect to come before the altar in the company of two or three of her sisters, it seems likely that the prominence given these three women pertained to the programme of likening the queen's consecration to that of an abbess.

These analogies between the cycle of Jeanne de Bourbon and the liturgy for the consecration of an abbess correspond to the episcopal theme developed in the Ordo of Charles V. In this way, the ministerial status of the royal pair is not merely likened to the state of a priest or nun, but to figures of episcopal authority in the Church. We have seen that the episcopal theme in the Ordo of Charles V elaborates an existing tradition of likening the king to a bishop originating in the Protocols of Hincmar for the coronation of Charles the Bald. However, the extension to the queen's ordo of the episcopal cathedra, with its connotations of educational, doctrinal and juridical authority, occurs for the first time in the Ordo of Jeanne de Bourbon.

3. The Royal Religion and Hereditary Succession

It is significant that many of the innovations in the cycle derive from innovations in the king's cycle that were inspired by the liturgy for the consecration of bishops. The text of the Ordo of Charles V includes a phrase declaring that the king shares in the ministry of the Church,[98] and the queen's ordo also refers to her ministry.[99] These phrases contribute to the theme that through their consecrations the king and queen enter into the 'royal religion'.[100] To accomplish these ends, according to Golein, the governance of the realm must be transmitted peacefully and with order from one generation to the next, necessating that the royal couple engender a suitable heir whom they must nourish and educate.[101]

The queen's assumption of a sacred religious *ministerium* through her consecration is forcefully expressed in the last scene of the queen's cycle in which she receives from the

172

hands of the archbishop the bread and wine of the Eucharist (ill. 55). Golein emphasized
that reception of both the body and the blood of Christ in the Eucharist was a privilege re-
served for priests.[102] This scene conforms in its major lines to the scene of the king's com-
munion, and its introduction into the queen's ordo emphasizes that the queen shares in
this sacerdotal privilege.[103]

Although not mentioned in the text of the Ordo of Jeanne de Bourbon or in any previ-
ous queen's ritual, a veil is given prominence in the illustration of Jeanne de Bourbon's
anointing (pls. 31–2). On a pragmatic and concrete level the importance given to this
splendid sheer white cloth must have been understood by the society gathered at Reims as
a concession to one of the principal industries of the region of Reims and Laon: the manu-
facture of sheer white linen cloth used for ecclesiastical garments, altar linens, and more
mundane articles such as kerchiefs, under garments, bed linens, towels, sheets and ban-
dages for the sick.[104]

Sheer white cloth had long been an intrinsic element in Church liturgy, not only for albs
and altar cloths. Already in the fourth century a white veil was one of the central motifs in
the marriage rite where, in the ritual of the *velatio nuptialis,* the bride and groom were sym-
bolically united as one beneath a veil extended over their heads.[105] In this rite a large white
cloth was suspended over the couple, although during the Middle Ages it was sometimes
draped over the shoulders of the couple or over the shoulders of the husband and over the
head of the bride. The term that was applied to the cloth varied somewhat: in some usages
it was called a *pallium album,* in others, a *linteus.* In either case, the term corresponds to the
word used interchangeably for the cloth that covers the altar or the shroud of the dead.[106]

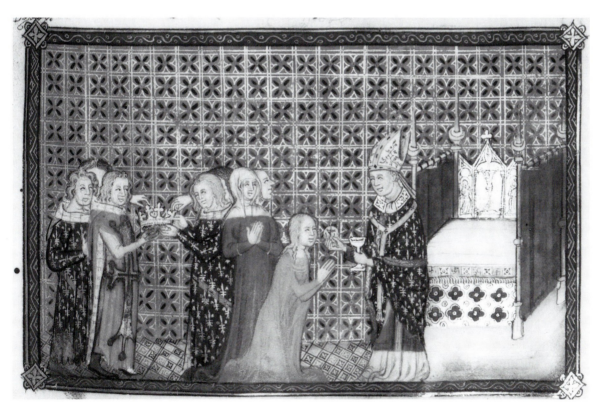

55. The Queen receives the Eucharist in Form of Bread and Wine, fol. 72 [pl. 37]

And although a bed sheet was in French called a *linceau*, it should be noted that *linceau* (*linteus* being the Latin word for linen) was also the word used for Christ's shroud.

During the course of the Middle Ages the veiling of the couple came to be reserved for the bride alone. But the ritual of the veil was also a central part of the consecration of a nun, a ceremony related to the marriage ceremony because it is essentially a marriage in which a virgin is consecrated as the bride of Christ: she receives a ring as a sign of her marriage to Christ; like the Early Christian bride, the nun had a crown, the 'crown of her virginity' (*corona perpetuae virginitatis*), and she received a veil in the rite of the *velatio virginum*, modelled on the *velatio nuptialis* of the Early Christian marriage liturgy.[107]

The imposition of the veil (*velatio virginum*) is the centre-piece of the liturgy for the consecration of a nun. The first part of the ritual is the blessing of the veil (*benedictio velaminum*), and the constitutive act in the ceremony is the transmission of the veil, the receipt of which marks the maiden's taking leave of the laity to enter into the religious state.[108] The liturgy of the consecration of nuns declares that the veil is the sign and the shield of the virgin's chastity that must be preserved as her marital responsibility to Christ her spouse.[109] Thus the veil signifies the nun's marital state as the bride of Christ who has elected her to be his spouse; according to the Roman Pontifical, it is also comparable to Aaron's priestly vestments.[110] The nun's garb, especially her veil, are outward signs of her religious ministry, meant to shield her from worldly view.

Numerous correlations between the consecration of Jeanne de Bourbon and the liturgy for the benediction of abbesses reinforce the theme of the queen's ministry and her entry into a religious state, a theme that sheds light on other new features of the cycle of Jeanne de Bourbon. It has already been noted that the tradition of comparing the queen's coronation with entry into the religious ministry is present in the Judith Ordo.[111] In the scene of the queen's anointing her breast has been shielded by a veil, although it is not mentioned in the text which merely calls for the queen's tunic and chemise to be opened to the waist in order for the archbishop to anoint her.

The presence of the veil in Jeanne de Bourbon's anointing functions analogously to the veil in the liturgy for the consecration of nuns[112]: it is the dominant motif in the constitutive act of anointing, and in that scene is used as a guard for her modesty, as Golein suggests in his treatise.[113] The queen's ordo contains a reference that is relevant to the virginal state of a nun where it states that the queen 'must always remain modest near to virginity' (*semper manens pudica proximan virginitati*).[114] Thus, as the sign and shield of the nun who is the consecrated bride of Christ, the queen's veil would similarly refer to her sacred duty to remain *proximan virginitati* after her entry into the 'royal religion' as the anointed spouse of the king who is the image of Christ. The veil in the scene of the anointing of the queen's breast underscores the religious and sacred nature of the queen's office and expresses the notion that the queen leaves the laity to enter the religious state. It seems significant that the veil is held before the queen's body in a manner that mirrors the shroud suspended before the body of Christ in several of the panel paintings of the Man of Sorrows in the Coronation Book. This visual analogy serves to compare her anointing to the anointing of Christ's body before it was wrapped in the shroud for burial, thus associating her anointing with Christ, his sacrificial death and his resurrection.

174

Concerning the duty of the queen to produce an heir and the issue of royal procreation, anointing in the early Carolingian coronation ceremony contained implications of fertility.[115] The long hair of the Merovingian kings was associated with fertility and the introduction of anointing was an effort to substitute this primitive fertility fetish with a transcendent spiritual fecundity. The introduction of anointing into the queen's ritual in the West Frankish Ordo of *c.* 900 emphasized her sacred role as servant of God and as a participant in the ministry. And prayers introduced into the Ordo of 1250 and the Last Capetian Ordo invoked the Old Testament matriarchs and the Virgin's conception of Christ, elevating royal motherhood to biblical sanctity. The addition of the nuptial veil further expresses the elevation of the queen's maternal role from a merely physical responsibility to a sacred ministerium. Above all it equates her ministerium to a union with Christ. It also proclaims her special duty to maintain marital chastity, of the utmost importance if she must produce a successor with incontestible rights of succession. The veil signifies the queen's assumption before Church and people of the sacred responsibility of maintaining absolute fidelity to her spouse, a fidelity likened to virginity, just as a nun consecrates herself as the bride of Christ.

The Ordo of Jeanne de Bourbon presents other analogies with the liturgy for the consecration of nuns. It is plausible that the exposure of the queen's long loose hair may have been necessitated by her anointing on the head, but it is not specified by the text of the ordo, nor by any previous ordo for the anointing of a French queen (although the ceremony for the consecration of a queen in the Pontifical of Durandus does indeed call for the queen's hair to be untied — *crine soluto*).[116] Rather than being a reference to fertility,[117] it is more plausible that Jeanne's long loose hair pertains to the programme of associating her sacre with the entry of a woman into the religious state. The entry of nuns into the religious state calls for the future nun to enter *nudo capite*.[118] At a time when women wore their hair long, including nuns, medieval liturgy for the blessing of nuns did not call for their hair to be cut, and the *nudo capite* of this liturgy would have meant that the young woman would have entered the church with her hair falling loose and free from all coverings and ornaments as Jeanne de Bourbon's in this image. Braids, chignons and curls of contemporary coiffures necessitated fastenings such as clips, pins, or ribbons, all of which would violate the stipulation *nudo capite*. Moreover, these curls, braids, clips, etc. were elements of fashion and luxury renounced by nuns who, in the course of the ceremony, expressly reject the vestments of the laity as an expression of their taking leave of that state. The *nudo capite* is thus an implicit expression that the queen has left the lay estate. Moreover, like the vassal whose bare head signifies his submission to his lord, the queen's uncovered head also signifies that she submits to her lord to become the bride of Christ.

Another illustration of the queen's cycle that responds to innovations in the king's cycle pertaining to the theme of the king's entry into the 'royal religion' is the scene illustrating the unlacing of the queen's garment in preparation for the anointing of her breast (ills. 48, 57). In this scene the queen turns her body to the left and bends forward, apparently to allow the woman standing behind her to open the back of her garment. This unduly

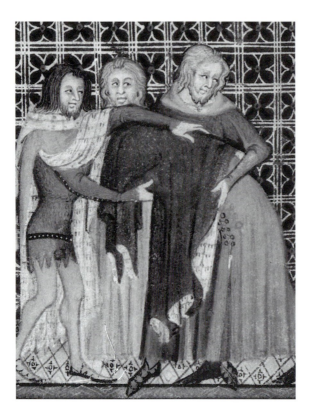
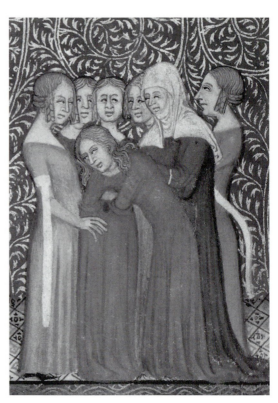

56. The King disrobes before his anointing, fol. 47v [detail of pl. 17]

57. The Queen unlaces her Garment before her anointing, fol. 67v [detail of pl. 31]

complicated position is illogical because there was no need to open the back of her garment since, unlike the king, she was not anointed on her back or on her shoulders. The following miniature and the accompanying text pertaining to the anointing of the queen's breast emphasize that the queen's tunic was opened to the waist, a phrase already in the Last Capetian Ordo. On the other hand, because the king was anointed on his back and shoulders as well as on his breast, it was necessary to open both the front and the back of the king's garment. Golein explained that the divestiture of the king's garments signified his entry into the 'royal religion'.[119] In the scene of his disrobing before the anointing (ill. 56), the king bends forward and turns his body to the left, and in the comparable scene of the queen's preparations for anointing (ill. 57) her position is sufficiently similar to the king's to suggest that it was derived from the equivalent scene in the king's cycle. The similarity between the poses of king and queen draws together and compares the same stages of the separate ceremonies.

The primary goal of the queen's cycle, then, was to establish a parity between the ministerial status of the king and queen. When the queen's cycle departs from the king's, differences between king and queen are thrown into high relief. These departures for the most part take the form of omissions. Some of these omissions require no explanation, for example the sword and spurs, as they belonged to the military duties of the king.[120] The anointing on the head endowed the king and queen with the wisdom of the Holy Spirit to fulfil their respective ministries. The queen was also anointed on the breast like the king, but un-

176

like him, she was anointed neither on the shoulders nor the hands, and because of the latter she did not receive blessed gloves, an omission which differentiates the queen's powers and ministry from those of the king. The king is exalted by the distinctions that are drawn between his ceremony and the queen's, the absence of the consecration of the hands and the investiture of the gloves from the queen's cycle heightening the importance of their presence in the king's cycle. This absence distinguishes the anointing of the king of France with the Celestial Balm from the anointing of ecclesiastics and other kings and thereby underlines the uniqueness and special privilege of his anointing. In his treatise Golein emphasized that, although the anointing of the king's hands does not give him the power of the priest to forgive sins or to consecrate the Eucharist, only the king of France is endowed with the miraculous capacity to cure scrofula.[121] He cites the queen's inability to cure scrofula as proof of the uniqueness of the king of France and his superiority over other consecrated rulers, for all of those who are anointed with lesser oils — the queen, other kings, priests and bishops — do not receive this miraculous faculty.[122] Heightening the sacerdotal and episcopal character of the queen's consecration sets the king's consecration apart from those consecrations which only use oils blessed by a bishop rather than the miraculous Celestial Balm.

Although an abbess was invested with substantial temporal authority and limited spiritual authority, neither a nun nor an abbess received sacerdotal powers to consecrate the Eucharist or to say the Mass. The absence of the consecration of the hands in the queen's cycle limits the scope of the queen's spiritual status. By virtue of her consecration she is given a higher spiritual authority than any other woman in the history of the Church, even more than the most powerful of abbesses. But she is not equal to an ordinary priest who can consecrate the Eucharist.[123]

The Ordo of Jeanne de Bourbon elevates the queen to a higher status than any previous woman in the history of Christianity. She is endowed with some aspects of episcopal authority, and she is raised higher in relation to the king than any previous queen in French history. But all of this has as its ultimate end the exaltation of the anointing of the king of France with the Celestial Balm. This point is clearly stressed by the miniature cycle of the Ordo of Jeanne de Bourbon.

Golein's treatise is like a handbook which explains the meaning of the verbal and pictorial imagery of the Ordo of Jeanne de Bourbon. It is especially informative on the innovations in that ordo which centre on the very themes emphasized by Golein: that the kingdom of France remains to the kings of France descending from the direct male line, and that the king of France engenders a male heir who has succession as his paternal heritage; that through her sacre the queen enters into the 'royal religion' for which it was her sacred duty to bring forth a male heir; and that a woman does not inherit the throne of France because she has no right to be anointed with the Celestial Balm and does not have the power to cure scrofula. Not only have traditional elements of the sacre of Jeanne de Bourbon been assembled in such a way that they contribute to the above themes, but new features have been added that reinforce the above themes in explicit ways.

Golein affirmed that the queen was indispensable to the cause of male succession to the throne of France, and he links the anointing of Jeanne de Bourbon to the king's and to the

cause of succession of the kings of France. According to Golein the ' … emperor of France (is) anointed with the precious ointment carried from heaven (so that he) would be more worthy to engender children having succession as their paternal heritage and ordained from God'.[124] Male succession is according to divine mandate:

> … and the kingdom of France remains to the kings of France descending from the holy and sacred line by male heir, so that this blessing remains in transfusion of one into the other. And because of this the queen also was consecrated with my said sovereign lord, Madame Jeanne de Bourbon, daughter of the noble prince the duke of Bourbon, who was descended from that holy line and was his cousin, but by the dispensation of the Church was permitted to wed. By this reason of holy consecration and from God without other means, blessed generation: I conclude that it is a greater dignity to be king of France than emperor.[125]

In this passage we see that the queen is central for the continuation of the sacred and holy line of French kings, the *christianissimum genus* of royal sainthood that has engendered saints. Her descent, combined with that of the king, assures the birth of an heir who is doubly endowed with the royal and saintly heritage of their progenitors. This heritage, this 'blessed generation', to use Golein's words, makes the heir born from this sacred couple the most worthy candidate for the anointing of 'the most holy worthiness'. This *is* divine election, simply to be born from such a sanctified union. All of this is advanced to demonstrate that it is 'greater dignity to be king of France than (German) emperor', elected not by God but by humans.

After elevating the queen to this unique position in Christian society, Golein developed his culminating, historically specific theme around the queen: that women do not have the right to inherit the throne of France, and that the English king, who claims otherwise, is in error. For, although she is anointed, she is not anointed with the Celestial Balm from the Holy Ampulla with which the king is anointed, but merely with the oil made by the blessing of the archbishop. Consequently, she cannot cure scrofula, a power transmitted exclusively through anointing with the Celestial Balm, with which, Golein argues, a woman cannot be anointed:

> to cure the malady of scrofula has not been given to a woman … [therefore a] woman cannot and must not inherit the kingdom by means of carnal succession in France, but it would be in error because the first anointed king made the ordinance that to woman does not pertain the anointing of the holy ampulla, therefore … to woman neither by royal succession nor by election, because Charlemagne, to whom was given the oriflamme and the ordinance of the election of the pope and of the emperor, and of the king of France, ordained with the Church, with the pope and the holy college of Rome, and many prelates and kings and dukes, and other Christian princes, by the accord of all, that the kingdom of France must be held by succession of the male heir the closest of the line because each reasonable man can conclude sufficiently that to woman does not pertain such dignity of such anointing,

nor of such arms to govern because that seems more a divine than a human ordinanceThe vermeil oriflamme signifies the Son in humanity raised on the cross reddened with his precious blood, therefore, it seems enough that this dignity pertains better to man than to woman and that the king of England, Edward, who has long held that error saying that because of his mother he has a right to the kingdom of France, he is not well-informed on this fact.[126]

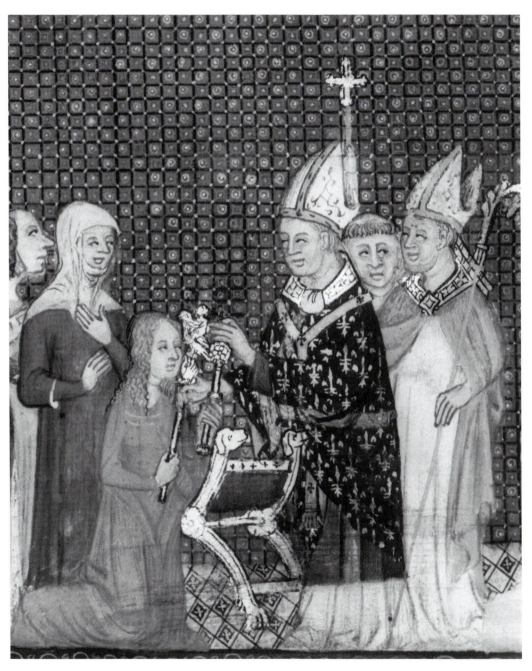

58. The Delivery of the Queen's Sceptre and Verge, fol. 69 [detail of pl.34, considerably enlarged]

ann confecrat episcops. Oratio.

Te invocamus domine sancte pater omnipotens eterne deus. ut hunc famulum tuum. N. quem tue divine dispensationis prouidentia in primordio plasmati usq; in hunc presentem diem. iuuenili flore letantem crescere concessisti: eum tue pietatis dono ditatum plenium q; gratia neritatis. de die in diem coram deo et hominibus ad meliora semper proficere facias. ut sumi regiminis solium. gratie superne largitate gaudens suscipiat. et misericordie tue muro ab hostium aduersitate undiq; muniuit: plebem sibi comissam cum pace propiciationis. et virtute victorie regere mereatur per dominum. Alia oratio.

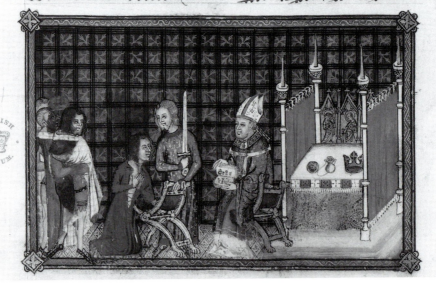

59. The Archbishop of Reims recites the `Te Invocamus', fol. 51v [pl. 15]

Chapter 5. The Coronation Book: Structure and Meaning

A N ILLUSTRATED MANUSCRIPT is more than the sum of text and images: the presence of an illustration on a page sets off a dialogue between text and image, placing the text in a precisely delineated framework and imposing upon it a point of view from which it is to be approached. The Coronation Book provides an exceptional opportunity to examine the interactive, indeed intertextual, process that occurs when a text is accompanied by images and, in this case, given the political nature of the text, the role played by images in shaping perceptions concerning political and religious ideas. The miniatures are virtually a visual text which actively relates to the accompanying ruler-making text in a way that affects the comprehension of the text and the ritual it describes. The miniatures do not merely illustrate the text: they supplement it with information concerning the implications of the ceremony. Not only do they give practical and concrete information for understanding both the technical and the symbolic content of the ruler-making text, they define the nature of the ruler created by this ritual, and in so doing visualize the structure of the monarchy of which he is the head.

A text is not inert. Once written it has an existence independent from its author and is capable of being understood quite differently by different readers.[1] The presence of an image submits the text to a process of interpretation that operates on several levels and introduces into the reading process extra-textual matter that may alter or transform the meaning of the text. The text will not be the only factor to determine the content of the illustrations. The point of view of the patron who commissioned the illustrated manuscript may intervene, and however strictly an artist adheres to the content of a text, the very act of illustrating it subjects it to interpretation that intervenes in the communication between author and reader. The same text can be read and understood differently by different artists, and whether or not the author personally directs the artist, the text is inevitably seen through the eyes of the artist.

An illustration imposes itself upon the act of reading: it circumscribes the perspective from which the text is viewed and shapes the way that the reader will take it in. A cycle of illustrations organizes and directs the reader's passage through the text. The intellectual process involved in reading a text is interrupted and even altered by the presence of illustrations, and the eye and the mind interact differently with a text when it is accompanied by images. In taking in a visual image, a reader's concentration on the regular linear flow of the written words is arrested and the direction of the eye diverted from its regular left to right, line-to-line movement. The reader no longer focuses only on what is read because the image impels the reader to engage in a different form of visual activity. Images invite the reader to regard them and to contemplate their visual content. Some images require a body of knowledge to be understood, while others may challenge the beholder's imaginative powers. The presence of a continuous sequence of illustrations accompanying the text is more complex still, developing a dialogue *in continuo* between text and images. These

cycles of images not only interact with the accompanying text, they also interact with each other across the folios of the manuscript, acting as visual *renvois* to signal interconnections and recurring themes within the text. There is a cumulative impact so that a text accompanied by such a cycle is quite a different matter from the same text without illustrations, or accompanied by different illustrations.

Because it is a text of ruler-making, the Coronation Book and its illustrations are concerned with the role of ritual and images in the creation of political perceptions and ultimately of political power itself. The sacre served to detach power from a single individual and transfer it to a recognized institution, putting access to power into the hands of those who performed the ritual. The Coronation Book is a receptacle for holding, preserving, and presenting that ritual. Particularly through its images, the book visualizes the process, not merely in its concrete technical details, but in its more profound ideological and symbolic levels of meaning. Through the interaction of text and images the Coronation Book provides exceptionally clear insight into the nature of the ruler-making ritual, of the ruler that it was designed to create, and of the individual who was charged with administering this ritual. The ritual of the Celestial Balm is the ritual of Reims, but, by means of the cycle of illustrations, the archbishop of Reims is presented as the instrument of God in the making of the *rex christianissimus*. The archbishop is shown to be a power behind the throne, not only in individual illustrations, but also through the structuring and interpretation imposed by the cycle as a whole on this ritual text.

This chapter investigates the role of this comprehensive cycle of illustrations in the *Coronation Book*. How was this cycle created? Are the miniatures individually and as a cycle original? In formulating this cycle of illustrations, did the artist follow models or was he guided by the text alone? Do the miniatures derive from eye-witness accounts of the coronation of Charles V and Jean de Bourbon? Other questions pertain to the function of the miniatures in relation to the text and to each other and what they reveal about the purpose of the manuscript as a whole. What function do the miniatures play? Were they meant merely to illustrate the text, or do they accomplish more? The codicological structure of the manuscript provides answers to some of these questions.

I. The Structure of the Coronation Book

1. Description of the Manuscript

The Coronation Book is composed of six gatherings, all originally having eight parchment leaves, now measuring 278 x 194 mm in their present trimmed condition. The present numbering of the folios begins with 35 and runs without interruption through to 80. The seventh leaf of the second gathering (between fols. 48 and 49) and the fifth leaf of the third gathering (between fols. 53 and 54) are missing, excised sometime after 1631 when John Selden published the text including the missing segments of the Ordo of Charles V in the second edition of his Titles of Honour.[2]

Sometime in the late sixteenth century or early seventeenth century the Coronation Book was bound together with an English pontifical that began on fol. 3 of the present numbering, was interrupted on fols. 35–80 for the insertion of the Coronation Book, and concluded on folio 188v. The two manuscripts are now rebound separately. The records of the British Library indicate that the manuscript was sent to the bindery in 1899, 1937 and 1938. The two works were still together when Dewick published his edition in 1899. A blank folio inserted before folio 35 indicates that the separation of the Coronation Book from the pontifical and their rebinding occurred in 1937. Both manuscripts still bear the same press mark and are now distinguished from each other by their respective folio numbers.[3] The Coronation Book has a modern binding of red morocco leather.

The folios of the Coronation Book are ruled for a single column of text of 20 lines, and the script is a *gotica textualis formata*, similar to that of many contemporary service books, written in dark brown ink with rubrics in the same script in red ink. The letters are large, upright, clearly-shaped, quadratic in form and very regular in size and spacing. Ascenders and descenders have been tightly contained within the rulings for the lines, and flourishes have been suppressed. The result is a text that is sober and restrained in appearance with a consistency and regularity suggesting that it was written by a single scribe. As was usual for service books that were made to be read in a liturgical setting, the size of the script is relatively large in relation to the page.

Individual formularies and rubrics throughout the text begin with unusually lavish filigree initials, alternately in red and blue ink and ranging in height between one and seven lines, their size corresponding to a hierarchy of importance of the prayers. Although quite elaborate, these initials are compact and usually contained within the rulings for the margins but for the exceptional flourish that intrudes into the left margin. Their consistency of style indicates that they are the work of a single filigree artist. When space remains at the end of a line it is filled with line endings composed of decorative scrolls that are always kept well within the rulings for the margins and lines.

The manuscript now has thirty-eight miniatures of which the first serves as a frontispiece for the text of the French translation of the Directory of *c.* 1230 (fols. 35–41); twenty-seven illustrate the Ordo of Charles V, the *Ordo ad inungendum et coronandum regem* (fols. 43–66); nine illustrate the Ordo of Jeanne de Bourbon, *Ordo ad reginam benedicendam* (fols. 66v–71v); and one, the blessing of the oriflamme, *Benedictio vexilli* (fols. 71v–72). Seven of these miniatures are contained within the rulings for the body of the text and thirty-one are located in the lower margins. A Latin text of the king's oath and a list of ancient and new peers of France appear between the French translation of the Directory of *c.* 1230 and the Ordo of Charles V (fols. 41v–42v).

Following the text of the queen's ordo on fol. 71v, the *benedictio vexilli* begins and concludes on fol. 72. This is followed by a litany (fols. 72v–74v) after which is the king's colophon and signature on fol. 74v. A series of oaths begins on the line after the king's colophon. The first is written in a notarial script which differs from the formal liturgical script of the ordo but is similar to the script of the king's colophon. The oaths which follow begin on fol. 75 and, as Michelle Brown has pointed out to me, are written by the same hand that corrected the king's oath on fols. 46v and 47. Dewick thought that these oaths

were added later. However, they were already in the manuscript before the death of Charles because their presence is mentioned in the description of the Coronation Book in the Louvre inventories.[4] The oaths are written on the ruled lines and within the margins on the folios following the text of the ordines. The first oath is that of the port-oriflamme (fol. 74v). The oaths of the peers, the barons of Guyenne, knights in the king's service, officers of the royal mint, heralds and captains begin on fol. 75 and conclude on fol. 80. After the last of these oaths an oath of allegiance to the king of England has been written in a different, fifteenth-century hand.[5]

2. The Lost Miniatures and the Original Cycle

There is evidence that the manuscript once had more than the present thirty-eight miniatures. As the entire text of the Ordo of Charles V was published in 1631 by John Selden, the manuscript was intact at that time. By calculating the length of the missing text, the excised leaf between 48v and 49 would have had sufficient space to accommodate two miniatures within the rulings of the text describing the blessing of the sword and the first transmission of the sword to the king by the archbishop of Reims. The length of excerpted text from the missing leaf between 53v and 54 would have allowed for one miniature within the body of the text, and possibly a second miniature partly within the text and partly in the lower margin. Or this folio could have had one large miniature within the rulings for the text. The missing text concerns the anointing of the king's head and breast. Considering the primary importance of these acts and the presence of a large miniature of the anointing of the king's breast in Charles V's copy of the *Rational of Divine Offices* (ill. 50), it is likely that this lost folio carried a textual miniature of this subject. There was probably a second miniature, partly within the rulings for the text, and possibly extending into the margins, and this would undoubtedly have illustrated the important ritual of the anointing of the king's head, the subject of the adjacent text.

Besides the missing leaf between fols. 48v and 49 of the present numbering, and a missing leaf between fols. 53v and 54, the exceptionally ample lower margins of fols. 45–45v and 71–71v have been cut out and the rectangular lacunae have the same dimensions as the marginal miniatures. The text on 45–45v pertains to the entry of the canons of Reims into the cathedral and the placement of the cathedra of the king in view of the archbishop's cathedra. Because of the importance of these rituals, both innovations of the Ordo of Charles V, it is plausible that there were two miniatures back-to-back on these cut-out margins. The rituals of the text on fols. 71–71v are the queen climbing her solium, her enthronement on the solium, and the barons sustaining her crown. It is likely that there was at least another marginal miniature illustrating the queen's enthronement on the solium and quite possibly a second marginal miniature on the verso illustrating the queen and barons climbing the solium.

Taking into account these projected lost miniatures, the original cycle of the Coronation Book had forty-six miniatures, eleven within the rulings for the text and as many as thirty-five in the lower margins. The king's cycle, with twenty-eight miniatures at present,

would have had thirty-four and the queen's cycle, now with nine miniatures, would have had eleven.

3. Marginal and Textual Miniatures: A Cycle within a Cycle

The miniatures within the body of the text are more closely associated with the text than are the marginal miniatures because of their placement within the rulings for the text, because the text is interrupted for their insertion, and because they are preceded and/or followed by rubrics that refer directly to the imagery of the miniature. For these reasons it is certain that these textual miniatures were planned from the outset.

Sherman argued that the marginal miniatures were not planned when the text was copied because of their location below the text where, in her estimation, they appear to have been squeezed into the lower margins, and because the frame of one of the marginal miniatures of the queen's cycle was painted over flourishes of an initial on the bottom line of the text. Against this hypothesis, the margins were once larger, for they have been trimmed to their present size, and, despite this trimming, the lower margins are still ample, sufficient to accommodate the miniatures comfortably and to leave enough space for a margin below the miniature. The instance of overlapping which she cites cannot be used as proof that the miniature was not planned when the text was copied because this same overlapping occurs in one of the textual miniatures of the king's cycle (fol. 59v) which indisputably belong to the original execution of the manuscript, space having been left for them when the text was copied. If the folio where this overlapping occurs is considered as a whole, it is evident that the overlapping was due to the filigree artist who, for one reason or another, did not contain the initial within the bounds of the rulings for the text as he usually did. It is not impossible that the artist sought to emphasize these initials and also, perhaps, to tie the miniature to the text in an especially concrete way. For, in the two places where this overlapping occurs, the filigree initial begins a rubric or prayer that refers directly to the illustration, acting like a title for the miniature, made more apparent by the liaison created by this overlapping.

There are many concrete indications that both the textual and marginal miniatures were planned as part of one continuous cycle. The consistency of the miniatures as a whole provides the first indication that both orders of miniatures were conceived at the same time. The structure of the manuscript reveals the processes by which the miniatures were made and shows that, together, textual and marginal miniatures constitute a single programme and that their consistency is the result of a deliberate effort. All of the miniatures, textual and marginal, partake of the alignments of the rulings of the text.[6] The sides of the frames of all the miniatures are drawn along the vertical rulings of the text column. The top and bottom of the frames of the textual miniatures correspond to horizontal rulings for the lines of text, while horizontal lines of motifs within the miniatures are often drawn over rulings for the lines of text. The top sides of the frames of the marginal miniatures are aligned with the bottom horizontal ruling for the text, and the bottom sides of many of the marginal miniatures are drawn from the lower prickings for the vertical rulings of the margins of the text. The measurements of textual and marginal miniatures

closely correspond. All the miniatures are approximately the same width, ranging between 115 mm and 117 mm, coinciding with the vertical rulings of the margins of the text. Differences in height between marginal and textual miniatures are insignificant and the measurements confirm that only minor differences exist between the marginal miniatures, ranging in height from 73 mm to 77 mm, while the textual miniatures range in height from 77 mm to 85 mm. The first two miniatures (pls. 1, 2) are perceptibly larger at 104 mm and 105 mm respectively, their dimensions dictated by their position as frontispieces for the French directory and for the Ordo of Charles V. Their supplementary height has been carved out of the upper margins which the miniature invades to the equivalent of as many as three lines of text.

The alternating rhythm of the red and blue of the backgrounds and frames is another indication that the textual and marginal miniatures belong to the same campaign. As a rule, a miniature with a predominantly blue background and a red frame alternates with a miniature having a predominantly red background and a blue frame. With a few exceptions, such as the two frontispieces and those places where the sequence is broken by miniatures that were cut out, this pattern of alternation is respected whether a textual or marginal miniature. Had the textual miniatures been painted in a first campaign, this consistent alternation of red and blue background should be evident in these miniatures, but as a separate group they lack this pattern of alternation. On the other hand, the present rhythmic pattern of alternation that runs through the continuous cycle would have been impossible to impose upon the cycle had the marginal miniatures been added in a second campaign.

Another sign that the marginal miniatures were planned at the time that the text was written is that frequently the bottom line or lines of text act as a title for the miniature in the margin below. Furthermore, several of the most important events of the sacre are marginal miniatures, such as the arrival of the Holy Ampulla, imposition of the king's crown, and the king climbing the solium. It is doubtful that rituals of such central importance would have been excluded from a first core of illustrations.

Many marginal miniatures form pendants with the scene on the facing folio.[7] In some cases the marginal miniatures of two facing folios are bound in a direct way to the text. For example the miniature on fol. 51v (ill. 59) refers directly to the text above it by the words of the prayer *Te invocamus*, the opening words of the prayer on that folio, which appear on the archbishop's open book shown in the miniature. Similarly the scene of the queen kneeling at the cathedra as the archbishop recites over her the prayer *Omnipotens eterne deus ...* (ill. 47) is bound to the text by the words of that prayer *super hanc famulam tuam* written directly above the miniature in which the queen's kneeling position refers directly to this expression of servitude in the text of the prayer.

These observations allow us to conclude that the cycle did not develop in two stages, but was planned from its inception to have a two-tiered cycle of miniatures, one group being singled out for special emphasis by location within the body of the text, and a second group in the lower margins. This conclusion is reinforced by the unified style and narrative continuity of the miniatures. The presence of two orders of miniatures lends insight into the processes by which the cycle of illustrations was created. The majority of the

186

miniatures are located in the lower margins, but, because of their placement within the margins, the textual miniatures assume priority in relation to the text. Their integration into the text tightly links them to it while also connecting them to each other. We have seen in chapter 3 that these miniatures constitute a sub-cycle exalting the priority of the archbishop of Reims in the making of the king and queen of France and defending his claims over the pretensions of the abbots of Saint-Denis and Saint-Remi and the archbishop of Sens.[8]

II. The Making of the Illustrations of the Coronation Book: Form and Meaning

No extant manuscript is sufficiently similar to the cycle of the Coronation Book to have served as the model for this manuscript. Consisting of fifteen miniatures subdivided to make thirty illustrations of successive ritual acts in the sacring of a king and queen, the miniatures of the illustrated copy of the Ordo of 1250 constitute a narrative cycle that makes it the most densely illustrated text for the consecration of a king and queen prior to the Coronation Book and its closest ancestor (ills. 23–26).[9] As already noted, the redactor of the Coronation Book almost certainly knew this manuscript.[10] The two manuscripts share common features: both eliminate divine personages and restrict the figures in the scenes to participants in the sacre; both have rectangular frames; and both have alternating red and blue backgrounds. Nevertheless, comparison of the Coronation Book with this manuscript reveals that individual miniatures of the Coronation Book were not copied from this manuscript, for it lacks precise historical details, it illustrates a different sequence of rituals, and when the same ritual actions have been illustrated they have been interpreted differently.[11] If the redactor of the Coronation Book was inspired by this miniature cycle, he borrowed very selectively, significantly transforming the model.[12]

The cycle of historiated initials in the University of Illinois coronation ordo (ills. 27, 28) also anticipates some of the illustrations of the Coronation Book, particularly as it has more than one scene illustrating the queen's ceremony and also emphasizes the archbishop of Reims. The redactor of the Coronation Book is likely to have known this manuscript, because, as we have seen, it contains details that associate it with the marriage of Philip VI and Blanche of Navarre, and it appears to have once been in the library of the archbishop of Reims. Yet, if it did serve as a model for the Coronation Book, it was only in the most general sense, for its illustrations present a different sequence of rituals and they differ significantly in format, being small historiated initials in a generic style devoid of the historical realism of the miniatures of the Coronation Book.[13]

But the absence of extant models for the Coronation Book is not the only indication that the cycle of miniatures is original. Compelling evidence of their originality is provided by the miniatures themselves, by their relation to the text and to each other. The cycle achieves a unity of conception, format, composition, colour scheme, and lively narrative action. This unity is remarkable, particularly as the miniatures illustrate rituals derived from a diversity of sources which were united for the first time in the Ordo of Charles V,

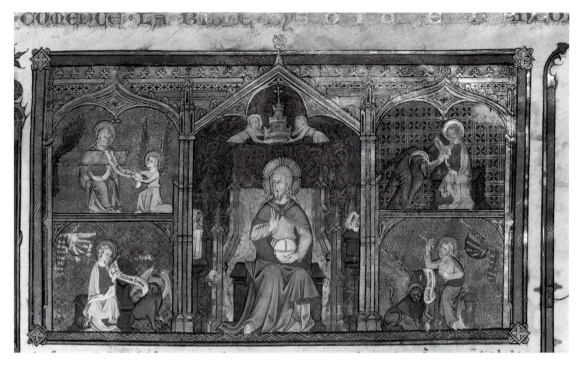

60. Detail of the Frontispiece of the *Bible Historiale of John the Good.* London, BL, MS Royal 19 D II, fol. 1

compiled not more than a year prior to the creation of the Coronation Book. Such unity is unlikely to have resulted had the illustrations been copied from extant illustrations in the diverse range of textual sources drawn upon for the compilation of the Ordo of Charles V. The unity and coherence of the miniature cycle result not only from the use throughout of the same rectangular frames, but also from the repetition of the same compositional formulae. Each scene is set off against a brightly coloured diapered geometric background and the composition of each scene adheres to the same tripartite formula with the main action isolated in the centre and a group of lay persons at the left and an altar and clerical personages on the right.

The process followed by the artist in executing the miniatures can be observed through close examination. In many of the miniatures the line sketches are visible through the paint, allowing us to see how they were composed. The figures, architectural features, and altars were drawn by the same hand directly on the vellum with pen lines in brown ink. Next, the backgrounds were painted in around the pen lines. Many of these backgrounds are very special, and almost all are of very high quality and finish, with considerable detail and workmanship. Many of these patterns appeared earlier in the *Bible Historiale* of John the Good (London, BL, MS 19 D VII) (ill. 60) in which almost all of the miniatures were painted by the Master of the Coronation Book. This makes it likely that the backgrounds of the miniatures in the Coronation Book were not executed by an assistant, but by the Master himself. At this same stage, the patterns of the altar cloths and altarpieces were painted, gold leaf was applied, and the patterns of the tessellated floors were also executed.

After the backgrounds were completed, translucent flesh tones were washed over the pen lines muting these lines to a paler shade of brown. The hair was given a flat base layer of opaque yellow, and the garments were also painted with various colours of under-painting.[14] Then a layer of greater detail was added to the figures: the faces of the most important figures were modelled with a rose-mauve wash, and the folds of the garments were painted in with transparent blue-grey wash.

The final stage of execution involved overpainting with some very special techniques. The virtuosity of the artist is most evident in the finishing details, and particularly in the finishing of the portraits. The faces of the most important figures, the king, the duke of Anjou, and the archbishop were finished with modelling built up with graduated tones in individual, extremely small brushstrokes and highlights in the same brushstrokes in an opaque impasto of slightly glossy white paint. The precision of the detail in the portraiture is astounding considering the very small scale of these portraits. As this detail is only fully visible with the use of magnification, it is clear that the painter used a magnifying lens. Clearly this artist was a master of the art of miniaturization.

The artist's virtuosity is also evident in the finishing of the detail of the jewels, crowns, altarpieces and the textures of fabrics which appear in these paintings. These details are so precise that it is fair to speak of portraiture with respect to these objects. The artist was a master in the portrayal of transparency in all of its various forms. One remarkable example is the alb in a sheer white fabric with opaque white folds painted over the pink robe of an acolyte on fol. 35v. The same technique appears in the veil in the scene of the anointing of the queen's breast. It was at this stage that the transparent glazes were applied over the brocade fabrics and backgrounds of the altarpieces throughout the miniatures.

Some of these altarpieces were painted with techniques that were actually employed in the painting of altarpieces of the period, testifying to the Master's familiarity with the workshop techniques of panel painters. On fol. 65v a special effect is visible on the altar-piece where the minute figure of St Catherine of Alexandria stands out in burnished gold against a matt gold background. The stages of execution are visible: first gold leaf was laid down, then the figure was defined when the background was painted around it with a transparent gold glaze, giving a matt finish to the gold leaf and leaving the figure of the saint to stand out in the original burnished gold leaf. Then the details of this figure were overpainted in almost microscopic lines of opaque white and black paint. All of these glazes present a craquelure, suggesting the use of an oil-based medium. The strands of the hair of all the figures were also overpainted with wavy lines in a transparent sienna colour that appears to be in the same medium. Another special technique is evident where a second kind of gold appears. This is more matt than the burnished gold leaf, and it is different from the matt gold surface applied to the altarpiece in the miniature of fol. 65v (ill. 61), for it uses an opaque impasto painting technique. In some places this gold paint has seeped through to the reverse side of the folio where it has left an oily stain and, with the aid of a cold light and magnification, the gold appears granulated, while on the front this gold paint presents the same craquelure. It is evident that the paint was made by suspending fine gold granules in the same medium, giving every appearance of being oil-based because it adheres to the gold leaf. Other media such as egg tempera, water or gum arabic,

would not have adhered so well to pliant, foil-covered parchment. Finally, there is a touching-up of details on the gold and on the eyes of all of the figures with very fine, firmly-executed, calligraphic black lines painted in with an extremely fine brush, perhaps even a single fine bristle. The whites of the eyes and highlights were touched in last with the same glossy, opaque paint. This technique is the hallmark of the Master of the Coronation Book.

The king's face has been distinguished from the others in that it has been given the greatest degree of finish, but there is no evidence that his face was painted by another hand as the hair and the eyes of the king's portraits are finished in exactly the same manner and with the same techniques as the other figures. It is not very likely that a master who specialized only in making the king's portrait would have intervened at the final stage to execute the king's portrait and then go on to touch up the eyes and hair of *all* of the other figures including the minor figures in the auxiliary groups, and it is also unlikely that a miniaturist responsible for secondary figures would have come in to touch up the eyes and hair of a portrait of the king otherwise painted by a specialist. This conclusion is supported by the fact that the size of the king's head, although larger than the other heads, was determined by the artist who drew the lines of the composition in pen onto the parchment, and also because the backgrounds conform to the outlines of the king's head. All the underdrawings, including those for the king's portraits, were executed by the same hand.

While there could have been plenty of opportunities for the intervention of assistants in this multi-layered process, this does not appear to have been the case, and everything indi-

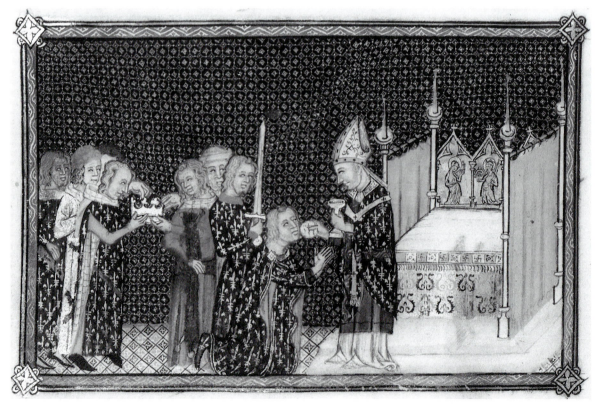

61. The King receives the Eucharist in Form of Bread and Wine, fol. 65v [pl. 28]

cates that the painting is the work of a single hand.[15] While it is not impossible that assistants were involved in the intermediate stages, if more than one artist is involved, the artists were working so closely under the direct supervision of the Master that all of the miniatures present the same techniques and the entire cycle achieves the net effect of a single artist. There is, however, variation amongst the miniatures throughout the cycle, but upon close examination one can see that this variation is due to the relative degree of finish that has been achieved in the miniatures. Less finished miniatures have a harder appearance in which the outlines of the underlying pen drawings are more evident. But where paintings have been worked up to a higher degree of finish with more layers of overpainting to model faces and indicate details, the pen outlines have been softened or obscured, and the faces are more expressive and the body forms and drapery more plastic. The original pen drawings and the final touching up of all of the faces have been executed by the same hand. Moreover, as noted, all of the backgrounds present a remarkable consistency of finishing and intricacy of detail. One must relinquish any notion that the Master delegated whole miniatures to assistants — indeed the entire cycle was his work, whether or not he was assisted in the intermediate stages. But the question of assistants here is wholly hypothetical, for there is no visible evidence for their intervention in the miniatures when examined at close range.

The miniatures have been composed with the use of stock figures which reappear from scene to scene, individualized for each instance by means of gesture, costume, attributes and often by portraiture. There are several basic stock figures. The groups of lay persons on the left side of most compositions include a standing male figure dressed in a cloak with an opening on the right side through which he extends his arm. This same stock figure reappears with his arms held under the cloak. The auxiliary bishops and the archbishop's cross-bearer are stock types throughout, and the figure of Louis of Anjou adheres to the same pattern throughout. The king is shown in five basic poses and the archbishop of Reims in four, some so similar that they are likely to have been traced from the same pattern (as for example, the archbishop in pls. 30 or 35, or the king in pl. 6, which is the reverse of his figure in pl. 3).

While this use of stock figures suggests that workshop patterns were used to compose individual figures and groups, it also demonstrates the originality of the illustrations in the Coronation Book, since the same stock figures reappear throughout the cycle in scenes of individual rituals that were derived from very different textual sources. The figure of the archbishop, for example, is the same in the scenes of the king's oath, the transmission of the sword and gloves, and the opening and closing of the king's tunic, none of which had ever been combined into a single ordo prior to that of Charles V. With only a minor adjustment of the hand gesture, the figure of the archbishop is the same in the above as in the scenes of the anointing of the king's hands, the prayer over the queen and the delivery of the queen's ring. Because all of these rituals were derived from different sources and were united for the first time only in the Ordo of Charles V and Jeanne de Bourbon, no single model could have contained illustrations for all of these scenes, evidence that the cycle originated as part of a comprehensive programme to illustrate the new ordo.[16]

191

Further proof that the miniatures are original is provided by the relationship of the images to the text and by the similarities and differences between the text and the images. As a rule, the miniatures are located in proximity to the text that they illustrate, usually on the same folio so that there is a visual tie between text and image. As this was a newly-compiled text, the tight connection between text and image is a further indication that the miniature cycle was designed for this manuscript. Some of the miniatures conflate into a single scene multiple actions illustrating more than one adjacent textual passage, as with the miniatures of the blessing and bestowal of the king's ring or the delivery of the sceptre and *main-de-justice*. But the analysis of the images and text presented in the preceding chapters and in the Catalogue demonstrates that many details in the miniatures are not in the text. Many miniatures include imagery that has been derived from other sources, whether from textual passages in another part of the manuscript,[17] from a source external to the manuscript,[18] or from other miniatures in the manuscript.[19]

Throughout the cycle miniatures are designed to refer to other miniatures, often by forming a pendant with the miniature on the facing folio. For example, the scene of the king taking his oath (fol. 46v; pl. 5) is a pendant to that of the presentation of the king to the archbishop (fol. 47; pl. 6). The visual resonances between the two scenes centre upon the repetition of the figures and actions of the king, the archbishop and the motif of the cathedra. Our review of the ordo shows that the oath was the condition for the king to be admitted to the sacre, and such a pairing expresses this conditional relationship in visual terms. Other examples are the facing scenes of the two acts of transmission of the sword (fols. 49v–50; ills. 62, 63); the matching of the two stages of the preparation for anointing (fols. 50v–51; ills. 64, 65); and the pairing of the scene of the anointing of the hands (fol. 55v) with that of the blessing of the gloves (fol. 56) (pls. 18, 19). In the queen's cycle the scenes of the opening of the queen's robe (fol. 67v) and the anointing of her breast (fol. 68) are paired (ills. 48, 49}. These pendants delineate a causal relationship between the comparable actions.

A more complex cross-referencing is apparent in the queen's cycle, where the scenes refer back to the king's cycle. We have seen that several miniatures in the queen's cycle do not have a textual basis in the queen's ordo and were inspired by the corresponding ritual in the text or miniatures of the king's ordo. Indeed, the queen's cycle is so derivative of the king's cycle that it becomes evident that its dependence belongs to a deliberate programme to assimilate her ceremony to his. For example, the illustration of the unlacing of the queen's tunic (pl. 31) was modelled on that of the removal of the king's outer garment (pl. 7), and the enthronement of the queen on the cathedra (pl. 36) and her anointing with the golden needle (pl. 32) were inspired by the respective scenes in the king's cycle (pls. 24, 18). The illustrations of the bestowal of the queen's sceptre, verge, ring, and crown, her enthronement *in cathedra*, and communion (pls. 33, 34, 35) mirror in significant ways the cognate scene in the king's cycle (pls. 21, 22, 23).

At the same time, because the miniatures contain much that is not in the text, and some miniatures have no textual reference at all, the queen's cycle is more independent of the text than is the king's. The processes operating in the creation of the queen's cycle are, therefore, more complex than those that shaped the king's, making them particularly in-

62. The Archbishop returns the Sword to the King,
fol. 49v [detail of pl. 11]

63. The King transmits the Sword to the Seneschal,
fol. 50 [detail of pl. 12]

64. The Archbishop prepares the Holy Balm,
fol. 50v [detail of pl. 13]

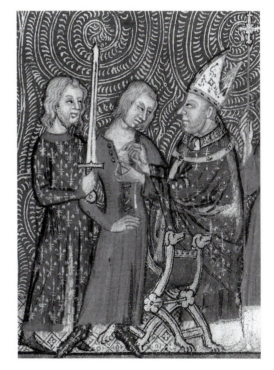

65. The Archbishop unfastens the King's Tunic,
fol. 51 [detail of pl. 14]

structive for the present consideration of the formulation of the illustrations of the Coronation Book.

The illustration of the queen's enthronement *in cathedra* (pl. 36) is especially informative about how the cycle was composed because it does not appear in the text of the Coronation Book nor in any previous ordo, thus making it most unlikely that the artist copied it from an illustrated text of a queen's consecration. The introduction of this act into the miniature cycle was not in response to the text. The most extensively illustrated queen's ordo prior to Jeanne de Bourbon's were the Ordo of 1250, with two illustrations for the queen's ceremony, and the Illinois coronation text, with eight initials, mostly of a heraldic or decorative character. One might conclude that the absence of extant models for the enthronement of the queen *in cathedra* underlay the artist's reliance upon the king's ordo for inspiration were it not for the fact that, although models existed for many of the rituals in the king's cycle, the artist did not copy them. The existence of models had little to do with the process of composing either cycle. The enthronement *in cathedra* was an innovation of the miniatures and not of the text of the Ordo of Charles V. The miniature of the queen's enthronement *in cathedra*, having been modelled so closely on the lines of the king's, shows most clearly that the queen's cycle was designed to reiterate the king's and to define analogies or differences with it.

As Clare Sherman has observed, many of the most important portraits of Jeanne de Bourbon are pendants of portraits of Charles V.[20] Keeping this in mind it should be noted that most of the scenes of the queen's cycle refer back to the king's in ways that delineate similarities and differences between the two rituals, suggesting that cross-referencing is intended to define formal and symbolic analogies between king and queen and that it is not the result of workshop copying procedures in which an artist adapted or copied extant models. This adaptation process is of a wholly different order, for it reveals the artist engaging in a process of textual commentary. This is particularly evident in scenes that are closest to their counterpart in the king's cycle, for they have not been traced from, nor do they adhere exactly to, the lines of the king's scene. Small but meaningful adjustments have been made. For example, the queen's communion (ill. 55) is closest to its counterpart in the king's cycle (ill. 61), but the attendants sustaining her crown have been differentiated from the king's by changes in their number, costume and portraiture. The two scenes of the enthronement *in cathedra* (ills. 39, 53) are so similar in outline that the queen's figure would seem to have been traced from the king's, but it has not: slight differences are evident where the king has been placed higher in his seat than the queen and he inclines his head towards Anjou whereas the queen faces frontally and her hands are placed differently. The delivery of the queen's ring (ill. 67) parallels the delivery of the king's ring (ill. 66) but for two details: the archbishop is shown blessing the king's ring, an action omitted in the queen's ceremony; and the king's ring is placed over his gloves whereas the queen's ring is placed directly on her finger as she does not receive gloves. These differences suggest that changes in the queen's scene result from a process in which a model in the king's cycle, chosen for its ritual and symbolic similarity, was adapted in order to enunciate the ways in which the queen's ceremony was equivalent to the king's, but also to demonstrate the ways in which it differed.

194

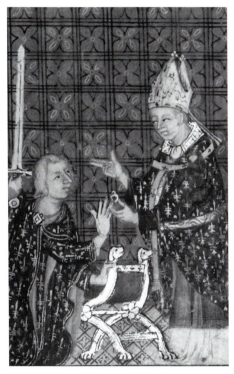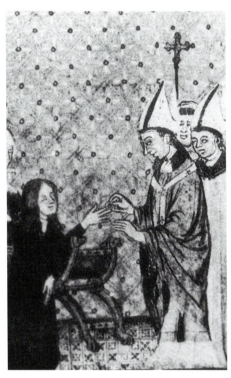

66 *(left)*. The Delivery of the King's Ring, fol. 57 [detail of pl. 21]

67 *(right)*. The Delivery of the Queen's Ring, fol. 68v [detail of pl. 33]

This point is made most concretely by the scene of the enthronement of the queen on the cathedra(pl. 36) which, while not in the queen's text, was inspired by the text and illustrations of the king's ordo. The invention of the rite of the enthronement of the queen *in cathedra* is the keystone of the programme of likening the queen to the king and of establishing a symmetry between her ceremony and his. If the density of illustrations accompanying the Ordo of Jeanne de Bourbon elevates her status vis-à-vis earlier queens and the king, the introduction of this scene into the queen's cycle is the crowning effort in that process because it demonstrates most forcefully that the cycle of miniatures depends less on the accompanying text of the queen's ordo than it does on the miniatures of the king's.

Even slight changes are meaningful and can disclose the artist's approach to an extant model, revealing further that the similarity does not result from workshop copying procedures but belongs to the programme of referring the queen's ceremony to the king's by expressing visual analogies between the two cycles. This conclusion is confirmed by the scenes of the anointing of the breast of king and queen in the *Rational of Divine Offices* (ills. 49, 50) and by the pairing of the scenes of the enthronement of the king and queen in the *Grandes Chroniques* of Charles V (ill. 54) where they derived from two separate scenes of the same subject in the Coronation Book and have been juxtaposed to form a pair.[21]

A more complex referral process is evident in the first three miniatures of the queen's cycle, each presenting motifs drawn from multiple scenes in the king's cycle. The queen's entry into the cathedral and her presentation to the archbishop (pl. 29) is a composite scene of two distinct ritual actions, but it contains features that refer back to five separate miniatures in the king's cycle. The architecture recalls the interior/exterior view of the church in the first two scenes of the king's cycle (pls. 1,2) and most closely resembles the structure in

the scene of the fetching of the king (pl. 3). The posture and gestures of the two bishops flanking the queen are almost identical to those of the two bishops in the scenes of the fetching of the king (pl. 3) and the presentation of the king to the archbishop (pl. 6). The archbishop's pose is the same as in the scene of the removal of the king's outer garment (pl. 7). Thus, elements corresponding to details in five separate scenes of the king's cycle have been telescoped into a single scene of the queen's cycle, further indication that the queen's cycle results from a process of selection and omission governed by the purpose of defining similarities with and differences from the king's ritual.

What has not been copied assumes as much significance as what has been. Only one scene has been devoted to the queen's entry, but five scenes were dedicated to the king's entry, and it is significant that no single element of the queen's entry was derived from the scene of the arrival of the Celestial Balm, underscoring the absence of this vital element from the queen's sacre and, by implication, the uniqueness of its presence in the king's cycle.

A final parallelism of the queen's cycle with the king's sheds further light on the ways in which it was designed to refer back to the king's. This is the scene of the unlacing of her garment in preparation for her anointing (pl. 31), collapsing into a single scene actions that were each given a separate illustration in the king's cycle. Although the rubrics direct that the garment be opened in the front to her waist so that her breast could be anointed, the miniature shows the queen bending forward while the countess of Artois opens the back of the garment. Given the systematic dependence of the queen's cycle upon the king's, this divergence of the miniature from the text is best explained as a deliberate reference to the king's cycle rather than an artist's misunderstanding of a model. In this case the parallelism refers back to the second stage of the king's consecration devoted to the preparation for anointing, the opening scene of which is the removal of the king's outer garments (pl. 7). Although superficially different, both correspond to the same stage in the respective ceremonies, that of preparing for the anointing. Besides the comparable postures of king and queen, the two scenes present gestural parallels such as those of the attendants and of the archbishop who looks on at the proceedings while extending his arm towards the altar to signal the succeeding act in the ceremony. In the queen's cycle, the archbishop reaches in the direction of the altar, presumably for the chrism, whereas in the king's, the archbishop reaches for the sword, as the rituals for the investiture and transmission of the sword precede the king's anointing. Only after the completion of the sequence of the sword does the archbishop take the Holy Ampulla from the altar, and in this scene his pose is identical to that in the scene of the unlacing of the queen's garment. Thus, the preparation of the queen for her anointing refers through the copying process to two distantly separated scenes in the king's cycle (pls. 7, 12). Finally, the preparation of the queen for anointing, involving the unlacing of her garment, refers back to the scene in which the king's garment is unlaced to the waist (pl. 14).

It is instructive to recall that Golein emphasized that the divestiture of the king's garments signified his taking leave of the secular estate to enter the royal religion. By likening the queen's disrobing ritual to the king's, the illustrations assert that she is similarly leaving the secular estate to enter into the royal religion. And in so doing the copying process articulates ideology and the artist engages in textual commentary.

As the referral process operating in the composition of this scene is the most complex, it is also the most revealing. It makes distinct reference to three scenes selected from the beginning and the conclusion of the sequence of miniatures in the king's cycle devoted to the preparation of the king for his anointing. This referral process necessitated some modifications in order that the similarity between the two preparations might be more clearly brought out, for what might appear to be incongruity — i.e. the queen's bending position — would seem to be motivated rather by the intention of assimilating her preparation scene to, and thus referring back to, the opening scene of the king's preparation. These devices are, in effect, visual *renvois*.

Nevertheless, the king's cycle has been given priority over the queen's in the sense that it has more illustrations, that themes which are treated independently in his are conflated into single composite scenes in hers, and that the design of individual scenes in the queen's cycle is derived from that of the king.

As the miniatures of the queen's cycle elevate the queen vis-à-vis the king and earlier queens, they simultaneously proclaim the uniqueness of the consecration of the king of France, since the cross-referencing visually expresses important differences between the two ceremonies. For example, they visibly demonstrate that the king is consecrated with the Celestial Balm and that the queen is anointed only with chrism; that the king's hands are anointed, but that the queen's are not; that both receive rings but that, unlike the king's ring, the queen's does not receive a blessing from the archbishop and is not worn over episcopal gloves. Therefore, one function of the miniatures is to define the importance of the king of France more clearly than if the queen's cycle had not been included. The presence in the king's cycle and absence in the queen's cycle of the miniatures of the arrival of the Holy Ampulla, the mixing of the Celestial Balm, the anointing of the king's hands, and the delivery of the blessed gloves proclaim the uniqueness of the anointing given the king of France and the nature of his kingship.

III. The Miniatures as a Visual Glossed Commentary

The preceding consideration of the processes shaping the miniatures of the Coronation Book and establishing relationships between the miniatures and the text bears implications for the function of the miniatures within the manuscript and for the purpose of the Coronation Book.[22] It reveals that the miniatures conduct a vigorous, creative dialogue with the text in ways that suggest they were meant to function in much the same fashion as glosses or commentaries, but in pictorial rather than verbal form. As pictorial, glossed commentary the miniatures perform all of the functions of their verbal counterpart: they order, correct, explain, interpret, criticize, and provide historical *exempla* of the text. Because of their interlinear and marginal placement, the miniatures resemble glosses in fourteenth-century manuscripts of canon law or scriptural commentary, where the gloss or commentary runs along beside and below the text without intruding into it. Anne D. Hedeman has shown that the miniatures of Charles V's copy of the *Grandes Chroniques*, executed by miniaturists working in collaboration with the scribes, particu-

larly Raoulet d'Orléans, played a significant part in structuring the text and organizing it in a manner that brought out particular political meanings.[23] Similarly, A. D. Menut, Susan Babbitt and Clare Sherman, in their respective investigations of Nicole Oresme's translations of Aristotle made for Charles V, have shown that Oresme used glosses and commentaries to elucidate the significance of his translations for the intended secular audience. Babbitt analysed the various types of glosses that Oresme employed, and Sherman's entire analysis succeeds in revealing that the miniatures are in many respects visual counterparts of Nicole Oresme's glosses and commentaries. Indeed she uses this as evidence for Oresme's part in designing the miniatures.[24]

Well before the creation of these works, the miniatures of the Coronation Book act as glosses by imposing a physical order on the text, dividing it into conceptually coherent segments. They announce the French translation, the king's ordo and the queen's ordo, and within each ordo they further identify sub-cycles, as, for example, the opening procedures, the sequences for the transmission of the sword, the investiture of robes and insignia, the anointing, the coronation, the enthronement, the mass and communion, and the sub-cycle of the archbishop of Reims. The miniatures provide a transition from one sub-cycle to the next, as where the king is shown giving the sword to the seneschal, concluding the sequence of the investiture of the sword, while the archbishop reaches for the chrismatory and ampulla on the altar, announcing the next ritual sequence in the coronation ceremony, namely the anointing. The miniatures emphasize selected segments merely by virtue of illustrating them, sometimes with a series of illustrations.

As most miniatures appear in proximity to the passage of text they illustrate, the sequence of miniatures expresses both the narrative sequence of the text and the ritual sequence of the ceremony described by the text. They also perform the important task of unifying a text compiled of components drawn from an unusually wide range of sources. Because of their regular, rhythmic distribution throughout the manuscript and their similar format of rectangular frames, background patterns and colours, the miniatures bind together the separate ordines for king and queen by establishing a linear visual continuity that runs from the beginning of the French translation, through the king's text, to the end of the queen's text. Thus the miniatures reinforce the integration of the two texts by means of formal and iconographic resonances between respective segments of each cycle.

The miniatures operate not only on a formal level by imposing order on the text, but also on an iconographic level by clarifying the meaning of the text. Form and meaning converge in the miniatures so that they act as a textual commentary. In effect, they constitute a separate visual text running parallel to the written text.

Glosses and commentaries elucidate interrelationships and make cross-references within the same text or manuscript or with another text or manuscript.[25] These cross-references expose formal and symbolic connections between texts that are physically separated from each other and would not otherwise be evident to a reader. Such cross-referencing is accomplished through reference to other miniatures, to texts within the manuscript, or to extra-textual sources such as the consecration of a bishop or an abbess.

The miniatures act as a gloss when they comment upon and correct the text. The miniatures occasionally contain imagery that brings to the reading of the text information neces-

198

sary for it to be understood. As a gloss might clarify the meaning of a difficult or ambiguous word or passage, the miniatures explain the form of the king's solium or that the term *'donner la paix'* refers to the king kissing the hand of the bishop, or the manner in which the veil is used in the queen's anointing. This imagery might clear up ambiguities or supplement the text which, because it had to adhere strictly to the liturgical formula, often left many details unspecified. This supplementary information was variously derived: from elsewhere in the manuscript, from extra-textual sources such as a pontifical, contemporary documents, or, occasionally, eye-witness testimony of the historical ceremony. The most important type of first-hand testimony is the description of objects such as the sceptres of king and queen and the main-de-justice, of costume, of armorials, and of the likenesses of individual participants, many not mentioned in the text. A gloss might also reinterpret a text by imposing upon it a meaning not intended when the text was written. The miniatures accomplish this when they introduce actions which are not in the text, such as the enthronement of the queen *in cathedra*. Or the miniatures might correct or emend the text, as when the miniature shows the king or queen being anointed with the golden needle.

Just as a gloss can expose the underlying meaning of a text, so the miniatures expose the symbolic programme inherent in the successive rituals and gestures of the ceremony. As the sacre is an event that operates simultaneously on a liturgical and a historical level, its illustrations are similarly polyvalent. On one level they illustrate the historical narrative of the sacre, while on another they demonstrate liturgical formulae. The miniatures disclose the symbolic significance of the ceremony through visual cross-references between scenes, showing them to be connected in meaning as well as in external form. This is particularly appropriate for miniatures in a liturgical manuscript since liturgy is 'constituted of symbols, not merely written or spoken, but performed'.[26] Liturgy is an ordering of symbolic forms, and symbolic meaning is conveyed in every aspect of the ritual through the visual parallelism of figures, metaphors and typology, imagery that has been selected and arranged to demonstrate the operation of an invisible reality.[27]

The theological method of constructing types, or typology, is founded on parallelism and similitude of form and meaning. Such is the substance of all liturgy, but of none more than that of the sacre. The text and miniatures of the Coronation Book are laden with typological images, and like a gloss which supplies a typological exegesis of a text, the miniatures of the Coronation Book translate the symbolic structure, language and gestures of the liturgy of the sacre into concrete pictorial form by means of the same techniques of parallelism that are used in the liturgy — figures, metaphor and typology — expressed in its miniatures through visual comparisons. All Christian ceremonies are explained through reference to Christ expressed in the liturgy through typological resemblance: for example, the sacrifice of bread and wine is compared to the Crucifixion, and the water of baptism refers to the water of Christ's baptism.[28] Typological comparisons of the king to Christ are made in the miniatures by the device of paintings within the miniatures. An obvious instance of this occurs in the scene of the enthronement of the king on the solium (pl. 26) where the king's torso rises above the solium to mirror the figure of Christ as the 'Man of Sorrows' rising above the sepulchre. In the scenes of the opening and fastening of the king's tunic, the delivery of his shoes and his coronation, the position of the king's body

also mirrors that of Christ as the 'Man of Sorrows' on the altarpiece in each scene. Typological parallels between the painting on the altar and the action before the altar are expressed in other miniatures. In the enthronement of the king on the cathedra (pl. 24), the panel on the altar represents a Crucifixion flanked by the Virgin and Saint John who are seated on the ground according to the iconographic formula of humility. This defines a conceptual analogy between the king's cathedra, his seat on the ground of the cathedral at the side of the altar, and the earthly seat of Christ's mother and St John below the Cross. Through typological comparisons to Christ, the miniatures refer to the ideology of anointed kingship according to which the king is a *christos* and an *imago Christi*.[29] The resemblance drawn in the miniatures between the figure of the king and the figure of Christ in the altarpieces refers to this theory of kingship and visual parallelism conveys the underlying symbolic meaning of the sacre.

Typological references are also made in the miniatures by the repetition of objects like the cathedra which reappears throughout the king's and queen's cycles. In keeping with the stipulation that the king's be placed 'in view of the cathedra of the archbishop', its form and location are shown to be comparable to the archbishop's cathedra and a distinction is made between it and the throne on the solium. This episcopal seat introduced the theme of the sacerdotal and episcopal character of the king, evoked also through typological references with the ceremony of the consecration of a bishop. Although these cross-references would be more evident today had the Coronation Book been part of a complete pontifical, they would certainly be apparent, nevertheless, to anyone familiar with the episcopal consecration ceremony.

The most frequent form of textual independence in the illustrations is the historic detail, little of which is provided by the text. Among these are details that identify specific individuals: portraits, armorials, costumes and attributes. The precise form of objects like the sceptre and *main-de-justice* is not described in the text, nor are many details of the staging of the ceremony. Instances include the exchange of glances between the king and Anjou (pl. 24); the manner in which the veil is held (pl. 32); the manner in which the king is presented to the archbishop and placed in the cathedra (pl. 6); the king's spurs in the two entry scenes (pls. 1,2); the episcopal garb of the abbot of Saint-Denis (pl. 4); and many of the participants, their placement and gestures. These details are not in the text and their inclusion advances the concerted effort to incorporate first-hand evidence of the historical event of the coronation ceremony of Charles V and Jeanne de Bourbon.

The pragmatic, descriptive realism of the miniatures makes possible a historicity which functions like a gloss that gives historical *exempla*, not from the biblical or historical past, but the contemporary, secular context. Through the precision of the historical detail, the miniatures record a particular historic enactment of the formulaic liturgical text, and in so doing a dialectic is engaged between the description of the facts of the historic event and the delineation of a supra-historical reality of the liturgical ritual. The miniatures do not merely illustrate how the successive rituals of a liturgical ceremony might or should be performed: they illustrate them as they were performed on a particular occasion, by particular individuals. This is accomplished by the portraits, armorials, and historically specific objects which invest the miniatures with a documentary dimension unprecedented in

illustrated coronation rituals and pontificals. In this way the manuscript provides a witness for when it was done and who did what. It is at once a liturgical manuscript and an historical document. The realism of the miniatures is not merely a stylistic exercise in modernism: it fulfils the practical purpose of enabling the miniatures to document and to witness an historical event. These images are thus a kind of eye-witness record; asserting that the sacre was performed according to prescribed formulae, they declare that specific actions were carried out and that the necessary prayers were recited. They show that some acts not mentioned by the text were performed.

The miniatures act like glosses, albeit in visual form, in so many ways one is led to the conclusion that this was their intended function: to gloss the text and to expose its many layers of meaning. These observations about the function of the miniatures within the manuscript have implications concerning the purpose for which Charles V commissioned the manuscript and its cycle of miniatures. Because the miniatures play a far more active and creative role than that of merely illustrating the text, and because they interpret, and, in the words of Charles V in his colophon, 'correct' the text, the miniatures lend authority to it. This conclusion is supported by Charles V's statement in his hand-written colophon that he had the manuscript 'compiled, corrected written, and illustrated', words that evoke an effort to establish a critical and authoritative edition of a text, which is indeed the ultimate purpose of a gloss. This authority supports the claim that the coronation of Charles V and Jeanne de Bourbon was carried out in an incontrovertibly correct and thorough way. The miniatures explain the significance of the successive acts of the ceremony, demonstrating the validity of the coronation of Charles V and Jeanne de Bourbon. They argue that the coronation was thorough and conducted with the utmost fidelity to the liturgical formulae. By meticulously delineating the sacerdotal and quasi-episcopal character of the consecration of the king and queen, they compare it to the consecration of priests, bishops, nuns or abbesses, which, if carried out according to the prescribed rituals, are indelible and above the challenge of any secular authority. Together, text and images defend the validity of the consecration of Charles V as king of France, making it visibly manifest that Charles V is the *rex christianissimus*.

All of these observations demonstrate that the artist worked hand-in-hand with the redactors of the ordo. The artist displays an uncommon ability to comprehend the liturgical and legal subtleties of this new text, and indeed to be an active participant in the process of textual commentary and exegesis by translating complex ideas and concepts into visual form. Naive notions about the artist as an ignorant hired hand who blindly copies the images of other artists without any comprehension of their inherent intellectual content do not apply to the Master of the Coronation Book. Indeed, the written texts that so often appear within his images — copied with wondrous precision despite their almost microscopic scale — are a testimony to his expertise with the written word and its relation to the image. This is an artist who moves comfortably amongst the intellectual and political elite of his era and who contributes to the formulation of their thought.

68. Golein presents his translation of Bernard Gui's works to Charles V. Vatican, Bibl. Apost. Vat., MS Reg. 697, fol. 1

Chapter 6. The Master of the Coronation Book

I. The Artist and his Oeuvre

DESPITE SOME UNEVENNESS in the quality of their execution, the thirty-eight miniatures of the Coronation Book are the work of a single artist, known as the Master of the Coronation Book of Charles V for his work on this manuscript.[1] As shown in the preceding chapter, the methods and techniques employed demonstrate that all the miniatures were painted by the same hand.[2]

The Master of the Coronation Book has been overshadowed by the reputation of his predecessor Jean Pucelle and his contemporary Jean le Noir, the leading exponent of the tradition of Pucelle, who continued to work until at least 1380.[3] Pucelle's work has been no less appreciated in our own time than it was during the fourteenth century for its lyrical beauty and mastery of the Italian perspective devices of the generation of Giotto and Duccio. Pucelle endowed his religious scenes with drama while reconciling these Italian-inspired qualities with the refined courtly elegance characteristic of French Gothic painting. His draperies reveal the volume of the figures as they fall into rhythmic and graceful folds and his figures sit, stand, and interact with courtly and mannered elegance.

Pucelle and le Noir, to judge from their surviving works, seem to have specialized in the illustration of devotional books which they produced for a host of aristocratic and royal patrons including Jeanne d'Evreux, Philip VI, Jeanne de Navarre, Blanche duchess of Savoy, Yolande countess of Flanders, Bonne of Luxembourg, Charles V, and Jean duke of Berry.[4] In the exceptional instances when historical persons do appear, they are represented, not from life according to observed physical likeness, but with generic and idealized countenances, as, for example, the portraits of Jeanne d'Evreux, St Louis, Jeanne de Bourgogne and Philip VI (ill. 69).[5]

The work of the Master of the Coronation Book suffers when judged by these standards, in particular for the absence in his paintings of the grace and mannered elegance characteristic of the art of Pucelle. The Master rejected the artificial sway of Pucellian figures for those that stand in more natural positions with their feet set on the ground plane, and he preferred to model folds that respond to the body form and to the laws of gravity to the artificial, melodic rhythms of Pucellian drapery. Indeed, the art of the Master of the Coronation Book differs in significant ways from the style of Pucelle and le Noir and this divergence appears to be a conscious choice with different artistic objectives. For although the art of Pucelle and his successors was unsurpassed for its harmonious and ideal grace, their work has none of the quest for historicity and empirical observation in the portrayal of contemporary persons, objects, and events, wherein lies the special strength of the Master of the Coronation Book.

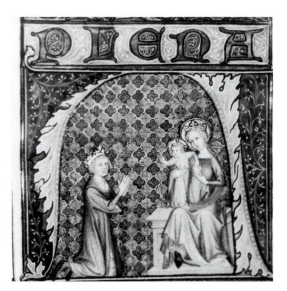

69. Jean Pucelle: Philip VI before the Virgin. *Miracles of Notre-Dame.* Paris, BN, MS nouv. acq. fr. 24541, fol. 234

70. Charles V before the Virgin and Child. *Petite Bible Historiale.* Paris, BN, MS fr. 5707, fol. 368

His surviving works suggest that the Master of the Coronation Book specialized in the illustration of literary and historical texts of a secular character. Until the death of Charles V the only identified patrons of the Master of the Coronation Book were kings — John the Good and his heir Charles V — which suggests that from the early 1350s until the late 1370s the Master was in the continuous and, it would seem, exclusive service of these two kings. Furthermore, judging from the extant manuscripts commissioned by John the Good and Charles V during this period, the Master was the favourite illuminator of these rulers, for the output of no other illuminator in the service of these kings from 1350 until 1378 rivalled either the quantity or the importance of the royal commissions which he received.

The greatest achievement of the Master of the Coronation Book is his introduction of lifelike portraiture into French manuscript painting. His earliest portrait is that of the future Charles V in the frontispiece of the *Livre des neuf anciens juges* of 1361 (Brussels, Bibl. Roy., MS 10319; ill. 75). The following year the Master illustrated the entire *Petite Bible Historiale* (Paris, BN, MS fr. 5707) which also has a portrait of Charles kneeling in prayer before the Virgin and Child (ill. 70). Both of these portraits are in the vanguard of the revival of veristic portraiture. Furthermore, he introduced the lifelike three-quarter view portrait and the group portrait into manuscript illumination, and he was the first manuscript painter to portray contemporary persons participating in a contemporary event.

Among the portraits in the Coronation Book, that of the king reveals the greatest attempt to reproduce physical traits. His homely features have been rendered without recourse to flattery: his long, pointed nose and receding chin, pale chalky complexion, reddish-golden hair and eyebrows, and his receding hairline, are all recognized as those of Charles V (ill. 71 a & b). Luckily, with this ruler, we are able to compare a considerable number of portraits made during his lifetime both by the Master and other artists.[6] The king's portraits have a consistent appearance throughout the manuscript. Ten of the portraits are

profile, nine viewed from the king's right side and one from his left. Sixteen of the portraits of the king are in a three-quarter view, fourteen of these from the right side. Although the king's likeness is individualized, it is usually set onto a stock figure. The Master makes the heads large in proportion to the bodies, but sometimes the king's head is exceptionally large in relation to the heads of the other figures. On close examination of these miniatures under a cold-light and with magnification one can see that the enlarged size of the head is evident even in the underdrawings, indicating that the large head size is intentional and part of the initial design. The features and the modelling of the king's face have greater detail and a higher degree of finish than the faces of the other figures, some of which also appear to be portraits. It should be stressed, however, that the finishing in all faces is still clearly by the same hand. This is especially visible in the lines and details of the eyes, mouths and the texture of the hair. The uniformity of the size and the main lines of the profile portraits, in particular, suggest that, rather than having been made directly from life, the artist referred to a model, perhaps even tracing from a pattern. However, because of the convincing likeness that is achieved, this pattern was clearly based upon a portrait of the king made from life, one that was probably not significantly different from the portrait of John the Good in the Louvre (ill. 5). Nevertheless, each portrait has been tailored to the individual scene so that the glance of the eyes varies according to the actions of each scene.

The three-quarter view portraits are more animated and more convincingly lifelike, fleshier, more robust and more modelled than the profile portraits. Among the most lively is the king's likeness in the enthronement on the solium (ill. 40): it is highly modelled without harsh outlines. In general the portraits in the miniatures within the text are more highly finished and more detailed than those of the marginal miniatures, but as already stated, these differences do not indicate that different hands are involved. Had another artist, a specialist in portraiture, painted the head of the king, it is improbable that the Master of the Coronation Book would have been called in after him to paint in all the eyes and hair, a particular hallmark of the artist. Rather, it would seem that the greater detail and finish in the portrait of the king in these miniatures reflect the importance given to the textual miniatures and the greater detail that was permitted in view of their slightly larger size.

Besides the portraits of the king, those of Louis d'Anjou present a convincing likeness since the consistency of his appearance throughout the miniature cycle and the attention to identifying features such as the colour and style of hair and beard convey the impression of intentional physical resemblance. The faces of the count of Etampes and the duke of Bourbon have also been individualized, and attention has been paid to the likeness of the portrayal of Charles's chancellor the bishop of Beauvais, Jean de Dormans, and the archbishop of Reims, Jean de Craon, whose portraits in the manuscript are the most numerous, and who, like Dormans, is identified by costume and heraldry. Craon in particular has been given consistent features throughout his portraits, such as high cheekbones, a broad forehead, strong, square jawline and a cleft chin. In general, the remaining ecclesiastics have been given rather stereotyped visages, with the exception of a tonsured cleric in the raising of the king (pl. 3) and a canon of Reims in the first two frontispieces (pls. 1–2), in which cases the features seem especially well-delineated. Among the groups of secular men throughout the miniatures, numerous faces have been individualized, and although

205

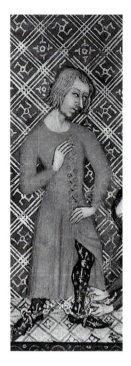
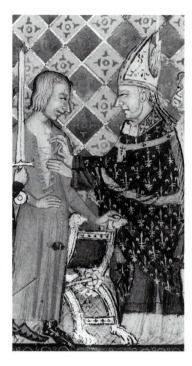

71a *(left)*. Charles V, fol. 48v
[detail of pl. 9]

71b *(right)*. Charles V, fol.54v
[detail of pl. 16]

somewhat like caricatures, they may well have been recognizable to their contemporaries even if there is no means for us to identify them today. While most women have been treated as stereotypes, the frontal portrait of Jeanne de Bourbon (pl. 36) resembles closely the queen's portrait in the Louvre (ill. 2) and that on her tomb in Saint-Denis (ill. 107). The countess of Artois is identified only by her widow's garb, but the profile portrait of the woman standing between the archbishop and the countess of Artois (pl. 36) so closely resembles the profile of Charles V that one might identify her as one of his sisters. What is remarkable is that the Master has gone to great lengths to invest all of his figures with some degree of individual characterization through costume and personalized physical details. Indeed, the sheer variety of his facial types is unparalleled in contemporary book illumination, and of all the miniaturists active in Paris from 1350 until 1380, the Coronation Book Master is matched in his consistent quest for individualization only by his closest collaborator, the Master of the Bible of Jean de Sy.[7]

The uniqueness of these portraits in book illumination of the period cannot be emphasized too strongly. Clearly, the Coronation Book Master was a pioneer in the revival of the lifelike portrait, and this was certainly one of the reasons, probably even the primary reason, for this artist's favour with John the Good and Charles V, both associated with the renaissance of the naturalistic portrait in sculpture, panel painting and manuscript illumination.[8] Photographs do not do justice to the remarkable detail of these incredibly small portrait likenesses.

Portraiture was not the Master's only strength. We have seen that the miniatures in the Coronation Book were designed expressly to accompany a newly-compiled text. In the creation of this cycle the artist displayed his ability to grasp the essence of a new text and to translate it into lively visual terms. He had already accomplished this, for sometime

206

around 1350 he worked under the direction of Guillaume de Machaut to create original illustrations in a manuscript that contains the poems and songs written by Machaut before 1349 (Paris, BN, MS fr. 1586; ill. 72).[9] It has been suggested that this manuscript may be that which is mentioned in an inventory of Charles's jewels and treasures compiled in 1363.[10] François Avril has identified the hand of the Master of the Coronation Book in the illustrations of the *Dit de l'Alérion* and the *Dit du Verger* (fols. 59–102) and the ballads and rounds contained in the final musical part (fols. 121–96). Thus, already at this early stage in his career the Master was collaborating with an author to formulate imagery to accompany a new text. Here the Master clearly demonstrated a predilection for a lively, even cinematic narrative style and empirical observation in the description of the texture and form of the objects of the physical world. He demonstrated a particular interest in details of fashion and textiles.

At about the same time the Master illustrated two copies of the *Roman de la Rose* (Montpellier, Bibl. Ecole de Médecine, MS 245 and Brussels, Bibl. Roy., MSS 9577 and 11187), giving further testimony to his activity in the illustration of secular French poetry.[11] In fact, throughout his career, and unlike the followers of Pucelle who had a predilection for copying their predecessor's work, the Coronation Book Master continually created original illustrations for new texts or translations, many of a secular nature.[12] Works that

72. Works of Guillaume de Machaut. Paris, BN, MS fr. 1586, fol. 59

73. Frontispiece of Golein's translation of the works of Bernard Gui. Vatican, Bibl. Apost. Vat., MS Reg. 697, fol. 2v

he illustrated for Charles include the translation made in 1369 by Jean Golein of the writings of the formidable Dominican inquisitor Bernard Gui (Vatican City, Bibl. Vat., MS Reg. Lat. 697; ills. 68, 73).[13] In the 1370s he contributed to the illustrations of Raoul de Presles' translation of the *City of God* (Paris, BN, MS fr. 22912–13), and many of the original illustrations in one of the copies of Nicole Oresme's French translations of the works of Aristotle (Brussels, Bibl. Roy., MS 11201–2; ill. 15). Clare Sherman has shown that the illustrations accompanying Oresme's translation are the product of a collaborative process between the translator Oresme, the scribe Raoulet d'Orléans, and the artists.[14] The Master of the Coronation Book was responsible for numerous illustrations in Charles's copy of the *Grandes Chroniques* (Paris, BN, MS fr. 2813), most notably the illustrations of the sacre of Charles and Jeanne (fol. 439) and the funeral of Jeanne (ills. 54, 74).[15]

In the illustrations of the Coronation Book, the Master accomplishes more than the creation of original illustrations for a new text: he illustrates an account of a contemporary court ceremony which he retells with an attention to detail that achieves the impression of archaeological reconstruction. The Master appears as a specialist in recording court ritual, costume, fabrics, armorials and objects.[16] He strives to describe people, objects and events with a relentless if somewhat academic precision that places him amongst the forerunners of the generation of artists whose rediscovery and empirical study of the physical world was fundamental for the subsequent development of northern Renaissance art. He displays a preference for strong, saturated colours applied in an opaque, painterly technique, often describing the texture of the objects, the transparency of fabrics or water, and the luminescence of fire and of golden brocade fabrics. This is already true of his early work in the Machaut manuscript and the *Bible Historiale* of John the Good (London, BL, MS Royal 19 D II; ill. 60), where, for example, he uses the Genesis cycle as an occasion for exploring the transparency of water and the dazzling red, gold and orange light of fire.

74. Funeral of Jeanne de Bourbon. *Grandes Chroniques of Charles V.* Paris, BN, MS fr. 2813, fol. 480v

There are, however, occasional references to Pucellian models in the work of the Master of the Coronation Book, for instance in the figure of the Madonna and Child in the portrait of the future Charles V in the *Petite Bible Historiale* of 1362–3 (Paris, BN, MS fr. 5707; ill. 70), copied directly from the illustration of Philip VI in prayer before the Madonna in the Pucellian *Miracles de Notre Dame* (Paris, BN, MS nouv. acq. fr. 24541, fol. 235v; ill. 69). The Virgin's pose and the lines of the folds of her robes are identical in each. Because of the dependence of the later painting upon the earlier, their juxtaposition highlights the differences separating the two artists. The Pucellian 'portrait' is generic and idealized, lacking both likeness of the sitter and indications sufficiently specific to permit this king to be identified with absolute certainty as Philip VI.[17] The Master of the Coronation Book has invested the Pucellian model with portrait likeness combined with historical precision and observed physical facts, leaving no doubt about the sitter's identity. We see him modernizing his predecessor's work, putting Charles in the place of Philip VI in a way that presents him as Philip's heir. One should not imagine that this resemblance indicates that the Master emerged from the studio of Pucelle. Rather, this is a manuscript that was among the possessions of John the Good when he was captured at Poitiers. The manuscript was ransomed by Charles,[18] and the return of the manuscript to France and to the prince is reflected in this act of copying. In this instance copying is a political statement rather than an indication of artistic dependence.

The historical exactitude of the miniatures of the Coronation Book derives from the artist's knowledge of court ceremony, costume, objects, furnishing and the technical language of heraldry. Indeed, all of these are a specialty of the Master of the Coronation Book. He is unique in the delineation of costume detail. He shows how clothes were cut and constructed, how they were finished and closed. His paintings — almost akin to a royal and ecclesiastical fashion show — drawings are so exact that one could reconstruct contemporary fashions on the basis of them. He is interested in textiles of all kinds, particularly the sumptuous and evidently very costly Italian (Lucchese) brocades which feature throughout the cycle in the altar hangings and the backgrounds.[19] The artist also paints a remarkable sheer white cloth that appears to be silk or perhaps a gauze-like linen. He paints ermine and other furs and feathers. More importantly, this painter understands who would wear what. He was a specialist in the semiotics and protocol of contemporary ecclesiastical and court fashion, identifying the participants in the rituals by class, rank, title, profession, all by means of costume details. Our artist is equally conversant with the construction of jewellery, gold-work and ecclesiastical vessels. He is preoccupied with details of crowns, sceptres, chalices, candlesticks, golden belts, swords, daggers, shields, spurs, armour and other military metalwork. Indeed many of his objects can be identified with specific objects mentioned in contemporary inventories. He seems to be equally familiar with the wares of the merchants of luxury commodities as he is with the higher ranks of the Church and court, almost as if he moved between these two societies. This detailed technical expertise points to the artist's intimate familiarity with every aspect of court life.

Although at first glance the Master's efforts to establish three-dimensional space might appear clumsy, on further consideration his work in the Coronation Book reveals him to be the first manuscript painter of the North to demonstrate an awareness, if not complete

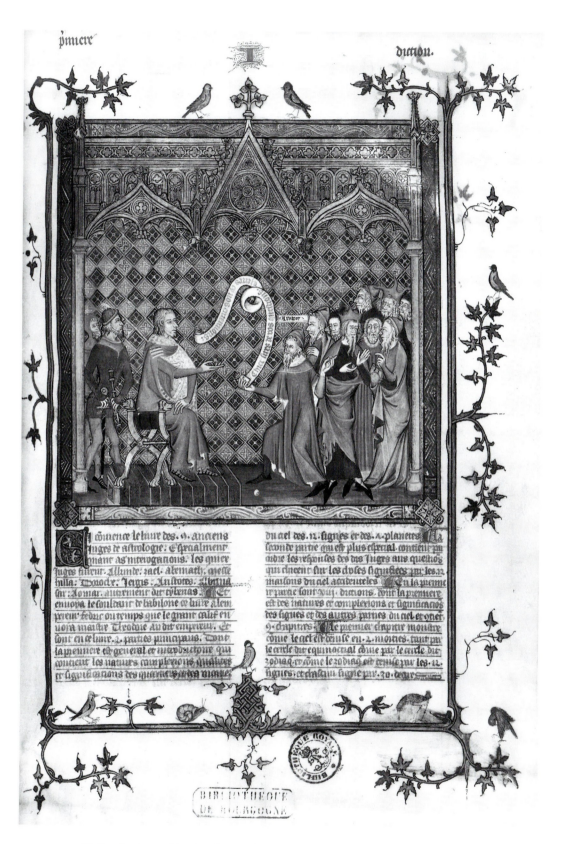

75. Frontispiece to the *Livre des neuf juges anciens*. Brussels, Bibl. Roy., MS 10319, fol. 3

76. Matteo Giovanetti: Fresco, Avignon, Palais des Papes,
Chapel of St. John the Baptist

77. Master of the Aix Annunciation: Annunciation.
Aix-en-Provence, Musée Granet

78. The Raising of Charles V, fol. 44v [detail of pl. 3]

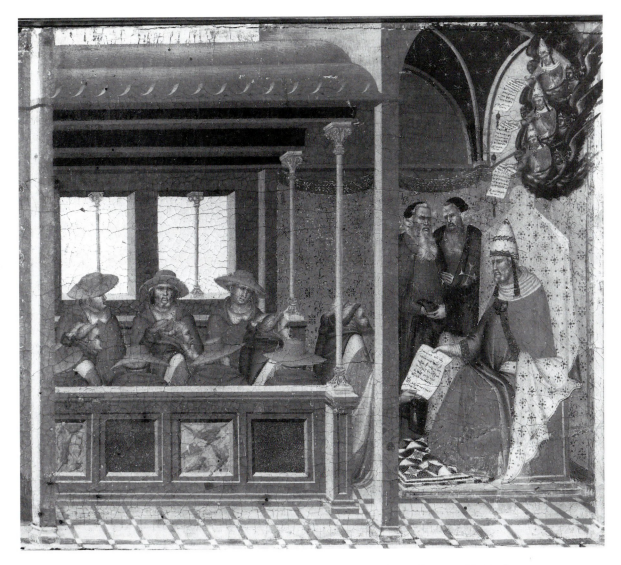

79. Pietro Lorenzetti: Pope Honorius confirms the Rule of the Order of Carmel. Siena, Pinacoteca Nazionale

80. Simone Martini: Predella of Robert of Anjou crowned King of Naples. Naples, Galleria Nazionale

understanding, of some of the developments in perspective of Sienese painters of the generation of the Lorenzetti, Simone Martini and their followers working in the 1340s in Avignon. Related to this, he introduced a new framing system into French book illumination: miniatures had been, as a rule, framed in quatrefoils of unpainted double lines drawn with the same ink of the text so that the miniature was linked with and subordinated to the text. In the Coronation Book the Master employs rectangular frames with broad sides painted in bright geometric patterns that set the miniature off from the text in a manner like a window frame. Similar rectangular frames had appeared in Italian manuscripts of the 1320s with the earliest illustrated manuscripts of the Divine Comedy.[20] Behind this outer frame the Master introduced a second, intricately-drawn architectural frame, placed parallel with the picture plane, which acts as a transition from the first frame to the space of the scene. Alternatively the Master also employed an elaborate gold architectural frame, resembling goldsmith's work, through which a scene is viewed (e.g. ills. 73, 75). By means of a series of illusionistic devices, he then endeavoured to construct a carefully measured, shallow pictorial space. The most important of his spatial devices is a clearly delineated ground plane receding from the lower frame of the picture to a background established by a backdrop or hanging of brocade fabric (e.g. ill. 70, 73). In order to emphasize his ground plane and to distinguish between the floor and the backdrop, the artist employed a patterned or a tessellated floor like those that were first developed by the Sienese masters Ambrogio and Pietro Lorenzetti (ill. 79), although he did not comprehend the converging orthogonals of such works. The Master betrays his preoccupation with the problem of measuring the recession of pictorial space especially in the frontispiece of the *Livre des neuf anciens juges* (ill. 75) where a platform supporting the seat of the duke of Normandy has been placed convincingly on the ground, just behind the architectural frame. To enhance the illusion of the spacial recession the Master placed over the platform a carpet with stripes that recede as converging orthogonals, and, to reinforce this spatial illusion, he placed figures behind the platform so as to leave no doubt as to the actuality of the space he was constructing.

The Master of the Coronation Book surpassed himself in the spatial showmanship of the scene of the raising of the king at the palace of the archbishop of Reims (ill. 78). Just behind the picture frame he set the archbishop's palace, and behind that the remarkable spatial structure of the bed-canopy. The Master often used architectonically-constructed furniture to define and measure space, and in this scene converging orthogonals are formed by the pillow and the point where the vertical member of the canopy — which also defines the right side of the chamber — bends to form the top of the canopy. This canopy further delineates the upper limits of the enclosed space, the skirts of the canopy establish the front, lower left side and rear sides of the space contained by the bed. The lines of the foot of the bed and the end of the canopy above it form converging orthogonals. Remarkably, shadows painted on the underside of the canopy in a new technique of a transparent grey-black wash, heighten the spatial illusion and simultaneously model the folds of the brocade bed cover. Then, the artist strategically placed the figures in the successive planes: a bishop in the space in front of the bed, the king seated on the bed, and the second bishop behind the bed. All of these devices have antecedents in Sienese painting, as, for ex-

ample, the predella of Simone's St Louis of Toulouse altarpiece (ill. 80), his frescoes in the chapel of St Martin in the lower church at Assisi, or in the work of his successors in Avignon, like the Master of the Aix Annunciation (ill. 77) and Matteo Giovannetti in the chapels of St Martin and St John commissioned by Clement VI in the papal palace (ill. 76).

The first two miniatures in the Coronation Book (pls. 1, 2) display a considerable advance in the construction of successively receding spatial planes. The foremost plane of the cathedral is indicated by the piers supporting flying buttresses leading back to the next plane, that of the cutaway exterior wall of the church. Behind the arches of this cutaway wall the eye is led by means of several illusionistic devices. Most notably, the arches supporting the vaults have been placed behind the buttress towers, and the interior is visibly two bays of vaults in depth, the far bays of vaults more deeply shaded than the near bay and the ribs accented by highlights. The steps of the altar direct the eye back from the forward wall of the church, and the hangings flanking the altar lead to the top of the altar with its altarpiece at the rear. Behind the altar a bishop turns his head so that his mitre is viewed from the side in a way that leads further back into depth. Finally, the procession of clergy progressing from one side of the picture to the other is viewed through the arches and columns of the cathedral which act like a series of framing arches. All of these devices recall the spatial innovations of Simone, the Lorenzetti and Matteo Giovannetti (ills. 76, 79, 80).

The Master of the Coronation Book employed illusionistic devices in his paintings from the beginning of his career. In the frontispiece to the *Roman de la Rose* (Montpellier, Bibl. Ecole de Médecine, MS 245) the floor plane was indicated and emphasized by the receding perspective of the circular base of a piece of library furniture.[21] Indeed, the artist displays an interest in the construction of furniture which he uses to enhance the illusion of space. In another early work, the *Bible Historiale* of John the Good (London, BL, MS Royal 19 D II), the frontispiece has a figure of Christ in Majesty enthroned before a brocade backcloth (ill. 60), similar to those that had appeared in the 1340s in Italian panel painting, a notable example being the Simonesque Annunciation in Aix (ill. 77). As with the Italian precedents, behind this cloth we see the vaults of the rear chamber. In 1369, the Master produced a variation of these spatial devices in the frontispiece of the translation of the works of Bernard Gui (Rome, Bibl. Vat., Reg. Lat. 697; ill. 73).

In the illustration of the early works of Guillaume de Machaut (Paris, BN, MS fr. 1586) the Master of the Coronation Book collaborated with an exceptionally creative artist with a brief career whom Avril named after the artist's illustrations of the *Remède de Fortune* in this manuscript (ill. 72).[22] The Master of the Remède de Fortune exhibits a predilection for the contemporary high fashion of the Paris court and as Avril puts it, a new `realism tempered with courtly elegance', combined with an interest in spatial problems and the lively interaction of figures, all marking a new beginning in fourteenth-century Parisian book illumination. Other collaborators of the Master of the Remède de Fortune in the vanguard of a new naturalist movement in book illumination include the artist who illustrated the texts of the *Jugement du Roi de Bohême* and the *Dit du Lion* in the same Machaut manuscript, the latter including one of the earliest independent landscapes to appear in European painting.[23]

81. Page from the Missal of Saint-Denis, London, Victoria and Albert Museum, MS 1346-1891, fol. 256v

Making his painting debut in the company of the Remède Master places the early ca-
reer of the Master of the Coronation Book in the milieu of artists working for the first two
Valois kings, since the first known work of the Remède Master is the remarkable *tour de
force* of book illumination, the *Bible Moralisée* of John the Good (Paris, BN, MS fr. 167). Avril
identified this manuscript with a Bible mentioned in royal expense rolls from 1349 to 1352
and recognized at least fifteen different hands amongst the 5,212 illustrations in what
might be described as a *summa* of Parisian book illumination at mid-century. Some of the
artists of these miniatures continue to work in a somewhat decadent and mannered
Pucellian mode, but others display a new style characterized by the direct observation of
reality and the rejection of mannered affectations. It is to the latter group that the Master of
the Remède de Fortune belongs as does his collaborator in the Machaut manuscript, the
Master of the Coronation Book.[24] Another manuscript illustrated by the Remède Master is
the Missal of Saint-Denis (London, V&A, MS 1346–1891; ill. 81), given to Saint-Denis by a
member of the royal family around 1350.[25] I would suggest that it was given to commemo-
rate the marriage of Philip VI and Blanche of Navarre at Saint-Denis in January of 1350,
marking the temporary reconciliation between the feuding houses of Valois and Navar-
re.[26] All of these manuscripts belong to a new trend towards empirical observation of the
actual contemporary environment.

Thus, from the beginning of his career, the Master of the Coronation Book collaborated
with an artist who had direct ties to the patronage of Philip VI and John the Good, allowing
us to place his beginnings in the context of the Parisian court.[27] His earliest works belong to
the artistic revolution that took place at the end of the reign of Philip VI and the beginning
of the reign of John the Good. All of the evidence suggests that the emergence of the Mas-
ter of the Coronation Book occurs in the context of the patronage of these monarchs. In all
of his manuscripts with identified patrons, those patrons were Valois kings or heirs to the
throne. His earliest works besides the Machaut manuscript include another copy of the
writings of Guillaume de Machaut in a private collection in New York and the two afore-
mentioned copies of the *Roman de la Rose*, that in Montpellier (Bibl. Ecole de Médecine, MS
245) and the other in Brussels (Bibl. Roy., MSS 9577 and 11187). The patronage of these
early works remains uncertain, although their luxury, the decorated borders and their lit-
erary content is in keeping with the literary and aesthetic tastes of John the Good. Cer-
tainly the Master of the Coronation Book was in the service of John the Good before 1356,
for he illustrated the volumes of John the Good's *Bible Historiale* that was confiscated at the
Battle of Poitiers and taken to England (ill. 60).[28]

The Master's next work was the frontispiece of the *Livre des neuf anciens juges* (ill. 75), a
translation of the *Liber novem judicum* made by Robert Godefroy and dedicated to Charles
on Christmas Eve 1361 (Brussels, Bibl. Roy., MS 10319).[29] Godefroy identified himself as
'master in arts and astronomer of the very noble and very powerful lord Charles', whom
he addressed as *ai[s]né fils du roi de France*. It is significant that Godefroy used this title for,
as we have seen above, it is a programmatic affirmation of the right of the first-born son of
the king of France to succeed to the throne.[30] This frontispiece is one of the earliest surviv-
ing portrait likenesses of the prince.[31] It is certainly noteworthy, therefore, that in this por-
trait Charles presents a striking physical resemblance to the portrait of John the Good in

217

the Louvre (ill. 5). His hair and beard are similar, and the prince's pose seems inspired by that of his father in the copy of the lost panel from the Sainte-Chapelle (ill. 86), which, as we shall see later, is closely connected to the work of the Coronation Book Master. In this frontispiece Charles wears the costume of the duke of Normandy, the cloak with three ermine bands on his right shoulder, as he sits on a golden faldstool extending his right hand to receive the group of nine judges headed by the figure identified as Aristotle. Given the references to the date 1361 and the title of *aisné fils du roi de France*, it should be recalled that this work concurs with the events of 1361 when Charles visited Reims and stayed in the house of Guillaume de Machaut, events that were so critical in advancing his cause for succession to the throne.[32] That he wears the garb of the duke of Normandy is especially meaningful when one remembers that John issued an act in November in which he ordered the reunion of the duchy of Normandy to the domain of the 'Crown'. This act is the earliest assertion of the principle of the inalienability of domains pertaining to the Crown,[33] and it also contained John's earliest assertion of Charles's right to succeed as his first-born son.[34] These observations put this portrait in a very special light: it emerges as a declaration of the right of Charles to succeed to the throne as the first-born son of the king of France and corroborates the assertion by its naturalistic portrayal of physical resemblance between the father and son. This situates the Master in a very precise political setting at the outset of Charles's career. Moreover, in this work in which the Master makes his debut as a specialist in political imagery, we witness a crucial link between the patronage of John the Good and his successor Charles V.

The Master of the Coronation Book was responsible for the entire cycle of miniatures in the *Petite Bible Historiale* (Paris, BN, MS fr. 5707) presented to Charles in 1362–3.[35] We have noted in chapter 1 that this manuscript includes, as does the *Livre des neuf anciens juges*, ex-

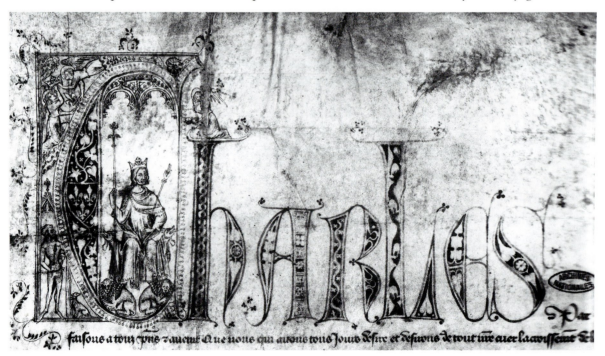

82. Charter of Charles V, July 1364. Paris, Arch. Nat. A1 11383 (J. 154, no. 5)

plicit assertions of the right of the prince to succeed his father on the principle of primo-geniture (ills. 70, 75). Once again, Charles wears the costume of the duke of Normandy, kneeling in prayer at a prie-dieu draped with a brocade cloth with the arms of the Dauphiné, and again his facial features resemble the Louvre portrait of John the Good (ill. 5). The assertion of the prince's right to succeed is made in an ingenious fashion by the text of a lengthy poem written below the portrait and signed by Raoulet d'Orléans, Charles's favourite scribe with whom the Master of the Coronation Book frequently collaborated. The initials of the 61 lines of this poem of praise to the Virgin spell out an acrostic giving the titles of Charles: *Charles aisné fils du roy de france duc de normandy et dalphin de viennoys*. This portrait by the Master of the Coronation Book and the poem and text written by Raoulet d'Orléans together proclaim Charles as the heir to the throne: with such works the Master emerges in the context of the entourage involved in the tutelage of Charles, shaping the political situation to favour his succession.

The very first commission of Charles V after his accession was awarded to the Master of the Coronation Book: he was called upon to provide historiated and decorated initials with Charles's portrait for the first charter promulgated by the newly crowned king in July 1364 forbidding the alienation of the Hôtel St-Pol (Paris, Arch. Nat., AE 11383 [J. 154, no. 5]; ill. 82).[36] Written in French rather than the customary Latin, this charter announces the official importance of vernacular French in his administration. The king's portrait resembles the figure of Charlemagne on the sceptre for Charles's sacre (ill. 10), a direct reference to the notion that the king of France is emperor in his kingdom. Moreover, the illustration includes in the upper left of the initial a depiction of the miraculous delivery by an angel of the crown and the shield of France with the Trinitarian symbol of the fleurs-de-lis, all specific images which Charles would use throughout his reign to advance his ideological doctrine of the *rex christianissimus*, that the king of France knows no superior because he has received his crown from God.[37] The presence of the crown carried by an angel is particularly significant, appearing as it does in the first image commissioned by Charles after his sacre, for, as we have already seen, the oath of the Ordo of Charles V introduced the new clause in which the king promised to 'keep the Crown of France inviolate and neither to transfer it nor alienate it'. As we have seen in the analysis of the innovations of the Ordo of Charles V, the introduction of this phrase into the sacre was the first official expression of the idea of the 'Crown' as a divinely ordained, sovereign institution separate from the person upon whose head the symbol was placed. This image explicitly declares that the crown is a divine gift like the Celestial Balm. The portrait of Charles mirrors his image on the official royal seal that would have been attached to this document.[38] This portrait at the top of his first official act marks the beginning of Charles's administration of government. It is his first official act in a campaign, pursued throughout his reign, of defining royal property as the possession of the Crown and of reclaiming royal domains that had been given away, transferred or alienated by kings of France since the time of Philip the Fair. The Hôtel St-Pol was established by Charles during the period 1361–4 to be his residence as heir to the throne, and after his sacre it was used for meetings of the Grand Conseil and for the college of notaries.[39] Throughout his reign the majority of royal *mandements* and charters were drafted at the Hôtel St-Pol. Immediately after the sacre Charles's chancellor

les temps

83a & b. Miniatures from Vincent of Beauvais' *Miroir Historial*. Paris, BN, MS nouv. acq. fr. 15939, fol. 82v

Jean de Dormans assembled the Conseil there for their first meeting. Thus the Master of the Coronation Book, at the outset of Charles's reign, demonstrates his capacity to turn ideology into synthetic official images.

In this initial we witness a fusion between the art of the painter and the art of the scribe. The Master's intimate involvement with the writing of official documents that is witnessed here, in particular, where the royal portrait is fully integrated into the opening letters of the text itself, raises the question of where the work of the artist leaves off and that of the scribe begins. The two disciplines are here commingled to a degree that scribe and illuminator appear to be one individual. This poses the very real possibility that the Master was already associated with the royal chancery at the beginning of Charles's reign, and even perhaps with chancellor Jean de Dormans. Indeed the Master of the Coronation Book frequently integrates scribal art into his images. Among some of the most notable examples is the frontispiece of the *Livre des neuf anciens juges* , where a scroll is inscribed with a text and an inscription identifies one of the judges as Aristotle (ill. 75); among numerous examples in the Coronation Book is the scene in which the king takes his oath over a book, on the open pages of which are inscribed the first lines of the oath itself, including a decorated initial (ill. 35). As already noted, this image reiterates the text of the oath above which was corrected, perhaps even by the king himself, so that the text and image would more effectively interact visually with each other. The letters of the oath in the painted book are perfectly formed despite their infinitesimal size, and I have often asked myself who executed these letters, for they reiterate the actual lines on the text of the real book itself. They have exactly the same form as the script of the text above, yet when the strokes of the letters on the book in the miniature are examined under magnification it is evident that they are also remarkably similar to the strokes that form the eyes and eyelids of the figures

in the paintings. This goes beyond simple collaboration between scribe and painter, yet it is probably dangerous to suggest that our miniaturist possessed the breadth of ability to be both scribe and painter. Nevertheless, the pen and ink line drawings beneath the paintings and the finishing touches of the miniatures betray the same fusion of the art of scribe and painter.

After the charter, the next work which the Master illustrated for Charles was the Coronation Book. The subsequent works of the Master of the Coronation Book were also made for Charles V. They include the double frontispiece and the illustrations in the French translation made in 1369 by the Carmelite Jean Golein of the works of the infamous inquisitor Bernard Gui which includes a miniature in which Golein is portrayed offering his translation to Charles V (Bibl. Vat., Reg. Lat. 697, fol. 1; ill. 68). This manuscript is the original exemplar of the translation and is prefaced with a lavish full-page image of the pope enthroned with the papal curia (fol. 2v; ill. 73). This had a pendant which showed a similar image of the king of France enthroned, and, although now lost, its existence is documented by notes in the manuscript. Among the contents of the manuscript is an illustrated genealogy of the kings of France delineating the succession of the Valois from Clovis to Charles V.[40]

After 1372 the Master was involved in several projects connected with the creation of the original miniature cycles to accompany French translations commissioned by Charles V. One of these was Nicole Oresme's translations of the political works of Aristotle (ill. 15).[41] Simultaneously he executed illustrations for Charles V's copies of Raoul de Presles' translation of Augustine's *City of God* (Paris, BN, MS 22912–3).[42] Amongst the Master's other works is a multi-volume copy of the *Miroir Historial* of Vincent of Beauvais (Paris, BN, MSS nouv. acq. fr. 15939–44; ills. 83 a & b) once in the library of Jean de Berry and identified by Delisle as that mentioned in the inventories of Charles's library at the Louvre.[43] He was also the artist of the *Bible Historiale* in Stuttgart (Württ. Landesbibl., Cod. 206).[44] He was responsible for the illustrations of the coronation of Charles V and Jeanne de Bourbon and the funeral of Jeanne de Bourbon in Charles V's copy of the *Grandes Chroniques* (Paris, BN, MS fr. 2813; ill. 74), and for many of the illustrations in another copy of the same version of the *Grandes Chroniques*, divided between folios in the British Library (MS Cotton Vitellius E. II) and a private collection in Great Britain.[45] He also collaborated with the Master of the Bible of Jean de Sy in illustrating a copy of the *Histoire Ancienne Jusqu'à César* now in the Schoyen Collection in Oslo.[46]

This impressive record of royal patronage becomes all the more significant when it is set against the patronage and the type of commissions received by Jean le Noir, another contemporary illuminator who also worked for Charles V, for le Noir executed devotional books for a pleiad of royal and aristocratic patrons.[47] There has been much scholarly interest recently in the Parisian book trade that developed in the periphery of the university in response to the demand for authoritative copies of texts for study. This demand contributed to the emergence of a new class of secular illuminators and scribes who operated ateliers in the proximity of the university, creating manuscripts at the order of the trade.[48] Independent secular artists were made possible by this new market. There are features in the work of the Master of the Coronation Book that are broadly comparable to the manu-

scripts made for this organized book trade. For example we find the alternating red and blue initials and rubrication.[49] However, these alternating red and blue initials in the Coronation Book are far more de luxe and elaborate than the usual products of the book trade of the period.

It would be a mistake, I believe, to identify the Master with this system of book production. His entire *oeuvre* reveals an artist who is intimately associated with two kings, John the Good and Charles V, and his production is so integral to their court and its political programmes, that it appears he worked very closely with these two kings and their most intimate and trusted advisors, even perhaps in an exclusive arrangement. Furthermore, both of his collaborators, the Sy Master and the Master of the Coronation of Charles VI, are also identified exclusively with manuscripts produced for John and Charles, until the death of the latter.[50] And like the Coronation Book Master, these artists also specialized in the illustration of translations made by scholars in the service of John or Charles.[51] The Master's astounding technical expertise with royal protocol, ceremony, costumes, armorials, insignia, and charters is perhaps the best evidence of his intimate association with the royal court. His facility with both Latin and French texts and his ability to read and comprehend the subtleties of their content, and even to decorate initials in these texts, all point to an artist who is collaborating directly with official court scribes and scholars. And this is further supported by the fact that his first work for Charles after his sacre was the king's portrait on his first official legal promulgation produced by the royal chancery. The royal scribes and notaries were products, not of the University of Paris, but of the law school of Orléans.[52] We might add that Charles's preferred scribe, Raoulet d'Orléans, is identified with many of the manuscripts illustrated by the Master of the Coronation Book, who emerges from all of this with a profile that looks very much like that of an official court illuminator, quite possibly having some association with the royal chancery.

II. Panel Painting and Book Illumination at the Valois Court

There is little in Parisian manuscript illumination of this date to match the portraiture and the array of spatial devices employed by the Master of the Coronation Book. We must also signal the presence of technical innovations in his paintings. He uses a technique of overpainting on gold ground with a transparent red glaze. This appears in the fabrics hanging on the elevated solium in the scene of the enthronement of the king and in the backgrounds of many of the altarpieces depicted in the miniatures of the Coronation Book. Meiss identified this technique in the work of the Parement Master, specifically in the miniature of the Man of Sorrows in the *Très Belles Heures de Notre Dame* (Paris, BN, MS nouv. acq. lat. 3093; ill. 84a), and he argued that the Parement Master was a panel painter rather than a miniaturist, crediting the Parement Master with introducing this technique of panel painting into book illumination. He further suggested that the medium used to achieve this transparent glaze was oil and noted that the presence of craquelure in the relevant passages of painting supported his hypothesis.[53]

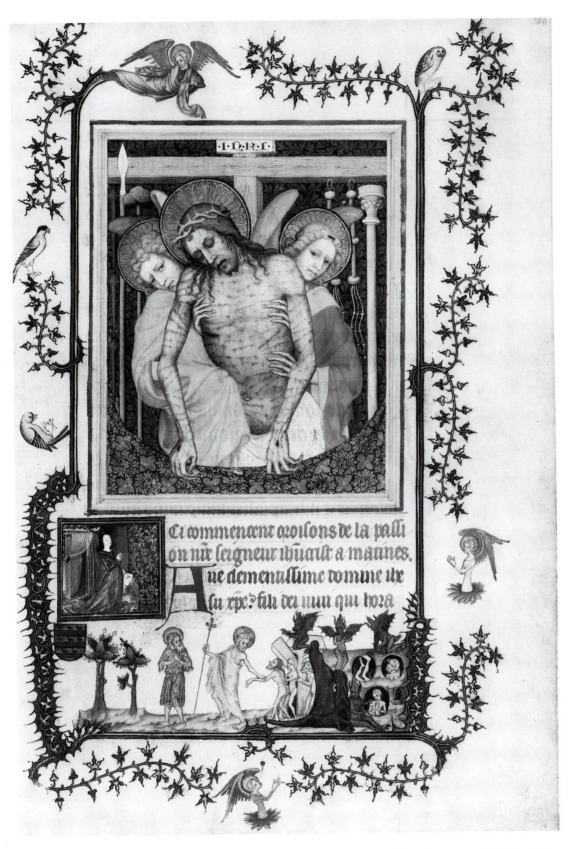

84a. Parement Master: Man of Sorrows. *Très Belles Heures de Notre Dame*. Paris, BN, MS nouv. acq. lat. 3093, p. 155

In the miniatures of the Coronation Book we see precisely this same technique twenty years before the works of the Parement Master in the *Très Belles Heures de Notre Dame* (hereafter referred to as the *Très Belles Heures*). The Master of the Coronation Book demonstrated a precocious expertise in painting transparency and translucency and the capacity to create varied textural and optical effects. On several occasions he produced transparent fabrics such as the veil in the scene of the anointing of the queen's breast in the Coronation Book (pl. 32) and the alb of the acolyte in the scene of the arrival of the king at the cathedral of Reims (pls. 1–2). It is possible that this transparent white, like the transparent red glaze, was achieved with an oil medium since it is painted in a glossy, thick but transparent layer over the queen's breast.[54] Indeed, the artist's painting technique is exceptional amongst French miniaturists, for the paint has been applied in thick, opaque layers of saturated colours that differ substantially from the pastel and transparent washes employed by his contemporaries and predecessors in book illumination. He builds up his forms with modelling in minute parallel brushstrokes, using extremely fine touches of thick white paint for highlights and, in some places overpainting shadows with a transparent wash of black-grey or pink-mauve. As Meiss observed when describing the same technique in the miniatures of the Parement Master, these methods are more suitable to the art of painting on solid wooden panels than pliable vellum.[55] Because of this painting technique some flaking and craquelure are evident in the miniatures of the Coronation Book as is also the case, as Meiss noted, with the *Très Belles Heures*, the Parement Master's *tour de force* of manuscript illumination.

We have just seen that the style of the Master of the Coronation Book differs in fundamental ways from most of his predecessors and contemporaries in manuscript painting, and that there is nothing comparable to his portraiture, his historical realism, his technique, and his repertoire of spatial devices in their work. It was also observed that this artist displays a knowledge, if not complete mastery of, the most recent advances in perspective of Italian panel and fresco painting and that his painting technique presents analogies with panel painting and anticipates by two decades the technique of the greatest French painter of the latter part of the century, the Parement Master, whom some have identified with the *pictor regis* of Charles V, Jean d'Orléans.[56] However, the closest parallels for the various innovations of the Master of the Coronation Book are to be found in the panel painting produced at the Valois court during the reign of John the Good.

The miniatures of the Coronation Book contain an important clue concerning the connection of the Master of the Coronation Book with the milieu of panel painting.[57] Appearing on the altars throughout the miniatures are detailed depictions of panel paintings, many with iconographic themes known until then only in Italian painting. These paintings within the miniatures provide some important evidence about the lost panel painting of the period, witnessing the arrival in France by 1365 of the iconography of the Man of Sorrows (fols. 47v, 48, 49v, 50v, 51, 55v, 56, 56v, 57, 59, 64,) and of the Virgin and Saint John seated on the ground in humility (fol. 59v).

Concerning this rapprochement with panel painting it is particularly significant that the earliest surviving representations of the iconography of the Man of Sorrows in French painting appear in the miniatures of the Coronation Book, and within the cycle of minia-

84b. Detail of fol. 50v [pl. 13] showing Triptych

84c. Detail of fol. 56 [pl. 19] showing Man of Sorrows

tures, in different variations of the theme.[58] These paintings of paintings must surely mean that the Master was acquainted with panel paintings of this special theme, and in this connection, it should be stressed that the only known antecedents for such panels at the time of the Coronation Book are in Italian painting and goldsmith work where the iconography of the Man of Sorrows began to appear during the last decade of the thirteenth century and became widespread during the first half of the fourteenth century.[59] Some of these comparisons are so close as to suggest that the Master had direct acquaintance with Italian prototypes. For example, the triptych shown on fol. 59v (pl. 24) with half length figures of saints (apparently Mary and John) flanking the Man of Sorrows is similar to the central panel of the predella of the polyptych painted in 1319–20 by Simone Martini for the church of Santa Caterina in Pisa (Pisa, Museo Nazionale).[60] This is a rectangular panel subdivided into three sections by an arcade frame, in which Christ as the Man of Sorrows appears in a half-length, upright position above his tomb with his head bent and his arms crossed before him. He is flanked by Mary and John. The triptych on the altar on fol. 55v with the Man of Sorrows flanked by half-length figures of saints (ill. 84b) recalls not only the predella in Pisa, but also Simone's Saint John now in Birmingham (Barber Institute of Fine Arts) which was once part of a similar group.[61]

In another (ill. 84c), a shroud is draped across a broad rectangular panel before the body of the dead Christ appearing in an upright and frontal position over his tomb. It is worth noting, in passing, that the *porte-oriflamme* Geoffroy de Charnay and his family had pos-

225

session of the Holy Shroud that is now in Turin. The broad rectangular shape of the panel is another motif that appeared in Italian painting around 1300 and was disseminated by Simone, among the earliest instances being Simone's predella of the St Louis Altarpiece (ill. 80), his *Maestà* and the portrait of Guidoriccio da Fogliano in the Palazzo Pubblico in Siena, and his frescoes in the Chapel of St Elizabeth in the lower church at Assisi.[62] Another variation in the Coronation Book is the gabled triptych with the Man of Sorrows before the Cross in which the side panels have half figures of angels turning in devotion towards the centre panel (pl. 7). The display of Christ's wounds is another theme that had been widely disseminated in Italian painting. Besides the presentation of the wounds in the various versions of the Man of Sorrows, the wounds are also displayed in the image of Christ enthroned in the altarpiece in the miniature on fol. 46 (pl. 4). In contrast to the abundance of Italian comparisons, besides a miniature executed *c.* 1375 by a collaborator of the Master of the Coronation Book,[63] the earliest surviving painting of the Man of Sorrows in French art is that by the Parement Master who conflated the variations encountered in the Coronation Book into one image in the Man of Sorrows of the *Très Belles Heures* (p. 155; ill. 84a).[64]

There is another importation into French painting of an iconographic theme of Italian panel painting, and that occurs in the scene of the enthronement of the king *in cathedra* (pl. 24) where the altarpiece is a scene of the Crucifixion with Mary and John seated on the ground below the Cross.[65] One of the earliest images of the Crucifixion with St John seated on the ground below the Cross was painted by a Roman painter *c.* 1300 and a slightly later Crucifixion with the Virgin and St John seated on the ground below the Cross.[66] The earliest appearance of the iconography of the Madonna of Humility in France is that by Simone Martini which was formerly on the porch of Notre Dame des Doms in Avignon.[67] The iconography had already appeared in the so-called *Heures de Jeanne de Navarre* (Paris, BN, MS nouv. acq. lat. 3145, fol. 112), for which Jean le Noir was the principal painter.[68] It also appears later in the work of the Parement Master in an historiated initial on a detached folio of the *Très Belles Heures* in the Louvre, Cabinet des Dessins.[69]

Clearly, with the Master of the Coronation Book we are in the presence of an artist who is no longer content to reproduce the spatial and iconographic formulae of Pucelle and the Italian perspective techniques of the generation of Giotto and Duccio. His remarkable repertoire of iconographic motifs and his advanced technical and illusionistic devices place him at the forefront of a new wave of Italian innovations imported into French painting during the last half of the fourteenth century. His command of the most recent developments in Italian painting is surely another reason for his favour with two of the most discriminating patrons of the day, John the Good and Charles V.

In what follows, evidence will be presented indicating that the Master was introduced to the most recent advances in Italian painting through his direct association with the official court painters of John the Good and Charles V, and that these painters were responsible for importing the most recent developments in Italian painting to the court of France. As much of the monumental painting commissioned by John the Good and Charles V has been destroyed, we will see that the art of the Master, particularly the paintings of paintings within the scenes of the Coronation Book, represent a valuable witness to this court school of painters.

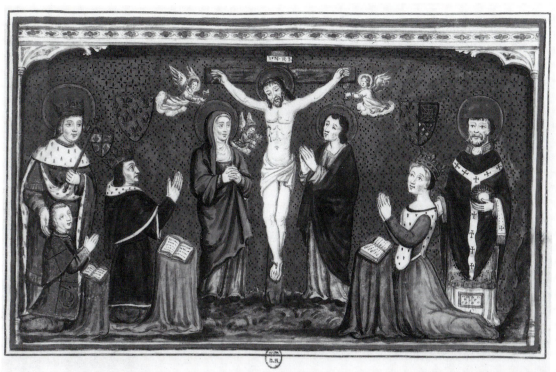

CE TABLEAU est contre le mur a main gauche dans la nef de la Chapelle de St Michel
dans la Cour du Palais a Paris. JEAN Roy de FRANCE, y est representé a genoux ayant
derriere lui son fils Charles premier Dauphin de France depuis le Roy Charles V. vis a vis
du Roy est aussy a genoux Blanche de Navarre sa mere. Ils sont presentés par St Louis
et St Denis.

85. Copy made for Gaignières of a lost panel formerly in the Chapel of Saint-Michel
in the Palais de la Cité. Paris, BN, Estampes Oa 11, fol. 89

Although Parisian panel painting of the fourteenth century is almost entirely lost, it is
known at least partially, in addition to the miniatures in the Coronation Book, through
several sources, the most important being the collection of copies of royal paintings assem-
bled in the eighteenth century by Rogier de Gaignières, whose historical and antiquarian
interest assured the reliability of these copies. In order to test the reliability of Gaignières'
copies, Sterling juxtaposed several of the copies with the extant originals, including Jean
Bondol's frontispiece for the *Bible Historiale* of Jean de Vaudetar in The Hague (Museum
Meermanno-Westreenianum, MS 10 B 23; ill. 14).[70] This example is especially relevant be-
cause, although it appears in a manuscript, it was painted by a panel painter, Jean Bondol
of Bruges, *varlet de chambre* and *pictor regis* of Charles V, who also supervised the illustra-
tion of this *Bible Historiale*, a commission documenting the interaction between miniature
and monumental painters at the court of Charles V.

One of Gaignières' copies which presents analogies with the paintings in the Corona-
tion Book is the copy of a panel that formerly hung in the chapel of Saint-Michel in the
Palais-de-la-Cité in Paris (ill. 85).[71] It represents the young Charles V, clad in the arms of
the Dauphiné, and his grandfather Philip VI kneeling before a lifelike Crucifixion group

227

with the Virgin and St John flanking the Cross. Facing them, the kneeling queen is probably Philip VI's second wife, Blanche of Navarre, whom he married in January 1350 at the moment when the Dauphiné was being transferred to the Crown. Blanche, a member of the family of Evreux, is presented by St Denis, a patron saint of the kingdom of France and of the family of Evreux, and the dauphin is presented by St Louis, a sainted ancestor of the entire royal group. The panel celebrates the marriage of Philip VI to Blanche of Navarre-Evreux on 19 January 1350 and the consequent reconciliation between the Houses of Evreux and Valois. Because the original was the earliest portrait of Charles V wearing the arms of the Dauphiné and was painted precisely at the moment when the Dauphiné was annexed to the Crown of France, the portrait celebrates and records precise historical events of dynastic and political importance for the Valois.[72]

The copy indicates that the royal personages were portrayed in the original panel with a concern for likeness, that it was painted in bright, saturated colours, and that it displayed patterned brocade fabrics, armorials and detailed rendering of contemporary fashion. Moreover, like the miniatures of the Master of the Coronation Book, the figures are placed on the ground plane in the foreground before a patterned background. The drapery falls into natural, organically constructed folds and the figures are posed naturally without exaggerated mannerism. Not only do these features coincide with those of the miniatures of the Coronation Book, but the compositional formula of this panel is also the same as that employed throughout the miniatures of the Coronation Book: the use of a tripartite organization consisting of a geometrically ordered group of figures at each side focusing upon a central group of figures. The juxtaposition of contemporary personages and saints that occurs in the panel is employed by the Master of the Coronation Book in the portrait of the dauphin before the Virgin in the *Petite Bible Historiale* of 1362 (ill. 7), and the figure of the dauphin in these paintings is similar, except that he is a youth in the panel and he is in his early twenties in the miniature. The Crucifixion flanked by Mary and John reappears in the altarpieces in many of the miniatures of the coronation cycle (e.g. pls. 1, 2, 17, 24, 29).

In keeping with the geometric ordering of the composition of figures, this new interest in geometric structure is reflected also by the rectangular frame which, like many miniatures by the Master of the Coronation Book, encloses a second, architecturally conceived frame placed parallel to and just behind it, similar also to those of the miniatures of the Master of the Coronation Book and in the frontispieces of the *Livre des neuf anciens juges* (ill. 75), the *Bible Historiale* of John the Good (ills. 60, 96), and the treatise of Bernard Gui (ills. 68, 73).

Closer still to the paintings of the Coronation Book is another copy of a lost painting in the Gaignières collection representing John the Good seated before a pope with a man kneeling between them who presents a diptych of Christ and the Virgin to the pope (ill. 86). A description accompanying this copy states that the panel once hung in the Sainte-Chapelle of the palace in Paris and that it represents John, 'King of France'.[73] Gaignières' copy suggests that the original, if indeed it looked like this, was a milestone in the development of late medieval painting with its consistent effort to depict, with a con-

cretely described naturalism unprecedented in medieval art, a meeting between identifiable historical figures in a spatially structured contemporary interior.

We will explore the significance of this panel in greater detail in the next chapter, but here we need only recognize that in this painting the artist deployed every means available at the time to heighten the impression of the true and the real, to create a convincing visual representation of actual people in an identifiable time and place. The composition is dominated by three monumental figures integrated into a clearly established interior space rendered with empirical perspective devices like foreshortening, receding orthogonals, cast shadows and a tessellated floor to define the ground plane and measure the recession of space from the bottom of the rectangular frame to the background. Precise details of costumes, objects, furniture, fabrics, and vaulted architecture reinforce the spatial and temporal realism to create a convincing contemporary setting. The figures are placed in relaxed positions without affectations or mannerisms, and organically structured drapery folds fall naturally to respond to the forms of the body without recourse to the artificial rhythmic patterns of earlier French Gothic painting. A subtle psychological interaction between the figures is accomplished with discreet facial expressions and restrained gestures differing from the exaggerated expression characteristic of French painting in the first half of the fourteenth century. Strongly contrasting, saturated colours describe the textures of the opulent contemporary materials of the fashionable, courtly setting: carmine red, maroon, deep azure blue, pale straw yellow, orange, forest green, pale pink, coral, brown, lavender grey, black (used as a colour and not as an outline), a remarkable transparent grey-black wash, a transparent white glaze and highlights overpainted with opaque white. There is even some suggestion in the copy that the original employed a transparent red glaze over gold in the robe of Christ in the diptych and in the brocade fabrics. The abundance of textile textures and colours match those of the Coronation Book.

No less than its pioneering effort to construct a three-dimensional space and to situate corporeally substantial figures within this space, the panel would have occupied a seminal position in the history of portraiture: among the earliest group portraits, it included not only profile but also three-quarter portraits, the latter among the first since ancient Roman painting. This is not a meeting between archetypal princely and papal figures, for the artist identified the figures by portraiture and details of costume which, as we will see in the following chapter, are sufficiently specific to identify the subject and date of the original panel. Indeed, costume plays a crucial role in the signification of the panel because, besides identifying the figures, it also defines their position in society and provides important clues concerning the actual event depicted on the panel, both in its specific historic significance and in its deeper symbolic meaning. By the portrayal of identifiable personages participating in a specific contemporary event, the panel achieved an unprecedented degree of historicity.

In keeping with this concern for history, integrity of time and place was maintained by introducing sacred personages into this contemporary scene through the device of a painting within a painting, avoiding the anachronistic juxtaposition of historical and divine figures. The portrayal of contemporary persons is accompanied by a complementary desire for the authentic portraiture of divine persons and the accurate representation of histori-

cally verifiable objects, the diptych being a copy of one of the venerable Early Christian icons of the 'True Image' of Christ and the Virgin.[74] As Pächt has shown, a fifteenth-century Provençal copy of the image of the Virgin in this diptych points to the presence of the diptych in the south of France, a further indication of the historical value of the Sainte-Chapelle panel.[75] The artist deliberately conjoined two very different categories of images, a scene of a contemporary historical event and devotional icons of Christ and the Virgin, their frontal and hieratic countenances isolated against a timeless and spaceless golden background and framed by Gothic gables, images of spiritual truths intended as aids in devotion but here factually treated as physical objects within the spatially and temporally defined setting of the contemporary scene of the papal audience. This painting within the lost Sainte-Chapelle panel is a gabled Gothic diptych like several of the altarpieces that appear throughout the cycle of the Coronation Book, while the Sainte-Chapelle panel and the illustrations of the coronation cycle and several of the altarpieces which appear within that cycle, all display similar rectangular frames.

Several analogies between the miniatures of the Master of the Coronation Book and the panel point to direct connections: in the scene of the presentation of the king by the bishops of Laon and Beauvais (pl. 6) the figure of Charles reiterates that of John the Good in the Sainte-Chapelle panel, and in the scene at the palace of the archbishop of Reims the figure of the king (pl. 3) is the reverse of John's figure (pl. 6); the perspective of the canopy of the bed in this scene is similar to the canopy over the pope, including the deep shadow in the underside of the canopy. Finally, in the frontispiece of the *Livre des neuf anciens juges* (ill. 75) the figure of the dauphin so closely corresponds to the king's in the lost panel that, despite differences in costume, it could very well be a copy, or both could derive from the same model. Certainly the large format of this frontispiece achieves a monumentality that is evocative of panel painting.

The Coronation Book Master employs the same spatial devices that are used in the lost Sainte-Chapelle panel, which is the first complete interior known in French painting of the sort first developed by the Lorenzetti, Simone Martini and his followers at Avignon. Comparison of this panel with the frescoes of Matteo Giovannetti in the papal palace in Avignon (ill. 76), with the panel of the Annunciation in Aix (ill. 77) by a follower of Simone Martini[76] and with works of the Lorenzetti such as the panel of *Pope Honorius II Confirming the Rule of Carmel* (ill. 79) is revealing. In all these the floor plane is clearly established and spatial recession measured by similar devices: a tessellated floor measures the recession from the picture frame to the background; the right side of the chamber in each is defined by receding orthogonals formed by a patterned hanging fabric; and the foreground is at once arrested and separated from the space of the background by the similar device of a patterned brocade hanging over which the vaults of the rear chamber can be seen. In all three paintings the rear wall is pierced by windows. The spatial illusion of the chamber in each is given further conviction by architectonically structured furniture rendered with orthogonals (sometimes converging, sometimes diverging). The paintings are enclosed in rectangular frames and the compositions of the pictures reiterate the geometric structure of the frame.

The resonances between the miniatures of the Coronation Book and the lost panel

230

painting from the Sainte-Chapelle reveal much about the Master of the Coronation Book and his place in French painting from the beginning of the reign of John the Good until the end of the reign of Charles V. Not only does it place the Master of the Coronation Book amongst a group of artists who were the vanguard of a new stylistic current that emerged in Italian painting of the 1340s, but it also sheds much light on the entire artistic milieu to which he belonged. The work of the Master of the Coronation Book provides a window from which to glimpse the activity of the royal image-makers who attended the Parisian court. This is the subject of the following chapter.

TABLEAU qui est au dessus de la porte de la Sacristie dans la S.^{te} Chapelle
du Palais a Paris, ou est representé JEAN Roy de France.

86. Copy made for Gaignières of a panel formerly in the Sainte-Chapelle.
Paris, BN, Estampes, Oa 11, fol. 85-88

Chapter 7. The King's Image Makers: Official Painting at the Valois Court

HAVING ESTABLISHED that the work of the Master of the Coronation Book and the Sainte-Chapelle panel share the same concern for historical veracity and that they also have in common significant stylistic, technical and iconographic similarities, we must now try to assess the date and precise subject matter of the panel itself and its place in the development of French art. For only then can the relationship of the Master to the milieu of the panel be evaluated.

I. The Date and the Subject of the Sainte-Chapelle Panel

It is true that the value of Gaignières' copy of the Sainte-Chapelle panel (ill. 86) as an historical document has been widely accepted even though there is considerable disagreement about the date and the subject depicted.[1] However, there are some precise historical details, thus far overlooked, that verify the validity of the copy and permit the date, subject and even the artist to be identified. The very nature of these unnoticed details yields valuable insights that go beyond identifying the particular context of the painting to reveal the circumstances in which works of art were produced at the French court during the reigns of the first Valois rulers.

The description accompanying Gaignières' copy states that the painting hung above the door of the sacristy in the choir of the Sainte-Chapelle and that it depicted a meeting in the audience chamber of the papal palace in Avignon between Pope Gregory V, named 'Grimoye', and King John after the latter's return from England, adding that John's violet or black robe was for the mourning of his recently deceased wife.[2] This description planted the seeds of the misunderstanding that endures to this day. Although some of its assertions have been accepted, such as the indication that the panel hung in the Sainte-Chapelle, little of the description has remained unchallenged, undermining the credibility of the copy itself. Investigators agree that the pope is not Gregory V (d. 999), most opting either for Clement VI or Innocent VI; and while there is general acceptance of the identification of John the Good, opinion is divided as to whether John appears here as king of France or as duke of Normandy.[3] The kneeling figure has been variously identified as Eudes, duke of Burgundy, or the painter John Coste. According to some, Coste presents a painting to the pope, but others follow Gaignières who thought that the scene represented a pope conveying a painting to the king. Given the disagreement concerning the subject of the scene, it is not surprising that the dating of the original panel varies widely, some attributing it to 1342 when John the Good, as duke of Normandy, attended the coronation of Clement VI, others to the end of the reign of John the Good in 1364, and others to the reign of John the Good's son Charles V.[4] The description raises other problems, for the attribution of John's 'violet or black' robe to his state of mourning casts doubts on the reli-

233

ability of the copy, which shows the robe to be deep blue. And it complicates the matter of the date of the meeting and of the subject depicted, because the mourning issue is equally valid and non-valid for both of John's wives, and is therefore of no practical use in dating the work.[5]

Some passages of the description correspond to the copy, as, for example, where it mentions that a kneeling man dressed in scarlet presents a 'portrait of Christ and the Virgin copied from the original in Rome made by the hand of Saint Luke'. However, the description mentions a fourth figure, identified as a papal *camerarius*, who does not appear in the copy. The historical errors and other difficulties in Gaignières' description have cast doubts on the validity of the copy; but, as we shall see, the problems originate with errors in Gaignières' description as provided by the abbé du Tronchay, a canon of the Sainte-Chapelle between 1665 and 1714, who had not consulted the painting but rather the notes of Nicolas Dongois, the brother and collaborator of Gilles Dongois who compiled the unpublished manuscript of the history of the Sainte-Chapelle.[6] Comparison of du Tronchay's description and Dongois' note reveals that du Tronchay embellished his source with his own additions: he named the pope as Gregory V whereas Dongois had not identified the pope, and he added the fourth figure whom he identified as a 'papal *camerarius*'.

The original note of Dongois corresponds closely to Gaignières' copy.[7] It does not mention the fourth figure and makes no reference to a papal camerarius. It refers to the vaulted room, the tapestry hanging behind the figures, the pope seated on a great chair with a back. It mentions 'King' John, seated on a backless faldstool, extending his arm to receive a diptych of Christ and the Virgin that is held by a man kneeling on one knee who wears a scarlet robe with a sword and knife at his side.[8]

Although the abbé du Tronchay's description is not reliable, where does that leave us with the evaluation of the fidelity of Gaignières' copy to the lost original? Given the correspondence between the earlier Dongois note and the Gaignières copy, it is fair to conclude that the original panel did not have the fourth figure.[9] The three figures in Gaignières' copy thus correspond to the earliest indications for the appearance of the panel. Why, then, did Gaignières use du Tronchay's description if he could see that the original painting had only three figures? When one examines the two descriptions side by side it is evident that du Tronchay wrote his description, not in response to the actual painting, but rather to the note in the Dongois manuscript, since he repeats many of the same words and phrases. Du Tronchay's fourth figure can only be explained by his having misread the original note and his failure to compare the note with the actual painting. It may be that only the copyist, and not Gaignières himself, saw the original note, but it would appear that in using the du Tronchay description Gaignières sought, not to interpret the panel or to impose upon it his own historical judgment, but rather to record a report gathered *in situ* from the most credible available source, in this case the abbé of the Sainte-Chapelle, du Tronchay, who had consulted the relevant manuscript records of the Sainte-Chapelle to which he had access. If anything, Gaignières' reliance upon this source, despite its divergence from the panel which he had copied, testifies to his methodological objectivity in recording his findings, suggesting that he would have treated the painting with a similar

87. Jean Bandol: Frontispiece
for the *Bible Historiale of Jean Vaudetar.*
The Hague, Museum Meermano-
Westreenianum,
MS 10 B 23, fol. 2

objectivity, refraining from imposing his own judgment or interpretation upon it to change it in any way from the original.

Convincing pictorial evidence shows that his historical and antiquarian concerns assured the reliability of the copies, a point of view defended most recently by de Vaivre and Sterling, the latter providing compelling evidence by juxtaposing Gaignières' copies with extant originals.[10] Amongst these comparisons Jean Bondol's frontispiece for the *Bible Historiale* of Jean de Vaudetar in The Hague (ill. 87), confronted with Gaignières' copy, shows that the copy faithfully reflects the composition, framing, colours, proportions, costume, corporeality of figures, drapery folds, portrait likeness, shadows, textures, and perspective devices of the original.[11] Minor differences suggest that, although the copyist did not introduce stylistic influences from his own time, he failed to capture the subtlety of the original. There is no reason to doubt the same degree of accuracy in the copy of the Sainte-Chapelle panel.

Much of the confusion about the date of the work is dispelled by the king's costume in the painting. Although the description accompanying the copy identifies John as 'King of France', the absence of a crown from John's head has led scholars to the widely-accepted, but mistaken, conclusion that the scene represents a meeting between a pope and John the Good when he was still duke of Normandy. A visit to Avignon when the young prince

235

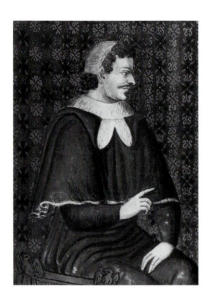
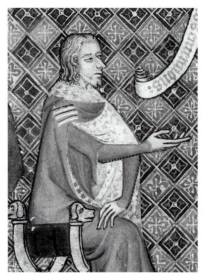

88 *(left)*. John the Good.
Detail of ill. 86

89 *(right)*. Charles V. Detail of the frontispiece
to the *Livre des neuf juges anciens*.
Brussels, Bibl. Roy., MS 10319, fol. 3

was accompanied by his maternal uncle Eudes, duke of Burgundy (identified by some as the kneeling man in the center of the panel) for the coronation of Clement VI in 1342 has received general acceptance.[12]

It is highly unlikely, however, that John appears in this panel as duke of Normandy since court protocol would not have permitted the duke of Burgundy, one of the most important princes in Europe and peer of the realm, to assume the servile position of kneeling on the ground before his younger nephew of the same rank, the duke of Normandy. Still more improbable would be the elevated position of a duke, seated face to face and on an equal plane with the pope. This position of parity is inconsistent with the servile role that John assumed at Clement's coronation, serving at the pontiff's table at the ceremonial feast.[13] More importantly, the protocol of papal audiences demanded that even persons of higher rank than the duke of Normandy, kings, emperors or even saints were not accorded a position of parity with a pope as is the case in the panel (e.g. ills. 79, 80).[14]

John the Good's garb in the Sainte-Chapelle painting differs significantly from the official costume of the duke of Normandy, which was not a short cape with a hood and white lappets like that worn by John in the lost panel. Instead the duke's official costume was a long *herigaut* or cape opening on the right side and attached over the right shoulder by three ermine bands (ills. 88, 89).[15] Moreover, John's cap is entirely inconsistent with the usual portrayal of the duke of Normandy, who elsewhere appears bareheaded, without cap or headdress of any sort. An uncovered head is a sign of homage and submission, as explicitly stated in the rubrics accompanying the oaths in the Coronation Book. There it indicates that when a peer of France made his oath of homage to the king, he was required to come before him with bare head and kneel before the king as a sign of his submission as the king's vassal.[16] As a secular peer of France and to signify his submission to the king, the duke of Normandy did not wear head covering for his official appearances and in his portraiture.[17] John the Good is dressed in the costume of the duke of Normandy in his portrait amongst the peers of France, all without head covering, in the frontispiece of the trial of

236

Robert of Artois (Paris, BN, MS fr. 18437).[18] The frontispiece of the *Livre des neuf anciens juges* (Brussels, Bibl. Roy., MS 10319; ills. 75, 89) shows the future Charles V as duke of Normandy, head uncovered and wearing the *herigaut*. Charles is similarly attired in his portrait in the *Petite Bible Historiale* of 1362–3 (Paris, BN,. MS fr. 5707, fol. 368; ill. 70) in which he appears as duke of Normandy and dauphin of the Viennois. Finally, John the Good's portrait in the Louvre (ill. 85) shows this prince bareheaded, the absence of a crown or any other type of head covering indicating that he is portrayed before his sacre in the rank of duke of Normandy even though the inscription — overpainted on the panel *after* John's sacre — affirms that he is *Roy de France*.[19]

The crucial detail in this portrayal is the presence or absence of head covering because, without exception, after his sacre the king of France covered his head out of reverence for the Celestial Balm with which he was anointed at that ceremony. Although from the Carolingian period kings, emperors and popes had been portrayed wearing crowns, the absence of a crown cannot be taken to mean that a king or a pontiff has not yet been crowned, for neither secular nor ecclesiastical rulers wore crowns on all occasions. Crown-wearing was strictly reserved for the high feasts of Christ — Nativity, Easter, Pentecost — and for the anniversary of the king's coronation.[20] Nevertheless, kings and ecclesiastical hierarchy did not go about bareheaded. For non-ceremonial and daily occasions kings, popes, emperors, bishops, etc. donned a head covering called, in fourteenth-century sources, a coif or *cale*,[21] precisely the cap worn both by the pope and the king in the panel. The pope wore a red *cale* for ordinary occasions and audiences in his private chambers, the sort of occasion shown in the panel, and the king wore a sheer white coif or *cale* like the one worn by John in our panel.[22] This cap was worn by the clergy and, as a sign of their consecrated clerical status, it was worn by university Masters and Doctors in Theology.[23] Clement VI, who was a Doctor in Theology and Master at the University of Paris, was one of the first popes to be portrayed wearing the *cale* in his tomb effigy at the monastery of La Chaise-Dieu where he wears it under his papal tiara (ill. 4).

Histories of costume have generally approached their subject primarily from a stylistic angle, organizing the material according to form, nomenclature, and historic and geographical period. Sociologists, anthropologists and linguists have been critical of this narrow approach, recognizing that larger sociological, anthropological and even linguistic issues are involved in the analysis of costume. More than a simple stylistic and historical matter, costume is a sociological phenomenon, like language — at once a system of classification and communication and a collective institution founded on the order of signs.[24] Costume plays a social function by designating the association of the individual to the group and to society at large. Not a simple matter of personal fashion and taste, costume is one of the symbolic systems by which society expresses the individual's position in the sociological order.[25] Nowhere is this more true than with royal and ecclesiastical costume. Most histories of costume have failed to recognize the shared ritual origins of royal and ecclesiastical dress and the vital sociological role which that dress plays, for in the Middle Ages costume distinguished the ruler and the clergy from the laity and set them above the laity. It was thus a means of making visible the hierarchical order of society. Bishops and archbishops, anointed at their sacre, and anointed kings were required by the prevailing

ecclesiastical and royal vestimentary codes to cover their heads at all times to protect the anointed head from the touch of the profane and to signal their consecrated status.[26]

Never a simple matter of individual taste or even of changing popular fashion, royal garb adhered to a strictly regulated dress code originating in the sacre itself. We have seen that during his sacre the French king was anointed with the Celestial Balm, and, beginning in the Carolingian period, the sacring ritual contained elements comparable to the consecrations of bishops.[27] We have seen that in their respective consecrations, similar prayers were recited, similar rituals were performed, and both bishop and king were invested with comparable vestments and insignia which signified their consecrated status.

A particularly relevant explanation of the coif or *cale* worn by the king of France is given by Jean Golein in his *Traité du Sacre*.[28] Golein emphasized that because of the nature of the anointing administered in the sacre, the king, like a priest, must 'wear the coif all of his life' out of reverence for that anointing and as an outward sign of this 'anointing of the most worthy holiness ... and because the chrism which has penetrated the body must not suffer contagion by being touched by anything unworthy of it'[29] Consistent with this, both John and his successor Charles V were always portrayed with head covered either with a crown or a *cale* after their sacre (e.g. ills. 12, 14, 68), whereas before their anointing they were portrayed bareheaded (e.g. ills. 5, 8, 9, 89).[30]

Besides the *cale*, both men wear the *super-tunica*, with fur-trimmed hood or *chapperon* and furred lappets, which corresponds to the costume of the university Regent Master of Theology.[31] John wears a *robe longue* covered by a short hooded cape, both indications of the king's anointed and consecrated status. The *robe longue* was a garment worn by Masters of Arts and Masters of Theology of the university,[32] whose costume was strictly regulated by papal privilege to distinguish them from the laity, signify their clerical dignity and mark them as under the protection of the king from corporal harm.[33] Similarly, as with a bishop at his sacre, the king is vested with priestly robes that are covered by an outer mantle to give added protection to his anointed shoulders and breast and to signify his consecrated sacerdotal and prelatial status and set him apart from the laity.[34] Like the crown and mitre, the royal and episcopal capes are subsequently worn only for the most solemn ceremonial occasions. But vestimentary usage called for a special covering for the consecrated shoulders and breast of kings as for the members of the Church hierarchy, and gloves for their anointed hands.[35] John the Good's robe, along with the short, hooded and ermine-lined cape is the royal equivalent of the *mozetta*, a short cape, often hooded, worn by ecclesiastical prelates, popes, cardinals and bishops, when seated *in cathedra*.[36]

John the Good's costume leaves no doubt that the lost panel from the Sainte-Chapelle represented John after his consecration as king of France. It did not, therefore, predate his sacre in September 1350. But which of John's visits to the papal court does it record? Although John the Good journeyed frequently to Avignon before his accession, he made two visits as king, one at the beginning of his reign in December 1350 to visit Pope Clement VI, and a second, near the end of his reign, from December 1362 until March 1363, to visit Pope Urban V before returning to England where he died in April 1364.[37]

The pope in the Sainte-Chapelle panel is also identified by costume. The ermine-lined carmine red robes and opulent golden brocades are not those of the ascetic Urban V who

vehemently condemned the sybaritic luxury and irresponsible expenditures of his Avignon predecessors. Urban expressly wore the monastic habit of his Benedictine order and lived in ascetic quarters.[38] In a letter to Urban, Petrarch praised him for precisely these reasons:

> … I know that you have laboured hard to bring back modesty and decency into the manner of dress … , for the absurd fashions introduced in our day were no longer to be endured, when men who thought to make themselves appear fine and interesting were really bringing dishonour on themselves. How indeed were the monstrous novelties displayed before us to be endured?
>
> … *shoes pointed like the prow of a galley*, hats with wings, *hair elaborately curled*, with long pigtails, and men with ivory combs set on their forehead, as though they were women? … .It was right that you, the Vicar of the Sun of Justice, should restore justice to its full power and *cause these damnable practices to disappear* … .[39] [emphasis is mine]

The sumptuous setting and the high fashion of the Sainte-Chapelle panel, the pointed shoes, the curled hair styles, are precisely the sartorial comportment condemned by Petrarch. It is doubtful that the punctilious and courtly John the Good would have been so politically and socially provocative as to have presented himself before the ascetic Urban in a display of the very sartorial excesses that Urban had banished from his court. It is most improbable that the ascetic Urban would have appeared in this sumptuous setting wearing ermine-lined silks. Surely the pope of the Sainte-Chapelle panel is not Urban V, but the sybaritic and luxury-loving Clement VI, a man obsessed with fashion and opulent materials, whose sartorial expenditures, as the Avignon financial registers show, made the Avignon papacy all that it was reputed to be.[40]

The same fashions, the pointed shoes, long *cotardies*, and coifs appear prominently throughout the paintings commissioned by Clement VI for the papal apartments. Long *cotardies*, such as that worn by the kneeling man were out of fashion by the 1360s and appear only rarely after 1350.[41] As noted, Clement was the first pontiff to wear the *cale* of the style shown in the panel and he is portrayed on his tomb effigy wearing a similar *cale* (ill. 4). It is also worth noting that, although restored, the profile of Clement VI on his tomb at La Chaise-Dieu resembles the pope in the Sainte-Chapelle panel. This abundant, precise, and concrete detail, which coincides so closely with the historical accounts of the period, leaves little doubt that the lost panel represented the visit of John the Good to Clement VI in December 1350 and January 1351, and that the panel was made either during, or not long after that visit.

Further evidence that the original painting should be dated to 1350 is the diptych of Christ and the Virgin which is being presented to the pope in the painting. We should recall that the Dongois description stated that this painting was a copy of the original in Rome painted by St Luke. Indeed, this image of Christ is a variant of the legendary True Image (*vera icon*) still kept in the *Sancta sanctorum*, formerly the pope's personal chapel in the Lateran Palace. This painting is referred to in the *Liber pontificalis* as an *'acheropsita'*, a corruption of *acheiropoiéton*, the image not made by human hands.[42] From 600 this 'true im-

age' was carried in procession around the city of Rome, and it was celebrated for its miraculous and salvatory powers, as when it saved the Romans from a Lombard attack.[43] According to legend the Apostles had asked Luke to paint a portrait of Christ so that they would have an image of him after the Ascension. Before Luke could finish, the painting miraculously completed itself through divine intervention: Christ's wish to leave a true image of himself was transmitted to this miraculous portrait, even endowing it with the power to replicate itself when an appropriate support was pressed to it.[44] Pope Innocent III had the image 'crowned' by enclosing it in a silver case that carries Passion imagery.[45]

A related 'true image', the Mandylion, was said to have saved Edessa from the Persians. According to the seventh-century Byzantine poet George the Pisidian, this icon represents a 'figure painted by God'.[46] Taken to Constantinople in 574, it was kept in the palace chapel until the sack in 1204 when it disappeared. Belting has suggested that the image of the 'Holy Cloth' mentioned in the inventories of the Sainte-Chapelle may even have been the Mandylion. Another variant of the 'true image' is the Veronica (*vera icon*), that first appeared during the thirteenth century and was kept in St Peter's in Rome. According to legend this was made when Christ pressed his face onto the cloth.[47] A complex of legends developed around these 'true portraits', including that of the *sudarium*, the cloth or veil that the holy woman Veronica offered to Christ on the way to Calvary to wipe his face. These images were a material connection with the historical Christ, and accordingly, the beholder was in the real presence of Christ who is transported through time and space into the present through his True Image.

The presence of these 'true portraits' in Rome, particularly that in the Lateran, was used to justify the primacy of the See of Saint Peter, since these images had been transported from the Holy Land to Constantinople, and thence to Rome. And indeed this very issue and these same icons were the subject of Clement VI's bull that declared 1350 to be the jubilee year.[48] In this bull Clement described how during the dedication ceremony of the Lateran basilica by pope Sylvester 'the *achiropiiton* (sic) made without hands appeared miraculously over the papal throne to be seen by all the people of Rome'. For Clement the miraculous appearance of this image over the papal throne served to emphasize that this 'seat is the seat of Christ's vicar on earth'.[49] Boniface VIII had declared 1300 a jubilee year, and it was incumbent upon Clement to do the same in 1350. But in so doing Clement presented himself with a dilemma because Rome was the city of the jubilee and not Avignon, which had neither an ancient tradition nor a Petrine foundation. As the ceremonies of the jubilee centre upon the sacred icons of Rome, and the Lateran icons could not be taken from their historical settings and transported to Avignon, declaring a jubilee would show up the absence of the papal see from Rome, underscoring the irony of Clement's presence in Avignon.[50] By presenting Clement with copies of two of the most venerable Roman icons — whose essence was their power to produce copies of themselves — John was in essence bringing to Avignon the True Image that had journeyed from Jerusalem to Constantinople and to Rome.

The presence of this famous True Image in the Sainte-Chapelle panel is more than a precise historical reference: it is a visual discourse on the nature of pictorial representation and the role of the artist as the interpreter of things visually perceived. It deliberately and

wryly conjoins a painted representation of the hieratic True Image 'not painted by human hands' with the precisely delineated interior and the 'true likenesses' of pope, king, and servant. Yet this icon is a modernized and updated version of the ancient exemplar, and as such it raises the question of who painted this *copy* of the image 'not painted by human hands', for the diptych is obviously a painted copy, one that indeed anticipates Jan Van Eyck's version. In the Sainte-Chapelle panel this copy is again copied by the artist of the panel who treated it as a physical object in the represented reality of the historical event unfolding in the papal audience hall. While we have seen that details identify the king and the pope and the historical moment, we are still left to wonder who the servant might be. It is not Eudes of Burgundy, and in what follows we will see that it cannot be the painter John Coste, as some have suggested. Yet this man bears the holy image and is thus associated with it, and despite his servile position, he is at the centre of the group, linking king and pope and the venerable icons of Christ and the Virgin and the actual represented reality of the people and events in the room. He is the messenger who brings the divine images to their precisely defined terrestrial setting. At this point one might be tempted to pose the question of whether this figure might be a self portrait of the artist who painted the original panel, although there is not sufficient evidence to reply.

But there is much more evidence about the artist of the painting to be gathered from the images under consideration and the visual and written documentation pertaining to the specific people and events surrounding the creation of this panel in 1350. Among the visual resources, Parisian manuscript painting, despite its miniature scale, at once confirms the stylistic reliability of the Gaignières copy of the lost panel from the Sainte-Chapelle and corroborates its dating to 1350 since elements of the panel's innovative style begin to appear in Parisian miniatures at exactly this date. Thus we have another valuable resource for the lost panel and fresco painting of the fourteenth century, particularly because manuscripts were produced in workshops of panel and fresco painters, and sometimes also included copies of monumental paintings or reflections of stylistic advances made by monumental painters, an issue that will be considered further later on in this chapter.

The scene of the 'Miraculous dedication of Saint-Denis' (ill. 81) in the Missal of Saint-Denis (London, V&A, MS 1346–1891) exhibits a rationally constructed interior space in which the vaults resemble those of Suger's choir.[51] The ground plane has been clearly established and the foreground separated from the vaults of the background by the motif of a brocade drapery, one of the earliest examples in manuscript painting of a device which had first appeared only a few years earlier in Italian panel painting. A few of the miniatures of the *Bible Moralisée* of John the Good (Paris, BN, MS fr. 167), begun in 1349, have comparable rationalized interiors and the earliest tessellated floors to appear in Parisian manuscript painting.[52] Thus, reflections of the spatial innovations of the Sainte-Chapelle panel appear in the work of the circle of the Remède Master exactly at this date. The Master of the *Remède de Fortune,* who was responsible for both of these works, is so named for his miniatures illustrating the work of that title by Guillaume de Machaut in the earliest manuscript of that author's works (Paris, BN, MS fr. 1586), dated to this same period, illustrations distinguished for the spatially conceived interior scenes and attention to contemporary fashion.[53] The Master of the Coronation Book makes his debut at this time as a

collaborator of these illuminators working in this new style. All these works reflect the impact of new ideas on the art of the French court that marked a departure from the established style of Pucelle and his followers. This evidence presents a possibility that the new style was imported into Paris about the time of John the Good's visit to the court of Clement VI, and furthermore, that an artist in the entourage of John the Good was instrumental in the introduction of this style.

The Sainte-Chapelle panel was a new genre of ruler portraiture that carried a new message about the relation of king and pope. It was not a traditional image of the two powers, the rulers of Church and State. For the deliberate individuation specifically identifies king and pope so that the subject of the panel is the relationship of a particular king, John the Good, and a particular pope, Clement VI. This individuation also identifies the specific encounter between these individuals.

What was the meaning of this new genre of painting portraying recognizable contemporary rulers engaged in a specific historical encounter? And what was the purpose for which this new genre of painting was developed? To answer this we must begin with the individuals depicted, for the two principal subjects were also the primary members of the intended audience of the panel. The Sainte-Chapelle panel departs from traditional ruler portraiture which, from the Carolingian period on, portrayed rulers and ecclesiastical prelates alike in the ceremonial garb of their respective offices. This is not a traditional representation of a ruler and a pope with its connotations of the submission and subordination of the secular estate to the papacy, for the panel emphasizes, through the details of costume, John's sacerdotal and prelatial status. Furthermore, as the first ruler portrait in which king and pope are attired in daily, non-ceremonial habits of their respective ministerial offices, it apparently refers to a private encounter between these prelates on common ground rather than to an official ceremonial occasion. The relationship presented here is not one which involves a pope conferring authority on a vassal, as in so many images in which the emperor kneels before the pope: the ruler neither bows nor kneels before the pontiff, nor does he place his right hand in the pontiff's right hand, the signs of vassalage and submission to a feudal lord. Rather, the painting asserts Clement's recognition of John's sacerdotal and prelatial status by presenting a relationship between two individuals of comparable anointed character who encounter each other on an equal plane. (It is indeed similar to the position of king and archbishop in the Coronation Book where both are seated together in *cathedra*.) It expresses their equality rather than the submission of the ruler to the pope. Here John sits at the right hand of the pope much in the way that Christ sits at the right hand of the Father. The painting presents John as King of France who has no terrestrial superior and thus the image expresses the ideology of the *rex christianissimus*.

Considerable care was taken to assure that the king and the pope were shown according to their physical appearance and rank. The portrayal was not, as with so many likenesses of the period, a funerary effigy, but showed these persons as living and engaged in a specific meeting, and, because of the precise historical detail, it represented a visual account of that encounter. Further consideration of the elements that permit recognition suggests that there is more to this panel than commemoration or even providing a pictorial record, for the particular relationship between the individuals portrayed is also an implicit

subject of this painting. Clement VI, the former Pierre Roger, had long been a partisan of Valois kingship and an unwavering defender of the claims of John the Good to succeed his father Philip VI to the throne on the principle of hereditary male succession.[54] As the former archbishop of Rouen he had been instrumental in securing John's accession as duke of Normandy, a crucial step for his eventual succession, and he had been equally instrumental in obtaining the homage of Edward III for Guyenne.[55]

The identification of John the Good and Clement VI thus suggests a more significant political context for this painting. John's meeting with Clement in Avignon in December 1350 was his first official journey since his sacre three months earlier. Clement's correspondence in the weeks between the death of Philip VI and John's sacre displays an unusual concern for assuring that John be recognized as king and that his sacre take place.[56] One of the strongest statements ever made by a pope in favour of the hereditary rights of the eldest son of a king of France to succeed to the throne appears in Clement's letter written on 2 September 1350. As Clement's first letter to John, written a day after Philip VI's death, the pontiff emphatically affirms John's 'right to be admitted to the sacre on the principle of hereditary succession'.[57] Because John's rights to succeed did not have universal support, this letter affirming papal support for his hereditary rights to be crowned would have carried enormous political weight due especially to Clement's magisterial authority as a Master of Theology from the University of Paris.

Clement's very first letter after the death of Philip VI, written not to John but to Edward III, exhorted the latter to continue the peace negotiations that he had started with Philip VI, and by referring in this letter to John as 'the illustrious king of France' (*Johannis, regis Francie illustris …*) Clement unequivocally declared his position that the son of Philip was the king of France, significantly even before the sacre had taken place.[58] Moreover, to allay any doubts that he fully supported the principle of the hereditary succession of the first born son of the king of France to the throne, Clement referred to John's eldest son Charles in two letters dated 11 September 1350 by the terms '*primogenito Johannes regis Francie, illustris* … .'[59] This demonstrates Clement VI's active role in promoting the succession of John the Good to the throne of France, and his support for the principle of the hereditary right of the son of the king of France to succeed to the throne of France.

The Sainte-Chapelle panel, recording the first official visit of John the Good to the pope after his coronation, must be understood in the light of Clement's role in defending John's right to succeed to the throne. On display in the Sainte-Chapelle, where in 1333 the barons had sworn before Pierre Roger (the future Clement VI) and Philip VI to recognize the rights of John as heir, the panel would have provided a visible reminder of that event and of the role of Clement VI in defending succession by primogeniture and in assuring the accession of John the Good. Here, recognition was intended to play an active political role: those who might see this panel, members of the court of France and the royal counsel, who would gather in this royal chapel on state occasions and for the secret sessions of the royal counsel, would have readily recognized the king and the pope. The successors of the élite and powerful who had been present in the Sainte-Chapelle in 1333 on the occasion of the oath would have been reminded of their legal obligations to honour that oath. This would have been particularly valuable during the early years of John's reign when he was striv-

ing to consolidate power and strengthen his support amongst the highest members of the Estates who made up his counsel. Commissioned for a context in which the very basis of rulership was questioned, the Sainte-Chapelle panel represents a new kind of ruler portrait, one that makes a precise argument concerning the individuals involved. Because of the specificity of the identity of king and pope, this panel was surely understood by its audience as upholding the position that John was king of France by the right of male succession, a principle affirmed personally by the former Master of Theology at the University of Paris, Pope Clement VI, on behalf of his former student and protégé. Political persuasion was the primary purpose of this new genre of painting.

II. *The Artist of the Sainte-Chapelle Panel: Girard d'Orléans, Pictor Regis of John the Good*

The obvious artistic and historical importance of the lost panel leads to the question of who painted this visual account of the encounter between John and Clement? Was the panel painted by an artist at the papal court, or was it the work of an artist in the service of the king of France? Do the Italian perspective techniques indicate that the artist was an Italian? Or was the artist a northerner who journeyed to Avignon with John the Good?

The preceding consideration of this lost panel provides several clues as to its maker. The nature of the subject of the panel yields insight into the position of that artist in the development of French painting at the beginning of the reign of John the Good, insight sufficient to disclose the artist's identity.

The lost panel was a milestone in the revival of the naturalistic portrait since it depicted specific historic individuals according to likeness, costume, and temporal context. As such it was the work of a portrait innovator who contributed to the development of the late medieval and early Renaissance portrait. The artist was also a pioneer of history painting, since the panel records through its naturalistic details a historically specific encounter between a pope and a French king. The exceptional care taken to identify the individuals and their rank in this face-to-face encounter between two of the heads of Latin Christendom suggests that the panel was meant not simply to commemorate the event but to give an eye-witness account and to interpret its meaning. Not only did the artist have access to these high-ranking individuals and the skill and talent to capture their physical appearance, but, more significantly, he appears to have played an integral part in formulating this complex and innovative visual statement about the meaning of the papal royal engagement, suggesting that he probably served as a trusted political collaborator. This artist demonstrates specialized technical knowledge of royal and ecclesiastical dress as well as of court ceremonial and protocol. All of this is consistent with the activity of a high-ranking court artist.

But was this painter working for the king or for the pope? And was he a northerner or an Italian? There is no visual evidence for the presence of comparable Italian perspective

techniques and monumentality of form in Parisian painting of the 1340s. The structure of the space and of the figures that inhabit it is far more advanced than anything produced by Pucelle and his followers. This panel is the earliest painting of a French subject to display an interior of the kind developed by Italian painters in the 1340s.[60] The artist of the panel surpassed Pucelle and his followers in the use of the techniques first employed by Sienese painters of the generation of the Lorenzetti, Simone Martini, and the latter's successors who worked in Avignon. Reminiscent of the works of Simone Martini, the Annunciation in Aix (ill. 77),[61] and the Lorenzetti (ill. 79), the Sainte-Chapelle panel displays the same pictorial formulae: the spatial structure and composition of these pictures reiterate the rectangular frame; the foreground and middle-ground are defined by receding orthogonals made by a brocade hanging that separates the foreground from the vaulted space of the chamber behind it where the rear wall is pierced by windows. The spatial illusion of the chamber in each is given further conviction by architectonically structured furniture rendered with orthogonals (sometimes converging sometimes diverging), and the figures of these panels are convincingly integrated into this structured spatial setting. The most striking resonance between the lost panel and Italian painting of the 1340s is the tessellated floor used as a device to define the ground plane and to measure the recession of space from the picture frame to the background, the earliest appearance in a northern context of this device developed by Simone Martini and the Lorenzetti and taken up by other Italians working in Avignon in the 1340s including Matteo Giovannetti (ills. 76, 90).[62]

As for portraiture, Simone Martini's numerous lifelike profile portraits, including those of Robert II of Anjou (ill. 91), Cardinal Napoleone Orsini, Guidoriccio da Fogliano, and the almost mythical lost portrait of Petrarch's Laura, constitute a founding chapter in the renascence of the portrait.[63] Simone's last works, including some of his portraiture, were executed at Avignon before his death there in 1344, presenting the possibility that Avignon played in some way a catalytic role for the portraiture of the lost Sainte-Chapelle panel.

These analogies suggest the artist's recent and direct contact with Italian painting of the 1340s, a point given special significance because the subject of the panel is a visit of a French king to the papal court on the Rhône. Indeed, it appears that the artist of the panel was not only recording a specific meeting between the king of France and the pope at Avignon, not merely displaying his own mastery of the most recent work of Italians in Avignon, he was also paying tribute to that innovative work and the papal patron who sponsored it. This increases the likelihood that Avignon was where the artist of the panel became acquainted with the latest Sienese techniques of spatial illusionism and figure construction.[64]

There can be little doubt that the artist of the panel was conversant with the perspective techniques current in painting in Avignon during the 1340s; indeed these particular stylistic affinities of the Sainte-Chapelle panel are so close to the frescoes of Matteo Giovannetti in the chapels of Clement VI in the papal palace in Avignon that the panel has even been attributed to him.[65] However, despite the clear dependence of its spatial construction upon Italian sources, the lost panel differs in fundamental ways from the work of the Italian painters, and numerous indications suggest that the artist was in the service of John and not Clement.

The primary interest of the Italian masters — Simone, the Lorenzetti and Matteo Giovannetti — is the human figure which attains in their paintings a substance and grandeur that dominates the spatial setting. This is largely because the new descriptive and spatial techniques in their painting are always subordinated to the figures and never allowed to overwhelm them or to distract from their actions. While these masters also describe the tapestry, mosaics, and architecture of the physical setting, this descriptive detail is never allowed to become the main subject of the painting. Moreover, they use bright and saturated colours with considerable restraint.

The artist of the Sainte-Chapelle panel displays very different aesthetic and expressive concerns. The sub-text of this painting is the discourse of material objects that define the space as well as filling it. Individuals are identified by what they wear. The clothing — indeed fashion — has pride of place. In this the artist is a master of sartorial semiotics as an instrument of social ordering. As we have noted with the Coronation Book Master, the artist of the Sainte-Chapelle panel takes similar delight in the description of the cut and construction of the clothes and the materials out of which they are made. He is equally interested in accessories, interior furnishings and draperies, furs, fabrics and textures. No Italian painter demonstrated an equal preoccupation with the surfaces of particulars of material reality. Rather, the Italians were concerned with the universals of mass, form, structure and space, as defined by light and shadow. Unlike the Italian masters who subdued the intensity of the light and colours of the background setting and secondary detail in order to allow the figures to dominate the scene as well as to reinforce the illusion of spatial recession, the artist of the Sainte-Chapelle panel gives equal attention to the main subject and to secondary objects, to foreground and to background. He uses the same intricate detail in foreground figures and background, and he also uses rich, saturated colours in the background that create the illusion of moving towards the viewer rather than receding: a brocade hanging behind the figures competes with the foreground because of the intricacy of detail and the saturated deep red colour. In his hands the advanced spatial devices of Italian painting are thus to an extent neutralized and there is a strident contradiction between the description of surfaces and the delineation of structure and space.

The palette of colours differs fundamentally from those employed by Simone and the Italian painters who succeeded him at Avignon. Significantly, some colours that are ubiquitous in Italian painting of this period do not appear in the Sainte-Chapelle panel or the related Parisian works: notably absent are the range of pale grey-green tonalities and the soft grey-blues so prominent in the painting of Simone and the Lorenzetti. Indeed, Italian painting avoids the profusion of saturated colours that characterizes Parisian painting from in the 1350s.

If there is nothing quite like the spatial construction of the Sainte-Chapelle panel in French painting of the 1340s, it is also true that there is nothing exactly like its historicity in Italian painting at Avignon or in Italy. This style is a synthesis of Italian and Parisian elements and its earliest appearance is around 1350, with the nearest analogies in French painting beginning in 1349-50.

Iconographic considerations are more compatible with an artist in the service of the French king rather than the pope. The panel records John the Good's presentation of a

painting to Clement VI and not the presentation of a painting to John the Good by the pope. The fact that the Virgin in the diptych was copied in a fifteenth-century Provençal miniature indicates that the diptych corresponds to an actual work that remained in the environs of Avignon rather than travelling to Paris as we might have expected had it been a gift to the king from the pope.[66] The formulation of the special imagery of the *rex christianissimus* also favours a French royal setting for the commission. The relationship of parity between the king of France and the pope is unparalleled in the Italian tradition of papal imagery where, as we have noted above, the pope appears almost without exception in an elevated position *vis-à-vis* the other figures in the room, even when they are saints, secular rulers or the clergy (e.g. ills. 79, 80).[67] By contrast, iconographic antecedents exist in Parisian copies of Gratian's Decretals in which the king of France and the pope appear seated on comparable thrones on the same level.[68] All of this, not the least of which is the exceptional importance given the king of France and the official character of the panel, is more consistent with a painter in the service of the king of France than one in the service of a pope, even a French pope such as Clement.

Although Italian painting in Avignon in the 1340s provides the nearest spatial precedents, the fact that the panel depicts the True Image of Christ that was hanging in the Lateran suggests that the artist had direct knowledge of that Roman painting, which might

90. Matteo Giovanetti: The Beheading of John the Baptist. Fresco, Avignon, Palais des Papes, Chapel of St. John the Baptist

247

91. Simone Martini: Robert of Anjou crowned King of Naples by St. Louis of Toulouse. Naples, Galleria Nazionale

favour the identification of the artist as an Italian. However, it was not necessary for an artist to go to Rome to see a replica of the True Image for, as noted above, the inventories of the Sainte-Chapelle mention 'the image of the Holy Cloth' which may have been the Mandylion. Moreover, an important copy of the Lateran icon had been in Laon since the mid thirteenth century when a copy of the Lateran image was sent to France. Indeed, the diptych in the Sainte-Chapelle panel reiterates the lifelike traits of this painting, the halo, the hair parted in the centre, the pointed beard, and especially the brocade garment worn by Christ in the Laon copy, suggesting that this might have been the source rather than the image in Rome.[69]

Although the lifelike portraiture was preceded by that of Simone and other Italian

painters who were the first to revive portraits based on the features of living persons, sur-viving Italian portraiture of the period does not present a comparable tradition of historic-ity in the portrayal of contemporary personages participating in contemporary events.[70] More usually when Italian painters of this period painted historical subjects, these subjects were drawn from the past rather than the present, as with Pietro Lorenzetti's *Honorius II Confirming the Rule of Carmel* (ill. 79), or the predella of Simone's St Louis altarpiece (ill. 80). Strictly speaking, these subjects are hagiographic narratives and do not represent contem-porary historical and political events. Simone's lifelike profile portrait of the French ruler of Naples and Sicily, Robert of Anjou (ill. 91), is a qualified exception: like the Sainte-Chapelle panel it is an image that defends a contested kingship (that of a distant cousin of John the Good, in fact).[71] But this hieratic political icon differs radically from the Sainte-Chapelle panel, for the lifelike portrait of Robert of Anjou appears in conjunction with the hieraticized and idealized countenance of the deceased St Louis of Toulouse so as to present an idealized, sublimated symbolic account of the source of Robert's kingship rather than a narrative account of a historically specific contemporary event.[72]

The single Parisian panel painting of the period to survive, the lifelike profile portrait of John the Good (ill. 5), painted in the months before John's accession, testifies to the presence of lifelike portrait painting in Paris shortly before 1350 and John's visit to Avignon.[73] The portrait sculpture of Paris from the reign of St Louis to Charles V — includ-ing André Beauneveu's *gisant* of that ruler in Saint-Denis (ill. 16), the Louvre portraits of Charles and Jeanne (ill. 2), and the portraits in the Coronation Book of Charles V — all pro-vide ample indication that the historical concern of the Sainte-Chapelle panel fits into a tradition at the Parisian court and that the artist's closest analogies in portraiture are with works made for that court.[74] The Sainte-Chapelle panel is the work of an artist who has ef-fected a Franco-Italian synthesis in which Italian spatial techniques of the 1340s have been adapted to serve Parisian courtly ends. In the final analysis, this art is sufficiently different from its nearest Italian counterparts to distinguish it as essentially Parisian, and it is at the Parisian court that the artist should be sought.

John the Good was crowned in September 1350 and the visit to Avignon took place three months later in December 1350, so that the painter of the panel already occupied a high-ranking position of trust and responsibility in the first months of the reign of John the Good. This would have been likely only if he had been in the service of the king for some time prior to his coronation.[75] It is also conceivable that the painter was known to the pope, for the artist portrayed the pope according to physical likeness suggesting that he had ac-cess to the pope and even, perhaps, was present at the meeting between John the Good and Clement VI, privileges unlikely to have been granted to an entirely unknown servant of a visitor to the papal court.

Of the artists whose names appear in the accounts of John the Good in 1349 and 1350, Jean de Wirmes, Jean Susanne, Guillaume Chastaigne and Jean de Montmartre are listed as illuminators.[76] François Avril identified the last of these as the head of the workshop that produced the *Bible Moralisée* of John the Good.[77] Also in the service of John the Good was the illuminator Jean le Noir, whose idealized portraits of John and his first wife Bonne of Luxembourg in the Psalter of that princess lack the verisimilitude of the Sainte-Chapelle

panel.[78] The painters Jean Quarré and Guillaume Bernier are each mentioned only once in the documents, so there is no evidence that they were leading painters in John's service.[79] The names of only two painters stand out prominently in the documents of the early 1350s: Girard d'Orléans and Jean Coste, and of the two, the records provide reasonable evidence, as we are about to see, that Jean Coste, though a painter of great talent, could not have been the author of the Sainte-Chapelle panel.

The names of Girard d'Orléans and Jean Coste appear together in two documents dated 25 March 1356 concerning an extensive project for the decoration of the château of Vaudreuil, the ducal residence in Normandy. The first is a *mandement* of the dauphin ordering payment to Coste of 600 *moutons d'or* for the completion of this project in which it mentions that Girard d'Orléans 'painter and *huissier de salle* of our *seigneur* (i.e. John the Good)' had been sent to visit the site and to evaluate it.[80] A letter written on the same day gives an unusually detailed description of this ambitious project. In this letter it is clear that Girard is the overseer of the project, for it is he who speaks in the first person: *C'est l'ordenance de ce que je Girart d'Orliens ai traitié à fere par Jehan Coste* concerning the works that he is to *parfaire* ('bring to completion'). This document reveals that Coste had been entrusted with the grand project of decoration that included frescoes and panels in the oil medium. It describes various cycles of paintings of classical, religious, secular and decorative subjects. The programmes of the grand chapel included cycles for the Virgin, the Passion, and St Nicholas. The centre-piece of another chapel was a painting of the Trinity, surrounded by cycles of St Louis, St Nicholas, and of the life of Caesar. In the oratory there was a 'Coronation of the Virgin surrounded by a great quantity of angels'. This document specifies that the vestments of the Virgin were to be in fine azure and that 'all of these things above described are to be made in fine oil colours with backgrounds in fine raised gold'.[81] Coste and Girard are thus the first painters whose names are linked with the use of the oil medium in France.

For these paintings Coste had been given illustrated manuscripts from which he was instructed to 'extract illustrations (*hystoriasque*) depicted in the said book' and he was 'to compose and form the said images with his own hand', a significant reference that demonstrates interconnections between monumental and miniature painting at this time as well as the role of miniatures for disseminating visual ideas.[82] For his work Coste was provided with costly materials including gold and azure.[83] Prestigious and gifted as Coste appears in this document it also indicates that he was not the original artist of the project, for in every direction the contract explicitly states that Coste was to complete work that had been started previously.[84] The document reveals that Girard was the director of the programme, for it is he who dictates the subjects of the paintings, the materials that Coste is to use, and the terms and schedule of Coste's work. Girard is also charged with evaluating Coste's work for payment.[85]

The documented chronology of Coste's employment for John the Good at Vaudreuil excludes the possibility that he was the artist of the Sainte-Chapelle panel. Information concerning the beginning of the project at Vaudreuil is provided by other documents. In a letter written on 2 March 1353 John the Good, complaining about the length of time Coste was taking to complete the project, mentions that at his command Coste went to Vaudreuil

'three years earlier around the feast of St Michael'.[86] Thus, Coste's work there began at the exact moment when John departed from his ducal residence for his coronation in Reims on the feast of St Michael in 1350. Coste's continued involvement with the Vaudreuil project is witnessed by payments made in 1352, 1353 and 1356.[87] Finally, when the work was still not complete in 1356, Girard d'Orléans returned to Vaudreuil to assess it for payment. This document contains a passage of great significance which states that Girard had 'arranged for the work at Vaudreuil to be done by Coste'.[88] Thus it appears that Coste received the Vaudreuil commission through the offices and mediation of Girard d'Orléans who dictated the subjects of the paintings and in the end evaluated the project for the dauphin. It was he who approved what amounted to an extension of time for the completion of the project and it was he who drew up a schedule of payments. Girard acted as an intermediary between the king and Coste who never, to judge from the unusually copious documentary evidence pertaining to him, dealt directly with the king. Because most of his contacts with the court were through the mediation of Girard d'Orléans, Coste's service to John the Good seemed to depend upon and even be directed by Girard d'Orléans.

Since the documents place Coste in Normandy continuously from September 1350 until 1356,[89] they exclude the possibility of his having been the author of the Sainte-Chapelle panel which was painted either during or after John the Good's visit to Avignon in December 1350 and January 1351 by an artist who accompanied the king on that visit. The documents show that Coste did not begin to work for the king until after the coronation, while the Sainte-Chapelle panel was painted by an artist who had been in service to the king prior to his coronation.

Just as the documentary evidence excludes Coste as the artist of the Sainte-Chapelle panel, so it reveals a configuration of circumstances that point to Girard d'Orléans as having the same profile as the artist of that work. The name of Girard d'Orléans first appears in a payment of 1344 issued by the count of Blois, placing Girard firmly within the Valois court, for the count had close ties to Clement VI and was a partisan of Philip VI, John the Good and Charles V.[90] The count of Blois was the son of Gui count of Châtillon and Marguerite of Valois, Philip VI's sister and the aunt of Jeanne de Bourbon (see Genealogical Chart, pp. 20-21). His daughter Marie was married to Louis d'Anjou.[91] Charles of Blois worked closely with his cousin, Jean de Craon, the archbishop of Reims who is so prominent amongst the portraits of the Coronation Book. The appearance of the name of the count of Blois on the first documentary reference to Girard suggests that it was he who introduced Girard to the court, just as he had brought so many of his own partisans into the service of the Valois rulers. One of the best known of these was Bertrand du Guesclin, the connétable of France responsible for the many military victories of Charles V, including the battle of Cocherel which, as we have seen above in chapter 1, made possible Charles's sacre.[92] Many of these partisans of the count of Blois appear in the miniatures of the Coronation Book although their presence is not stipulated by the text, and their prominence in that manuscript reinforces other indications that the Master of the Coronation Book was associated with their protégé Girard d'Orléans and his son Jean.[93]

By 1348 Girard was working for Philip VI, as evidenced by a substantial payment he received for work that he did for the king.[94] By 8 July 1349 the accounts of John, then duke of

Normandy, record a payment to Girard for the purchase of 'fine azure and other needs to do the commands of monseigneur le Duc'.[95] This is followed by another payment dated 23 July 1349, testifying that Girard was in the service of John the Good for at least a year prior to the latter's accession.[96]

The most suggestive document is a royal *mandement* of 4 November 1350, less than two months after John's sacre, and one month prior to the journey to Avignon, ordering payments of a daily wage to 'our beloved servant Girard d'Orléans, painter at our court', a wage, we are informed, accorded him 'before we came to govern the kingdom'.[97] The language of this document reflects an exceptionally intimate and privileged relationship between the artist and the king. Not only does the document demonstrate that Girard had been in the service of John the Good for at least a year prior to the king's accession, but it also shows that within two months of the coronation Girard occupied the official position of 'painter at our court', placing him at the Paris court and in the company of the king at precisely the time of John's journey to Avignon. It should be stressed that Girard was paid in wages and not for each job. When he received individual payments in the *mandements* these were to reimburse him for expenses incurred in purchasing special materials.

Because Girard was serving John during his last year as duke of Normandy, it appears likely that he worked for him in Normandy, even on the Vaudreuil project. There is some evidence that Girard was then painting for John since he received payments during that time for precisely the same materials that are later specified in the lengthy description of the Vaudreuil project. Second, the evidence cited already shows Girard as having supervised and evaluated Coste's work at Vaudreuil. All this reflects his involvement with that project from its inception. The documentation placing Girard at John's court immediately after the sacre supports the hypothesis that the artist accompanied his master in the move from the ducal residence in Normandy to the royal residence in Paris at the time of the sacre. That Coste was called in from Paris to complete the Vaudreuil project at exactly the moment when John the Good and his favourite artist left Normandy to take up residence in Paris indicates that Coste's task was to complete work already begun by Girard.[98]

The records reveal that Girard enjoyed John the Good's trust and affection, not only because of the familiar terms in which the artist is mentioned, but especially because Girard accompanied the king throughout the years of his imprisonment in England after his capture at the battle of Poitiers, proving that Girard travelled with his master.[99] Throughout his captivity John was accompanied by a team of servants and *varlets de chambre*, and the accounts of this captivity record numerous payments to Girard for a range of commissions including payments for materials for paintings, chess pawns, saddles, and elaborate chairs. In June 1359 thirty-five members of John's group were allowed to return to France, but Girard's name appears amongst those who remained with John.[100] A painter who accompanied his master on the move from the ducal residence at Vaudreuil to the court in Paris at the moment of the accession and who later stayed with him during his imprisonment in England could be expected to have accompanied him on state visits such as that to the papal court at Avignon which is recorded by the Sainte-Chapelle panel.

Given John's exceptionally close association with Girard before the sacre, there is reason to believe that Girard was acquainted with Clement VI. Both the pope and the artist

had served Philip VI, for we must recall that prior to his election to the papacy Clement had been president of the Chambre des Comptes, one of Philip's closest advisors, and, according to some, even chancellor of France.[101] Moreover Clement had been archbishop of Rouen when John the Good was installed as duke of Normandy, and throughout his papacy he had remained close to John.[102]

The documents show Girard to have been involved with activities germane to the imagery of the panel. As the king's *varlet de chambre* he was responsible for the acquisition of furniture, objects, tapestry hangings, draperies and costumes, often bearing coats of arms or fashioned from brocade of Lucca.[103] He ordered entire suites of clothing for many members of the court including the queen and the royal children. He purchased expensive fabrics from a number of cloth merchants, mostly Italians. Girard was in charge of the physical arrangements for great feasts of the court including that for the Order of the Star.[104] These facts testify to his specialized competence with court dress, ceremonial and protocol of the nature shown in the lost panel and to his central role in the dispensation of royal commissions of every sort. In the documentation Girard emerges as a master of works for the royal household.

Girard worked for John as *huissier de salle*, but by November 1350 he is referred to as 'painter at our court'. In 1352 he is referred to as *peintre du roy*, and between 1357 and 1358 as *peintre et varlet des chambres du roy*.[105] In most of the documents, Girard is referred to as *peintre*.[106] His function, therefore, should not be misinterpreted as one of mere furnisher to the court.[107] He was a painter of *ymages*, as witnessed by several documents including that which states that he was buried in the convent of the Chartreuse of Paris in a 'little cloister' near a '*bel ymage* of the Virgin that he had made'.[108] This document describes him as a *pictor* suggesting that the *ymage* in question was a painting and not a sculpture, and it proves that Girard's activity as a painter was not limited to armorials and fleurs-de-lis, but that he was known for 'beautiful' works of religious subject matter similar to the painting that is being presented to Clement VI in the Sainte-Chapelle panel.[109] Thus, Girard d'Orléans, alone of all the documented artists in the service of John the Good, presents a profile consistent in every respect with the artist of the lost panel.

The artist of that panel was first and foremost a master of portraiture. Lifelike portraiture implies personal and direct contact between sitter and artist, who is also expected to probe the spiritual and political state of the sitter. The portrait painter must have access to the sitter whose trust he must gain. In the documents Girard is the only artist who had the unconditional trust and access to John, who described him as our 'beloved servant'. A considerable body of circumstantial and documentary evidence supports the case for Girard. The Sainte-Chapelle panel furnishes extensive information about portrait painting and official painting at the court of John the Good at the time of his accession in 1350 when Girard was painting in John's service and overseeing the distribution of all kinds of commissions at that court. He emerges as the head of the royal workshop. The Sainte-Chapelle panel in particular shows that of its artist's many talents, portrait painting was his specialty. Its artist stands at the beginning of a long line of *pictores regis* whose primary duty was to provide portraits of the king and courtiers and record great events of the court.

The portrait naturalism of the lost panel is rivalled only by one contemporary painting,

the portrait of John the Good in the Louvre (ill. 5), the earliest extant independent portrait painting since antiquity, attributed by some critics to Girard.[110] Disagreement over the date of the panel and the identity of the sitter has been resolved by de Vaivre who has shown that, in particular because of the age of the sitter and the absence of a crown, the portrait represents John the Good shortly before his sacre.[111] The Louvre panel, therefore, predates by a few months at most the Sainte-Chapelle panel. Painted within months of each other in the court of John the Good, the two portraits are milestones in the development of portraiture; unparalleled for their truthful likeness, both have the same sitter and patron. Each was the work of an innovator in the revival of the naturalistic portrait, among the first since antiquity to observe the sitter from life and to record the physical likeness without recourse to idealized, stereotyped formulae. Circumstances converge to join John the Good, his two portraits, and his official court painter. If the Louvre portrait was not painted by Girard when he served as John's painter at the court of Normandy, it was painted under his direction, for he clearly supervised painting and furnishing projects in the household of John the Good.

III. The Workshop of Girard d'Orléans, Jean d'Orléans, and the Master of the Coronation Book

If we want to place the Master of the Coronation Book of Charles V in the context of official court painting of the early Valois kings, we must look more closely at the identity of the foremost painters who served Charles's predecessors and produced works that set the style, the life-like portraiture and the innovative standards of later court art. In the preceding consideration of the date and artist of the lost Sainte-Chapelle panel we have seen that the latter and the Louvre portrait of John the Good present close analogies with the miniatures of the Coronation Book. They belong to the same context, they share the same patronage, and together they shed much light upon the place of official painting and painters at the court of the early Valois kings. This is not to say that Girard d'Orléans was the artist of the miniatures in the Coronation Book, for he died three years before the accession of Charles V.[112] Moreover, the style of the Master of the Coronation Book is less accomplished than that which we have associated with Girard who, unlike the illuminator, demonstrates a superior command of perspective devices and mastery of human anatomy. However, the quantity and the importance of the commissions given by John the Good and Charles to the Coronation Book Master, the official nature of many of these commissions, his demonstrated expertise in court costume, ceremony, protocol, and his portraiture of the kings and the highest members of the royal court, all indicate that he enjoyed a privileged access, even attachment to, the royal court. This situation parallels in most respects that of Girard d'Orléans and Girard's son Jean as *peintres du roi* and *varlets de chambre*. The Coronation Book Master was in the service of John the Good from the early 1350s, and the beginning of his service coincides with the period when Girard was serving John the Good as *pictor regis* and *varlet de chambre*.

We have seen that Girard was involved in every aspect of court art, directing the deco-

ration of royal châteaux, palaces, hôtels and chapels, and the physical arrangements of court ceremonies.[113] He supervised assistants, some with considerable talent like Jean Coste, he exercised tight control over the distribution and execution of court commissions, determined the form that works of art were to take, and evaluated the finished work to determine the arrangements for final payments to be made to the artists.[114] The record indicates that Girard gave these artists manuscripts to use as models to be followed in his absence, testifying to close ties between monumental and miniature painting in this court workshop.[115] It is difficult to believe that an artist of Girard's stature would have used manuscripts as intermediaries between himself and his assistants had these manuscripts themselves not closely represented his visual expectations. This presents us with the likelihood that Girard was himself involved with manuscript production, as we know was the case with the Parement Master (painter of the Parement de Narbonne, ill. 92), who has been identified with Girard's son Jean, a point to which we will return.

We may, therefore, draw the following conclusions from the preceding review of documentary evidence: that the Master of the Coronation Book began his career working at the court where the chief painter of John the Good directed artists who were kept busy with every conceivable kind of royal commission. The style of the Master presents many concrete reflections of details in the Sainte-Chapelle panel, and his works can be regarded as the manuscript equivalent of that official court painting which we have identified with Girard d'Orléans. The Master of the Coronation Book was formed in and worked in the milieu of this court workshop, probably under the supervision of the head master, Girard d'Orléans, the favorite and personal painter of John the Good.

Upon Girard's death on 6 August 1361 his son Jean d'Orléans succeeded him in the positions of *peintre du roi* and *varlet du chambre*, first of John the Good and then of Charles V, inheriting Girard's responsibilities in the service of John the Good.[116] Jean d'Orléans served John during the last years of his reign and at the same time he also served the dauphin.[117] Upon Charles's accession Jean was *peintre du roi* and *varlet du chambre* and on 1 June 1364, he was officially named *pictor regis* of Charles in a document that refers to him as *filius deffuncti magistri Gerardi de Aureliano*, terms that evoke his succession to the position of his father.[118] Indeed, the documents reveal that the earliest paintings commissioned by Charles V upon his accession were ordered from Jean d'Orléans, a commission that was made at exactly the same time as the charter illustrated by the Master of the Coronation Book (ill. 82).[119] Jean d'Orléans appears in every respect the successor of his father as the king's leading painter.

In December 1361 Jean d'Orléans was retained as *peintre du roi* of John the Good.[120] This coincides with the date of the first manuscript painted for the dauphin by the Master of the Coronation Book, the *Livre des neuf anciens juges* (Brussels, Bibl. Roy., MS 10319; ill. 75) which is dated to Christmas Eve of that year. By May 1364 (exactly one month to the day after the death of John the Good and eleven days before the sacre of Charles V), he is referred to as *peintre du roy*. At this time he was commissioned to paint the *cerf de la grand salle du palais* and on 1 June, only two weeks after his sacre, Charles V confirmed Jean d'Orléans in these functions.[121] Jean d'Orléans' involvement with the physical arrangements for the sacre of Charles V is shown by an act dated 24 January 1365 in which Charles V ordered a

payment of the sum of 54 francs to Jean d'Orléans 'our beloved painter and *varlet de chambre*' for various works, including a panel painting that he made for *nostre sacre*.[122] Jean d'Orléans, furthermore, is the only painter mentioned in the accounts in connection with the execution of physical arrangements for the sacre and the records reflect the same privileged relationship that existed between John the Good and Girard d'Orléans. Charles ennobled Jean in May 1368, another sign of the special regard in which the king held his painter.[123] Jean d'Orléans is the only painter named in the accounts between the death of John the Good and the accession of Charles V, a time so crucial to the succession of the latter and for the Coronation Book, and this involvement with, and payment for, work for the sacre support the conclusion that the Coronation Book is a product of the court atelier the direction of which Jean d'Orléans had inherited from his father.

There are abundant indications that the son collaborated with the same artists as had the father, further substantiating the continuity between the workshop of father and son. For example, on two documented occasions Girard called upon the goldsmith Hennequin (Jean du Vivier) to execute gold-work that included a frame for one of his paintings, and documents of 1371 and 1377 show Hennequin executing gold-work for some paintings of Jean d'Orléans.[124] As John the Good had sent Girard to Vaudreuil to appraise the finished works of Jean Coste, so Charles sent Jean to appraise paintings left in the bequest of Jeanne d'Evreux upon her death in 1372.[125] This shows that Jean, like his father, was entrusted to act on behalf of the king in evaluating works of art, unique amongst contemporary artists to be charged with this sort of responsibility.

A *continuum* of royal patronage links Girard's activity to that of his son Jean since both artists worked respectively for John the Good and his successor Charles V. Both were given the most important painting commissions mentioned by the documents of the period: paintings and objects for royal ceremonies, royal chapels, palaces, châteaux. The subjects of their paintings are also similar: besides innumerable images of the Virgin, both artists painted *hystoires de St Loys*, and both painted *draps diaprez*, countless armorials, and paintings with gold backgrounds.

The name of Jean d'Orléans has been identified with the artist known as the Parement Master (see ills. 92–94).[126] This attribution has recently been strengthened by the recovery of documents which have also permitted some clarification of the relationship of the

92. Parement Master: Parement de Narbonne. Paris, Musée du Louvre

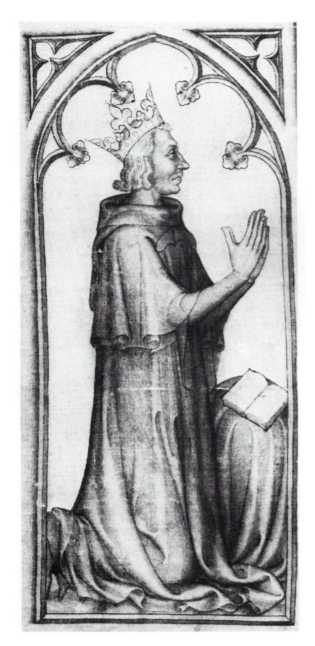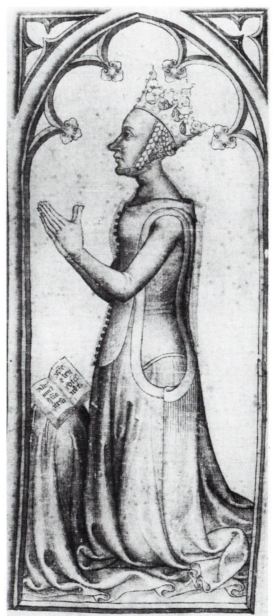

93-94. Parement Master: Charles V and Jeanne de Bourbon. Details of the Parement de Narbonne.
Paris, Musée du Louvre

Parement Master and Jean d'Orléans to the *Très Belles Heures de Notre Dame* (Paris, BN, MS nouv. acq. lat. 3093; ill. 84a) in which the cycles of the Virgin, the Passion, the Man of Sorrows and the Office of the Dead have been attributed to the Parement Master.[127]

Documentary evidence shows that Jean d'Orléans reworked the ideas of his father. In support of the attribution of the Parement de Narbonne (ill. 92) to Jean d'Orléans, the description of a remarkably similar grisaille painting of the same subject on silk by Girard d'Orléans: the inventories of Charles V contain an entry which describes a *chapelle pour*

257

caresme cothidiane de samyt blanc pourtraicte de noir. The ensemble, called in the document *la Chappelle maistre Girard*, included in *la table d'en hault* a representation of *ung Crucifiement environné de plusieurs ymages et histoires.*[128] If, as we have argued, Girard d'Orléans can be identified as the artist of the lost Sainte-Chapelle panel, and given that Jean d'Orléans is the artist responsible for the Parement de Narbonne and the *Très Belles Heures*, does the visual evidence reflect the documentary evidence for a workshop *continuum*?

Consideration of the iconographic and formal principles displayed in the *oeuvre* of the Parement Master against those evident in the Sainte-Chapelle panel reveals that, despite a chronological separation of approximately three decades, a network of shared conceptions, techniques, iconography, and patronage draws the two together into a tightly knit relationship consistent with the documentation on Girard and Jean d'Orléans.

A stylistic continuity is evident between the Sainte-Chapelle panel and the miniatures of the *Très Belles Heures*. Although the format and function of the Parement de Narbonne differ considerably from those of the Saint-Chapelle panel, the miniatures of the *Très Belles Heures* continue the naturalist approach in the depiction of corporeal, sculpted figures with expressive faces which have been convincingly situated in an architecturally structured space. Details of the lost panel are mirrored in the later miniatures: the clear glass windows on the rear wall of the vaulted chamber; a brocade hanging to delineate the receding side of the pictorial space and to separate the foreground from the background; the device of a tessellated floor to measure the recession of space and upon which the figures are firmly situated. The direct descendant of Clement VI is the mitred figure of the high priest Caiphas on page 189 of the *Très Belles Heures* (ill. 95), while the man who kneels in the diagonal position to present the diptych is the antecedant of figures like the kneeling king in the Adoration of the Magi (*Très Belles Heures*, p. 50).

The art of the Master of the Coronation Book provides crucial evidence for the succession of the art of Jean d'Orléans (the Parement Master) from that of Girard. As observed above, the illustration of the Man of Sorrows on page 155 of the *Très Belles Heures* (ill. 84a) displays a range of special painting techniques consisting of the application of opaque layers of paint; finishing layers painted with very tiny and short individual strokes; highlights overpainted in the same strokes in opaque white in an evident impasto; the use of translucent grey-black washes and the leitmotif of a transparent red glaze over gold in the brocade cloth. Precisely this same range of techniques appears throughout the miniatures of the Coronation Book. As the lost panel only exists as a copy, one cannot be certain about the techniques that were employed in the original, but the colours and the effects of texture suggest that the same techniques were used in the diptych, the brocade fabrics, John's *cale*, and the windows in the background. As already noted, this transparent glaze gives the appearance of an oil medium, and in this light it is especially meaningful that the document concerning Girard's direction of Coste's commission to complete the painting campaign at Vaudreuil specifies that the oil medium was to be used, confirming Girard's involvement with this new technique and its use by artists working under his direction.[129] The presence of this technique in the documents and in manuscript illumination of the Coronation Book and the *Très Belles Heures* is a compelling indication of a working association between the Master of the Coronation Book and the two panel painters. The same palette of colours

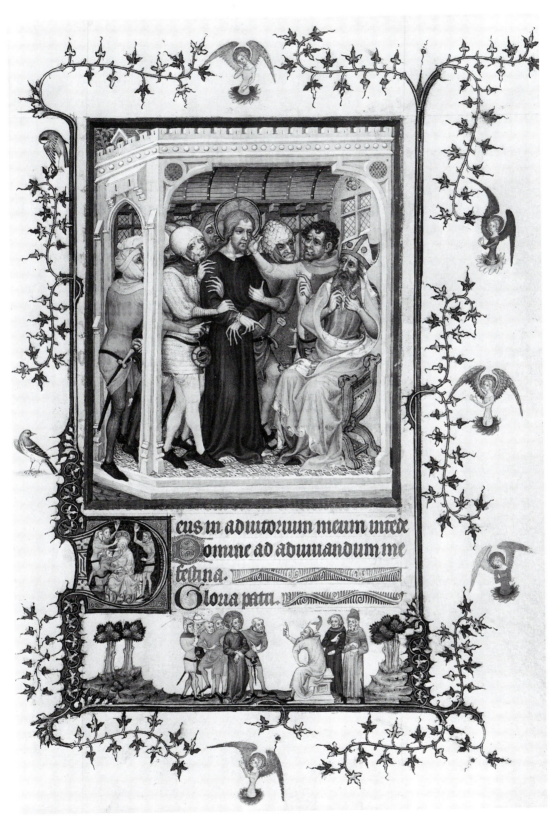

95. Parement Master: Christ before Caiaphas. *Très Belles Heures de Notre Dame.*
Paris, BN, MS nouv. acq. lat. 3093, p. 189

that was catalogued above in the Sainte-Chapelle panel and in the works of the Master of the Coronation Book appears in the *Très Belles Heures*. All three of these artists, who prove themselves to be conversant with the most recent Italian advances in perspective, also used colour in strident juxtapositions, often with bright, advancing tones in the background and deeper tones which tend to recede in the foreground in a way that contradicts the effects of the new spatial devices employed.

Many of the most important innovations that have been attributed to the Parement Master already appear either in the lost Sainte-Chapelle panel or in the documents concerning Girard d'Orléans, or indeed are anticipated in the paintings of the Master of the Coronation Book. Perhaps the best example to illustrate this point is the Man of Sorrows in the *Très Belles Heures* (ill. 84a), especially because it is universally regarded to be the work of the Parement Master himself without the intervention of an assistant.[130] Among the numerous innovations in this painting is the reinterpretation of the iconography of the Man of Sorrows where a brocade cloth has been suspended across the painting before the body of Christ held in an upright position by two flanking angels in half-figure. This innovative reinterpretation of the iconography of the Man of Sorrows, until then a subject of Byzantine or Italian painting, has its counterpart in the documentation that records Jean d'Orléans receiving on 8 July 1383 a payment of 50 francs from the duke of Burgundy for two *tableaux rondes en l'un dezquelz avoit un ymage de Nostre Seigneur dedens le sepulcre et I angle qui le soutenoit*.[131] Although the work in question is not the manuscript painting — it was a round panel and had only one angel — this document shows that Jean d'Orléans painted a panel of this innovative variation of the Man of Sorrows supported by an angel and that he did so at approximately the same time that the *Très Belles Heures* was being painted.[132] It adds further support to the identification of the Parement Master with Jean d'Orléans and strengthens the association of this artist with especially innovative variations on the theme of the Man of Sorrows. It was particularly in reference to the transparent red glaze of the brocade cloth in this illustration that Meiss argued that the Parement Master was a panel painter, because he identified this special effect as the result of an oil medium, a technique of the panel painter translated to the folio of a manuscript.

The rarity of images of the Man of Sorrows in French painting is significant, for there are only two earlier known antecedents in French painting: those in the Coronation Book and another in a manuscript of *c.* 1375 by a collaborator of the Coronation Book Master.[133]

96. The Expulsion from Paradise.
Detail from *Bible Historiale of John the Good.*
London, BL, MS Royal 19 D II, fol. 9

We noted above that several versions of the Man of Sorrows appeared simultaneously for the first time in French painting in the miniatures of the Coronation Book, and we have seen that each of these versions contains elements later used by Jean d'Orléans, according to documents that refer to the now lost panel painting as well as to the miniature of this subject in the *Très Belles Heures*, most notably the cloth suspended before the body of Christ.[134] It is unlikely that Jean d'Orléans' source was the miniatures of the Coronation Book and equally unlikely that the Master of the Coronation Book was the artist who painted the first panels of the Man of Sorrows in French painting. The Coronation Book Master made historically accurate depictions of objects such as the coronation sceptre of Charles V (ill. 10), attributed to the favorite goldsmith of John the Good and Charles V, Hennequin, who collaborated with Girard and Jean d'Orléans on several occasions. It is tempting to see these paintings in the miniatures of the Coronation Book as 'portraits' of paintings owned by the court, some even the work of the king's chief painter, perhaps copies of paintings that Jean d'Orléans made expressly for Charles's sacre and which are mentioned in the accounts. By incorporating these 'portraits' of paintings into the miniatures of the Coronation Book, the master would have paid tribute to their painter, who was presumably also his *chef d'atelier*. Thus, in a very real sense these paintings were signatures or trademarks identifying the workshop and its chief artist.

Besides the Man of Sorrows, the paintings within the miniatures of the Coronation Book anticipate other innovations until now attributed to the Parement Master in the *Très Belles*, where one of the initials includes a Crucifixion with Mary and John 'in humility', seated on the ground at the foot of the Cross, a rare version of the Crucifixion that first appeared in Italian panel painting and then in one of the panel paintings depicted in the miniatures of the Coronation Book (pl. 24).[135] Although no French panel paintings representing St Michael or St Catherine survive from this period, the miniatures of the Coronation Book include a panel of St Michael (pl. 34) and one of St Catherine of Alexandria (pl. 28), and the documents refer to paintings of these same subjects by Jean d'Orléans.[136]

There are many other concrete anticipations of the art of the Parement Master in the works of the Master of the Coronation Book. For example, the remarkable nude figures of the Parement Master are anticipated by the nude figures of Adam and Eve in the creation cycles in the *Bible Historiale* of John the Good (London, BL, MS Royal 19 D II; ill. 96), in illustrations in Nicole Oresme's translation of Aristotle (Brussels, Bibl. Roy., MS 11201–2;

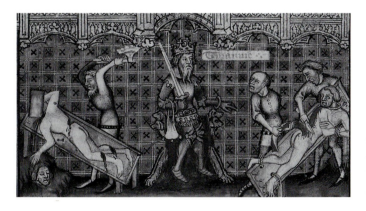

97. `Tyranny'. Detail of Nicole Oresme's translation of Aristotle's *Politiques et Economiques*. Brussels, Bibl. Roy., MS 11201-2, fol. 1v (detail of Ill. 15)

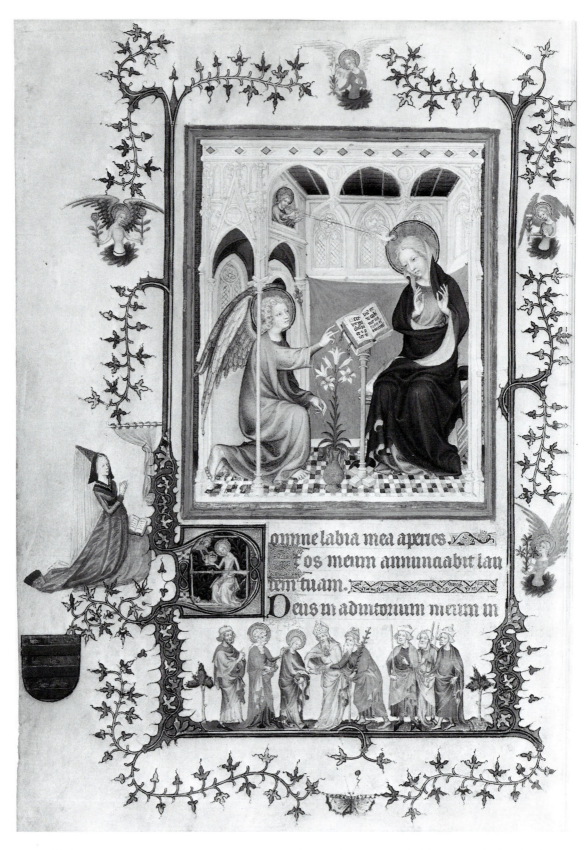

98. Parement Master: Annunciation. *Très Belles Heures de Notre Dame*. Paris, BN, MS nouv. acq. lat. 3093, p. 2

99. Continuous arcading used as a frame.
Detail of pl. 2

ill. 97), and in the half-nude figure of Jeanne de Bourbon in the scene of the anointing of her breast in the Coronation Book (pl. 32). The frames of the miniatures of the Master of the Coronation Book, including those of the paintings within the paintings of the coronation cycle, anticipate the Parement Master's frames in both the Parement de Narbonne and in the *Très Belles Heures*. A variation of the continuous arcade used as a frame through which figures are seen, as discussed above in the first two miniatures of the Coronation Book (pls. 1, 2; ill. 99), occurs in the scenes of the Annunciation (p. 2; ill. 98), Visitation (p. 28) and the Presentation in the Temple (p. 56) in the *Très Belles Heures*.[137] The *bas de page* illustrations of a marriage (see ill. 98) and another of a funeral in the *Très Belles Heures* testify to the involvement of the Parement workshop with the depiction of court ceremonies and recall, respectively, the scene of the queen's entry in the Coronation Book (pl. 29) and the funeral of Jeanne de Bourbon in the *Grandes Chroniques* of Charles V (ill. 74).[138] Innumerable individual stock figures of the Master of the Coronation Book reappear in the *bas de pages* and historiated initials of the *Très Belles Heures*.[139]

Throughout the 1370s the Master of the Coronation Book collaborated with an artist who is called the Master of the Coronation of Charles VI for his best-known painting, the full-page illustration of the coronation of Charles VI in the *Grandes Chroniques* of Charles V (Paris, BN, MS fr. 2813, fol. 3v; ill. 100).[140] The activity of the Master of the Coronation Book declines after 1378, and while prior to that date he alone was called upon to illustrate miniatures of major court ceremonies, the fact that his collaborator was called upon shortly after 1380 to make the important full-page illustration of the coronation of Charles VI in the *Grandes Chroniques* suggests that the latter succeeded the Coronation Book Master in illustrating official court ceremonies. The Parement Master planned the programmes of the initials, marginal decoration and *bas de pages* of the *Très Belles Heures*,

263

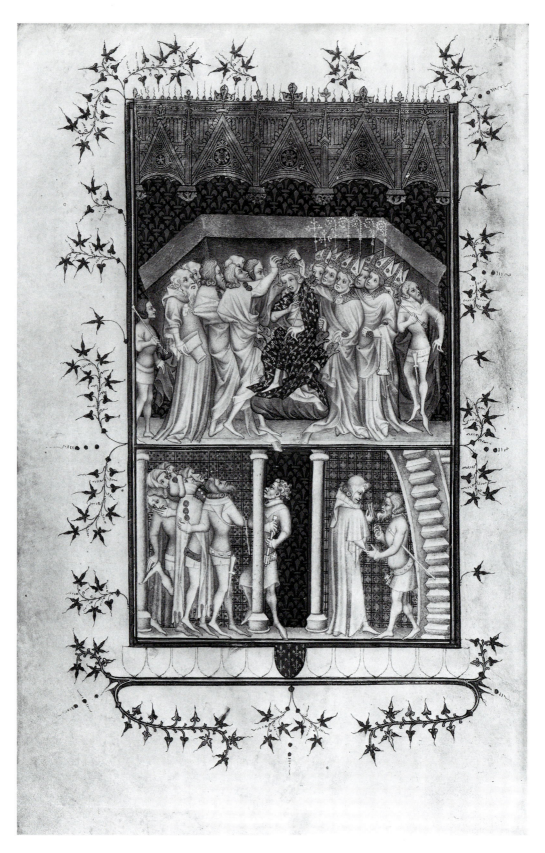

100. Coronation of Charles VI. *Grandes Chroniques of Charles V.* Paris, BN, MS fr. 2813, fol. 3v

all painted by miniaturists working under his direction.[141] And there is yet one more link between the Coronation Book Master and Jean d'Orléans: the very collaborators and successors of the Master of the Coronation Book — the Master of the Coronation of Charles VI and the Sy Master — executed the historiated initials and *bas de pages* of the *Très Belles Heures*.[142]

There is a document that may associate Jean d'Orléans with the production of Nicole Oresme's translations of Aristotle, illustrated by these same artists, the Sy Master and the Master of the Coronation of Charles VI, as well as the Master of the Coronation Book. A *mandement* concerning this translation that is dated 21 May 1371 is addressed to Jean d'Orléans and orders him to pay Nicole Oresme 'as quickly as possible and without delay the sum of 200 francs d'or'.[143] Delisle identified the Jean d'Orléans of this document with the Jean d'Orléans mentioned in other payments as Charles's treasurer.[144] However, there are many aspects of this payment that distinguish it from the other payments. Unlike most orders of payment that are written and signed by notaries of the chancery, Charles wrote this and signed it himself. In fact it is not a normal *mandement* at all, for those are orders of payment issued by the chancery, usually from the Hôtel St-Pol, and this is a letter written by the king from the abbey of Chaalis. Charles addresses this letter directly to Jean d'Orléans, and nowhere in it is Jean qualified as treasurer, as in most other payments addressed to the treasurer Jean d'Orléans. Here Charles speaks to Jean in personal and familiar terms which indicate that both are already involved in this project of translation. It is clear from the language that Jean is already *au courant* with Charles's project to have Aristotle translated and that the king regards Jean as aware of the importance which these translations had for him.[145] The tone of this letter reveals that this Jean d'Orléans is very close to the king. If there were two Jean d'Orléans in the king's household, one must ask what their relationship was. That we have associated the three illustrators of the Aristotelian translations with the workshop of Jean d'Orléans is another piece to the puzzle. If indeed the Jean d'Orléans of this letter *is* the painter, then it is a document of the first order for the interaction of king, artists and intellectuals: not only does it document Jean d'Orléans' connection with the Aristotelian translation, but it gives documentary proof of his direct involvement with the production of illustrated manuscripts of Charles's project of translations. It also shows that the artist was far more instrumental as an intermediary between the king and his theoreticians than has ever been suspected.

However, even without this document, the *Très Belles Heures* reveals the extent of the Parement Master's involvement with manuscript painting. Jean d'Orléans is identified with the Parement Master, a monumental painter who executed the most important miniatures in this manuscript himself and directed several manuscript painters in the remaining illustrations and marginal decoration. This evidence shows that his atelier produced manuscripts and that it included painters who were exclusively involved in manuscript painting for Charles V until his death, just as we have seen a similar involvement with manuscript illustration on the part of Girard d'Orléans.

These resonances between the workshop of Girard d'Orléans, the Master of the Coronation Book, and the *Très Belles Heures* are supplemented by a *Bible Historiale* dated to 1356 and 1357 in the British Library (MS Royal 17 E VII; ill. 101). The frontispiece of volume I is a

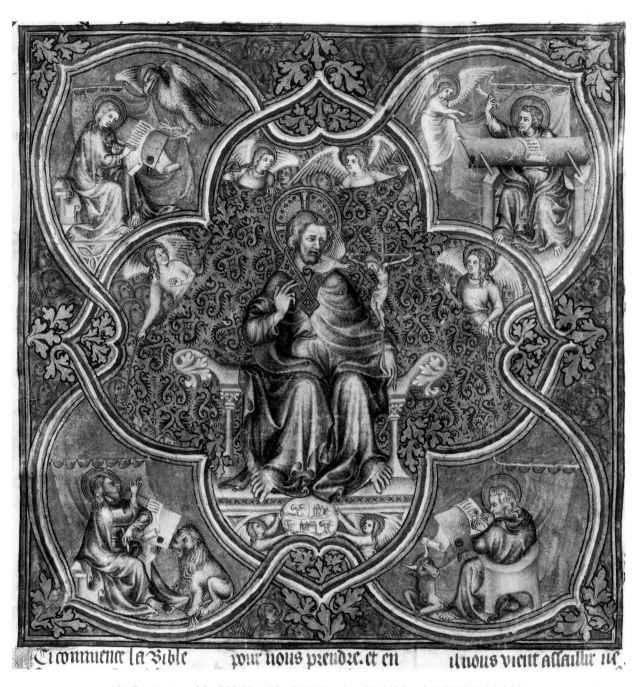

101. Frontispiece of the *Bible Historiale* of 1356. London, BL, MS Royal 17 E VII, Vol. I, fol. 1

magnificent and iconographically innovative image of the Trinity (fol. 1) in which the youthful and Christlike enthroned figure of the First Person of the Trinity regards the image of Christ on the Cross which he holds in his left hand as the Holy Spirit descends from his mouth towards the crucified Son. The Trinity figure is modelled in high relief in strongly contrasting lights and darks that become progressively deeper as they recede.

266

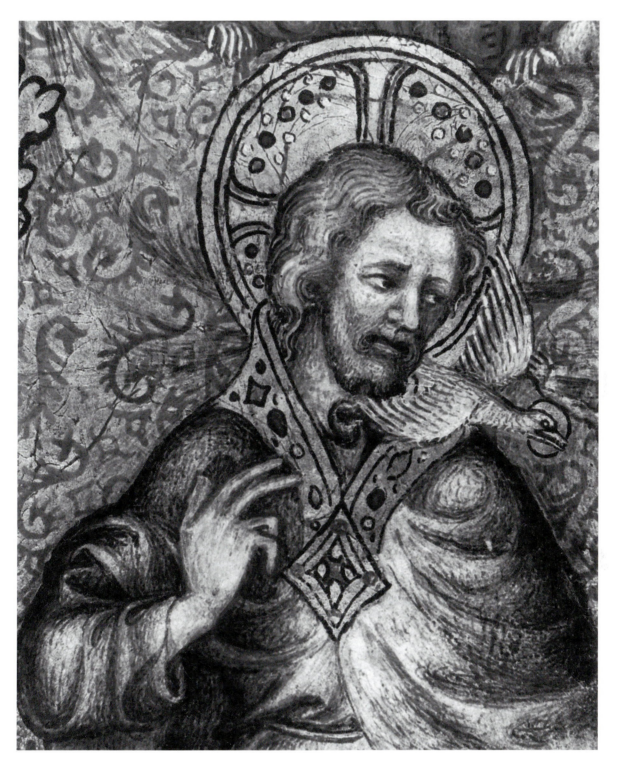

102. Detail of ill. 101

The expressive face has also been modelled, but, unlike the velvety grisaille of the garment, in a painterly build-up of flesh tones with highlights of opaque white paint and transparent shadows that bring out the musculature and the skeletal structure of the face and head (ill. 102). The eyes are especially expressive, deeply set, with furrowed brows, feathered strokes for the eyebrows with the upper eyelid indicated with highlighting over a broad black stroke and the lower lid modelled with shading. The left side of the face is deeply shaded. The hair has been rendered with a flat layer of opaque yellow overpainted in transparent brown wavy strokes with added white highlights. The joints of the hands and the exceptionally long fingers have been articulated to indicate the underlying bone structure and tendons. The head is surrounded by a halo in burnished gold with outlines and cross and small bead-like motifs overpainted in sooty black lines — the same motifs have long been regarded as the leitmotifs of the Parement Master's haloes, occuring both in the Parement de Narbonne and in the *Très Belles Heures*. Angels suspend a brocade drapery behind the figure. This drapery has been created through a multi-layered process in which a layer of gold leaf has been overpainted with feathered, lyre-like patterns in glazes of transparent red, and the folds of the cloth shaded in a transparent grey-green glaze. Cracquelure is evident in these transparent glazes. Behind this hanging is a background of angel heads painted in opaque black and white over deep blue.

We have seen that these techniques are all present in the Coronation Book and in the *Très Belles Heures*. The face of the Trinity is painted in the same technique, though not by the same hand, as the portrait of the king in the Coronation Book. The very same pattern and technique on the brocade backcloth of the Trinity frontispiece appears in several of the miniatures of the Coronation Book and in the Man of Sorrows in the *Très Belles Heures*. The Master of the Coronation Book painted a similar backcloth behind the figure of the Creator in the *Bible Historiale* of John the Good. Like the illustrations of the *Très Belles Heures*, the Trinity frontispiece has the same monumental scale and, like the folios of the *Très Belles Heures*, the entire folio has been designed as a unified composition in which marginal decoration has been coordinated both visually and thematically with the main illustration, as the eight prophet figures look out from their quatrefoil frames in the margins to regard the figure of the Trinity. In the *Très Belles Heures* the faces of the masculine figures, in particular, have been painted with exactly the same technique as the Trinity face, and the hands and feet resemble those of the Trinity figure. The faces of the host of angels of the background of the Trinity, painted in black and white on a deep blue ground, reappear in several of the miniatures in the *Très Belles Heures*, in the Coronation of the Virgin and in the night sky of the Nativity, for example.[146] Indeed, the Trinity Master is the stylistic intermediary between the artist of the Sainte-Chapelle panel, the Master of the Coronation Book and the Parement Master. The stylistic innovations of the Trinity Master, coming as they do several decades before the Parement Master, necessitate the re-evaluation of the latter's position in French painting at the end of the fourteenth century.

Several details of the *Bible Historiale* of 1356–7 associate it with Charles V. Lions figure prominently in this manuscript (ill. 103), and the dauphin used lions as his symbol, as they appear in many of his manuscripts and they were the symbols used in his Parisian residence at the Hôtel St-Pol where he kept a menagerie that included numerous lions and a

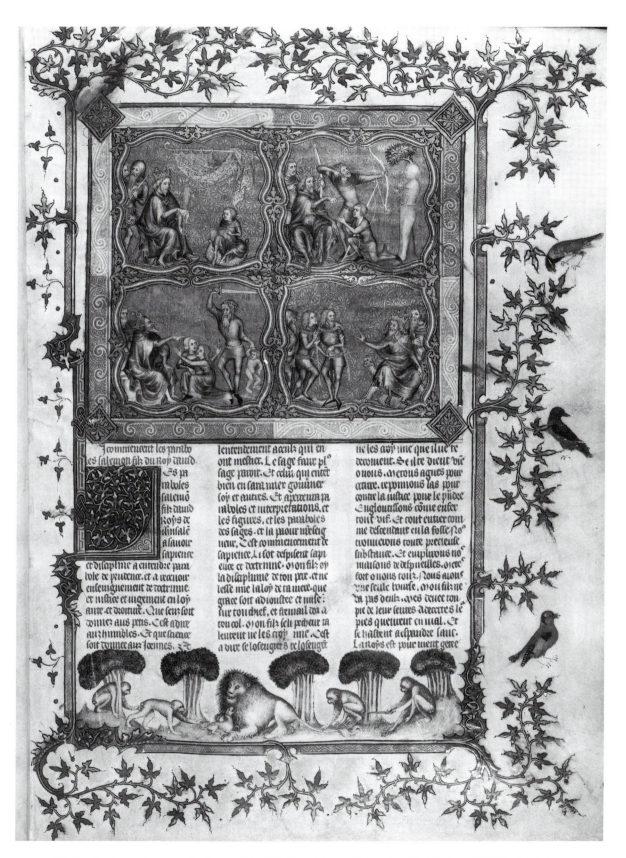

103. Frontispiece of the second volume of the *Bible Historiale of 1356*. London, BL, MS Royal 17 E VII, Vol. II, fol. 1

104. Nature brings `Sens',
Rhetoric and Music to the Poet.
Works of Guillaume de Machau[t]
Paris, BN, MS fr. 1584, fol. 59

varlet des lions who tended to them.[147] Volume I (fol. 230) contains a notation to the effect that it was completed on 12 January 1356, just two days after Charles's installation as duke of Normandy.[148] That in itself would not prove that the manuscript was connected with that event, but the manuscript includes a Norman litany at the end of the Psalter, and Volume II mentions the name of the dauphin's mentor and political advisor, William archbishop of Sens, a partisan of Charles's campaign to succeed.[149] The dauphin's devotion to the Trinity was demonstrated throughout his life in numerous manuscripts which contain special illustrations of this subject, usually considered to be a reference to his sacre on the feast of the Trinity.[150] However, his devotion to the Trinity began well before his sacre, for we must recall that a panel of the Trinity, painted with the new technique of oils, was the centre-piece of the programme of decoration of the chapel of the ducal palace at Vaudreuil. Charles held the first assembly of the Estates of Normandy at this castle shortly after his installation. With the Trinity frontispiece in this manuscript, it we may well be in the presence of a work that reflects these paintings at Vaudreuil that are connected with Girard and his assistant, Coste.

The illustrations of the *Bible Historiale* of 1356–7 are attributed to the artist known as the Master of the Bible of Jean de Sy,[151] the most frequent collaborator of the Master of the Coronation Book along with the Master of the Coronation of Charles VI. All three illuminators appear to have worked exclusively for kings John the Good and Charles V in the illustration of their most important projects of translation and manuscript production, at least until Charles's death, and because of their constant association and collaboration, it can be said that they constituted a royal workshop.

270

A close examination of the Trinity frontispiece reveals subtle differences from the other works of the Sy Master, including those in this very manuscript. The differences appear greater when compared with the frontispiece of Volume II of the *Bible Historiale* (ill. 103), or with later works such as the two frontispieces of the Works of Guillaume de Machaut of 1377 (Paris, BN, MS fr. 1584; ill. 104). The artist of the Trinity frontispiece displays a superior command of anatomy and of the placement and movement of figures in space; the faces have greater psychological intensity and are painted with a different technique; the modelling of the figure is more plastic and the heads and faces are sculpted with deep, graduated shadows and opaque white highlights. The figures of the Sy Master in Volume II of the *Bible Historiale* by contrast are less monumental and less sculpted, with slighter proportions and diminutive feet that are not placed on the ground plane with the substance and conviction of the figures on the Trinity frontispiece. The painting technique does not display the same density of superimposed layers of opaque paint, impasto and transparencies.

The dating given in the two volumes may shed some light upon these differences. As noted already, Volume I was painted before 12 January 1356, while a rhymed acrostic colophon at the end of Volume II indicates that it was completed in 1357. It may not be irrelevant to recall that on 18 September 1356 John the Good, along with William of Sens and those of the French nobility who had not been killed, were captured at Poitiers and taken to England.

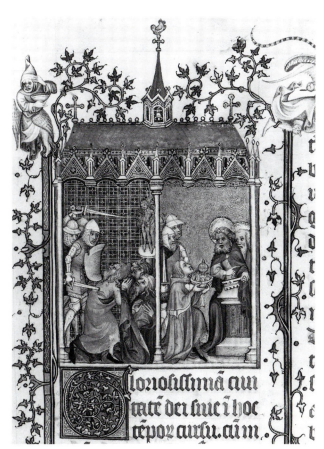

105. Raoul de Presles' translation
of Augustine's *City of God.*
London, BL, Add. MS 15244, fol. 3

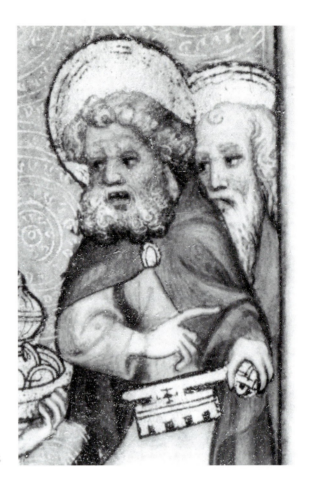

106. Head of St. Peter. Detail of ill. 105

A similar conjunction of styles manifests itself in the illustration at the beginning of the copy of Raoul de Presles' translation of Augustine's *City of God* in London (BL, Add. MS 15244, fol. 3). In this illustration (ill. 105) that bears so many similarities with the architectural settings and patterned backgrounds of the Coronation Book Master, the hand of the Master of the Coronation of Charles VI is recognizable everywhere except in the face of St Peter (ill. 106). In this we see a contrast of styles in a single illustration, for St Peter's face is expressive and plastic, executed in the painterly strokes and impasto that appear both in the Trinity frontispiece and in the *Très Belles Heures*, particularly in the Nativity and in the scenes of the Passion. This face gives the appearance of having been painted, not by a miniature painter, but by a panel painter. The technique of the face anticipates that of Joseph in the Nativity of the *Très Belles Heures*.

The preceding review of the documentary and manuscript evidence brings forth the outlines of a court workshop that began at the end of the reign of Philip VI and spanned the reigns of John the Good and Charles V to culminate in the art of the Parement Master whose identification as Jean d'Orléans is confirmed. The latter is revealed to be a product, albeit a brilliant one, of the court workshop directed by his father Girard d'Orléans who is identified with a progressive new phase in Parisian painting characterized by the empirical observation of the visible world combined with a vocabulary of spatial devices derived from Italian painting of the generation of Simone Martini and his successors at

Avignon. It is to Girard and his assistant Jean Coste that the new technique of oil painting is to be credited. All of the most innovative aspects of Parisian painting that are manifested in the *oeuvre* of the Parement Master, whether spatial, technical, or iconographic, are shown to have appeared first in the works of art produced either by Girard or under his direction, already by 1350.

IV. Further Perspectives

Some critics have attributed the naturalist aspects of the miniatures of the *Très Belles Heures*, particularly the use of the tessellated floors and the expressive figures and faces and description of surface textures, to the intervention of a Flemish assistant of the Parement Master, perhaps even Jean Bondol, the *pictor regis* of Charles V who painted the frontispiece of the *Bible Historiale* in The Hague presented by Jean de Vaudetar to Charles (Museum Meermanno-Westreenianum, MS 10 B 23, fol. 2; ill. 14).[152] But the present re-evaluation of Parisian painting from 1350 to 1380 has shown that these very features were firmly entrenched in the tradition of Parisian painting by 1350. Such features are identified with Girard and Jean d'Orléans and thus cannot be attributed to Flemish intervention, particularly because, with the exception of the Bondol frontispiece, there is no evidence to connect them with any recognized tradition of Flemish painting, at least not before Bondol. Indeed, in Bondol's frontispiece, which has often been compared with the Sainte-Chapelle panel, it is fair to say that the newly-named *pictor regis* (Bondol) was declaring in this work his complete assimilation to the, by then, long-established tradition of official painting at the Parisian court and his position as a successor to Girard and a peer of Jean d'Orléans. Certainly that is what Jean de Vaudetar was doing in offering this *Bible Historiale* to the king, for Vaudetar's predecessor in this position was his father Guillaume de Vaudetar.

This association of Vaudetar and Bondol raises further issues concerning the association and interaction of artists at the court. Guillaume was *varlet de chambre* successively to Philip VI, John the Good and Charles.[153] Documents connect Guillaume de Vaudetar to the *garde des lyons du Roy* at the Hôtel St-Pol and with commissions for a royal tomb before the main altar of the cathedral of Rouen.[154] Gaborit-Chopin cites unpublished documents discovered by François Avril that identify Guillaume de Vaudetar as a Parisian goldsmith, the son of Leandro di Valderato, a nobleman from the region of Parma and Piacenza, and of Leonora Ghini, the sister of cardinal Andrea Ghini di Malpigli, counsellor to Philip VI. Guillaume was married to Yolande of Melun, a first cousin of William archbishop of Sens. Guillaume de Vaudetar not only appears in the documentation as goldsmith and *varlet de chambre*, but from 1356 is described as *lapidarium* to John the Good and the dauphin, so he was also a sculptor in stone. In 1368 he was commissioned to complete and to gild a tomb of copper for the cathedral of Rouen intended for the burial of Charles's heart. The name of Guillaume de Vaudetar is mentioned with great frequency in the inventory of the dauphin's treasure which was drawn up in 1363 and in the accounts of John the Good. He repaired and set pearls into the crown of St Louis that was used for the crowning of John the

Good.[155] He received a payment for a gold image of St Jean, golden candlesticks, a crown, a series of golden vessels, and many other works.[156] His son Jean de Vaudetar was Master of Moneys and *varlet de chambre* of Charles V and he was ennobled in 1373, evidence suggesting that goldsmith-sculptors could have important political offices in the royal administration.[157] His bare head and kneeling pose signify his homage to the king, and his gift of the *Bible Historiale* was probably related to his ennobling.

Guillaume de Vaudetar's uncle, Cardinal Andrea Ghini di Malpigli, also known as Andrea de Florence, was a member of the Grand Conseil of Philip VI, and indeed was the most powerful member of the Italian community in Paris. During the reign of Charles IV, he had been made bishop of Arras by Pope John XXII. He was a close associate of Clement VI, who made him a cardinal in 1342. Throughout Philip VI's reign Andrea was a devoted Valois partisan: it was he who received the submission of Bruges in 1328 on behalf of Philip; and along with Clement VI he was instrumental in obtaining the homage of Edward III for Guyenne, after which the cardinal was overseer of affairs in Guyenne. Andrea used his considerable fortune to found the College of Lombards at the University of Paris.[158] Italian merchant-bankers such as the Scatisse, Spifame and Tadelin of Lucca, had infiltrated the ranks of the Valois financial administration as tax collectors, treasurers and masters of moneys.[159] Among the most patronized were the Belenati and Spifame, both from Lucca.[160] The fact that a Florentine ecclesiastic became archbishop of Arras is an indication that the Church was crucial for facilitating this international movement. We might recall that Charles's physician was an Italian, Christine de Pizan's father. Italians were very much present in Paris, and the gallicization of the name Valderato into Vaudetar and the intermarriage between Italians related to members of the Avignon curia with members of the French aristocracy is a warning that one cannot always rely upon a name as an indication of nationality.

But where was the art of Girard formed, and how does he relate to the other *varlets* at the royal court? His name might allow us to suspect that he originated from Orléans, but although there was a university with an important law school in that city there is no evidence for the existence there of a tradition of painting that could have produced an artist of Girard's stature.[161] Philip the Fair brought the most important Roman artists to Paris where they remained and their offspring continued to paint for the court for several decades.[162] Surely their presence accounts at least in part for the Italian element that has been identified in Parisian painting of the first half of the fourteenth century. The name Orléans had been associated with court artists since the reign of Philip the Fair.[163] The leading *peintre du roi* during the reigns of the last Capetians and Philip VI was Evrard d'Orléans, and although there is no documentary proof that Girard was related to Evrard, it does present the possibility that Girard was in some way connected with this artist and that he emerged from a family of painters who had been in the service of the court from the time of Philip the Fair.[164]

If Pucelle was unquestionably the greatest manuscript painter in Paris, he was Evrard's contemporary, and there is some documentary evidence to suggest that Pucelle's work, particularly the Book of Hours of Jeanne d'Evreux reflects the monumental programmes painted by Evrard, specifically works that he executed in the Louvre and other royal resi-

dences.[165] Evrard's commissions were not limited to monumental painting, for his name is also associated with panels as well as with commissions for robes made for Charles IV for Pentecost and with works for Jeanne d'Evreux's coronation.[166] As the Parement de Narbonne repeated a comparable work by Girard, perhaps the echoes of Pucelle that have been identified in the Parement de Narbonne are reflections of these monumental programmes painted by Evrard and by Girard rather than modernized and enlarged copies of Pucelle's manuscripts or of his workshop patterns. Indeed, these works are connected primarily by common iconographic motifs, since, as we have argued, stylistic differences separate the Parement de Narbonne from Pucelle's work. What has intervened, in particular, is the spatial innovation of Italian painting of the 1340s.

So how did Girard become acquainted with these recent Italian developments, for there is no evidence for their presence in Parisian painting before 1349? Indeed it appears that Girard was largely responsible for establishing this style in Paris. The expertise of Guillaume de Vaudetar in all of the plastic arts of stone sculpture, goldsmith's work, and even monumental tomb sculpture in copper appears to be an Italian import to the French court during the latter part of the reign of Philip VI. Since Italian goldsmiths and sculptors were already prominent at the Parisian court by the late 1330s, it was possible for Girard to have learned *some* of his Italian techniques in Paris. However, these artists appeared in Paris during the early part of the reign of Philip VI and Girard's Italian importations pertain to a more recent stage of Italian painting.

Besides the great Italian talents who came to Avignon during the reign of Clement VI, the papal court of Clement VI was also populated by French notaries, merchants and artists, the latter employed to decorate the papal palace along with the Italians in Clement's service. Avignon was a melting-pot for the interaction of French and Italians in every aspect of its functioning, for besides the French there were Italian merchants, bankers, legists, physicians in addition to the Italian artists. There were many ways that a Parisian could have gained entry to the papal court. Clement had been a counsellor of Philip VI, and he certainly took notaries from Paris to Avignon where they worked for him in the papal chancery. We have already seen that these notaries were a link between patron and artist, for it was they who wrote out the *mandements* that paid the artists. But Clement was not the only ticket to Avignon. The second wife of John the Good was Jeanne de Boulogne, the niece of Cardinal Gui de Boulogne, a member of the Avignon curia. The cardinal's pontifical was painted by the leading Italian illuminator, the Master of the Saint George Codex, the miniaturist *alter ego* of Simone Martini.[167] As John the Good made many trips to Avignon before his accession, there were several possible routes for a gifted Parisian artist in his service to enter the Avignon court. It is not unlikely that he was accompanied by *varlets de chambre* when he sojourned there in 1344–5. Had Girard been one of these he would have encountered the painting of Matteo Giovannetti and the last works of Simone Martini who died in Avignon in 1344. Perhaps Girard was among the French artists who painted in the papal palace where the frescoes in Clement's private apartment are ascribed to French artists. These commissions came to an abrupt end upon the death of Clement in 1351 and, with the accession of the puritanical and ascetic Urban, a diaspora of talent no doubt occurred.

This entire study has revealed the prevalence of a spirit of cultural engagement, competition, collaboration and dialogue that reigned in every aspect of political and cultural life at the Valois court of Paris. There, intellectuals conducted an ongoing debate throughout the reigns of John the Good and Charles V over opposing ideas: *artiens* opposed jurists, Augustinians countered Aristotelians, philosophers denounced astrologers (and vice versa). The intellectual approach of a Nicole Oresme encountered the opposing positions of a Jean Golein or an Evrard de Tremaugon. But in the translations and commentaries that were made for Charles, a synthesis between conflicting positions was usually reached. These opposing schools were brought together under the direction of Charles himself.

Everything leads to the conclusion that there was a comparable process of competition, dialogue, collaboration and synthesizing amongst the artists at the court. The astounding constellation of resonances between the Sainte-Chapelle panel, Bondol's frontispiece and the painting of the Parement Master raises questions about artistic identity, because it is clear that these works were created by three distinct artists who worked in the same context, the French court, over a period of more than fifty years. The evidence presented reveals that, although Girard played a fundamental role in determining the artistic vision of the court of France from 1350 until after 1400, this aesthetic vision was not the creation of any single individual. Girard was a coordinator, a teacher, a polymathic visual administrator who also happened to be an artist of outstanding talent. He was capable of formulating an aesthetic synthesis that became the norm for the kind of visual expression which reigned at the Valois court for the duration of his lifetime and that of his son. He was a constant companion of the king who entrusted him with the expenditure of substantial sums of money. He was the interlocutor between the king and the goldsmiths, the cloth merchants, and the hosts of painters and artisans who served the court. He was the trusted aid of the king who did more than coordinate style at the court: he helped to shape a political vision. But he cannot be given sole credit for this vision. Rather it was generated in a context of cultural and political engagement that took place in a setting in which individuals from different backgrounds and opposing perspectives confronted each other in an ongoing discourse on good government. The artists worked directly with ideological advisors and with the leading political figures, particularly the king, to articulate a reconfigured vision of monarchical government not only in written but also in visual form. The court workshop is an integral part of the political condominium that is described in the Coronation Book and was brought forth in the sacre according to the Ordo of Charles V, a corporate body with a head and many members working in unison, ostensibly for the Common Good. As the king is the head, in a very real sense the artists were the eyes of this corporate body politic.

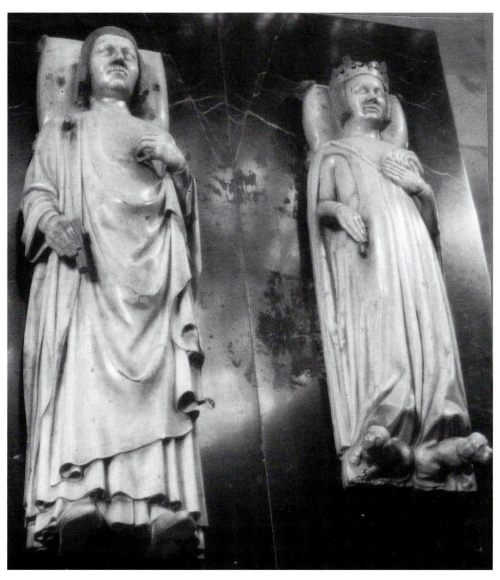

107. André Beauneveu: Tomb of Charles V and Jeanne de Bourbon.
Cathedral of Saint-Denis

Epilogue: The Coronation Book since 1365

WHY DID CHARLES commission the Coronation Book? What did he intend to do with it? Who would have used it and how would it have been used? Was its complex political content meant to be put into action, and if so, how? Some of these questions are answered by details in the manuscript, while others are answered by evidence from other sources.

Made in 1365, the Coronation Book was certainly not used for the sacre of Charles V and Jeanne de Bourbon. Nevertheless, we have seen that the miniatures, in particular, leave one in no doubt that the Ordo of Charles V *was* used in their sacre. Prior to his sacre in 1364, Charles was not an avid patron or collector of illustrated manuscripts, not apparently having commissioned the few manuscripts which he possessed up until then. But from that point forward Charles embarked upon a campaign of patronage that would eventually distinguish him as one of the most influential patrons of illustrated manuscripts in history. The Coronation Book marks that departure.

The inventories of Charles's library in the Louvre mention eight different *livres du sacre*. Of these one is described as *un livre ancien du Sacre des Roys*, another as *un très petit livret noté à sacrer les roys de France*. Five of the remaining manuscripts are described as *très bien escript* or with *lettres de forme*; five copies include a Latin and a French text while two have only a Latin text. Among all these manuscripts only two had illustrations. Another manuscript contained the ordo for the coronation of the emperor by the pope. These books are listed in the inventories after the king's service books, following a series of pontificals (which would normally have contained the liturgy for the sacre) and before his books of hours. The inventories of the *mobilier* of Charles also mention a *livre du sacre*.[1] These inventories thus show that Charles had an interest in different sacring rites, and the presence of the 'very old *livre du sacre*' as well as of the manuscript with the ceremony for the coronation of the emperor and the Roman pontificals testifies to an interest in comparing and studying sacring liturgies.

Although it does not appear in the inventory of the Louvre library compiled by Gilles Malet in 1380, after the death of Charles V, the inventories of the library indicate that the Coronation Book remained there during the reign of his son and successor Charles VI, for Delisle identified the Coronation Book with entries in the inventory of the library of the Louvre compiled in 1411 by Jean Le Bègue, Bureau de Dammartin, and Oudart Boschot after the death of the royal librarian Gilles Malet. It is included in the inventory compiled in 1413 by Jean Le Bègue, maître Thomas d'Aunoi, and Jean de La Croix when Jean Maulin was named guard of the library. And it appears in the inventory of 1424 compiled at the death of Charles VI.[2] It is described thus:

Un Livre de l'ordonnance à enoindre et couronner le roy, partie en latin et partie en francois, tres bien escript et historié ès marges d'en hault et bas, et en la fin y sont pluseurs seremens que doivent faire les pers de France et autres vassaux et prelaz et autres gens. Comm.: les matines. Fin: nemi ou mal vueillant. Couvert d'un vielz drap d'or, à deux fermoirs d'argent dorez, esmaillez de France, et une petite pipe d'argent doré.

It has sometimes been proposed that the Coronation Book was commissioned to be used for the sacre of Charles's son, but the future Charles VI was not born until 3 December 1368. Of course at the time of their sacre the royal couple no doubt had hopes that they would have a male heir, and the prayers in the queen's ordo which invoke the fertility of biblical queens have been interpreted as responses to the couple's childlessness at that time. We have seen, however, that these prayers had been part of queen's ordines for centuries, so their presence in the Ordo of Jeanne de Bourbon was not directly addressed to the couple's childlessness at the time of the sacre. There is some indication that the Coronation Book was consulted at the sacre of Charles VI in 1380, since it is absent from the inventory of the Louvre library compiled by Gilles Malet immediately after the death of Charles V in 1380 but reappears in all of the subsequent inventories of the library (a point to which we will return below). The manuscript's absence from the Louvre in 1380 could therefore be related to the preparations for the sacre of Charles VI, although the inventories also indicate that Charles VI used another manuscript for his sacre.[3] In any event the archbishop of Reims would undoubtedly have used the Pontifical of Reims rather than the Coronation Book for an actual ceremony. The illustration of Charles VI enthroned on the solium in the *Grandes Chroniques* of Charles V (pl. 88; ill. 100) corresponds in many respects with the comparable scene in the Coronation Book (pl. 26), but there are also noticeable differences which do not derive either from the text or the illustration in the Coronation Book, and this indicates that other sources also contributed to the imagery of that painting. All of this presents the likelihood that the Coronation Book was consulted for the sacre of Charles VI, but in conjunction with other sources. Nothing points to the conclusion that the manuscript was made expressly to be used for the sacre of Charles VI.

Prayers written in a contemporary fourteenth-century hand have been added in the margins of fols. 45, 55, 57, and 59. Dewick identified these with prayers in the English *Liber Regalis* and other texts of the fourth recension of the English coronation ceremony, and he observed that they are not in other texts of the French coronation service. This suggests that the manuscript was used by someone with an interest in comparing selected passages with the sacring rite currently in use in England. In this connection it may be relevant that Isabel, the six-year-old daughter of Charles VI, was wed to Richard II of England in 1396, an event which resulted in a reconciliation between the English and the French which lasted until the death of Richard II.

A coronation is a very complex ceremony, lasting several hours and involving a large number of participants. The *mise en scène* of such an endeavour would be extraordinarily cumbersome and challenging.[4] A royal consecration must be executed correctly and according to the most authoritative liturgical formulae, if it is to be regarded as incontestable and indelible. Even if a sacre were enacted every year, remembering the staging of all the

details would be a daunting task. Some monarchs had short reigns, but sometimes decades separated one sacre from another. Charles VI reigned from 1380 until 1424. Edward VII was crowned king of England in 1901, sixty-four years after Queen Victoria and seventy-one years after William IV, the previous king to be crowned. Those coronations were not part of the living memory of many who had participated in the sacre of Edward VII. Indeed, mistakes have occurred, as when the officiants of the coronation of Edward VI misread the rubrics pertaining to the anointing of the king's chest (*pectes*) and, instead, anointed his feet (*pedes*).[5] One can well imagine that a detailed pictorial account might be of use for the staging of future coronations and for avoiding such mistakes.

Yet this could be accomplished with detailed rubrics and, perhaps, but not necessarily, diagrams. There would be no need for the precise and detailed portraiture of the Coronation Book if the manuscript had been made primarily to guide the *mise en scène* of future sacres. Indeed, in many respects detailed portraiture would undermine the paradigmatic quality of a prototype. Also superfluous is the network of cross-references and parallels created by the miniature cycle. The fact that the miniatures provide a glossed commentary to explain the abstruse implications of the text goes far beyond the problems of staging to explain and even to argue about the meaning of actions. It is clear that the miniatures were meant to be studied in conjunction with the text. Yet, even here, the individualized portraiture is unnecessary, if it is simply a matter of defining symbolic meaning and bringing out existing interrelations between one part of the ritual to the other.

Because of the portraiture, the miniatures not only describe what is done at *a* sacre, they describe precisely what was done by whom at the sacre of Charles V and Jeanne de Bourbon. It is this personal particularity and the intention to identify that are the most important clues about the intended function of the manuscript. Through the portraits the miniatures provide a witness, even an eye witness, to the event. They document the presence, the deeds, and even the words of specifically identified individuals. Moreover, because of the presence of the oaths sworn by the most important participants, the manuscript also documents their legally binding vows, a point to which we will return momentarily.

We have seen the complexity of the political and liturgical content of this manuscript. But how was this content intended to be used? Was this symbolic content merely of theoretical value or was it converted into practical political action? And if so, how was this accomplished? The kingdom was in a state of anarchy when Charles was crowned, but could a mere ceremony, and the illustrated manuscript which recorded it, effect change and bring about order? One could not pretend that the sacre changed anything immediately. The grand companies of unemployed mercenaries continued to plunder throughout France. The partisans of Charles of Blois, the duke of Brittany, were omnipresent at the sacre, but a few months later Charles of Blois was engaged in a war with Jean de Montfort who was aided by Edward III. On 29 September 1364 Charles of Blois was killed, Brittany fell to Jean de Montfort, a partisan of Edward III, and Bertrand du Guesclin was captured. Charles of Navarre claimed his rights both in Normandy and Burgundy against Philip the Bold, the youngest brother of Charles V. And the succession of Flanders was unsettled because the marriage of the only child of the count of Flanders, his two-year-old daughter

Marguerite, was still being negotiated. Would this heiress of a wealthy and strategic apanage be wed to a son of Edward III or to Philip the Bold of Burgundy? The crown which the peers had sustained on May 19 was very far from being a solid, unbroken circle.

One of the features of the Coronation Book that has received little attention is the oaths of the peers and of the barons, including, in particular, the barons of Guyenne (fols. 75–80). These provide a clue about how the manuscript was intended to be used. Oaths are legally binding and, with them, coronation liturgy enters into the domain of civil and contractual law. We have seen that the sacre is the ritual of the Crown *par excellence*. By participating in a sacre in any capacity, even as a witness, an individual affirms consent to the premises of that ritual. The king submitted himself to those premises, in particular through the oaths that he made and through the insignia that he accepted to bear with all of their signified responsibilities. In sustaining the crown the peers affirmed their consent to assist the king in supporting the burdens and responsibilities of membership in the Crown. But with the addition of the oaths of the peers and the barons at the end of the sacre, the burdens and responsibilities were spelled out in clear legal terms in vernacular French. I think it is quite plausible that the political potential of the Coronation Book was pressed into active service to give visible testimony to all of these acts which were ritually affirmed at the sacre on 19 May 1364, most particularly by means of these oaths. The oaths of the peers and barons reinforce the oath sworn by the king. In the oath inscribed in the Coronation Book the peer swore to remain:

> *bon, loyal, feal et obeissant au Roy de france notreseigneur qui cy est, et a ses hoirs et successeurs, son corps, ses membres, son heritage, les droiz et noblesces de la coronne de france et de sa souverainete, garderez et deffendrez envers touz et contre touz qui pevent vivre ne mourir. Et loial et bon conseil li donrez toutes foiz quil vous en requerra. Et tendrez secret son conseil et toutes choses qui sont a tenir secretes pour le bien de lui et son royaume.*

In making this vow, the rubrics instruct the peer to remove his *chaperon* (the hood) and to place both of his hands in the hands of the king. As he does this the chamberlain asks him: '*Vous devenez homme lige du Roy de france notreseigneur qui cy est. Et li promettez a portez foy, loyaute, obeissance …* ' to which the peer must reply: *Uoire, je le promet ainsi.* This is a very serious pledge in which the peer pays liege homage and swears, like the king, to uphold the Crown, its rights, its dignities and its sovereignty. It is thus a corollary to the oath of the king which reiterates the words of the phrase on the sovereignty and inalienability of the Crown introduced into the Ordo of Charles V. Moreover, the peer affirms in this oath his recognition of the heritage of the king and of the king's heirs and successors as kings of France. The peer thus swears to his recognition of the hereditary system of monarchy. Furthermore, the peer makes his oath for his own heirs and successors who are also bound by his oath.

The oaths of the peers and of the *porte-oriflamme* are followed in the Coronation Book by a lengthy oath sworn by 'the barons of Guyenne who are entering into obedience to the king.' In this oath the baron recognizes as his lord 'Charles by the grace of God king of France, and his successors kings of France, by my free will and consent without constraint I swear and promise, and I swear and promise for my successors'. The oath of the baron

continues by affirming that he will remain a 'feal and loyal and true subject, obedient always to my redoubtable lord and his successors, kings of France, and I will guard his sovereignty and jurisdiction and all his other Royal rights I will guard and aid to hold and guard against the king of England and his children or allies' (fols. 76–76v).[6] Following this are oaths of knights, of the officers of the royal mint, heralds of France, and captains.

As already noted in chapter 5, the oaths begin on fol. 74 and are written in a contemporary script which closely resembles the main script, by the same hand that corrected the king's oath. The oaths are written within the margins on the ruled lines of the folios and they end on the last folio of the Coronation Book (fol. 80). These facts argue that the oaths belong to the original content of the Coronation Book and that they are not a later addition as has been supposed. It is also significant that the inventories of the Louvre note the presence of these oaths in the Coronation Book, which not only proves their presence in the manuscript during the reign of Charles VI, but also suggests that the oaths were regarded as a significant part of the manuscript. The inventory of the *mobilier* of Charles V, compiled upon the death of the king, lists a very similar *Ordonnance du Sacre* that also included the 'seremens des Pers de France, de celuy qui porte l'oriflambe et des officiers des monnoies du roy, des héraux et autres … '. This manuscript is included in the inventory of *parties des nouveaulx habiz royaulx et joyaulx ordonnez pour le fait du sacre des roys de France.*[7]

Some insight into the use made of these oaths and of other documents concerning oaths sworn by peers or barons in the past is provided by an account of a session of the Grand Conseil in 1366 when the new duke of Brittany, Jean de Montfort, came to Paris to pay homage for his duchy. Charles demanded liege homage, but Montfort, advised by Edward III, would at first only agree to simple homage.[8] It appears to be a question of feudal law but, as Autrand has observed, because it involved sovereignty over the duchy, it was a matter of civil law.[9] Jean de Dormans, chancellor of France, presided at this session which included prelates, barons, knights, clergy. Dormans explained that 'The king of France holds his kingdom only from God. He recognizes no sovereign on earth and all the vassals of his kingdom, princes, barons and others, are his *hommes liges.'*[10] Dormans explained that the duke of Brittany was a peer of France, whose duchy was one of the principal fiefs of the kingdom, and that his predecessors had always sworn liege homage.[11] Here we witness the ideology, which is developed to its fullest in the liturgy of the Coronation Book, being pressed into real political action.

After Dormans' speech a notary read to Montfort two verbal processes of homage, that of Arthur I to Philip Augustus of 1202 and that of Jean le Roux to St Louis of 1240. The notary explained that the duke was badly advised to refuse liege homage and that such a course would lead to war. Then Jean de Dormans 'put under their noses' the letters of the dukes, and in doing so used physical documentation as an instrument of proof and persuasion. Ten hours later the duke returned to the room and his chancellor announced that he consented to do the homage which had been done by his predecessors. The young duke came before the king with bare head and he knelt and put both hands in the king's and made his oath of homage as had the preceding dukes of Brittany since 1202.[12]

As Autrand observed, in this situation the cornerstone for the reconstruction of the kingdom was the notion of sovereignty and a reconfigured conception of the kingdom, the

relation between the centre and the provincial apanages, the king and the princes, on which rested the power to surmount the crisis. The solution was to give the kingdom a structure resembling that of a confederation, a kingdom formed of principalities whose relation to the centre was precisely delineated.[13] Autrand cites Christine de Pizan's comment that the intellectuals took 'the trowel of the plume (pen) to the field of scripture to construct the city.'[14]

What has gone unnoticed is that the Ordo of Charles V, with its binding ritual actions and oaths, was the effective instrument for constructing this relationship between the king and the peers. This relationship, which constitutes 'the Crown', was constructed in the ritual of the sacre through the actions of the peers in sustaining the crown and in the sworn oaths of the king and the peers as set out in the Ordo of Charles V and as recorded in the Coronation Book. In the account of the session of the Grand Conseil we see the use of material documentation of legally binding actions of the peers of the past, which was brought out and presented to the reluctant peer. Jean de Montfort had replaced Charles of Blois, the former duke of Brittany, who had been present at the sacre of Charles V and who would have sworn liege homage for his duchy at that time. The account speaks of the documents presented to the new duke as evidence of past precedents. Montfort had ten hours to think things over, and in this period one can imagine that a useful tool of persuasion might have been a beautiful, but nevertheless, clear and explicit record of the words and deeds of the peers in the sacre where, in a solemn sacramental ritual, they made their homage before God and the assembled representatives of the Crown.

Further indication of how these oaths were enforced emerges from a sequence of events of 1368 and 1369. Edward III had not fulfilled his promises made at Bretigny to evacuate the companies of marauding mercenaries from France, and he imposed heavy taxes on his newly acquired territories in Guyenne. The barons of Gascony wished to appeal for aid to the king of France, but the king was not in a position to hear those appeals because of the conditions of the Treaty of Bretigny. The oaths of the peers and the barons sworn at the sacre and explicitly set out in word and image in the Coronation Book provided Charles with a legal pretext to intervene. According to the terms of the oaths sworn at the sacre and the ritual actions of the sustaining of the crown performed in the sacre, Guyenne belonged, not to an individual, but to the Crown. The peers and barons had consented to this principle by virtue of participating in the sacre and particularly by sustaining the crown. By consummating their respective oaths, king and peers together had consensually vowed to uphold the sovereignty of the Crown and all its rights. This provided Charles with a legal pretext, a mandate even, to intervene. And intervene he did. Although Edward III asked Charles not to hear the Gascon appeals, with the advice of parliament and the full Grand Conseil Charles nevertheless decided to hear these appeals. This was an assertion that he as the king of France was sovereign over these domains. By November 1369 Charles had confiscated the duchy of Guyenne. This was the first step in the reconquest of the territories signed away at Bretigny. Edward responded by declaring himself king of France. It was a declaration of war, an episode of the Hundred Years War that lasted seven years.[15]

The Coronation Book provided a visible testimony to the ceremony of 19 May 1364, its ritual, its participants, and the promises that were exchanged. The manuscript explained

in word and image the meaning of every detail of that event and spelled out the engagement of the various participants. Charles's interest and involvement with the Coronation Book, as evidenced by the colophon and signature, along with its presence in the inventories of the Louvre, indicate that it remained in this library throughout his reign. Its audience was the population that used the library, that is, the members of the court, indeed the same society that is depicted in the images. Its presence in the library of the Louvre is witnessed by the influence which it had in informing the point of view of the various users of that library.[16]

We have seen throughout this study ample evidence that the content of the Coronation Book informed the translation and commentaries of Jean Golein. There are also indications that it informed the stance of Nicole Oresme in his translations and commentaries of Aristotle's *Politics*, in particular. For example, while Oresme's defence of hereditary succession reinforces the positions advanced by the Coronation Book, he also argues against the doctrine of the royal religion as developed therein.[17] I would also suggest that the Coronation Book was consulted by Raoul de Presles for his translations and commentaries of St Augustine's *City of God*[18] and that its ritual was fundamental for the extreme positions put forward in the anonymous *Songe du Vergier*.[19] These works do not defend a unified point of view. Rather, they present differing interpretations of the theory of the sovereignty of the Crown and the place of the king in the structure of power. But their point of departure on these matters is the liturgy of the Ordo of Charles V as presented in the Coronation Book. All of these illustrated translations were commissioned to advance a discourse on the nature of the monarchy and the question of the distribution of political power. Different points of view are presented by each of these works, but they all belong to the context of the court and the library which was the setting of this continuous colloquium on good government conducted by Charles V and his advisors who appear in the frontispieces of these manuscripts.

After the death of Charles's son and heir Charles VI, the Coronation Book was most probably acquired by the duke of Bedford, regent of France after the defeat of the French at Agincourt. It appears in the aforementioned inventory of the library of Charles VI made in 1424 at the order of the English commissioners after the death of Charles VI, not long before ownership of the remaining books in the library of Charles VI was transferred to Bedford in June 1425. The library remained at the Louvre until 15 October 1429 when Bedford and his wife, Anne of Burgundy, the sister of duke Philip the Good of Burgundy, moved to English-controlled Rouen. The books were probably moved at that time to the castle of Rouen. After Bedford's death on 14 September 1435 his library was dispersed.[20] Some of Bedford's books were certainly transported to London. One of these was the presentation copy of Golein's translation of the *Rational of Divine Offices* that includes the *Traité du Sacre,* which was bought in London in 1441 by Jean d'Angoulême, the younger brother of Charles d'Orléans. According to Jenny Stratford, his signature and inscription are the only documentary evidence that books in the library came to England.[21] Unfortunately, none of Bedford's most important surviving books are listed in the inventory of his goods, including the Bedford Hours.[22]

It is not impossible that the Coronation Book left Bedford's library before his death. Dewick noted that the oath of allegiance to the king of England on fol. 80 of the Coronation Book may perhaps have been inserted when Bedford's nephew Henry VI of England was crowned king of France in Notre Dame in Paris on 17 December 1431 by his uncle, the cardinal bishop of Winchester, who was the brother of the duke of Bedford. Dewick, however, thought that the script should be dated to around 1450.[23] The year before his sacre as king of France, Henry VI's aunt and uncle, the duke and duchess of Bedford, gave him the beautiful Bedford Hours when he stayed with them in Rouen on Christmas Eve of 1430. The duke and duchess of Bedford were in Paris for much of 1431, and it is not inconceivable that, given the close political and blood ties between Bedford and Henry VI, and considering that the duke had already given his precious Book of Hours to his nephew, that he presented the Coronation Book to Henry VI for his coronation in Paris on 17 December.[24] The presence of oaths of allegiance to the king of England points to the use of the Coronation Book for the sacre of the English king as King of France, and also presents the likelihood that the Coronation Book was used by the English in the same way that it had been used by the French king, as an instrument for securing the homage of the peers and barons. This evidence also points to its possession by the English Crown during the fifteenth century, although it is also conceivable that, after the sacre of the nine year old Henry VI, the manuscript was kept by his uncle, the cardinal bishop of Winchester who crowned him in Paris.

There is no concrete evidence of how the manuscript made its way to England. The oath of allegiance to the English king is the most tangible evidence that it was in the possession of an English king or someone closely associated with the sacre of an English king, and this would be the most likely way that it travelled to England. Given its politically controversial stance where the disputed territory of Guyenne was concerned, the manuscript would have had considerable strategic interest for any English king, even one who had not been crowned king of France. The sovereignty that it establishes for the king at the head of a corporate body politic constituted of the episcopacy and the peers of the realm would have been of great interest to Henry VIII and his counsellors in formulating their position with respect to the papacy and the German emperor. Because of the prominence given to the sacring of the queen and its treatment of the question of female exclusion, the Coronation Book would have had enormous impact in the context of the accession and sacring of Elizabeth I, if one could be certain of its whereabouts at that time.

At a later date the Coronation Book was bound with the English pontifical and, because of their shared existence for several centuries, notations in both manuscripts shed some light on their history. The English pontifical began on fol. 3 of the present numbering, was interrupted on fols. 35–80 for the insertion of the Coronation Book, and concluded on fol. 188v.[25] When the two works were bound together the English pontifical was divided, and the Coronation Book was inserted into the English pontifical immediately before the sacring rite in the latter, a detail which suggests a special interest in sacring rites on the part of the owner who had the works rebound.

The English Pontifical contains the third recension of the English coronation ordo. The script of this pontifical is a large and clearly written liturgical hand of the twelfth century.[26]

285

Wilson noted that the English Pontifical differs slightly from other exemplars of the third recension in that it contains numerous affinities with the diocese of Rouen. These include the examination of the bishop-elect that has questions which appear in a form used in the province of Rouen but which do not recur in later English pontificals.[27] The professions of the bishop-elect in the ordo for the consecration of a bishop indicate that the pontifical was intended for the province of Canterbury, but added to the manuscript was an ordo for the consecration of an abbot according to the Use of the diocese of Glasgow. Wilson identified this as written in a later hand, perhaps of the fourteenth century, which might suggest that the manuscript was in the possession of a bishop of Glasgow by the end of the fourteenth century, although it does not necessarily indicate that the pontifical was in Scotland.[28] Because the Coronation Book was in the library in the Louvre until 1424 (and perhaps even until 1429), the insertion of the ordo for the consecration of an abbot must have been made in the English Pontifical before it was bound with the Coronation Book.

Dewick noted that the fourteenth-century hand responsible for the additions from the *Liber Regalis* in the Coronation Book does not appear in the English Pontifical, an indication that the two manuscripts were not yet joined together by the end of the fourteenth century. The shared existence of the Coronation Book and the English Pontifical might have come about when they were joined, perhaps in an ecclesiastical library, or a royal library, either of which might be expected to have a special interest in liturgy and in collecting and comparing sacring rituals. However, we will see presently that there is another possibility.

The title *Liber Pontificalis* is inscribed on the flyleaf of the pontifical, followed by the signature and date: 'Thomas Potter, 1566'. The inscription does not refer to the Coronation Book but rather to the pontifical, so it appears that the two works were not yet joined by 1566. On the lower margin of fol. 3 of the pontifical appears the name 'Robertus Cotton Bruceus, 1604', indicating that the manuscript had by that date entered the Cotton collection.[29] On fol. 2 a librarian of the Cotton library has written a List of Contents (*Elenchus contentorum in hoc codice*). The first item on this list is the pontifical. This is followed by item 2 which corresponds to the Coronation Book ('*Liber Gallicanus et coronationis ritu pulcherrimis figuris depictus … olim ad Carolum 5 Gallorum Regem cum sacramentis quae praestare …* '). Item 3 is the continuation of the English pontifical beginning with the sacre of the English king and queen (*Ordo coronationis Regis et Reginae Anglicae*), etc. The pontifical and the Coronation Book are clearly together for the first time in the Cotton library, and every indication is that this is where they were put together. On an unnumbered flyleaf, at the beginning of the English pontifical, the following instructions to the binder are written in a seventeenth-century hand (and orthography) resembling Cotton's:

> Bind this book as strong as you can with twisted waxed thred mak it as hamsom as may be and gild it one the Egges but have a care you cut non of the old notes Lett the Claspes be mayd very hamsom as he can and have an Especiall car of this book.[30]

Cotton had a predilection for binding together different manuscripts into a single collected volume, frequently dividing manuscripts to insert other manuscripts. And he had a habit of cutting out sections or folios to paste them into other manuscripts.[31] All of these

patterns occur in Cotton Tiberius B. VIII. He was especially interested in items pertaining to English history, English Church history, nobility, genealogy, and ceremonial. Sir Robert Cotton acquired many of his manuscripts from the royal libraries at Westminster and Whitehall. I have not been able to determine whether this was the source from which he acquired the Coronation Book, although this is the most likely hypothesis.

From Cotton's library the Coronation Book entered the collection of the British Museum with the gift of his library to the British Crown. The records of the British Library show that the manuscript was sent to the bindery in 1899, 1937 and 1938. The two works were still together when Dewick published his edition in 1899. Janet Backhouse kindly searched the records of the British Library on my behalf and provided photocopies of the relevant pages of the ledgers. When the Coronation Book was sent to the bindery in 1899 it was resewn and fastened and the cover was refurbished, and cleaning and mending is noted. Records show that the separation of the Coronation Book from the pontifical occurred in February 1937 when the pontifical was returned to its old covers without fols. 35–80 and the Coronation Book, fols. 35–80, was put into temporary covers. The manuscript was given its present red morocco binding stamped in gold with fleurs-de-lis and the arms of the Cotton Library in 1938. The pontifical is now bound in dark reddish brown leather stamped with gold fleurs-de-lis. According to Janet Backhouse this change took place when the Coronation Book was prepared for display in the exhibition held by the British Library in honour of the coronation of George VI and Elizabeth. She provided copies of exhibition labels in the records of the British Library which show that the manuscript was also exhibited for the coronation of Edward VII in 1902, and of Elizabeth II in 1953. Both the Coronation Book (fols. 35–80) and the English Pontifical still bear the same press mark, the two distinct manuscripts being distinguished from each other only by their respective folio numbers.

If monarchy has survived as a viable political system for more than five millennia this is due to its particular capacity to reconcile the opposing forces of change and order: to allow for change within a stable and apparently unchanging framework. The essence of monarchy is consent — of those who are ruled and those who rule — to the premises of the system. Any complex symbolic system, whether political, economic or linguistic, can work only if the members play by the rules. The rules must be understood, internalized and lived by all.

The Coronation Book holds up a mirror that reflects the workings of a monarchical system in the process of reforming itself to accommodate far-reaching social, political and economic change. The reforms envisioned by the Coronation Book and its ritual are subtle and profound. The innovations of the Ordo of Charles V as presented in the Coronation Book and its images instituted a profound change in the political organization of monarchy, transforming it from an order founded upon fidelity and loyalty to the person of the monarch to an order founded upon loyalty and fidelity to a corporate institution, the Crown. For these innovations to be realized, it was necessary for them to be understood by the constituents who are both the subject and the audience of this manuscript. The text and images delineate the specific actions of specific individuals and groups who had assem-

bled at Reims on 19 May 1364, not merely to consecrate a new king and queen, but to affirm their binding consent to a new political covenant in which the king is the head of a corporate body of government that is made up of representatives of the French episcopate and provincial aristocracy.

As realistic as the images purport to be they are essentially idealistic, for this realism was the vehicle, not for depicting the world as it was in May 1364, torn asunder by a host of human and natural causes. Rather the realism was designed to reveal the specifics of a new order that was instituted in the sacre enacted on that date: it is an ideal picture of how reality must be. It reveals the sacre, not as a rigid symbolic ritual, but as an apparatus for reforming society and for negotiating consent of the constituents to their respective positions and duties in this reformed order.

A. The Cycle of Charles V

Folio 35
The Archbishop of Reims blesses the King
[Plate 1]

*Et apres prime chantee li roys doit venir a leglise et
avecques lui les arcevesques et les evesques et les barons
que il voudra faire mettre ens et doit venir aincois que
lyaue benoit soit faite ... [fol. 35]*
*Episcopis paribus videlicet primo Laudunensi post ea
Belvacensi deinde Lingonensi post ea Cathalanensi
ultimum Noviomensi cum alijs episcopis
archiepiscopatus remensis ... Et episcopi laudunensis et
belvacensis qui sunt primi pares de episcopis debent esse
in predicta processione habentes sanctorum reliquias
colo pendentes. [fols. 43v-44]*

The first two miniatures introduce the major
themes of the manuscript as a whole: the liturgical,
the historical, and the political. This miniature, the
only illustration in the first gathering, is the fron-
tispiece of the French translation of the Directory
of c. 1230 which has been included in its entirety at
the start of the Coronation Book. Although this di-
rectory was compiled at the beginning of the reign
of St Louis, the miniature depicts Charles V and his
contemporaries. The Ordo of Charles V and the
French translation call for the king to make a night
vigil in the cathedral on the `Saturday preceding
the Sunday on which the king is to be crowned'.
Both also state that `after the first chant in the com-
pany of the archbishop, bishops, barons, and oth-
ers the king comes before the church where he will
receive a blessing of holy water'. This second visit
is the subject of the first two miniatures of the Cor-
onation Book.

The archbishop of Reims asperges the king
who stands before the façade of the cathedral of
Reims in the company of a group which includes
nobles and knights, some of whom carry golden
batons which identify them as seneschals of the
great apanages. The miniature thus includes the
prominent lay presence which was introduced
into the sacre of the French king with the Directory
of c. 1230.

The prominence of the archbishop of Reims in
the two opening scenes announces his pre-eminent
role in the sacre of Charles V and Jeanne de
Bourbon. Although given secondary importance
in the text, the archbishop is emphasized in the
miniatures, being singled out for identification by
armorials on his cope (France ancient a cross
argent) and by a high degree of portrait likeness.
Contemporaries would no doubt have recognized

him as Jean de Craon, a member of a great family
from the Anjou, whose niece, Marie de Blois,
was married to Louis of Anjou. Among the
episcopal peers only the archbishop of Reims has
been so identified. The hierarchical order of the
clergy presented by the miniature contradicts the
order indicated in the text which assigns first place
amongst the episcopal peers to the bishop of Laon,
after whom is Beauvais, then Langres, Châlons and
Noyon. Neither the French nor the Latin text calls
for the archbishop of Reims to perform this
blessing. This prominence exceeds the text of the
Coronation Book as well as the earlier pontificals of
Reims.[1]

Although the text mentions five bishops be-
sides the archbishop, the first miniature includes
only three, and the second, four. This difference
between text and image seems significant, for its
explanation would seem to rest in an effort to sup-
plement the formulaic liturgical text with details
concerning the specific historical enactment of the
sacre, documentary accounts of which differ. For
example, the *Grandes Chroniques* do not mention
Châlons, but do mention the participation of the
bishops of Laon and Beauvais, and other accounts
mention the presence of the bishops of Langres
and Noyon. Although the identities of the men
who occupied these sees are known they are nei-
ther identified in the text nor in the miniatures.[2]

The king is emphasized in the miniatures by
his size and by the fact that he alone of the laity is
shown full-figure, his body unobstructed by either
person or object. The miniatures delineate a hierar-
chical order different from that in the text.
Whereas the text mixes secular figures and ecclesi-
astics together into a single group, the two opening
miniatures and the cycle as a whole separate the
orders of society, with the laity on the left and ec-
clesiastics on the right.

In the first scene, standing behind the arch-
bishop of Reims, an acolyte holds a crozier in his
right hand while with his left he extends a holy wa-
ter pot for the easy reach of the archbishop. Behind
him, a deacon carries a large crozier and an incense
boat with his right hand and holds a thurible with
his left. In the second scene the archbishop is fol-
lowed by the acolyte holding a crozier and holy
water vessel as a deacon carries a cross and a third
swings an incense boat. The liturgical and sacra-
mental nature of the sacre is introduced in these
two scenes by means of the emphasis given to li-
turgical objects and to members of the clergy
which are not mentioned in the adjacent text.

290

Folio 43
The Archbishop of Reims blesses the King
[Plate 2]

Post primam cantatam debet rex cum archiepiscopis et
episcopis et baronibus et alijs quos intromittere voluerit
in ecclesiam venire antequam fiat aqua benedicta ...
[fol. 43v]

But for minor changes in the identity, placement,
attributes, and gestures of the secondary charac-
ters, this illustration, which is the frontispiece for
the Latin text of the Ordo of Charles V, represents
the same action as the first. One might ask why
two nearly identical scenes begin the Directory of
c. 1230 and the Ordo of Charles V, for they seem to
be almost redundant in content. Yet the two minia-
tures provide a visual continuity between the two
ordines and in this way reinforce the link between
the directory from the time of St Louis and the
Ordo of Charles V. The Ordo begins with elaborate
rubrics which detail the preparations for the sacre.
But for the last paragraph which is new, the intro-
ductory rubrics reproduce the same opening ru-
brics which appear in the three earlier French or-
dines including the Latin source of the French di-
rectory at the beginning of the Coronation Book.

Although the main action of the two opening
illustrations is inspired by the text, some details of
the miniatures are not specified by the texts. The
spurs which the king wears in the first two scenes
have been misinterpreted as referring to the
prince's journey to Reims, leading to the incorrect
identification of the first two scenes as the arrival
of the king and his retinue at the cathedral of
Reims and their reception there by the archbishop,
an event which is not in the text.[3] Beginning with
the Directory of c. 1230, the French king was in-
vested with royal spurs.[4] This action is included in
both the French and Latin texts in the Coronation
Book, but does not take place until later in the cere-
mony, so the spurs in the first two scenes are
clearly shown not to be the royal spurs which he
will receive in the ceremony. History, and not lit-
urgy, suggests that the present spurs are those the
prince received when knighted by his father John
the Good immediately after the latter's sacre on 26
September 1350.[5]This was the first public cere-
mony in the career of the prince and it was John the
Good's first official act in designating his eldest
son as his successor. The presence of these spurs
makes a claim for the worthiness of the prince to
succeed on the basis of his knighthood and de-
clared fealty to the king and by virtue of his desig-
nation by that king for succession. Thus the detail
defines the subject of the first two illustrations as a
'presentation of the elect'. Combined with the em-
phasis given the archiepiscopal blessing in this

context, it assumes the importance of an ecclesias-
tical sanction for the candidate in general, and in
particular it emphasizes the role played by Jean de
Craon in bringing about the succession of Charles
V. By means of the spurs the miniatures introduce
the controversial political theme of succession
which runs throughout the Coronation Book.

In keeping with the theme of succession, the
king is followed throughout the entire cycle by his
brother Louis of Anjou. Charles was without a
male child at the time of his coronation, and ac-
cording to the laws of primogeniture, as the sec-
ond son of the deceased king John the Good, Louis
was the successor should Charles V die without
male issue.[6] Anjou's prominence in the cycle seems
best explained on this basis, for neither is his pres-
ence specified by the liturgical text, nor was the
duke of Anjou one of the traditional peers or bar-
ons. He did perform the function of seneschal, but
this was an optional role as explicitly stated in the
rubrics of the text at a later point in the ceremony.[7]
Anjou's quasi-omnipresence assumes further
meaning when considered in the context of the im-
portance accorded the archbishop of Reims, Jean
de Craon, whose niece was married to Louis of
Anjou.

Folio 44v
The Procession of the Canons of the Church of Reims to the Palace of the Archbishop of Reims where the Bishops of Beauvais and Laon raise the King from the Thalamus
[Plate 3]

... Et debent canonici ecclesie remensis processionaliter
cum duabus crucibus cereis et thuribulo cum incenso
ire ad palatium archiepiscopale. Et episcopi
laudunensis et belvacensis qui sunt primi pares de
episcopis debent esse in predicta processione habentes
sanctorum reliquias colo pendentes. Et in camera
magna debent reperire principem in regem
consecrandum sedentem et quasi iacentem supra
thalamum decenter ordinatum. Et cum ad dicti
principis presentiam applicaverint. Dicat laudunensis
episcopus hanc orationem ... [fol. 44].
... qua oratione dicta statim suscipiant eum duo
predicti episcopi dextera levaque honorifice et ipsum
reverenter ducant ad ecclesiam canentes hoc ... Rx ...
cum canonicis predictis. [fols. 44-44v]

The two separate actions combined in this scene
are innovations of the Ordo of Charles V. The text
calls for the canons of the see of Reims to go in pro-
cession to the palace of the archbishop of Reims led
by the suffragan bishops of Laon and Beauvais
wearing relics of saints around their necks. The
group of figures on the left arrives at a structure
identified in the rubrics as the palace of the arch-

bishop of Reims, where the king sits on a bed covered with a canopy draped with the arms of the archbishop of Reims. The king, wearing a red tunic under a dark brown mantle, the roba communis, is flanked by two bishops. The rubrics stipulate that the bishops of Beauvais and Laon raise the prince with honour while reciting a prayer over him. The bishop of Beauvais has been identified by his cope marked with the arms of his see (or, a cross between four keys paleways, wards in chief, gules), but the armorials of the bishop of Laon (azure, semé de fleurs-de-lis) have not been differentiated from those of the archbishop of Reims so as to permit certain identification. In this case the text should prevail in identifying the figure as Laon.[8]

No previous royal ordo, including those of the diocese of Reims, had put so much emphasis upon the archbishop and the canons of the cathedral of Reims. The raising of the king in the grand chamber of the archiepiscopal palace on the morning of his sacre makes a special reference to the association between the prince and the archbishop, Jean de Craon, who played a central role in assisting the prince to claim his right to succeed to the throne of France. This scene also announces the prominence of the bishop of Beauvais, Jean de Dormans, who was one of the prince's stalwart advisors during much of his public life.

The text does not mention a bed but a `thalamus', a word with connotations of a nuptial chamber. Because this thalamus is in the palace of the archbishop, the prince is likened to a bridegroom in the sense of an ordinand to the priesthood or to the episcopate who at his consecration becomes the bridegroom of the Church. The thalamus thus announces the episcopal-royal programme of the Ordo of Charles V.

Folio 46
The Abbot of Saint-Remi conveys the Holy Ampulla to the Archbishop of Reims
[Plate 4]

Entre prime et tierce doivent venir les moines de saint remi a procession o les croiz et les cierges. Et avecques la sainte ampole la quele li abbes doit porter a tres grant reverence souz une courtine de soie portee sus iiij perches de iiij moines vestus en aubes. Et quant il vendront a leglise saint denis. ou se il couvenoit miex pour la presse se estoit trop grant. iusques a la porte greigneur de leglise li arcevesques doit aler encontre. et avecques lui li autres arcevesques et les evesques. et les chanoines se ce se puet faire. Et se ce ne puet estre fait pour la grant presse qui seroit dehors. alassent avecques lui aucuns des evesques et des barons. Adonques li arcevesques doit prendre lampole de la main de labbe. Et si il doit promettre en bonne foy que il li rendra. Et en tele maniere li arcevesques doit porter ycelle ampole a

lautel o grant reverence du pueple. Et le doit acompaignier li abbes avec aucuns de ses moines. Et les autres doivent attendre tant que tout soit parfait. Et donques la sainte ampole sera raportee ou en leglise saint denys ou en la chapele saint nicolas ... [fols. 36-36v]

Quando sacra ampulla debeat venire. [fol. 45v]

Inter primam et terciam debent venire monachi beati remigij processionaliter cum crucibus et cereis cum sacrosancta ampulla quam debet abbas reverentissime deferre sub cortina serica. quatuor particis a quatuor monachis albis indutis sublevata. Rex autem debet mittere de baronibus. qui eam secure conducant. et cum venerit ad ecclesiam beati dyonisij vel usque ad maiorem ianuam ecclesie. propter turbam comprimentem. Debet archiepiscopus superpilitio stola et capa sollempni indutus cum mitra et baculo pastorali sua cruce precedenti cum ceteris archiepiscopis et episcopis. baronibus necnon et canonicis si fieri potest. occurrere sancte ampulle. et eam de manu abbatis recipere. cum pollicitatione de reddendo bona fide. et sic ad altare cum magna populi reverentia defferre. abbate et aliquibus de monachis pariter cum[eam or con]comitantibus. Ceteri vero monachi debent expectare in ecclesia beati dyonisij vel in capella beati nicholai donec omnia peracta fuerint. et quousque sacra ampulla fuerit reportata. [fols. 45v-46]

Originally the cycle included two scenes dedicated to the transmission of the Celestial Balm by the abbot and monks of Saint-Remi to the archbishop of Reims, so that this essential element would have had greater prominence in the cycle than at present. This scene was preceded by an illustration of the procession of the abbot and monks of Saint-Remi which has been cut out of the lower margin of the folio on which the above text appears. According to the French and Latin texts the `sacrosanct ampulla' must be borne in procession with the utmost reverence to the church of Saint-Denis at Reims by the abbot of the monastery of Saint-Remi where the ampulla and the Celestial Balm are guarded. There, they are met by the archbishop, accompanied by bishops and canons of the see of Reims. The abbot of Saint-Remi transmits the ampulla to the archbishop who vows to guard it in good faith and return it to the abbot of Saint-Remi after the sacre. The present miniature adheres closely to the French and Latin texts, although the text of the latter adds to the archbishop's entourage the king and barons, none of whom appear in the miniature.

Four tonsured monks dressed in albs stand on the left behind the abbot whose episcopal rank is emphasized by the mitre and gloves which he wears and by the crozier borne by one of the monks. The abbot's episcopal status endows the act of transmission with added validity by virtue of

292

the fact that the ampulla is conveyed by a bishop to an archbishop, both of whom handle the ampulla with hands covered by the blessed episcopal gloves. The archbishop of Reims is thus honoured as the ultimate custodian of the Celestial Balm since the episcopal status of the abbot of Saint-Remi shows him to be a suffragan of the archbishop of Reims. In the two opening scenes the full complement of bishops specified for the coronation by the text is lacking. The episcopal status of the abbot reinforces the authority of the coronation by complementing the number of episcopal participants.[9]

In his treatise on the sacre of Charles V, Golein uses the Celestial Balm to defend Valois succession. The emphasis given the balm in this scene would have been understood in the light of its implications for the succession issue.

Folio 46v
The Archbishop of Reims administers the Oath to the King
[Plate 5]

Et quant larcevesque sera venus a lautel. il ou aucuns des evesques pour touz. et pour les eglises qui leur sont souzmises. doivent demander au roy que il promette et afferme par son serement a garder et a faire garder les droitures des evesques. et des eglises. si comme il avient au roy a faire en son royaume. et les autres choses si comme elles sont contenues en lordinaire ou trois choses li sont proposees a estre promises et iurees hors le sairement de la nouvelle constitution du concile de latran. Cest a savoir de mettre hors de son royaume les hereges. [fol. 37]
Entre ce len doit avoir appareillie et mis sus lautel la couronne le roy. et sespee mise dedens son fuerre. ses esperons dor. son ceptre dor. et sa verge a la mesure dun coute ou de plus qui ara au dessus un main dyvoire … [fol. 37v]
… Rex debet assurgere reverenter. Cum autem venerit archiepiscopus ad altare debet pro omnibus ecclesijs sibi subditis a rege hec petere. [fol. 46]
Ammonitio ad regem dicendo ita … [fol. 46]
Item hec dicit rex et promittit et firmat iuramento. [fol. 46v]
Postmodum surgit iam ante preparatis et positis super altare corona regia. [fol. 47]

The oath or *promissio regis* is an essential preliminary for the sacre which was introduced in the Carolingian period in the Protocols of Hincmar for the sacre of Charles the Bald in Metz in 869.[10] In this scene the archbishop of Reims holds an open book in the centre of the composition as the king, portrayed in a three-quarter view, places his right hand on the book and raises his left hand in a gesture of adjuration. Although the French translation

specifies that the oath is sworn on the Gospels, the words which are legibly inscribed on the open book are not from the Gospels but from the first lines of the oath which is administered to the king: *promitto vobis et perdono quia uni* ….The book in the miniature is associated with the adjacent text by the first words of the oath legible on the book and the prominent initial `P' which occupies the same position as the filigree initial `P' of the oath written above in the text on the same folio.

Although not called for at this point in either text, the duke of Anjou, standing next to the king, raises his right hand in a gesture which replicates the king's gesture, suggesting that the duke is acting as a witness to the oath of the king as well as implying his own support for the king in upholding that oath.

The presence of the crown and the sword on the altar are in direct response to the content of the oath in which the king swears to defend the Crown, an innovation in the text of the oath which is introduced in the Ordo of Charles V.[11] Both the Latin and the French texts call for the crown and the sword in its sheath along with the golden spurs and golden sceptre to be placed on the altar after the oath is administered, although the miniature shows only the crown and the sword.

Folio 47
The Bishops of Laon and Beauvais place the King on the Cathedra
[Plate 6]

Qua oratione dicta ducant predicti episcopi regem consecrandum ad sedendum in cathedra sibi preparata in conspectu cathedre archiepiscopi et ibi sedebit donec archiepiscopus veniat cum sancta ampulla … [fols. 45-46v]

This action is not included in the French directory. This scene illustrates the passage `the aforesaid bishops lead the king who is to be consecrated to sit in a cathedra prepared in the view of the cathedra of the archbishop and seat him in it …', a phrase which was introduced into the Ordo of Charles V and explicitly announces the analogy with the episcopal consecration, where, upon the completion of his oath, the bishop-elect is placed in the cathedra by two bishops, precisely in this manner.[12] Standing on the left, the bishop of Beauvais places his right arm over the king's breast, and on the king's right the bishop of Laon places his left hand on the king's shoulder, gestures which indicate that they have just placed him in the golden seat identified as a cathedra by the accompanying text. The archbishop of Reims dons the episcopal gloves, an action not mentioned by the text, which serves to accentuate the episcopal character of the

ritual. Looking on, Anjou is recognized in the company of four lay persons. At the right of the scene the crown and sword rest on the altar which is adorned with a triptych depicting haloed figures in half-length.

Folio 47v
The Removal of the King's outer Garments
[Plate 7]

Li roys sera a lautel en estant et despoillera sa robe fors sa cote de soye et sa chemise qui seront ouvertes bien aval devant et darrieres. Cest a savoir ou pis. et entre les espaules. Et les ouvertures de la cote seront a la foiz recloses et reiointes avecques attaches dargent ... [fols. 37v-38]

Tunc primo rex stans ante altare deponit vestes suas preter tunicam sericam et camisiam apertas profundius ante et retro in pectore videlicet et inter scapulas. aperturis tunice sibi inuicem connexis ansulis argenteis ... [fol. 47v]

Two lay attendants remove the king's outer garment, the brown *roba communis*, revealing the shirt (*camisia*) and red tunic (*tunica*) beneath it, illustrating both the Latin *ordo* and the French translation which stipulate that `the king will be at the altar and will be divested of his outer robes'.

On the altar is a triptych with a `Man of Sorrows' in the centre flanked on each side by panels with adoring angels. The royal garments are designated by terms which have their counterpart in priestly garb: the silk tunic is comparable to the *tunica serica* and the shirt to the *camisia* of the priesthood. In the consecration of a bishop the bishop-elect is divested of his garments in similar fashion at this point in the ceremony.[13] In the *Traité du Sacre* Golein states that divesting the king of his garments signifies that he relinquishes the worldly state to take up that of the `royal religion', by which Golein means the divinely ordained mission or ministry of the French monarchy.[14] The scene is thus crucial for identifying important themes of the Coronation Book, notably, the sacerdotal and prelatial character of the *roi très chrétien* and the `Royal Religion'.

Folio 48
The Duke of Bourbon vests the King with the Royal Shoes
[Plate 8]

Item les chauces de soye de couleur de violete. broudees ou tissues de flours de lys dor. [fol. 37v]

Adonc tout premierement. li grans chamberiers de france chaucera illvecques au roy les devant dictes chauces. Les queles li abbes de saint denis li baudra ... [fol. 38]

Item caligis sericis et iacinctinis per totum intextis lilijs aureis. [fol. 47]

Qua oratione dicta statim ibi a magno camerario francie. Regi dicte calciantur ... [fol. 48]

This illustration begins a sequence devoted to the investiture of the garments and insignia. In accordance with the French translation and the Ordo of Charles V, the Grand Chamberlain of France puts on the king's feet the silk shoes of hyacinth colour embroidered with golden fleurs-de-lis. Although both texts emphasize the role of the abbot of Saint-Denis in carrying the vestments and regalia to the cathedral of Reims, his importance has been effaced in the miniatures, and indeed, if he is represented at all, he has not been identified either by armorials or individualized portrait likeness anywhere in the cycle.

The French translation at the beginning of the Coronation Book calls for the action to be performed by the Grand Chamberlain of France, while the rubrics of the Latin text indicate only that the Grand Chamberlain stands to hear the blessing of the archbishop. Although neither text identifies him, naturalistic portraiture and the mantle blazoned with the arms of the duke of Bourbon identify him as Louis II, the brother of Jeanne de Bourbon.[15] In keeping with the Directory of *c.* 1230 which reintroduced the laity into the status-changing segments of the *sacre*, the Ordo of Charles V places exceptional emphasis on the actions of individual members of the secular estates.

The king is supported by a noble whose portrait likeness resembles that of the king. Yet it is not Anjou, nor is it Jean who was captive in England at the time of the *sacre*, and it seems too mature to be Philip the Bold who was still a boy and who is rather to be identified as the duke of Burgundy in the following scene. It is probably Louis d'Evreux, the count of Etampes who was Charles's cousin, closest childhood companion and trusted friend. Four laymen witness on the left, the first recognized by armorials and portrait likeness as Anjou. On the right, the archbishop of Reims, accompanied by another bishop, raises his right hand in blessing.

The sword and crown continue to be prominently in view on the altar in front of a triptych with the Man of Sorrows, flanked by adoring angels, as in the previous scene. The iconography of the Man of Sorrows features the robes and implements of the Passion, arranged in an emblematic, devotional manner around the body of Christ. This altarpiece is a reminder of the theoretical resemblance between the earthly king and the kingship of Christ, the *Rex imago Dei*, drawing as it does a parallel between the robes and instruments of

Christ's passion and the robes and instruments of kingship.

Folio 48v
The Duke of Burgundy vests the King with the Spurs
[Plate 9]

Et apres li dux di borgoigne li mettra les esperons es piez que li abbes de saint denys li baudra. et maintenant li seront ostez. [fol. 38]
Et post modum a duce burgondie calcaria eius pedibus astringuntur et statim tolluntur … [fol. 48]

Although the investiture of the spurs receives only a brief mention in the text, an entire miniature is devoted to this act. First introduced in the royal ordo from Reims of c. 1230, the transmission of the spurs was the central act in the investiture of a knight which expressed his role as a `miles Christi'.[16] The knightly ceremony had a liturgical and quasi-sacramental character, and the knight, like the king and the priest, was endowed with a sacred mission to defend the Church. However, these sections of the rite go beyond investing the king with mere chivalric duty, for, because of the king's special oaths to defend orthodoxy and to expel heretics from the kingdom, the investiture of the spurs and sword pertain to his divinely ordained mission as the *roi très chrétien*. This may explain why two different sets of spurs were worn by the king: those in the two opening scenes, which he received when he was knighted by John the Good, and the royal spurs.

The accompanying text specifies that the spurs be delivered to the king by the duke of Burgundy. The latter's prominence had special significance at the moment of the coronation of Charles V. Eudes, the last of the Capetian line of the dukes of Burgundy, had died shortly before the death of John the Good, leaving the choice of his successor to the king of France. The *Grandes Chroniques* state that John the Good had named his son to this apanage before his death and that Charles V merely rendered public his father's decision. One of Charles V's first official acts after the sacre was to name his youngest brother Philip the Bold to the succession of Burgundy.[17] The chronicles do not indicate whether this prince assisted at the sacre of his brother, but the youthful appearance of the figure in the miniature suggests that the king's youngest brother Philip the Bold participated in the coronation in the role of the duke of Burgundy, although he had not yet been officially invested with that title at the moment of the coronation. The miniature is the earliest testimony to the investiture of Philip with this great apanage.

The altar, draped with blue curtains hanging from four columns each surmounted by an angel bearing a candle, is more elaborately furnished than in previous scenes. The triptych on the altar has a Crucifixion on the centre panel and a standing figure, evidently the Virgin, on the left panel. The crown and the sword in its scabbard continue to be visible on the altar.

The archbishop of Reims extends his left arm towards the ampulla. This action anticipates the prayer which follows the investiture with the spurs, the benediction of the sword. The text does not specify that this prayer is recited by the archbishop of Reims, although the rubrics emphasize that the archbishop transmits the sword to the king. The bishop who looks on is perhaps the abbot of Saint-Denis who was obliged to guard the regalia for the duration of the ceremony, but as elsewhere his identity is not indicated.

Folio 49
The King offers the Sword on the Altar
[Plate 10]

Apres li arcevesque tout seul seindra au roy sespee. avecques le fuerre. la quelle espee ceinte. li arcevesques meismes traira hors du fuerre. Et le fuerre sera mis seur lautel. Et li arcevesques mettra au roy lespee en sa main. Et le roy la doit offrir humblement a lautel. Et maintenant il la reprendra de la main larcevesque … [fol. 38]
Postmodum rex a solo archiepiscopo gladio accingitur. quo accincto. statim idem gladius discingitur e vagina. et ab archiepiscopo extrahitur. vagina super altare reposita. et datur ei ab archiepiscopo in manibus cum ista oratione dicendo quem rex in manu sua teneat cuspide elevato donec antiphona … [fol. 48v]
Gladium debet rex humiliter recipere de manu archiepiscopi et devote flexis genibus offerre ad altare … [fol. 49]

This is the first of a sequence of scenes dedicated to the transmission of the sword, which, because it had so many illustrations in the original state of the manuscript, occupied a special importance in the cycle. Clerics were forbidden to take up arms, a function reserved for the laity. As with the spurs, the investiture of the sword pertains to the military aspects of the king's mission as the defender of the faith. Unlike the shoes and spurs, the sword is blessed.[18]

For the first time the king kneels, an expression of humility intensified by virtue of its being performed by the highest member of the Christian state.[19] The rubrics stress the need for humility, stating that the king must receive the sword from the hand of the archbishop with `humility and bended knee'. In the earliest known representation

of a kneeling Christian ruler, a fresco once in the Lateran in Rome, Charlemagne was portrayed kneeling to receive his *vexilla* from Saint Peter, an image relevant to this scene as the sword of the sacre of the kings of France was reputed to be the sword of Charlemagne.[20] According to William of Nangis this sword was used at the sacre of Philip III, and was at that time identified as the sword of Charlemagne which was called *la Joyeuse*.[21]

Standing behind the king, the archbishop of Reims raises his right hand to bless the king and another bishop looks on from behind the head of an acolyte holding a cross. The miniature illustrates in a literal way the text which states that the king must receive the sword from the hand of the archbishop. The text also calls for the king to hold the sword erect during the recital of the antiphon *Accipe gladium*. The French text specifies that the archbishop bless the sword and take it out of the scabbard before he places it back on the altar. Four unidentified lay persons, whose individualized likenesses suggest that they were portraits of participants in the sacre, raise their hands in a gesture of witness to the present act.

The objects on the altar are relevant to the symbolism of the text and the ritual, especially as explained by Golein. The altarpiece is a scene of the Crucifixion which is pertinent to the symbolic meaning of the sword, not only because of its cruciform shape, but also because the sword sometimes appears as an instrument of the Passion. This is also true of the crown on the altar, for the crown also bears christological meaning in juxtaposition with the image of Christ, crucified and crowned with thorns. This imagery reinforces the christological aspect of kingship in this sacring rite.

Folio 49v
The Archbishop of Reims returns the Sword to the King [Plate 11]

Et maintenant il la reprendra de la main larcevesque. [fol. 38]
… et statim genibus regis in terra positis resumere de manu archiepiscopi … [fol. 49]

This scene illustrates the passage `and he [the king] takes back (the sword) from the hand of the archbishop', a brief clause which has been emphasized with a full illustration, underscoring the role of the archbishop of Reims in the transmission of the sword. According to Golein this signifies that `he [the king] makes homage to God for the kingdom which he holds from God and not only from the sword, as some wish to say, but from God, as is witnessed on his gold coins when he says *Christus vincit, Christus regnat, Christus imperat*. He does

not state here that the sword reigns and conquers but that Jesus reigns and commands'.[22]

A chalice, paten, and crown sit on the altar before an altarpiece with a Man of Sorrows flanked by figures which appear to be Mary and St John. At the left a group of seven laymen includes Anjou who raises his right hand in a gesture of witness, his presence anticipating the succeeding passage and its illustration. Behind him, a man wearing a short *cotardie* has a garter of cloth and gold below his right knee which indicates that he was a Knight of the Garter. He is possibly the sire de Coucy, married to Isabel, the daughter of Edward III; inducted into the Knights of the Garter in 1364, he later became the earl of Bedford.[23]

Folio 50
The King transmits the Sword to the Seneschal and the Archbishop of Reims prepares to bless the Holy Ampulla [Plate 12]

Et la baudra tantost au seneschal de france a porter devant lui en leglise iusques a la fin de la messe. Et apres la messe quant il yra au palais. Ces choses ainsi faites et le cresme mis a lautel sus une patene consacree. Li arcevesques doit appareiller la sainte ampole sus lautel. [fol. 38]
… et incontinenti dare seneschallo francie si seneschallum habuerit. Sin autem cui voluerit de baronibus ad portandum ante se et in ecclesia usque in finem misse. et post missam usque ad palatium.Tradito per regem gladio ut dictum est dicat archiepiscopus hanc orationem … [fol. 49]
Hucusque de gladio. Post hec preparatur unctio in hunc modum. Sed quamdiu ab archiepiscopo paratur incipit cantor … [fol. 50v]

This is a scene of multiple actions in which the archbishop of Reims blesses the sword and transmits it to the seneschal who is identified by arms and through portraiture as the duke of Anjou. As he bestows the sword, the archbishop simultaneously turns in the direction of the altar and reaches for the Holy Ampulla on the altar next to the crown and the paten for mixing the Celestial Balm with the chrism. This scene concludes the preparatory stages of the ceremony and announces the next stage of the ceremony, the anointing.

The rubrics call for the king to hand over his sword to the seneschal who will carry it in front of the king in the church until the end of the ceremony and after the mass when they are at the palace. The Ordo of Charles V indicates the optional nature of the seneschal by adding the phrase `if there is one'. The text does not identify the seneschal nor justify his importance in the cycle of miniatures. In spite of this, he has been given

exceptional prominence in the entire cycle of miniatures, and has been identified by likeness and armorials as Louis, duke of Anjou, the eldest of the king's brothers. Anjou features throughout the cycle as the bearer of the king's sword. In his personal copy of Golein's treatise on the sacre, Charles V crossed out the word `seneschal' with his own hand and substituted the words *a son plus prochain heretier* which confirms the relevance of the succession issue for this miniature, as it does for the role of Anjou throughout the miniature cycle of the Coronation Book.[24] In this connection it should be noted that Charles had served as seneschal at his father's sacre.[25] At the time of the coronation, Charles V and Jeanne de Bourbon were childless, their first two children, both of whom were daughters, having died. In these circumstances Charles's next younger brother, Anjou, would have been his successor in a system of primogeniture until 1368 when the future Charles VI was born. The importance given the seneschal underscores the importance of the active presence of a designated heir at the sacre. Having no real textual basis, Anjou's presence would seem best understood as a special declaration that this prince, the closest male successor to the new king, is his designated successor. Anjou's prominence throughout would constitute an effort to reinforce the theme of hereditary succession as a right of kingship.[26]

Folio 50v
The Archbishop of Reims prepares the Holy Balm [Plate 13]

Li arcevesques doit appareillier la sainte ampole sus lautel. et en doit traire a une aguille dor aucun petit de luyle envoyee des cieux et meller o grant diligence avecques le cresme qui est appareillie a enoindre le roy. Li quiex roys seulement resplendist devant tous les autres roys du monde de ce glorieux privilege que il singulierement soit enoint de luyle envoyee des cieux ... [fol. 38v]

... Chrisma in altari ponitur super patenam consecratam et archiepiscopus sacrosanctam ampullam quam abbas beati remigij attulit super altare debet aperire. et inde cum acu aurea. aliquantulum de oleo celitus misso attrahere. et crismati parato in patena diligentius cum digito immiscere ad inungendum regem. qui solus inter universos reges terre hoc glorioso profulget privilegio: ut oleo celitus misso singulariter inungatur. [fol. 51]

In the opening scene of the anointing sequence the king kneels at the cathedra with his hands folded and the archbishop stands before the altar on which stand the crown and the paten for the preparation of the holy chrism. He holds the Holy Ampulla from which he extracts the Celestial Balm with a golden needle in accordance with both texts. Anjou stands behind the king while a group of laymen standing behind him witness the action. The Ordo of Charles V calls for the archbishop to use his finger to mix the balm with the chrism, but, contrary to this, the archbishop is shown using the golden needle not only to extract the balm but also to mix the balm with the chrism. According to Golein the mixing of the Celestial Balm with the chrism signifies the mixing of the royal with the priestly.[27]

Folio 51
The Archbishop of Reims unfastens the King's Tunic [Plate 14]

Adonc li defferme les devant dictes attaches des ouvertures devant et derriere. Apres il se doit mettre a genoulz a terre.... [fol. 38v]
Parata unctione qua rex debet inungi ab archiepiscopo debent dissolvi ansule aperturarum vestimentorum regis ante et retro. et genibus regis in terram positis prostrato super faldistorium. archiepiscopo eciam consimiliter prostrato.... [fols. 51-51v]

The archbishop of Reims unfastens the laces of the king's tunic to anoint the breast of the king, who stands, although the text instructs him to kneel at the faldstool. Despite only a brief mention in the text, an entire scene has been devoted to this act, witnessed by the archbishop's cross-bearer and a second bishop, a group of five laymen along with Anjou who bears the king's sword.

The altar is hung with green curtains and adorned with a diptych with an image of the Man of Sorrows. As in many previous scenes the pose of the king mirrors the position of Christ in the altarpiece, a continuing reminder that the king is an image of Christ.

The illustration adheres to the rubrics which specify that the garment is to be opened front and back, and in so doing gives emphasis to the preparations for the anointing of the king's breast and shoulders. A similar accent is placed upon the preparations for the anointing of a priest in the liturgy for holy orders.

Folio 51v
The Archbishop of Reims recites the *Te Invocamus* [Plate 15]

Archiepiscopus debet super eum dicere has orationes antequam eum inungat debet autem sedere sicut sedet cum consecrat episcopos. [fol. 51v]

The king kneels at the cathedra as he raises his hands to pray. His tunic is now open to the waist as the *Te invocamus* is recited by the archbishop, seated on his cathedra. The rubrics which call for

this action are an innovation of the Ordo of Charles V. They state that the archbishop is seated for the recitation of this prayer just `as he sits for the consecration of a bishop', explicitly declaring the intended analogy between the consecration of a king and the consecration of a bishop.[28]

On the open book from which the archbishop reads, the words *Te invocamus domine* are legible, the initial `T' echoing the filigree initial `T' which begins the prayer on the same folio.

The crown, paten and Holy Ampulla continue to remain visible on the altar adorned with an altarpiece representing Saint Peter holding a single key and Saint Paul bearing a sword in a manner similar to Anjou, who bears the sword in his right hand and rests his left hand on the archiepiscopal cathedra.

This miniature preceded the lost miniature of the Anointing of the King's Breast and probably also a miniature of the Anointing of the King's Head on the missing folio between fols. 53v and 54. The illustration of the same subject in Charles's copy of Golein's translation of the *Rational of Divine Offices* (pl. 33) provides some notion of the appearance of the lost miniature of the Anointing of the King's Breast.

Folio 54v
The Archbishop of Reims closes the King's Tunic after anointing the King's Breast [Plate 16]

Apres len li doit refermer les attaches des ouvertures pour lonction. [fol 39]
Hijs dictis orationibus connectuntur ansule aperturarum vestimenti regis ab archiepiscopo. vel sacerdotibus vel dyaconibus propter unctionem.... [fol. 55]

This scene followed the lost illustration of the Anointing of the King's Breast, one of the most essential acts of the coronation ritual which, however, has been cut out of this manuscript. The hiatus in the manuscript at this point indicates that at least one folio has been removed.[29] This scene which concludes the sequence of the anointing of the king's breast adheres closely to the rubrics of the Latin ordo. Following the last prayer for the anointing of the king's breast the rubrics call for the laces of the openings of the king's vestment to be connected by the archbishop or by a priest or deacon `on account of the unction'. Although the seneschal is not mentioned, Anjou, still bearing the sword, stands prominently at the side of the king as a group of five lay persons witnesses the action. Behind the archbishop stand his cross-bearer and two bishops, the first of whom raises his right hand in a gesture of benediction. The triptych on

the altar represents the Man of Sorrows flanked by images of Mary and John as in scenes 11 and 13 above.

Folio 55
The Chamberlain of France vests the King in the Tunic and Mantle [Plate 17]

Et la cote de cele couleur et de celle oeuvre meismes faite en maniere de tunique. dont les souzdyacres sont vestus a la messe. Et avecques ce le sercot qui doit estre du tout en tout de celle meismes couleur et de celle meismes oeuvre. et si est fait a bien pres en maniere dune chappe de soie sens chapperon. [fol. 37v]
Adonc li chamberiers de france li doit vestir la devant dicte cote de levure et de la couleur devisees ci dessus. Et li abbes de saint denys la doit baillier a ycelui chamberier. Et aussi li doit li chamberiers vestir par dessus le devant dit sercot. En tele maniere que il doit avoir la destre main delivre devers louverture du sercot. Et sus la senestre main doit estre leve le sercot aussi comme la chasuble dun prestre. [fol. 39]
Item...et tunica eiusdem coloris et operis in modum tunicalis quo induuntur subdyaconi ad missam, necnon et socco prorsus eiusdem coloris et operis. qui est factus fere in modum cappe serice absque caperone que omnia abbas beati dyonisij in francia de monasterio suo debet remis afferre. et stans ad altare custodire. [fols. 47-47v]
...vel sacerdotibus vel dyaconibus propter unctionem. et tunc a camerario francie induitur tunica iacinctina. et desuper socco ita quod dexteram manum habet liberam in apertura socci. et super [sinistram] soccum elevatum sicut elevatur casula sacerdoti. [fol. 55]

The rubrics preceding this miniature call for the Grand Chamberlain of France to vest the king in the tunic, `the hyacinth colour of which symbolizes the heavens', described as comparable to those `with which subdeacons are vested in the mass'. Over this he is instructed to place the mantle which has an aperture leaving the king's right arm free as `in the manner of the chasuble of a priest'. The chamberlain's mantle, blazoned with the arms of Bourbon, as well as a realistic likeness, identify him as Louis, duke of Bourbon, the brother of the queen, who makes his second appearance in the miniature cycle. Anjou, bearing the sword, stands at the king's left side. The archbishop of Reims, accompanied by another bishop and a cross-bearer, raises his right hand in a gesture of blessing. On the altar a triptych with a Crucifixion flanked by Mary and Saint John brings heavenly personages to the proceedings.

Folio 55v
The Archbishop of Reims anoints the King's Hands [Plate 18]

Tunc ab archiepiscopo unguantur sibi manus de predic-to oleo celitus misso.... [fol. 55]
Facta autem manuum unctione iungat rex manus ante pectus.... [fol. 55v]

Now dressed in the royal vestments the king kneels at the cathedra as the archbishop of Reims anoints the palms of his hands with the Celestial Balm and chrism using the golden needle. Accompanied by his cross-bearer and two bishops, the archbishop holds a golden paten in his left hand. The rubric of the Latin ordo stress that the archbishop anoints the hands with chrism sent from heaven. The anointing of the king's hands was first performed in royal consecrations in the early Carolingian period, inspired by the ritual of the anointing of the hands in sacerdotal ordinations. Hincmar did not include hand anointing in his protocols, introducing, instead, the anointing of the king's head. The early German Ordo included the anointing of the breast, shoulders, elbows, and hands, but the Roman recension of the early German Ordo omitted the anointing of the hands, perhaps to suppress the strident parallelism which this ritual draws between sacerdotal ordination and royal consecration. The anointing of the hands is not in the French directory at the beginning of the Coronation Book nor in its Latin source. The anointing of the king's hands was reintroduced into the coronation ritual in the French Ordo of c. 1250 but was eliminated again in the Last Capetian Ordo.

In keeping with the sacerdotal origin of the ritual of the anointing of the hands, the prayers which accompany this ritual were borrowed from ecclesiastical ordinations in the Merovingian *Missale Francorum*, derived in turn from the Early Christian Bobbio Missal where it was part of a baptism ordo.

Folio 56
The Archbishop of Reims blesses the King's Gloves [Plate 19]

Facta autem manuum unctione iungat rex manus ante pectus. Post ea si voluerit rex cirotecas subtiles induere sicut faciunt episcopi dum consecrantur. ob reverenciam sancte unctionis ne manibus nudis aliquid tangant primo ab archiepiscopo benedicentur cyrotece in hec verba sequentia.... [fol. 56]
Et aspergantur cyrotece aqua benedicta deinde.... [fol. 56v]

The transmission of the gloves is an innovation of the Ordo of Charles V.[30] Already an element of episcopal garb in the tenth century, the gloves were not incorporated into the episcopal consecration liturgy until the Pontifical of Durandus, compiled between 1292 and 1295. The introduction of gloves in the Ordo of Charles V was inspired by the episcopal consecration in the Pontifical of Durandus and declares in text and images the parallelism between the consecration of the king and the bishop. Although Durandus included numerous parallels with the episcopal ceremony in his king-making ritual, he did not introduce gloves and their accompanying ritual into the royal ordo in his Pontifical.

Although only one scene was devoted to the anointing of the king's hands, no less than three illustrations are dedicated to the king's gloves. Here, the king kneels, hands folded, at the cathedra. Anjou, as usual bearing the sword, stands behind him while the gloves are held by a lay attendant dressed in a blue *cotardie* with a red mantle lined with pink. The archbishop of Reims asperges the gloves with holy water, illustrating the rubrics of the Latin text which state that after the anointing of the hands, the king must wear `*cyrotecas subtiles ...* out of reverence for the holy unction lest anything touch these bare hands ...'.

The illustration shows the king's gloves to be identical in appearance to those worn by the archbishop. The details inform the viewer that the anointing of the king's hands goes beyond the anointing of a priest's hands in holy orders, for the priest is not obliged to wear gloves to cover his anointed hands. The prayer in the Ordo of Charles V that is recited for the blessing of the gloves is addressed to `the creator who made man in His image and created hands with fingers as an organ of intelligence'. This prayer was derived from the blessing of the bishop's gloves in the Pontifical of Durandus.[31] According to the prayer the king veils his hands with humility by covering them with gloves. In addition to signifying the episcopal character of kingship, the gloves signify the virtue of humility essential for rulers. The prayer compares the gloves to the flesh of Christ whose divine nature was concealed by mortal flesh in His incarnation, and the gloves thus serve to reiterate the resemblance of both king and archbishop to Christ.

The liturgy of episcopal consecration places great importance upon the hands which are the instruments of sacerdotal power. The ritual of the anointing of the hands and its accompanying ritual of the investiture of the gloves establishes the parallelism between sacerdotal hands and the wonder-working hands of the king of France which, through anointment with the Celestial Balm, were endowed with the miraculous power to cure scrofula.

299

Folio 56v
The Archbishop of Reims places the Gloves on the King's Hands [Plate 20]

Et aspergantur cyrotece aqua benedicta deinde imponuntur manibus regis per archiepiscopum dicentem.... [fol. 56v]

The king remains kneeling at the cathedra as the archbishop of Reims, having applied a glove on the king's right hand, places a glove on the king's left hand. The rubrics stipulate that the archbishop must place the gloves on the hands of the king, while the archbishop recites a prayer which compares the gloves to the skin of young goats which covered the hands of Jacob when he received his father's blessing. This prayer ends by invoking Christ `who in the likeness of sinful flesh offered himself ...', a phrase which thus draws an analogy between the flesh of Christ, which covered His divine nature, and the flesh of the gloves which covered the consecrated hands of the king. Not surprisingly, this same prayer is also recited for the delivery of the gloves in the episcopal consecration.[33]

Folio 57
The Archbishop of Reims blesses the Ring and places it on the King's Finger

[Plate 21]

...benedicat archiepiscopus anulum sic dicens. Oremus.... [fol. 57]
...Sed notandum antequam dantur sceptrum et virga. datur anulus. et in datione anuli dicitur hec oratio. Hic detur anulus et dicatur.... [fol. 57-57v]
Dato anulo statim post detur sceptrum.... [fol. 57v]

Still kneeling at the cathedra the king raises his right hand, covered by a glove, for the archbishop to place the gold ring on his third finger. The archbishop simultaneously performs two actions which occur consecutively in the text: he raises his right hand to bless the ring while with his left he places the ring on the king's finger, actions which occur only in the Latin text of the Coronation Book.

The prayers for the blessing and delivery of the king's ring are borrowed from the prayer for the delivery of the ring in the episcopal consecration ceremony. The bishop's ring has the connotation of marriage according to the episcopal consecration ceremony: `Receive the ring, the symbol of fidelity in order that ... you may keep inviolably the spouse of God namely His holy Church.'[34]

In appropriating this passage the royal consecration liturgy likens the king to a bishop who, like a bridegroom, is pledged to protect and to be faithful to his spouse, the Church.[35] This prayer also indicates that the ring's circular form, which has no beginning or end, symbolizes the Trinity, and that it is a sign of faith and of the solidity of the kingdom.[36] In addition to being a symbol of the Trinity, the liturgy indicates that the ring is also a seal.[37] This connection between the royal and episcopal rings and their respective prayers of benediction, had existed since the end of the ninth century when it first appeared in a pontifical from the diocese of Sens. The earliest reference to the episcopal ring is found in a letter of Charles the Bald of 867 A.D. to Pope Nicholas I. In this letter Charles the Bald mentioned Ebbo, archbishop of Reims who returned to Rome after the death of Louis the Pious where his suffragans received their rings and crosses `according to the custom of the Gallican Church'. This letter therefore suggests that the custom was traditional by the reign of Louis the Pious and, furthermore, that it was a special practice of the Gallican Church.[38] By the tenth century the ceremony of the bestowal of the ring appeared in the coronation liturgy in the Romano-Germanic Pontifical. In the thirteenth century Durandus included the ring among the episcopal insignia.[39]

Folio 58
The Delivery of the Sceptre and Main-de-Justice [Plate 22]

Et apres li arcevesques li met le ceptre en la main destre. et la verge en senestre. [fol. 39]
Deinde datur ei ab archiepiscopo sceptrum in manu dextera. et in datione sceptri et virge dicentur iste orationes... [fol. 57]
Dato anulo statim post detur sceptrum in manu dextera et dicatur hec oratio.... [fol. 57v]
Oratio post sceptrum datum. [fol. 58]
Post statim datur ei virga in manu sinistra et dicitur... [fol. 58]

Although they are consecutive actions in the coronation ritual, the archbishop of Reims simultaneously places the golden sceptre into the king's right hand and the main-de-justice into the king's left hand in this miniature. The sceptre shown in the miniature corresponds closely to that made for the coronation of Charles V and now in the Louvre, which is surmounted by a golden figure of Charlemagne enthroned and holding a sceptre in his right hand. The miniature is an almost perfect portrait of the Louvre sceptre, but for a few details, such as the globe from which the fleur-de-lis now rises which was added after the sacre.[40] As an image of the first Frankish king to bear the name Charles it had special importance for a king who often referred to himself as `Charles, the fifth of our name'.[41] It has already been noted in the introduction that this image refers to the Carolingian

300

themes which are key elements in the political ideology of Charles V.

The sceptre was amongst the first royal insignia to be included in the investitures of the coronation. It is first mentioned, along with the crown, in the Protocols of 869 written by Hincmar archbishop of Reims for the coronation of Charles the Bald as king of Lotharingia in that year. The Carolingian kings were the first Frankish rulers to carry sceptres. The Merovingian king Childeric is shown on his seal rings carrying a spear. The sceptre may have been inspired by the sceptre of the Byzantine emperor, [42] although Anglo-Saxon kings also carried sceptres, and it is not impossible that Anglo-Saxon usage inspired the Carolingian practice considering that Hincmar consulted Anglo-Saxon models when he compiled the Judith Ordo.

The *main-de-justice* was a rod surmounted by an ivory carving of a right hand with the index and middle fingers extended. The ivory hand represents the right hand of God as indicated by the text of the ordo where the benediction following the imposition of the crown contains a prayer which asks that `God will extend his right hand …'.[43] According to a tradition of Saint-Denis the ivory was said to have come from a unicorn.[44] The Latin text of the coronation ordo describes this verge *ad mensuram unius cubiti vel amplum habente de super manum eburneam* (fol. 47) in an obvious allusion to the rod of Moses, as Golein points out in his treatise.[45] The *main-de-justice* was a relatively late addition to the royal insignia. Abbot Suger of Saint-Denis mentioned in his *Life of Louis VI* that the king was `consecrated and crowned at the church of the Holy Cross at Orléans where he received a sceptre and a rod … both insignia of his reign.' In an illustration accompanying the Ordonnances of the Hotel of the King (Arch. Nat. J.J. 57) Louis IX is portrayed holding in his right hand a sceptre surmounted by a fleur-de-lis and the *main-de-justice* in his left hand.[46]

The royal-episcopal parallelism continues in the delivery of the sceptre and main-de-justice, as king and bishop both receive staffs indicative of their jurisdiction.[47] This notion finds expression in the respective liturgies where both king and bishop are asked to accept sceptre or rod as a `sign of their reign'.[48] The prayer for the transmission of the sceptre refers to it as the *sceptram regie potestatis insigne virgam scilicet regnis … rectam virgam virtuta in quatinas de temporale regno ad aeternum regnum pervensas ipso adiuviante … regnum et imperiam sine fine premanuent in secula seculorum.*

The central panel of the triptych on the altar is a figure of Saint John the Baptist, a patron saint of the Valois dynasty, and on the left wing is Saint Agnes, one of Charles V's patron saints by virtue of his birth on that saint's feast day, who carries a martyr's palm and a lamb.[49] Anjou bears the sword, and a group of eight laymen probably represent the lay peers who are called together with the chancellor of France according to the rubrics which follow the transmission of the rod. Two in the forefront who wear mantles with ermine capelets indicative of princely status are princes of the blood.

Folio 59
The Archbishop of Reims places the Crown on the King's Head [Plate 23]

Et darrainnement appellez les pers de france et qui sestent entour. Li arcevesques prent la coronne royal. et il seul la met ou chief du roy. Et ycelle coronne mise tuit li per. et clers et laiz y doivent mettre les mains et soustenir la deca et dela. [fol. 39]

Post istam orationem convocantur pares nomine suo a cancellario suo si presens est. Sin autem ab archiepiscopo primo laici. post ea clerici. quibus vocatis et circumstantibus archiepiscopus accipit de altari coronam regiam. et solus imponit eam capiti regis. Qua posita omnes pares tam clerici quam laici manum apponunt coronam et eam undique sustentant et soli pares. Tunc archiepiscopus dicit istam orationem antequam coronam situet in capite sed eam tenet satis alte ante caput regis.... Oratio... [fol. 59]

Qua oratione dicta ponendo coronam in capite dicat archiepiscopus.... [fol. 59v]

Holding the crown with both hands, the archbishop of Reims places it on the head of the king who kneels at the cathedra. The French and Latin texts call for the peers of France to surround the king as the archbishop, alone, places the crown on the head of the king. As he does so, the archbishop recites two prayers, the first of which proclaims that `God crowns the king with the crown of glory', indicating that the archbishop of Reims acts as a *vicarius Dei*: the king of France is crowned, not by a mortal, but by God, through the intermediary of his chosen representative, the archbishop of Reims. It should be emphasized that the foundation of this claim was the heavenly origin of the Celestial Balm carried to St Remi by an angel or the Holy Ghost, depending upon the source. In the second prayer the king is asked to `accept the crown of the kingdom in the name of the Father and the Son and the Holy Spirit', a Trinitarian reference traditional to the coronation ceremony with special relevance to the day on which the sacre of Charles V occurred.[50] The Trinitarian symbolism of the crown was conveyed by the tripartite form of the fleurs-de-lis with its three petals, as well as by the circular form of the crown, said to be without beginning or end like the Trinity.

301

Standing behind Anjou, a group of lay peers is headed by a figure identified through portraiture and by a mantle with the arms of the count of Flanders. The presence of the count of Flanders poses a problem because documents place the current count, Louis de Male, in Flanders at the moment of the coronation of Charles V.[51] However, his mother was present. As the widow of Louis of Nevers she was dowager countess of Flanders and as the countess of Artois she was a peer of France in her own right.[52] It is likely that she represented Louis at the sacre of Charles V. The prominent role played by the countess in the queen's cycle recognizes the double role that this woman played in legitimizing Charles's sacre, as a peer in her own right and as the dowager countess of Flanders who represented the count of Flanders. Behind the archbishop is his cross-bearer and Jean de Dormans, bishop of Beauvais, who has been identified through portraiture and a cope blazoned with the arms of his episcopal see (Or, a lion rampant sable).

The crown with four fleurs-de-lis appeared in seals dating from the regency of Louis IX and the reign of his son. Charles IV, the last king of the Capetian line, introduced in his seals a crown with four fleurs-de-lis alternating with large pearls or with smaller fleurons. This crown, used by the early Valois rulers, appears in many of the illustrations of the Coronation Book and has been identified as the crown which was called the `crown of Charlemagne'.[53] The crown in the miniature has eight fleurs-de-lis, similar to the crown worn by the figure of Charlemagne on the sceptre (excluding the cross and the arches which support it). However, there is considerable uncertainty over the precise crown which was used at the sacre of Charles V. From the time of Louis IX when the kings of France came into the possession of the Crown of Thorns, the king's crown was compared with the crown of Christ's passion and of Christ's kingship. The Crown of St Louis was also called the *Sainte Couronne*. Representations of this crown show that it had four large fleurs-de-lis. One of the large garnets of this crown enclosed a thorn from the Crown of Thorns, so that it was a reliquary crown. There was a tradition that this thorn had once belonged to Charlemagne and that Charles the Bald gave it to the abbey of Saint-Denis, along with a nail from the Holy Cross and the arm of St Simeon. But the presence of these objects in the abbey has no substantiation before the eleventh century. This reliquary crown is cited in documents of Saint-Denis only from the beginning of the twelfth century. The accounts of John the Good record that in 1350 sixty pearls inherited from the estate of his mother Jeanne de Bourgogne were delivered to the goldsmith Guillaume de Vaudetar to be used to embellish this crown.[54] And although John the Good probably *was* crowned with the Crown of St Louis, or the *Sainte Couronne*, this does not appear to be the same crown which is shown in the miniatures of the Coronation Book which has eight fleurs-de-lis instead of the four large ones which appear in the depictions of the Crown of St Louis. It would seem plausible that the crown corresponds to the crown known as the *Couronne de Roi*. However, that crown was composed of four separate plaques, each surmounted by a large fleurs-de-lis, and the plaques were joined together with hinges, whereas the miniatures of the Ordo of Charles V show a crown with a continuous and unsegmented circlet. On the other hand, the crown worn by Charles V in the miniatures of the Coronation Book is quite similar to the crown which appears on the reliquary bust of St Louis which was ordered by Philip the Fair.[55] Charles displayed an unusual interest in crowns throughout his lifetime, and he had already collected a considerable number of crowns by the time that an inventory was compiled before his sacre. He demonstrated a special devotion to the Crown of Thorns, which since the time of St Louis had a special association with the crown of the king of France who possessed it.[56] The inventory of 1363 indicates that he commissioned a special crown to house a relic of the Crown of Thorns. Given the abundance of crowns which appear in his inventories, it renders almost impossible the task of identifying for certain which of these served as the crown at his sacre.

Folio 59v
The Peers sustain the Crown; and the Enthronement of the King on the Cathedra
[Plate 24]

Et ycelle coronne mise tuit li per. et clers et laiz y doivent mettre les mains et soustenir la deca et dela. [fol. 39]

Qua posita omnes pares tam clerici quam laici manum apponunt coronam et eam undique sustentant et soli pares... [fol. 59]

The king is seated in the centre of the composition in a frontal position as he holds the sceptre in his right hand and the *main-de-justice* in his left. Although at first glance this may appear to be the traditional enthronement, it is not, for a later sequence of scenes is devoted to that particular act. This seat is placed on the floor of the church directly before the altar and not on the elevated platform where the throne is located. This seat is the cathedra against which the king has knelt in many of the previous scenes, now covered with brocade drapery.[57]

Anjou stands at his side in the position usually occupied by the archbishop of Reims. On the altar is a panel of the Crucifixion with Mary and John seated on the ground in humility before the Cross, an appropriate image to accompany this seat which is placed on the ground of the church in contrast to the throne which is elevated on the *solium*.

The archbishop of Reims alone, as God's minister and *vicarius*, has placed the crown on the king's head, and here the peers raise their hands to sustain the crown in recognition and support of the burden of governing which is now placed on the king's head. The sustaining of the crown is distinct from the coronation and expresses the consent of the magnates, an act which owes its ultimate origin to the *collaudatio* of the people. But it is not an expression of popular election. After the eighth century when anointing was introduced as the effective act of king-making, election of the magnates was eliminated from the status-changing segments of the royal rite. With anointing the elector is God who impresses his divine will on the electors who acclaim the king as the chosen of God's will.

In this scene the peers stand in a relationship to the king and the crown which is symbolic and evocative of their place in the hierarchical structure of the government of the French Crown. Attention has been given to identifying the peers. In addition to Anjou, five lay peers stand on the left while on the right are four eccesiastical peers, all of whom extend their arms in order to sustain the crown. Of the ecclesiastical peers only the bishops of Reims and Beauvais are identified by armorials and through portraiture. Of the lay peers the count of Flanders, identified by armorials, stands at the far left. Immediately preceding him is Louis II, duke of Bourbon, the Grand Chamberlain of France. At the king's immediate right is a figure clad in the arms of the count of Toulouse (gules, a cross argent voided sable). Two lay peers who stand in the rear are not identified by armorials. Comparison of the peers in the miniatures and the peers listed in the text of the coronation ordo turns up serious discrepancies between the text and the miniatures which are further complicated by historical documents relevant to the coronation ceremony. The French text specifies `that in former times there were twelve peers ... and there are seven new peers'.[58] The number of peers in the miniature coincides neither with the old nor the new lists, for there are ten peers, four of whom are ecclesiastical and six of whom are lay. The presence amongst the peers of the count of Flanders is affirmed by lifelike portraiture and armorials. He does not appear in the list of peers and contemporary documents indicate that he was in Flanders when the coronation of Charles V took place.[59] The effort at histori-

cal description in this miniature does not appear to fit the historical reality of the event.

Folio 63
The Peers lead the King to the Throne
[Plate 25]

Lors doit li arcevesques avecques li pers qui soustiennent la coronne mener le roy ainsi aourne en la chaiere qui li est appareilliee et aournee de draps de soye.... [fols. 39-39v]

Deinde coronatus rex et ducatur per manum ab archiepiscopo concomitantibus paribus tam prelatis quam laicis de altari per chorum usque ad solium iam ante preparatum. Et dum rex ad solium venerit. [fol. 63]

The king, holding the sceptre in his right hand and the main-de-justice in his left, climbs the stairs to the solium, or elevated tribune, escorted by the peers who continue to support his crown. Anjou leads the procession, followed by the archbishop of Reims who places his arm around the king to guide him to the throne. Behind the king follow the bishop of Beauvais, John of Dormans, and the duke of Burgundy. The statuette of Charlemagne surmounting the sceptre penetrates the frame, linking the miniature to the text and emphasizing the figure of the king's Carolingian namesake.

In preceding scenes the king was the same size as the laity and slightly shorter than the archbishop of Reims, but here he appears taller than the other figures including the archbishop; in previous scenes the king's head was bowed, but now it is held erect as he looks up to the throne. His crown is against the archbishop's mitre with the points of the respective headgear at equal height.

The enthronement is in both the French and Latin text. The Ordo of Charles V calls the throne a `sedes', distinguishing it from the seat in the preceding miniatures, as we have already seen, called a `cathedra'. The rubrics at the beginning of the Ordo of Charles V stipulate that `first a solium is prepared in the mode of a scaffold, contiguous to the exterior of the choir of the church and placed in the middle'. It is reached by `stairs which ascend to it'.[60] The French text adds that the sedes [Fr. chaiere (fol. 39)] is appointed with drapery of silk and that `this chair must be so high that all can see'. The miniature gives practical information about the form of the solium, showing the stairs.[61]

The throne on the solium resembles in certain details the so-called Throne of Dagobert, formerly kept in the treasury of Saint-Denis and brought to Reims for coronations, and now in the Bibliothèque Nationale in Paris.[62] Considerable care has been taken in this miniature to describe the physical appearance of the central objects of

the enthronement, thus making a deliberate appeal to the historical event of the coronation of Charles V, evoking the two races of Frankish kings, the Carolingian by means of the sceptre, and the Merovingian with the Throne of Dagobert (and the sceptre of Dagobert which the queen receives).

This scene expresses the transition or journey from the locus of anointing and investiture to the place of enthronement and acclamation. In all of the preceding scenes the king either stood or knelt on the floor of the church. In feudal ritual, the vassal bent his knee and placed it on the ground as a sign of subordination to his sovereign lord. Given the association of the archbishop of Reims with God in this ceremony, the king's gesture would express the notion that he is the vassal of God. Here the king climbs the stairs of the solium for a change of elevation which has symbolic significance. The enthronement is divided into two separate actions: the lifting up, or *sublimatio* and the placement of the king on the throne, or *intronisatio*. The origin of the enthronement is a matter of dispute. It has been suggested that this lifting up of the king in the company of the consecrator and the peers harks back to the ritual *sublimatio* or lifting up on a shield of the later Roman emperors, a practice of some of the Germanic legions which was taken over in the fourth century by the Romans and in the Byzantine empire. This ritual is known to have been performed, if only rarely, by the Merovingian Franks who imitated many Roman imperial practices.[63] The present scene differs significantly from the imperial shield-raising ceremony. Alternatively, it has been suggested that the enthronement was adapted from the bishop's ceremony which included the *intronisatio* of the new bishop on the throne of the consecrator. Yet another theory has it that under the influence of the liturgy of the bishop's sacring, the traditional imperial usage of the *sublimatio* on the shield developed into the *intronisatio*.[64] However, by introducing an episcopal enthronement in addition to the traditional enthronement on the solium, the Ordo of Charles V distinguished between two separate enthronements, one with episcopal connotations, the other with imperial connotations.

The importance of the stairs in the text and image may refer to symbolic stairs as those leading up to the throne of Solomon and perhaps also to Jacob's ladder which led from earth to heaven. Golein interpreted the symbolic meaning of the elevated solium. The king is 'thus raised toward heaven and estranged from the earth on this scaffold',[65] where 'the king is lifted up so that all can see him'. Golein explains further that 'Saul was ordained the first king of Israel, the most grand of all the sons of Israel, as it is written in the first book of Kings, the tenth chapter, who was so high that he

appeared over the shoulders of the others ...'.[66] Golein indicates that the scaffold or solium must be sufficiently large to hold all the prelates and princes, in particular the twelve peers of France ... this signifies that in judgment there must be many assistants, (as) in all other royal things'. This act therefore signals that the judicial aspects of the king's duties are shared by the secular and ecclesiastical peers. The solium is mounted by degrees because thus is virtue attained gradually. Finally, and most significantly, Golein states that the solium also signifies that 'the king of France does not recognize any temporal lord on the earth ... in demonstrating that he must rule by divine law, which he must obey, and not imperial law nor canon law, unless they are in accord with theological and divine law'.[67] Thus the enthronement on the solium demonstrates that the king of France is sovereign in his kingdom and that he is subject to no other mortal. By sustaining the crown, the peers affirm their support for and participation in this sovereignty.

Folio 64
The Enthronement; the `Sta Et Retine'; the Kiss of the Archbishop; the Acclamation `Vivat Rex In Eternum'; the Sustaining of the Crown by the Peers [Plate 26]

Lors doit li arcevesques avecques li pers qui soustiennent la coronne mener le roy ainsi aourne en la chaiere qui li is appareilliee et aournee de draps de soye et le doit illvecques mettre en son siege qui doit estre si haut que touz le puissent veoir. Et doit li arcevesques pour reverence baisier le roy en tele manier soiant en son siege. Et apres li evesque et li lai pers qui soustiennent la coronne. [fol. 39v]

Et dum rex ad solium venerit. archiepiscopus ipsum collocet in sede. El hic regis status designatur et dicat archiepiscopus. [fol. 63]

Sta et retine a modo statum quem huc[usque] paterna successione tenuisti hereditario iure tibi delegatum per auctoritatem dei omnipotentis et per presentem traditionem nostram omnium scilicet episcoporum ceterorumque servorum dei. Et quanto clerum propinquiorem sacris altaribus prospicis: tanto ei pociorem in locis congruentibus honorem impendere memineris. quatinus mediator dei et hominum te mediatorem cleri et plebis ... [fol. 63-63v]

hic faciat eum sedere archiepiscopus tenendo eum per manum. [fol. 63v]

in hoc regni solio confirmet et in regno eterno secum regnare faciat. [fols. 63-63v]

Hijs expletis archiepiscopus cum paribus coronam sustentantibus regem taliter insignitum et deductum in solium sibi preparatum sericis stratum et ornatum ubi collocabit eum in sede eminenti unde ab omnibus possit videri. Quem in sede sua taliter residentem. mox

archiepiscopus mittra deposita osculatur dicens. `Vivat rex in eternum.' Et post eum episcopi et laici pares qui eius coronam sustentant. hoc idem dicentes ... [fols. 64-64v]

Five separate actions are conflated into this single scene. The rubrics of the Latin ordo emphasize that the archbishop alone places the king in the throne and that he recites the prayer of the Sta et retine which affirms the right of paternal hereditary succession. The enthronement completed, the archbishop kisses the king and acclaims *Vivat rex in eternum*, here expressed in writing on the banner held by the archbishop. These actions completed, the rubrics indicate that the peers sustain the crown a second time.

A formal elevation of the king on a throne came into use only in the Carolingian period. Given the symbiotic relationship between episcopal and royal consecration liturgies in that period, it is quite likely that the ritual of the king's enthronement may have taken shape under the influence of the consecration or elevation of a bishop.[68] According to Schramm the kiss in the coronation ceremony was at first a simple act of vassalage. But there are abundant indications that the kiss in the sacre is more than a traditional sign of homage. The kiss of peace was one of the earliest actions in the Early Christian consecration of a bishop, mentioned in Book 8 of the Apostolic constitution (nos. 4-32 and especially 4 and 5). Throughout the centuries the kiss has remained part of the episcopal consecration ritual, rendered to the newly consecrated bishop by the consecrator immediately after he has been installed in his cathedra.[69]

By the eleventh century the kiss of peace made its appearance in the Ratold Ordo. Thus, since the early Capetian era the kiss was imbued with connotations of the episcopal-royal parallelism which is so emphatically stressed throughout the present coronation ceremony.

Another special feature of the coronation ceremony of Charles V is the stipulation that the archbishop of Reims alone proclaims the *Vivat rex*. Earlier ordines required the acclaim to be shouted by the laity and clergy together.[70] Schramm pointed out that underlying these biblical words and the kiss are three fundamental legal acts: first, the acclaim by the people and clergy; second, enthronement; and third, homage of magnates and feudal lords. This acclaim represented the *collaudatio* of the people, and as such, it corresponded to a popular election.[71] That the Latin text reserves this acclamation for delivery by the archbishop of Reims is an important change which is consistent with the elevated position accorded him throughout the Ordo of Charles V. Both the miniature, which places the inscription on a band held

by the archbishop, and the rubrics of the Latin ordo reserve for the archbishop of Reims alone this formerly popular function, now entirely eliminated from the coronation Ordo of Charles V. In theory it was not the archbishop who crowned the king, but God, as the text of this ordo states that the archbishop of Reims is the *vicarius Dei* chosen to interpret and express God's will.[72] Therefore, through the archbishop of Reims, God acclaims, and therefore elects, the king in this scene. At the same time this change also likens the actions of the archbishop to those of the consecrator in the episcopal consecration who acts for God in the election of a new bishop.

Like the prayer recited for the imposition of the crown which distinguishes between the rights of the bishop and the king, the enthronement prayer states that the king is a mediator between God and men, clergy and people. Among the ritual texts of the period, there are none in which the prevailing conception of the relation between sovereign, Church, and people has been so clearly formulated.

At this point in the ceremony the rubrics indicate that the metropolitan and canons of the church of Reims chant the *Te Deum*. This is yet another point of comparison between the sacring of the king and the consecration of a bishop, for after the latter is enthroned, he is kissed by the consecrator, the newly consecrated bishop kisses the ring of the consecrating metropolitan, and the *Te Deum* is then chanted.

Folio 65
The King makes an Offering and kisses the Archbishop's Hand [Plate 27]

Et quant len chante lofferende len doit sollempnelment mener le roy et la royne de leurs eschaufaus a faire leurs offerendes. Et offre lun et lautre a la main larcevesque un pain et vin en un orceau dargent et xiij deniers dor. La quele chose faite lun et lautre doit estre ramene en son eschaufaut. et a son siege. Apres sen repaire li arcevesques a lautel pour faire le sacrement de la messe. Et aincois quil die `pax vobis' il doit faire la beneycon seur le roy et seur la royne et seur le peuple. Et apres cilz qui a baillie leuangile a baisier doit prendre la paiz de larcevesque. Et la doit porter au roy de sa bouche. [fol. 40v-41]

Quando legitur evvangelium rex et regina debent deponere coronas suas. Notandum quod lecto evvangelio maior inter archiepiscopos et episcopos accipit librum evvangelij. et deffert domino regi. ad deosculandum et post ea regine. et post ea domino archiepscopo missam celebranti. Post offertorium pares deducunt regem ad altare coronam eius sustinentes. Rex autem debet offerre panem unum. Vinum in urceo argenteo. Tresdecim bisantos aureos et regina similiter

... Sed notandum est quod ille qui dedit ei evvangelium ad deosculandum debet post `pax domini' accipere pacem ab archiepiscopo missam celebrante et defferre regi cum oris osculo. et regine in libro. et post eum omnes archiepiscopi et episcopi unus post alium dant osculum pacis regi in suo solio residenti ... [fols. 65-65v]

The king kneels on the ground before the altar to kiss the hand of the archbishop as he simultaneously places his offering in the hand of the acolyte standing behind the archbishop. The text does not call for the king to kiss the hand of the archbishop, but instead states that the archbishop offers the book to the king for him to kiss and then to the queen. The miniature reinterprets the ritual kiss of peace of the Gospel book in order to liken it to the ritual kiss of the hand of the consecrator in the episcopal consecration. This occurs after the offertory of the Mass when the newly consecrated bishop is accompanied to the altar by the bishops who assisted in the ceremony. There, the newly consecrated bishop kneels before the consecrator, presents his offerings and kisses the consecrating metropolitan's ring.

This act does not occur within the king's ceremony, but rather before the king's communion during the Mass which follows the queen's consecration. The scene has no doubt been placed at this point in the manuscript in order to keep the king's actions intact. The king is not wearing his crown according to the rubrics which call for it to be removed and handed over to the peers who are to support it while the king receives communion. At the altar the king offers bread, wine, and thirteen gold *bisantos*, as does the queen. Anjou stands behind the king bearing the sword upright, and recognizable among the peers are the counts of Toulouse and Etampes, identified by armorials and, in the case of the latter, through portraiture.

Folio 65v
The King receives the Eucharist in form of Bread and Wine

[Plate 28]

Apres ce que li arcevesques aura pris le corps nostreseigneur. Le roy et la royne doivent descendre de leurs eschaufaus. et venir humblement a lautel. Et prendre de la main larcevesque le corps et le sanc nostreseigneur. [fol. 41]

In eundo autem et redeundo gladius nudus defertur coram eo. finita missa iterum pares adducunt regem coram altari. et communicat corpus et sanguinem domini: de manu domini archiepiscopi missam celebrantis. [fol. 65]

According to the French and the Latin texts in the Coronation Book `... the king and the queen must descend the ... scaffold and take from the hand of the archbishop the Body and Blood of Our Lord'.[73] The reception of the Eucharist in two forms by the king and the queen was first introduced in the Directory of c. 1230. The phrase is an explicit declaration of adherence to the doctrine of transubstantiation and to the doctrine of the necessity for the sacrament to be consecrated by the hand of an ordained priest, both of which were proclaimed at the Fourth Lateran Council in 1215. Charles kneels with his hands folded as the archbishop of Reims places the communion wafer, imprinted with a cross, in the king's mouth. The archbishop holds the chalice with the consecrated wine which he will next give to the king. Anjou, bearing the sword, stands behind the king, but in this exceptional instance the text mentions that the king has been led to the choir with the `nude' sword carried before him. The nude sword would also seem to be a reference to the decisions of the Fourth Lateran Council and to the clause in the Directory of c. 1230 in which the king swears to expel heretics from his kingdom. The group of peers, now only six in number, hold the king's crown, the count of Toulouse on the right, and the duke of Bourbon, the counts of Flanders and Etampes at far left. The importance given to the count of Toulouse is especially relevant because the decrees of the Fourth Lateran Council and the oath of the king in the Directory of c. 1230 were instrumental in annexing to the kingdom of France territories of the count of Toulouse.

At the time of the coronation of Charles V the taking of communion in two forms was a privilege reserved for the clergy, as Golein emphasized in his treatise.[74] The Holy Roman Emperor was one of the first lay figures to receive the privilege and in 1344 Philip VI asked Pope Clement VI to bestow a similar prerogative on the king of France.Charles assiduously assembled all rites and traditions which would emphasize the sacerdotal and episcopal character of royalty, and the king's communion in two kinds is the culminating point.[75] He receives the communion in two kinds, not as the only lay person permitted to receive it, but because of the sacerdotal, and even episcopal, character of his kingship. In support of this argument Golein, in his *Traité du Sacre*, does not go so far as to state that anointing renders the king a priest, but he does say that `royal unction approaches very closely the priestly order'.[76] The reception of both forms of the Eucharist is key for developing the ideology of the `Royal Religion'.

B. The Cycle of Jeanne de Bourbon

Folio 66
The Queen's Entry into the Cathedral
[Plate 29]

Cest comment la royne doit estre enointe et coronnee.
[fols 39-40]
Et se il avient que la royne doie estre enointe et coronnee
avecques le roy. lon li appareille un eschaufaut devers la
senestre partie du cuer. Et lors doit estre mis
leschaufaut du roy devers la destre partie du cuer un
pou plus haut que celui a la royne. Et puis que li roys
sera assis en son eschaufaut en la maniere devant dicte
… [fols. 39-40]
Ordo Ad Reginam Benedicendam. [fol. 66]
Ordo ad reginam benedicendam que debet consecrari
statim post sanctam consecrationem regis. debet ei
parari solium in modum solij regis. debet tamen
aliquantulum minus esse. debet autem regina adduci a
duobus episcopis in ecclesiam et rex in suo solio sedere
in omnibus ornamentis suis regijs … [fol. 66]

In this scene, which serves as the frontispiece for
the Ordo of Jeanne de Bourbon, the queen is led
into the cathedral by two bishops who present her
to the archbishop of Reims. On the right the arch-
bishop of Reims blesses the queen as he extends
his left hand in the direction of the chrismatory,
which placed on the altar before an altarpiece with
the Crucifixion flanked by Mary and John.

The queen wears a bright red tunic and cape
and her long hair falls in loose locks over her
shoulders. Two women follow. One is dressed as a
widow which suggests that she is to be identified
as Marguerite, dowager duchess of Flanders and
countess of Artois, heiress of the counties of Bur-
gundy and Artois in the succession of her
great-nephew Philip of Rouvre. As countess of
Artois she was a peer of France in her own right,
and as the widow of Louis of Nevers she was the
dowager countess of Flanders.[77] Her presence thus
played a double role in legitimizing the sacre of
Charles V, for by representing these two peerages,
the complement of secular peers was brought to
the essential number of six. Because of her promi-
nence in the cycle and her portrait resemblance to
the king, the young woman, who also appears in
the following scenes, is almost certainly one of the
king's sisters, either Isabelle or Marie de France.[78]

Although not as elaborate as the king's entry,
this miniature announces the programme of
sacralizing the queen's role by likening the queen's
consecration to the king's. The Last Capetian Ordo
introduced an entrance for the queen, but in that
ordo the queen was led into the cathedral by a sin-
gle bishop. The specification that two bishops lead
the queen into the cathedral is meaningful because
the Ordo of Charles V was the first French ordo to
have two bishops lead the king into the cathedral
and to present him to the consecrator. The intro-
duction of two bishops at this point in the queen's
cycle compares Jeanne de Bourbon's consecration
with the king's.

Another similarity with the king's entry is that,
just as the king is accompanied by a group of lay
and clerical attendants, so the queen is accompa-
nied by numerous attendants of her own gender.
The two attendants are not mentioned at this point
in the text of the queen's ceremony, so their pres-
ence would seem to be explained as part of the ef-
fort to liken the queen's ceremony to that of the
king. As the escort of two bishops for the king's
ceremony was modelled upon the liturgy for the
consecration of bishops, similarly the presence of
the two female attendants recalls the consecration
of abbesses who enter their consecration accompa-
nied by two or three of their sisters.

Although amplified in comparison with earlier
queen-making ordines, the queen's entry has been
treated with considerably less panoply than that of
the king. Only one scene is devoted to the queen's
entry whereas six scenes were devoted to the
opening events of the king's ceremony, two of
which were dedicated to his blessing before the
portal of the cathedral of Reims and one to the
transmission of the Holy Ampulla to the arch-
bishop. The king's rite also contains several acts
which were never performed in a queen-making
ceremony, i.e. the raising of the king in the arch-
bishop's palace; the oath; and his presentation to
the archbishop of Reims by two bishops who also
place him in his cathedra. The absence of these acts
from the Ordo of Jeanne de Bourbon, though not
exceptional for a queen's ordo, nevertheless serves
to highlight their presence (and thus importance)
in the king's cycle.

Folio 66v
The Queen kneels at the Cathedra as the
Archbishop of Reims recites a Blessing over
her [Plate 30]

Regina autem adducta in ecclesiam debet prosterni ante
altare. et prostrata debet orare. qua elevata ab oratione
ab episcopis debet iterum caput inclinare et
archiepiscopus hanc orationem dicere … Deinde dicat
archiepiscopus hanc orationem. [fol. 66v]

307

The queen kneels against a faldstool which resembles the cathedra of the king's cycle while the archbishop of Reims reads a prayer from the open book which he holds. On the altar are the queen's crown and a chalice. The countess of Artois and Marie de France are joined by another woman and several male attendants. The *Grandes Chroniques* mention the duchesses of Orléans and Anjou in the queen's cortège entering Paris after the sacre,[79] and although the third woman in this scene could be either of these, the prominence of Anjou and the archbishop of Reims, Jean de Craon, would favour the duchess of Anjou, Marie de Blois, a niece of Jean de Craon.

The prayer which the archbishop recites over the queen celebrates great biblical women such as Judith, Sarah, Rebecca, Leah, Rachel, all `blessed with the fruit of their wombs'. These biblical mothers are cited as predecessors of the Blessed Virgin Mary `from whom Christ was born'. The prayers, therefore, introduce the queen's vital role as mother of the hoped-for heir to the throne, comparing her to the biblical progenitors of kings, priests, and prophets.[80]

The action shown in the present scene is not mentioned in the French directory, and the rubrics of the Latin ordo instruct only that the queen prostrate herself in order to pray before the altar, that she rise, helped by the bishop, and that she incline her head for the next prayer recited by the archbishop. The prostration of the queen before the archbishop recalls the beginning of rites for the ordination of priests, benediction of nuns, and consecration of bishops where the candidate prostrates before the consecrating archbishop. The cathedra is mentioned neither in the French translation nor in the Latin text of the Ordo of Jeanne de Bourbon, nor is it specified in any previous ordo for the consecration of a queen. It is an innovation introduced in the minatures of the Coronation Book, inspired by the cathedra in the text and illustrations of the Ordo of Charles V. Abbesses were endowed with some episcopal powers, and the ceremony for the consecration of an abbess included the ritual enthronement of the abbess on a cathedra, an act intended not only to bestow upon her aspects of episcopal authority but also to express and signify that authority. The presence of the queen's cathedra thus reinforces the parallel with the king's ceremony and expresses the notion that this seat was meant to promote the perception that the queen, like the king, was invested in her consecration with quasi-episcopal responsibilities, comparable to those of an abbess.

Folio 67v
The Opening of the Queen's Tunic in preparation for Anointing [Plate 31]

Notandum quod tunica regine. et camisia debent esse aperte usque ad corrigiam. [fol. 68]

The queen's female attendants gather around her to shield her body from the view of the witnesses. With an expression of displeasure on her face, Jeanne de Bourbon leans forward with her arms folded, supported by Marie de France, while the countess of Artois opens the back of the queen's garment in preparation for the anointing of her breast. Standing on the right, the archbishop of Reims observes while he reaches, presumably, for the chrismatory which the artist also omitted to represent.

Several details of this scene are not explained by the text which merely states that `the tunic of the queen must be open to the waist'. One detail is the posture of the queen who bends forward, apparently to allow the countess of Artois to open her garment although it is the front of the garment which must be opened for the anointing of the breast. The queen's posture echoes that of the king in the corresponding scene of the disrobing of the king in preparation for his anointing. The compositions of both illustrations are almost exactly the same — the placement of the archbishop and his entourage of a cross-bearer and two bishops, and the group of lay attendants at the left is almost identical in both scenes. The queen's posture expressly recalls the king's. The text pertaining to this action in the queen's ordo refers to her garments as a *tunica* and a *camisia*, exactly the terms applied to the king's garments and to priests' garments. Golein explained that the disrobing of the king signified his taking leave of the lay state to enter into the `royal religion' a meaning which would also appear to apply to the queens's cycle, expressing her entry into the royal religion.[81]

Folio 68
The Anointing of the Queen's Breast [Plate 32]

Et que li arcevesques sera retourne a lautel. il enoindra la royne qui doit estre vestue de soye. et sera enointe en chief tant seulement et ou piz. nompas de lonction le roy envoiee des cieux. mais duyle simple saintifiee. [fol. 40] et dominus archiepiscopus debet inungere eam oleo sancto in capite et in pectore. et dicere dum inungit in qualibet unctione. [fol. 68]

The queen kneels at the cathedra as the archbishop of Reims, holding a vial of ointment in his left hand, uses a golden needle to anoint her breast. Witnessing this scene is the countess of Artois; she

stands just next to one of the young women holding a sheer white veil to shield the queen's breast from the view of four male lay attendants who witness the action. On the altar is a triptych with a female saint on each panel, Saint Catherine in the centre.

This wealth of detail illustrates merely one passage of the Latin rubrics: `and the lord archbishop must anoint her with holy oil on the head and on the breast'. Although the scene of the anointing of the king's breast has been cut out of the manuscript, this miniature includes details, not present in the queen's ceremony, which were derived from the king's ceremony. The Ordo of Charles V introduced the use of the golden stylus for the anointing of the king, and although the text of the Ordo of Jeanne de Bourbon does not mention the golden needle, the miniature indicates that one was used for the anointing of the queen. Nor is the veil mentioned in the text. It may be significant that the constitutive act in the benediction of a nun is the delivery of the veil, and in introducing the motif of the veil the miniatures construct a parallel with nuns for whom `taking the veil' at their entry into religious life signifies their marriage to Christ. The marriage theme is continued in the following act of the ritual, the delivery of the ring.

Folio 68v
The Delivery of the Queen's Ring
[Plate 33]

Tunc debet ab archiepiscopo anulus immitti digito et dicere. [fol. 68v]

The queen kneels at the cathedra as the archbishop places the ring on her right hand. Although not mentioned in the text, the queen's garments have been closed after her anointing. Standing behind the queen are ten attendants who include the countess of Artois accompanied by a woman similarly attired in blue. Amongst this group of women is a knight dressed in a red cotardie and mantle lined with fur, his right hand on a short sword hanging from a scabbard.

The rubrics state that the archbishop places the ring on the queen's finger while reciting a prayer which begins with the words `Accept the ring, sign of faith in the Holy Trinity'. The ring reinforces the Trinitarian symbolism which occurs elsewhere in the ceremony. Although this symbolism is especially appropriate for the feast day on which the ceremony took place, this prayer was not written specifically for that occasion. It is a traditional prayer which was already in the Judith Ordo.

The ring is one of the earliest of the traditional insignia of queenship, introduced into the queen's regalia and coronation liturgy before it was intro-

duced into the king's ordines. In the oldest surviving queen-making text, the Judith Ordo, it was given to the queen in the context of a royal marriage, and thereafter the royal ring was endowed with nuptial connotations.[82] The prayer which accompanied the delivery of the ring in the Judith Ordo was derived from marriage liturgy, as indeed is the Trinitarian symbolism of the prayer in the present ordo. These prayers compare the indissolubility of the sacrament of marriage to the eternity of the Trinity and in this way the rite asserts the indissolubility of the queen's ministerium.

Although one of the first attributes given to queens, the ring was omitted from most post-Carolingian ceremonies and was not reintroduced until the Last Capetian Ordo which also included the ring amongst the king's insignia. The illustration for the transmission of the queen's ring reiterates in most respects the scene of the transmission of the king's ring. The queen kneels at the cathedra in exactly the same way as the king, the position of the countess of Artois reiterating Anjou's in the king's scene. Both king and queen receive on their right hand an insignium endowed with marital significance which on one level refers to the marriage which binds the queen to the king and on another level is a reference to the basis for the queen's royal status. The ring is an attribute of bishops who wear it as a sign of their marriage to the Church, and nuns and abbesses are given a ring as a sign of their status as brides of Christ.

While furthering the programmatic comparison of the queen and the king, the illustration also distinguishes between their respective ring ceremonies. The king's cycle includes a scene for the blessing of the ring, while the queen's ring is not blessed, and the king wears his ring over gloves which the queen does not receive, differences which heighten the importance of the anointing of the king's hands. The omission of the blessing of the queen's ring and the bestowal of the gloves from the queen's ceremony underscores the crucial importance of the anointing of the king's hands and in this way exposes the uniqueness of the king's anointing with the Celestial Balm.

Folio 69
The Delivery of the Queen's Sceptre and Verge
[Plate 34]

Et apres lonction li arcevesques li baille un petit ceptre dautre maniere que ceptre royal. Et si li baille un verge semblant a la verge le roy. [fol. 40]
Post istam orationem datur ab archiepiscopo sceptrum modicum alterius modi quam sceptrum regium et virga consimilis virge regie. Et in tradendo dicat archiepiscopus. [fol. 69]

Sequitur post dationem sceptri et virge hec oratio.
[fol. 69]

Two consecutive actions are conflated in this scene: the archbishop places the sceptre into the queen's right hand and the verge into her left hand. The scene illustrates the rubrics of the Latin and French texts which specify that the `archbishop gives the queen a sceptre of a size different from that given the king and a verge similar to that of the king'.

As with those of the king, the physical appearance of the queen's sceptre and verge have been meticulously depicted. Her sceptre, surmounted by an armed figure riding upon a bird perched on a hand, corresponds to the so-called sceptre of Dagobert once kept in the treasury of Saint-Denis.[83] The precise detail goes beyond the text to describe the physical appearance of these objects and testifies to firsthand knowledge of the actual objects used in the coronation of Charles V and Jeanne de Bourbon. For these objects shown in the illustrations are identified with historically documented objects, some of which still exist today. The investiture of the queen with a sceptre and a verge is one of the most emphatic parallels with the king who is invested with both insignia. Both sceptres refer to specific kings of French history: Charles V's to Charlemagne and the Carolingian race, the queen's to Dagobert and the Merovingian race. Not only does the transmission of the rod and sceptre establish a parallel with the king's cycle; it also contributes to the theme of the queen's religious status, for, while the king's rod and sceptre were analogous with the *baculum* of the bishop, the queen's are comparable to the *baculum* which the abbess receives as a sign of her jurisdiction.[84] Despite these similarities, distinctions are drawn in text and image between the insignia of king and queen. The text calls for the queen's sceptre to be of `a different size from that of the king,' and for the queen's verge to be `similar to the king's verge.' The illustrations show the queen's sceptre and verge to be smaller and different in form from the king's. The queen's verge is short and surmounted by a rosette, different therefore from the main-de-justice which the king holds in his left hand. Only the French directory specifically states that the queen's sceptre must be smaller than the king's. These distinctions were not innovations of the Ordo of Jeanne de Bourbon but belonged to the traditional elements of the queen's ordo since the era of St Louis.

On the altar is a triptych with a scene of St Michael slaying the dragon on the left panel, St Lawrence holding the grill in the centre panel, and on the right St Peter holding a key. Behind the queen stands the countess of Artois and six other attendants among whom is a male carrying a mace. St

310

Michael was honoured by the Valois, perhaps because he is the patron of the duchy of Normandy where his shrine was founded by Duke William before his conquest of England. In this connection, the sacre of John the Good took place on the feast of St Michael.

Folio 69v
The Archbishop of Reims imposes the Crown on the Queen's Head; the Barons sustain the Queen's Crown
[Plate 35]

Et apres larcevesque tout seul li met sa coronne en son chief. La quele coronne mise doivent soustenir li baron deca et dela. [fols. 40-40v]
Tunc debet ei imponi a solo archiepiscopo corona in capite ipsius quam impositam sustentare debent undique barones. archiepiscopus autem debet dicere in impositione orationem. [fol. 69]

Both the Latin and French texts emphasize that the archbishop of Reims alone crowns the queen, and both texts call for the crown to be sustained by the barons. This illustration contains two separate actions which take place consecutively in the text but are shown to occur simultaneously in the miniature: the queen kneels against the cathedra as the archbishop alone crowns the queen followed by the sustaining of the crown by the magnates. The miniature distinguishes between the actions of archbishop and barons by showing that the crown is imposed by the archbishop who grips it firmly as if to bear its weight while placing it on the queen's head whereas the others merely extend their arms and touch the crown with the tips of their fingers.

The text differentiates between the the king's ceremony and the queen's by calling for the king's crown to be sustained by peers, a higher order than the barons who sustain the queen's crown. Yet the miniature presents something different, for these `barons' are shown to be the dukes of Bourbon and Burgundy, the count of Toulouse and the countess of Artois, all peers of France.

The crown worn by Jeanne de Bourbon has been identified as the *Couronne de la Reine*, the mate of the king's crown known as the *Couronne du Roi*, both made in 1180 for the double sacring of Philippe II and Isabelle de Hainaut at Saint-Denis.[85] The crown worn by Jeanne de Bourbon in the miniatures has four fleurons as did the *Couronne de la Reine* as it appears in water-colours made by Montfaucon.[86] However the *Couronne de la Reine* was a smaller version of its mate and like it was made of four plaques joined together by hinges, whereas the crown of Jeanne de Bourbon appears to be a continuous and unbroken circlet. The crown is endowed with symbolism by the

prayers recited by the archbishop which refer to it as a `crown of glory the exterior of which is abundant with gems and the interior with the gold of wisdom'. It thus evokes the virtue of wisdom necessary for the queen to assist the king in governing. This prayer reinforces the theme of wisdom by comparing the wearer to the wise virgins who await their perennial spouse Jesus Christ, another matrimonial reference to the queen as the Bride of Christ which runs throughout the queen's ceremony.

Since Early Christian times crowns were an attribute of brides and in the Carolingian period the crown in the Judith Ordo signified both marriage and royalty.[87] The conjunction of wisdom and marriage themes continues in the second prayer for the crowning of the queen which asks that she be endowed with the virtues of magnitude, wisdom, prudence and intellectual abundance, invoking the models of biblical women and the consorts of kings and priests, who were celebrated for their virtues of leadership, intelligence, or fecundity such as Sarah, Rebecca, Judith and Esther.[88]

The parallelism between the king and the queen's cycle is furthered in this scene through actions which duplicate those of the king and a composition which reiterates the king's crowning. The background of this scene with the large gold scrolls is identical to the background of the scene of the king's coronation where the scrolls form a halo-like ring around the crown. The frames of the two coronation scenes are similar. Both scenes adhere to their respective texts by showing the archbishop of Reims alone imposing the crown. In both scenes the archbishop stands in the same position and the king and queen kneel in the same position. The compositions of both coronation scenes are almost identical. The queen occupies the same position as the king and the archbishop stands in the same place in both scenes, holding the crown in the same manner.

Folio 70
The Enthronement of the Queen on the Cathedra and her Crown sustained

[Plate 36]

[no textual counterpart]

Parallelism between the king and queen's ceremony is continued in this double scene of the queen's enthronement on the cathedra and the second sustaining of her crown, events not mentioned in the text. Their source is the illustration of the same action in the king's cycle.[89] The seat is that against which the queen knelt throughout the preceding consecration ceremony. It is not the queen's throne which the French directory [fol. 40], the rubrics at the beginning of the Ordo of Jeanne de

Bourbon [fol. 66], and the rubrics of the Ordo of Charles V [fol. 64v] specify as a sedes similar to the king's. Rubrics stipulate that before the ceremony the queen's throne [sedes] must be placed on a solium similar to, but smaller than, the king's solium, and that the queen's solium must be in the choir at the left of the king's solium. In the present scene, the queen sits upon a seat which is clearly placed on the floor of the church before the altar and not on an elevated solium. It is not, therefore, the throne but a second seat, comparable to the cathedra of the king's ceremony.

Considering the pattern of parallelism displayed between the king's and queen's cycles, it appears likely that the model for this miniature is the illustration of the enthronement of Charles V on the cathedra. The placement of figures is similar in both. The queen, like the king, is seated just left of the centre of the composition, and like him, for the first time in the cycle, she is shown seated in a frontal pose associated with royal majesty. She holds her sceptre and verge in the same position as does the king. The pattern of the squares of the background is comparable in both scenes. Several figures appear in both scenes such as the archbishop of Reims, the bishop of Beauvais, the count of Toulouse and the count of Etampes. One of the peers of France consistently absent from the king's cycle was the countess of Artois, though by right she was entitled to sustain his crown.[90] She is given central importance in the queen's cycle including her appearance in the scenes of the queen's enthronement at the cathedra and the sustaining of her crown, although her participation is not mentioned by the text. Her prominence can be explained by her position as a peer.

Folio 72
The Communion of the Queen in form of Bread and Wine

[Plate 37]

Apres ce que li arcevesques aura pris le corps nostreseigneur. Le roy et la royne doivent descendre de leurs eschaufaus. et venir humblement a lautel. Et prendre de la main larcevesque le corps et le sanc nostreseigneur. [fol. 41]
...in communione penitus est ordo regis superius annotatus observandus... [fol. 71]

The French text states that both the king and queen `take from the hand of the archbishop the Body and Blood of Our Lord', and the Ordo of Jeanne de Bourbon's communion specifically refers back to the king's communion which calls for him to receive the body and blood. The queen kneels before the archbishop who gives her a Eucharist wafer, imprinted with a Crucifix, as he holds the chalice with the wine which, it is implied, he will give her

next. The French directory calls for both the king and queen to remove their crowns and for the magnates to support the crowns while the king and queen receive the Eucharist. As the reception of the Eucharist in two kinds was limited to the clergy during this period, this action is a vital element in developing the theme of the `royal religion' according to which the king and the queen are consecrated into a ministerium which accords to them significant qualities of the ecclesiastical hierarchy.

Folio 73
The Blessing of the Oriflamme
[Plate 38]

Benedictio vexilla... [fol. 71]

As one of the miraculous signs of the divine favour of the king of France, along with the Celestial Balm and the fleurs-de-lis, the presence of the oriflamme contributes to the theme of the king of France as the most Christian king. Until the end of the thirteenth century, the oriflamme was regarded as the standard of the abbey of Saint-Denis [*vexillum beati Dionysii*], transmitted to the king as the vassal of the monastery of Saint-Denis for the Vexin. Beginning with Philip Augustus, the oriflamme increasingly became the *vexillum regale* of the kingdom of France, and it is not surprising that from thence the associations of the banner as the sign of the king's feudal subordination to the abbey of Saint-Denis were pushed into the background.[91] After Philip Augustus carried it at Bouvines, it symbolized the divinely ordained victory of the *roi très chrétien* as the defender of the Church and God's people.[92]

The blessing of the oriflamme was introduced into the sacre in the Last Capetian Ordo. It was not in the Directory of c. 1230 which concluded with a ceremony for the return of the Holy Ampulla to the monastery of Saint-Remi. This scene shows the archbishop of Reims blessing not one, but three banners held by a knight dressed in a red *cotardie* with a pink, fur-lined mantle or *hérigaut*, as a group of six figures look on. Contamine argued that this scene represents an event which took place independently of the sacre of Charles V, primarily because lists of *porte-oriflammes* do not indicate who occupied this post in 1364.[93] The name of Arnoul d'Audreham, who served as maréchal of Normandy for the dauphin, appears in the lists beginning in 1368.[94] According to Beaune, from 1304 until 1369 the *porte-oriflamme* was a member of the de Noyers family,[95] so it is not impossible that Miles X de Noyers or Jean de Noyers, both ardent partisans of the dauphin, occupied the position during this period.

However, every indication in the manuscript points to the conclusion that the scene was painted as part of the same campaign as all of the preceding illustrations. Its presence at the end of the sacre clearly belongs to an effort to integrate this insignium with the preceding actions of the sacre, and especially with the archbishop of Reims. It is noteworthy that the scene omits any specific reference to the abbot of Saint-Denis who was responsible for the oriflamme which was kept on deposit in his abbey and who had been the individual who had traditionally blessed the oriflamme.[96]

In his *Traité du Sacre* Golein deploys the oriflamme in defense of the claims of Charles V against Edward III by recounting his version of the legend of the oriflamme. As Golein tells the story, the emperor of Constantinople, in danger of losing his empire to the Saracens who had conquered Jerusalem, had a visionary dream of a knight riding on a large horse and carrying in his hand a lance `gilded with resplendence like the sun' from which emanated a flame in the manner of a flaming banner. In this dream an angel announced that the knight would deliver his empire from the Saracens. Golein identified the knight as Charlemagne, `king of France', who swore on the Gospels to guard the banner and to deliver the Holy Land and Constantinople. Golein then presented a lengthy interpretation of the symbolism of the oriflamme, the red signifying the the humanity of Christ and the `blood of Jesus Christ shed for us on the cross'. Charlemagne was given this banner `flaming in the sign that he was ennobled by the blessed Trinity signified by the trinity of the fleurs-de-lis'. According to Golein `the banner foretold that Charlemagne was to be emperor of the Roman peoples and that he left this banner in France as a sign of the perpetual empire by succession of male heirs, and not by election as the Roman Empire of Germany'. The oriflamme was thus instrumental for developing the theme of the king of France as the *roi très chrétien*. Golein then launched into a diatribe `that because of this a woman cannot nor must not inherit in France, because she is not anointed with the liqueur of the Holy Ampulla but with that which is only blessed by an archbishop'. Golein links the oriflamme to the issue of the Valois struggle against the English: `the oriflamme signifies the Son (of God) in humanity raised on the cross, reddened with the precious blood. This dignity pertains better to men than to women, and Edward, the king of England who has long held this error (according to which he) says that because of his mother he has a right to the kingdom of France. The presence of the scene of the transmission of the oriflamme in this cycle should be understood in the light of Golein's argument.

Notes

Notes to Introduction

1. The indispensable reference for the reign of Charles V remains Delachenal, 1909. Recent studies are Cazelles, 1982; Quillet, 1984; Autrand, 1994.

2. For the Hundred Years War see esp. Sumption, 1990; Allmand, 1988; Perroy, 1965.

3. For the sacre of Charles V see Delachenal, 1916, III, 65–101 and esp. 66, 77 n. 1, 88f. and 99 n. 4 citing Arch. Nat. LL, 106B, 504. For the Coronation Ordo of Charles V see esp. Jackson, 1984; Golein, ed. Jackson, 1969, 305-24. The ordo of Charles V was studied by Schramm, 1938, 39-47 and 24ff. Chronicles that refer to the sacre of Charles V are the *Chronique des règnes de Jean II et de Charles V*, ed. Delachenal, 3 vols., Paris, 1917-20, vol. 1, 345; *Les Grandes Chroniques de France*, ed. P. Paris, 1837, vol. 6, 233 which names some of the participants in the sacre; *Chronique des quatres premiers Valois*, (1327-1393), ed. S. Luce, Paris, 1862, 148f. which describes the entry into Paris of the entourage of Charles after the sacre; Jean Froissart, *Chroniques*, eds. Luce, Raynaud, Mirot, Paris, 1869-1967, 14 vols., vol. 6, 133. Some expenses of the sacre, many paid by the archbishop and bourgeoisie of Reims, are published by Varin I (ii), *1839, 919 n. 1 and III, 1848, 287-90, 293. Delisle, 1874, Nos. 6, 15, 21, 49, 151, 167, also mentions some expenses of the sacre.*

4. Dewick, 1899 passim; L. Delisle, 'Notes sur quelques manuscrits du Musée britannique', *Mémoires de la Société de l'histoire de Paris*, 4, 1877, 226-9; G. Leroy, 1896; Delisle, 1907, I, 218f.; Delachenal, III, 1916, 66, 76–93 first recognized the historical value of the Coronation Book of Charles V; Millar, 1933, 26f.; Schramm, 1938, 42–7; Schramm, 1960, I, 237–41; Sherman, 1969, 34–6, pls. 16–9, 22–3; R.A. Jackson, 'Les manuscrits des "ordines" du couronnement de la bibliothèque de Charles V, roi de France', *Le Moyen Age*, 1976, 76ff.; Avril, 1978, 24–8, pls. 27–8; Avril, 1968, no. 170. pl. VI; the most comprehensive study of the art patronage of Charles V is Paris: Galeries Nationales du Grand Palais, 1981, *passim*, and for the Coronation Book, 324ff; the queen's cycle in the Coronation Book has been studied by Sherman, 1977, 255–98; P. Pradel, 'Art et politique sous Charles V', *Revue des Arts*, 1951, 89–93. Sherman, 1977, 256 signalled the historical value of the illustrations and Avril, 1978, noted the 'concern for documentation' evident in the illustrations of this manuscript.

5. Schramm, 1938, 39f. made the observation that this is the earliest direct evidence of the intervention of a monarch in the redaction of a coronation ordo.

6. Schramm, 1938, 39f. and Sherman, 1977, 255–98 conclude that the ordo was used for the sacre of these monarchs. Jackson, 1984, 29–30, argued that the miniatures do not attempt to present an actual picture of the setting. Jackson, however, does not fully take into consideration the evidence presented by the miniatures, although he concludes that the ordo was used for the sacre of Charles V.

7. Schramm, 1938, 39–47 and 24ff.; Jackson, 1984, 207ff. corrected Schramm's dating to the end of the thirteenth century. Also Jackson, 1985, 63–74; and most recently Jackson, ed., 1995.

8. Jackson, 1984, 74 and n. 189.

9. For a full description of the contents see the description of the manuscript ch. 5 below.

10. Schramm, 1938, 39–47. Noting the international character of the Ordo of Charles V, Schramm followed Dewick, 1899, who was the first to identify the various origins of some of the formularies: e.g. notes on cols. 71f., Roman Pontifical; cols. 76, 82, Milan Pontifical; col. 77, German Imperial Pontifical; cols. 78, 81f., English Egbert Pontifical; col. 79f., Saxon ceremonial; and formularies from Protocols of Hincmar, cols. 69, 73f, 85. Also, Jackson, 1984, 26–34, 73–81, 222–3; Jackson, 1985, 70–1.

11. Schramm, 1938, 39f.

12. For example Schramm, 1938, 39ff.; Avril, 1978, 93f., 28f.

13. For the portraiture of Charles V and Jeanne de Bourbon see Sherman, 1969, *passim* and esp. 34–6, pls. 16–19, 22–3; *idem*, 1977, 255–97.

14. The Master of the Coronation Book was recognized first by S. Cockerell as the artist of the majority of paintings in a copy of the *Grandes Chroniques de France* made in Paris between 1370–1380, now in a private collection in Great Britain, some fragments of which are in the British Library (MS Cotton Vitellius E. II). For this see his *Exhibition of Illuminated Manuscripts*, Burlington Fine Arts Club, London, 1908, no. 145, pl. 100, and Paris: Musée du Louvre, 1904, no. 53. The list of works attributed to the Master of the Coronation Book was expanded by Avril, 1968; Avril, 1981; Avril, 1978, no. xii, 92–5. See chapter 6 below for the Master of the Coronation Book.

15. Delachenal, 1916, III, 66 follows Dewick, 1899, ix, and adds that it probably contained the forms which had been used for the ceremony and that it may have been intended to have served as a model for future coronations.

16. For historiography in the Middle Ages c.f. B. Guenée, *Histoire et culture historique dans l'occident médiéval*, Paris, 1980, *passim*; and R.H.C. Davis and J.M. Wallace-Hadrill, ed., *The Writing of History in the Middle Ages. Essays Presented to R.W. Southern*, Oxford, 1981.

17. Sherman, 1977, *passim* and for an update of this article see *idem*, 1982, 101–17.

18. This issue is discussed below in ch. 2.

19. For this complex problem and further literature see especially Bautier, 1987, 3–55; A. Lewis, 1981, Introduction and ch. 1. See also Spiegel, 1971–2, 145–74.

20. The issues of election and hereditary succession are considered below in chs. 1 and 2. The *Sta et retine* appears on fols. 63 and 63v of the Coronation Book. For this see chs. 2 and 3.

21. Delachenal, 1909, I, 55, and *Grandes Chroniques*, VI, 1.

Notes to Chapter 1

1. Delachenal, 1909, I, 1–9.

2. Delachenal, 1909, I, 25–55.

3. Delachenal, 1909, I, 26, n. 1, 33–4.

4. Wrigley, 1970, 433–71; D. Wood, 1989, esp. ch. 1, 1–18, and ch. 6, 122–41; Delachenal, 1909, I, 25–55.

5. Humbert specified the condition that he was not conveying the Dauphiné to the king of France, but to 'the eldest son of the king of France', so that this domain was from thence held by the king's eldest male heir. Delachenal, 1909, I, 25–47; D. Wood, 1989, 126–7.

6. Delachenal, 1909, I, 35.

7. Besides Delachenal, 1909, I, 25–55, for a brief account of the acquisition of the Dauphiné and the title see Autrand, 1994, 51–3.

8. Delachenal, 1909, I, 25ff.

9. See Krynen, 1993, 364–72 and Beaune, 1985, 126–64.

10. Delachenal, 1916, III, 24ff. first emphasized the uncertainty of the succession of Charles V. The problem of Valois succession dominates the literature on the Valois rulers as a group and individually. See Viollet, 1894, 125–78. Reconsideration of the succession problem is given by Cazelles, 1982, ch. 42, 455ff. The accession of Philip of Valois to the throne is considered by Cazelles, 1958, 35–73; Beaune, 1985, 264–90.

11. Lewis, 1986, 166.

12. For an overview of the exclusion of women and the election of the first Valois king see Cazelles, 1958, 35–57; Beaune, 1985, 264–90. A pioneering study of the legal rights of queens that has been largely overlooked by historians but deserves to be credited and resuscitated is the published thesis submitted to the law faculty of the University of Lille by Françoise Barry, 1932 (revised and published again in 1964). Barry pointed out that the Salic Law had not been used in these instances and she also cited the chronicler Jean de Saint-Victor who wrote that there was no obstacle to prevent women from reigning.

13. Barry, 1932 made these observations. See Cazelles, 1958, 35–44; Hallam, 1980, 325f. Beaune, 1985, 234, 266–8, 287; Lehugeur, 1897, 37–43; Giesey, 1961, *passim*.

14. See Beaune, 1985, 265–8, 287–8.

15. Cazelles, 1958, 46ff.

16. Cazelles, 1958, 44–9.

17. See Cazelles, 1958, 47f citing *Grandes Chroniques*, ed. Viard, IX, 72 n. 2. mentioning a number of doctors in canon and civil law who were partisans of the king of England and who raised objections to the candidacy of the count of Valois. See the discussion of Beaune, 1985, ch. IX, 264–90 on the Salic Law of the Franks and its revival at the time of the substitution of the Valois for the direct Capetian line.

18. Cazelles, 1958, *passim; also Giesey, 1961, passim.*

19. Strictly speaking, contemporary sources distinguish between Gascony, the coastal territory between the Pyrenees and the Garonne, and Guyenne, the strategic wedge of territory between the rivers Dordogne and Garonne. See e.g. P. Chaplais, 'Le Traité de Paris de 1259 et l'inféodation de la Gascogne Allodiale', *Le Moyen Age*, 61, 1955, 121–37; also M.G.A. Vale, *English Gascony, 1399–1453*, Oxford, 1970, especially 81–6 for the distinction between Gascony and Guyenne; Sumption, 1990, 69ff; Le Goff, 1996, 257–63.

20. Vale, 1970, op. cit., loc. cit.; Le Goff, 1996, 263; Sumption, 1990, 80–2.

21. See, for example, Cazelles, 1958, 151–91.

22. See Cazelles, 1958, 73 and n. 1 where he cites an edition of the *Revelations of Saint Brigitte* after a manuscript cited by Eric Colledge, 'Epistola solitarii ad reges. Alphonse of Pecha as organizer of Birgittine and Urbanist propaganda', *Medieval Studies*, 1956, 32.

23. The fact that Brigitte considers the election valid until Philip's death is an implicit recognition on her part of the permanence and indelibility of the sacre, for secular elections, even then, were not normally regarded as irreversible and above repudiation. Brigitte's criteria correspond to the criteria that apply to episcopal and papal elections which are permanent and indelible because of the consecration involved.

24. Cazelles, 1958, 193ff.; Cazelles, 1982, 129.

25. Delachenal, 1909, I, 31 n. 4: letter of 11 April 1344 recognizing as successor of Humbert II a *'cadet'* of the royal house which states '... *que jean, nostre dit filz ainsné est plus prochain pour venir à la succession du royaume et que par li pourra estre le dit Dalphine plus poissamment gouverné que par le dit Philippe'*. Arch. Nat. K. 44 no I. The treaty signed by Humbert in June 1344 substitutes for *cadet fils aine de roy de France* son of Phil VI. John did not use the title 'heir' in his acts until the last days of the reign of his father, and the *Chronicle of Guillaume de Nangis* reports that on his deathbed he called his two sons to his side and presented them with letters in which doctors in theology and in law proved that the Crown of France pertained to him legitimately and that it must be transmitted *jure hereditario* to his sons and not to Edward III, as well as with letters advocating the contrary position, that Edward III was the rightful heir. Philip VI's dying advice was that his son John must claim the Crown and fight to guard it. Cazelles, 1982, 129–30; *idem*, 1956, 204f.; G. Mollat, 'Philippe de Valois et son fils Jean, duc de Normandie', *Bibliothèque de l'Ecole des Chartes*, 1958, 209f.; Géraud, ed., 1843, 221f. See also D. Wood, 1989, 126–7.

26. Cazelles, 1982, 127ff.

27. D. Wood, 1989, 1ff.; Wrigley, 1970, 433–71. See chapter 7 below for a discussion of the portrait of Clement VI and John II.

28. The threat to the succession of John the Good is witnessed in a letter from Charles of Luxembourg, who promises aid in the event of an attempt to block John's succession. See Cazelles, 1958, 202–3 who cites from Arch. Nat., J 612, no. 45.

29. Cazelles, 1982, 13ff. and 85ff.

30. Beaune, 1985, 287.

31. Beaune, 1985, 234, 264–89.

32. Beaune, 1985, esp. 264–9, 286–9.

33. Beaune, 1985, 268: Paris, BN, MS fr. 1728, fols. 165–165v.

34. Beaune, 1985, 268–9.

35. Delachenal, 1909, I, 298–307 first noted the importance of the reformers for Charles V for his rise to power. See L. Carolus–Barré, 'La grande ordonnance de reformation de 1254,' *Académie des Inscriptions et Belles–Lettres, comptes rendus,* 1973, 181–7; Cazelles, 1982, 28ff.; and Cazelles, 1962–3, 92ff.

36. Delachenal, 1909, I, 316–7 and Cazelles, 1982 identified Jean de Craon as a member of the partisans of reform.

37. See esp. Cazelles, 1982, 28ff.

38. Delachenal, 1909, I, 2, 25–55 gives a detailed account of the acquisition of the Dauphiné and the arrangements for the marriage to Jeanne de Bourbon. One of John the Good's first acts to pave the way for the succession was to make him a knight immediately after his own sacre; also ibid., 55 and *Grandes Chroniques,* VI, 1. Following this John named the dauphin *lieutenant du roi* in Normandy to organize the defence of Normandy, March 1355. See Delachenal 1909, I, 95 who notes that after the preceding actions John sent Charles to Languedoc where he held the title *lieutenant du roi.* See Delachenal, 1909, I, 122ff.

39. The same action prepared the way for John's succession to the throne. See Delachenal, 1909, I, 119 and *Grandes Chroniques,* VI, 20 where it is noted that on 7 December 1355 John the Good awarded Charles the duchy of Normandy.

40. See the interpretation of Autrand, 1994, ch. 12; Cazelles, 1982, 229–37; Delachenal, 1909, I, 189–249.

41. Cazelles, 1982, 230 ff.

42. Delachenal, 1909, I, 370ff.: 14 March 1358 the dauphin substitutes the title *Regent du royaume* for his earlier title of *lieutenant du Roi.* The *Grandes Chroniques,* VI, 97f. state: *Le merquedy, xiiiie jour du dit mois de mars fu publié a Paris que le duc qui par avant se estoit appelli lieutenant du Roy, depuis sa prise, se appelleroit des la en avant regent le royaume. Et fu son titre tell 'Karolus primogenitus regis Francorum regnum regens etc'.* Delachenal, 1909, I, 371 n. 1 observed that P. Paris was incorrect in reporting *Regent du royaume* which should be *Regent le royaume* and he also noted that the dauphin referred to himself in a *mandement aux tresoriers* of 1 March 1358: *Charles ainsné filz du Roy et regent le royaume de France, duc de Normandie et dauphin du Viennois,*etc. Delachenal cites Paris, BN, P.O. 1474, d. 33408, Hangest, no. 22. See also E. Berger, 'Le titre de regent dans les actes de la chancellerie royale,' *Bibliothèque de l'Ecole des Chartes,* 1900, 418f. For the regency of the dauphin see Cazelles, 1982, 307–9.

43. Delachenal, 1909, I, 250 and n. 2 for text of the *Journal des Etats Généraux réunis à Paris au mois d'Octobre 1356.* Cazelles, 1982, 231 notes that Jean de Craon was the orator for the clergy at this session.

44. Cazelles, 1982, 244–5; Autrand, 1994, 266–7; Delachenal, 1909, I, 299–304.

45. Delachenal, 1909, I, 323f.

46. Delachenal, 1909, I, 337–9.; Cazelles, 1982, 300ff.

47. Delachenal, 1909, I, 354–64; Autrand, 1994, ch. 13.

48. Delachenal, 1909, I, 370–1.

49. Delachenal, 1909, I, 370–9; Autrand, 1994, ch. 13, *passim.*

50. Cazelles, 1982, 318–32.

51. Delachenal, 1909, I, 372–3.

52. Cazelles, 1982, 333; Delachenal, 1909, I, 394–416, 422–3; Autrand, 1994, 337.

53. Delachenal, 1909, I, 437–48.

54. Delachenal, 1909, I, 448–64; Cazelles, 1982, 335–7.

55. Delachenal, 1909, II, 59–87; Cazelles, 1982, 354–61.

56. Delachenal, 1909, II, 119–31.

57. Delachenal, 1909, II, 89–140; Cazelles, 1982, 229–74.

58. Delachenal, 1909, II, 141–61; Autrand, 1994, 383–97.

59. Delachenal, 1909, II, 239, n. 1.

60. Delachenal, 1909, II, 161–93.

61. Delachenal, 1909, II, 193–218.

62. Y. Congar, 'Quod omnes tangit, ab omnibus tractari et approbari debet', *Revue de l'histoire de droit français et étranger,* series 4, 34, 1958, 210–54; Krynen, 1993, 246–52.

63. Delachenal, 1909, II, 291–301.

64. Delachenal, 1909, II, 315–22; Cazelles, 1982, 436–7.

65. Delachenal, 1909, I, 249–50, n. 6; 371, n. 1 and *Grandes Chroniques,* VI, 97; see also following note.

66. Delachenal, 1909, I, 370ff. and *Grandes Chroniques,* VI, 97. Barbeu du Rocher, 1854, 172–288 and esp. 225; Delachenal, 1909, II, 271, n. 5.

67. Varin, III, 1848, 206f.; Cazelles, 1982, 455–6 and n. 456: *Mondict seigneur le duc respondit de sa bouche aus dictz eschevins que ilz avoient petite congnoissance de sa personne … quy estoit filz aisné du roy et heritier … sur ce que le descort touch le droit et heritage du roi … comme son droit et son heritage soit le votre comme son fils ainé à succéder à la couronne de France.*

68. Delachenal, 1909, II, 352–70.

69. Cazelles, 1982, 428–30.

70. Delachenal, 1909, II, 344–5; Cazelles, 1982, 430–1.

71. See Avril, 1968, no. 198, 114f.; Delachenal, 1909, II, 367 and note where he identified the translator as Nicole Oresme and not the all but unknown Guillaume Oresme. In chapter 7 an earlier manuscript will be associated with Charles.

72. Avril, 1968, no. 167, 93f.

73. For this charter see Jackson, 1984, 72.

74. See e.g. Cazelles, 1982, 447f.

75. Delachenal, 1909, II, 352 and n. 4.

76. Delachenal, 1916, III, 25, n. 1 suggests that the death of John the Good ushered in an interregnum and he notes many signs of reserve in recognizing the dauphin as king upon the death of his father. He cites Froissart, *Chronique*, VI, 109; Cazelles, 1982, 455–61 follows Delachenal.

77. Delachenal, 1916, III, 25. For example, the newborn John I was recognized as king from his birth until his death five days later. For further arguments that Charles V did not succeed through primogeniture, but by election by the magnates see Cazelles, 1982, 459f. who cites *Récits d'un bourgeois de Valenciennes*, ed. Luce, 1862, VI, 109.

78. Delachenal, 1916, III, 9 n. 1, 21–4 and 65–97, followed by Cazelles, 1982, 459.

79. For example, it is not impossible that it was out of a desire to express the notion that royal majesty is retained in the body of the king until he is buried when it passes to the successor. It is also quite possible that this points to an intention to signify that the sacre is the decisive act of king-making.

80. Delachenal, 1916, III, 38ff.

81. Delachenal, 1916, III, 27ff. for the Battle of Cocherel and the evidence that it was an organized effort to prevent the sacre of Charles V. Delachenal, 1916, III, 63f. for the impact that it had on the course of French history, compares the battle at Cocherel to the American revolution. Jean Golein is the earliest source to mention the battle of Cocherel as the decisive event that made possible the sacre of Charles V, see Golein, ed. Jackson, 1969, 305–24, 310.

82. Delachenal, 1916, III, 27ff.

83. Christine de Pizan, Paris, BN, MS fr. 10153, fol. 31 v: '… *pour aler empeschier et rompre le couronnement du dit Charles* … ', cited by Delachenal, III, 1916, 37 n. 1. The passage in question is cited in Christine de Pizan, ed. S. Solente, 1936–40, II, vi.

84. Delachenal, 1916, III, 37 and n. 1.

85. Golein, ed. Jackson, 1969, 310 (fol. 44): *Mais au retourner li vindrent et lencontre pluseurs grans prisonniers pris a la bataille de Cocherel. les quelz avoient entrepris de empeschier le devant dit sacre.* See Delachenal, 1909, II, 362ff. and 1916, III, 27ff.

86. Golein, ed. Jackson, 1969, 305ff.

87. Delachenal, 1916, III, 61, n. 5 citing *Chronique des quatres premiers Valois*, 148.

88. For a learned and accessible introduction to this issue, see Imbach, 1996, 1–20; for the citation from the Decretals see E.Friedberg, ed., *Corpus Iuris Canonici*, Leipzig, 1881, I, 678; Y. Congar, *Jalons pour une théologie du laïcat*, Paris, 1953, ch. 1.

89. Humbert of Silva Candida, *Adversus simoniacos* 3.9, PL 43.1153C, and Honorius of Autun, *De offendiculo* 38, cited from C. Waddell, 'The Reform of the Liturgy from a Renaissance Perspective', in R.L. Benson and G. Constable, eds., 1982, 95.

90. *De eruditione praedicatorum*, II, tract. 1, col. 71, cited from Imbach, 1996, 11.

91. Alexander Minorita, *Expositio in Apocalypsim*, in Imbach, 1996, 13.

92. Conrad of Megenberg, *Contra Occam*, in Imbach, 1996, 14. For Ockham's complete text, see R. Scholz, ed., *Unbekannte kirchenpolitische Streitschriften aus der Zeit Ludwigs des Bayerns,* Rome, 1914, II, 367.

93. Mundy, 1973, 320–2 who cites Gregory VII, *Registrum*, 7, 14a, ed. P. Jaffé, *Bibliotheca rerum Germanicarum: Monumenta Gregoriana*, Aalen, 1865, reprint., II, 404.

94. Mundy, 1973, 320, citing Letter no. 27 in PL ccxiv, 21.

95. Mundy, 1973, 322, citing Letter no. 131 in PL ccxvi, 923–4.

96. Barraclough, 1968 (repr. 1972), 120.

97. Aegidius Romanus, *De ecclesiastica potestate*, II, col. 10; ed. R. Scholz, Weimar, 1929, 95. Cited in Imbach, 1996, 18–20.

98. Power, 1992, 178–9; Little, 1978, 113–46.

99. Power, 1992, 241–50. For a recent study see Lambert, 1998, *passim.*

100. See Lambert, 1998, esp. 4–23, 60–111; Little, 1978, 113–146.

101. See e.g. Lambert, 1998, 149.

102. See e.g. Sayers, 1997, 189–92.

103. Sayers, 1997, 120–6.

104. Sayers, 1997, 123.

105. McCue, 1968, 385–430. Power, 244–7; Lambert, 1998, 108–11.

106. Lambert, 1998, 108–11.

107. Krynen, 1993, 70 ff.

108. Krynen, 1993, 25.

109. Hallam, 1980, 313–7.

110. Hallam, 1980, 315–6 citing *Corpus Iuris Canonici*, II, ed. Friedburg, 1881, 1245–6; For the conflict between Philip the Fair and Boniface VIII see C.T. Wood, *Philip the Fair and Boniface VIII*, 2nd ed., New York, 1971, *passim*; J. Favier, *Philippe le Bel*, Paris, 1978, *passim*; B. Tierney, *The Crisis of Church and State, (1050–1300)*, New York, 1964, 186. For the development of the theory of plenitude of power see R.L. Benson, '*Plenitudo potestatis*: evolution of a formula from Gregory IV to Gratian', *Studia Gratiana*, XIV, [Collectanea Stefan Kuttner, IV], Bologna, 1967, 195–214.

111. Krynen, 1993, 85–91; P. Saenger, 'John of Paris, principal author of the *Quaestio de potestate papae*', *Speculum*, 56, 1981, 41–55; J. Watt, 'The *Quaestio in utramque partem* reconsidered', *Studia Gratiana*, 13, 1967, 412–453.

112. Krynen, 1993, 91–100; Renna, 1978, 309–24; *idem*, 'Kingship in the *Disputatio inter clericum et militem*', *Speculum*, 48, 1973, 675–93.

113. Krynen, 1993, 108; R. Bossuat, 1973, 113–186.

114. See e.g. C. Lohr, 'The Medieval Interpretation of Aristotle', in Kretzmann, Kenny, Pinborg, eds., 1982, 80–98.

115. See Epstein, 1991, 207–61.

116. Lohr, in Kretzmann, Kenny, Pinborg, eds., 1982, 80–98.

117. Dunbabin, 1982, 723–37.

118. For a recent treatment of this subject and bibliography see esp. Deborah K.W. Modrak, *Aristotle. The Power of Perception*, Chicago, 1987, *passim*.

119. The bibliography on this issue is vast. For accessible introductory essays see e.g. Joseph Owens, 'Faith, ideas, illumination, and experience', in Kretzmann, Kenny, Pinborg, eds., 1982, 440–59; Eileen Serene, 'Demonstrative Science', ibid., 496–518.

120. D.E. Luscombe, 'The state of nature and the origin of the state', in Kretzmann, Kenny, Pinborg, eds., 1982, 757–70. The bibliography on Aristotelian natural philosophy is vast, but for an up-to-date introduction to the state of the question see J. Barnes, ed., 1995, esp. articles by C.C.W. Taylor, 'Politics', 233–58; S. Everson, 'Aristotle on the foundations of the State,' *Political Studies*, 36, 1988, 89–101. Also, F.D. Miller, 'Aristotle's political naturalism,' *Apeiron*, 22, 1989, 195–218.

121. Taylor in Barnes, ed., 1995, 233–52; M.V. Clarke, *Medieval Representation and Consent*, New York, 1964.

122. See Dunbabin, 1982, 723–37; Imbach, 1996, 87–125; P.A. Vander Waerdt, 'Kingship and philosophy in Aristotle's best régime,' *Phronesis*, 30, 1985, 249–73; R.G. Mulgan 'Aristotle's sovereign,' *Political Studies*, 18, 1970, 518–19.

123. See Renna, 1978, 309–24.

124. Although it focuses on a later period see the informative essay by J.H. Burns, *Lordship, Kingship and Empire. The Idea of Monarchy, 1400–1525*, Oxford, 1992, esp. 18–30.

125. Mundy, 1973, 402, citing *Summa Theologiae* I–II, 105, I, c.

126. Mundy, 1973, 441–2 who cites *De regimine principum*, 4, 18, ed. Spiazzi, 347, and Augustine's *De Civitate Dei* 15, 8(a). [Migne PL 41]

127. Mundy, 1973, 443, citing *De regimine principum*, 3, 2, 5, ed. Rome, 1607, 237

128. Brian Tierney, 'Origins of Natural Rights Language: Texts and Contexts, 1150–1250,' *History of Political Thought*, 10, 1989, 615–46.

129. See esp. Sherman, 1995, 27–8.

130. Taylor, in Barnes, ed. 1995, 233–57; C. Johnson, 'Who is Aristotle's citizen?,' *Phronesis*, 29, 1984, 73–90; C. Mosse, 'La conception du citoyen dans la *Politique* d'Aristote,' *Eirene*, 6, 1967, 17–21.

131. Lohr, in Kretzmann, Kenny, Pinborg, eds., 1982, 80–98.

132. Dunbabin, 1982, 734–7.

133. A founding essay attacking Latin as a language of sovereignty and advancing the notion of the intrinsic value of vernacular language for establishing the sovereignty of a land is presented by Dante in Book I of his *Convivio*. Dante argues that Latin cannot be understood by all of the people of a land, whereas the vernacular language is loved and understood by all. In this Dante was inspired by Cicero and was followed by Petrarch, who was crucial in transmitting these Ciceronian ideas to the court of John the Good and particularly to Pierre Bersuire whom he encouraged to translate Livy's *Histories* into French. These same notions are reiterated by, among others, Nicole Oresme. The bibliography concerning the emerging importance in this period of vernacular languages is enormous, although the focus of the majority of these studies is literary and cultural rather than legal and political. Among the most valuable recent contributions on the subject of vernacular languages are Rita Copeland, *Rhetoric, Hermeneutics, and Translation in the Middle Ages. Academic traditions and vernacular texts*, Cambridge, 1991, and Serge Lusignan, *Parler vulgairement: les intellectuels et la langue française aux XIIIe et XIVe siècles*, Paris, 1986.

134. Folz, 1950, 439–40.

135. *Hic nomen magni Karoli de nomine sumpsit, Nomen et indicium sceptra tenendo sua*, cited by E. Jeauneau, 'L'Abbaye de Saint-Denis introductrice de Denys en Occident,' *Denys l'Aréopagite et sa postérité en orient et en occident*, Actes du Colloque International, Paris, 21–24 Sept. 1994, ed. Y. de Andia, Paris, 1997, 366–7, and n. 22. Also see Folz, 1950, 439–41 for veneration of the name of Charlemagne by other descendants of the Carolingian dynasty.

136. Folz, 1950, 371ff.

137. Folz, 1950, 207.

138. For this and the following see in particular Spiegel, 1971–2, 145–74.

139. For the oriflamme see Contamine, 1973, 179–244, Beaune, 1985, 112–3, 226–7; and Lombard-Jourdain, 1991, 151–76.

140. Zeller, 1934, 80, and esp. Spiegel, 1971–2, 145–74.

141. Spiegel, 1971–2, 145–74.

142. Spiegel, 1971–2, 160.

143. Folz, 1950, 439.

144. Quillet, 1977, 22, and *passim*.

145. Quillet, 1977, 39–50, and 84–6.

146. Krynen, 1993, 49–51, 384–6.

147. Krynen, 1993, 348–52.

148. Krynen, 1993, 386–7.

149. Christine de Pizan, ed. Solente, Bk. III, i.

150. Golein, ed. Jackson, 1969, 309, 323. This issue is discussed further in chs. 3 and 4.

151. Among the authors who compared Charles to Charlemagne and Charles the Bald are Golein in his *Traité*, ed. Jackson, 1969, 309 and 322 (fol. 43 v); Christine de Pizan, ch. 10; Denis de Foulechat in his prologue to his translation of John of Salisbury's *Policraticon*, Paris, BN, MS fr. 24287, fol. 3, and Raoul de Presles in his translation of Augustine's *City of God*, Paris, BN, MS fr. 21212, fol. a. iiii.

152. Wrigley, 1970, 433–71.

153. For an account of Charles's youth see Delachenal, I, 1909, *passim*. For a brief discussion of the role of Charles's ancestors in fostering his interest in translations and

works of art see Avril, 1968, introduction. For a study of the patronage of John the Good, see Avril, 1972, 89–125.

154. For a semiotic analysis of the usage of the words *sage* and *sagesse* in French literature of the twelfth and thirteenth centuries see Charles Brucker, *Sage et Sagesse au Moyen Age (XII et XIII siècles). Etude historique, semantique et stylistique*, Geneva, 1987.

155. William Ockham, *Prologue to Expositio super VIII Libros Physicorum*, trans. P. Boehner, O.F.M., Indianapolis, 1964, 3.

156. Sherman, 1971, 83–96.

157. Christine de Pizan devotes Part III to Charles's wisdom; see ed. Solente, 1936–40, III, i, ii, iii.

158. For this and the subsequent quotations from Christine de Pizan, I have based my translations on the recent translation into modern French by Hicks and Moreau, 1997, 295–6.

159. Christine de Pizan, III, i, 1997, 196.

160. Dunbabin, 1982, 734f.

161. Golein, ed. Jackson, 1969, 324.

162. Christine de Pizan, III, lxiii, 1997, 295.

163. Krynen, 1993, 397–401.

164. Krynen, 1993, 22.

165. *Gregorii VII Registrum*, 6.5b (Decree of 1078), ed. E. Caspar, MGH Epist. sel. 2 (Berlin, 1920; repr. 1955) 402[xxxi]: *Ut omnes episcopi artes litterarum suis ecclesiis doceri faciant et ornamenta ecclesie sine certa utilitate aut gravi necessitate nullo modo nulloque ingenio ecclesiis subtrahant ne periculum sacrilegii, quod absit, incurrant*, cited by R.W. Southern, 'The Schools of Paris and the School of Chartres', in Benson and Constable, eds. 1982, 117, n. 8

166. Charlemagne and Charles the Bald exercised these same prerogatives, but it is also likely that they were doing so in the sacerdotal and episcopal capacity with which they had been endowed when they received their royal anointing. See ch. 2 for the development of the Carolingian ritual.

167. Golein, ed. Jackson, 1969, 316, 320. See below chs. 3 and 4 for further discussion of this issue.

168. For a discussion of the robes see ch. 7.

169. These passages are at the beginning of the manuscript in the table of contents of the original presentation copy of Golein's translation, Paris, BN, MS fr. 437, fol. iii and also fols. 44–5.

170. Besides the Coronation Book, works signed or corrected by Charles include a Latin Bible (known as the Bible of Charles V or Bible of the Celestines), Paris, Bibl. de l'Arsenal, MS 590, autograph on fol. 527v, Avril, 1981, no. 163; Guillaume Durand, *Rational des divins offices*, trans. Jean Golein, Paris, BN, MS fr. 437 has several corrections and an autograph on fol. 403; *Les Voies de Dieu, ou Visions de Sainte Elizabeth*, trans. Jacques Bouchant, BN, MS fr. 1792, autograph fol. 89v; Tite-Live, *Histoire romaine*, trans. Pierre Bersuire, Paris, Bibl. Ste-Geneviève, MS 777, fol. 1; *Grandes Chroniques*, Paris, BN, MS fr. 2813,

with the king's signature and numerous corrections made by the king.

171. See Sherman, 1995, *passim.*

172. See Quillet, 1977, 134.

173. Delisle, 1907, I, intro.

174. Avril, 1981; Avril, 1978; Sherman, 1969, *passim.*; Avril, 1968. Sherman, 1995.

175. Manuscripts commissioned by Charles V containing declarations of their public utility include: translation of the *Policraticon*, Paris, BN, MS fr. 24287, fol. 5r: ' … un tres grant et pfont livre qui est appele policratique pour translater de latin en francois afin que tous gens si puissant grandement proffiter … '; Raoul de Presles' translation of the *City of God*, Paris, BN, MS fr. 22212, fol. a. iiii: `… translate de latin en francois pour le prouffit et utilite de vostre royaume, de vostre peuple et de toute crestiene cest assavoir le livre de monseigner saint augustin de la cite de dieu'; Nicole Oresme's French translation of Aristotle's *On the Heavens*, Paris, BN, MS fr. 1082, ed. Menut, 1968, p. 3; and Christine de Pizan, 1997, 229 states that the king's patronage of art and science was for the public good.

176. Baron, 1981, 115ff., no. 64.

Notes to Chapter 2

1. A.O. Anderson, M.O. Anderson, eds. and trans., *Adomnan's Life of Columba*, London, 1961, 472–5. M.O. Anderson, *Kings and Kingship in Early Scotland*, Totowa, 1973. Enright, 1985, 8–24 and *passim.*

2. Enright, 1985, 17.

3. Julian of Toledo, *Historia Wambae regis*, ch. 4, M.G.H. (Monumenta Germaniae Historica) SS. rer. Merov. V, 503–4 (Migne, P.L. 96 col. 766); M.G.H. Legum Sect. I, 1, 461, (Migne, P.L. 96, col. 766). See Bouman, 1957, xi. For a recent discussion and further references see Bautier, 1989, 9–11.

4. Rouche, 1996, 252–85.

5. Rouche, 1996, esp. 252–8; de Pange, 1955, II, 349–54. Dewick, 1899, col. 69 states that the tradition cannot be traced beyond the time of Hincmar. For the letter de Pange cites *Mon. Germ. Capit. Reg. Franc.*, II, 340. Both de Pange and Dewick cite Hincmar, *Vita S. Remigii* [apud Surium], *De vitis Sanctorum*, Venice, 1581, I, fol. 92v. Most recently see Krynen, 1993, 24–7. Also the classic study of the Holy Ampulla by Oppenheimer, 1953, *passim.*

6. Bourdieu, 1977, 405–11. The literature on ritual is vast, but for a valuable recent consideration with an extensive bibliography see Bell, 1992, *passim.*

7. Recently Bell, 1992, *passim* and esp. 19–46, 197–223; Emile Durkheim, *The Elementary Forms of the Religious Life*, trans. J.W. Swain, New York, 1965, first ed. 1915, esp. Book III; Victor Turner, *The Ritual Process: Structure and Anti-Structure*, Chicago, 1966; Gilbert Lewis, *Day of Shining Red: An Essay on Understanding Ritual*, Cambridge, 1980.

8. Bell, 1992, *passim*, and esp. ch. 9, 197–223.

9. Nelson, 1986, 259–81, 282–304. Some notable considerations of ritual from an anthropological perspective: M. Fortes, 'Of Installation Ceremonies', in *Proceedings of the Royal Anthropological Institute*, 1967, 5–20; Arnold van Gennep, *Les rites de passage*, 2nd ed., Paris, 1969; Edmund Leach, *Culture and Communication, Cambridge, 1976*.

10. Clifford Geertz, *Negara. The Theatre State in Nineteenth-Century Bali*, Princeton, 1980, 136. Bourdieu, 1977, *passim*.

11. See esp. Bourdieu, 1977, 405–11.

12. See especially Price, 1984, 234–48; Clifford Geertz, 'Centers, kings, and charisma: reflections on the symbolics of power', in *Culture and its Creators. Essays in honor of E. Shils*, eds. J. Ben-David and T.N. Clark, 1977, 150–71; *idem*, 'Religion as a cultural system', in *The Interpretation of Cultures*, ed. C. Geertz, New York, 1973, 87–125; P.L. Berger and T. Luckmann, *The Social Construction of Reality*, 1966; Charles D. Laughlin, 'Ritual and the Symbolic Function: A Summary of Biogenetic Structural Theory', *Journal of Ritual Studies*, 4 no. 1, 1990, 15–39.

13. Clifford Geertz, *Negara. The Theatre State in Nineteenth-Century Bali*, Princeton, 1980, 136.

14. For a relevant analysis see Walter Burkert, *Creation of the Sacred. Tracks of Biology in Early Religions*, Cambridge, Mass., 1996.

15. See especially Bouman, 1957, *passim*; Valensise, 1986, 543–77; Kantorowicz, 1957, *passim*.

16. Kantorowicz, 1946, *passim*. Ullman, 1969, 9f., 52–78.

17. Bouman, 1957, xi. Nelson, 1977, 245, n. 3, repr. in Nelson, 1986, 133–71, and esp. 137; W. Levison, *England and the Continent in the Eighth Century*, Oxford, 1946, 88ff. and 119ff. For Boniface see Mayr-Harting, 1972, repr. 1991, 262–73. Bautier, 1989, 7ff.

18. See Bautier, 1989, 8–13 for a recent discussion and references. Nelson, 1986, 289ff.

19. Enright, 1985, 8–24; Bouman, 1957, xi. Boniface was an aristocrat from the region of Devon. His original name was Wynfryth. He was a monk at Exeter before embarking on missionary work amongst the Frisians and afterwards with the Carolingian Franks. See Mayr-Harting, 1972, repr. 1991, 262–73. Bautier, 1989, 8–9 attributes the inspiration to the Visigothic anointing of Wamba, but does not refer to the literature on the Insular sources.

20. de Pange, 1955, 352–3; Hincmar, *Vita S. Remigii*, 1581, I, fol. 92 v.

21. See Bautier, 1989, 7–33.

22. For the relevant passages in the Coronation Book see Dewick, 1899, cols. 36 and 85–7. For the interdependent development of the episcopal and royal consecration rituals, see esp. Andrieu, 1953, 22–73 and Batiffol, 1923, 732–63.

23. Nelson, 1977, 241–79, repr. in Nelson, 1986, 133–71.

24. These issues are considered in ch. 3.

25. de Pange, 1955, II, 349–54. See also Jackson, 1984, 190ff.

26. For the contractual dimension of the sacraments and the relevance for royalty see esp. Alain Boureau, 'Pierre de Jean Olivi et l'émergence d'une théorie contractuelle de la royauté', in J. Blanchard, ed., 1995, 165–75.

27. Leroquais, 1937, I, iv–lxxiv.

28. Chenu, 1957, repr. 1968, esp. 'The Symbolist Mentality', 99–145 and 117f. A basic reference on the sacraments is I.H. Dalmais, *Introduction to the Liturgy*, trans. R. Capel, Baltimore, 1961, esp. 8–12 'Forest of Symbols'.

29. Chenu, 1968, 132.

30. Especially Pseudo Dionysius, *Ecclesiastical Hierarchy*. For an English translation see *Pseudo-Dionysius: the Complete Works*, trans. C. Luibheid, New York, 1987, 193–259.

31. Chenu, 1968, 99–145.

32. On the history of the doctrine of transubstantiation see H. Chadwick, 'Ego Berengarius', *Journal of Theological Studies*, 40, 1989, 414–45; McCue, 1968, 385–430.

33. McCue, 1968, 385–430; Power, 1992, 244–7.

34. M. Rubin, *Corpus Christi. The Eucharist in Late Medieval Culture*, Cambridge, 1991; G. Macy, *The Theologies of the Eucharist in the Early Scholastic Period*, Oxford, 1984.

35. For a survey and edition of the Frankish and French ordines see Jackson, ed., 1995, 1–48. Both Bouman, 1957, *passim*, and Nelson, 1986, *passim*, remain valuable.

36. See MacCormack, 1981, 177–92.

37. Bautier, 1989, 7–13; Jackson, 1995, 22–4, 51–4 for royal texts in the Sacramentary of Gellone and 55–68 for royal texts in the Sacramentary of Angoulême, and 66–8 for a collection in St. Emmeram which has one prayer which later appears in the Ordo of Charles V.

38. Nelson, 1980, 29–48, repr. Nelson, 1986, 341–60. The missal was edited by F.E. Warren, *The Leofric Missal*, Oxford, 1883. For the re-dating Nelson cites Elaine Drage, 'Bishop Leofric and Exeter Cathedral Chapter: a reassessment of the manuscript evidence', D.Phil dissertation, Oxford University, 1978. The manuscript is named after Leofric, the first archbishop of Exeter, who gave it to his cathedral. He was was once thought to have brought it to England from the Continent when he accompanied Edward the Confessor in 1042 on his return from exile at the court of his cousin Robert, duke of Normandy, the father of William the Conqueror. However, it has been demonstrated that this manuscript was in England in the 950s, long before Leofric. Jackson, 1995, 10, excluded Leofric from his consideration because Nelson had identified the missal as English.

39. See esp. for what follows Nelson, 1980, 29–48, repr. Nelson, 1986, 341–60; Schramm, 1968, II, 140–248, argued that the ordo in Leofric was Frankish and that it derived from the related ordo which was used for the consecration of Judith. His views have received a wide following despite the evidence presented by Ward, 1939, 160–78, and Robinson, 1918, 56–72, indicating that both the ordines of Judith and Leofric derive from an earlier model. Others who argue against Schramm are Bouman, 1957, 9–15, 23–4 and Hohler, 1975, 60–83, and nn. 217–27.

40. Nelson, 1980, 29–48, repr. Nelson, 1986, 341–60. One might note the similarity with the treasure of the Sutton Hoo ship burial in which the king or prince was buried with a helmet and a sceptre. See eg. M.O.H. Carver, ed.,

The Age of Sutton Hoo. The seventh century in north-western Europe, Bury St. Edmunds, 1992, *passim* and esp. 131–48 and 167–74.

41. Nelson, 1980, 29–48; Schramm, 1968, II, 140–248, esp. 223–33.

42. For the Lanalet Pontifical see G.H. Doble, The Henry Bradshaw Society, LXXIV, London, 1937.

43. See Bautier, 1989, 9 n. 9; Nelson, 1986, 285; W. Levison, *England and the Continent in the Eighth Century*, Oxford, 1946, 119. Bouman, 1957, xi, n. 3.

44. Bautier, 1989, 33–43.

45. Nelson, 1977, 241–79, repr. in Nelson, 1986, 132–71. Bouman, 1957, 15, 103–12ff.

46. Bouman, 1957,15, 103, 112ff; the lost manuscript from Liège which preserved Hincmar's ordines was edited in *Hincmari ... Opera*, ed. Sirmond, 1645, I, 741–755 and reprinted in *Mon. Germ. Cap. Reg. Franc.*, II, respectively, 425–7, 453–5, 456–8, 461–2). See most recently Jackson, 1995, 87–109.

47. Nelson, 1977, 245.

48. Bautier, 1989, 38.

49. Nelson, 1977, 241–79 and esp. 248–52.

50. Nelson, 1977, 241–79, esp. 247–52; David, 1950, esp. 127ff.

51. Nelson, 1977, 247.

52. Andrieu, 1953, 22–73, and Nelson, 1977, 248–52 who points out that Hincmar was striving to consolidate the authority of the archbishop of Reims over the Frankish Church.

53. Nelson, 1977, 241–79 and esp. 252ff.

54. Bautier, 1989, 7–14.

55. Bautier, 1989, 37.

56. Bouman, 1957, 165.

57. Bautier, 1989, 37, and nn. 66, 100–1.

58. For the facsimile of the Sacramentary of Metz, *Sakramentar von Metz, Fragment. MS lat. 1141, Bibliothèque Nationale, Paris*. Introduction F. Mütherich, Graz, 1972. See also A.M. Friend, 'Two Manuscripts of the School of Saint-Denis', *Speculum*, I, 1926, 59–70.

59. F. Mütherich and J. Gaehde, *Carolingian Painting*, New York, 1976, 96–109.

60. It may be relevant that illegitimate sons of Carolingian emperors were often bishops. One of these, Ebbo of Reims, an illegitimate son of Charlemagne, has been linked with the commissions of the Reims painter. The substitution of imperial sons for bishops in the context of arguments for succession and legitimacy echoes the theme of the Constantinian work.

61. Bautier, 1989, 38–9.

62. J. Porcher in J. Hubert, J. Porcher and W.F. Volbach, *The Carolingian Renaissance*, New York, 1970, 121–48.

63. Bautier, 1989, 41 and n. 114.

64. Bautier, 1989, 47–9.

65. Nelson, 1986, 361–74; Bouman, 1957, 15–17, 155–6, 168–9; Schramm, 1939, 17–18; Jackson, 1984, 222.

66. Bouman, 1957, 15–16, 168–9. First recognized by Pierre Delalande, *Conciliorum antiquorum Galliae a Iac. Sirmondo S.I. editorum supplementa.*, 1666, 355–8. It is also published in Staerk, 1910, I, 166ff. and Schramm, 1939, 279 as the *Westfränkische Ordo um 900*.

67. Jackson, 1995, 142–53.

68. Nelson, 1986, 367, n. 22.

69. Bautier, 1989, 49–50. If indeed this ordo was compiled for this sacre, it is a quarter of a century later than it has traditionally been dated. This would affect its relationship to the Ratold Ordo and its English source which are usually considered to have derived from the West Frankish Ordo. There are several features that would be appropriate for Raoul, the first West Frankish king whose lands lay outside of Francia, and who, furthermore, based his government in his native Burgundy. Raoul imposed his authority from Flanders to Navarre, establishing a balance of power amongst the nobles of these lands. He did not succeed to the throne but was a compromise candidate elected to kingship at an episcopal synod, and was anointed by Gautier, the archbishop of Sens, the metropolitan primate of Burgundy and Gaul. Having been elected by Frankish magnates and the episcopate after a bitter internecine struggle of succession, Raoul was consecrated along with his consort Emma, the sister of Hugh the Great of Neustria. It may well be that the sacre of Emma at the same time was inspired by that of Ermintrude, the first wife of Charles the Bald, at a synod held in Soissons in 866. As already noted, the bishops justified Erminitrude's anointing because of the necessity for God to give posterity to the king for the defence of the kingdom. Like Charles the Bald, Raoul's position was precarious. Besides blessing the couple with prayers for fertility, anointing both king and queen would have enhanced the ministerial character of the couple's rule and sanctified the queen in order that she might be protected in the event of the king's death before an eventual heir reached majority. In keeping with these observations, Emma was given important responsibilities including the administration of Burgundy during her husband's absence, and even such traditional male roles as directing the defence of the city and bishopric of Laon. Bautier, 1989, 37. McKitterick, 1983, 309–11.

70. Nelson, 1986, 361. Bouman, 1957, 21f.; Erdmann, 1951, 87–9. Jackson, 1995, 154–67 calls it the Ordo of Eleven Forms.

71. Erdmann, 1951, 87f.; Bouman, 1957, 31f. Jackson, 1995, 163 for the text of the *Sta et retine* and 164–6 for the text of the queen's ordo.

72. Bouman, 1957, 112–9; Nelson, 1986, 361–74. Ward, 1942, 345–58; Hohler, 1975, 64–7.

73. Nelson, 1986, 361–74; Ward, 1942, 345–58.

74. Ward, 1942, 345–58, esp. 357 for the *Sta et retine*; Turner, 1971, *passim* and esp. 89–95; Jackson, 1995, 173; See also E. Brown, 1992, 15–30.

75. Nelson, 1986, 362ff.; Bouman, 1957, 112–9.

76. Nelson, 1986, 368ff.; Bouman, 1957, 112–9. The passage in the consecration prayer of the Coronation Book appears on fol. 53v. Dewick, 1899, 27.

77. See chart in Nelson, 1986, 362.

78. Nelson, 1986, 366–7.

79. Nelson, 1986, 366–9.

80. Turner, 1971, xxxiii; Nelson, 1986, 368.

81. See D.A. Bullough, 'The Continental Background of the Reform', in *Tenth Century Studies*, ed. David Parsons, London, 1975, 20–37.

82. Mayr-Harting, 1991, II, 177; Pächt, 1986, 72–5; Alexander, 1978, 13–15.

83. Nelson, 1986, 369–70.

84. Wilson, 1903, 39, and for the royal ordo, 140–7. The benedictions are for the feast of Grimbald, mentioned as *tantus patronus*. See also J. Backhouse, D.H. Turner and L. Webster, eds., *The Golden Age of Anglo-Saxon Art, 966–1066*, London, 1984, 60.

85. Temple, 1976, II, 19, 53ff.

86. Ward, 1939, 170.

87. Nelson, 1986, 369–74.

88. Temple, 1976, II, 19, 53ff..

89. Wilson, 1903, 140–47.

90. For the text of the royal ordo see C. Vogel and R. Elze, 1963, I, 246–69; Bouman, 1957, 138–9.

91. Bouman, 1957, 27.

92. Molin and Mutembe, 1961, 27–8, 254–70.

93. *Oxford Latin Dictionary*, ed. P.G.W. Glare, Oxford, 1982, 8 [S–Z], col. 1935, where 'thalamus' is defined as an inner chamber or apartment, especially for sleeping; bedroom or apartment occupied by a married couple; inner shrine or sanctuary. The term appears at the beginning of the ordo for the consecration of a bishop.

94. Mayr-Harting, 1991, I, esp. 12–19, 60ff.

95. In addition to the traditional prayer, the *Deus Dei filius Iesus Christus … qui a patre oleo exultationis unctis*, further Christological references are added including the formula for the acceptance of the rod and sceptre which celebrates Jesus Christ: *Ego sum ostium, per me si quis introieret salvabiter … ad exemplum illum, quem ante secula unxerat oleo exultationis prae participibus suis, Iesum Christ. d. n.*, and is recited before the crowning. The crowning formula adds references to Christ. The ritual culminates in the *Sta et retine* of the enthronement sequence in which the metropolitan prays that the king be confirmed in his seat of governing by 'Jesus Christ, king of kings and lord of lords … who reigns with him … '.

96. Mayr-Harting, 1991, I, esp. 52–65, 119–38, 175–6 and II, 86–94.

97. See esp. Mayr-Harting, 1991, I, 180–99.

98. Mayr-Harting, 1991, I, 194.

99. Mayr-Harting, 1991, I, 194. For a recent reconsideration of the Holy Lance see Lombard-Jourdain, 1991, 129–76; also Keller, 1985, 290–311, 297 and n. 34.

100. Mayr-Harting, 1991, I, 194.

101. Mayr-Harting, 1991, I, 196.

102. Fols. 81r–105v. For this ordo see Brückmann, 1969, 99–115.

103. Brückmann, 1969, 108, who also gives further references; Ward, 1939, 174–6.

104. Ward, 1939, 173ff.

105. For the text of this ordo see Wilson, ed., 1910, 89–97.

106. The text of the pontifical in London, BL, MS Cotton Tiberius B VIII is published in Legg, 1901, 30–9.

107. Brückmann, 1969, 107.

108. Theo Koelzer and Marlis Staehli, *Petrus de Ebulo. Liber ad Honorem Augusti Sive de Rebus Siculis. Codex 120 II der Bürgerbibliothek Bern*, Sigmaringen, 1994.

109. This manuscript has been identified as a source for the *Philippide*, the epic poem written for Philip II Augustus. It is possible that Philip acquired this manuscript when he allied himself with the brother of Henry VI, Philip of Swabia, whom he backed in his struggle to gain the imperial crown after the death of Henry VI.

110. Jackson, 1984, 190ff. and Schramm, 1960, 112–20.

111. Dewick, 1899, col. 69 noted that the Celestial Balm was mentioned in the writings of Hincmar, *Vita S. Remigii*, 1581, I, fol. 92v. The West Frankish Ordo of *c.* 900 and the Ratold Ordo do not mention the Celestial Balm, which, however, is given prominence in the French ordines after 1230. Jackson, 1984, 223ff. demonstrated that all three ordines were compiled during the reign of St Louis and he argued that the emphasis upon the Celestial Balm points to Reims, whether the monastery of Saint-Remi, the canons, or archbishop of the cathedral of Reims. See also *idem*, 1985, 63–74 and 73, n. 25 where he identifies the three manuscripts as Reims, Bibl. Mun., MSS 328, 329, and 330. Jackson, 1995, 14ff. has decided to call what he had formerly called a 'directory', a 'modus'. To avoid confusion I prefer to retain the earlier terminology.

112. Jackson, 1984, 223ff.

113. The Latin texts call this structure a *solium* and the French an *eschaffeau*(or *eschaufaut*), literally a temporary platform not unlike a scaffold. The *Oxford Latin Dictionary*, ed. P.G.W. Glare, 7, 1784, defines *solium* as a high-backed chair; a royal chair, throne, the position of authority; a bath-tub, a tub; a kind of sarcophagus.

114. London, BL, MS Cotton Tiberius B. VIII, fol. 35v.; Varin, 1848, II, 2, 528.

115. *et doit traire à une aiguille d'or aucun petit de l'huile envoye des cieux, et mesler o grant diligence avec le cesme qui est appareillé à enoindre le roy, liquels roys seulement resplendist devant tous les autres roys du monde de ce glorieux privilége que il singulierement soit enoint de l'[h]uille envoye des cieux.* Varin, 1848, I, pt. 2,; 529; and London, BL, MS Cotton Tiberius B. VIII, fol. 38v.

116. Jackson noticed the presence of this passage in the Last Capetian Ordo but its presence in the Directory and in the Ordo of 1250 escaped his attention. See n. 131 for reference

117. *'il promecte et afferme par son serment à garder et à faire garder les droictures des évesques et des églises, si comme il avient au roy à faire en son royaume, et les autres choses, si comme'*, Varin, 1848, I, 529.

118. *' ... hors le serment de la nouvelle constitution du concile de Latran; c'est assavoir, de mettre hors de son royaume les herges.'* Varin, 1848, I, 529. Dewick, 1899, col. 7., London, BL, MS Cotton Tiberius B. VIII, fol. 37.

119. See Lambert, 1998, 130–6.

120. Lambert, 1998, 136.

121. See Hallam, 1980, 133–7.

122. See J.W. Williams, *Bread, Wine, and Money. The Windows of the Trades at Chartres Cathedral*, Chicago, 1993, for a detailed study of the struggle between the counts and countesses of Chartres and the cathedral canons against the bishop and the king of France. She considers the importance of bread and wine imagery incorporated into the windows of the cathedral during this period. What was happening at Chartres was not a local Chartrain matter: it was the most grievous problem with which Christendom was to be faced for the next four hundred years, and one finds comparable struggles throughout the emerging kingdom of France.

123. McCue, 1968, 385–430. Also Emmanuel LeRoy Ladurie, *Montaillou. The Promised Land of Error*, trans. B. Bray, New York, 1979, Introduction vii–xvii. Mundy, 1982, 229–47.

124. Leroquais, 1937, I, cxx.

125. See Leroquais, 1937, cxx for a pontifical for the Use of Paris (Metz, Bibl. Mun., 1169) which has two illustrations, one for the king's ceremony (fol. 122) and another for the queen's (fol. 131v). Although Paris, BN, MS lat. 1246 contains litanies from Châlons-sur-Marne in the archdiocese of Reims, Leroquais' assertion that it was once part of a pontifical from Châlons has been challenged because its small format and autonomy suggest that it was never part of a fuller manuscript of a pontifical. See Leroquais, 1937, I, iv–lxxiv, and Le Goff, 1990, 46f.

126. Le Goff, 1990, 46f.

127. Branner, 1977, 69, 87–91; F. Avril, annotation no. 216 in *La France de Saint Louis: Catalogue de l'exposition*, Paris, 1970. Bonne, 1990, 58ff.; Le Goff, 1990, 46.

128. Schramm, 1938, 30–33; Godefroy, 1619, I, 13–30; Jackson, 1984, 222–3; Le Goff, 1990, 46–57. Jackson, 1995, 14–5, 30–1.

129. Le Goff, 1990, 46.

130. Bautier, 1989, 47–50; Hallam, 1980, 66.

131. Jackson, 1984, 28–9 identified numerous prayers and ritual actions in the Ordo of Charles V as new. However, although these prayers are not in the Last Capetian Ordo, all of them are included in earlier coronation ordines. The majority of these prayers are in the compilation of *c.* 1250. They are the following: *Omnipotens sempiterne Deus qui famulum tuum; Deus qui scis humanum genus; Omnipotens Deus, caelestium moderatur; Deus inenarrabilis auctor mundi; Ungatur manus istae de oleo; Deus qui es justorum gloria; Accipe coronam regni.* The remaining are

from the following sources: the Gregorian Sacramentary, *Missa Tempore Synodi pro rege dicendi, Ecce mitto angelum meum,* cited Dewick, col. 72; *Prospice omnipotens Deus* and the *Deus pater aeternae glorie* which are in a Milan Pontifical of the ninth century and in the ordo for the coronation of an emperor, according to Dewick, 1899, col. 77.

132. See preceding note and also Schramm, 1938, 30ff. who identified Paris, BN, S lat. 1246 as the Ordo of 1250. Schramm identified this manuscript with no. 233 bis of the Library of Charles V in Delisle, 1907, no. 3.

133. Le Goff, 1990, 51 noticed this detail, although he did not note that it appeared in the German Ordo.

134. *Sta et retine locum a modo quem hucusque paterna successione tenuisti haereditario jure tibi delegatum, per auctoritatem Dei omnipotentis et praesentem traditionem nostram, omnium scilicet episcoporem, ceterorumque Dei servoru, et quanto clerum sacris altaribus propinquiorem respicis, tanto ei potiorem in locis congruis honorem impendere memineris: quatenus mediator Dei et hominum te mediatorem cleri et plebis constituat.*

135. These points are discussed further in ch. 3. The prominence given to the *Sta et retine* suggests that it was compiled in order to assure the succession of the son of a ruling king, perhaps a son of Louis IX.

136. Bouman, 1957, 15f. and Staerk, 1910, 169.

137. There is some suggestion in the wording of the Ratold Ordo, based on the earlier West Frankish Ordo of *c.* 900, that the king and queen communicated in two kinds.

138. Bonne, 1990, 61 makes this point for which he credits Avril.

139. Schramm, 1938, 33ff., 223 and nn. 5, 6, 7; and for Jackson's re-evaluation and re-dating of the three French ordines, see esp. Jackson, 1984, 207ff.

140. Jackson, 1985, 68–70; Jackson, 1995, 31–2.

141. Leroquais, 1937, I, iv ff.; Andrieu, 1940, III, 88.

142. See Bouman, 1957, 17ff. and 118ff.; Schramm, 1938, 20ff. called the Ratold Ordo the Fulrad Ordo and he referred to the Westfrankish Ordo of Sens of *c.* 900 as the Erdmann Ordo.

143. *`Sta et retine a modo statum quem huc usque paterna vel sugess[t]ione tenuisti haereditario jure tibi delegatum per auctoritatem Dei omnipotentis ... '* (which is the wording of the Ratold Ordo), instead of *successione* (which is the wording of the German Ordo).

144. Bober, 1958, 1–12; Sherman, 1977, 261, n. 20, 263.

145. Bober, 1958, 1–12; Sherman, 1977, 261, n. 20, 263.

146. Bober, 1958, 1–12.

147. There are other possibilities, such as the daughter and only child of Louis X, le Hutin, Jeanne of France, queen of Navarre and her husband Philippe d'Evreux, the brother of Jeanne d'Evreux. According to Cazelles, 1982, 92, a sire de Montmorency is recorded as having been in their service in 1337; however, certain facts argue against this hypothesis. Jeanne had been denied her rights to succeed to the throne of France; as king and queen of Navarre the couple's coronation would not

have taken place at Reims, it would not have been performed by the archbishop of Reims, and neither king nor queen would have been anointed with the Celestial Balm, all of which figure in the imagery of this manuscript.

148. Charles de Montmorency, in particular, is frequently recorded at the court and was commissioned to carry out diplomatic missions. His name often appears in documents together with the names of Jean de Craon and Jean de Dormans, officiants in the sacre of Charles V. Charles de Montmorency was the principal godparent of Charles V's son, Charles VI, and in order to commemorate this occasion, he commissioned a golden reliquary for the abbey of Saint-Denis which displayed gold figures of Charles V, Jeanne de Bourbon, and the young prince Charles kneeling before a figure of Mary Magdalen, a gift which testifies to his patronage of sumptuous gifts to the Valois kings. See Delachenal, I, 1909, 105; II, 124, 194, n. 3, 205, 260, and esp. III, 534f. for a description of the reliquary which he cites from D. Felibien, *Histoire de l'Abbaye royale de Saint-Denis*, Paris, 1706, 536, 538. He also notes that cardinal Jean de Dormans, one of the peers in the coronation of Charles V, officiated at the baptism. The second godparent of Charles VI was Matthieu de Trie-Mouchy, one of the partisans most involved in efforts to reconcile the feuding houses of Valois and Navarre. Members of the house of Trie were among the most loyal partisans of Philip VI, John the Good and Charles VI.

149. See Avril, 1981, 317f., no. 270, and 316, no. 268. According to Avril the two artists who executed the miniatures of the Montpellier Bible belong to the second generation of Pucellian imitators and one of them (whom I believe to be the closest to the artist of the Illinois MS), makes frequent and flagrant borrowings from Pucelle's works, although his figures are squat with truncated legs, similar to those in the Illinois MS. Avril identified this artist as the author of illustrations on fols. 1, 5, 112v, 143v, and 215v, and also miniatures of a missal of the Use of Paris, (Lyon, Bibl. de la Ville, MS 5122), made in Paris *c.* 1345–50, an evangeliary of the Use of Paris, (Paris, Bibl. de l'Arsenal, MS 161) and an epistolary (London, BL, MS Yates Thompson 34). Avril adds that although these manuscripts came from the Sainte-Chapelle, they did not appear in the inventories of that royal chapel until 1363 (in the case of the two lectionaries) and 1366 (in the case of the missal). Their liturgical content conforms to the general Use of Paris, and the feasts specific to the Sainte-Chapelle do not appear until an insertion of *c.* 1400. Avril believes that it is probable that the three volumes had been destined from their origin for some royal chapel, and were only subsequently sent to the treasury of the Sainte-Chapelle.

150. See references in the previous note.

151. Legg, 1900, xxxi–xxxvii, 39–49, pl. 1.

152. Wilkinson, 1933, 405–16; *idem*, 1944, 445–69.

153. Ward, 1939, 177–8; Richardson and G.O. Sayles, 1935–6 (XIII), 129–45.

154. Ward, 1939, 177–8.

155. Hughes, 1990, 197–216.

156. J. Wickham Legg, ed., *Missale ad usum ecclesie Westmonasteriensis*, The Henry Bradshaw Society, I, V, XII, London, 1891–97; Legg, 1901, xxxi; Ward, 1939, 177–8; Richardson and Sayles, 1935–6 (XIII), 129–45 and 1936–7 (XIV), 1–9, 145–8.

157. Sturdy, 1990, 228–245.

158. Avril, 1981, 298–99, nos. 245–6.

159. Legg, 1900, xxxi–xxxvii.

160. Legg, 1900, xxxi–xxxvii.

161. For the text see Legg, 1900, xxxi–xxxvii.

Notes to Chapter 3

1. For the dating of the French ordines see preceding chapter and Jackson, 1984, esp. 24–34, 222–3; and *idem*, 1985, 63–74. Jackson corrected the dating of Schramm, 1938, II, 3–55.

2. Following Dewick, 1899, cols. 71, 73, 76–82, Schramm, 1938, 42–7, noted the internationalism of the sources of the formularies in the Ordo of Charles V.

3. Schramm, 1938, 42–7.

4. Schramm, 1938, 25–6; Jackson, 1985, 63–74.

5. We might mention the abundant Carolingian references in the miniatures and text of the Ordo of Charles V, including the so-called crown and sword of Charlemagne used in the sacre and appearing throughout the miniature cycle, and the sceptre of Charles V surmounted by an effigy of Charlemagne in the scene of the king's enthronement on the solium, now in the Louvre. Golein states in his introduction to the *Rational des divins offices* that Charlemagne is the patron saint of the kings of France. Golein, ed. Jackson, 1969, 310. Beginning with Philip the Fair, the feast of Charlemagne was celebrated in royal chapels. See Folz, 1950, 394.

6. '*car premierement a prendre vostre nativite il est certain que vous estes filz de roy de France et qui plus est roy de france est le plus grant le plus hault et le plus catholique et le plus puissant roy crestien. Et avec ce estes extrait du lignage des empereurs romains qui portent laigle pour ce que ce fut le premier signe*' Augustine, *La Cité de Dieu*, trans. Raoul de Presles, Abbeville, 1486, f. a. iii.

7. Mentioned in the inventory of his treasures compiled in 1363. For this see Gaborit-Chopin, ed., 1996, 33, no. 17.

8. Krynen, 1993, 365; Beaune, 1985, 224; Lewis, 1986, 177–82.

9. Gaborit-Chopin, ed., 1996, 33, n. 31 and 78, n. 750 for example: '17 – *Item la grande coronne ou sont des saintes espines de la coronne de Notre Seigneur, que Monseigneur fit faire des florons qui furent la royne de Bolongne ou estoient les larges esmeraudes*', identified by Gaborit-Chopin with no. 805 of the same inventory: '*Item la belle coronne d'or neufve que Monseigneur a faict faire, en un estuy de cuir, et son pied d'argent doré*'. The entry is preceded by a notation that it is kept 'in a chest sealed with the seals of Bertran Du Clos and Guillaume de Vaudetar', and '14 – *Item le cercle que le Roy achepta de Bernait Belon* ... ' whom Gaborit-Chopin identifies as a member of a wealthy family of merchants from Lucca; see 33, n. 26.

10. Delisle, 1874, no. 149.

11. Delisle, 1874, no. 167.

12. Delisle, 1874, nos. 151, 82.

13. Known today as 'white lawn'; cf. Delisle, 1874, nos. 539, 1267, 1720.

14. Autrand, 1994, 352.

15. Autrand, 1994, 352–4.

16. The bibliography is vast but one of the best studies of this subject remains Little, 1978, *passim*. See also Hallam, 1986, *passim*; Cazelles, 1982, *passim*; Epstein, 1991, *passim*.

17. Cazelles, 1982, 30–31; *idem*, 1962–3, 92–4.

18. It might be noted that the doctrine of transubstantiation continued to be a divisive issue thoughout the entire fourteenth and fifteenth centuries; one of the most vehement oppositions came from England and was led by John Wyclif, whose teachings were condemned at the Council of Constance. See M. Keen, 'Wyclif, the Bible and Transubstantiation', and G. Leff, 'Wyclif and Hus: A Doctrinal Comparison', both in *Wyclif and His Times*, ed. A. Kenny, Oxford, 1986, 1–16 and 105–26.

19. Schramm, 1938, 33ff., 26, 28ff. and 42–8. Jackson, 1984, 207–8 and n. 3. See also Jackson, 1985, 63–74.

20. Jackson, 1984, 207–8; Leroquais, 1937, I, iv ff.; Andrieu, III, 1940. The Last Capetian Ordo also included elements from the Ratold Ordo which, as we have seen, is the early version of the Second English Ordo revised for a Continental situation. See esp. Bouman, 1957, 17ff. and 118ff. Schramm, 1938, 20ff. called the Ratold Ordo the Fulrad Ordo and he referred to the West Frankish Ordo of Sens of *c.* 900 as the Erdmann Ordo.

21. See ch. 2.

22. Hand anointing was first introduced into the sacre in the Carolingian period but subsequently eliminated. It was re-introduced in the *Pontificale Romano-Germanicum*. See ch. 2.

23. '*Sta et retine locum a modo quem hucusque paterna* successione *tenuisti haereditario jure tibi delegatum, per auctoritatem Dei Omnipotentis … .*' The *Sta et retine* in the Last Capetian Ordo follows the formula in the Ratold Ordo that gives *suggestione* instead of *successione*, and thus constitutes a less forceful statement in affirmation of the principle of hereditary succession. See above ch. 2.

24. See Schramm, 1938, 30ff. where he identifies the richly illustated codex Paris, BN, MS lat. 1246 as an example of this compilation and identifies this manuscript with no. 233 bis of the Library of Charles V. See Delisle, 1907, II, 41, no. 233.

25. Hincmar, *Vita S. Remigii* [apud Surium], *De vitis sanctorum*, Venice, 1581, I, fol. 92v. Dewick, 1899, col. 69. West Frankish Ordo of *c.* 900 and the Ratold Ordo do not mention the use of the Celestial Balm, which, however, occupies a prominent position in the French ordines after 1200. See chapter 2.

26. Jackson, 1984, 222–3 and 1985, 63–74 demonstrated that all three ordines were compiled during the reign of St Louis and he made the important observation that the emphasis upon the Celestial Balm points to the influence of Reims, whether the monastery of Saint-Remi, the canons, or archbishop of the cathedral of Reims.

27. Krynen, 1993, 61, 347. Hallam, 1980, 135, 179.

28. Hallam, 1980, 131–2 and Krynen, 1993, 62.

29. Krynen, 1993, 353.

30. Bossuat, 1973, 12.

31. See especially Beaune, 1985, *passim* and 226–7.

32. '*car premierement a prendre vostre nativite il est certain que vous estes filz de roy de France et qui plus est roy de france est le plus grant le plus hault et le plus catholique et le plus puissant roy crestien. Et avec ce estes extrait du lignage des empereurs romains qui portent laigle pour ce que ce fut le premier signe romain. Se condement en ce que vous estes le plus digne roy crestien car avec ce que en vostre baptesme vous estes enoint du saint cresme come est ung chascun bon crestien. Encore par excellence estes vous roy consacre et si dignement enoint come de la saincte signeur qu par un coulomb q nous tenons fermement que ce fut le saint esperit mis en celle fourme aporta du ciel en son bec en une petite ampole ou fiole et la mist venant tout le peuple en la main de monseignr saint remy fors archevesque de reims q ta tost en co sacra les fons et en enoint le roy clovis premier roy crestien. Et en ceste reverence et pour ce tres grant et noble mistere tous les roys de france qui de puis ont este a leur premiere creacion ont este consacrez a reins de la liqueur de celle saincte ampole. Et ne tiengn vous ne autre que celle consecracion soit sans tresgrant digne et noble mistere car par icelle voz devanciers et vous aves telle vertu et puissance qui vous est donnee et attribuee de dieu que vous faictes miracles en vostre vie, telle si grandes et si appertes q vous garissiez dune tres horrible maladie qui sapelle les escroelles de laquelle nul autre prince terrien ne peut garir, fors vous … *', Augustine, *La Cité de Dieu*, trans. Raoul de Presles, Abbeville, 1486, 2 vols., fols. a. iii–iv for the relevant passages on the Celestial Balm. For Charles V's presentation copy, Paris, BN, MSS fr. 22912–13. Raoul de Presles also praised the Celestial Balm in earlier works which he presented to John the Good and Charles V such as *La Musa*, Paris, BN, MS lat. 3233 and Oxford, Balliol Coll., MS 274, fols. 238–53v. For a discussion of these works see Robert Bossuat, 1973, 1–74. Lombard-Jourdain, 1981, 191–207.

33. Golein, ed. Jackson, 1969, 324. Golein states in the concluding paragraphs of this treatise that Raoul de Presles was his master.

34. Golein, ed. Jackson, 1969, 309.

35. Cited by de Pange, 1955, 349–50.

36. Krynen, 350–2. Passage translated from the *Songe du Vergier*, ed. Schnerb-Lièvre, 1982, I, 51.

37. Beaune, 1985, *passim*, esp. 207–29; Krynen, 1993, 348–9.

38. For the symbiotic development of the episcopal and royal consecration rituals see esp. Andrieu, 1953, 22–73 and Batiffol, 1923, 732–63. Dewick, 1899, cols. 75 and 87 noted: 'There are so many analogies between the service for the coronation of a king and the consecration of a bishop that it is possible that the fact that the newly consecrated bishop received communion in two kinds may have secured the same privilege for the kings of France'. In addition to the communion Dewick, col. 87 compared the blessing of the gloves to the comparable ritual in the

episcopal consecration. Delachenal, III, 1916, 86 also commented upon the similarity of the sacre to the consecration of a bishop, though neither made a systematic effort to compare the Ordo of Charles V with the consecration of a bishop.

39. See esp. Bouman, 1957, *passim*.

40. See esp. Andrieu, 1953, 22–73 and also Bouman, 1957, *passim*.

41. Dewick, 1899, cols. 36 and 85–7. This reference occurs in the prayer *Accipe coronam regni*, recited at the imposition of the crown. The relevant passage is as follows: ' … *et per hanc [coronam] te participem ministerij nostri* … '. Delachenal, III, 1916, 87 also observed that the king, through the sacre, is charged with a ministry comparable to that of a bishop.

42. In the formula for the imposition of the crown,' … *et per hanc te participem ministerij nostri.*' See Vogel and Elze, 1963, I, 257 (appendix, lxxii, 22–3).

43. Golein, ed. Jackson, 1969, 315.

44. Golein, ed. Jackson, 1969, 315.

45. The coif, which was also called a *cale* in the documents of the period, is a cap which was tied under the chin. Golein, ed. Jackson, 1969, 317f.

46. Golein, ed. Jackson, 1969, 316.

47. One might cite, for example, the case of Robert Le Coq, the bishop of Laon who was condemned as a co-conspirator of Marcel and Toussac. Although Marcel was murdered and Toussac executed for their role in the disorders of 1358, the bishop of Laon was merely exiled. Similarly, Charles of Navarre was not executed for his treasonous murder of Charles of Spain, but was imprisoned. And there is the example of John the Good at Poitiers, although admittedly in his case his ransom price was probably a far more important deterrent against his murder than his anointed status.

48. Krynen, 1993, 128–30. Krynen cites Lev. I, 23, which is incorrect. Rather, the reference should be to Exodus 29 and Leviticus 8.

49. Krynen, 1993, 129 and Bossuat, 1973, 113–86.

50. Krynen, 1993, 130; Oresme, ed. Menut, 1970, 155–6.

51. The innovations of the queen's ordo are considered in the following chapter.

52. Schramm, 1938, 40–7.

53. Schramm, 1938, 40–7.

54. David, 1950, parts 1,2,3, *passim*.

55. Dewick, 1899, col. 19 and n. 1. This erasure is barely visible and the script is not significantly coarser than the original script of the manuscript.

56. Jackson, 1984, 73–5.

57. Some of the manuscripts corrected by Charles include Paris, Bibl. de l'Arsenal, MS 590, fol. 527v. See Avril, 1981, no. 163; Paris, BN, MS fr. 437 with several corrections and an autograph on fol. 403; Paris, BN, MS fr. 1792, fol. 89v.

58. Krynen, 1993, 155ff.

59. Cazelles, 1982, 512–3 and nn. 27–8, citing *Ordonnances*, IV, 212–3.

60. See ch. 1 for the Treaty of Bretigny. Cazelles, 1982, 512–3; Krynen, 1993, 155ff.

61. Krynen, 1993, 157 citing the *Songe du Vergier*, ed. Schnerb-Lièvre, 1982, II, 202.

62. Krynen, 1993, 125–60.

63. Golein, ed. Jackson, 1969, 314.

64. Golein, ed. Jackson, 1969, 311.

65. Golein, ed. Jackson, 1969, 318.

66. Golein, ed. Jackson, 1969, 311.

67. Golein, ed. Jackson, 1969, 317.

68. Golein, ed. Jackson, 1969, 310.

69. Golein, ed. Jackson, 1969, 310–11.

70. Golein, ed. Jackson, 1969, 317.

71. It is beyond the scope of the present study to resolve the problems involved with the passage on the crown, but the Directory of *c.* 1230 and the Ordo of *c.* 1250 both appear to articulate a special role for the image and motif of the crown which anticipates this clause. Moreover, the role of the peers in sustaining the crown in all of the French ordines also seems to be instrumental in defining this theory.

72. Cazelles, 1982, 505–16.

73. Jackson, 1984, 68–85 has shown the influence which this passage had in the successive centuries.

74. See esp. Beaune, 1985, 16, 112–3, 226–7.

75. Beaune, 1985, 97, 112–3, 214, 226–7.

76. Lombard-Jourdain, 1991, 161 claims that the blessing of the oriflamme in the Coronation Book is accompanied by the following passage: *Et la messe chantee et le drap de soie vermeille desplié par le prelat et mis en la lance doree et faite sur ycelle la beneicon.* She cites Dewick, 1899, col. 50 for this quote, but this passage appears neither in the original manuscript in the British Library nor in Dewick's edition. Nor does it occur in conjunction with the blessing of the oriflamme in the Last Capetian Ordo. The source for this quote remains obscure.

77. For further discussion and references see the discussion for pl. 38.

78. Contamine, 1973, 218–23 and discussion for pl. 3; Lombard-Jourdain, 1991, 154–5.

79. Lombard-Jourdain, 1991, 155.

80. Lombard-Jourdain, 1991, 155 citing Golein in BN, MS fr. 437, fol. 53.

81. Contamine, 1973, 221, and Lombard-Jourdain, 1991, 151–76.

82. Lombard-Jourdain, 1991, *passim*, and esp. 129–207.

83. See e.g. Lombard-Jourdain, 1991, 175.

84. Lombard-Jourdain, 1991, 175.

85. Other miniatures with icons of angels on the altar include fols. 50, 54v, 70.

86. Lombard-Jourdain, 1991, 157 and n. 76 identifies Golein's sources as the legends of the Dream of Constantine and the *Descriptio qualiter Karolus magnus clavum et coronam Domini a Constantinopoli Aquisgrani detulent*, the latter written at Saint-Denis between 1080–95.

87. Golein, ed. Jackson, 1969, 320–4.

88. E.g. the delivery of specific regalia and the sacre of the queen.

89. Golein, ed. Jackson, 1969, 315.

90. Dewick, 1899, col. 17 (fols. 45–45v): '... *ducant predicti episcopi regem consecrandum ad sedendum in cathedra sibi preparata in conspectu cathedre archiepiscopi* ... '.

91. Dewick, 1899, 25 (fol. 51v): *Archiepiscopus ... debet autem sedere sicut sedet cum consecrat episcopos.*

92. Dewick, 1899, col. 40 (fol. 63): *Deinde coronatus rex e[s]t ducatur ... ad solium iam ante preparatum. Et dum rex ad solium venerit archiepiscopus ipsum collocet in sede.* The text states that the 'solium was prepared *beforehand.*' The opening rubrics of the Ordo of Charles V pertain to the preparation of the solium, Dewick, 1899, col. 15 (fol. 43), and are as follows: *Primo paratur solium in modum eschafaudi aliquantulum eminens contiguum exterius choro ecclesie inter utrumque corum positum in medio in quo per gradus ascenditur.*

93. For this ritual in the episcopal sacre see e.g. Andrieu, I, 1938, 138ff. and III, 1940, 374ff. (episcopal) and 436ff. (royal).

94. Presentation by two bishops occurs in the Ratold Ordo.

95. See e.g. Andrieu, I, 1938, 138ff., and III, 1940, 374ff.

96. See Andrieu, (*Pontifical*) III, 1940, 330, 374–93, 436–46. Schramm, 1938, 42ff. observed that the Ordo of Charles V is the first king-making ceremony in which the ritual of the blessing and delivery of the gloves was performed.

97. See also the discussion of the gloves in the Catalogue.

98. Andrieu, 1953, 55ff. and Batiffol, 1923, 753 ff.

99. For the above parallels between the episcopal and royal ceremonies compare e.g. Andrieu, III, 1940, 436–46 (king's ceremony) with 374–93 (bishop's ceremony). Dewick, 1899, 87 observed that the king's reception of communion in two kinds was connected with the episcopal consecration in which the newly-consecrated bishop communicates in two kinds.

100. Delachenal, 1916, III, 85 n. 4.

101. There are innumerable instances in which medieval prelates went into battle and led armies, but it has never been a legitimate and canonically sanctioned activity. See e.g. Mundy, 1973, 320.

102. Dewick, 1899, col. 23 (fol. 49): *et incontinenti dare senescallo francie si senescallum habuerit.*

103. Dewick, 1899, 15 (fol. 43) and 40 (fol. 63).

104. See Dewick, 1899, col. 25 (fol. 51) where the king is directed to kneel against the faldstool prior to the anointing: *et genibus regis in terram positis prostrato super faldistorium.* No further instructions are given for the

king to rise until after the delivery of the insignia and crown when the king is led to the seat prepared for him on the elevated tribune on fol. 63, Dewick, col. 40: *Deinde coronatus rex e[s]t ducatur per manum ab archiepiscopo ... ad solium iam ante preparatum. Et dum rex ad solium venerit archiepiscopus ipsum collocet in sede.*

105. Batiffol, 1923, 736ff.

106. Golein, ed. Jackson, 1969, 310.

107. The Ordo of Charles V includes other formularies which originated in the Carolingian period, specifically in the Protocols of Hincmar, e.g. the *A vobis perdonare*. See Dewick, 1899, col. 73f.

108. Dewick, 1899, cols. 35 and 84.

109. Golein, ed. Jackson, 1969, 313.

110. The two thrones are seemingly an expression of the two natures of the king, his terrestrial nature and that part of his nature which transcends the terrestrial.

111. See Dewick, 1899, col. 8f. (fol. 38v): `Li arcevesques doit appareillier la sainte ampole sus lautel et en doit traire a une aguille dor aucun petit de luyle envoyee des cieux et meller o grant diligence avecques le cresme ... '.

112. Dewick, 1899, col. 25 (fol. 51): '... *et inde cum acu aurea aliquantulum de oleo celitus misso attrahere et crismati parato in patena diligentius cum digito immiscere ad inungendum regem ... '.*

113. Referring to the anointing ritual thus: *regem qui solus inter universos reges terre hoc glorioso profulget privilegio: ut oleo celitus misso singulariter inungatur*, Dewick, 1899, col. 25 (fol. 51).The notion of the uniqueness of the anointing of the king of France is also expressed by the French translation, Dewick, 1899, col. 9 (fol. 38v).

114. Golein, ed. Jackson, 1969, 316.

115. Golein, ed. Jackson, 1969, 313.

116. For a consideration of the function of the miniatures in the *Grandes Chroniques* of Charles V see Hedeman, 1985, 171–81.

117. Dewick, 1899, 169 (fol. 44)

118. Dewick, 1899, 16 (fol. 44v)

119. Dewick, 1899, col. 71 observed that the scene in the bedroom chamber in the Ordo of Charles V corresponded to the *Ordo Romanus* published by M. Hittorpus, *De Divinis Catholicae Ecclesiae Officiis*, Paris, 1624, and he cites Constantin Leber, 1825, 156–80 and Dom Bevy, *Histoire des Inaugurations*, 1776, 519 who gave an account of this ceremony, referred to as the 'lever du roi'. Dewick considered this scene in the *Coronation Book* to be the earliest appearance of the ritual that became a prominent part of sacres after the coronation of Charles V. Jackson, 1984, 126 notes the precedent of the Pontifical of Mainz and the relevant passages for the fetching of the king in the Ordo of Charles V. He did not remark upon the coincidence of the word 'thalamus' in each ordo nor on the double meaning of this word which signifies both a secret chamber and a bridal bed. He conjectured that the bed of this scene was inspired by the ceremony for the dubbing of a knight in which the knight takes a ritual bath after which he lies in a bed until he is dry. Jackson conceded that the ritual bath does not appear in any

royal ordo including that of Charles V. This argues against the dubbing ritual as the source for the bed, since the bed in that ceremony is introduced in order to accommodate a need created by the ritual bath. This, along with the remarkably close correspondence between the texts of the Ordo of Mainz and that of Charles V, make it appear very certain that the earlier ordo is the source for the later.

120. See Molin and Mutembe, 1961, 27–8, 284; also see preceding chapter. For the nuptial theme in the royal and episcopal consecration ceremony see e.g. Valensise, 1986, 64f.

121. Schramm, 'Die Krönung in Deutschland bis zum Beginn des Salischen Hauses (1028)', *Zeitschrift für Rechtgeschichte, kan. Abt.*, 24, 1935, 310–11: *Primum, exeunte illo [rege] thalamum, unus episcoporum dicat hanc orationem: Omnipotens, sempiterne Deus [...]. Postea suscipiant illum duo episcopi dextera levaque, honorifice parati, habentes sanctorum reliquias collo pendentes; ceteri autem clerici sint casulis adornati. Praecedente sancto evangelio et duabus crucibus cum incensu boni odoris, ducant illum ad ecclesiam, canentes responsorium: Ecce mitto angelum meum [...]. Versus: Israel, si me audieris [...] cuncto eum vulgo sequente.* Cited by Jackson, 1984, 125f.

122. French translation of the Directory of c. 1230, Ordo of 1250 and the Last Capetian Ordo.

123. For all that follows on Dormans see L. Carolus-Barré, 'Le Cardinal de Dormans, chancelier de France, principal conseiller de Charles V', *Mélanges d'archéologie et d'histoire. Ecole française de Rome*, 52, 1935, 314–48.

124. Autrand, 1994, 702–8.

125. Autrand, 1994, 702 ff.

126. See e.g. Cazelles, 1982, 249–50, 443.

127. See n. 119 above.

128. Michel Bur, 'Reims, ville des sacres', in *Le Sacre des rois*, 1985, 39–48.

129. Hallam, 1980, 99.

130. Krynen, 1993, 14–16.

131. Bur, 1985, 40.

132. See Spiegel, 1971–2, 145–74.

133. For the rivalry between Saint-Denis and Reims over the right to crown the king of France see Spiegel, 1975, 43–69.

134. Delisle, 1916, III, 69 and n. 3 who cites Varin, 1839–48, I(1), 209 n. 1, 384, II(2) 527–31, 919 n. 1, II(1) 172 n. 1, 284.

135. Dewick, 1899, 15f. (fol. 43v): *episcopis paribus videlicet primo Laudunensi, post ea Belvacensi, deinde Lingonensi post ea Cathalanensi ultimum Noviomensi ... cum alys episcopis archiepiscopatus remensis.*

136. Golein, ed. Jackson, 1969, 310 and 313.

137. Delachenal, 1909, II, 155ff. and Père Anselme de Sainte-Marie, *Histoire généalogique et chronologique de la maison royale de France*, 3rd ed., vol. VIII, Paris, 1726, 567–70, repr. 1967.

138. Varin, 1848, III, 204–9.

139. Cazelles, 1982, 196f.

140. Jean de Craon was related to the Bourbons through his great-grandmother Isabelle de la Marche who was an ancestor of the duke of Bourbon, the father of Queen Jeanne de Bourbon.

141. Cazelles, 1982, 272. Delachenal, 1909, II, 281 and n. 1.

142. The importance of Clement VI for the Valois was considered above in ch. 1. See esp. Delachenal, 1909, I, 25–47; Cazelles, 1958, 70, 90, 91, 111, 137; and *idem*, 1982, 196f.

143. Cazelles, 1982, 196f.

144. Delachenal, 1909, I, 316f. and n. 7; Cazelles, 1982, 278f.

145. Cazelles, 1982, 430ff.

146. Varin, 1848, III, 204, n. 1.

147. Varin, 1848, III, 206; Cazelles, 1982, 455f.

148. Varin, 1848, III, 207; Cazelles, 1982, 440ff. and 455f. The bourgeoisie of Reims did not acknowledge their loyalty to the person of the prince, but rather to the king, whose right, they affirmed, was that his eldest son succeeded him.

149. Cazelles, 1982, 440ff., 455f. The close ties between the Valois, Bourbon and the House of Craon were furthered when Jean de Berry's son Charles de Berry was betrothed to Marie de Sully, daughter of Louis de Sully and Isabeau de Craon. This was however only of temporary consequence, for the young prince died in 1383. See Meiss, 1967, I, 449.

150. Golein, ed. Jackson, 1969, 305.

151. Delachenal, 1909, I, 1–25; Cazelles, 1982, 30, 44, 59, 90, 98, 455.

152. Varin, 1848, III, 206: letter of the dauphin to the echevins of Reims, 5 February 1361, *'au mois de decembre suyvant, mondict seigneur duc de Normandye vint en ladicte ville de Reims, ou estant, il manda aux eschevins dudict Reims l'aller veoir en son logis chez maistre Guillyaume de Machault ... '.*

153. Delachenal, 1916, III, 93–4.

154. For this see ch. 6 below.

155. See Epilogue.

156. Autrand, 1994, 702–7.

157. For this see ch. 6 below.

158. Golein, ed. Jackson, 1969, 318.

159. Golein, ed. Jackson, 1969, 309.

Notes to Chapter 4

1. Janet Nelson, 'Queens as Jezebels: the Careers of Brunhild and Balthild in Merovingian History', in D. Baker, ed., *Medieval Women. Essays Presented to R.M.T. Hill* [SCH subsidia 1], Oxford, 1978, 31–77.

2. E. Ward, 'Caesar's Wife: The Career of the Empress Judith, 819–29', in P. Godman and R. Collins, eds., *Charle-*

magne's Heir: New Perspectives on the Reign of Louis the Pious (814–40), Oxford, 1990, 205–27.

3. D.M. Mayer, 'Studies in the history of Queen Melisende of Jerusalem', *Dumbarton Oaks Papers*, 26, 1972, 93–182.

4. M. Chibnall, *The Empress Matilda: Queen Consort, Queen Mother, and Lady of the English*, Oxford, 1991.

5. W.W. Kibler, ed., *Eleanor of Aquitaine: Patron and Politician*, Austin, 1976, in particular the article by E.A.R. Brown, 'Eleanor of Aquitaine: Parent, Queen and Duchess', 9–34.

6. J.C. Parsons, ed., *Eleanor of Castile, 1290–1990: Essays to Commemorate the 700th Anniversary of her death, 28 November 1290*, Stamford, UK, 1991.

7. E. Berger, *Histoire de Blanche de Castille, reine de France*, Paris, 1895.

8. See esp. the bibliography in Parsons, ed., 1993.

9. See e.g. Lois Huneycutt, in Parsons, ed., 1993, 189–201; Facinger, 1968, 3–48.

10. Facinger, 1968, 3ff. and 8–12, and esp. 8. Also F. Barry, *La Reine de France*, Paris, 1964.

11. For a recent discussion see Poulet, in Parsons, ed., 1993, esp. 98–101, drawing upon Poulet's thesis *La régence et la majorité des rois au moyen âge: histoire de la continuité monarchique et étatique sous les Capétiens et les Valois directs*. PhD thesis, Faculté des Sciences Historiques, Université des Sciences Humaines de Strasbourg, 1989.

12. The distinction between the king's wife and the queen as a public figure was made by Françoise Barry in her published doctoral dissertation for the Law Faculty of the University of Lille, see Barry, 1932. P. Stafford, 'The king's wife in Wessex 800–1066', *Past and Present*, 91, 1981, 3–27; idem, *Queens, Concubines and Dowagers. The King's Wife in the Early Middle Ages*, Athens, GA, 1983.

13. Poulet, 1993, 93–106.

14. E.A.R. Brown, 'The political repercussions of family ties in the early fourteenth century: the marriage of Edward II of England and Isabelle of France', *Speculum*, 63, 1988, 573–95.

15. See esp. Barry, 1932, and idem, 1964; See also Poulet, 1993, 112–3.

16. Poulet, 1993, 106–9.

17. See e.g. Cazelles, 1958, esp. 157–63.

18. Poulet, 1993, 112–3.

19. Berger, 1884, 228.

20. See e.g. Berger, 1884, 228; Cazelles, 1958, esp. 159–61.

21. See Cazelles, 1958, 160.

22. See ch. 2 above for the discussion of the West Frankish Ordo of c. 900.

23. For Jeanne de Bourgogne's correspondence with popes and her patronage of translations and of illustrated manuscripts see Berger, 1884, 221, 228, and Avril, 1981, 296 (no. 241), 298–9 (no. 245).

24. Beaune, 1985, 264–9; Krynen, 1993, 127–42.

25. Beaune, 1985, 264–9; F. Autrand, 1995, 25–32.

26. Cazelles, 1982, 580; Autrand, 1994, 628.

27. See Autrand, 1994, 636.

28. See Autrand, 1994, 635–6 and Cazelles, 1982, 579–81.

29. See e.g. Poulet, 1993, 113–14; Cazelles, 1982, 579–81; Krynen, 1993, 140–2, Autrand, 1994, 628–40, esp. 635–7.

30. Krynen, 1993, 140–2, Autrand, 1994, 635–7.

31. See e.g. Autrand, 1994, 636; Cazelles, 1982, 580; Poulet, 1993, 113–4.

32. Autrand, 1994, 635.

33. Sherman, 1977, 255–98.

34. Sherman, 1977, 257 and n. 7. Sherman states that 'a comparison with ordines of the queen's ceremony going back to 980 shows that the text for Jeanne de Bourbon's consecration and coronation includes thirteen prayers, almost twice the number included in previous examples'. However, I would emphasize that all of the thirteen prayers appear either in the Last Capetian Ordo or the Ordo of 1250. The editor of the Ordo of Jeanne de Bourbon essentially combined these two ordines to create this new ordo.

35. Sherman, 1977, 271 makes the point that 'the queen's cycle is slightly more densely illustrated than the king's if one compares the nine miniatures in the seven folios of the queen's ordo to twenty-seven miniatures in the twenty-three folios of the king's portion'. For further discussion see ch. 5 below.

36. Displayed where elements of the queen's ceremony were moved forward and incorporated into the king's ordo. For example, the instructions for the actions of the queen in the Mass which takes place after the double sacring are located at the end of the king's ordo where the actions of the king at the Mass are detailed. See Dewick, 1899, col. 42.

37. See ch. 5 for further discussion of this observation.

38. According to Sherman, 1977, 271, 286, the queen's ordo contains nearly twice the number of liturgical elements as queens' ordines from the thirteenth and fourteenth centuries. She notes that Schramm and others have emphasized the increased length of Charles V's ordo, but she makes the point that it was not inevitable that the queen's ordo would be increased so significantly over earlier queens' ordines. Sherman, 291ff. attributes the expanded coronation rites for Jeanne de Bourbon to the couple's childless state at the time of the ceremony arguing that 'the emphasis on fertility in the paradigmatic prayers included in the text of the queen's ordo lends validity to this idea'. Although she cites in n. 7 the texts of the Fulrad (Ratold) Ordo, the Ordo of 1250, the Ordo of Reims of c. 1230 in Reims, Bibl. Mun., MS 328, and the Last Capetian Ordo, Sherman does not identify precisely with which ordines and formularies she compared the text of the Ordo of Jeanne de Bourbon. It appears that she compared it only with the queen's ceremony in the Last Capetian Ordo, which was the ordo in use prior to the sacre of Charles V. Indeed, the Ordo of Jeanne de Bourbon is twice as long as the queen's ceremony in the Last Capetian Ordo, but the added prayers in the Ordo of

Jeanne de Bourbon are not new and were not written spe-
cifically for the sacre of Jeanne de Bourbon. See n. 33
above. Not having observed that the prayers were de-
rived from the Last Capetian Ordo and the Ordo of 1250,
Sherman's interpretation of the relevance of the ordo to
the couple's childlessness in 1364 is compromised; the
references to the fertility of biblical matriarchs which she
relates to the childlessness of Jeanne de Bourbon are not
innovations of the Ordo of Jeanne de Bourbon.

39. For an early study of the sacring of queens see
Wintersig, 1925, 150–3; also Facinger, 1968.

40. Bouman, 1957, 151 and n. 2; and Facinger, 1968, 8ff.

41. Bouman, 1957, 17 and 19ff.; Facinger, 1968, 8ff.;
Schramm, 1960, I, 21ff.

42. See ch. 2 above; also Bouman, 1957, 151 and n. 1.

43. Bouman, 1957, 151 and 164 for the following passage
from the Judith Ordo: '*Accipe anulum fidei et dilectionis
signum ... quos coniungit Deus qui vivat et
regnat ... despondeo te uni viro ... sanctificatore nuptiarum
Iesu Christo Domino nostro qui vivat et regnat ... *', and
107ff., and esp. 110 and n. 2 for the protocol for the mar-
riage of Judith to Aethelwulf, king of the Anglo-Saxons
on 1 October 856; also 8ff. for a discussion of this and
other Protocols of Hincmar. See in addition Schramm,
1938, 8–12 and Schramm, 1960, I, 21ff.; Andrieu, 1953, 23f.

44. Facinger, 1968, 17ff. and Schramm, 1960, I, 21f.

45. See Staerk, 1910, 168 and Bouman, 1957, 15 and 155ff.

46. Bouman, 1957, 151f. and 155f.

47. Staerk, 1910, I, 169: '*Adesto Dne. supplicationibus
n[ost]ris. et quod nre humilitatis ministerio
gerendum ... benedictionis ... super hanc famulam tuam ... *'.
'*D[eu]s cuius omnis potestas. omnisque dignitas ... da
famule tuae... *'.

48. Bouman, 1957, 151.

49. Bouman, 1957, 151.

50. See e.g. Vogel and Elze eds., 1963, I, 48–51, 62–9,
76–82.

51. Bouman, 1957, 15 and 155f.

52. Bouman, 1957, 17 and n. 3 and esp. 118ff. However,
this relationship may be subject to reversal if Nelson is
correct about the dating of the Edgar Ordo to 900 and if
Bautier is correct that the West Frankish Ordo was com-
piled for King Raoul and Queen Emma. See the sections
concerning these ordines in ch. 2 above.

53. Facinger, 1968, 17.

54. For the Ratold Ordo see Martène, 1736, II, 218–19 and
for the West Frankish Ordo see Staerk, 1910, II, 169–70.

55. For the text of the Directory of *c.* 1230 see Dewick,
1899, cols. 6–11.

56. The texts are published in Martène, 1736, II, 222–3 for
the Ordo of 1250, and 227 for the Last Capetian Ordo.

57. Bouman, 1957, 151.

58. Enright, 1985, 137f.

59. Compare the text of the Ordo of Jeanne de Bourbon,
Dewick, 1899, col. 45 with that of the Last Capetian Ordo
and the Ordo of 1250, Martène, 1736, II, 222, 227.

60. Golein, ed. Jackson, 1969, 318.

61. Golein, ed. Jackson, 1969, 323.

62. Golein, ed. Jackson, 1969, 315.

63. Golein, ed. Jackson, 1969, 320.

64. Golein, ed. Jackson, 308. For a concise biography of
Golein see introduction in Jackson, ed., 1969, 305ff.
Sherman, 1977, 266ff.

65. Facinger, 1968, 17ff. and 26ff.

66. Dewick, 1899, col. 90.

67. See Staerk, 1910, I, 166ff.

68. Dewick, 1899, 90, citing Adomnan, *Vita Sancti
Columbae*, Lib. III. cap. 5, ed. Reeves, 198.

69. The West Frankish Ordo and the Ratold Ordo do not
mention the Celestial Balm. For the Celestial Balm see
chs. 2 and 3. All three ordines from Reims call for the king
to be anointed with a mixture of Celestial Balm from the
Holy Ampulla and chrism, and they also specify that the
queen is anointed with blessed oil. Thus this important
distinction between the anointing of the king and queen
is something that entered the royal consecration liturgy
with the three ordines from Reims.

70. For the text of the Coronation Book see Dewick, 1899,
col. 46 where there is the notable absence of any mention
of the Celestial Balm for the anointing of the queen;
Golein, ed. Jackson, 1969, 323 (fol. 54) and esp. 319
(fol. 50v). This has been emphasized by Facinger, 1968,
18ff.; Schramm, 1960, I, 124ff. and 202; Bloch, 1924, 487f.;
Luchaire, 1891, and *idem*, 1892, 477.

71. Golein, ed. Jackson, 1969, 324.

72. Golein, ed. Jackson, 1969, 313.

73. Golein, ed. Jackson, 1969, 311 and 320.

74. Golein, ed. Jackson, 1969, 309 and esp. 319.

75. Golein, ed. Jackson, 1969, 318f.

76. Golein, ed. Jackson, 1969, 319.

77. These ideas are expressed in the benediction prayers
of the Ordo of 1250 and the Last Capetian Ordo. See
Martène, 1736, II, 227; also, Facinger, 1968, 23ff.

78. Facinger, 1968, 3–13 and 23ff.

79. Golein, ed. Jackson, 1969, 309.

80. Bouman, 1957, 16 and n. 7 observed that the Erdmann
Ordo (West Frankish Ordo of *c.* 900) is the earliest in
which the blessing for the queen follows that of the king,
giving ritual expression to the role of the queen as the
mother of the future successor.

81. Krynen, 1993, 347; Beaune, 1985, 216–26.

82. For a consideration of the formal parallels between
the two cycles see ch. 5 below.

83. See the preceding chapter for innovations in the Ordo
of Charles V.

84. Dewick, 1899, col. 46. for the text. Nor does the French translation mention the use of a golden needle for extracting or mixing the queen's chrism nor for anointing her, Dewick, col. 10.

85. For the codicological evidence see the following chapter.

86. Golein, ed. Jackson, 1969, 309 *'Par ceste raison de sainte consecracion et de Dieu sans autre moien … '.*

87. Golein, ed. Jackson, 1969, 318.

88. Golein, ed. Jackson, 1969, 314 and 317.

89. Golein, ed. Jackson, 1969, 323.

90. For further discussion of the formal dependence of the queen's cycle upon the king's see the following chapter on the form and function of the miniatures.

91. For example in the Ratold Ordo, the Ordo of 1250 and the Last Capetian Ordo the queen is not accorded a prominent entry.

92. Sherman, 1977, 271 and 284. Hedeman, 1990, 74ff. identifies this scene as the coronation of the queen.

93. Dewick, 1899, col. 44 and col. 10 for the French translation.

94. See the following chapter for further discussion.

95. Eckenstein, *Women under Monasticism*, London, 1896; Thomas Oestreich, 'Abbess', in *New Catholic Encyclopedia*, I, 7–10; Joan Morris, *The Lady Was a Bishop. The Hidden History of Women with Clerical Ordination and the Jurisdiction of Bishops*, Toronto, 1973.

96. See Andrieu, 1940, III, 409ff.; Vogel and Elze, 1963, I, 48–51, 62–9, 76–82.

97. Dewick, 1899, col. 90 also notes that this phrase occurs in the *De benedictione abbatis*. For both he cites *Pont. Rom, 1520, fol. 69. He also notes that although it has no parallel in a king's ceremony, it is possible that the laying-on of hands was once general practice at coronations, and that when it fell into disuse for the king's coronation, the expression may have remained in the office for (what he considers to be 'the comparatively unimportant office for the queen'. To support this hypothesis he cites an account of such a laying on of hands in the story of Columba's ordination of King Aidan: imponensque manum super caput ejus, ordinans benedixit,* cited from Adomnan, *Vita Sancti Columbae*, Lib. III, cap. 5, ed. Reeves, 198. Andrieu pointed out that in the Early Christian period the bishop was consecrated by the laying on of hands. He was not anointed, as noted above in ch. 3 until the Carolingian practice in emulation of the royal consecration.

98. *'Accipe inquam coronam … et per hanc te participem ministerij nostri … '*, Dewick, 1899, col. 36 and col. 85; Delachenal, 1916, III, 87.

99. *'A desto domine supplicationibus nostris et quod humilitatis nostre gerendum est ministerio tue virtutis impleatur effectu … ,* Dewick, 1899, col. 44. This prayer first appeared in the West Frankish Ordo.

100. Golein, ed. Jackson, 1969, 315.

101. Golein, ed. Jackson, 309 and 323.

102. Golein, ed. Jackson, 1969, 320.

103. See the following chapter for further consideration of the derivation of the queen's miniature from the miniature of the king's communion.

104. See Delisle, 1874, nos. 539, 1267, 1720. For Champagne linens see Abu-Lughod, 1989, esp. 64–6.

105. Molin and Mutembe, 1961, 25–7, 228–33. They cite Ambrose, the Leonine Sacramentary of Verona, for references to the most ancient formulae, slighty modified in the Gelasien Sacramentary and the Gregorian Sacramentary.

106. Molin and Mutembe, 1961, 229 and n. 24.

107. See Molin and Mutembe, 1961, 25–6, 228–37.

108. Metz, 1954, 294, 375f.

109. Metz, 1954, 121ff., 392f.

110. Metz, 363ff.; Vogel and Elze, 1963, I, 39–44.

111. Metz, 1954, *passim*.

112. Metz, 1954, 363ff.

113. Golein, ed. Jackson, 1969, 319.

114. Dewick, 1899, col. 45 (fol. 67v).The prayer in which this phrase occurs appeared earlier in the Ordo of 1250. See Martène, 1736, II, 222.

115. Enright, 1985, 137ff.

116. See Andrieu, III, 1940, 444. This was also the source for the gloves in the Ordo of Charles V. See also Sherman, 272 and n. 3 for references to a Burgundian ordo which calls for *crine soluto* in reference to the queen's coif.

117. Sherman, 1977, 272 and n. 64 suggests that it was somewhat like a magic charm.

118. See e.g. Vogel and Elze, 1963, 40; Andrieu, *Pontifical*, 1940, 416.

119. Golein, ed. Jackson, 1969, 315.

120. Golein, ed. Jackson, 1969, 323 states that a woman's inability to bear arms is yet another reason disqualifying her from kingship.

121. Golein, ed. Jackson, 1969, 323.

122. Golein, ed. Jackson, 1969, 323.

123. Golein, ed. Jackson, 1969, 323 makes this point not only by comparing the queen's anointing with chrism to that of priests but by differentiating between the powers of a priest to consecrate the Eucharist and of the king to cure scrofula received by anointing the hands with the respective oils.

124. Golein, ed. Jackson, 1969, 322.

125. Golein, ed. Jackson, 1969, 309: *'...et le royaume de france demourroit aux Roys de france descendans de la sainte et sacree lignie par hoir masle. afin que ceste beneicon demourast en transfusion de lun en lautre. Et pource est aussi la Royne sacree et le fu avec mon dit soverein seigneur Madame Jehanne de bourbon fille de noble prince le duc de bourbon qui estoit descendu dycelle sainte lignie et estoit sa cousine, mais par la dispensacion de leglise il lot a espouse. Par ceste raison de sainte consecracion et de dieu sans autre moien benoite generacion: conclus je que cest greigneur dignite estre Roy de france que lempereur'.*

126. Golein, ed. Jackson, 1969, 323 (fol. 54).

Notes to Chapter 5

1. On this issue see Guglielmo Cavallo, *Libri, editori e pubblico nel mondo antico. Guida storica e critica*, Rome and Bari, 1975, 5–24.

2. John Selden, *Titles of Honour*, 2nd ed., London, 1631 (3rd ed., London, 1672).

3. For further discussion of the history of the Coronation Book in the last three centuries see Epilogue.

4. See Epilogue.

5. See Dewick, 1899, 59–62.

6. For a study of the role of rulings in determining the design and placement of the miniatures see Donal Byrne, 'Manuscript Ruling and Pictorial Design in the Work of the Limbourgs, the Bedford Master and the Boucicaut Master', *The Art Bulletin*, 66, 1984, 118–36.

7. For these pendants see below in this chapter.

8. For the miniatures of this cycle see ch. 3.

9. Evidence for the originality of the miniatures is given in the chapter. It is instructive to compare these miniatures with the extensive documentation for crowning imagery given by Ott, 1998, *passim*. For the Ordo of 1250 in a pontifical of Châlons-sur-Marne, see Leroquais, 1937, I, 145ff. and pls. xxx–xxxvii.

10. The Pontifical of Châlons-sur-Marne has been identified with a manuscript in the library of Charles V: Schramm, 1938, 31, 42; Delisle, 1907, II, 41, no. 233 bis. We also noted in the study of innovations in the Ordo of Charles V, ch. 3, that the only precedent for the detail of the use of the golden needle for anointing is the miniatures of the Ordo of 1250 which include scenes of the archbishop using a golden needle to anoint the king (pls. 58–9).

11. For the coronation text which is now in the library of the University of Illinois in Urbana-Champaign see Bober, 1958, 1–12.

12. Although it is not impossible that the miniature was derived from a miniature of the consecration of a bishop in an unidentified pontifical, it appears rather unlikely that the miniature was copied from an extant miniature because, in instances when such a miniature is known to exist — and it is even probable that the redactor of the Coronation Book knew the miniature (such as the miniature of the anointing of the king with the golden needle in the Pontifical from Châlons-sur-Marne) — the Master of the Coronation Book approached the miniature with considerable independence, selecting only elements which suited his purpose, changing the composition and the treatment of the subject of the miniature.

13. For further discussion see ch. 2 above.

14. Up until this point the method of execution is fairly traditional. For example, it is quite similar to the processes described by Alexander, 1992, 35–51.

15. This observation receives some support from the comments of Alexander, 1992, 127 who questions the assumption that the workshops of successful illuminators necessarily employed a considerable number of assistants.

16. For example, the Last Capetian Ordo includes the transmission of the queen's ring, but not the anointing the king's hands or the rituals for the blessing and delivery of his gloves. The Ordo of 1250 includes the anointing of the king's hands but not the ceremony for the queen's ring or the rituals of the blessing and delivery of the king's gloves. The Roman Pontifical, as revised by Guillaume Durand (Durandus), introduced the glove ritual for the episcopal ceremony but not for the royal ceremony, and did not include the ritual for the Celestial Balm.

17. As a rule the miniatures of the king's cycle appear in proximity to their relevant text — in the scene of the enthronement of the king on the solium (pl. 24), for example, the form of the solium is described in the lengthy rubric at the beginning of the ordo.

18. Among these are the presentation of the king to the archbishop, the placement of the king *in cathedra* (pl. 6) and the blessing and bestowal of the gloves (pls. 19, 20). They all which include actions and gestures not accounted for by the text but which were inspired by the ceremony for the consecration of a bishop.

19. For example, many miniatures of the queen's cycle which reiterate analogous scenes in the king's ordo.

20. Sherman, 1977, 291.

21. Paris, BN, MS fr. 2813, fol. 439; and Paris, BN, MS fr. 437, fols. 44v and 50.

22. For recent investigations of the interaction of miniatures and text in a manuscript commissioned by Charles V see Hedeman, 1985, 171–81; and *idem*, 1984, 97–117; Sherman, 1995, *passim*.

23. Hedeman, 1985, 171–81.

24. A.D. Menut, ed. and trans., *Maistre Nicole Oresme. Le Livre de yconomique d'Aristote*. Transactions of the American Philosophical Society, 47, 5, Philadelphia, 1957, e.g. 795. Susan M. Babbitt, *Oresme's* Livre de Politiques *and the France of Charles V*. Transactions of the American Philosophical Society, 75, 1, Philadelphia, 1985, esp. 11–13; Sherman, 1995, *passim*, esp. 29–30, 179.

25. For what follows concerning glosses and commentaries see the analysis of Chenu, 1968, esp. 99–145. Others have made the same observations, including Babbitt, 1985, 11–13.

26. Chenu, 1968, esp. 99–145.

27. See ch. 2 above and Chenu, 1968, ch. 3, 99–145, 147ff. and 157.

28. Chenu, 1968, 99–145.

29. Kantorowicz, 1958, *passim*; Ullman, 1971, 106–7; J. Funkenstein, 'Samuel und Saul in der Staatslehre des Mittelalters', *Archiv für Rechts-und Kirchengeschichte*, 129–40; Chenu, 1968, 157ff.; L. Réau, *Iconographie de l'art chrétien. Introduction générale*, Paris, 1955, Ch. 4, 'Le symbolisme typologique ou la concordance des deux testaments'.

Notes to Chapter 6

1. Avril, 1968, 96, (no. 170), attributed the paintings in the Coronation Book to a single artist whom he called the Master of the Coronation Book whose hand he identified in the following manuscripts: Paris, BN, MS fr. 5707 (no. 167); London, BL, MS 19 D II; Brussels, Bibl. Roy., MS 10319 (no. 200); Paris, BN, MS fr. 2813 (no. 195); Paris, Arch. Nat. AE 11383 (J. 154, no. 5), (no. 22); St Augustine, *Cité de Dieu*, trans. Raoul de Presles, Paris, BN MSS fr. 22912–3; *Grandes Chroniques*, Paris, BN, MS fr. 2813; *Grandes Chroniques*, Great Britain, private collection, and London, British Library, MS Cotton Vitellius E. II, (no. 196); Brussels, Bibl. Roy., MS 11201–2 (no. 204). Avril, 1968, 113 cited S. Cockerell as having first identified the Master of the Coronation Book with the illustrated *Grandes Chroniques* in a private collection in Great Britain, fragments of which are in the British Library. According to Avril, 1978, 28ff. and 93f., the Master of the Coronation Book's earliest work was as assistant to the artist known as the Master of *Le Remède de Fortune*, with whom the master collaborated in the illustration of the works of Guillaume de Machaut (Paris, BN, MS fr. 1586). See also Avril, 1981, nos. 271, 276, 277, 278, 279, 281, 284 where Avril further discussed the identification of these manuscripts with the Master of the Coronation Book. Sherman, 1977, 265 noted the unevenness of quality of the miniatures and concluded that different hands were involved and that 'a carefully controlling hand must have been responsible for the consistency of the portrait types of Charles V and Jeanne de Bourbon, the groupings of the main actors, and the carefully delineated costumes'. For the Master's contribution to illustrating the Nicole Oresme translations of Aristotle's *Politics* and *Economics* see Sherman, 1995, *passim*, esp. 178, 241–4.

2. See the description of the manuscript in the preceding chapter for further discussion and evidence.

3. Meiss, 1967, I, 6, 19ff., identified the works of a follower of Pucelle with the name Jean le Noir, and credits Pucelle with the introduction of the artist's signature into French manuscript painting, and for the inventories (I, 99–118 and 160–9). Avril, 1981, 292, no. 239, notes that Jeanne d'Evreux left her Book of Hours to Charles V upon her death, and that this book is mentioned in the inventories of Jean de Berry and in the inventory of jewels of Charles V. For works of Le Noir which depend upon Pucelle's see Avril, 1981, 297 (no. 243), 312ff.(no. 265). Another work, the Breviary of Charles V, Paris, BN, MS lat. 1052, reproduces miniatures of Pucelle's Belleville Breviary. See also Sterling, 1987, 119ff.

4. For a review of Pucelle's works and patrons see esp. Avril, 1978, 12–26 and 44–75 and Meiss, 1967, I, 18ff., 44, 107–13. Pucelle's works include the following: Bible of Robert of Billying, Paris, BN, MS lat. 11935, signed by Pucelle and dated 1327; Belleville Breviary, Paris, BN, MSS lat. 10483–4, *c*. 1323–6 (the first owner was Jeanne de Belleville, wife of Olivier Clisson, one of the Normans who rebelled against Philip VI; see Delisle, 1909, I, 182–5); the Hours of Jeanne d'Evreux, New York, Metropolitan Museum of Art, The Cloisters, acc. no. 54.1.2, *c*. 1325–8; *Miracles de Notre Dame*, Paris, BN, MS nouv. acq. fr. 24541, *c*. 1330–35 (possibly for Jeanne de

Bourgogne); Avril, 1978, 17f. has identified as Pucelle's earliest known work a Franciscan Breviary, Rome, Bibl. Vat., Urb. Lat. 603, destined for Blanche of France, a daughter of Philip V 'le Long'.

5. The portrait of Jeanne d'Evreux is in the initial below the Annunciation and in the scene of Jeanne at the tomb of St Louis in the Book of Hours of Jeanne d'Evreux. St Louis is also portrayed in a series of illustrations in this manuscript, New York, Metropolitan Museum of Art, The Cloisters, acc. no. 54.1.2, fols. 16, 102v, 154v–60. See Avril, 1978, pls. 3, 8–10; the portraits of a king, presumably Philip VI, and several of a queen, presumably Jeanne de Bourgogne, appear in the *Miracles de Notre Dame*, Paris, BN, MS nouv. acq. fr. 24541, fol. 238v. Focillon, 1950, 30, cited Delisle who associated the manuscript with Jeanne de Bourgogne or Bonne of Luxembourg. See also Avril, 1981, 296, no. 241; portraits of Philip VI, John the Good and many others appear in the frontispiece of the *Trial of Robert of Artois*, Paris, BN MS fr. 18437, Avril, 1981, 314–15, no. 266.

6. For the portraits of Charles V see esp. Sherman, 1969, *passim*.

7. The Sy Master is named for the illustrations which accompany the French translation and commentary on the Bible commissioned by John the Good in 1355, a project financed by a special tax imposed on the Jews. The scribe of this manuscript signed his name as Jean de Sy, hence the origin of the name of both the manuscript and the artist who illuminated it. The manuscript was largely copied, and the drawings made, for what would have been an extremely ambitious project. But the manuscript was left in an unfinished state, only to be taken up again around 1380 under the patronage of Louis d'Anjou, Louis d'Orléans and his son Charles. It is generally presumed that the project was halted by the battle of Poitiers. This artist, formerly identified as the Master of the Boqueteaux, executed many illustrated manuscripts for Charles V, including the *Bible Historiale* dated 1357 (London, BL, MS Royal 17 E VII), and an illustrated copy of the works of Guillaume de Machaut dating to the end of the poet's life (Paris, BN, MS fr. 1584). He produced illustrations for Charles's projects to translate the works of Aristotle and Augustine, and he illustrated the frontispiece for the *Songe du Vergier* (London, BL, MS Royal 19 C IV). The artist's latest works are dated to *c*. 1378. See Avril, 1978, 28, 96–105 and *idem*, 1981, 325–6 no. 280; Sterling, 1987,174–86.

8. For a fundamental study of the portraits of Charles V see Sherman, 1969, *passim*; for a study of portraiture of the period see e.g. H. Keller, 'Die Entstehung des Bildnisses am Ende des Hochmittelalters', *Römisches Jahrbuch für Kunstgeschichte*, 3, 1939, 227–356.

9. See esp. Avril, 1978, 84–91; Avril, 1981, 318f., no. 271.

10. Gaborit-Chopin, 1996, no. 577, n. 585.

11. Avril, 1981, 322f., no. 276 for the attribution of the illustrations in Montpellier, Bibl. Ecole de Médecine, MS 245 and Brussels, Bibl. Roy., MSS 9577 and 11187 to the Master of the Coronation Book.

12. For the use of Pucelle's models by his followers see e.g. Meiss, as cited nn. 2–3 above; Avril, 1978, 20ff.; Avril, 1981, 316f., nos. 268–270, and Avril, 1972, 89–112.

13. The manuscript was published by A. Thomas, 'Un manuscrit de Charles V au Vatican: notice suivi d'une étude sur les traductions françaises de Bernard Gui', *Mélanges d'Archéologie et d'histoire*, I, 1881, 259–83.

14. Avril, 1968, no. 204, 118f. identified the work of the Master of the Coronation Book in Nicole Oresme's translation of Aristotle's *Politics* and *Economics* in Brussels, Bibl. Roy, MS 11201–02. For an extensive analysis of the miniatures of Nicole Oresme's translations see the recent study by Sherman, 1995, *passim* and esp. 256 for the point made above.

15. Hedeman, 1990, in Bak, ed. 72–87. Avril, 1981, no. 284.

16. Besides his illustration of the Coronation Book the Master illustrated the scenes of the coronation of Charles V and Jeanne de Bourbon and the funeral of Jeanne de Bourbon in the *Grandes Chroniques* in Paris, BN, MS fr. 2813 and most of the illustrations in a *Grandes Chroniques* in a private collection in Great Britain. See Avril, 1968, no. 195 and no. 196; Hedeman, 1995.

17. See Focillon, Paris, 1950; Avril, 1981, 296, no. 241.

18. Avril, 1978, 35, discussion for pl. V; Avril, 1981, 296, no. 241.

19. The inventories of Charles V of 1363 contain numerous references to purchases of brocades and textiles, particularly from Lucca. The inventories record his transactions with several Italian merchants including Barthélémy (also Barthélémi) Spifame (also Spifamme, Spifaine, or even Spiafame), a bourgeois from Paris who belonged to a family of Lucchese cloth merchants and money lenders. He furnished fabrics for Charles's sacre. See ch. 1 for further discussion and see also Gaborit-Chopin, 1996, nos. 605–7 and nn. 26, 504, 522 and 602. The fabrics appear comparable to brocades produced in Venice and Lucca. I have compared them with examples in M. Lemberg and B. Schmedding, *Abegg-Stiftung in Riggisberg. II: Textilien*, Berne, 1973, pls. 27, 28, 30. See also J. White, *Art and Architecture in Italy 1250–1400*, Baltimore, 1966, pls. 99 a, b.

20. I owe this observation to Janet Backhouse. See e.g. P. Brieger, M. Meiss, C.S. Singleton, *Illuminated Manuscripts of the Divine Comedy*, 1969, II, pls. 55 b (Florence, Bibl. Nazionale, MS Palatino 313, Florentine, 1330s), 7 (Florence, Bibl. Laurenziana, Pluteo 40.3, Sienese, *c.* 1345), 40 (Budapest, Univ. Lib., MS 33, Venetian, *c.* 1345)

21. Avril, 1981, 322, no. 276. The piece of furniture is described in contemporary records as a *demoiselle à atourner*. A similar lectern appears in the frontispiece of the French translation of the *Policraticon* of Jean of Salisbury (Paris, BN, MS fr. 24287) by an associate of the Master of the Coronation Book (pl. 51). For this see Avril, 1968, 119–20.

22. For the Master of the Remède de Fortune see Avril, 1972, 95–125; Avril, 1978, 28ff., and Avril, 1981, 318f. (no. 271), 319f. (no. 272), 321f. (no. 273).

23. Avril, 1978, 28ff.

24. Avril, 1972, 89–125; Avril, 1981, 319–21, no. 272.

25. The most recent obits in the manuscript include that of the abbot Gui de Castres who died in February of 1350. The obit of Philip VI, which one would expect to find in the book, is not mentioned, although he died in August

of that year, thus making it likely that the manuscript was given to the abbey after February and before August of 1350. For the Missal of Saint-Denis see Avril, 1981, 321f., no. 273; Avril, 1978, 81–3; Avril 1972, 89–125.

26. In January 1350, shortly after the death of Jeanne de Bourgogne in 1349, Philip VI married Blanche of Navarre. Saint-Denis was the traditional site for such marriages which also involved the sacring of the queen. Furthermore, the house of Evreux to which Blanche belonged had been important patrons of Saint-Denis. This wedding is celebrated and Blanche is portrayed with St Denis as her patron saint in a painting considered later in this chapter.

27. Avril, 1978, 28ff. identified the earliest work of the Master of the Coronation Book in Paris, BN, MS fr. 1586, fols. 59–102 and 121–196 where he works with the Master of the Remède de Fortune, who appeared earlier in the *Bible Moralisée* of John the Good, Paris, BN, MS fr. 167. See also Avril, 1972, 89–125.

28. A notation in the manuscript states that it was confiscated in that year when the king was captured at the Battle of Poitiers: *'Cest livre fust pris ové le roy de Ffrannce a la bataille de Peyters...'*. See Avril, 1981, 323f.; Avril, 1972, 123 n. 4; Millar, 1933, 29 pl. 35; G.F. Warner, J.P. Gilson, *Catalogue of Western Manuscripts in the Old Royal and King's Collections*, London, 1921, II, 341, pl. III; S. Berger, 1884, 391–2.

29. See Avril, 1968, 116 and Gaspar and Lyna, 1937, I, 337–8.

30. Godefroy identifies himself in another translation made for Charles. See e.g. Autrand, 1994, 744. For the text see F.J. Carmody, *Arabic Astronomical and Astrological Sciences in Latin Translations: A Critical Bibliography*, Berkeley, 1956, 103–12.

31. For a recent reference to this portrait see Sherman, 1995, 16–71; *idem*, 1969, 18–19.

32. See Introduction above.

33. Cazelles, 1982, 512–3.

34. Cazelles, 1982, 512–3.

35. For the *Livre des neuf anciens juges*, Brussels, Bibl. Roy., MS 10319, see Avril, 1968, 116 (no. 200) and Gaspar and Lyna, 1937, I, 337–8; for the *Petite Bible Historiale* of Charles V, Paris, BN, MS fr. 5707, see Avril, 1981, 324, no. 278, and Avril, 1968, 93f., no. 167.

36. Paris, Arch. Nat. AE 11383 (J. 154, no. 5). See Avril, 1968, 13f. (no. 22), and *Musée des Archives nationales*, 217–18 (no. 383).

37. For discussion of this issue see ch. 1 above.

38. Avril, 1968, 13–4 (no. 22); Avril, 1981, 362, no. 319.

39. See Cazelles, 1982, 517–30.

40. See Thomas, 1881, 258ff.

41. Aristotle, *Météorologiques*, trans. Mathieu le Vilain, Brussels, Bibl. Roy., MS 11200; Aristotle, *Ethiques*, trans. Nicole Oresme, Brussels, Bibl. Roy., MS 9505–6 and The Hague, Museum Meermanno-Westreenianum, MS 10. D. I; Aristotle, *Politiques et Economiques*, trans. Nicole Oresme, Paris, private collection and Brussels, Bibl. Roy.,

MS 11201–2. The miniatures in these manuscripts which were painted by the Master of the Coronation Book were first identified by Avril, 1981, 326–7, no. 281. For the iconography of the miniatures Sherman, 1977, 320–30 and Sherman, 1995, *passim*, and esp. 241–4 and 262–3.

42. Another copy of the same date is in Cambridge, Massachusetts, Collection P. Hofer, MS Typ. 201 H.

43. Delisle, 1909, I, 306–7.

44. Although the ownership has not been determined for this manuscript it presents all of the characteristics and iconography of other *Bibles Historiales* commissioned by Charles V. For this manuscript see Zahlten, 1979.

45. See Avril, 1968, 112–3 (nos. 195–6). A manuscript identified with an entry in the inventories of Charles V which permits it to be identified with certainty as a manuscript executed for a member of the royal family during the life of Charles. The manuscript has been in England since the middle of the sixteenth century. Then, 176 folios were detached of which some fragments are conserved in the British Library (MS Cotton Vitellius E. II). Two artists worked on the manuscript, the Master of the Coronation Book and the Master of the Bible of Jean de Sy. Raoulet d'Orléans was responsible, at least in part, for copying the text. See also Bouchot, 1904, no. 53.

46. Oslo, the Schoyen Collection, MS 027. Oslo, *The Schoyen Collection. A Checklist of Western MSS*, 6th ed., 1991, 11. The manuscript is attributed to a date around 1375. The script has been identified as that of Raoulet d'Orléans, and its original owner was either Charles V or Jean de Berry according to the catalogue description. Carl Nordenfalk brought this manuscript to my attention.

47. Meiss, 1967, I, 20 identified the artist of the Hours of the Passion in Jean de Berry's *Petites Heures*, Paris, BN, MS fr. 18014, with Jean le Noir, an attribution which has received general acceptance as evidenced e.g. by Avril, 1978, 66–75 and 112–17 (nos. 20–3); Avril, 1981, 312f. (no. 265), 314 (no. 267), 315 (no. 268), 316 (no. 269), 332 (no. 286), 333 (no. 287), 343–5 (no. 297). For the patrons of Pucelle see n. 4 above. The production and patronage of le Noir from his earliest work, the *Bible Historiale* in Geneva (Bibl. Publ. et Univ., MS fr. 2) of the 1330s to his last work of *c.* 1380, reveals that all but two are devotional manuscripts. His patronage varies widely: two of his extant works were produced for a ruling monarch and the others pertained to queens or princesses including Jeanne of Navarre, Bonne of Luxembourg, Jean de Berry, Yolande de Flandre and Blanche of Savoy. Works attributed by Avril to le Noir, Pucelle's closest imitator and apparent successor include: Missal of the Use of Paris, Lyons, Bibl. de la Ville, MS 5122, *c.* 1345–50; Evangelary of the Use of Paris, Paris, Bibl. de l'Arsenal, MS 161; the Hours of Yolande of Flanders, London, BL, MS Yates Thompson, 27; the Hours of Jeanne, Queen of Navarre, Paris, Bibl. Nat. MS nouv. acq. lat. 3145; the Psalter of Bonne of Luxembourg, the first wife of John the Good, New York, Metropolitan Museum of Art, The Cloisters, inv. 69.88; the Geneva *Bible Historiale*, Geneva, Bibl. Publ. et Univ., MS fr. 2, possibly for Queen Jeanne de Bourgogne); Breviary of Charles V, Paris, BN, MS lat, 1052, *c.* 1370–5; *Bible Historiale* of Charles V, Paris, Bibl.

Arsenal, MS 5212, *c.* 1370–5; *Petites Heures* of Jean de Berry, Paris, BN, MS lat. 18014, 1372–5.

48. See esp. R.H. Rouse and M.A. Rouse, 2000; *also M. Rouse and R.H. Rouse, 'The Book Trade at the University of Paris, c. 1250–1350', in La Production des livres universitaires au moyen âge: Exemplar et pecia*, eds. L. Bataillon, B. Guyot and R. Rouse, Paris, Centre Nationale de la Recherche Scientifique, 1988, 41–114

49. See Sherman, 1995, 23–4 for a brief discussion of the book trade and further references.

50. The Master of the Coronation Book disappears around 1378, but his collaborators continue to work after the death of Charles V. They collaborated with the Parement Master in the decoration of the margins of the *Très Belles Heures de Notre Dame*. This is considered further in ch. 7.

51. For further consideration of the collaboration of these three artists see ch. 7.

52. See esp. Cazelles, 1982, 520–3.

53. Meiss, 1967, I, 112 ff.

54. Whether or not this medium is oil has yet to be confirmed. It resembles oil in its transparency and glossy surface. It is also evident that the artist is able to vary the transparency by increasing or decreasing the concentration of pigment that is suspended in the medium, one of the principal advantages of oil. See the following chapter for documentation pertaining to the use of oil painting at the French court at this time.

55. Meiss, 1967, I, 123–5.

56. See especially Sterling, 1987, 219–44, taking up the proposals of Bouchot, 1904, I, which were developed with documentation assembled by Henwood, 1980, 137–40, and followed most recently by König, 1992, 216–18. A convincing comparison emerges in the above scholarship between the documentation on Jean d'Orléans and the painting activity of the Parement Master. This issue will be considered in the following chapter.

57. For a recent consideration of the interrelationship between miniature painters and panel painters see Alexander, 1992, 122ff.

58. Hans Belting first brought this to my attention. See pls. 7, 8, 11, 13, 14, 16, 18, 19, 20, 21, 23, 26.

59. Meiss, 1967, I, 112 ff.; E. Panofsky, 'Imago Pietatis', in *Festschrift für Max Friedlaender*, Leipzig, 1927, 206–308; Belting, 1981, 1ff. See also Colin Eisler, 'The Golden Christ of Cortona and the Man of Sorrows in Italy', *Art Bulletin*, 51, 1969, 107ff.

60. For this see Martindale, 1988, 26–8, 198–9, pls. 49–50.

61. Martindale, 1988, 184–5, pl. 108

62. See Martindale, 1988, pls. 1, 47, 88.

63. For which see e.g. Meiss, 1967, II, pl. 545.

64. Meiss, 1967, I, 122–4.

65. For this iconography see Meiss, 1967, I, 112ff.

66. See Meiss, 1967, II, pls. 529–30.

67. For this see Martindale, 1988, 47–8, 181–3, pls. 102–6

68. Sydney Cockerell identified this manuscript with Jeanne de Navarre because of the presence of the arms of Navarre, Evreux and Burgundy. Jeanne was the daughter of Louis X who was excluded from claiming her rights to succeed to the throne. She was the mother of Charles of Navarre and was married to Philip count of Evreux who was a partisan of the Valois. Although Jeanne is an obvious candidate, she is not the only possibility as the same armorials would also apply to her daughter who was the second wife of Philip VI. This would be more in keeping with the presence of the allusions to a crusade in the manuscript which Marcel Thomas identified with the projects for a Crusade first taken up by Philip VI in 1330–34. Philip failed to carry out these plans but he renewed them again when he married Blanche of Navarre. See Avril, 1981, 312–3, no. 265 and Meiss, 1967, II, pl. 544.

69. For this see Meiss, 1967, II, pl. 37.

70. Sterling, 1987, 167 and esp. figs. 108–9 compared several of the copies made for Gaignières with their extant originals including Jean Bondol's frontispiece for the *Bible Historiale* of Jean de Vaudetar which demonstrates the accuracy of the copy. Concerning the reliability of the copies made for Gaignières see esp. Pächt, 1961, 402–21; Kahr, 1966, 3–16; de Vaivre, 1981, 131–56; Pinoteau, 1975, 2nd ed., 1979, 120–76; Cazelles, 1978, 53–65; Pradel, 1951, 89–93. Many of the works which were copied for Gaignières were published by Dom B. de Montfaucon, *Les monuments de la monarchie française*, Paris, II, 1730, esp. 325 pl. LV for the panel under consideration. Also, Mirot, 1913, 271–8.

71. Montfaucon, II, 1730, esp. 325, pl. LV for the panel under consideration; Mirot, 1913, 271–278; Pradel, 1951, 89–93; Pinoteau, 1975, 2nd ed. 1979, 120–76; de Vaivre, 1981, 131–56; C. Sterling, 1987, 167 and fig. 87.

72. See esp. de Vaivre, 1981, 131ff. and Sterling, 1987, 167–8 and fig. 87.

73. For the Sainte-Chapelle panel see the following: Sterling, 1987, 140–4; Laclotte and Thiébaut, 1983, 53–4; de Vaivre, 1981, 131–56; Avril, 1978, 22, 27; Pinoteau, 1975 (2nd ed. 1979), 120–176; Cazelles, 1978, 53–65; A. Erlande-Brandenbourg and F. Salet, 'Chronique', *Bulletin monumental*, 1971, 198; G. Schmidt, *Gotik in Böhmen*, Munich, 1969, 193f.; Kahr, 1966, 3–16; Pächt, 1961, 402–21; Sterling, 1938, 26; P.-A. Lemoisne, *La Peinture française à l'époque gothique, XIVe et XVe siècles*, Florence and Paris, 1931, 22; L. Dimier, *Les Primitifs français*, Paris, 1929, 28; C. Maumené and L. d'Harcourt, 'L'iconographie des rois de France', *Archives de l'Art français*, 1928, 41f.; Mirot, 1913, 271–8; Durrieu, 1907, 110; E. Petit, *Histoire des ducs de Bourgogne*, VII, Dijon, 1901, v–vii, 272f.; H. Bouchot, *Inventaire des dessins exécutés pour Roger de Gaignières, et conservés aux Départements des Estampes et des Manuscrits de la Bibliothèque Nationale*, Paris, 1891, I, 39, no. 302; Prost, 1890–91, 37–40.

74. Belting, 1994, esp.47–77. This diptych is discussed further below in ch. 7.

75. Pächt, 1961, 402–21. This point suggests that the diptych was a gift to the pope from John the Good and not a gift of the pope to John the Good as Sterling, 1987, and others have argued.

76. For this painting see Thiébaut, 1981, 367–8 (no. 320); Laclotte and Thiébaut, 1983, 21, 193–

Notes to Chapter 7

1. See Cazelles, 1978, 92 and Kahr, 1966, 3–16, for a review of the dating. Pächt, 1961, argued that the original panel was produced for a visit which John the Good made to Avignon late in his reign and proposes the visit which he made in 1363. Kahr, followed by Avril, 1978, 27 and Sterling, 1987, 141f. proposed John the Good's visit in 1342 made to honour the newly-crowned Clement VI while the former was still duke of Normandy. Although Kahr, Avril and Sterling correctly believed the pope of the panel to be Clement VI, we will see that their identification was based upon a mistaken premise.

2. For the text of the description see de Vaivre, 1981, 132ff.

3. Gregory XI is the only fourteenth-century pope of that name but his reign did not begin until 1370, six years after John's death. The name `Grimoye' could be a corruption of Grimoard, the family name of Urban V who reigned from 1362–70. For a review of the divergent opinions on this work see de Vaivre, 1981, 133ff.; Sterling, 1987, 140–144; Cazelles, 1978, 92; Kahr, 1966, 3–16, for additional review of the dating.

4. For a review of the various opinions see de Vaivre, 1981, 133–5.

5. Bonne of Luxembourg died in 1349, a little more than one year before John's visit to Clement VI in Avignon in December 1350. John had all but repudiated Bonne, and one chronicler accused him of causing her death. Shortly before this John accused Bonne of infidelity and had her suspected lover beheaded. Historical facts put the mourning issue to rest because five months after Bonne's death he married Jeanne de Boulogne, a woman who brought him important political advantages including the protection of her uncle, the Avignon cardinal Gui de Boulogne. When John visited Avignon in 1350 he had been married to his second wife for nearly a year so it is unlikely that he would have dressed in mourning for Bonne. It is just as unlikely that he would have been mourning Jeanne de Boulogne who died in 1360, shortly before John returned from his four-year captivity in England. It is difficult to believe that John was still in mourning at the time of his meeting with Urban V in December 1362, as it took place two-and-a-half years after the death of his second wife. The couple lived apart, and during the last four years of their marriage John was captive in England where he is reported to have had a love affair and fathered a child whereas he and Jeanne de Boulogne produced no offspring. See Cazelles, 1981, 45 and n. 56.

6. de Vaivre, 1981, 132–4; Mirot, 1913, 271–8 citing Arch. Nat., LL 630, 31–3.

7. For the text see de Vaivre, 1981, 134.

8. Dongois' description is not without problems, as it mentions a reliquary on a *credenza* which is instead on the floor. He also ascribed the king's *violet* (not black) robe to John's mourning for his second wife Jeanne de Boulogne, and he interprets John's action as one of receiving rather

than of giving the painting, a point which will be taken up below.

9. Otherwise we would have to believe that Dongois failed to observe a fourth figure when he wrote his note and that the artist of the Gaignières copy failed to notice a fourth figure when he was making his copy.

10. Concerning the reliability of the copies made for Gaignières see esp. Pächt, 1961, 402–1; de Vaivre, 1981, 131–56; and Sterling, 1987, 141–9, 167–8, and 187–92. See e.g. Kahr, 1966, 5, after Pächt, 1961, 416 who argued that some of the elements such as cast shadows and the spatial setting were not possible before the end of the fourteenth century. However, cast shadows appear in the work of the Lorenzetti at Assisi in the 1330s, in the miniatures of the *Bible Historiale* of John the Good, begun in 1349, and in a Parisian *Bible Historiale* of 1356, considered later in this chapter.

11. For the Gaignières copy see Sterling, 1987, fig. 109.

12. Sterling, 1987, 141–4 follows Kahr, 1966, 10 who dated the panel to 1342, when Jean, still duke of Normandy, was present for the enthronement of Clement VI, and contends that the pope gave the picture to the duke. Kahr's reasoning hinges on the assumption that John the Good is not wearing royal robes, but as we are about to see this costume is that of an anointed king of France.

13. Schimmelpfennig, 1990, 179–96.

14. See Ladner, 1970, esp. I, pls. 159–61, tabs. XVIIIa, XIX a-d, XXIVa; II, pls. 7–10, 26–7, 133, tabs. III, IV a-b, XXIV a-c, LXXXIIIa, LVIIa. One might note in particular King Charles of Anjou kneeling before Clement IV, in II, Taf. XXXIII. There is one exception which shows Urban III and Frederick II on an equal plane and scale: II, taf. V, manuscript of Godfrey of Viterbo, Paris, BN, MS lat. 4895 A., fol. Av.

15. See esp. Pradel, 1951, 89–93.

16. Dewick, 1899, col. 55, fol. 75.

17. This point has already been made in ch. 6 concerning the portraits of the duke of Normandy. Further evidence is given presently and also in the discussion of homage in the epilogue.

18. Also in the Psalter of Bonne of Luxembourg, New York, Metropolitan Museum of Art, The Cloisters, Inv. 69.88. For the Trial of Robert of Artois and the Psalter see e.g. Avril, 1981, 314–6, nos. 266–267.

19. de Vaivre, 1981, 146ff; A. Erlande-Brandenburg, 'La Peinture à Paris sous les premiers Valois', *Bulletin monumental*, 1979, 137, II, 170–1. Concerning this portrait see esp. Thiébaut, 1981, 370–1, no. 323, All three authors interpret John's barefheaded appearance in this portrait, without crown or head-covering, as representing him prior to his sacre. Thiébaut emphasizes that the inscription was overpainted at an unspecified later date, *légèrement postérieure au règne de Jean le Bon*.

20. Kantorowicz, 1946, 93.

21. For ecclesiastical garb see e.g. Nainfa, 1909; Lesage, 1960; Braun, 1907; Mayo, 1984.

22. Nainfa, 1909, 90ff; Mayo, 1984, 61; Braun, 1907. According to Nainfa, 90, non-clergy were not entitled to

wear the *calotte* or *zucchetto*, also known by its Latin nomenclature *pileolus*, and only cardinals were permitted to wear it in the presence of the pope.

23. Nainfa, 1909, 90ff.

24. See Barthes, 1957, 430–1. For some recent efforts to address this problem see e.g. Blanc, 1989; M.D. Fontanes and Y. Delaporte, eds., *Vêtement et sociétés* [Actes des journées des 2 et 3 Mars 1979 of La Société des Amis du Musée de l'Homme]. *L'Ethnographie*, 80, 1984.

25. Barthes, 1957, *passim*. See also Pierre Bourdieu, 'Haute couture et haute culture', *Questions de Sociologie*, Paris, 1982, 196–206.

26. An apparent contradiction is the tonsure, but in consecrative liturgy the tonsure signified a `crown of glory'. See the references given in ch. 2, n. 90.

27. See ch. 2 and also Andrieu, 1953, 54ff.; Batiffol, 1923, 753ff.; Nelson, 1977.

28. Although written at the command of Charles V, it is relevant for French kingship at least from the late thirteenth century as it was part of Golein's translation of the extensive treatise on the liturgy written by Durandus of Mende in 1296 to accompany his revision of the Roman pontifical. Guillaume Durand, *Rational des divins offices*, trans. Jean Golein, Paris, BN, MS fr. 437. See Golein, ed. Jackson, 1969, 305–24. For Guillaume Durand and his pontifical see Andrieu, 1940, III, *passim*. Furthermore, although Golein wrote the treatise for John the Good's son, there is reason to believe that Golein had some association with John the Good and also with John's tutor, Pierre Roger, as Golein was born in Rouen in 1330 where he entered the Carmelite order. Rouen was the capital of the duchy of Normandy during John's reign as duke there, and Pierre Roger was during this period archbishop of Rouen. Golein then went to Paris to take a degree in theology and then became a Master of Theology at the University of Paris. Because of his familiarity with Avignon, Golein was chosen to serve Charles V as ambassador to Avignon.

29. Golein, ed. Jackson, 1969, 317f. (fol. 49v): *Pour semblable cause apres linonction du chief larcevesque li met la coiffe sur le chief et la doit touz jours porter en signe quil a receu la sainte inonction ou chief et de plus digne saintete et afin quil en ait touz jours memoire il doit porter coiffe tout sa vie 93 afin que le cresme nait aucune contagion moins honeste. car elle touche le corps penetrativement.*

30. In keeping with Golein's explanation, Charles V always appears with covering for all of the points of his body which were anointed. Most obvious of these coverings are the gloves which he wears, meant to cover his hands which have been anointed like those of a bishop.

31. W.N. Hargreaves-Mawdsley, *A History of Academical Dress in Europe until the End of the Eighteenth Century*, Oxford, 1963, 38.

32. Concerning the *robe longue* see e.g. François Boucher, *20,000 Years of Fashion. The History of Costume and Personal Adornment*, expanded edition, New York, 1987, 201–2. Boucher observes that the long costume went out of fashion for men around the middle of the fourteenth century with some exceptions, among whom he identifies royal councillors and administrators. He attributes this sur-

vival of the long robe amongst this class to a desire on the part of men, drawn from the universities but of modest origins, to distinguish themselves from the middle classes and nobility. The *robe longue* was at the time of John the Good very much an expression of clerical status. See the following note.

33. The University of Paris was, from its foundation, not a secular institution but one which grew out of the episcopal school of Notre Dame for the education of the clergy. Secular histories of costume ignore the clerical signification of academic costume. For the clerical status of both masters and students at the University of Paris and for the role played by St Louis and Philippe Augustus in endorsing the clerical privileges of the scholars see e.g. John Baldwin, 'Masters at Paris from 1179 to 1215. A Social Perspective', in Robert Benson and Giles Constable eds., 1982, 138–73, and esp. 141–9 where he emphasizes the importance of the clerical status of masters and students alike in the famous founding royal charter of 1200 which established special protections to the scholars on the basis of their clerical status, and 158–63, which includes a statistical analysis of the clerical composition of the University of Paris. The bibliography on the University of Paris is enormous, but for an extensive study of the clerical privileges of the scholars see Robert Génestal, *Le privilegium fori en France du Décret de Gratien à la fin du XIVe siècle*, Bibliothèque de l'Ecole des Hautes Etudes, Sciences religieuses 35, 39, Paris 1921–24. Clerical costume was essential so that they be recognized as clerics by the population at large who were, under pain of severe penalties, bound to respect their clerical rights and privileges. Any harm done to a cleric was a sacrilege, and their clerical status protected them from arrest by representatives of secular justice, even if they were accused of serious crimes such as murder. See *Chartularium Universitatis Parisiensis*, eds. Denifle and Chatelain, I, 1. The priest was vested with a long robe at his ordination, a garment intended to set him apart from the laity (who wore short dress by custom) and to declare the privileged priestly status of its wearer, an important factor in academic garb as both students and masters of the University of Paris enjoyed special protections and privileges based upon their priestly status.

34. See esp. Andrieu, 1953, 22–73; Batiffol, 1923, 732–63.

35. See Golein, ed. Jackson, 1969, 317f.

36. Nainfa, 1909, 47f. This garment similar to a cassock has a short capelet to cover the shoulders and often a small hood. It is a sign of jurisdiction worn by the pope and cardinals and, within their jurisdiction, by archbishops, bishops and abbots. It is not for ceremonial or liturgical wear, but is to be worn in a domestic or an official, non-liturgical setting. When the bishop is seated in his cathedra he wears his *mozetta* according to Lesage, 1960.

37. Cazelles, 1982, 120. John the Good went to Avignon in 1342 sent by his father at the time of the election of pope Clement VI; he journeyed there in 1348, in December 1350 and January 1351, and in 1363 months, before his death in April of 1364.

38. See e.g. Mollat, 1950, 84–96 (for Clement VI) and 109–12 (for Urban V).

39. Petrarch's letter is cited in Mollat, 1950, 114 and Prou, *Etude sur les relations politiques du Pape Urbain V avec les rois de France, Jean II et Charles V*, Paris, 1887. For Petrarch's letter see F. Petrarca, *De rebus senilibus*, Bk. VII, Ep. 1.

40. See Yves Renouard, 'Achats et parements de draps flamands par les premiers papes d'Avignon', in *Mélanges d'archéologie et d'histoire. Ecole Française de Rome*, LII, 1935, 273–313. On 308 he notes that the figures of purchases of Flemish luxury textiles rises from 2,000 florins in 1341–2 to 10,000 florins in 1343, the year after Clement VI's accession.

41. Kahr, 1966, 3–16. For the paintings of Matteo Giovannetti see esp. Laclotte and Thiébaut, 1983, 35–48, 155–184; Enrico Castelnuovo, *Matteo Giovannetti al palazzo dei Papi ad Avignone*, Milan, 1965, *passim*; idem, 1962, *passim*.

42. Belting, 1994, 56–65, and esp. 56 where the author notes that the Greek term emerged in the Judaeo-Christian vernacular to refer to anything that was a living image, including a human being.

43. Belting, 1994, 498, appendix 4B, citing *Liber Pontificalis*, i: 443.

44. Belting, 1994, 64–5.

45. Another miraculous True Image was 'restored as the Holy countenance unharmed to its old place' when the apse of the Lateran was rebuilt by Nicholas IV (1288–92). See Belting, 1994, 65.

46. Belting, 1994, 55.

47. Belting, 1994, 208f. and 218.

48. D. Wood, 1989, 89–91.

49. D. Wood, 1989, 94 citing Clement VI, *Acta Clementis Papae VI (1342–52)*, ed. A.L. Tautu, Pontificia Commissio ad Redigendum Codicem Iuris Canonici Orientalis, Fontes, Series 3, ix, Vatican City, 1960, no. 155, par. 521.

50. Simone Martini was inspired by this icon for his image of Christ in the portal of Notre-Dame-des-Doms in Avignon; and other copies of this icon were already circulating in the West. For the Roman liturgy surrounding these icons see Belting, 1994, 65 ff. For Simone's version of the True Image see Martindale, 1988, 181–3 and pls. 98–101.

51. See Avril, 1981, 321f. no. 273.

52. See Avril, 1981, 319f. no. 272 and Avril, 1972, 95–125.

53. Avril, 1981, 318f., no. 271; Avril, 1978, 28ff., 8491; Avril, 1972, *passim*.

54. See discussion in ch. 1. Most recently see D. Wood, 1989, *passim*, and Wrigley, 1970, 433–44, 457, esp. 461 and n. 466.

55. He presided over the councils of Normandy and in 1328 Philip VI appointed him to parliament. Cazelles, 1982, 446–8, 457. There, Pierre actively defended the Valois cause representing Philip VI in numerous diplomatic missions to negotiate peace with representatives of Pope John XXII and of Edward III. As abbot of Fécamp, a monastic fief of the English king in the Norman diocese of Rouen, Pierre convinced Edward II to swear liege

homage to the king of France for the duchy of Guyenne. In 1337 he represented Philip at Avignon. When Edward III proclaimed war in 1338, Pierre Roger represented Philip VI in negotiations at Arras between envoys of Edward and Benedict XII, who raised him to the cardinalate for these efforts at peacemaking. Pierre Roger's name appears in papal correspondence concerning efforts to further the cause of Valois succession in a letter of Benedict XII of 2 August 1339 informing Philip VI of his refusal of a dispensation for the eldest son of the king of England to marry the daughter of Duke John of Brabant, a marriage which would have threatened the security of the Valois had it taken place. Wrigley, 1970, 443, 462, 466–71 and Cazelles, 1982, 446–8.

56. Déprez and Mollat, III, fasc. 5, 1959. In several letters he mentions his nephew Guillaume Roger, vicomte de Turenne, who was to represent him at the coronation; op. cit, 127, no. 4715, (11 September 1359), 128, no. 4716 (11 September 1350: mentions that the vicomte de Turenne was the dauphin's *scutiferum*); 129, no. 4719 (12 September 1350); 129, no. 4721 (13 September 1350).

57. Déprez and Mollat, III, fasc. 5, 1959. p. 122, no. 4688, 2 September 2 1350, Avignon: '… *intuens et considerans etiam quod fastigium regium ad quod te successione paterne hereditatio admisit*'.

58. Déprez and Mollat, III, fasc. 5, 1959. 121, no. 4684: 31 August 1350, Avignon.

59. Déprez and Mollat, III, fasc. 5, 1959, 127, no. 4715, 11 September 1350, to the maréchal of France: '… *rex preter dilectum filium nobilem virum Karolum, primogenitum suum, dalfinum viennensem* 93 '; and 128, no. 4716, 11 September 1350, to Charles, the dauphin: '… *Dilecto filio nobili vero Karolo primogenito Johannes regis Francie illustris, dalphino viennensi…. Johannes, rex Francie illustris, genitor tuus …* '.

60. For a discussion of the development of the interior in the painting of Simone Martini and the Lorenzetti see e.g. Meiss, 1967, I, 119ff.; John White, *The Birth and Rebirth of Pictorial Space*, New York, 1967, 83–92, 93–102; for Simone Martini see also Martindale, 1990, esp. 20f. and pls. II–III.

61. Two panels of a triptych, the Annunciation and Nativity, are in Aix-en-Provence, Musée Granet, Inv. 820–1–11 and 11 bis. The third panel of this triptych is an Adoration of the Magi in New York, Metropolitan Museum of Art, Lehman Collection. Thiébaut attributes the triptych to the Avignon atelier of Simone. According to Thiébaut, the triptych was given by Robert of Anjou, king of Naples (d. 1343) and Queen Sancha to the convent of the Clares at Aix. An eighteenth-century description of the three panels mentions the arms of Anjou and Aragon on the reverse of the panels, no longer visible. There is a question over whether the work was executed at Naples and sent to Aix before 1343, the date of the death of Robert, or whether it was ordered from an Italian artist living in Provence in the 1340s. Thiébaut observed that the work betrays the influence of the later works of Simone at Avignon and that it may even have been made during his lifetime. For a detailed discussion see Thiébaut, 1981, 367f. no. 320 and Laclotte and Thiébaut, 1983, 21–2, 193–4.

62. See Meiss, 1967, I, 119ff. who argues that the Parement Master follows Jean Bondol in the use of the tessellated floor for the indexing of space. However, the Master of the Sainte-Chapelle panel antedates both Bondol and the Parement Master.

63. See esp. Martindale, 1988, e.g. 183–4, 192–4, 210–1, for a consideration of the portraiture of Simone.

64. The question of a possible connection between the painting for Clement VI in Avignon and the lost painting of John the Good and Clement VI was raised by Laclotte and Thiébaut, 1983, 54: '… la Remise par Jean le Bon d'un diptyque à Clement VI, était présenté dans un lieu prestigieux, la Sainte-Chapelle de Paris. Est-il interdit de comparer le célèbre Portrait de Jean le Bon du Louvre avec le profil de ce prince tel qu'il apparaît dans le tableau en question … et, plus généralement, avec les innombrables visages si caractérisés peints par Giovannetti sur les murs du Palais?'

65. See e.g. Kahr, 1966, 10–13. Observation of these frescoes *in situ*, however, allows one to see that Matteo did not delineate surface detail to the extent nor in the manner of the Sainte-Chapelle panel and that his painting technique differs from the French works and from the detail presented in the copy of the Sainte-Chapelle panel.

66. Pächt, 1961, 140ff. There are numerous reasons to reject Sterling's argument, based on Gaignières' descriptive statement, that the pope is presenting the diptych to the king. The pope is shown looking at the diptych with great interest, and he examines it as he reaches with his right hand as if to accept it, the gesture of a recipient and not of a donor who would be holding the diptych in such a way as to enable his intended recipient to see it. Furthermore, the kneeling man faces the pope and he clearly bears the weight of the diptych while the pontiff regards the work, another indication that he is presenting the diptych to the pope. It is the pope and not the king who looks at the painting, which is what would be expected of a recipient. The king looks at the face of the pope to assess the reaction to the painting as the servant presents it to the pope for his perusal. In the Sainte-Chapelle panel the recipient is the pope, whereas, in Bondol's frontispiece to the *Bible Historiale* of Jean de Vaudetar, the king is the recipient who regards the work which is being given to him. But most importantly the garb of the servant corresponds to the secular dress of the servants at the royal court rather than to the clerical dress of papal servants.

67. See references cited above in n. 14.

68. A comparable relationship between the image of a king and the pope appears, for example, in the frontispiece of a copy of the Decretals of Gratian made in Paris *c.* 1320. For this see Avril, 1981, 288, no. 234: Paris, BN, MS lat. 3898.

69. For this see Belting, 1994, 218 and pl. 131.

70. There is, however, one known instance in Italian painting where contemporary personages were portrayed participating in a contemporary event: the lost painting of the Jubilee of 1300 with Boniface VIII before the portal of St John Lateran. For a reproduction of the water-colour copy of this lost painting see e.g. Ladner, 1970, II, pls. LXVI–II.

71. For this see Martindale, 1988, 192–4; the Guidoriccio poses many problems that complicate its identification as a contemporary historical portrait. See esp. Martindale, 1988, 210–1; M. Mallory and G. Moran, 'New evidence concerning "Guidoriccio"', *Burlington Magazine*, 128, 1986, 250–9.

72. See Martindale, 1988, 192–4.

73. For the dating of this panel see de Vaivre, 1981, 146–54.

74. For the portraits of Charles V see Sherman, 1969, *passim*. Numerous portraits are mentioned in the inventories of Charles V. For example see Labarte, 242, no. 2217.

75. John the Good was crowned on 26 September 1350, as noted by Delachenal, 1909, I, 55 and *Grandes Chroniques*, VI, I. His visit to Avignon in December 1350 and January 1351 is recorded by Froissart, ed. Luce, IV, xli n., and Arch. Nat., J.J. 80 n. 767.

76. Dufour, 1877, 60ff.; Prost, 1896, 389–403; Prost, 1890–1, 37–40, 81–92; also Avril, 1972, 95–125, who identified fifteen hands amongst the miniatures of the *Bible Moralisée* of John the Good, a work which he attributed to the workshop of the miniaturist Jean de Montmartre. See also B. Bapst, 'Les enlumineurs Jean de Montmartre (1349–53), Jean de Wirmes (1349), Jean Susanne (1350–1356) et Guillaume Chastaignes', *Archives historiques, artistiques, et littéraires*, II, 1890–1, 177–9; also R. Cazelles, 'L'argenterie de Jean le Bon et ses comptes', *Bulletin de la Société nationale des Antiquaires de France*, 1966, 51–62; and Douët D'Arcq, *Comptes de l'argenterie des rois de France au XIVe siècle*, Paris, 1851, esp. 126.

77. Avril, 1972, 95–125.

78. Psalter of Bonne of Luxembourg, New York, Metropolitan Museum of Art, The Cloisters, Inv. 69.88. See esp. Avril, 1981, 315f., no. 267, and Avril, 1978, 74f.

79. Prost, 1890–1, 85.

80. Delachenal, 1909, II, *pièces justificatives* vii, 376–7; the documentation for Jean Coste's work at Vaudreuil was assembled by Bernard Prost, 'Jean Coste, peintre des rois Jean II et Charles V: Mélanges artistiques', *Archives historiques, artistiques et littéraires*, II, 1890–1, 37–40, and 81–92.

81. Delachenal, 1909, II, *pièces justificatives* vi, 374.: `Et touches (sic) ces choses dessus devisées seront fetes de fines couleurs à huile et les champs de fin or enlevé … '.

82. The reference to the use of manuscript illustration appears in an earlier document concerning the same project, 2 March 1353; the relevant passage is as follows: ' … *dictas ymagines manu propria componere et formare, hystoriasque inibi depictas de quo dicti (dequodam) libro extrahere* …'. Cited in Dufour, 1877, 154.

83. Delachenal, 1909, II, *pièces justificatives* vi, 375.

84. Delachenal, 1909, II, *pièces justificatives* vi, 375: '*parfaire l'ystoire de la vie Cesar et au dessouz en la derreniere liste une liste des bestes et d'images, ainsi comme elle est commenciee … Item, la galerie à l'entrée de la sale en laquelle est la cha[ce], parfaire ainsi comme elle est commenciée … Item, l'oratoire qui joint a la chapelle parfaire … '* Also *pièces justificatives* vii, 376: ' … *Jehan*

coste, pointre, qui a fait les dictes pointures ait promis et acorde a les parfaire, etc … '. Also see following note.

85. Ibid., 374: '*C'est l'ordenance de ce que je Girart d'Orliens à fere par Jehan Coste … sur les ouvrages de pointure qui y sont à parfaire … '.* An especially clear indication that works were already begun and in place is the following passage: '*Et en VII archez qui y sont VII ymages, c'est assavoir en chascun archet un ymage, et* les visages que sont commenciez *parfaire tant de taille comme de couleurs et les draps diaprez noter et parfere … '.*

86. Dufour, 1877, 153–6: '*1353 (2 Mars) Johannes, Dei gracia Francorum rex, notum facimus universis presentibus et futuris, quod, cum nos, circa festum beati Michaelis ultimo preteritum fuerint tres anni elapsi, mandaverimus per nostras litteras magistro Johanni, dicto Coste, pictori, ut ad castrum nostrum Vallis Ruelli, accederet ut aulam, capellam, cameras et alia loca ejusdem castri depingeret … '.*

87. Prost, 1896, 389f.; Prost, 1890–1, 37–40 and 81–92; Dufour, 1877, 60ff.

88. Delachenal, 1909, II, *pièces justificatives* vi, 374f.: '*Mars 25, 1356, Le Vaudreuil. C'est l'ordenance de ce que je Girart d'Orleans ai traitie a fere par Jehan Coste ou chastel du Val de Rueil sur les ouvrages de pointure qui y sont a parfaire, tant en la salle comme ailleurs … '.*

89. Prost, 1890–91, 37–40, and 81–92; Delachenal, 1909, II, *pièces justificatives* vi and vii, 374–76.

90. Dufour, 1877, 45f.; de Laborde, 1851, III, 2.

91. Delachenal, 1909, II, 281 and n. 1, 296, n. 5, 347 and III, 100, 197.

92. See ch. 1 above.

93. Dufour, 1877, 46.

94. Cited by Dufour, 1877, 46ff.: December 1348. '*Philippe VI avait amorte 20 livres de rente que ce peintre devait consacre a la dotation de la chapelle de sainte-Marguerite dans leglise du St Sepulcre, a Paris … '*, cited from Arch. Nat., Trésor des Chartes, II. 77.410.

95. Prost, 1890–91, 88, cited from Arch. Nat., KK 7 fol. 12, 8 July 1349, which records that Girard received 24 ecus from the duke of Normandy (John II) '*pour acheter fin azur et autres couleurs pour certaines besoignes faire du commandement de mons. le duc'.*

96. Prost, 1890–1, 89, 23 July 1349 for 80 ecus from the same prince cited from Arch. Nat., KK 7 fol. 15v.

97. Prost, 1890–1, 89, cited a *mandement* of 4 November 1350 ordering payment '*dilecto nostro familiari Gerardo de Aurelianis, pictori, hostiario aule nostre … '.* These wages for 6 sols parisis per day were accorded him *antequam ad regimen regni nostri devenissemus.* Prost cites as his source Paris, BN, MS fr. 26700, no. 6. Dufour, 1877, 153 published a letter of John the Good of 2 March 1353 which states that Coste was called to Vaudreuil three years earlier around the Feast of St Michael (29 September). Prost, 1890–1, 37f. published the earliest documentary reference to John Coste as *xv jour fevrier, cccxlix* which would have been 25 February 1350. The document states that Coste was called to do this *au ledit seigneur* (John II) *descent au palays.* Thus the document dates the start of Coste's employment for John the Good to the moment

when that prince descended (from Normandy) to the royal palace, his residence after his sacre.

98. For references see preceding note.

99. Dufour, 1877, 68ff. cites H. d'Orléans, duc d'Aumale, *Notes et documents rélatifs à Jean, roi de France, et à sa captivité en Angleterre*, London, 1857.

100. Along with John's tailor Tassin du Breuil, his pharmacist Jehannin l'Espicier, his secretary and chaplain, Denys de Collors, and the falconer Jehan de Milan. Dufour, 1877, 68–77.

101. Mollat, 1950, 85ff. But D. Wood, 1989, 10 is doubtful that he was chancellor.

102. Mollat, 1950, 85ff. Girard's name appears in contracts which are signed by a notary whose signature occurs on other documents in conjunction with the signature of the personal secretary of Clement VI. The signature on the document is reported by Dufour, 1877, 64 as 'Mareuil' which is close in spelling to the name of 'J. Marceuil' whose signature appears on other documents with Nicole de Veres, a protégé and secretary of Clement VI. See Cazelles, 1982, 520.

103. Dufour, 1877, 45–81; Prost, 1890–1, 37–40 and 81–92; Prost, 1896, 389–403. For reference to Lucca brocades see also following note and Mirot, 1927, 50–86.

104. Prost, 1890–1, 89 for the Feast of the Star; and Dufour, 1877, 53, 71, 72, 73 where Girard is charged to make numerous ceremonial seats for the king, and 73 where Girard is responsible for arrangements for Christmas festivities at Sommerton in England during John the Good's captivity.

105. Prost, 1896, 398; Dufour, 1877, 70.

106. For references to Girard as *peintre* see e.g. Dufour, 1877, 46(1344), 47(1348), 49(1352), 50(1353), 51(1353), 52(1355), 62(1355), 70(1358), 72(1358). Girard's name rarely appears without mention of his function as painter. For references to Girard as *huissier de salle* see e.g. Dufour, 1877, 45, 62(1355), and, as *peintre du roi*, Dufour, 1877, 50(1355). Also Prost, 1896, 398–400.

107. For a discussion of the role of *peintre du roi, varlet de chambre* and *huissier* see A. Martindale, 1972, 132ff. with special reference to the documentation on Girard d'Orléans, to whom he attributes the Louvre portrait of John the Good.

108. Prost, 1896, 393f., 399; Prost, 1890–1, 88.

109. Evidence that Girard painted pictures appears in the references cited by Dufour, 1877, 46, 47, 49, 50, 51, 52, 62, 70, 72 where Girard is referred to as *peintre*, and 48, 69, 71, which contain references to *tableaux* painted by Girard, and 70, which contains references to Girard's acquisition of materials used for painting.

110. Among those who have attributed the panel to Girard are Martindale, 1972, 132 and E. Castelnuovo, *Il gotico internazionale in Europa*, Milan, 1966, not paginated. Most recently in Thiébaut, 1981, 370f., no. 323 reviewed the literature and the controversies surrounding this panel in the Louvre including its attribution to Girard d'Orléans, and hesitated to attribute the panel to this artist.

111. de Vaivre, 1981, 146ff.

112. Prost, 1890–91, 398.

113. See n. 104 above.

114. The documents present many indications that Girard d'Orléans acted in a supervisory capacity over artists carrying out royal commissions. Some documents contain direct statements that Girard was responsible for the work of another artist and some reveal the manner in which Girard directed and supervised the works of artists. Among such documents is the previously cited ordinance of 25 March 1356 concerning Jean Coste, who was carrying out the royal commission for the decoration of the château of Vaudreuil, cited by Delachenal, 1909, II, 374f., which states '*C'est l'ordenance de ce que je Girart d'Orleans ai traitie a fere par Jehan Coste, ou chastel du Val de Rueil, sur les ouvrages de pointure qui y sont a parfaire …* '. A *mandement* of the dauphin written at Vaudreuil on the same day, cited by Delachenal, 1909, II, 376, concerning the project at Vaudreuil states that Girard d'Orléans had visited the painting work at Vaudreuil for the dauphin and the king: '*Comme nous aiens fait aviser et viseter l'ouvrage des pointures, faites et a faire en nostre chastel du Val de Rueil, par Girart d'Orleans, pointre et huissier de sale de nostre dit seigneur et le nostre, les queles nous voulons estre parfaites le plus tost que l'en pourra, et Jehan Coste, pointre, qui a fait les dictes pointures …* '. Not only does this *mandement* show Girard d'Orléans inspecting the work for payment, but it also shows him working as an intermediary between John II, the future Charles V, and artists executing royal commisssions. In other documents Girard is charged with employing an artist — sometimes even an important one — to execute a royal commission. See for example Dufour, 1877, 66ff. where Girard is paid in 1358 for a *tablier qui fut maistre J. de Savoie fait du commandement du Roy*, and another payment to *hannequin l'orfevre … pour l'argent de 11 paires de charnieres pour tabliaux qu maistre girart fait pour le roy* and a payment in 1359 to Edouard Thadelin *pour une aune de veluyau asure des fors bailliees a mestre Girart d'Orléans, paintre*. See Dufour, 1877, 71 for the preceding and 75 for the following payment: '*Pour une clef a une serriere que maistre Girart lui a fait faire (a Hannequin l'orfevre) pour le roy …* '. Another indication of Girard's supervisory functions is the range of media with which his name is associated: furniture, drapery, painted candles, hangings, saddles, arrangements for festivals, chess pieces, goldsmith's work ordered from Hennequin, sculpture, numerous *tableaux*, and the elaborate project at Vaudreuil which in addition to panels in oils, appears to have included frescoes. For all of these see Dufour, 1877, 46–80. Finally, the titles which Girard held suggest a supervisory role: as well as *peintre du roi*, a title held by other artists including Coste, in the mandement of the dauphin of 25 March 1356, Girard is *peintre et huissier de sale de nostre dit seigneur et le nostre* which implies wider responsibilities than simply *peintre du roi*; and Dufour, 1877, 68f. cites *mandements* of John the Good in which Girard is *valet de chambre*. While Girard is almost always referred to as painter, the addition of the titles *varlet de chambre* and *huissier de sale* imply broader responsibilities and Girard's upward mobility in the hierarchy of court servants.

115. Arch. Nat., Trésor des Chartes, J. Reg. 81. 1353, 2 March, John the Good to Jean Coste. See n. 82 above.

116. Prost, 1896, 398 discovered the date of the death of Girard in the Comptes de l'Hôpital Saint-Jacques, Arch. de l'Assistance publique de Paris, August 1361; Henwood, 1980, 137–40; Dufour, 1877, 83–130.

117. Henwood, 1980, 137ff.

118. Prost, 1896, 399 citing Arch. Nat., P 2294, 117, 483, 853; Henwood, 1980, 137ff.

119. Dufour, 1877, 84–5.

120. Henwood, 1980, 137ff.

121. Henwood, 1980, 137–40.

122. Delisle, 1874, 80–1, no. 167. Also Henwood, 1980, 137, citing a letter of 24 January 1365 in Paris, BN, Coll. Clairambault, no. 214, 9549, piece no. 60 which Henwood cites from Dehaisnes, *Documents et extraits diverses*, Lille, 1883, I, 457.

123. Henwood, 1980, 137.

124. For documents showing Girard working with Hennequin the goldsmith see Dufour, 1877, 71, 75. For the sceptre see Paris: Galeries Nationales du Grand Palais, 1981, 249, no. 202 and D. Gaborit-Chopin, 1987, 80–3. Henwood, 1980, 137–40.

125. Henwood, 1980, 137–40.

126. Meiss, 1967, I, 99–118 for discussion of earlier scholarship on this question; Henwood, 1980, 137–9; Sterling, 1987, 219–44; König, 1992, 216–18; Avril, 1981, 339–41, no. 295; Avril, 1978, 30, 37, 118–9, pl. 40. The manuscript was begun by the Parement Master but left unfinished, and several subsequent campaigns are evident. Moreover, the manuscript was divided in the fifteenth century. One section that ended up in Turin was destroyed in a fire and another section known as the Milan Hours was transferred to Turin (Museo Civico) after the fire. Among the later artists to execute miniatures in the manuscript are the Limbourgs and an artist closely related to Jan Van Eyck. For a recent discussion of the complicated history of the manuscript and the attribution of the various miniatures see esp. König, 1992, *passim*.

127. Henwood, 1980, 137–9; Sterling, 1987, 219–44; König, 1992, 216–8; Meiss, 1967, I, 99–118; Avril, 1981, 339–41, no. 295; Avril, 1978, 30, 37, 118–9, pl.40.

128. Sterling, 1987, 224, citing P. Durrieu, 1907, 108.

129. Delachenal, 1909, II, *pièces justificatives* vi, 375.

130. Meiss, 1967, I, 112ff.; Sterling, 1987, 230–44.

131. Henwood, 1980, 137ff. For the origins of the Man of Sorrows in Byzantine Eucharist liturgy and its subsequent migration to the West, particularly to Rome see Hans Belting, 'An Image and Its Function in the Liturgy: The Man of Sorrows in Byzantium', *Dumbarton Oaks Papers*, 1981, 1ff.

132. There is considerable disagreement amongst experts about the date of the work of the Parement Master in this manuscript. I accept the dating of *c.* 1380 of Avril, 1981. The illustration for the Office of the Dead (p. 104) is universally recognized as the work of the Parement Master without assistants. As this scene includes a group of clergy who appear according to portrait likeness, it would seem to depict a particular funeral vigil. The coffin in this scene is surrounded by shields bearing three fleurs-de-lis. This has been identified by many scholars as the shield of Jean de Berry, which I believe is not quite accurate, for the shield with three fleurs-de-lis is that of the king of France. If Jean de Berry used it, it was in his capacity as son of the king of France, or as guardian of the young Charles VI, still a minor at the time of his accession after the death of Charles V in 1380. Charles V was the first king to use in a programmatic way the shield with three fleurs-de-lis. Raoul de Presles, in the prologue to his translation of the *City of God*, BN, MS fr. 22912, fols. 1–2, is the earliest source to celebrate the shield with three fleurs-de-lis as the sign of the Trinity, carried from God for the use of the king of France, accompanied by illustrations by the Sy Master. This funeral scene is a royal funeral, and the only royal funeral that occured during the possible dates for the work of the Parement Master in the *Très Belles Heures de Notre Dame* was that of Charles V. The young king in the scene of the Nativity (p. 42) has been identified as a portrait of Charles VI. And in this connection a treatise on the three fleurs-de-lis was written at the beginning of his reign by Etienne de Conti and another by Jean Gerson. See esp. Lombard-Jourdain, 1991, 18–24.

133. New York, Pierpont Morgan Library, MS 90, fol. 130. See ch. 6 above and Meiss, 1967, II, pl. 545.

134. The miniatures of the *Coronation Book* contain paintings of the Man of Sorrows in which the body of Christ is placed before a cross, or with drapery suspended across the front of the painting, or with two half-figures of angels in the wings. All of these motifs were conflated into the single image of the Man of Sorrows in the *Très Belles Heures de Notre Dame*.

135. This appears on a detached folio from the *Très Belles Heures de Notre Dame* that is in the Louvre, Cabinet des Dessins; see Meiss, 1967, II, pl. 37. A more common subject, like the Christ in Majesty in the section of the manuscript that was burned in the Turin Library fire (fol. 39v), is anticipated by the panel on the altar of the miniatures of the *Coronation Book* (pl. 4). And the miniature of the Coronation of the Virgin surrounded by a ring of clouds and angels in the *Très Belles Heures* is anticipated by the illustration of the Coronation of the Virgin in a manuscript of the *City of God* (Cambridge, Mass., Collection P. Hofer, MS Typ. 201, fol. 288) illustrated by the Master of the Coronation Book and his collaborator who later painted the initials and *bas de pages* of the *Trés Belles Heures*. Meiss, 1967, I, 112ff. and II, pl. 535.

136. See Henwood, 1980, 137ff.

137. Paris, BN, MS nouv. acq. lat. 3093, p. 2, Annunciation; p. 28, Visitation; and p. 56, Presentation. For these see Meiss, 1967, II, pls. 6, 7, 10.

138. For these see Meiss, 1967, II, pl. 6, Marriage of the Virgin; 14, Funeral procession; 16, Baptism; 17, Baptism; 18, Confirmation; 19, Eucharist; 20, Marriage.

139. These are especially to be found in the ceremonial scenes that are cited in the preceding note.

140. For the Master of the Coronation of Charles VI see esp. Avril, 1981, 319f. (no. 272), 326f. (no. 281), 332f. (no. 286), 339ff. (no. 295); also Avril, 1972, 95 ff.

141. Meiss, 1967, I, 112 ff.

142. Avril, 1981, 339–40, no. 295.

143. Cazelles, 1982, 536 and n. 25 citing Delisle, 1874, no. 889.

144. Given the polyvalence of the goldsmith Jean de Vaudetar who also served as Master of Moneys, it does not seem unreasonable to ask whether Jean d'Orléans the treasurer and Jean d'Orléans the *pictor regis* and *varlet de chambre* might not be the same person. For Vaudetar see the discussion that follows. Many of the *mandements* in which Jean d'Orléans' name appears shows that he ordered many of the same goods and materials and services that are associated with the documents of Girard and Jean. See e.g. Delisle, 1874, no. 717. If indeed there are two Jean d'Orléans in the household of Charles, what is their relationship? See n. 145 below.

145. See Delisle, 1874, 458, no. 889: Orig. Clairambault, Sceaux, 187, p. 6997. Charles, writing from the abbey of Chaalis, 21 May 1371: '*Jehan d'Orleans, Nous faisons translater à nostre bien amé le doyen de Rouen, maistre Nicolle Oresme, deux livrez, les quiex nous sont très necessaires et pour cause, c'est assavoir politiques et yconomiques … si gardez, sur toute l'amour que vous avez à nous et le plaisir que vous desirez nous faire, et si cher que vous doubtez encourir nostre indignacion, que en ce ne faitez faulte, quelque chevance que fere en doiez. Car ainssi li avons promis. Et pour ce que vous sachiez que ce vient de nostre conscience, nous avons en ces presentes cy dessoulx escript de nostre main … '. 'Escrit de notre main' 'Charles'.*

146. This is on page 42 of Paris, BN, MS nouv. acq. lat. 3093.

147. Delachenal, 1909, II, 278 and 281 n. 3. F. Avril, 'Une Bible historiale de Charles V', *Jahrbuch der Hamburger Kunstsammlungen*, 1970, 45–76, cites the prevalence of lions in Charles's manuscripts as a criterion for identifying the Hamburg *Bible Historiale* with Charles.

148. See Delachenal, 1909, I, 134–5 and n. 4. The ceremony took place on the Feast of the Epiphany, January 10.

149. The archbishop's residence in Paris was adjacent to the Hôtel St-Pol. The brother of William was the chamberlain of Normandy, and, given this Norman connection, William may well have participated in the installation of Charles as duke of Normandy. See Cazelles, 1982, 410f. In this connection, it is worth noting that the Trinity was especially associated with Sens since the great debate on the Trinity between Abelard and Bernard of Clairvaux which took place at Sens.

150. Among numerous manuscripts associated with Charles having a similar reinterpretation of Trinitarian imagery are the *Bible Historiale* in the Arsenal, MS 5212, the *Bible Historiale* of Jean de Vaudetar, The Hague, Museum Meermanno-Westreenianum MS 10 B 23, the *Bible Historiale* in Berlin, (Philips), the Hours of Milan, Turin, Museo Civico, fol. 87).

151. See Avril, 1981, 325–6.

152. Sterling, 1987, 238.

153. See e.g. Cazelles, 1982, 416.

154. Cazelles, 1982, 534, n. 14.

155. For all of the above see Gaborit-Chopin, 1996, 34, n. 38.

156. Gaborit-Chopin, 1996, nos. 36, 73, 254 and 437ff.

157. Cazelles, 1982, 416, 537, 550.

158. For the above see Cazelles, 1958, 79n., 90–1, 280–1, 290.

159. See e.g. Cazelles, 1958, 274–8. Also see George Holmes, *Florence, Rome and the Origins of the Renaissance*, Oxford, 1986, 175–85, 193–203. This is a vast and virtually uncharted area of study that is beyond the scope of the present book. The *mandements* include abundant references to these Italian merchant-bankers. See e.g. Delisle, 1874, nos. 151, 278, 324, 392, 395, 740, 1431, 1712–4, etc. See Gaborit-Chopin, 1996, no. 470 among many other references. The *mandements* and published registers reveal the outlines of an economic sub-system involving loans ostensibly to fund military operations and tax collection by royal officers. Some of the financial officers charged with the collection of taxes from the population of the provinces were associated with these mercantile and banking firms, and it seems to be more than coincidence that these collections coincide with payments for purchases of considerable amounts of luxurious textiles from the same Italian firms who were involved in the textile trade and banking. See Abu-Lughod, 1989, 67–70 for Italian merchant-bankers in the fairs of Champagne and for further references on this subject.

160. Bernart Belenati received an enormous payment for textiles for Charles's sacre, Delisle, 1874, no. 715; and Barthélémi Spifami, see Gaborit-Chopin, 1996, no. 470.

161. Prost, 1896, 399: '*Johannes de Aureliano, filius deffuncti magistri Gerardi de Aureliano, pictor regis … '.*

162. Prost, 1896, 395–6. *Idem*, 1897, 323–5:'*Philippus Bizuti, de Roma, pictor … Johannes, ejus filius, pictor … , Nicolaus dictus Mars, pictor … .'* This is very likely to be the Philippo Rizuti who executed the façade decoration of St John Lateran during the reign of Boniface VIII.

163. Prost, 1896, 390–5.

164. For Evrard see Prost, 1896, 393–4.

165. Prost, 1896, 390–95. First mentioned in the *taille* of Paris of 1292 as 'Evrart d'Orliens, *ymagier*', Evrard is recorded as '*Evrardus pictor, adjutor in artilleria Lupare*'. He was thus working in the Louvre during the reign of Philip the Fair and in 1305 was receiving a salary of 12 deniers per day. This arrangement continued according to accounts in the Trésor of 1322–23. He made robes for Charles IV for Pentecost and in 1326 for the coronation of Jeanne d'Evreux. In 1327 he held the title *pictor regis*. A document of 1329 cites payments that include '*le tableu des* vadia officialium regis'. In 1350 *magister Evrardus de Aurelianis, pictor domini regis* received payment for *de pluribus operibus tam picturis quam alis per ipsum factis ab anno CCCXXVIII usque ad annum CCCXL*. During this period an 'Evrart le peintre' is mentioned in connection with the

decoration of the Hôtel St-Pol. He probably died in 1356–7.

166. Prost, 1896, 393.

167. Boulogne-sur-Mer, Bibliothèque de la Ville, MS 86. Avril, 1981, 308, no. 258. For the Master of the St. George Codex see especially L.B. Kanter et al., *Painting and Illumination in Early Renaissance Florence, 1300–1500*, New York, 1995, 84–105.

Notes to Epilogue

1. Delisle, 1907, II, 40–1, nos. 226–33 bis. J. Labarte, 1879, 354, no. 3450. This is probably not the *Livre du Sacre* because the inventory states that it begins on the second folio with the word *l'église*. This is probably the same manuscript as Delisle no. 228 because both inventories indicate that the respective manuscript was given to the abbey of Saint-Denis.

2. Delisle, 1907, II, 41, no. 232, citing the inventories compiled in 1411 (inventory D, no. 743), 1413 (inventory D, no. 768), 1424 (inventory F, no. 687), and I, notice XXXII, 218–19.

3. Delisle, 1907, II, 40, no. 230.

4. I owe this observation to Janet Backhouse.

5. Legg, 1900, xxxvi. A much earlier instance of a similar error appears in the Pontifical of Pierre de Tregny, bishop of Senlis from 1350–6, Paris, Bibl. Sainte-Geneviève, MS 148, fols. 84v–92, which has what must be a scribal error where *pedes* appears instead of the word *pectes*. See Jackson, 1995, 240–7.

6. Dewick, 1899, 55–8.

7. Labarte, 1879, 352–4, no. 3450.

8. Delachenal, 1916, III, 77–81 and 169–76. He cites Arch. Nat., J. 241B., no. 47.

9. Autrand, 1994, 528–9.

10. Delachenal, 1916, III, 169–176 and Arch. Nat. J. 241B, no. 47.

11. Autrand, 1994, 528–9.

12. Delachenal, 1916, III, 173; Autrand, 1994, 528–9.

13. Autrand, 1994, 523.

14. Autrand, 1994, 528–9.

15. These events are detailed by Delachenal, 1928, IV, chs. 1–5 inclusive.

16. There are numerous reflections of the ideology of the *Coronation Book* in the writings of Christine de Pizan. In defence of Charles's actions Christine commented that the Treaty of Bretigny had been 'signed under constraint'. The lands signed away at Bretigny 'were among the most ancient possessions of *the Crown*.' Christine emphasized that Charles decided that 'a treaty bringing prejudice to the Public Good (*Bien Public*) cannot be respected, above all when such accord has been established under constraint. He convoked his Conseil and after long debate it was decided that the king of France had just cause to take up arms, and even more so because the English have not respected that which was agreed by the arti-

cles of the treaty'. The sacre according to the Ordo of Charles V with its new oaths for king, peers, barons and royal officers, had constituted the Crown and its sovereignty. Because the peers of the great apanages are asserted to have participated in that event, their participation was an affirmation of their subordination to the Crown. This was instrumental, as we have just seen, in imposing the king's authority over these domains, and thus in giving him the pretext to override the mistakes of Bretigny.

17. This is a subject that requires extensive demonstration and I hope to be able to present a fuller account of my findings in a sequel to the present study where I intend to consider the political discourse conducted by means of the illustrated translations that Charles commissioned. However, at this point I would signal that Nicole Oresme appears to have responded to the positions advanced in the Coronation Book where, for example, in his commentary on Aristotle's *Politics*, he presented arguments against the doctrine of the royal religion. See e.g. Krynen, 1993, 392–4, also 115–16 for a discussion of Oresme's defence of hereditary monarchy. Oresme excludes from participation in the body politic farmers, craftsmen and merchants, all of whom he considers insufficiently free of spirit and devoid of the necessary qualities. These same categories are also absent from the population that appears in the Coronation Book. See e.g. A.D. Menut, ed. and trans., *Maistre Nicole Oresme: Le livre de politiques d'Aristote* [Transactions of the American Philosophical Society, n.s. 60/6], Philadelphia, 1970, 137, 142, 274.

18. Raoul de Presles' positions are in line with those of Golein: both reveal themselves to be adamant defenders of the royal religion and both are proponents of the sacre as the constitutive factor in the making of the monarch. While considerable research has been carried out on Oresme, there has been no modern analysis of the political ideas of Raoul de Presles as advanced in his translation and commentary of Augustine's *City of God*. However, at this point, I would signal that some of his positions that appear to respond both to those advanced in the Coronation Book and at the same time to oppose those of Nicole Oresme are his development of the ideology of the *rex christianissimus*, his focus on the sacrality of the king realized through the sacre and anointing with the Celestial Balm, and the other celestial signs of divine prerogative such as the oriflamme and the fleurs-de-lis. See e.g. Krynen, 1993, 346–7.

19. Much of the *Songe du Vergier* is devoted to a consideration of the meaning of the sacre and of the king's anointing with the Celestial Balm. Its author does not present exactly the same interpretation as either Golein or Raoul de Presles, but rather a more extreme version of their positions. However, like them, the author of the *Songe*, presumably the jurist Evrart de Trémaugon, reveals himself to be an opponent of the positions of Nicole Oresme. See e.g. Krynen, 1993, 348–51.

20. Delisle, 1907, I, 139. See the recent study of Bedford's collections by Stratford, 1993, *passim*.

21. Stratford, 1993, 96.

22. Stratford, 1993, 91–7.

23. Dewick, 1899, x and n. 4.

343

24. For a succinct history of the duke and duchess of Bedford and their Hours see esp. Backhouse, 1990, *passim*.

25. For this manuscript see Wilson, 1910, 89–95.

26. Wilson, 1910, xiv; Brückmann, 1969, 99–115.

27. Wilson, 1910, xxx.

28. Wilson, 1910, xxvi. When Scotland came under English domination it is likely that the primate of England would have incorporated Scottish rites into his pontifical.

29. For the history of the Cotton Library see Colin G. Tite, 'The early catalogue of the Cottonian Library,' *British Library Journal*, VI, 1980, 144–57; *idem*, 'Lost, stolen or strayed. A Survey of the Mss formerly in the Cotton Library,' *British Library Journal*, 18,2, 1992, 107–48; *idem*, 'A Catalogue of Sir Robert Cotton's printed books,' *British Library Journal*, XVII, 1991; K. Sharpe, *Sir Robert Cotton, 1586–1631. History and Politics in Early Modern England*, Oxford, 1979.

30. I have followed the spelling in the manuscript.

31. See Janet Backhouse, 'Sir Robert Cotton's Record of a Royal Bookshelf,' *British Library Journal*, 18, 1992, 44–52; James P. Carley, 'The Royal Library as a source for Robert Cotton's Collection, a preliminary list of acquisitions,' *British Library Journal*, 18, 1992, 52–73; Colin Tite, 'The Early Catalogues of the Cottonian Library,' *British Library Journal*, 6, 1980, 144–57;

Notes to Catalogue

1. The evidence is considered above in chapters 2 and 3.

2. Delachenal, 1916, III, 88f. citing *Grandes Chroniques*, VI, 233.

3. Dewick, 1899, notice for plates 1 and 2.

4. Schramm, 1938, 24f. and Jackson, 1984, 207f.

5. Delachenal, 1909, I, 54ff. and 57 citing *Grandes Chroniques*, VI, 1.

6. Delachenal, 1916, III, 14ff.

7. See also below notice for plate 12.

8. Dewick, 1899, notice for pl. 3 and Avril, 1978, 93, who identified the figure as the bishop of Reims rather than the bishop of Laon.

9. There is conflicting testimony about which episcopal peers were present. Golein, ed. Jackson, 1969, 312 and n. 54 gives Reims, Laon, Langres, Beauvais, Chalons, Noyons which are those which appear in the text of the Ordo of Charles V. The miniatures show only Reims, Laon, Beauvais, and perhaps Noyon is one of the bishops with a reliquary hanging from his neck as the text of the ordo specifies. See Delachenal, 1916, III, 88.

10. See Chs. 2 and 3 for further discussion of the oath and references.

11. See Ch. 3.

12. See Ch. 2 and Andrieu, 1953, 22-73, Battifol, 1923, 732-63.

13. See Ch. 2 and Andrieu, 1940, III, 376.

14. Golein, ed. Jackson, 1969, 315 (fol. 48).

15. Jeanne de Bourbon's father, Duke Pierre de Bourbon was killed in the Battle of Poitiers. See Delachenal, 1909, I, 240 and *Grandes Chroniques*, VI, 33.

16. Schramm, 1938, 24f.and 27ff; Jackson, 1984, 207 ff.

17. Delachenal, 1916, III, 102, n.1. cites the *Grandes Chroniques*, VI, 234.

18. Schramm, 1938, 24f.

19. See also pls. 13, 15, 18, 19-23, 27, 28.

20. Delachenal, 1916, III, 85 noted the resemblance of the sword to the double-edged sword called the "sword of Charlemagne" in the Louvre that was used for coronations since the twelfth century. Ladner, 1941, 111ff. and Bullough, 1975, 242ff.

21. See Guillaume de Nangis, *Histoire de Philippe III*, ed. Daunou et Naudet (*Recueil des historiens des Gaules et de la France*, XX), Paris, 1840, 88; Gaborit-Chopin, 1987, 64-72.

22. Golein, ed. Jackson, 1969, 310f. (fol. 46).

23. Dewick, 1899, notice for plate 11.

24. Golein, ed. Jackson, 1969, 314 (fol. 48) and n. 66.

25. Delachenal, 1909, I, 57 cites Paris, Bibl. Nat. MS fr. 20684, fol. 211.

26. Delachenal, 1916, III, 11-6 for Anjou's efforts to assert his rights as the heir to Charles V immediately prior to the coronation.

27. Golein, ed. Jackson, 1969, 316 (fol. 49).

28. See Andrieu, 1940, III, 378, no. 17 and 381 no. 25 line 10 and no. 27 line 15 for comparable segments in the episcopal consecration in the *Pontifical of Durandus*.

29. Dewick, 1899, xi reconstructed the lost text in this hiatus using the text of John Selden, Titles of Honor, 2nd ed. London, 1631, 236 copied from the *Coronation Book* before the loss of these folios.

30. Schramm, 1938, 42ff. noted that this ritual was performed for the first time at the coronation of Charles V, but he overlooked the fact that this ritual was an innovation of that Ordo derived from the consecration of a bishop in the Pontifical of Durandus. See Andrieu, 1940, III, 427-46 and 374-93. See above Chapter 3.

31. e.g. Compare with Andrieu, 1940, III, 390 (lines 7-15).

32. Golein, ed. Jackson, 1969, 317 (fol. 49v) and 323f. (fols. 54-4v).

33. For the prayer for the delivery of the gloves in the episcopal sacre see e.g. Andrieu, 1940, III, 390 (lines 7-15).

34. See Andrieu, 1953, 54ff; Batiffol, 1923, 753 ff.; Kantorowicz, 1957, 222 and n. 84.

35. Bouman, 1957, 129ff.; Andrieu, 1953, 54-9.

36. See e.g. Golein, ed. Jackson, 1969, 314 and 318.

37. Bouman, 1957, 130 n.3.

38. Bouman, 1957, 129f.; The origin of the episcopal ring in the Gallican liturgy is also attested to by Isidor of Seville. Andrieu, 1953, 54-9.

39. Hincmar's revision of the episcopal consecration included a ring for the king and bishop. See esp. Andrieu, 1953, 54-59 and Battifol, 1923, 753ff. For the ring in the Pontifical of Durandus see Andrieu, 1940, III, 385-6.

40. See Gaborit-Chopin, 1987, 71-83.

41. See Montesquiou-Fezensac, 1973-7, I-II, #116 and III 79ff; Gaborit-Chopin, 1975, 74-9; idem., in Paris. Galeries Nationales, *1981, nos. 202, 248. For the importance of Charlemagne see esp. Cazelles, 1982, 529f. and Folz, 1976.*

42. Pinoteau, 1956, 12f.

43. Dewick, 1899, col. 35. Pinoteau, 1956, 12ff.

44. Gaborit-Chopin, 1987, 76-7.

45. Golein, ed. Jackson, 1969, 314.

46. Pinoteau, 1956, 15.

47. Andrieu, 1953; Bouman, 1957, 129ff.

48. Compare Dewick, 1899, 34 and Andrieu, 1940, III, 385 (lines 14-7)

49. Delachenal, 1909, I, 1.

50. For Trinitarian themes elsewhere in the ceremony, the ring, the anointing, the crowning are accompanied with prayers invoking the Trinity. Golein, ed. Jackson, 1969, esp. 322f.(fols. 53-4, emphasizes the Trinitarian references of the sacre.

51. e.g. Delachenal, 1916, III, 88. He is not mentioned by the *Grandes Chroniques*, VI, 233.

52. Delachenal, 1916, III, 89, and n. 2 cites Arch. du Pas-de-Calais, A. 708.

53. See esp. Pinoteau, 1972.

54. Gaborit-Chopin, 1987, 85-103.

55. Gaborit-Chopin, 1987, pl. 23.

56. Christine de Pizan, ed. Solente, II, 186ff. Cazelles, 1982, 568.

57. See above ch. 3 for the king's cathedra.

58. Dewick, 1899, col. 13, (fol. 42).

59. Delachenal, 1916, III, 88f.

60. Dewick, 1899, 15.

61. Bouman, 1957, 140, n.3.

62. Dewick, 1899, notice for pl. 25. For the throne see Schramm, 1954-6, 326-31.

63. For Roman imperial and Byzantine practice of raising the new emperor on a shield see Ostrogorsky, 1955, 246-56; Nelson, 1976, 98-120; Bouman, 1957, 139f.

64. Bouman, 1957, 138ff.

65. Golein, ed. Jackson, 1969, 310 (fol. 45).

66. Golein, ed. Jackson, 1969, 310 (fol. 45).

67. Golein, ed. Jackson, 1969, 310 (fol. 45).

68. Bouman, 1957, 138ff.; Nelson, 1976, 98-120.

69. Bouman, 1957, 139.

70. Schramm, 1937; Bouman, 1957, 140.

71. Schramm, 1937, 141ff.; see also above, ch. 3.

72. See above ch. 3.

73. Dewick, 1899, (fol. 41).

74. 3. Golein, ed. Jackson, 320 (fol. 51).

75. Delachenal, 1909, III, 93. M. Bloch, 1924.

76. Golein, ed. Jackson, 315 (fol. 48) and 316 (fol. 49).

77. Delachenal, 1916, III, 93, followed by Sherman, 1977, 273.

78. Delachenal, ed. *Les Grandes Chroniques de France: Chronique des règnes de Jean II et de Charles V*, I, 3.

79. *Grandes Chroniques*, VI, 233 mentions only one woman, the countess of Flanders and Artois. Delachenal, III, 60 n.1, 92ff. and 100 identified the woman in widow's garb as the countess of Flanders and not as Dewick believed, the widow of Pierre de Bourbon, the queen's mother. Delachenal identified the countess of Flanders as Marguerite de France, dowager Countess of Flanders and mother of Louis of Male. She received two counties of Artois and Burgundy in the succession of her grand-nephew Philippe of Rouvre.

80. Sherman, 1977, 269, 291ff. emphasizes this prayer and its significance in defining the queen's importance for bearing and educating royal children.

81. Golein, ed. Jackson, 1969, 323 states that no woman comes so close to the priestly status.

82. Schramm, 1938, 8ff.

83. For the sceptre and rod see Pinoteau, 1956; idem. 1972, 13f. 155n.78; B. de Montfaucon, *Les Monuments de la monarchie francoise*, 5 vols., Paris, 1729-1733, I pl. 3; B. de Montesquieu-Fezensac and D. Gaborit-Chopin, 1973, 46 n. 4 and no.l 87, 168f. Sherman, 1977, 279 reports that Golein, ed. Jackson, 1969, 319 states "le ceptre un petit mendre que celui du roi".

84. As a rule the abbess, like an abbot, carried a baculum as a symbol of her ministerium. See "Abbesses," *New Catholic Encyclopedia*, I, 8.

85. Pinoteau, 1972, 305-12, 351, 362, 381, 399. The crowns are described in an inventory of Saint-Denis. See also Sherman, 1977, 282.

86. Gaborit-Chopin, 1987, pl. 19.

87. For the Judith Ordo see Schramm, 1938, 8ff.

88. Dewick, 1899, col., 44f.

89. See above ch. 5.

90. See above notice for plate 29.

91. Contamine, 1973, 228-9.

92. Contamine, 1973, 197-210.

93. See Contamine, 1973, 223.

94. For the oriflamme see Contamine, 1973, *passim*; Cazelles, 1982, 428 and 484.

95. For this see Beaune, 1985, 254.

96. See Contamine, op.cit.

Select Bibliography

Bibliographic references are cited in an abbreviated form throughout the text by name and date.
Listed here are publications both referred to more than once in this study and some, not cited, but consulted
and of relevance to research for this book.

Abu-Lughod, Janet L.
Before European Hegemony. The World System
A.D. 1250–1350, Oxford, 1989.

Alexander, Jonathan J.G.
The Decorated Letter, New York, 1978.

– *Medieval Illuminators and their Methods of Work*,
New Haven, 1992.

Alletz, Pons.
Cérémonial du sacre des rois de France, Paris, 1775.

Allmand, C.
The Hundred Years War: England and France at
War c. 1300–1450, Cambridge, 1988.

Andrieu, M.
Les Ordines romani du haut moyen-âge, 5 vols.,
Louvain, 1931–61

– *Le Pontifical romain au moyen-âge*, 4 vols. [Studi e
Testi, 88], Vatican City, 1938–41.

– `Le sacre épiscopal d'après Hincmar de
Rheims', *Revue d'histoire ecclésiastique* 48, 1953,
22–73.

Anselme de Sainte-Marie, Pierre (de Guibors).
Histoire généalogique et chronologique de la maison
royale de France, 3rd ed., 9 vols., Paris, 1726
(repr. 1967).

Autrand, Françoise.
Charles V, Paris, 1994.

– `La succession à la couronne de France et les or-
donnances de 1374', in Joel Blanchard ed., 1995,
25–32.

Avril, François, ed., 1968. See Paris, Bibliothèque
Nationale.

Avril, François.
`Un chef-d'oeuvre de l'enluminure sous le
règne de Jean le Bon: *la bible moralisée*
manuscrit français 167 de la Bibliothèque
nationale', *Monuments Piot* 58, 1972, 89–125.

– *Manuscript Painting at the Court of France: The*
Fourteenth Century (1310–1380), New York,
1978.

– `Manuscrits', in Paris. Galeries Nationales du
Grand Palais, 1981, 276–362.

– `Les Manuscrits enluminés de Guillaume de
Machaut. Essai de chronologie', in *Guillaume de*
Machaut. Colloque (Reims, 19-22 Avril, 1978).
Actes et Colloques 23 (C.N.R.S.), Paris, 1982,
117–33.

Bak, Janos M., ed.
Coronations. Medieval and Early Modern Monar-
chic Ritual, Berkeley, 1990.

Bapst, G.
`Les enlumineurs Jean de Montmartre
(1339–53), Jean de Wirmes (1349), Jean Susanne
(1350–56) et Guillaume Chastaignes', *Archives*
historiques, artistiques, et littéraires 2, 1880–1,
177–9.

– *Testament du Roi Jehan le Bon et inventaire de ses*
joyaux publié d'après deux manuscrits inédits des
archives nationales, Paris, 1884.

Barbeu de Rocher, A.
`Ambassade de Pétrarque auprès de Jean le
Bon', *Mémoires présentées à l'Académie des In-*
scriptions et Belles-Lettres, 2nd series, no. 3, 1854,
172–288.

Barnes, Jonathan, ed.
The Cambridge Companion to Aristotle, Cam-
bridge, 1995.

Baron, Françoise.
`Enlumineurs, peintres et sculpteurs parisiens
des XIIIe et XIVe siècles, d'après les rôles de la
taille,' *Bulletin archéologique du Comité des*
travaux historiques et scientifiques n.s. 4, 1969,
37–121.

– `Enlumineurs, peintres et sculpteurs parisiens
du XIVe et XVe siècles d'après les archives de
l'hôpital Saint-Jacques-aux-Pèlerins', *Bulletin*
archéologique du Comité des travaux historiques et
scientifiques n.s. 6, 1970–1, 77–115.

– `Sculpture', in Paris. Galeries Nationales du
Grand Palais, 1981, 55–166.

Barraclough, G.
The Medieval Papacy, New York, 1968 (repr.
1972).

Barry, Françoise.
Les Droits de la reine sous la monarchie française
jusqu'en 1789, [University of Lille PhD thesis],
Paris, 1932.

– *La Reine de France*, Paris, 1965.

Barthes, Roland.
`Histoire et sociologie du vêtement. Quelques observations méthodologiques', *Annales. Économies, sociétés, civilisations* 12(3), 1957, 430–41.

– *Système de la Mode*, Paris, 1967.

Batiffol, Pierre.
`La liturgie du sacre des évêques', *Revue d'histoire ecclésiastique* 23, 1923, 733–63.

Bautier, Robert-Henri.
`Sacres et couronnements sous les Carolingiens et premiers Capétiens', *Annuaire-Bulletin de la Société de l'Histoire de France*, 1987 (publ. 1989), 7–56.

Beaune, Colette.
Naissance de la nation France, Paris, 1985.

Bell, Catherine.
Ritual Theory. Ritual Practice, Oxford, 1992.

Belting, Hans.
`An Image and its Function in the Liturgy: The Man of Sorrows in Byzantium', *Dumbarton Oaks Papers* 34–5, 1981, 1–16.

– *Likeness and Presence. A History of the Image before the Era of Art*, trans. E. Jephcott, Chicago, 1994.

Benson, Robert, and Constable, Giles, eds.
Renaissance and Renewal in the Twelfth Century, Cambridge, Mass., 1982.

Berger, Samuel.
La Bible française au moyen âge, Paris, 1884.

Berlière, Ursmer.
Lettres de Clement VI (1342–1352) [Analecta Vaticano-Belgica, 6], Rome, 1924.

Bischoff, Bernhard.
Latin Palaeography. Antiquity and the Middle Ages, trans. D.O. Croinin and D. Ganz, Cambridge, 1990.

Blanc, Odile.
`Historiographie du vêtement: un bilan. *Le Vêtement. Histoire, archéologie et symbolique vestimentaire au Moyen Age*, intro. Michel Pastoureau, Paris, 1989.

Blanchard, Joel, ed.
Représentation, pouvoir et royauté à la fin du moyen âge, Paris, 1995.

Bloch, Marc.
Les Rois thaumaturges: étude sur le caractère surnaturel attribué à la puissance royale particulièrement en France et en Angleterre [Publications de la Faculté des Lettres de l'Université de Strasbourg, no. 19], Strasbourg, 1924.

– *The Royal Touch: Sacred Monarchy and Scrofula in England and France*, trans. J.E. Anderson, Montreal, 1973.

Bober, H.
`The Coronation Book of Charles IV and Jeanne d'Evreux', in *Rare Books; Notes on the History of Old Books and Manuscripts Published for the Friends and Clients of H.P. Kraus*, 8.3, 1958, 1–12.

Bonne, Jean-Claude.
`The Manuscript of the Ordo of 1250 and its Illuminations', in Bak ed., 1990, 58–72.

Bossuat, Robert.
`Raoul de Presles', *Histoire littéraire de France*, 40, 1973, 33–40.

Bouchot, Henri.
Inventaire des dessins executés par Roger de Gaignières et conservés aux Départments des Estampes et des Manuscrits de la Bibliothèque Nationale, Paris, 1891.

– 1904(1). See Paris, Musée du Louvre, 1904.

– 1904(2).
Les Primitifs français 1292-1500. Complément documentaire au catalogue officiel de l'exposition, Paris, 1904.

Bouman, Cornelius A.
Sacring and Crowning: The Development of the Latin Ritual for the Anointing of Kings and the Coronation of an Emperor before the Eleventh Century [Bijdragen van het Instituut voor Middeleeuwse Geschiedenis der Rijksuniversiteit te Utrecht, 30], Groningen, 1957.

Bourdieu, P.
`Sur le pouvoir symbolique', *Annales. Economies, sociétés, civilisations* 32(3), 1977, 405–11

Boureau, Alain.
`Pierre de Jean Olivi et l'émergence d'une théorie contractuelle de la royauté au XIIIe siècle', in Blanchard ed., 1995, 65–75.

Branner, Robert.
Manuscript Painting in Paris During the Reign of Saint Louis: A Study of Styles, Berkeley/Los Angeles/London, 1977.

Braun, Joseph S.J.
Die liturgische Gewandung im Occident und Orient. Nach Ursprung und Entwicklung Verwendung und Symbolik, Freiburg-im-Breisgau, 1907.

Brightman, F.E.
`Byzantine Imperial Coronations', *Journal of Theological Studies* 2, 1901, 353–92.

Brown, Elizabeth A.R.
`Royal salvation and the needs of the state in late Capetian France', *Order and Innovation in*

the *Middle Ages. Essays in Honor of J.R. Strayer*, eds. W.C. Jordan, B. McNab and T. Ruiz, Princeton, 1976, 365–79.

– `Franks, Burgundians and Aquitanians and the Royal Coronation Ceremony in France', *Transactions of the American Philosophical Society* 82, 1992, 15–30.

Brückmann, John J.
`The Ordines of the Third Recension of the Medieval English Coronation Order', *Essays in Medieval History presented to Bertie Wilkinson*, eds. T.A. Sandquist and M.R. Powicke, Toronto, 1969, 99–115.

Bullough, Donald.
`*Imagines Regum* and their Significance in the Early Medieval West', in *Studies in Memory of David Talbot Rice*, eds. Giles Robertson and George Henderson, Edinburgh, 1975.

Byrne, Donal.
`Manuscript Ruling and Pictorial Design in the Work of the Limbourgs, the Bedford Master, and the Boucicaut Master', *The Art Bulletin* 66, 1984, 118–36.

Byvanck, A.W.
Les Principaux Manuscrits à peintures de la Bibliothèque Royale des Pays-Bas et du Musée Meermanno-Westreenianum à la Haye [Société française de reproduction de manuscrits à peintures], Paris, 1924.

Calmette, Joseph.
Charles V, Paris, 1945.

Cannadine, D. and Price, S., eds.
Rituals of Royalty, Cambridge, 1987.

Carolus-Barré, L.
`Le Cardinal de Dormans, Chancelier de France', *Mélanges d'archéologie et d'histoire de l'Ecole française de Rome* 52, 1935, 314–48.

Castelnuovo, Enrico.
Un pittore italiano alla corte di Avignone: Matteo Giovannetti e la pittura in Provenza nel secolo XIV, Turin, 1962.

Cazelles, Raymond.
Société politique et la crise de la royauté sous Philippe de Valois, Paris, 1958.

– `Une exigence de l'opinion depuis Saint-Louis: la réformation du royaume', *Annuaire-Bulletin de la Société de l'Histoire de France* 92–4, 1962–3.

– `L'argenterie de Jean le Bon et ses comptes', *Bulletin de la Société des Antiquaires de France*, 1966, 51–62.

– `Le Portrait de Jean le Bon au Louvre', *Bulletin de la Société des Antiquaires de France*, 1971, 227–9.

– 1978(1). `Peinture et actualité sous les premiers Valois — Jean le Bon ou Charles dauphin', *Gazette des Beaux-Arts* 92, 1978, 53–65.

– 1978(2). `Les trésors de Charles V', *Académie des Inscriptions et Belles-Lettres. Comptes rendus*, 1978, 214–25

– *Société politique, noblesse et couronne sous les règnes de Jean le Bon et Charles V* [Mémoires et documents publiés par la société de l'Ecole des Chartes, 28], Geneva/Paris, 1982.

Chenu, M.-D.
Nature, Man and Society in the Twelfth Century. Essays on New Theological Perspectives in the Latin West, eds. and trans. J. Taylor and L.K. Little, Chicago, 1968.

Clausel de Coussergues, J.-Cl.
Du Sacre des rois de France et des rapports de cette auguste cérémonie avec la constitution de l'Etat aux différens âges de la monarchie, Paris, 1825.

Cochin, Henry.
`Pétrarque et les rois de France', *Annuaire-Bulletin de la Société de l'Histoire de France*, 1917, 127–46.

Contamine, Ph.
`L'oriflamme de Saint-Denis aux XIVe et XVe siècles. Etudes de symbolique religieuse et royale', *Annales de l'Est* ser. 5, 25 année, 1973, 179–250.

David, Marcel.
`Le Serment du sacre et son évolution de la fin du XIIe à la fin du XVe siècle', *Revue du Moyen Age Latin* 6, 1950, 5–272.

– *Le Serment du sacre du IXe au XVe siècle. Contribution de l'étude des limites juridiques de la souveraineté*, Paris, 1958.

Delachenal, Roland, ed.
Chronique des règnes de Jean II et de Charles V, 3 vols., Paris,.
1910–20 (I. 1350–64, 1910; II. 1364–80, 1916; III. Continuation, appendix, 1920).

Delachenal, Roland.
Histoire de Charles V, 5 vols., Paris, 1909–31.

Delaissé, Louis M.J.
Brussels, the Royal Library of Belgium: Medieval Miniatures from the Department of Manuscripts, New York, 1965.

Delisle, Leopold, ed.
Mandements et actes divers de Charles V (1364–1380) recueillis dans les collections de la Bibliothèque nationale … Collection de documents inédits sur l'Histoire de France 35, Paris, 1874.

Delisle, Leopold.
Recherches sur la librairie de Charles V, 2 vols., Paris, 1907.

Déprez, E., Mollat, G. and Glénisson, J.
Clement VI (1342–52). Lettres closes, patentes et curiales se rapportant à la France, 3 vols. (in 6 fasc.) [Bibliothèque des Ecoles françaises d'Athènes et de Rome, ser. 3, 3], Paris, 1901–60.

Désportes, P.
Reims et les rémois aux XIIIe et XIVe siècles, Paris, 1979.

Dewick, E.S.
The Coronation Book of Charles V of France (Cottonian MS Tiberius B. VIII), Henry Bradshaw Society 16, London, 1899.

Douët d'Arcq, Louis.
Comptes de l'argenterie des rois de France au XIVe siècle [Société de l'Histoire de France], Paris, 1851.

– *Nouveau recueil de comptes de l'argenterie des rois de France* [Société de l'Histoire de France], Paris, 1874.

Dufour, Valentin.
Une famille de peintres parisiens aux XIVe et XVe siècles. Documents et pièces originales, Paris, 1877.

Dunbabin, J.
`The reception and interpretation of Aristotle's *Politics*', in Kretzmann, Kenny and Pinborg, eds., 1983.

Durrieu, Paul.
`La peinture en France de Jean le Bon à Charles V (1350–1380)', in André Michel, *Histoire de l'Art* III.1, Paris, 1907, 101–37

Eichmann, E.
`Königs- und Bischofsweihe', in *Sitzungsberichte der Bayerisches Akademie der Wissenschaft, Philosophisches-philologisches und historisches Klasse* 6, 1928, 26ff.

Ellard, G.
Ordination Anointings in the Western Church before 1000 A.D. [Medieval Academy of America Monographs, 8], Cambridge, Mass., 1933.

Elze, R.
Die Ordines für die Weihe und Krönung des Kaisers und der Kaiserin [Monumenta Germaniae Historica Fontes iuris germanici antiqui, 9], Hanover, 1960.

– `Königskrönung und Ritterweihe. Der burgundische Ordo für die Weihe und Krönung des Königs und der Königin', in Fuhrmann, 1984, 327–42.

Enright, Michael J.
Iona, Tara and Soissons [Arbeiten zur Frühmittelalterforschung, 17], Berlin, 1985.

Epstein, Steven A.
Wage, Labor and Guilds in Medieval Europe, Chapel Hill, NC, 1991.

Erdmann, C.
Forschungen zur politischen Ideenwelt des Frühmittelalters, Berlin, 1951.

Facinger, Marion.
`A Study of Medieval Queenship: Capetian France, 987–1237', *Studies in Medieval and Renaissance History* 5, 1976, 1–47.

Fasolt, C.
Council and Hierarchy. The Political Thought of William Durant the Younger, Cambridge, 1991.

Fisher, J.D.C.
Christian Initiation; Baptism in the Medieval West, London, 1965.

Focillon, Henri.
Le Peintre des Miracles de Notre-Dame, Paris, 1950.

Folz, R.
Le Souvenir et la légende de Charlemagne dans l'empire germanique médiéval [Publications de l'Université de Dijon, 7], Paris, 1950.

Friend, A.M.
`Two Manuscripts of the School of Saint-Denis', *Speculum* 1, 1926, 59–70.

Froissart, Jean.
Chronique, ed. S. Luce. Société de l'histoire de France, Paris, vol. 5: 1356–60, 1874; vol. 6: 1360–66, 1876.

Fuhrmann, Horst. 1984.
`Rex canonicus — rex clericus?', in *Institutionen, Kultur und Gesellschaft im Mittelalter. Festschrift für Josef Fleckenstein zu seinem 65 Geburtstag*, eds. Lutz Fenske, Werner Rösener and Thomas Zotz, Sigmaringen, 1984, 321–6.

Gaborit-Chopin, Danielle.
`Le baton cantoral de la Sainte-Chapelle', *Bulletin monumental* 132, 1975, 67–81.

Gaborit-Chopin, Danielle, ed.
Regalia. Les Instruments du sacre des rois de France [Monographies des Musées de France], Paris, 1987.

– *L'inventaire du trésor du dauphin futur Charles V. 1363*, Nogent-le-Roi, 1996.

Gaborit, J.R.
`Les statues de Charles V et de Jeanne de Bourbon au Louvre: une nouvelle hypothèse', *Revue du Louvre* 31, 1981, 237–45.

Gaspar, C., and Lyna, F.
Les Principaux Manuscrits à peintures de la Bibliothèque Royale de Belgique, 2 vols., Paris, 1937.

Géraud, H., ed.
Chronique de Guillaume de Nangis et de ses continuateurs, 2 vols. [Societé de l'histoire de France], Paris, 1843

Giesey, Ralph E.
The Juristic Basis of the Dynastic Right to the French Throne [Transactions of the American Philosophical Society, 51(5)], Paris, 1961.

Godefroy, Théodore.
Le Cérémonial françois, Paris, 1619.

– Le Cérémonial françois, enlarged edition publ. by Denys Godefroy, 2 vols., Paris, 1649.

Golein. See Jackson, 1969.

Grandes Chroniques. See Paris, 1836–38.

Guillaume de Nangis. See Géraud, 1843.

Guillemain, B.
La Cour pontifical d'Avignon 1309–1376, Paris, 1966.

Hallam, Elizabeth.
Capetian France 987–1328, London, 1980.

Hedeman, Anne D.
`Valois Legitimacy: Editorial Changes in Charles V's Grandes Chroniqes de France', The Art Bulletin 66(1), 1985, 97–117.

– `Restructuring the Narrative: the Function of Ceremonial in Charles V's Grandes Chroniques de France', Studies in the History of Art 16, 1985, 171–81.

– `Copies in Context: The Coronation of Charles V in His Grandes Chroniques de France', in Bak ed., 1990, 72–87.

– The Royal Image: The Illustrations of the `Grandes Chroniques de France' 1274–1422, Berkeley/Los Angeles, 1991.

Henwood, Philip.
`Jean d'Orléans, peintre des rois Jean II, Charles V, et Charles VI (1361–1407)', Gazette des Beaux-Arts 95, 1980, 137–40.

Hohler, Christopher.
`Some Service Books of the Later Saxon Church', Tenth Century Studies, ed. D. Parsons, London, 1975, 60–83, 217–27.

Hughes, A.
`The Origins and Descent of the Fourth Recension of the English Coronation', in Bak ed., 1990, 197–216.

Imbach, Ruedi.
Dante. La Philosophie et les laïcs. Initiations à la philosophie médiévale, Paris/Fribourg, 1996.

Instinsky, Hans U.
Bischofsstuhl und Kaiserthron, Munich, 1955.

Jackson, Richard A.
`The Traité du Sacre of Jean Golein', Proceedings of the American Philosophical Society 113, 1969, 305–24.

– `Les manuscrits des ordines de couronnement de la bibliothèque de Charles V, roi de France', Le Moyen Age 82, ser. 4, 1976, 67–88.

– Vive le Roi!: A History of the French Coronation Ceremony from Charles V to Charles X, Chapel Hill, 1984.

– `Les ordines des couronnements royaux au moyen-âge', in Le Sacre des rois, 1985, 63–74.

– Ordines Coronationis Franciae: Texts and Ordines for the Coronation of Frankish and French Kings and Queens in the Middle Ages, Philadelphia, 1995.

John of Paris.
On Royal and Papal Power, trans. and intro. J.A. Watt, Toronto, 1971.

Kahr, M.
`Jean le Bon in Avignon', Paragone 197, 1966, 3–16

Kantorowicz, Ernst H.
Laudes Regiae: A Study in Liturgical Acclamations and Mediaeval Ruler Worship, Berkeley/Los Angeles, 1946 (2nd ed. 1958).

– The King's Two Bodies. A Study on Medieval Political Theology, Princeton, 1957.

Keller, Hagen.
`Herrscherbild und Herrschaftslegitimation zur Deutung der ottonischen Denkmaler', Frühmittelalterlichen Studien 19, 1985, 290–311.

König, Eberhard.
Les Très Belles Heures de Notre-Dame de Jean, duc de Berry. Manuscrit nouv. acq. lat. 3093, Bibliothèque Nationale, Paris, Lucerne, 1992.

Kretzmann, N., Kenny, A. and Pinborg, J., eds.
The Cambridge History of Later Medieval Philosophy, Cambridge, 1982.

Krynen, Jacques.
L'empire du roi. Idées et croyances politiques en France, XIIIe-XVe siècle, Paris, 1993.

Kuttner, Stephen.
`The Revival of Jurisprudence', in Benson and Constable eds., 1982, 299–323.

Labarte, J.
Inventaire du mobilier de Charles V roi de France [Collection de documents inédits sur l'histoire de France, 3e série: archéologie], Paris, 1879.

Laborde, L. de.
Les Ducs de Bourgogne, 3 vols., Paris, 1849–51.

Laclotte, Michel, and Thiébaut, Dominique.
L'Ecole d'Avignon, Paris, 1983.

Ladner, Gerhart.
Die Päpstbildnisse des Altertums und des Mittelalters [Monumenti di antichità cristiana pubblicati dal Pontificio Istituto di Archeologia Cristiana, II ser. IV], 2 vols., Vatican City, 1970.

Lambert, Malcolm.
The Cathars, Oxford, 1998.

Leber, J. M. C.
Des Cérémonies du sacre, ou recherches historiques et critiques sur les moeurs, les coutumes, les institutions et le droit public des français dans l'ancienne monarchie, Paris/Reims, 1825.

Leber, Constantin.
Collection des meilleures dissertations, notices et traités particuliers relatifs à l'histoire de France, vol. xix, Paris, 1838.

Legg, John Wickham.
Three Coronation Orders, Henry Bradshaw Society 19, London, 1900.

Legg, Leopold G. Wickham.
English Coronation Records, London, 1901.

Le Goff, J.
`A Coronation Program for the Age of Saint Louis: The Ordo of 1250', in Bak ed., 1990, 46–57.

Le Goff, J.
`Le Ritual symbolique de la vassalité', in J. Le Goff, *Pour un autre moyen âge. Temps, travail et culture en Occident*, Paris, 1977, 349–420.

Le Goff, J.
Saint Louis, Paris, 1996.

Lehugeur, P.
L'Histoire de Philippe le Long, Roi de France (1316–1322), Paris, 1897.

Le Noble, Alexandre.
Histoire du sacre et du couronnement des rois et reines de France, Paris, 1825

Leroquais, Victor.
Les Pontificaux Manuscrits des bibliothèques publiques de France, 4 vols., Paris, 1937.

Leroy, G.
`Le livre du sacre des rois ayant fait partie de la librairie de Charles V au Louvre actuellement conservé au British Museum à Londres', *Bulletin historique et philologique du Comité des travaux historiques et scientifiques*, 1896, 613–25.

Le Sacre des rois [Actes du colloque international d'histoire sur les sacres et couronnements royaux, Reims, 1975], Paris, 1985.

Lesage, Robert.
Vestments and Church Furniture, trans F. Murphy, New York, 1960.

Lewis, Andrew W.
Royal Succession in Capetian France: Studies on Familial Order and the State, Cambridge, Mass., 1981.

– *Le Sang royal. La famille capétienne et l'Etat. France, Xe-XIe siècles*, Paris, 1986.

Little, Lester.
Religious Poverty and the Profit Economy in Medieval Europe, Ithaca, 1978.

Lombard-Jourdain, Anne.
`A propos de Raoul de Presles. Documents sur l'homme', *Bibliothèque de l'Ecole des Chartes*, 1981, 191–207.

– *Fleurs de lys et oriflamme. Signes célestes du royaume de France*, Paris, 1991.

Lot, F. and Fawtier, R.,.
Histoire des institutions françaises au Moyen Age, 3 vols., Paris, 1957–62.

Lot, F.
`Quelques mots sur l'origine des pairs de France', *Revue historique* 54, 1893, 3–28.

Luce, Siméon, ed.
Chronique des quatre premiers Valois (1327–1393), Société de l'histoire de France VI, Paris, 1862.

Luchaire, Achille.
Histoire des institutions monarchiques en France sous les premiers Capétiens (987–1180), 2 vols., 2nd ed., Paris, 1891.

– *Manuel des institutions françaises; période des Capétiens directs*, Paris, 1892.

MacCormack, Sabine G.
Art and Ceremony in Late Antiquity, Berkeley, 1981.

Magistretti, M., ed.
Pontificale in usum ecclesiae Mediolanensis, Milan, 1897.

Martène, Edmond.
De antiquis ecclesiae ritibus, 4 vols., 2nd ed., Antwerp, 1736.

– *De antiquis ecclesiae ritibus*, 4 vols., 3rd ed., Venice, 1788.

Martin, H.
La miniature française du XIIIe au XVe siècles, Paris/Brussels, 1923.

Martindale, Andrew.
The Rise of the Artist in the Middle Ages and Early Renaissance, New York, 1972.

– *Simone Martini. Complete Edition*, Oxford, 1988.

Mayo, Janet.
A History of Ecclesiastical Dress, New York, 1984.

351

Mayr-Harting, Henry.
The Coming of Christianity to Anglo-Saxon England, 3rd ed., University Park, PA, 1972, repr. 1991.

Mayr-Harting, Henry.
Ottonian Book Illumination. An Historical Study, 2 vols., London, 1991.

McCue, J.
`The Doctrine of Transubstantiation from Berengar through Trent,' *Harvard Theological Review* 61, 1968, 385–430.

McKitterick, Rosamond.
The Frankish Church and the Carolingian Reforms, 789–895, London, 1977.

– *The Frankish Kingdoms under the Carolingians*, Harlow/New York, 1983.

Meiss, Millard.
French Painting in the Time of Jean de Berry, I. The Late Fourteenth Century and the Patronage of the Duke, 2 vols., London/New York, 1967.

Menin, M.
Traité historique et chronologique du sacre et couronnement des rois et reines de France, Paris, 1723.

Menut, Albert D., ed.
Maistre Nicole Oresme: Le livre de politiques d'Aristote [Transactions of the American Philosophical Society, n.s 60/6], Philadelphia, 1970.

Metz, René.
La Consécration des vierges dans l'église romaine, Paris, 1954.

Millar, E.G.
Souvenir de l'exposition de manuscrits français à peintures organisée à la Grenville Library (British Museum) en janvier-mars 1932. Etude concernant les 65 manuscrits exposés [Société française de reproductions de manuscrits à peintures], Paris, 1933.

Mirot, L.
`Note sur un tableau de la Sainte Chapelle', *Bulletin de la Société Nationale des Antiquaires de France*, 1913, 271–8.

– `La colonie lucquoise à Paris au XIIIe et au XIVe siècle', *Bibliothèque de l'Ecole des Chartes* 88, 1927, 50–86.

Mitchell, L.
Baptismal Anointing, London, 1966.

Molin, Jean-Baptiste, and Mutembe, Protais.
Le rituel du mariage en France du XIIe au XVIe siècle, Paris, 1974.

Mollat, G.
`Philippe de Valois et son fils, Jean, duc de Normandie', *Bibliothèque de l'Ecole des Chartes* 116, 1958, 209ff.

– *Les Papes d'Avignon (1305–1378)*, 9th ed. rev., Paris, 1950.

Montfaucon, B. de.
Les Monuments de la monarchie française, 5 vols., Paris, 1729–33.

Montesquiou-Fezensac, Blaise de, Gaborit-Chopin, D.
Le Trésor de Saint-Denis: Inventaire de 1634, 3 vols., Paris, 1973–7.

Moranvillé, H.
`Extraits de journaux du Trésor', *Bibliothèque de l'Ecole des Chartes* 49, 1888, 149–214, 368–437.

Morris, Joan.
The Lady was a Bishop. The Hidden History of Women with Clerical Ordination and the Jurisdiction of Bishops, Toronto, 1973.

Mundy, John.
Europe in the High Middle Ages, 1150–1309, London, 1973.

– `Urban Society and Culture', in Benson and Constable eds., 1982, 229–48.

Nainfa, A.
Costume of Prelates of the Catholic Church according to Roman Etiquette, Baltimore, 1909.

Nelson, Janet.
`Symbols in Context: Ruler's Inauguration Rituals in Byzantium and the West in the Early Middle Ages', in *The Orthodox Churches and the West* [Studies in Church History, 13], ed. Derek Baker, Oxford, 1976, 98–120.

– `Kingship, law and liturgy in the political thought of Hincmar of Rheims', *The English Historical Review* 363, 1977, 241–79 (repr. Nelson ed., 1986, 132–71).

– `The Earliest Surviving Royal Ordo: Some Liturgical and Historical Aspects', in *Authority and Power: Studies on Medieval Law and Government Presented to Walter Ullmann on His Seventieth Birthday*, Cambridge, 1980, 29–48.

– `The Second English Ordo', in *Politics and Ritual in Early Medieval Europe*, ed. Janet Nelson, London, 1986, 361–71.

– `Hincmar of Reims on King-making: The Evidence of the *Annals of St. Bertin*', in Bak ed., 1990, 16–34.

– `Early medieval rites of queen-making and the shaping of medieval queenship', in *idem, Rulers and Ruling Families in Early Medieval Europe. Alfred, Charles the Bald and Others* [Variorum Collected Studies Series, CS657], Aldershot, 1999 (in press).

Newton, Stella M.
Fashion in the Age of the Black Prince, Woodbridge, 1981.

Nicol, D.M.
`Kaisersalbung: The Unction of Emperors in Late Byzantine Coronation Ritual', *Byzantine and Modern Greek Studies* 2, 1976, 37–52.

Oppenheimer, Francis.
The Legend of the Sainte Ampoule, London, 1953.

Ordonnances.
Ordonnances des rois de France de la troisième race, 22 vols., Paris, 1723–1849.

Ostrogorsky, G.
`Zur Kaisersalbung und Schilderhebung im spätbyzantinischen Krönungszeremoniell', *Historia* 4, 1955, 246–56.

Ott, Joachim.
Krone und Krönung. Die Verheissung und Verleihung von Kronen in der Kunst von der Spätantike bis zum 1200 und die geistige Auslegung der Krone, Mainz, 1998.

Pächt, Otto.
`The Avignon Diptych and its Eastern Ancestry', in *De artibus opuscula: Essays in honor of Erwin Panofsky*, ed. M. Meiss, New York, 1961, 402–21.

– *Book Illumination in the Middle Ages*, London, 1986.

Pange, Jean de.
Les rois très chrétiens, Paris, 1949.

– `Le Sacrement de Reims', *Recueil de travaux offert à Clovis Brunel*, 2 vols. [Société de l'Ecole des Chartes, 2], 1955, 349–54.

Panofsky, Erwin.
Early Netherlandish Painting. Its Origins and Character, 2 vols., Cambridge, Mass., 1953.

Paris, Paulin, ed.
Les Grandes Chroniques, 6 vols., Paris, 1836–38.

Paris. Bibliothèque Nationale.
La Librairie de Charles V, exh. cat., Paris, 1968.

Paris. Galeries Nationales du Grand Palais.
Les Fastes du gothique, exh. cat., Paris, 1981.

Paris. Musée du Louvre.
L'Exposition des primitifs français. La Peinture en France sous les Valois, exh. cat, Paris, 1904.

Parsons, John Carmi, ed..
Medieval Queenship, New York, 1993.

Perroy, E.
The Hundred Years War, trans. W.B. Wells, London, 1965.

Petrarca, Francesco.
Epistolae Seniles, IX, in *Francesci Petrarchae Florentini Opera Omnia*, Basle, 1554.

Pinoteau, Hervé.
`Quelques réflexions sur l'oeuvre de Jean du Tillet et la symbolique royale française', *Archives héraldiques suisses* 70, 1956, 1–24 (repr. Pinoteau, 1982, 100–40).

– `L'ancienne couronne française dite `de Charlemagne' (ll80?–1794)', *Bulletin du Vieux Papier* 243–5, 1972, 305–12, 351–62, 381–99 (repr. Pinoteau, 1982, 375–430).

– `Tableaux français sous les premiers Valois', *Cahiers d'héraldique* 2, 1975, 120–76.

– *Héraldique capétienne*, 2nd ed., Paris, 1979.

– *Vingt-cinq années d'études dynastiques*, Paris, 1982.

Pisan (Pizan), Christine de.
Le livre des faiz et bonnes meurs du sage roy Charles V, ed. S. Solente, 2 vols., Paris, 1936–40.

– *Le Livre des faits et bonnes moeurs du roi Charles V le Sage*, trans. Eric Hicks and Thérèse Moreau, Paris, 1997.

Porcher, Jean .
L'Enluminure française, Paris, 1959.

Porter, H.B.
`The Origin of the Medieval Rite for Anointing the Sick or Dying', *Journal of Theological Studies* n.s. 7, 1956, 211ff.

Poulet, André.
`Capetian Women and the Regency: the Genesis of a Vocation'. See Parsons ed., 1993, 79–116.

Power, D.
The Eucharistic Mystery, New York, 1992.

Pradel, P.
`Art et politique sous Charles V', *Revue des Arts*, 1951, 89–93.

Price, S.R.F.
Rituals and Power. The Roman Imperial Cult in Asia Minor, Cambridge, 1984.

Prost, Bernard.
`Quelques documents sur l'histoire des arts en France', *Gazette des Beaux-Arts* 1, 1887, 322–30.

– `Liste des artistes mentionnés dans les Etats de la Maison du Roi du XIIIe siècle à 1500', *Archives historiques, artistiques et litteraires* 1, 1889, 425.

– `Mélanges artistiques', *Archives historiques, artistiques et littéraires* 2, 1890–1, 37–40 (`Jean Coste peintre des rois Jean II et Charles V'), and 81–92 (`L'auteur probable du portrait du roi Jean').

– `Recherches sur les *peintres du roi* antérieurs au règne de Charles VI', in *Etudes d'histoire du moyen âge dediées à Gabriel Monod*, Paris, 1896, 387–403.

Puller, F.W.
The Anointing of the Sick in Scripture and Tradition, London, 1904.

Quillet, Jeannine.
La philosophie politique du Songe du Vergier: 1378; Sources doctrinales, Paris, 1977.

– *Charles V, le roi lettré*, Paris, 1984.

Renna, Thomas.
`Aristotle and the French Monarchy, 1260–1303', *Viator. Medieval and Renaissance Studies* 9, 1978, 309–24.

Richardson, H.G. and Sayles, G.O.
`Early Coronation Records', *Bulletin of the Institute of Historical Research* VIII (1935–36), 129–45 and IV (1936–37), 1–9, 145–8

Richardson, H.G.
`The English Coronation Oath', *Speculum* 24, 1949, 44–75.

– `The Coronation in Medieval England: The Evolution of the Office and the Oath' *Traditio* 16, 1960, 1111–202.

Robinson, J.A.
`The Coronation in the Tenth Century', *Journal of Theological Studies* 19, 1918, 56–72.

Rouche, Michel.
Clovis, Paris, 1996.

Rouse, R.H. and Rouse, M.A.
Manuscripts and their Makers. Commercial Book Producers in Medieval Paris 1200–1500. 2 vols., London, 2000.

Saffroy, Gaston.
Bibliographie généalogique, héraldique et nobiliaire de la France. Des origines à nos jours, Paris, 1636 (repr. 1968).

Santantoni, A.
L'Ordinazione episcopale. Storia e teologia dei riti dell' ordinazione nelle antiche liturgie dell'occidente, Rome, 1976.

Sawyer, P. and Woods, I., eds.
Early Medieval Kingship, Leeds, 1977.

Sayers, Jane.
Innocenzo III (1198–1216), Rome, 1997 (trans. of *Innocent III. Leader of Europe 1198–1216*, New York, 1994).

Schimmelpfennig, Bernhard.
`Papal Coronations in Avignon', in Bak ed., 1990, 179–96.

Schmidt, G.
`Review of C.R. Sherman, *The Portraits of Charles V of France (1338-1380)* New York, 1969', *Zeitschrift für Kunstgeschichte* 82, 1971, 82.

Schramm, Percy Ernst.
A History of the English Coronation, trans. L.G. Wickham Legg, Oxford, 1937 (trans. of *Geschichte des englischen Königtums im Lichte des Krönung*, Weimar, 1937).

– `Ordines-Studien II: Die Krönung bei den Westfranken und den Franzosen', *Archiv für Urkundenforschung* 15, 1938, 3–55.

– *Herrschaftszeichen und Staatssymbolik: Beiträge zu ihrer Geschichte vom dritten bis zum sechzehnten Jahrhunderts* [Monumenta Germaniae Historica, Schriften 13], Stuttgart, 3 vols., 1954–6.

– *Der König von Frankreich. Das Wesen der Monarchie vom 9. zum 16. Jahrhundert. Ein Kapitel aus der Geschichte des abendländischen Staates*, 2nd ed., 2 vols., Weimar, 1960 (1st ed. 1939).

– *Kaiser, Könige und Päpste*, 4 vols., Stuttgart, 1968–71.

Schnerb-Lièvre, M. ed.
Le Songe du Vergier. Etude et édition, 2 vols. [Positions des thèses de l'Ecole des Chartes], Paris, 1982.

Selden, John.
Titles of Honor, 2nd ed., London, 1631 (3rd ed. 1672).

Sherman, Claire R.
The Portraits of Charles V of France (1338–1380) [Monographs on Archaeology and the Fine Arts Sponsored by the Archaeological Institute of America and the College Art Association of America, 20], New York, 1969.

– `Representations of Charles V of France (1338–1380) as a Wise Ruler', *Medievalia et Humanistica* n.s. 2, 1971, 83–96.

– `The Queen in Charles V's *Coronation Book*: Jeanne de Bourbon and the *Ordo ad Reginam Benedicendam*', *Viator. Medieval and Renaissance Studies* 8, 1977, 255–98.

– `Taking a Second Look: Notes on the Iconography of a French Queen, Jeanne de Bourbon (1338–1378)', *Feminism and Art History: Questioning the Litany*, eds. N. Broude and M.D. Garrard, New York, 1982, 101–17.

– *Imaging Aristotle. Verbal and Visual Representation in Fourteenth-Century France*, Berkeley, 1995.

Shils, E.
`The Meaning of the Coronation', *Center and Periphery. Essays in Macrosociology*, ed. E. Shils, Chicago, 1975, 135–52.

Spiegel, Gabrielle M.
`The *Reditus Regni ad Stirpem Karoli Magni*. A New Look', *French Historical Studies* 7, 1971–2, 145–74.

– `The Cult of Saint Denis and Capetian Kingship', *Journal of Medieval History* 1, 1975, 43–69.

– *The Chronicle Tradition of Saint-Denis: A Survey*, Brookline/Leiden, 1978.

– *Romancing the Past: The Rise of Vernacular Prose Historiography in Thirteenth-Century France*, Berkeley and Los Angeles, 1993.

Staerk, Antonio, O.S.B.
Les Manuscrits latins du Ve au XIIIe siècles conservés à la Bibliothèque Impériale de Saint Petersbourg, 2 vols., St Petersburg, 1910.

Sterling, C. and Adhémar, H.
Musée du Louvre. Peintures, école française, XIVe, XVe, et XVIe siècles, Paris, 1969.

Sterling, Charles.
La Peinture médiévale à Paris 1300–1500, I, Paris, 1987.

Stratford, Jenny.
The Bedford Inventories. The Worldly Goods of John, Duke of Bedford, London, 1993.

Sturdy, David.
`"Continuity" versus "Change": Historians and English Coronations of the Medieval and Early Modern Periods', in Bak ed., 1990, 228–46.

Sumption, Jonathan.
The Hundred Years War. Trial by Battle, Philadelphia, 1990.

Temple, Elzbieta.
A Survey of Manuscripts Illuminated in the British Isles. II, *Anglo-Saxon Manuscripts 900–1066*, London, 1976.

Thiébaut, Dominique.
`Peinture', in Paris. Galeries Nationales du Grand Palais, 1981, 363–78.

Thomas, Antoine.
`Un Manuscrit de Charles V au Vatican. Notice suivi d'une étude sur les traductions françaises de Bernard Gui', *Mélanges d'archéologie et d'histoire* 1, 1881, 259–83.

Thomas Aquinas.
On the Government of Rulers (On Kingship), rev. and trans. Gerald Phelan, Toronto, 1949.

Turner, David H.
The Claudius Pontificals, Henry Bradshaw Society 97 (issued for 1964), London, 1971.

Treitinger, Otto.
Die oströmische Kaiser und Reichsidee nach ihrer Gestaltung im höfischen Zeremoniell, Jena, 1938 (2nd ed. Darmstadt, 1956).

Ullman, Walter.
The Carolingian Renaissance and the Idea of Kingship, London, 1969.

Vaivre, J.-B. de.
`Sur Trois primitifs français du XIVe siécle et le portrait de Jean le Bon', *Gazette des Beaux-Arts* 97, 1981, 131–56.

Valensise, Marina.
`Le Sacre du roi: stratégie symbolique et doctrine politique de la monarchie française', *Annales. Economies, sociétés et civilisations*, 1986, 543–77.

Varin, Pierre.
Archives administratives de la ville de Reims. Collection de pièces inédites pouvant servir à l'histoire des institutions dans l'intérieur de la cité, vols. I-III, Paris, 1839–48.

Vernet, A., ed.
Histoire des bibliothèques françaises. Les bibliothèques médiévales du VIe siècle à 1530, Paris, 1989.

Viard, J.
Documents parisiens du règne de Philippe VI de Valois. I. 1328–1333, and II. 1339–1350 [Société de l'Histoire de Paris], Paris, 1899–1900.

– *Les journaux du Trésor de Philippe VI de Valois, suivis de l'ordinarium thesauri de 1338–9*, Paris, 1899.

Viard, J. ed.
Les Grandes Chroniques de France [Société de l'histoire de France], 10 vols., Paris, 1920–53.

Viollet, P.
Histoire des institutions politiques et administratives de la France, 4 vols., Paris, 1890–1912 (repr. 1966).

– `Comment les femmes ont été exclues en France de la succession à la couronne', *Mémoires de l'Académie des Inscriptions et Belles-Lettres* 34, 1895, 125–78.

Vivier, R.
`La grande ordonnance de février 1351. Les mesures anticorporatives et la liberté du travail', *Revue historique* 138, 1921, 207ff.

Vogel, Cyrille and Elze, Reinhard, eds.
Le Pontifical romano-germanique du dixième siècle, 2 vols. [Studi e Testi, 226–7], Vatican City, 1963.

Vogel, Cyrille.
`Les rites de la célébration du mariage: leurs significations dans la formation du lieu durant le haut moyen âge', *Settimane Spoleto* 24, 1977, 299–466.

Wallace-Hadrill, J.M.
The Long-Haired Kings, London, 1962.

– *Early Germanic Kingship*, Oxford, 1971.

Walter, C.
`Raising on a Shield in Byzantine Iconography',
Revue des études byzantines 33, 1975, 133–75.

Ward, Paul L.
`The Coronation Ceremony in Medieval England', *Speculum* 14, 1939, 160–78.

– `An Early Version of the Anglo-Saxon Coronation Ceremony', *English Historical Review* 57, 1942, 345–61.

Warner, G.F.
Illuminated Manuscripts in the British Museum, series I-IV, London, 1903.

Warner, G.F. and Gilson, J.P.
Catalogue of Western Manuscripts in the Old Royal and King's Collections, 2 vols., London, 1921.

Welte, B.
Die Postbaptismale Salbung, Freiburg-im-Breisgau, 1939.

Wilkinson, B.
`The Coronation of Edward II', in *Historical Essays in Honour of James Tait*, eds. J.G. Edwards, V.H. Galbraith and E.F. Jacob, Manchester, 1933, 405–16.

– `The Coronation Oath of Edward II and the Statute of York', *Speculum* 19, 1944, 445–69.

– `Notes on the Coronation Records of the Fourteenth Century', *English Historical Review* 70, 1955, 581–600.

Williams, S.S.
`An Author's role in fourteenth-century book production: Guillaume de Machaut's *livre ou je mets toutes mes choses*', *Romania* 90, 1969, 433–54.

Williman, P.
Le Racional des divins offices. An introduction and partial edition [Unpublished PhD thesis, University of North Carolina, Chapel Hill], 1967

Wilson, H.A.
Benedictional of Archbishop Robert, Henry Bradshaw Society 24, London, 1903.

– *The Pontifical of Magdalen College*, Henry Bradshaw Society 39, London, 1910.

Wintersig, A.
`Zur Königinenweihe', *Jahrbuch für Liturgiewissenschaft* 5, 1925, 150–3.

Wood, Charles.
`Queens, Queans and Kingship. An Inquiry into theories of Royal legitimacy in late medieval England and France', *Order and Innovation in the Middle Ages. Essays in Honor of Joseph R. Strayer*, eds. W.C. Jordan, B. McNab and T. Ruiz, 1976, 385–400.

Wood, Diana.
Clement VI. The Pontificate and Ideas of an Avignon Pope, Cambridge, 1989.

Wrigley, J.
`Clement VI before his Pontificate: the Early Life of Pierre Roger, 1290/91–1342', *Catholic Historical Review* 56, 1970, 433–71.

Zahlten, Johannes.
Creatio Mundi. Darstellungen der sechs Schöpfungstage und Naturwissenschaftliches Weltbild im Mittelalter [Stuttgarter Beiträge zur Geschichte und Politik], Stuttgart, 1979.

Zeller, Gaston.
`Les rois de France, candidats à l'Empire: Essai sur l'idéologie impériale en France', *Revue historique* 173, 1934, 273–311, 497–534.

List of Illustrations

357

Index of Manuscripts

General Index

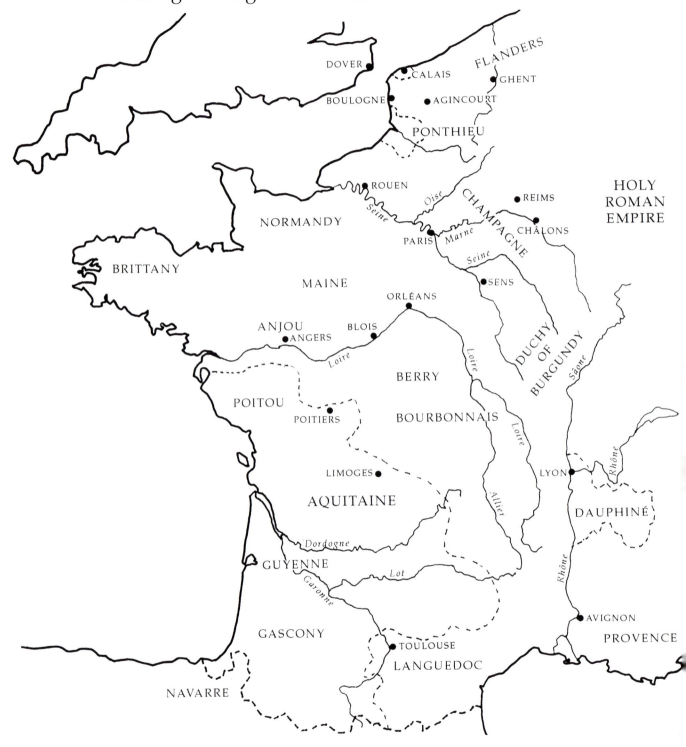

Map of France
during the reign of Charles V

DOVER

CALAIS

FLANDERS

GHENT

BOULOGNE

AGINCOURT

PONTHIEU

ROUEN

Oise

CHAMPAGNE

REIMS

HOLY
ROMAN
EMPIRE

NORMANDY

Seine

PARIS

Marne

CHÂLONS

Seine

SENS

BRITTANY

MAINE

ORLÉANS

DUCHY
OF
BURGUNDY

Saône

ANJOU

BLOIS

ANGERS

Loire

BERRY

Loire

POITOU

BOURBONNAIS

POITIERS

Loire

LYON

Rhône

LIMOGES

Allier

DAUPHINÉ

AQUITAINE

Dordogne

Lot

GUYENNE

Garonne

Rhône

AVIGNON

GASCONY

TOULOUSE

PROVENCE

LANGUEDOC

NAVARRE